Frames of Reference

Art, History, and the World

Janet Marquardt & Stephen Eskilson

Frames of Reference

Art, History, and the World

Janet Marquardt & Stephen Eskilson

Boston Burr Ridge, IL Dubuuque, IA Madison, WI New York San Francisco St. Louis
Bangkok Bogotá Caracas Kuala Lumpur Lisbon London Madrid Mexico City Milan
Montreal New Delhi Santiago Seoul Singapore Taipei Toronto

Higher Education

Frames of Reference

Published by McGraw-Hill, an imprint of The McGraw-Hill Companies, Inc., 1221 Avenue of the Americas, New York, NY 10020. Copyright © 2005 McGraw-Hill. All rights reserved. No part of this publication may be reproduced or distributed in any form or by any means, or stored in a database or retrieval system, without the prior written consent of The McGraw-Hill Companies, Inc., including, but not limited to, in any network or other electronic storage or transmission, or broadcast for distance learning.

10 9 8 7 6 5 4 3 2 1

ISBN 0-07-282948-6

Publisher Christopher Freitag
Senior sponsoring editor Joseph Hanson
Editorial assistant Torrii Yamada
Marketing manager Lisa Berry
Field publisher Zina Craft
Media producer Shannon Gattens
Senior supplements producer Louis Swaim

This book was designed and produced by Laurence King Publishing Ltd, London
www.laurenceking.co.uk

Design Andrew Lindesay
Maps Advanced Illustration
Picture research Julia Ruxton

Printed in China

Library of Congress Cataloging-in-Publication Data

Marquardt, Janet, 1953-
 Frames of reference : art, history, and the world / Janet Marquardt & Stephen Eskilson.
 p. cm.
 Includes bibliographical references and index.
 ISBN 0-07-282948-6
 1. Art--History. I. Eskilson, Stephen, 1964- II. Title.

N5300.M28 2003
709--dc22

 2003061511

www.mhhe.com

On the cover

FRONT Edouard Manet, *Portrait of Emile Zola*, 1868. Oil on canvas, 4ft 9½ ins x 3ft 8⅞ ins. Musée d'Orsay, Paris.

BACK Kunisada Utagawa, *The Actor Bando Hikosaburo*, published 1850. Color woodblock print. Private collection.

Cover art Manet's portrait of his friend, the art critic, collector, and novelist, Emile Zola, encapsulates the spirit that lies behind *Frames of Reference*, exploring as it does cross-cultural influences in the arts, across time and place: Zola, the writer, holds an art history text in his hand, and just visible on his desk is a small pamphlet he wrote about Manet's works. Above him is a study for Manet's own painting, *Olympia* (see fig. 6.33), which itself refers to the long Western tradition of reclining female nudes. Tacked up alongside this is a copy of a painting by the Spanish artist, Velázquez, and a Japanese *ukiyo-e* print similar in style to the *The Actor Bando Hikosaburo* by Kunisada Utagawa (see back cover and fig. 6.27). The cross-cultural influences are amply demonstrated: clearly influenced by the *ukiyo-e* form, Manet employs the shallow space and cut-off shapes of the Japanese prints so popular in his era. Moreover, in their turn, the landscape works of Kunisada reveal his knowledge of Western perspective techniques.

Contents

1 The Earth as Art — 2

2 Representations of the Gods — 24

3 The Art of Rulers — 50

Introduction

The rationale behind *Frames of Reference* is to introduce students to some key issues to consider when looking at art. Each chapter focuses on a limited number of significant art-historical examples illustrating the chapter's theme. The chapters are generally chronologically ordered, and relevant comparisons with artworks outside the main framework of each chapter are introduced to suggest broader application of these themes.

The strength of a thematically organized book lies in its ability to make connections between cultures and time periods. However, this strength creates some challenges: it is impossible to treat so wide a subject as the history of art comprehensively in a single volume. In designing *Frames*, we are not attempting either to analyze any given era or to consider all major art movements exhaustively. Rather, we have designed this volume not only to stand alone as a thought-provoking guide to many important issues in art history, but also to serve as a complement to standard surveys, of which there are many admirable examples available. The text's themes allow instructors to address representative questions of style, authorship, patronage, politics, and national identity in specific time frames, all supported with high quality color and black-and-white illustrations. When appropriate, we also focus on the relationship of race, social class, and gender to the production of art.

Any project such as this must acknowledge the existence of a canon of art history. The art historical canon is a group of works that are considered important by a majority of scholars and the public. However, far from being judged on a set of definitive criteria, the canon has been formed by many different factors. Some people erroneously believe that the canon is based simply on an empirical scale of artistic greatness. While this is at times the case, artworks also become a part of the canon because they are especially good examples of a certain national style, an important part of a famous artist's career, or because they illustrate a significant historical moment. Works may also enter the canon because they are part of a notable collection or have been written about by an influential scholar. Once ensconced in the canon, works are then more likely to be included in art history books (like this one), ensuring their continuing significance to the discipline. It is important to remember that the art historical canon is never permanently fixed. It is, in fact, constantly changing, as the views of scholars, collectors, and the general public shift and shift again. For example, the Mexican Surrealist painter Frida Kahlo, who is now an important part of the canon, was virtually unknown two decades ago. Our text may in some small way itself affect the canon, for instance, by bringing more attention to some lesser-known contemporary artists.

Frames of Reference also considers how art history came to be a discipline and which institutions played important roles in establishing the boundaries of artistic production. Considering the authors' Western education, the book's place of publication and intended public, our text is necessarily grounded in a Western viewpoint. The field of art history was conceived in Western Europe as a study of the style and subject matter of art as a means of evaluating the great works, many of them originally commissioned by wealthy patrons. Concomitantly, most of the themes

presented here privilege the art of large-scale societies that devoted substantial resources to cultural production. Readers will find that Asian and Western examples predominate to a certain degree.

It is important to acknowledge the violence done to non-Western cultures during the last six centuries. Artifacts with profound meaning to indigenous societies were lifted out of their context and became objects of curiosity in Western collections. As we attempt to fit the artistic production of non-Western peoples into our notions of "art" and "decoration," it is often possible to see close similarities in the purpose, meaning, or function of the works. When these coincidences fit one or more of the general themes selected as introductory art history topics here, we have been able to fulfill our goal of making connections between cultures and time periods. However, we have tried not to force examples of non-Western visual artwork into the book. Instead, we have aimed to select only the most cogent examples of "world art" that support the book's themes.

Students and instructors are encouraged to explore more art, more cultures, and more themes on their own, both in and outside the classroom. To aid this study, we have provided two forms of stimulus: the boxed insets and the discussion topics (a detailed Instructor's Manual and a customizable anthology of readings is also available for educators). Insets have a number of functions—they can serve to define specialized terms, to give historical background, to relate interesting anecdotes, or to introduce examples from societies or time periods not covered in a given chapter that suggest new applications of the principal theme. Similarly, the topics for discussion facilitate classroom debate whereby students can reassess the material and consider the themes in relation to their own lives and experiences.

Because of our belief that education ought to be a process of inquiry rather than submission to received wisdom, our implicit goal is to develop students' appreciation of our examples by showing interesting intersections between the viewpoints of critics, artists, and historians. We feel the best learning takes place when students can engage in the process of investigation with their instructor. In a classroom setting, *Frames* is meant to raise questions and foster discussion. Instructors and students may agree or disagree with our point of view. It is our hope that the text will serve to provoke dialogue and inspire the reader's critical thinking. To this end, we have included specific recommendations for further reading at the end of each chapter and at the conclusion of the book there is a bibliography that provides more information on the subjects covered and that also stands as a survey of relevant scholarship. We have relied extensively on these sources and acknowledge our debt to their authors. We encourage readers with constructive criticisms of our work to communicate them to us through our publishers, via email to <art@mcgraw-hill.com>.

Synopsis *Chapter 1: The Earth as Art*
Ranging across the globe and through millennia, chapter 1 demonstrates the broadest possible theme. It begins with the creation of sacred or artistic space in the landscape through the earliest structural forms that are termed architecture: the mounds and

henges in Neolithic Britain. Next, it examines examples of similar constructions from Japan and North America and, more briefly, of those from the ancient Mesoamerican city of Teotihuacán and the ziggurats of Mesopotamia. From this preliterate notion of using the earth as a medium for artistic expression, we move to the American landscape and its role in American culture as a symbol of national heritage. Representative of the book's thematic approach, the chapter ends with a discussion of twentieth-century artists who were inspired by these early examples and returned to the landscape itself as their canvas.

Chapter 2: Representations of the Gods
The representation of religious deities, one of the universal—and most controversial—subject matters of artistic imagery, is the subject of chapter 2. Three primary religious traditions serve to illustrate the similarities and differences among representations of the gods in world cultures. Using the precedents of Mediterranean antiquity as a springboard, we follow the conception of the Greek gods and their fusion with Judaic tradition to form Christian imagery. We then move east to India where we briefly introduce Hindu traditions as a background to the representation of the Buddha and its development in East Asian Buddhism. Within these presentations, interesting similarities emerge between the young male gods of rather distant societies: the Greek Apollo, European Christ, and Asian Buddha. Finally, Aztec Mexico provides examples of how figural representation could be combined with hybrid animal forms to evoke terrifying deities.

Chapter 3: The Art of Rulers
The third chapter investigates another central subject of artistic expression: the artwork made for rulers. It starts with a discussion of the Middle East, where conflicts over territory have determined the didactic use of art for millennia, focusing on the ancient predecessors of Iraq and Iran. Next, we move to the continent of Africa with an overview of royal commissions from the earliest Egyptians through some of the sub-Saharan cultures of more recent centuries. Returning to the West, we offer a survey of Roman imperial imagery that continues from the discussion of Early Christian art in the previous chapter and leads into the artworks of the kings of the Middle Ages. Boxed insets offer additional examples from Ottoman and Hawaiian rulers. Finally, the ambitious temples built by Southeast Asian dynasties show the fusion of expressions of temporal power with sacred space—comparable to the structures discussed in chapter 1.

Chapter 4: Pilgrimage
People have always traveled to broaden their own experience. Traditionally, one of the strongest reasons for traveling has been to visit sacred sites on pilgrimages, primarily as a religious quest but increasingly to see the works of art that were made to encourage such endeavors. Chapter 4 considers the sacred temples of the Greeks, the Early Christian commemorations of important sites in Christ's life, and then the most powerful manifestation of the pilgrimage phenomenon, the cult of relics in medieval Europe. In the subsequent development of the Islamic faith, elements of the Christian pilgrimage were incorporated, but applied without the same proliferation of didactic

imagery. The design of the Dome of the Rock mosque in Jerusalem refers to elements from Jewish and Christian sites in the same city as part of the ruler's message to both Muslim and non-Muslim pilgrims.

Chapter 5: Patrons and the Role of the Artist

For students of art history, there are important questions to be asked about the interaction between the artist and the patrons who commission the artwork. This pivotal relationship has often determined the collective status of artists and their roles in society. Chapter 5 opens with a discussion of the legendary patronage of the Benin kings, followed by two key developments on opposite sides of the globe: Chinese Song and Ming dynasty painting, and Italian Renaissance art. New Ireland, Mughal India, and absolutist France provide further contrasting examples.

Chapter 6: Art and Collecting

Centered on the influence of artistic collecting strategies, chapter 6 brings together several threads from other chapters. It was primarily through the exchange of artworks, whether as gifts, purchases, or spoils, that influences passed between cultures and the first collections were conceived. Since our working definition of art history begins with European collectors who both documented and tried to explain their acquisitions, chapter 6 is chiefly concerned with the various European manifestations of collecting which stand as the precursors of today's museums and galleries. This chapter also directly addresses the phenomenon of art as a spoil of war. After a consideration of the influence of Japanese artists on European art of the nineteenth centuries, the chapter concludes with an account two of the world's most renowned modern collections.

Chapter 7: Art and Revolution in the Modern World

In chapter 7 we look at art produced during times of great social conflict. Examples are drawn from some of the best-known and influential revolutions of recent history: those in eighteenth- and nineteenth-century France, the eighteenth-century War of Independence in the United States, and the conflicts in twentieth-century Mexico, Russia, and China. The notion of "revolution" is applied not only to political battles between social forces, but also to concurrent radical changes in artistic style and vision.

Chapter 8: Utopia and Dystopia

Carrying the notion of change even further, chapter 8 revolves around art that suggests utopian visions for new societies. Beginning where chapter 7 left off, with avant-garde artists in late nineteenth-century France and the subsequent concentration of artists in the "School of Paris," it alternates between an exploration of "primitivist" visions of the past and idealized fantasies of the future.

Chapter 9: Art, the Spirit World, and the Inner Mind

The final two chapters consider art that broadens the definition of artistic function and meaning. Chapter 9 surveys various manifestations of art as a medium for expressing spiritual or inner realms. Moving beyond the metaphorical religious art discussed in

earlier chapters, we introduce the ephemeral art of Australia and the American Navaho tribe as well as the doll-like objects that are treated as living presences in a diverse group of societies. Northwest-Coast American masks and garments show the power granted artistic objects to change human wearers into other beings. Next, we examine the extraordinary impact in the West of psychoanalysis alongside the rejection of traditional artistic meaning in certain styles of modern European art.

Chapter 10: Identity in Contemporary Art
Finally, in chapter 10 we consider the recent interest in issues of artistic identity and show how this realm has been opened up to questions of gender, race, sexual orientation, and multiculturalism. We hope that readers will ponder all these concerns as they continue to explore the history of art.

Acknowledgments

This has been a long project with many parts. We are grateful to numerous people for their suggestions and assistance in their reviews of the manuscript in its various stages, especially: Peter Chametzky, Southern Illinois University; David Darst, Florida State University; Linda Frickman, Colorado State University; Lynn Galbraith, University of Arizona; Marion J. de Koning, Grossmont College; Thomas Larson, Santa Barbara City College; John C. Lavezzi, Bowling Green State University; James Murley, Elizabethtown Community College; Robert S. Petersen, Eastern Illinois University; Robyn Roslak, University of Minnesota, Duluth; John F. Scott, University of Florida; Malia Serrano, Grossmont College; Susan Smallwood Herold, University of Northern Colorado; Michael Stone, Cuyahoga Community College. Their expertise and insights were often brilliant. Any remaining errors are our own.

At Laurence King Publishing, we have had the most professional and helpful editors in the business: Lee Ripley Greenfield, Kara Hattersley-Smith, and Jessica Spencer. Without their remarkable commitment, this book would never have come together. We are also very happy to thank Julia Ruxton (picture research) and Andrew Lindesay (designer) who took our ideas and made them look so sharp. Likewise, we enjoyed working with the team at McGraw-Hill, including Joe Hanson and Torrii Yamada.

Janet Marquardt would also like to thank Brad Nickels, who was a crucial partner on the initial idea and sample chapters; Kenneth Lapatin, Daphne Rosenzweig, and Ioli Kalavrezou for advice; Otto-Karl Werckmeister for rigorous pedagogical training; the Chauche family for many years of hospitality during study in France; her family and friends who cheered her on. This work is dedicated to her father, Wallace W. Marquardt, whose support has made all things possible.

Stephen Eskilson would also like to thank Jordi Friedman, Kermit Champa, and Dietrich Neumann, as well as all of his terrific colleagues at the Eastern Illinois University Art Department. This work is dedicated to his family.

Pedagogy

Elements and Approaches to Art History

This illustrated 8-page introduction (pp. 351–59) provides the beginning art historian with an overview of the fundamental tools to assess and analyze works of art. Familiar words, such as form, line, and color, have specific meanings when applied to artworks, and these are explored, with reference to works discussed in the main text. The principal styles employed by artists are illustrated, and there is a survey of different media available to artists, ranging from painting, to sculpture, architecture, photography, the graphic arts, textiles, and digital media.

Timeline

At the front of the book, there is a timeline of general historical periods addressed in the text. The chapter topics are plotted on this line by designated colors that correspond to each chapter. Since comparative examples are the core of the text's thematic demonstrations, the timeline provides readers with a visual overview of the temporal relationships between different themes and cultures.

Maps

Two clear maps show the reader at a glance the geographical position of the key regions, towns, and sites referred to in the text. The maps contribute to the text's overview of the diversity of art production, in terms of both time and place, while allowing the reader to detect the many cross-influences, and similarities.

Key Topics

Each chapter begins with a bullet-pointed color inset outlining the Key Topics to be discussed in the chapter, strategically placed next to the introduction. Readers will immediately be able to relate the chapter's theme to the material that is discussed.

Further Reading

Suggestions for further reading follow each chapter. These concentrate primarily on specific reference to short passages in key works. Particularly in the later chapters, however, reference is broadened to books from which the reader may glean a more general understanding of the topics discussed. All titles referred to should be easily located in well-stocked libraries.

Discussion Topics

Carefully chosen topics for discussion appear in color insets at the conclusion of each chapter. These are designed to provoke further critical thinking of the material covered in the text, and simultaneously to serve as a starting point for a wider classroom debate on the themes and issues addressed.

Glossary Terms

A Glossary of essential art-historical terms has been compiled at the end of the book, focussing on techniques, media, and the vocabulary of architecture. At the first mention of each term included in the Glossary, the word is ►highlighted◄ in the text.

Ancillaries

Interactive CD-ROM

Frames of Reference's Core Concepts in Art, Version 2.0, CD-ROM is packaged FREE with every copy of the text providing valuable supplemental materials.

Description Conceived, designed, and written by students for students under the leadership of Bonnie Mitchell (Bowling Green State University), one of the preeminent multimedia designers, *Frames of Reference*'s Core Concepts in Art provides supplemental exercises and information in areas students experience difficulties.

Contents

Elements of Art Allows students to interact with the formal elements of art by working through over 70 interactive exercises illustrating line, shape, color, light, dark, and texture.

Art Techniques Takes your students on a tour of art studios. *Art Techniques* illustrates working with a variety of media from bronze casting, to painting, to video techniques and animation, all presented with extensive, narrated video segments.

Chapter Resources Study resources correlated to each chapter of *Frames of Reference*; both a review and test preparation. Students will find key terms, chapter summaries, and a self-correcting study quiz to help prepare for in-class tests, midterms, and finals.

SAWYER (Study Art With Your Electronic Resource) SAWYER is an electronic study tool that engages, interacts with, and supports students in their art course. Designed to maximize multimedia interactivity and support well-established pedagogy in art history, SAWYER is comprised of four interrelated and interlocking exercises: **Guess the Artwork**, **Search the Internet**, **Flashcard Generator**, and the **Quiz Engine**.

Research and the Internet Introduces students to the research process from idea generation, to organization, to researching on- and off-line, and includes guidelines for incorporating sources for term papers and bibliographies.

Study Skills Helps your students adjust to the rigors of college work. The *Study Skills* section of the CD-ROM provides practical advice on how to succeed at college.

Online Learning Center (OLC) <www.mhhe.com/frames>

The OLC is an Internet-based resource for students and faculty alike. The instructor's resources are password protected and include downloadable supplemental information and links to professional resources.

Additionally, the OLC offers chapter-by-chapter quizzes for student testing. These brief quizzes are separate from those offered in the test bank and generate instantaneous feedback for students, and/or the results may be e-mailed directly to their instructor.

Instructor's Resource CD-ROM (IRCD)

McGraw-Hill offers an IRCD to all instructors adopting *Frames of Reference*. The IRCD includes a computerized test bank and valuable supplemental materials for teaching with *Frames*.

For more information about these and other ancillaries available to adopters of *Frames of Reference*, including supporting slide sets, please contact your local McGraw-Hill sales representative or e-mail <art@mcgraw-hill.com>.

Timeline

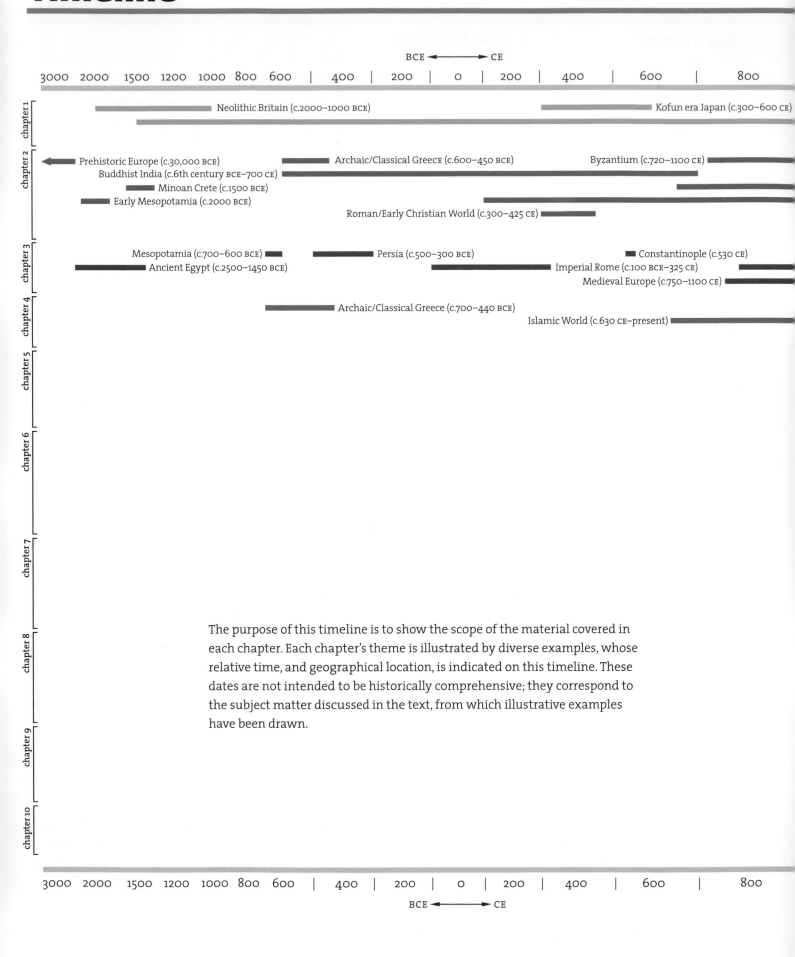

3000 2000 1500 1200 1000 800 600 | 400 | 200 | 0 | 200 | 400 | 600 | 800

BCE ← → CE

chapter 1

Neolithic Britain (c.2000–1000 BCE)

Kofun era Japan (c.300–600 CE)

chapter 2

← Prehistoric Europe (c.30,000 BCE)

Archaic/Classical Greece (c.600–450 BCE)

Byzantium (c.720–1100 CE)

Buddhist India (c.6th century BCE–700 CE)

Minoan Crete (c.1500 BCE)

Early Mesopotamia (c.2000 BCE)

Roman/Early Christian World (c.300–425 CE)

chapter 3

Mesopotamia (c.700–600 BCE)

Persia (c.500–300 BCE)

Constantinople (c.530 CE)

Ancient Egypt (c.2500–1450 BCE)

Imperial Rome (c.100 BCE–325 CE)

Medieval Europe (c.750–1100 CE)

chapter 4

Archaic/Classical Greece (c.700–440 BCE)

Islamic World (c.630 CE–present)

chapter 5

chapter 6

chapter 7

chapter 8

The purpose of this timeline is to show the scope of the material covered in each chapter. Each chapter's theme is illustrated by diverse examples, whose relative time, and geographical location, is indicated on this timeline. These dates are not intended to be historically comprehensive; they correspond to the subject matter discussed in the text, from which illustrative examples have been drawn.

chapter 9

chapter 10

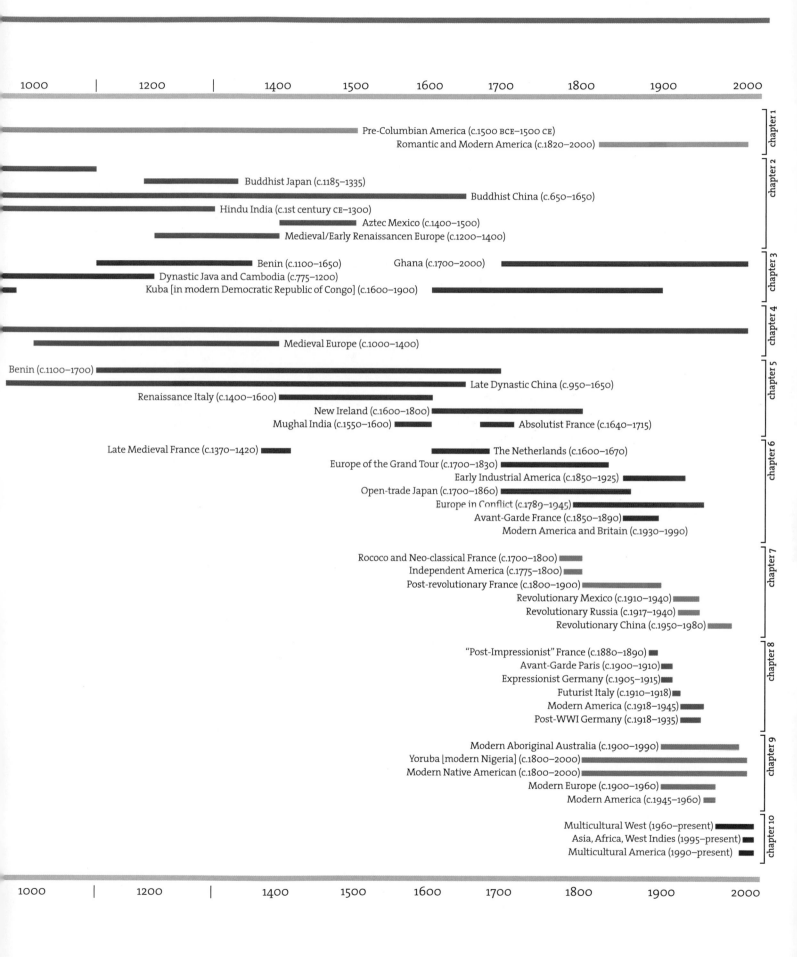

1000 | 1200 | 1400 1500 1600 1700 1800 1900 2000

chapter 1
Pre-Columbian America (c.1500 BCE–1500 CE)
Romantic and Modern America (c.1820–2000)

chapter 2
Buddhist Japan (c.1185–1335)
Buddhist China (c.650–1650)
Hindu India (c.1st century CE–1300)
Aztec Mexico (c.1400–1500)
Medieval/Early Renaissancen Europe (c.1200–1400)

chapter 3
Benin (c.1100–1650) Ghana (c.1700–2000)
Dynastic Java and Cambodia (c.775–1200)
Kuba [in modern Democratic Republic of Congo] (c.1600–1900)

chapter 4
Medieval Europe (c.1000–1400)

chapter 5
Benin (c.1100–1700)
Late Dynastic China (c.950–1650)
Renaissance Italy (c.1400–1600)
New Ireland (c.1600–1800)
Mughal India (c.1550–1600) Absolutist France (c.1640–1715)

chapter 6
Late Medieval France (c.1370–1420) The Netherlands (c.1600–1670)
Europe of the Grand Tour (c.1700–1830)
Early Industrial America (c.1850–1925)
Open-trade Japan (c.1700–1860)
Europe in Conflict (c.1789–1945)
Avant-Garde France (c.1850–1890)
Modern America and Britain (c.1930–1990)

chapter 7
Rococo and Neo-classical France (c.1700–1800)
Independent America (c.1775–1800)
Post-revolutionary France (c.1800–1900)
Revolutionary Mexico (c.1910–1940)
Revolutionary Russia (c.1917–1940)
Revolutionary China (c.1950–1980)

chapter 8
"Post-Impressionist" France (c.1880–1890)
Avant-Garde Paris (c.1900–1910)
Expressionist Germany (c.1905–1915)
Futurist Italy (c.1910–1918)
Modern America (c.1918–1945)
Post-WWI Germany (c.1918–1935)

chapter 9
Modern Aboriginal Australia (c.1900–1990)
Yoruba [modern Nigeria] (c.1800–2000)
Modern Native American (c.1800–2000)
Modern Europe (c.1900–1960)
Modern America (c.1945–1960)

chapter 10
Multicultural West (1960–present)
Asia, Africa, West Indies (1995–present)
Multicultural America (1990–present)

1000 | 1200 | 1400 1500 1600 1700 1800 1900 2000

The Earth as Art

The first monumental "artworks"—though their creators would not have described them as such—were made by shaping the earth itself into symbolic forms. Massive mounds of dirt, circles of giant hewn stones, carved and painted caves all tell us of astounding prehistoric labor forces and early engineering techniques throughout the entire world. Here, we consider examples from the British Isles, Japan, and North America. Many of these spaces reflect their creators' reverence for the scale, variety, and power of natural elements, including the celestial bodies and forms from the earth itself. Many were dedicated to the dead, or to the supernatural realm, and some became the sites of religious ritual. A separation was thus made between the mundane areas used for everyday living and special precincts.

The human impulse to revere nature and natural resources did not end with the rise of technology, however, especially in the United States, a vast land that boasts a varied and awesome landscape. In the modern era, people responded to the Industrial Revolution by turning to the power and purity of natural forms. After centuries of institutionalized religions, which many people found stifling, God seemed more apparent in virgin forests, in striking mountain formations, endless rivers, or in the glorious and varied appearances of the sky. The early American Protestant rejection of lavish Church symbolism and artistic decoration established a tradition in the United States in which religious truths could be verified through close observance of the living world rather than through imaginative renditions of unknown realms.

During the twentieth century, when ecological awareness surged because of concerns about using up the earth's resources, artists again began shaping the landscape to make statements about the earth, the cosmos, and our place in nature. The task of restoring damaged or sullied landscapes by encouraging the regeneration of plants, designing pathways and resting areas, or incorporating natural phenomena into public courtyards and parks, was undertaken by artists who wished to work on a grand scale and make a qualitative difference to the world in which their audience lived. Others acquired access to vast, uninhabited locations where they modified the shape of the earth or installed objects that moved, sounded, or in some other way interacted with the physical environment. Many of these artists looked back to the massive forms of prehistoric monuments for inspiration and tried to capture the profound grandeur of those sacred landscapes.

1.1 Ana Mendieta, *Untitled*, from the *Arbol de la Vida* (Tree of Life) series, 1976. Color photograph: earth/body work with cloth and tree, 1ft 1¼ins x 1ft 8ins, Galerie Lelong, New York.

Key Topics

The natural world at the center of human and artistic consciousness. How the earth has been used by artists worldwide across the last five millennia.

▶ The first monumental earthworks: mounds and henges and their practical and symbolic purposes, including use in burial rites, for marking out sacred spaces, and reflecting celestial orientations.

▶ Construction of monumental earthworks: evidence of engineering and mathematical ingenuity in early societies.

▶ Modern earthworks: once altering the earth no itself longer presented great difficulties, post-Industrial Revolution artists returned to the earth as a medium to express ecological concerns and to examine humanity's place in the cosmos.

Mounds and Henges

Mounds and ►henges◄ are the first known large communal building projects and occur in many parts of the world in different eras. Although not formally considered art, or even architecture, they were built for both practical and symbolic use and therefore serve as precursors to later monumental structures. This chapter begins with a brief survey of three sites that serve as significant historical examples: the ►cairns◄ and stone henges built in the British Isles from the Neolithic period; the large mounded tombs, called "tumuli," built during the Kofun era in Japan; and the platform or burial mounds from the earliest known Native American cities in North America.

The building projects of these three disparate cultures, which range in date between 3000 BCE and 1500 CE, share two major similarities. First, the structures were nearly all built within funereal contexts, and were set in locations considered sacred. Second, these projects provide the first evidence of human involvement with the earth as an artistic medium, as a ►ground◄ (both literally and figuratively) for three-dimensional, sculptural design. Thus, although done centuries earlier and created to serve ritual or religious rather than purely "artistic" purposes, they stand as important models for the work of many twentieth-century artists such as Robert Smithson, Nancy Holt, and James Turrell. These contemporary artists design artworks using the earth itself as their medium, availing themselves of natural resources on site.

Neolithic Britain

Some of the earliest evidence of monumental building projects can be found in Europe and date from the same time as the pyramids in Egypt and the ►ziggurats◄ in Mesopotamia (beginning around 3000 BCE). They can be found in western areas of the continent as well as in the British Isles. During this Neolithic or New Stone Age, the English Channel was only a narrow, shallow waterway since the islands were only separated from the mainland at the end of the last Ice Age, approximately seven thousand years earlier (10,000 BCE). It was across this easily navigable divide that the peoples of continental Europe had migrated, first in search of better hunting and gathering and then, after 7000 BCE, of better farmland. They introduced agriculture to the British Isles and with it the concept of permanent settlements. Hunters and gatherers did not need substantial housing or monumental building programs. Their possessions were small and portable and their art was either handheld "mobiliary" sculpture or wall paintings in caves (see fig. 2.2).

With agriculture, however, came the need to plan for the future. Decisions about location were very important since natural resources were crucial to a community's survival. Consequently, the ancestors who had made those decisions came to be appreciated in an entirely new light by later generations. Burial took on a different aspect. Dead bodies, which would previously have been disposed of somewhere on the migratory path, now needed to be interred near the area inhabited by the living. Burial areas had to be demarcated in order to be kept separate from land used to cultivate crops. At the same time, the more successful and healthy the community, the greater the number of living and dead it generated. For the living, the size of a burial area could be seen to signify the wisdom and foresight of those in it, and one way to honor them was to distinguish their final resting place.

Perhaps with these concerns in mind, Neolithic people created monumental burial mounds. The simple timber barrow or stone cairn mound, which contained a small number of bodies, developed into a sophisticated series of underground chambers used for multiple mortuary purposes. Well-supported entrances and massive mounds of dirt made these large group burials visible from great distances in the surrounding countryside. In this way, the ancestors were not only honored, but the living community also signaled its prosperity and strength to neighboring groups. This served both to advertise the possibility of good trade in items manufactured from local resources and to warn newcomers of a community's ability to defend its position.

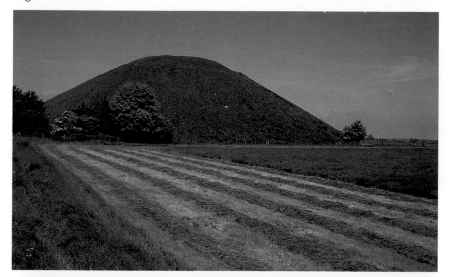

1.2 Silbury Hill, Avebury, Wiltshire, England, begun c.2660 BCE.

Although most monumental mounds contained burials, not all of them did. Those that did not may have marked sacred space or functioned simply as signs of vast human resources, such as Silbury Hill, Avebury, Wiltshire, the largest artificial monument in Europe ▶ **fig. 1.2**. Building these mounds often took many generations as the labor was hard and the size of the mounds kept growing. Dirt was moved in baskets. Since the wheel and animal harness were not yet used here, human labor was crucial. Inner chambers were supported with rock slabs and stone beams in other sites where the outer mound is only the external sign of complex stone chambers below ground, such as the one at Maeshowe on the Orkney Islands ▶ **fig. 1.3**. This structure, which includes a box-shaped roof, a window slot over the doorway for light to enter or sound to escape, and a large stone basin in the primary passage, may have been used for ceremonial functions, possibly centered on a prophetic oracle.

The sacred function of such places increased as the importance of the role of the ancestors grew. In many societies, ancestral figures became deified. They were worshiped for their intermediary status between the things of this earth and those of the world beyond. Since burial sites were seen as thresholds between these two worlds, ritual practices developed as a means of attempting to control

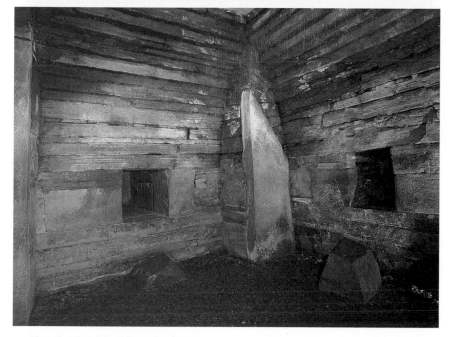

1.3 Chamber tomb, interior, Maeshowe, Orkney Islands, Scotland, c.1500 BCE.

these powers. Many of the mounds were designed with chamber openings and passages that corresponded to solar and other astronomical illuminations. Some scholars who have calculated the measurements of mounds built in Ireland around

1.4 Standing stones, Castle Rigg, Cumbria, England, c.3000 BCE.

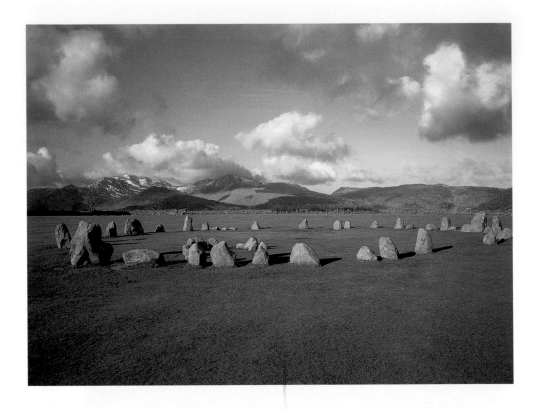

3500 BCE believe that they add up to ancient power numbers, such as those found in the Bible or used by the ancient Egyptians. Stone carvings in and around the entrances seem to record symbols, directions, and movements of planetary bodies. Since agricultural concerns were paramount to the survival of these early peoples, they undoubtedly developed a heightened awareness of the seasons and other forces of nature.

Once communities had grown in geographical breadth, political control, and sociological organization to such an extent that mounds no longer sufficed for burial needs, communal graves were introduced for the general population and individual graves for leaders with objects denoting their importance. The sacred function of the sites, no longer specific to a small group of ancestors, was therefore expanded to be enshrined in an evocative natural setting of sky, earth, and, if possible, water ▶ **fig. 1.4**. Rather than building a mound of dirt, yet still relying solely upon human labor, these early people moved huge stones to create circles or henges. The stones, often weighing many tons, from quarries up to 60 miles away, were cut into rectangles, dragged on sleds, further cut and polished, and then arranged upright in circles. Millions of labor hours were spent on each monument.

These circles of stone marked out sacred spaces. Although their exact ceremonial or communal uses remain uncertain, their grandeur, like that of the larger earth mounds, would have conveyed visual messages of power and prosperity to local populations and visitors alike. Some of the circles were also carefully aligned with astronomical points to allow for the calculation of celestial movements and seasonal calendars, such as the times of the summer and winter solstices.

1.5 Stonehenge, Wiltshire, England, c.2500–1300 BCE.

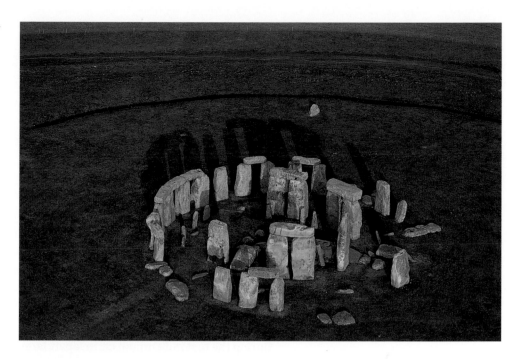

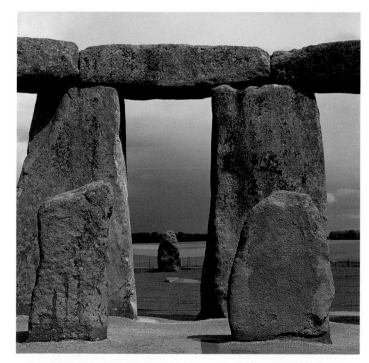

1.6 Heelstone, seen in the gap between two standing stones, Stonehenge, Wiltshire, England, c.2500–1300 BCE.

The greatest surviving stone henge, or circle, is the one in Wiltshire called, simply, Stonehenge ▶ **fig. 1.5**. It seems clear from excavations that it was built in four distinct phases, ranging from around 2500 to 1300 BCE. The construction was not based upon a single plan, but shows evidence of later stages of removal and remodeling. As with many other henges, there is more to the site than just the stones. Aerial photographs make this apparent. A wide "avenue" leading to the circle is defined by ditches dug on either side. This ditch continues around the henge, the outer shape of which is determined both by the depth of the ditch itself and the height of the dirt bank heaped outside it. That the ditch has endured for so many centuries attests to its importance in the original design. Inside the line of the ditch fifty-six holes were dug, presumably to bury stones in. However, in a later phase they were filled in. The earliest stones and primary markers are set at measured distances. Four stones form an accurate rectangle within the circle and two more once marked the entrance. Further down the avenue, a single stone known as the heelstone was put up; now by the side of a national highway, it has marked the position of the rising sun at the summer solstice for over four thousand years ▶ **fig. 1.6**.

During subsequent phases, many more holes were dug, the ditch was shifted, and stones were removed or added. Work was done to improve the alignment with celestial events, and to increase the size and number of the stone circles. Although many stones have fallen, it is still possible to see the basic structural form, that of a

▸trilithon◂, or two upright posts joined by a lintel stone laid on top. Niches were cut into the lintels to allow them to fit over corresponding knobs left on the tops of the uprights; this construction method is termed "mortice and tenon." The lintels were also curved to echo the circular shape of the henge. The largest set of these forms an inner horseshoe made out of ▸sarsen◂ stones weighing up to 51 tons each. They were found about 20 miles away and transported on log rollers. The earlier circles were built of ▸bluestones◂, weighing about 4 tons, brought from a site much further away in South Wales.

Reasons for the building project's huge scale and multiple renovations have been put forward on the basis of archeological evidence, though they remain conjectural. However, by analogy with later societies, it is likely that competitive factors, whether of design or administration, played a role. Since it seems that the visual presentation of wealth and control was an important motive, threats to the community from outside may have generated new attempts to strengthen this monumental statement.

Japan

During the first millennium CE, in Japan, large mounds were also built for burial purposes. The Japanese word for an ancient grave mound is *kofun*, after which the Kofun era (300–600 CE) is named, though it overlaps with other periods in some regions. Built for regional leaders during a time of growing political and economic power in Japan, the largest grave mound is one thought to have been built for Emperor Nintoku around 400 CE near Osaka ▶ **fig. 1.7**. Because the Japanese government does not allow these sites to be disturbed for excavation purposes, little is known about the construction or contents of imperial mounds. Nevertheless, it seems that the early

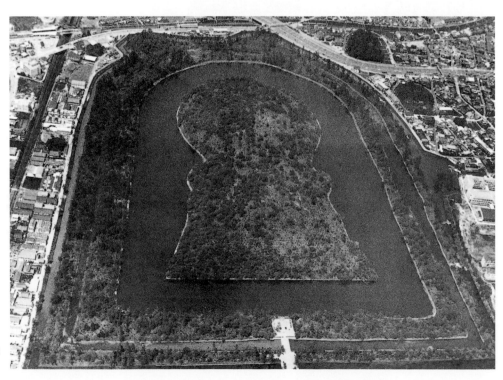

1.7 Tumulus of Emperor Nintoku, Sakai, Osaka prefecture, Japan, Kofun era, c.400 CE.

Japanese custom of interment on hills probably led to the construction of artificial hills over shaft graves in a circular shape or in a combination of circular and triangular shapes (the latter type is termed "keyhole" by Western archeologists). As the scope of the layouts grew, moats were added to separate the area from the surrounding communities; in the case of Nintoku's mound, there are two moats.

Set across the tops of some mounds were unglazed clay cylinder sculptures (*haniwa*) of houses, figures, weapons, and shields, all of striking simplicity but showing high-quality workmanship ▶ **fig. 1.8**. Many are of soldiers and their horses, indicating the origins of the Kofun people in a powerful military dynasty. The *haniwa* also provide valuable documentation of military uniforms and weapons, house types, and shield decoration. Although the purpose of *haniwa* is not entirely clear, there can be no doubt about the overall significance of these tombs as memorials to power and wealth. Like the mounds and henges in the British Isles, huge workforces were necessary to realize these vast projects. Also like the large, engraved stones at the entrances of Neolithic tombs in the British Isles, *haniwa* may have served to demarcate the margin between this life and the afterlife .

North America

Within this apparently universal activity of creating sacred landscapes, the so-called "Mound Builders" of North America made highly diverse types of earthworks. These mounds are concentrated in an area roughly equivalent to the broad central section of the United States excluding the coastal areas and stretch in time from around 1500 BCE to 1500 CE. They include both burial and platform mounds in conical, flat-topped, and effigy shapes ranging in size from just a few feet to well over 100 feet high and 300 feet long.

These constructions were initially made at trade centers of hunter-gatherer societies and later at the political and religious hubs of settled communities. Probably due to the heavy use of waterways for travel and trade in North America, most mound sites are situated near the great rivers. Their designs were dependent upon both geometric formulas and astronomical correspondences. The largest mounds usually afforded a view to the east, often over water, to allow sunrise-related ritual usage. They share many characteristics with other, more ancient, mound constructions elsewhere in the world, for example in their inclusion of interior ditches. Most North American tribes took several generations to build their mounds, and it is thought that most of the work was done by women transporting the dirt in baskets.

Many of the mounds for burial were simple cones but there are a remarkable number in the Mississippi Valley, dating from around 400 to 1100 CE, that are shaped like animals, birds, or humans (see fig. 1.10). The largest mounds served as platforms for temples, palaces, or even whole tiered streets of houses (see fig. 1.9). These are flat-topped and do not always contain burials.

The earliest massive earthwork construction was in the southeastern United States. These mounds show the influence of MesoAmerican techniques that probably came

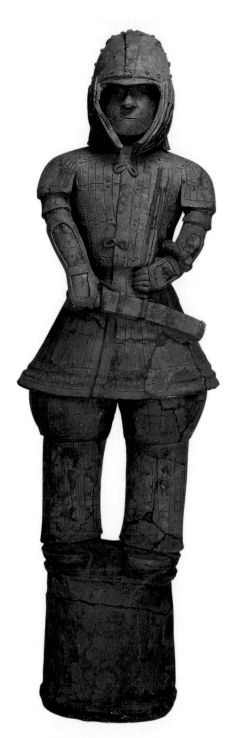

1.8 *Haniwa* of a warrior, Gumma prefecture, Japan, late Kofun era, 6th century CE. Terracotta, height 4ft 1in. Aikawa Archeological Museum.

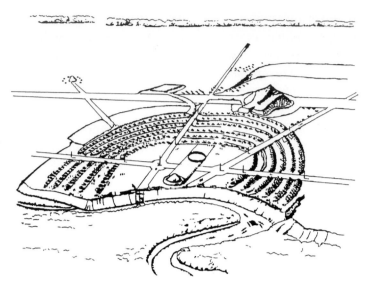

1.9 Poverty Point, Louisiana, c.1200 BCE.

in the wake of trade migration from Mexico (see inset, opposite). One impressive example, at Poverty Point in Louisiana, shows a huge, banked platform for the organized layout of dwellings around a central plaza ▶ **fig. 1.9**. There were six terraces stepping up and out from the plaza, which was oriented toward the rising sun in the east. Concentric streets run between the terraces while four steep "avenues" cut down through all levels to give access to the plaza. Two of these avenues aligned with the summer and winter solstices through the siting of posts in the central arena. The settlement was prosperous and its success as a trading hub is clear from the rediscovered remains of goods from as far away as the northern Great Lakes and the Appalachian Mountains, as well as areas to the south such as Mexico and present-day Florida.

Poverty Point was far more than a carefully constructed refuge from the floodwaters of the Arkansas River at the Mississippi Delta. It may have taken several generations to build, but it also lasted nearly a millennium. The emphasis was, however, not just on durability, but on ritual arrangement of the shaped earth. The settlement's placement at a bend in the river to allow for an eastern alignment, the layout of the semicircular ridges to define the top of a bluff as the central plaza, the building of a 25-foot-high mound just to the west of the ringed area that facilitated viewing of the equinox activity—all this was part of a strong understanding of the relationship between earth and sky and the place of human activity in relation to the vast cycles of nature. Such concerns would continue to inform Native American shapers of landscape as well as the funereal cults of the tribes that used mounds in their burial practices.

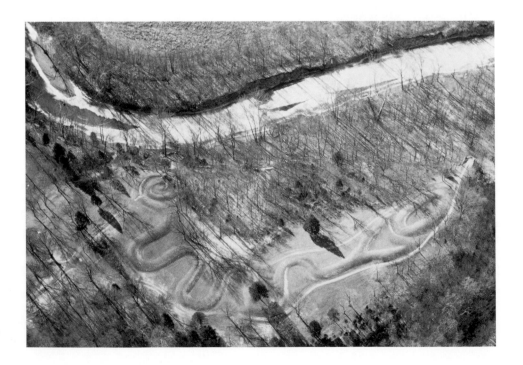

1.10 Serpent Mound, Adams County, Ohio, c.200 BCE.

Burials in most sites show careful orientation of the bodies in the same direction. The earlier mounds feature group burials, and temples show treasury collections of ancestral bones or grave goods. As in Britain, individual burials were introduced later, with the status of the deceased indicated by body decoration and accompanying gifts. In the case of North America, however, the change from group to individual burial seems to have occurred around the same time as the move from migratory to farming communities, indicating the formation of political leadership.

The central-eastern areas of the United States designated as "woodlands" and "plains" were home to successive cultures identified by the names Adena, Hopewell, and Mississippian. The Adena lasted from about 1000 to 200 BCE in the woodland area now known as the Ohio River Valley. At the peak of their trading activity and population, the Adena peoples worked on elaborate, multi-generational earth constructions of which many were in ritual shapes, called "effigy mounds." One near Peebles (Adams County) in southern Ohio is still perceivable in its form as a large snake ▶ **fig. 1.10**. The head of the snake was formed on the highest point of a ridge above a

Celestial Orientation in MesoAmerica

Between around 150 BCE and 750 CE the great city of Teotihuacán in the Valley of Mexico was built according to cosmic principles. Here the natural valley location on the San Juan River was incorporated in the layout and conception of the city as a sacred site. The city was aligned on a grid according to the sun and stars so that streets lined up to cardinal directions. Cross-circles designating the same directions were carved on surrounding mountain rocks and in the streets and plazas. Even structures miles away were built according to the geometric orientation of the city. The Temple of the Moon was set directly in front of the looming Cerro Gordo mountain behind, which beckons processions on the long ceremonial avenue heading north through the center of the city ▶ fig. 1.11. In MesoAmerican belief, the water needed for agricultural fertility is associated with the mountains from which rain clouds appear to originate (see also the discussion of Aztec Mexico in chapter 2). The city was set within a comforting circle of such mountains.

As Teotihuacán is near the Tropic of Cancer, the Pleiades constellation is visible to the naked eye on the same day that the sun appears to pass directly overhead. The alignment of the urban layout would have facilitated observation of such astronomical phenomena and

possibly could have served as evidence of Teotihuacán's sacred location. The east–west axis led to dramatic views of dawn and sunset at the Temple of the Sun. People lived in dense multi-purpose spaces that were sectioned in quadrants according to their occupations. Harmonious organization seems to have been at the root of every aspect of life. Imagery carved and painted on temple surfaces emphasizes a fertile paradise, even if set against a backdrop of warfare or sacrifice.

Later peoples in MesoAmerica documented their great respect for the power of Teotihuacán in manuscript illustrations and stone reliefs. The pyramids there, with their sloping sides, influenced those of Maya and Aztec builders. Mayan kings, who created elaborate stone reliefs demonstrating their own power, show themselves in diplomatic negotiations with people from Teotihuacán, which is in fact an Aztec name. Only about 30 miles northeast of the Aztec capital city of Tenochtitlán (now Mexico City), Teotihuacán was already a ruin by the time the Aztecs discovered it. The Aztecs considered the former inhabitants of Teotihuacán to have been their sacred ancestors; they revered the site as a shrine and their leaders made pilgrimages to it.

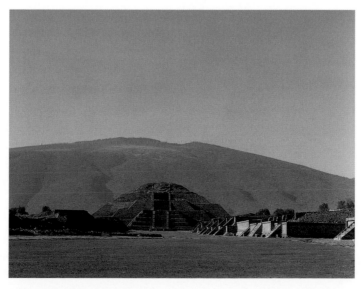

1.11 Temple of the Moon, with Cerro Gordo in the background, 1st to 7th century CE. Teotihuacán, Mexico.

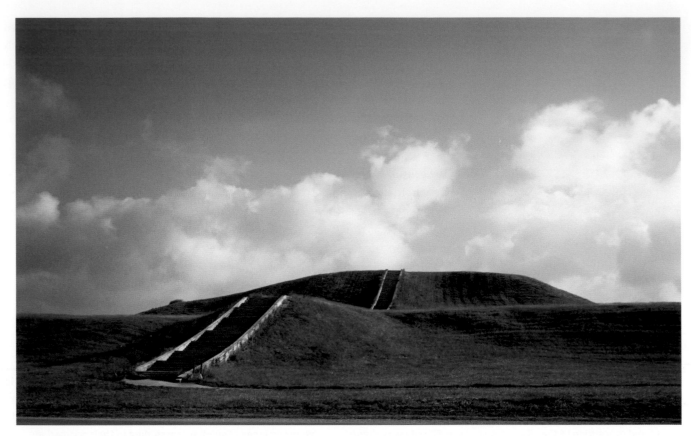

1.12 Monk's Mound, Cahokia, Illinois, c.900–1250 CE.

waterway. The body meanders in curves for over 1200 feet. Nearby is a substantial burial mound, suggesting that the two areas were related in usage.

Cahokia Mounds, a product of the Mississippian civilization in west-central Illinois, stands as the remains of one of the largest Mound Building communities, as well as one of the last ▶ **fig. 1.12**. This ceremonial site reached its peak of development in 1000–1250 CE. Estimates of the population have been set as low as 500 by some scholars, while others have suggested a figure as high as 75,000 when including the inhabitants in surrounding farming villages. It seems likely, however, that during Cahokia's most prosperous years, the on-site population was between 20,000 and 30,000. Around 120 mounds include nearly fifty large, flat-topped platforms. The largest was later named "Monk's Mound." Built in fourteen stages between 900 and 1250 CE, it has a mass exceeding that of the greatest of the Egyptian pyramids at Giza (see chapter 3) and is about 100 feet high at the fourth and final terrace. It was apparently used as the base for either a religious temple or a leader's house. From a round wood henge nearby, visible from the summit of Monk's Mound, viewers could align the direction of the sunrise and other astronomical events.

Besides being an important political and religious center for the region, Cahokia served as a trade and manufacturing center on the Mississippi River (the river has since changed its course, and is no longer close to the site). Objects from as far away as

present-day Canada and Mexico have been found in excavations. In turn, high-quality Cahokian pottery and flint hoes appear in these distant locations. The primary crop grown in the region was, as is still the case today, corn. This provided food for the entire population as well as being another export item in long-distance trade.

Around 1150 CE, stockades were built around the main center. The inner one was over 14 feet high and had 14,000 logs with raised platforms 150 feet apart. About 1375 CE, all construction at Cahokia stopped and the city began to decline. Archeological evidence suggests that the area had become overpopulated and could not produce enough food. In addition, Cahokia's farming methods did not include crop rotation, so the soil was probably exhausted and yields became progressively smaller. The final blow to this community may well have been a climate change that evidently occurred in the mid-fourteenth century.

Another important factor in Cahokia's demise could be that its very size and long prosperity attracted malevolent outsiders. The stockade probably reflected the need of many later Mississippi Valley settlements to protect themselves against the increasingly aggressive raids of the Iroquois tribe. Furthermore, Spanish explorers, such as Hernando de Soto (c. 1496–1542), introduced epidemic diseases previously unknown to Native American populations.

The Ziggurat

The earliest literary reference to the function of the Mesopotamian ziggurat, or baked-brick hill (the word is derived from the Assyrian for "high"), appears in the *Epic of Gilgamesh*, which is about an ancient legendary king of the Sumerian city-state of Uruk. It was composed about 2000 BCE and was a source for the later story of Noah in the Old Testament. Written in the first person, the *Epic of Gilgamesh* describes a terrible flood that occurred in the Tigris-Euphrates river valley. (Flooding would have occurred regularly each spring, when the snows melted in the higher regions and rains were heavy.) Gilgamesh and his people are forced to take refuge in a floating vessel; after the skies have cleared, he releases birds to test for dry land. When the third reveals that the waters are receding, Gilgamesh conducts a thanksgiving ceremony upon a "mountain top," which in a landscape of this type can only be the temple at the summit of a ziggurat. There is evidence of such a structure in the White Temple at Uruk, modern-day Warka ▶ fig. 1.13. There the artificial mountain was topped by an elaborate temple complex that not only housed effigies of deities, but served as a safe storehouse for community goods. Putting these valuables under the protection of the city god, each Sumerian king served as a steward who protected his people from the annual flooding through maintenance of canal systems and elaborate processional ceremonies during which gifts were deposited in the god's care. There are thus two reasons for the height of the construction: it promised safety from the water and proximity to the gods in the sky.

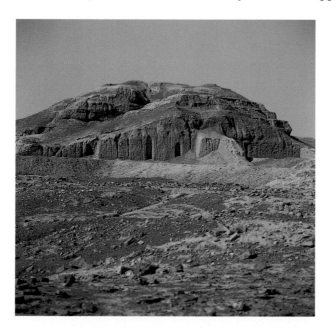

1.13 White Temple, Uruk (modern Warka, Iraq), c.3500–3000 BCE.

It has been said that "architecture" did not exist until people began baking earth into bricks and piling stones into walls. Yet the earth mounds of North America, like the ziggurats or brick mounds of ancient Mesopotamia, can be considered among the first formal architectural structures (see fig 1.13 and inset). Built in the fertile Tigris-Euphrates river valley, which flooded annually, Sumerian ziggurats of around 3000 BCE were made to store harvested crops and other commodities in structures at the top. At the same time, like platform mounds in North America, the summits included religious temples that could relate to the celestial realm. De Soto observed earth embankments in the sixteenth century built by communities around lakes in Florida to raise buildings in areas prone to flooding.

In both cases, huge amounts of labor were employed to create these sophisticated and scientifically designed structures. The societies that realized them were highly developed and prosperous, and gave rise to inventions and traditions that would inform visual culture for the rest of time.

Modern Earthworks

The pervasive presence of Native American mounds in the United States and the popularity of ancient Western European sites such as Stonehenge generated a renewed interest in the earth as an artistic medium in the second half of the twentieth century. Among the factors that contributed to this form of expression was a general revival of ancient lore and a search for a new spirituality. People looked for meaning in their lives through such sources as Native and non-Western religions, psychic predictions, goddess lore, and beliefs in the powers of geometric crystals, healing herbs, or visions from drug-induced trances. A particularly popular area of folk-religious wisdom lay in Celtic songs and stories. The sacred associations of Northern European sites with astronomy, time, and landscape were studied afresh.

In addition, with the rise of ecological awareness in the second half of the century, protection and reclamation of the environment became public issues. Artists who were involved in designing public sculpture or architects whose projects involved public spaces were drawn into these concerns. There was a strong call for the quieter and healthier environment of parks and nature reserves over polluted, traffic-ridden city streets. The sterile grounds of corporate complexes entirely composed of steel, glass, and cement spaces lost their allure with proliferation and repetition.

These concerns were not new in the United States. During the early nineteenth century, Native American mounds had already captured people's imagination and some were even excavated. The artifacts within the mounds and drawings of the overall site designs were exhibited as Native art. They were seen as the products of an ancient American society contemporary with the greatest founding empires of Western civilization. Like Europe, which had revived an interest in natural scenery and the spiritual renewal of the landscape in the face of the Industrial Revolution by the end of the eighteenth century, Americans soon "discovered" their own extraordinary natural resources and began a craze of tourism to the "picturesque." Places such as the Niagara Falls or the Hudson River Valley and the Catskill Mountains provided the thrill of the wild to travelers in the eastern United States. Landscape artists and writers recorded their attractions and wove them into fictional scenes and tales that served as an American literary history. Romantic paintings, such as Thomas Cole's *The Course of Empire: Savage State* ▶ **fig. 1.14** and W. H. Bartlett's *Niagara Falls* ▶ **fig. 1.15**, or writings by Washington Irving (see inset, p. 16) and James Fenimore Cooper, evoked feelings that spurred some people to make tours in the tradition of the great religious pilgrims of Western Europe (see chapter 4). The sacred and solemn reverence felt by visitors in the presence of impressive landscape appealed to an essentially Protestant, secular culture. Thus morally and spiritually exalted experiences could be generated by the fabric of America itself, rather than by sectarian idols and the decadent trappings of the "popish" Roman Catholic Church rejected by early American settlers.

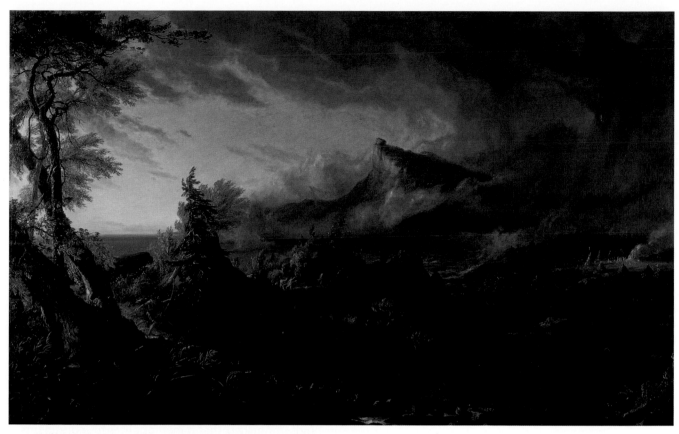

1.14 Thomas Cole, *The Course of Empire: Savage State*, c. 1834. Oil on canvas,
3ft 3¼ins x 5ft 3¼ins. New York Historical Society.

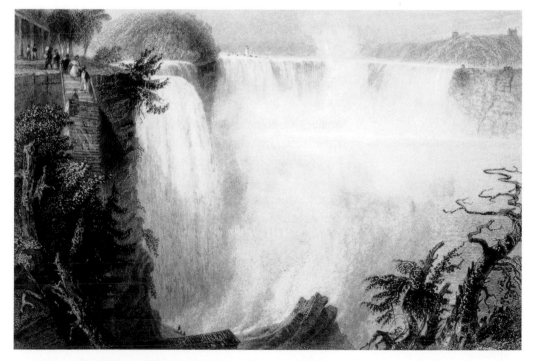

1.15 W.H. Bartlett, *Niagara Falls*, 1840. Engraving. Private collection.

Thomas Cole (1801–48), in particular, generated images that bridged the old and new worlds. *Savage State* evidences the early influences of European Neoclassical painters who depicted historical ruins in the landscape as a visual map of civilized history. The painting is the first in a series Cole entitled "The Course of Empire." America offered Cole a pure, primeval landscape as yet untouched by the destructive effects of human progress. He romanticized this view by depicting stormy skies and tortured tree forms, and his contemporaries hailed the results as "noble." Cole himself gave lectures in 1835 in which he referred to the American wilderness as a "place to speak of God." In Cole's late works, the atmosphere of the American sky was a key element in illustrating the "sublime," a concept borrowed from the writings of Ralph Waldo Emerson, who rejected institutionalized religion in favor of nature, maintaining that individuals can only find redemption in their own souls.

This appreciation of the scope and power of American landscape was reinforced by Gutzon Borglum (1871–1941), whose carving of Mount Rushmore into *The Shrine of Democracy*, begun in 1927, created a cultural monument and a symbol of national identity ▶ **fig. 1.16**. The fact that it stands unfinished, that it memorializes four presidents whose political ideals may not hold up to close scrutiny, and that it was effected with the modern mining technology of controlled explosives and power tools— none of this has prevented viewers marveling at the seemingly miraculous appearance of the portrait heads of Washington, Jefferson, Lincoln, and Theodore Roosevelt on the side of a steep mountain in the Black Hills of South Dakota. Seen from a distance, in a wilderness spoiled only by the parking and visitor area, Mount Rushmore seems ancient, fragmentary, and magical. Although the land was acquired from the Sioux tribe through conquest, it seems unclaimed; the carved image appears to be an innocent and natural justification for the existence of American government.

Among the works of the later twentieth century that best evoke the timeless presence and natural forms of prehistoric sites are pieces by Robert Smithson, Nancy Holt, Walter de Maria, James Turrell, Ana Mendieta, and Mel Chin termed either "earthworks" or "environmental art." Created as public sculpture, though sometimes in very remote locations, and using the natural elements as primary media, these pieces look back to the scale and presence of ancient monoliths. The most famous early piece in this movement was Robert Smithson's *Spiral Jetty* of 1969–70 in Utah's Great Salt Lake ▶ **fig. 1.17**. Affected by the prevailing styles of Abstract Expressionist painting and Minimalist sculpture, which reduced the subject to its simplest forms, modern artists working with landscape returned to the simple contrasts of earth, water, and

Washington Irving's *The Legend of Sleepy Hollow*, 1819

Washington Irving adapted German folktales to the American landscape, Christianizing the continent's primitive past. This is an excerpt from a short story set in a place he called Sleepy Hollow (today Tarrytown, New York). The extreme effects of landscape sought by the Hudson River School painters are here evoked by Irving's prose.

The sequestered situation of this church seems always to have made it a favorite haunt of troubled spirits. It stands on a knoll, surrounded by locust-trees and lofty elms, from among which its decent whitewashed walls shine modestly forth, like Christian purity beaming through the shades of retirement. A gentle slope descends from it to a silver sheet of water, bordered by high trees, between which peeps may be caught at the blue hills of the Hudson. To look upon its grass-grown yard, where the sunbeams seem to sleep so quietly, one would think that there at least the dead might rest in peace. On one side of the church extends a wide woody dell, along which raves a large brook among broken rocks and trunks of fallen trees. Over a deep black part of the stream, not far from the church, was formerly thrown a wooden bridge; the road that led to it, and the bridge itself, were thickly shaded by overhanging trees, which cast a gloom about it, even in the daytime, but occasioned a fearful darkness at night. This was one of the favorite haunts of the headless horseman; and the place where he was most frequently encountered. The tale was told of old Brouwer, a most heretical disbeliever in ghosts, how he met the horseman returning from his foray into Sleepy Hollow, and was obliged to get up behind him; how they galloped over bush and brake, over hill and swamp, until they reached the bridge; when the horseman suddenly turned into a skeleton, threw old Brouwer into the brook, and sprang away over the tree-tops with a clap of thunder.

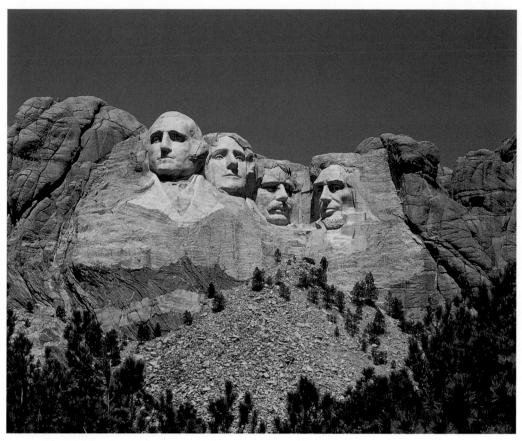

1.16 Gutzon Borglum, *The Shrine of Democracy*, 1927–41. Mount Rushmore, Black Hills, South Dakota.

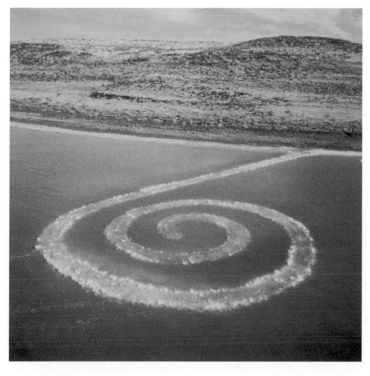

1.17 Robert Smithson, *Spiral Jetty*, 1969–70. Black rock, salt crystal, and earth, diameter 160ft, length 1,500ft, width 15ft. Great Salt Lake, Utah.

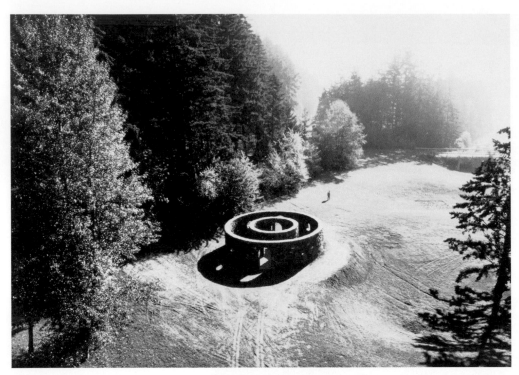

1.18 Nancy Holt, *Stone Enclosure: Rock Rings*, 1977–78. Hand-quarried schist, diameter of outer ring 40ft, height of ring walls height 10ft. Western Washington University, Washington, D.C.

sky known from the mounds and henges of ancient peoples. Smithson (1928–73) even reused an ancient symbol, the spiral shape found on prehistoric British tomb decoration and grave goods, but also appearing at the microscopic level in the natural salt crystals around the lakeshore. This form also pays homage to a local legend about a subterranean passage between the ocean and the Great Salt Lake, via a whirlpool-opening in the center. Initially forming a spit of mud and rock land curving out into the lake with the build-up of algae turning the water inside the spiral red, *Spiral Jetty* was best viewed from afar or from the air. The artist called it an "immobile cyclone." Smithson created it using land he leased for only twenty years, knowing that the piece would soon be under water and no longer visible. The work was thus an integral part of the environment from its conception.

That Nancy Holt (born 1938) was also inspired by stone henges is evident in her early pieces, such as *Stone Enclosure: Rock Rings*, at Western Washington University ▶ **fig. 1.18**. Here two concentric circles of mountain stone are pierced by semicircular archways and round "windows," arranged according to the primary compass points. Open to the sky, the structure casts shadows within and outside its perimeter according to the movements of the sun and moon. This evidence of the movement of celestial bodies on the earth's surface became a key theme in Holt's work. In 1973 she made a site in a Utah desert with huge concrete pipes lined with holes. The end openings of the pipes line up with the summer and winter solstice, reminding us of the heelstone at Stonehenge (see fig. 1.6), while the small internal holes are for viewing the stars. Later works, such as *Annual Ring* (1980–81) at the Federal Building in

1.19 Nancy Holt, *Solar Rotary: Sundial*, 1993–94. Aluminum, height 20ft with a 1 million-year-old meteorite found in Florida at the center. University of South Florida, Tampa.

Saginaw, Michigan, or *Solar Rotary:Sundial* at the University of South Florida in Tampa ▶ **fig. 1.19**, continue to play with celestial alignments and the related implications of the passage of time; *Solar Rotary* is a sundial that incorporates a million-year-old meteorite found in Florida.

Working with even larger spaces and conceiving their art on even grander scales, Walter de Maria (born 1935) and James Turrell (born 1943) also turned to the desert. Between 1974 and 1977 Walter de Maria set up 400 stainless steel poles evenly spaced over nearly a square mile of dry earth in the high desert of New Mexico, where lightning often strikes. The poles became lightning rods, causing extraordinary displays of electric energy against darkened skies ▶ **fig. 1.20**. Turrell's work shows a fascination with natural light and perceptual psychology. In 1974 he began building an observatory within a dormant volcano in northern Arizona ▶ **fig. 1.21**. The pre-existing shape of the crater and its circular opening, whose contour Turrell is redefining to aid in the viewing process, determine the visitors' perceptions of the sky. The ultimate experience of earthbound viewers takes the form of what perceptual psychology terms "celestial vaulting," or the impression that the patch of sky visible through the oculus (round opening) is not light and air but a solid, architectural dome. Nestled inside the earth, using only its matter for shaping the space, *Roden Crater Project* seems to take the universal mound of ancient civilizations and turn it inside out. Rather than reaching up to the sky by ascending an artificial height, the visitor moves down into the earth to get a better view of the firmament from within its framework. Native American creation myths tell of the first humans coming up out of the ground and of

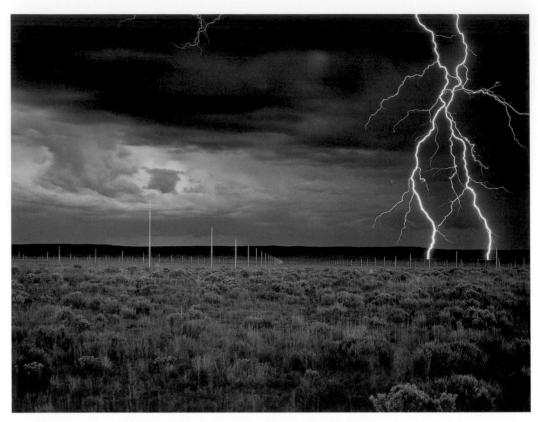

1.20 Walter de Maria, *The Lightning Field*, 1974–77. Permanent earth sculpture: 400 stainless steel poles; work must be seen over a 24-hour period. Quemado, New Mexico.

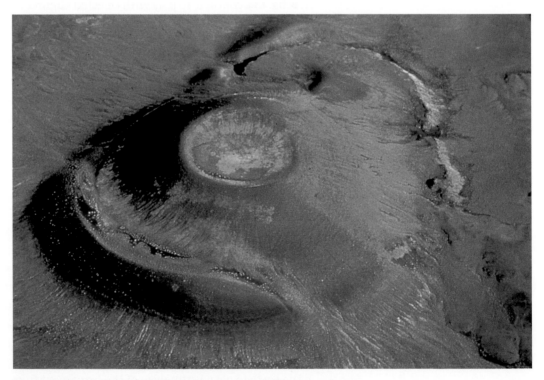

1.21 James Turrell, *Roden Crater Project*, begun 1974. Cinder cone volcano, approx. height 540ft, diameter 800ft. San Francisco Peaks, Arizona.

the dead going to a better existence in the heavens. Thus many tribes buried their dead not back within the earth, but on top of mounds, closer to the sky. Turrell's crater brings into question humanity's relationship with the earth.

At the opposite end of the spectrum from Turrell, Ana Mendieta (1948–85) created small, personal artworks out of natural materials within the landscape, whose duration was momentary but which also evoked timeless questions of the place of human life within the larger world. Exiled as a child, Mendieta felt closest to her Cuban roots when creating pieces about identity and landscape. Her work was also deeply committed to feminist themes of creation and nature. Many of her works exist today only in the photographs or films made at the time of their production. Some of the earliest, like the Silhueta and Tree of Life series made in Iowa while she was in graduate school in the late 1970s, were made out of gunpowder, candles, sand, or mud and specifically designed to be temporary and to merge again quickly with the environment ▶ **fig. 1.1** (see p. 2). Others, such as the carvings she made in a cave wall when she visited Cuba in 1982, lasted longer but were deliberately left without protection to allow the natural process of erosion ▶ **fig. 1.22**. Nearly every shape she made was related to the female body, and many works had titles that referred to themes of birth and pain, regeneration and death. Mendieta found the earth to be both a home and an alien space, and, as a living body, to represent a spiritual mother, an antidote to exile and modern disaffection.

1.22 Ana Mendieta, *Itiba Cahubab* (Old Mother Blood), from the Rupestrian series, Cueva del Aguila, Escaleras de Jaruco, Havana, Cuba, 1982. Photo etching on *chine collé*, 10ins x 7ins. Galerie Lelong, New York.

The work of Mel Chin (born 1951) echoes that of Holt and Smithson but moves away from their intensely constructed visual effects to explore territory where nature seems more in control. His pieces serve primarily to highlight what is already going on in the natural world and incorporates what he calls "green remediation." In his *Revival Field*, begun in 1990, Chin integrated art and science. The piece was conceived in collaboration with a researcher at the United States Department of Agriculture. Using a fence to delineate an area of landfill in St. Paul, Minnesota, which had been ruined by toxins, Chin introduced plants whose growth would help absorb heavy metals and serve to detoxify the dirt. The circular shape was sectioned into quadrants by paths forming an "X," delineating the area and separating the species of plants. Funding sources encouraged the gathering and dissemination of scientific data about the effects of pollution on natural resources. Even though the location is not open to the public, the distribution of test results guarantees that its message is accessible. Chin went on to do more "revival fields," which are used by the Department of Agriculture as laboratories while also serving as public sculpture. Chin feels that his work is like carved stone or wood artforms; the process is one of material reduction and reshaping of the very elements of the earth.

The use of the earth as a material for art has a long history. Since many of the ancient forms discussed at the beginning of this chapter were associated with burial or religious ceremony, the term "sacred landscape" came to imply the union of earthworks with supernatural beliefs. Some of these concerns have been carried over into large-scale modern artworks that return to the environment as both a setting and a medium for artistic expression. Through this one theme, it is possible to see how related approaches to monumental landscape construction have existed in different times and places. One can glimpse the ways in which essential, traditional, and timeless human relationships with the earth have informed artistic investigations of form and symbolic meaning specific to given societies.

Further Reading

D.V. Clarke, T.G. Cowie, and A. Foxon, *Symbols of Power at the Time of Stonehenge* (Edinburgh, 1985) chapter 3, pp. 35–80

G. Kubler, *The Art and Architecture of Ancient Mexico* (Baltimore, MD, 1962/1975) chapter 2, pp. 23–66

P. Mason, *History of Japanese Art* (New York, 1993) chapter 1, pp. 13–32

M.K. O'Riley, *Art beyond the West* (London, 2001; New York, 2002), pp. 268–277

E. Pasztory, *Pre-Columbian Art* (Cambridge, UK, 1998), chapters 2 and 3, pp. 64–97

E. Pasztory, "The Natural World as Civic Metaphor at Teotihuacán," in *The Ancient Americas: Art from Sacred Landscapes*, ed. R.F. Townsend (Chicago, 1992), pp. 135–145

J. Pomeroy, "Selections from 'Rushmore—Another Look' (with an Afterword)," in *Critical Issues in Public Art: Content, Context, Controversy*, ed. H.F. Senie and S. Webster (New York, 1992), pp. 44–56

O. Rodriquez Roque, "The Exaltation of American Landscape Painting," in *American Paradise: The World of the Hudson River School*, exh. cat., Metropolitan Museum of Art (New York, 1987), pp. 21–48

J.F. Sears, *Sacred Places: American Tourist Attractions in the Nineteenth Century* (New York, 1989) Introduction, pp. 3–11

H.F. Senie, *Contemporary Public Sculpture: Tradition, Transformation, and Controversy* (New York, 1992), chapter 4, "Landscape into Public Sculpture: Transplanting and Transforming Nature"

To visit Turrell's Roden Crater or de Maria's Lightning Field contact the DIA Center in New York City by visiting http://www.mhhe.com/frames

Source References

p. 16 "The sequestered situation of this church . . ."
W. Irving, *The Legend of Sleepy Hollow* (1819), in *The Tradition in American Literature*, ed. G. Perkins, S. Bradley, R. Beatty, and E. Long (New York, 1985), vol. 1, pp. 478–79

Discussion Topics

1. What can the scale and technology of a prehistoric building project tell us about the community that built it?

2. Compare and contrast the forms and functions of mounds in the three premodern civilizations discussed in this chapter.

3. How was interest in the American landscape manifested before modern American artists began creating earthworks?

4. Discuss some of the similarities and differences between the artwork of Ana Mendieta and that of the other twentieth-century artists mentioned in this chapter.

5. What did the builders of Teotihuacán have in common with those of Stonehenge?

6. How have prehistoric monuments influenced the work of twentieth-century environmental artists? How did their intentions differ? Did the premodern builders anticipate or even incorporate erosion into their designs?

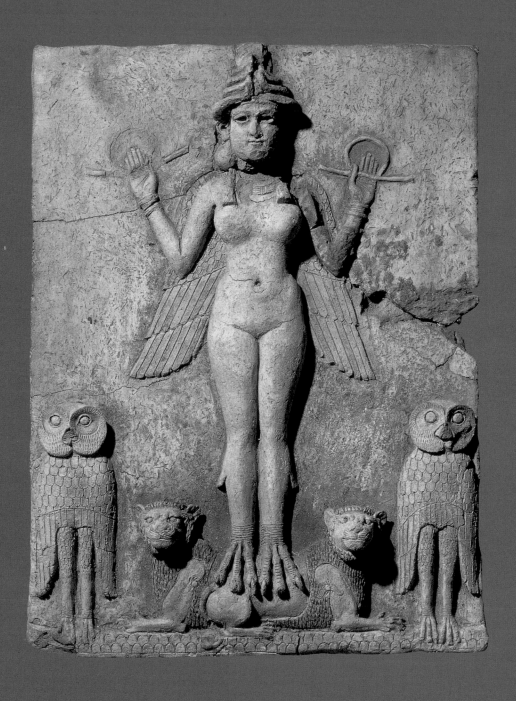

Representations of the Gods

Giving visual form to an idea of how a supreme being might appear has always been controversial. Some religions, such as Judaism or Islam, teach that divine power is so great and inconceivable that the faithful are prohibited from making images of their "creator gods." However, most other religions have based representation of their gods either on the human form, or on the form of the animal in which they believe their spirit god becomes incarnate. As a result, in the same way that threads of similar beliefs and rituals can be detected across different religions, so too do the images of gods from widely divergent cultures often share surprisingly similar characteristics.

Although there are generally acknowledged to be only three "major" religions in the modern world (Christianity, Islam and Buddhism), there is considerable overlap between them and other religions: Christianity and Islam are both indebted to Judaism, while Buddhism came about as a response to the practice of Hinduism and was later influenced by Daoism. In addition, there have always been many other religions practiced by smaller populations or less dominant societies such as that of pre-Columbian America, and those still in existence in Australia and sub-Saharan Africa. This chapter opens with an overview of goddesses and gods from the societies of antiquity, followed by a discussion of Greek, Christian, Hindu, and Buddhist images of the divine. Since most religions have historically priviliged the male divinity over the female, the examples in the main core of the chapter focus on some of the most commonly portrayed male figures.

We will discover that similarities between cultures abound, and often reveal the effects of long-distance trade routes as well as the common human inclinations toward making religious imagery. The ancient Greek god Apollo had many qualities that later appear in representations of male prophet or hero gods, such as those carried into Central Asia from the eastern edges of the Hellenistic Empire and handed down to Christianity via the Romans.

2.1 Inanna/Ishtar wearing a crown of lunar horns and a rainbow necklace with lions and owls, Sumer, Mesopotamia, Larsa period, c.2000 BCE. Terracotta relief, height 1ft 8ins. Private collection.

We also examine the other features that link Eastern and Western male deities: Christ and Krishna, for instance, were both divine sons sent by their fathers to save humankind; Buddha and Christ both renounced earthly pleasures. Native American representations of divine powers combine human features and body parts with animal characteristics. Rich legends tie supernatural activities to natural and historical events. Two examples from the Aztec culture of Ancient Mexico appear in this chapter to demonstrate this even richer anthropomorphic approach to deity imagery. North American figures from tribes of the northwest coast that are similar in concept appear in chapter 9.

Key Topics

The human impulse, across history, to use art to express notions of the divine.

▶ Mother goddesses: female figures were created in the earliest societies for ritual purposes, to encourage fertility, both in women and the earth itself.

▶ Gods in human form: ancient Greek gods were usually portrayed in recognizably human form, and their ideals influenced subsequent artistic practices in the West.

▶ The figure of Christ: central to the work of artists in Europe, the portrayal changing over centuries to reflect changes between Church and State.

▶ Celebration of the gods: in contrast to Christian depictions, Hindu art celebrates the eroticism of its gods.

▶ *Nirvana*: the quest of Buddhist artists, across time and place, to portray Buddha in this state.

▶ Anthropomorphism: Aztec gods were represented in animal form with human characteristics.

Antiquity

Gods and Myths

The American scholar Joseph Campbell (1904–87) spent his life comparing the myths of the world. Of his many works, *The Hero with a Thousand Faces* (1949) delves behind the words and symbols of the heroes of religion, myth, and fairytale to discover that people all over the world and throughout time have continually recreated the same archetype in whom to place their faith and hope—the same god appearing in different guises.

RIGHT **2.2** Female figurine found at Dolcí, Vèstonice, Moravia, Central Europe, c.34,000–26,500 BCE. Molded of clay and bone ash, height 4½ins. Moravske Museum, Brno, Czech Republic.

The two most common forms for gods to take have been that of the female creatrix and the male hero. The first springs from explanations of genesis—how humans came to be in the very beginning—centered on a mother figure, a fertile female who could bear life and nurture its continuation. The male hero, on the other hand, is an image of someone at once both protective and retributive, powerful and procreative.

Representations of mother goddesses seem to be among the earliest forms of visual art in many cultures. This was probably due to the reverence given to nature and rebirth; to women and their role in maintaining the population of the clan; to the seasonal cycles of the hunted animal and the gathered vegetation in hunter-gatherer societies. The importance of the female role is evident in even the simplest forms of representational art such as early handheld figurines from prehistoric Central Europe ▶ **fig. 2.2** or the ▸reliefs◂ of Sumer in Mesopotamia ▶ **fig. 2.1** (see p. 24). The former suggest ▸abstract◂, generalized, shapes that emphasize associations with childbearing and nurturing. Some have sharp-pointed stakes instead of legs and feet in order to allow placement in the earth for ritual ceremonies. Other goddess figures are shaped with phallic heads in a combination of male and female reproductive imagery.

Sumerian texts, recorded from 2000 BCE, give the first stories about and hymns to a goddess: Inanna, also known as Ishtar or Astarte, goddess of heaven and earth, whose stately, cylindrical form became a visual prototype for female deities throughout Western civilization. Her story and love song capture the magic of myth when linked with the natural reality of a people who now cultivate the land for food:

Inanna spoke:

"What I tell you
Let the singer weave into song.
What I tell you,
Let it flow from ear to mouth,
Let it pass from old to young:

My vulva, the horn,
The boat of Heaven,
Is full of eagerness like the young moon.
My untilled land lies fallow.

As for me, Inanna,
Who will plow my vulva?
Who will plow my high field?
Who will plow my wet ground?

As for me, the young woman,
Who will plow my vulva?
Who will station the ox there?
Who will plow my vulva?"

Dumuzi replied:

"Great Lady, the king will plow your vulva.
I, Dumuzi the King, will plow your vulva."

Inanna :

"Then plow my vulva, man of my heart!
Plow my vulva!"

At the king's lap stood the rising cedar.
Plants grew high by their side.
Grains grew high by their side.
Gardens flourished luxuriantly.

Many symbols of fertility and power are mentioned in this text. The vulva, symbolized by the scallop shell, as well as the horn and boat, suggests the ready womb. The moon stands as the female equivalent of the male sun, just as the horned ox symbolizes a virile male animal. The ripe grains and gardens are familiar images of "Mother Earth," reinforcing claims of good resource management. Most importantly, the king is a mortal chosen to seed the goddess. Finally, unlike many erotic texts of later centuries written with the subjugation of the woman in mind, here the goddess initiates the encounter and thoroughly enjoys the results.

Elaborate goddess/priestess representations from Minoan Crete ▶ **fig. 2.3** seem to provide information about the people who made them. The precious materials and fine craftsmanship have been considered evidence of the wealth and artistic development of these mild island-dwellers, whose merchant ships may once have ruled the Mediterranean Sea. The figures are dressed in costumes that can be found repeated on small sculptures, vases, and wall paintings of the era. The style celebrates the large, full breasts and wide hips of the mature goddess. Minoan art as restored by Sir Arthur Evans (1851–1941) favors the light, bright colors and wavy lines of marine life, as well as the long flowing hair, tiny waists, and elegant gestures of an apparently happy, healthy, and prosperous people.

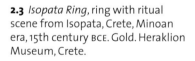

2.3 *Isopata Ring*, ring with ritual scene from Isopata, Crete, Minoan era, 15th century BCE. Gold. Heraklion Museum, Crete.

Greece

The Greeks were fascinated by the large-scale sculpture of the ancient cultures that preceded them around the Mediterranean Sea: civilizations in Mesopotamia and Egypt had both begun around 3000 BCE and were still flourishing when Greek society became prosperous enough to consider making monumental art around 600 BCE. While Greek figure composition echoes that of Egypt (see figs. 3.9, 3.13, 3.14), the Greeks separated the limbs from the sculptural base, thus creating a different balance and proportion in their works (see figs. 2.4–5). The use of marble, however (a material not available in Egypt), and the portrayal of the male figures as heroic icons set new standards. What was an authoritative style for the Egyptian kings became the so-called Greek "Archaic" style—human-scale figures who are powerful yet restrained, bold yet discreet, modeled yet tied to decorative patterns and the cubic volume of a

RIGHT **2.4** *Kouros* figure from Sunion, Greece, c.580 BCE. Marble, height 9ft 10ins (partly restored). National Museum, Athens.

monumental medium. To illustrate this latter point, consider the head of their male youth, or *kouros* (pl. *kouroi*) ▶ **fig. 2.4**. The side of the cheek clearly reflects the corner of the stone block before it turns the corner to the face. The hair is formed by regular, repeated patterns, reminiscent of Mesopotamian predecessors (see the beards and hair on figs. 3.2, 3.8). The ear is also a decorative form, in this case one that can be traced back to much earlier gold warrior masks buried on the Greek mainland by these sculptors' ancestors.

Herodotus and the Ideal Citizen

Herodotus, in his *History* (an account of the fifth-century BCE war between the Persians and Greeks, see also chapter 4), demonstrated the superiority of Greek civilization over its "decadent" adversaries by illustrating the Greek virtues. One of his stories explains the subject of a set of *kouroi* named *Cleobis and Biton* ▶ fig. 2.5, casting light on how *kouroi* represent the ideal Greek citizen: Cleobis and Biton are young and strong, and equally devoted to their mother and to the goddess Hera.

They were men of Argive race and had a sufficiency of livelihood and, besides, a strength of body such as I shall show; they were both of them prize-winning athletes, and the following story is told of them as well. There was a feast of Hera at hand for the Argives, and their mother needs must ride to the temple; but the oxen did not come from the fields at the right moment. The young men, being pressed by lack of time, harnessed themselves beneath the yoke and pulled the wagon with their mother riding on it; forty-five stades they completed on their journey and arrived at the temple. When they had done that and had been seen by all the assembly, there came upon them the best end of a life, and in them the god showed thoroughly how much better it is for a man to be dead than to be alive. For the Argive men came and stood around the young men, congratulating them on their strength, and the women congratulated the mother on the fine sons she had; and the mother, in her great joy at what was said and done, stood right in front of the statue and there prayed for Cleobis and Biton, her own sons, who had honored her so signally, that the goddess should give them whatsoever is best for a man to win. After that prayer, the young men sacrificed and banqueted and laid them down to sleep in the temple where they were; they never rose more, but that was the end in which they were held. The Argives made statues of them and dedicated them at Delphi, as of two men who were the best of all.

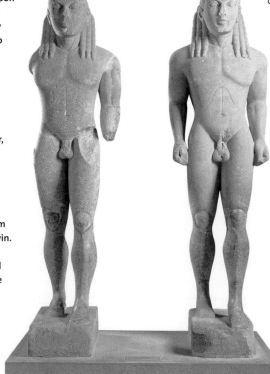

2.5 *Cleobis and Biton*, from Argive Treasury at Delphi, Greece, c.580 BCE. Marble, height 6ft 6ins. Delphi Museum.

Scholars have long debated whether *kouroi* represent Apollo or are memorials to young men. Since they have been found both in temples and on grave sites, they can be identified as either. The confusion is understandable because Apollo's youth, fitness, and intelligence as the god of light and medicine, archery and music, shepherding and prophecy served as model virtues for male Greek citizens. So, even if the figures were not always specific representations of the god Apollo, his characteristics were adapted to portray an idealized form of the Greek citizen (see inset).

The female figure, or *kore*, is also indebted to both the Egyptian representations of the queen as Hathor, the Great Goddess, and her Middle Eastern incarnation: Inanna/Ishtar/Astarte ▶ **fig. 2.6**. In this tradition (compare the Sumerian example, fig. 2.1), the monumental female body is primarily made up of a cylinder for the skirt with a triangular upper torso and head. Her authority is conveyed by the stable base of this cylinder as well as the regular, vertical folds of the drapery on it, which resemble the flutes of a column. Her strong facial features,

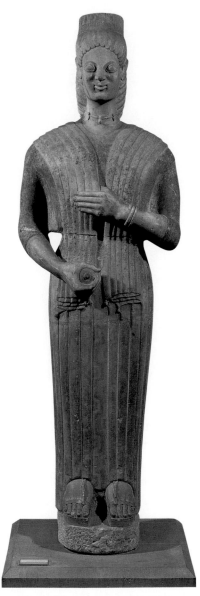

2.6 *Kore* from Keratea, Greece, c.570 BCE. Marble, height 6ft 4ins. Staatliche Museen, Berlin.

like those of the *kouroi*, exaggerate the eyes and thus her apparent alertness. This is done not only through the size of the eyes but through the way in which they seem to make up two complete halves of the face on either side of a very long, straight nose that grows from continuous overarching eyebrows.

Another type of mythological female with supernatural powers was pictured by the Greeks as a monster, a Gorgon. This seems to be a response to the Minoan snake goddess, who was beautiful and powerful. In the legends, the Gorgons were once beautiful and sensual as well, but incurred the wrath of the Athena goddess who made them so ugly that one, Medusa, was said to have a face that would turn men to stone ▶ **fig. 2.7**. The Greeks often pictured her death by the sword of Perseus on vases and sculptural reliefs, complete with snakes in her hair and around her body, her other grotesque features including a long tongue.

As the Greeks refined their techniques, the *kouroi* figures became more ►naturalistic◄ through the intrinsic qualities of control and serenity. At the Temple of Zeus at Olympia, a *kouros* figure does actually represent the god Apollo in a narrative scene, standing as a symbol of order amidst chaos ▶ **fig. 2.8**. Here, characters from the famous wedding story of the Lapiths whose neighbors, the Centaurs (who had the bodies of horses and the heads of men), began a drunken brawl, fight over the Lapith women in active groups of two and three, bending their forms down into the shape of the triangular pediment. The fighting Lapiths and Centaurs are rendered more realistically than Apollo, increasing the contrast between their struggling bestiality and his divine perfection.

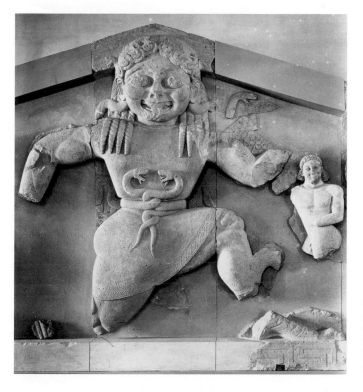

2.7 Figure of the Gorgon, Medusa, from West Pediment of Artemis Temple, Corfu, Greece c.580 BCE. Limestone, height (of Gorgon) c.9ft 4ins. Corfu Museum.

RIGHT **2.8** *Apollo with Centaur and Lapith Woman* , from West Pediment of Temple of Zeus at Olympia, Greece, c.460 BCE. Marble, height of figure c.10ft 8ins. Olympia Archeological Museum.

Three-dimensional projections into space are able to imply the movement of an athletic body, and Greek sculptors continued to generate new forms that demanded a stronger material than marble (see inset). A good example of the bronze works of the ▸Classical◂ period (fifth century BCE) is the figure found off Cape Artemision ▶**fig. 2.9**. Whatever he held in his hand has been lost, so it is unclear whether this is the god Zeus, identifiable through his thunderbolt, or his brother, the sea god Poseidon, identifiable by his trident. Both deities were usually shown with the beard of maturity. Whichever god it is, the nobility of presentation has been coupled

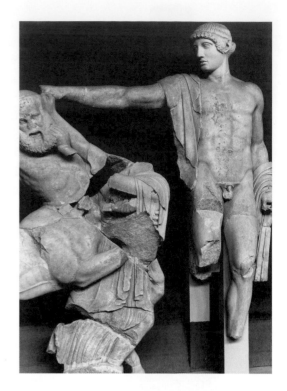

with a dynamic suggestion of engagement in a powerful action. As his muscles strain and he balances his arms and feet against the weight of the weapon he held in his right hand, the god is concentrating on the direction of the great force he is about to throw. His scale has been

Marble Versus Bronze

Greek sculptors experimented with the best materials for their large-scale works. Marble, which is of very high quality and plentiful in Greece, is softer than Egyptian or Mesopotamian ▸diorite◂. This type of modeling, where one chips away material to leave a form standing free, is called "reductive" or ▸subtractive◂ sculpture. In order to come closer to a realistic representation of the human body, particularly in movement, the Greeks removed more of the block than their predecessors did, opening holes between the arms and the body and between the legs. This weakened the overall support, especially in the case of marble, which has little tensile strength, i.e., it is not always capable of supporting its own weight. This is why Greek

statues often have their arms, legs, or even heads missing. In order to correct this weakness, the sculptor turned to an ▸additive◂ process, making a model of the final work built up out of clay. This model was then covered with wax and a plaster mold. Hot liquid bronze was poured through a hole in the top of the mold and the melting wax ran out of a hole in the bottom (thus it was called the ▸lost-wax process◂). Once cooled, the bronze was much stronger than marble and could support any figural pose with long extended limbs.

When the Romans copied original Greek bronzes in poses that extended outward into the viewer's space, they used marble with its low-tensile strength. As a result, Roman sculptors often had to resort to the addition of awkward supports, such as short tree trunks at the legs or rectangular struts linking the arms and body. There are also drawbacks to bronze as a material for sculpture. For one thing, working with wet clay is not always as rewarding as carving a resistant surface. More regrettably, bronze can be used again, and many of the finest works from history may have been melted down for recycling into cooking pots and cannon balls.

2.9 *Zeus* or *Poseidon*, from the sea near Cape Artemision, Greece, c.460–450 BCE. Bronze, height 6ft 10½ins; length fingertip to fingertip 6ft 10¾ins. National Museum, Athens.

coupled with the energy of implied movement, a three-dimensional balance achieved through the extension of his powerful arms and legs into space. The viewer is thus caught up in both the imagined sequence of the implied action (pulling back and thrusting forward) as well as in the reaction to a complex pose, which is arresting from all angles. However monumental and impressive the immobile stone presence of a divine figure, in bronze, the god's inherent power no longer seems at rest, but interacts with the viewer's space to demonstrate physical authority.

Christian Europe

The Greek city-states fought among themselves as well as trying to hold off invaders such as the Persians and Macedonians (see chapter 4). Against the latter they failed to defend themselves in the fourth century BCE and so became the core of Alexander the Great's huge empire. After Alexander's death, his holdings broke apart and the small republic of Rome on the Italian peninsula was eventually able to add Greece to its own expanding territories. The Romans were fascinated with Greek society and emulated many aspects of its culture. It was the Roman assimilation of Greek religion that really established Greek myths and deities in the West. In particular, gods such as Apollo were adopted by Roman rulers as symbols of their own political identities. In the coin shown in ▶ **fig. 2.10**, the late-Roman emperor Constantine associates his powers with the "sun god" by layering his profile with that of Apollo. This tradition would continue centuries later in Europe: Louis XIV of France (see chapter 5) called himself the "sun king," also after Apollo.

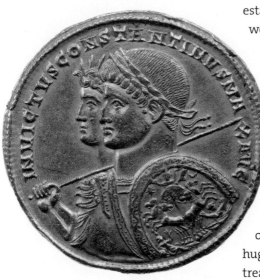

2.10 Coin of Constantine with Apollo, 4th century CE. Bibliothèque Nationale, Paris.

By the time of the decline of the Roman Empire, the dire state of the economy and the great class separation between rich and poor people were giving rise to new or revived religions that promised a better existence after death—something not found in most Classical beliefs. One of these, Christianity, was based upon the teachings of a Jew named Jesus and began in the Roman province of Judaea, on the east coast of the Mediterranean Sea. Early in the first century CE, huge crowds gathered to listen to Jesus' preaching on equality and the charitable treatment of others. As a prophet in the Judaic tradition, he claimed to represent the Jewish creator god who would reward the virtuous, even if they were poor and miserable. The teachings of Jesus grew in popularity as many of his followers joined him hoping he would free them from the harsh occupation of the Romans. In written records of his life, Jesus calls the Jewish creator god his father, thus linking his life to the historical formula of the divine offspring. Jesus was given the title "Christos" or "Christ," a Middle Eastern term for a savior god. Non-biblical sources confirm that his mother, Mary, was a *kadesha*, a Jewish temple maiden whose function was that of a priestess and whose offspring were called "virgin-born."

By Constantine's time (c.280–337 CE), this group had become a political force to be reckoned with, and the emperor offered to grant their religion official status within the empire, thus reducing the rebellious significance of their practices. In doing so, Constantine styled himself as their great benefactor, building churches and furnishing lavish gifts for cult ceremonies that soon came to resemble Roman state ritual (see also chapter 4). At first there had been no images of Christ, only symbols of his presence.

The first representations of him as human had been humble and reassuring, as in a third-century ►fresco◄ from the catacomb of Calixtus in Rome, where he is depicted as the good shepherd with his sheep ► **fig. 2.11**. Such images appeared in homes, burial catacombs, or other private locations. However, once Constantine had formalized state adoption of Christianity, references to the notion of protection changed in quality. Taking after Constantine's identification with Apollo, the Christian cult adopted many of Apollo's holidays (such as "sun" day—the traditional date for the festival of the sun) and related the notion of a god of light to Christian promises of salvation. Rather than standing only as a symbol of spiritual shepherding, Christ was given imperial garb and

2.11 *The Good Shepherd,* Catacomb of Calixtus, Rome, Italy, 3rd century CE. Fresco.

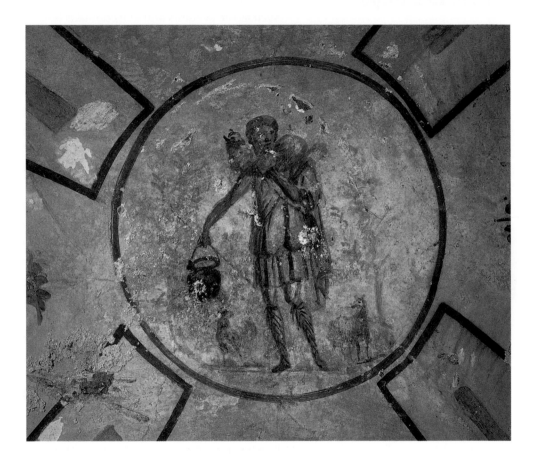

the instruments of martial power over death, as can be seen in a ►mosaic◄ in Ravenna, Italy ► **fig. 2.12**. One can compare the two figures of Christ as the Good Shepherd to see this change quite clearly.

In the third-century fresco (see fig. 2.11), Christ appears as a humble worker in a lowly profession, accessible to all people, no matter how poor. He cares for his flock by carrying nourishment in a pail and a small lamb on his shoulders. Such an image of rural comfort, common in Roman wall painting, had been used for over four centuries to suggest the agrarian roots of Roman religion and economic stability. Now it was adapted as a representation of Christ's promise to care for the Christian soul in the afterlife, to save it from the kind of everyday misery that many Romans were suffering.

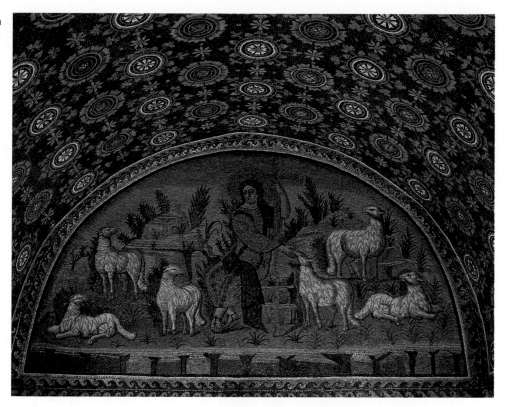

2.12 *The Good Shepherd*, Mausoleum of Galla Placidia, Ravenna, Italy, c.425 CE. Lunette with mosaic.

In the fifth-century mosaic (see fig. 2.12), Christ is no longer a humble peasant. He wears the purple and gold robes of a Roman emperor and is seated upon a rock shaped like a throne bolster. He does not carry food or a lamb. His outstretched hand is met humbly by his flock, but Christ looks up toward the sky, rather than at the sheep who surround him. In the manner of an enthroned ruler, his hand gesture resembles more the act of offering a ring to be kissed by his subjects than a solicitous caress toward those in his care. His face has acquired definition: the large eyebrows, dark shadows beneath his eyes, and long, straight nose are no longer as naturalistic as in the earlier fresco. Rather, these elements exaggerate the power of his gaze in a manner long used to portray those in authority. His shepherd's staff appears in the form of a cross, suggesting Christ's victory over death in his resurrection. He was killed in a way the Romans associated with the greatest humiliation, on a wooden cross, as a common thief with no right to a quick end. By taking the instrument of that death, the cross, and making it a part of his regalia (royal instruments like a crown or scepter), Christ's death was turned into a powerful symbol of triumph. The Good Shepherd is here more symbolic than representative, and the divine Jesus is now a figure fit for worship by higher-class Romans.

This Roman imperial image of Christ lasted with few variations throughout the Middle Ages. In the eastern half of the former Roman Empire, called Byzantium, the Greek

Fresco Versus Mosaic

Two popular methods of decorating interior walls were employed in Mediterranean countries (further north, where it is colder, walls were often lined with tapestries or rugs to provide insulation). In the technique of fresco, ►pigments◄ in a water base are worked into sections of wet plaster as it is applied, making the colors an intrinsic part of the wall surface that cannot peel off and resulting in a matte surface. Frescos are subject to damage from damp and light, so many of them are now in poor condition. The mosaic technique was developed as a more durable medium. Small colored tiles of glass or ceramic (►*tesserae*◄) are embedded into a cement base. Their shiny surface reflects and thus increases interior light while the harder materials resist water absorption. Because *tesserae* could be quite expensive—some of them include real gold flakes and many other colors are made from semi-precious gemstones—mosaic was generally available only to wealthier art patrons.

Orthodox version of Christianity was (and still is) practiced. Because the churches were subdivided between an open space for the first part of the service and a smaller, closed area for the most sacred moments of the ceremony, there was a screen between the people and the altar. Upon this were hung ▸icons◂, popular images of the saints painted on wood; hence the term for the screen, iconostasis. Icons were also kept in people's homes for private devotion, while particularly old or elaborate ones were among the prized possessions of monasteries. As the demand for them increased, emperors and Church authorities became concerned not only about the enormous income generated in donations to monasteries holding them, but about the implications of worshiping a painted picture. There is a commandment in the Old Testament prohibiting idol worship. A huge debate arose in the Eastern Church that split people into two camps: those in favor of images and those against them. This Iconoclastic Controversy lasted from 726 to 843. Laws were even passed forbidding the production or worship of icons during the reigns of rulers who were against them. Violent enforcement of the laws caused much destruction. Iconodules, people in favor of images, claimed that the original pictorial source for portraits of Christ was a miraculous imprint of his face upon a cloth and that St. Luke himself had painted the first icon of the Virgin. A manuscript from the ninth century, the Khludov Psalter, made after icons were reinstated, equates ▸iconoclasts◂ (those against images) with the Roman soldiers who tortured and killed Christ ▶ **fig. 2.13**. The crucifixion is pictured, showing soldiers with the bucket of vinegar and the sponge with which they are said to have offered Christ drink while he was dying. Below, another scene alludes to this event. In place of the cross is a traditional icon of Christ and, in place of the soldiers, a wild-looking iconoclast wields a bucket of whitewash and a long brush.

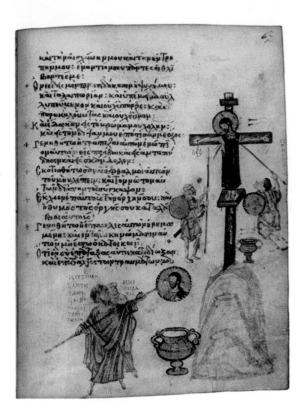

2.13 Scene showing the crucifixion and iconoclasts whitewashing an icon of Christ, Khludov Psalter, Constantinople (modern Istanbul, Turkey), c.843 CE. State Historical Museum, Moscow.

Once the iconodules triumphed, images were returned to church decoration. The form of Christ Pantocrator, or ruler of the world, appeared in domes ▶ **fig. 2.14**. Subtle variation occurred between versions. In this early eleventh-century example, Christ is heavily outlined against a gold background, placing him outside any naturalistic context. The halo, or aura of light around his head, a standard Roman feature showing that the figure was worthy of veneration, has acquired a cross to symbolize his victory. His features are severe and exaggerated, giving him an authoritative, even frightening, appearance. The great distance from the floor to dome, for which the mosaic was designed, accounts for some of the contrasts. Although appearing out of the dome of heaven, Christ does not look directly down at the people below, but follows late imperial tradition, which keeps the ruler's gaze distant. In his hand, he holds the book of his gospels, the divine "Word" that Christians believed was necessary for their salvation.

Chapter 4 discusses the images of Christ on Romanesque and Gothic churches in Europe from the eleventh to the fourteenth centuries. These generally show Christ as an enthroned judge, again in the Roman tradition, changing in style only gradually

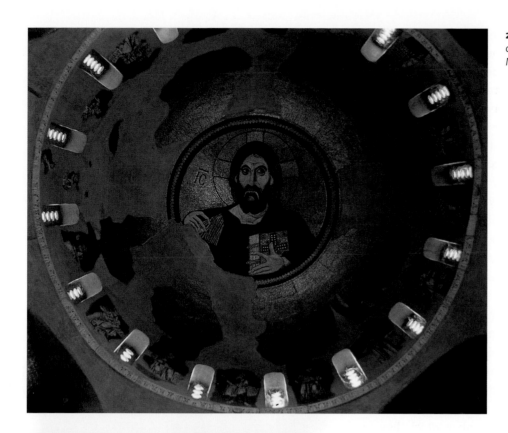

2.14 *Christ Pantocrator*, in dome of Dormition church, Daphni, near Athens, Greece, c.1020 CE. Mosaic.

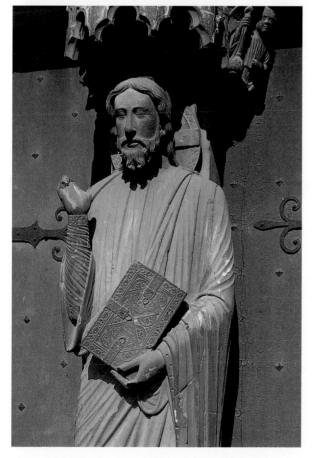

from rather harsh and abstract to more sympathetic and realistic representations. During the Middle Ages, innovation was not encouraged. Nonetheless, the image of Christ that greeted visitors to medieval pilgrimage churches softened. Even when visions of Christ as the Judge at the end of time appear above doorways, single figures of Christ as a benevolent lord, or the *Beau Dieu*, often decorate the central pillar below. At Chartres Cathedral, the central portal of the South Transept entrance features an early *Beau Dieu* in which the standing Christ, holding the gospel book of Christian salvation, makes a gesture of blessing ▶ **fig. 2.15**. This figure has a more approachable quality than its eleventh-century forebears. His well-modeled stature and serene expression may also bring to mind early Apollo figures (see fig. 2.8) and the enlightened Buddha (see below).

2.15 Christ as the *Beau Dieu* (Benevolent Lord, or Teaching Christ), jamb statue, central portal, South Transept entrance, Chartres Cathedral, Chartres, France, c.1225. Limestone.

The greatest change to the image of Christ happened around the fourteenth century, when artists began to focus on his crucifixion. Now his body is not defined by rich robes but rather by attention to the ravages of physical pain. The carved head from a crucifix by the German sculptor Claus Sluter (c.1379–1405) is just one example of an artist offering the message of divine salvation: it was Christ's death that paved the way to Christian redemption ▶**fig. 2.16**. Another is a fresco by Masaccio (1401–28?), painted for a prominent Florentine family's memorial at Santa Maria Novella ▶**fig. 2.17**, which shows Christ's death on the cross directly above an illusionistic sarcophagus representing the tomb in which they are laid. The figures of two family members who paid for the work appear as if kneeling on a ledge projecting out above the tomb. They therefore seem to be more in the viewer's space than in the deep, ▸vaulted◂ chamber where Christ's cross is set. His death prefigures their own, and his sacrifice suggests their entry into the everlasting life of the soul hoped for by Christians. An inscription links the visitor to the church with death as well, translating as "I was what you are, you will become what I am."

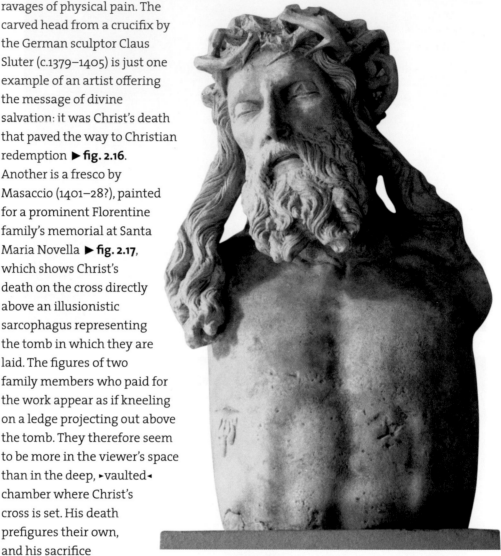

2.16 Claus Sluter, *Head of Christ*, from the *Moses Fountain*, 1395–1403. Wood with traces of polychrome, height 2ft. Musée Archéologique, Dijon.

Employing a medieval and Renaissance convention suggesting goodness through association, the figures of Mary and St. John are placed in Masaccio's fresco just behind the family members, as if at the foot of the cross. In this way, the donors, and by extension the viewer, are in the presence of holy persons while in the church. Note, too, the illusionistic treatment of space in the painting. As in Roman imperial imagery, the most important figure, in this case Christ, is centered under an ▸arch◂ supported by columns. But now a space opens up behind the arch, covered by a ▸barrel vault◂ with a

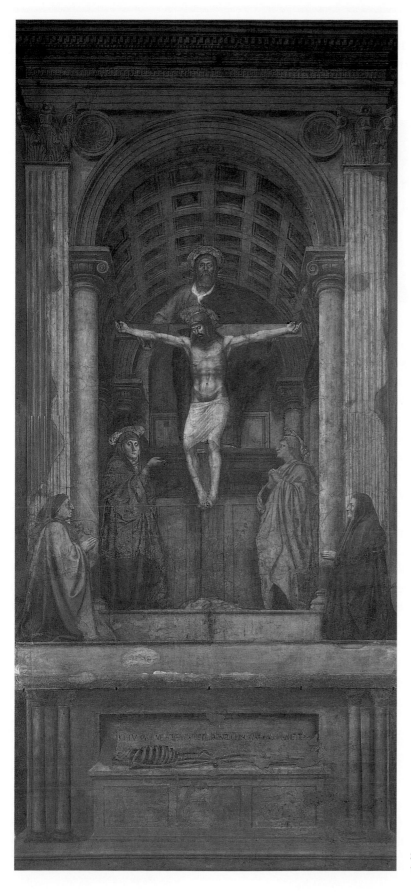

▸coffered◂ ceiling. At the back there is another arch set on columns, in front of which there appears to be another ledge, or table, much as an altar would have been set into the apse of a church. It is thus fitting that God the Father seems to stand on this ledge as he leans forward to hold up the cross upon which his son, Christ, is hanging. Between God the Father and Christ, a small white dove represents the Holy Spirit, the third member of the Christian godhead, the Trinity.

Christ's body hangs heavily against his outstretched arms and the muscles are rendered deeply to enhance the visual tension. His head falls to one side and his lower body twists in pain. Masaccio's mastery of spatial depth focuses the viewer's attention on the crucifixion. The coffered vaulted space is achieved by rendering the entire composition from a single vanishing point at the viewer's eye level, creating a pyramidal triangle to encompass the three members of the Trinity.

2.17 Masaccio, *The Holy Trinity*, c.1427. Fresco, 21ft 10⅝ins × 10ft 4¾ins. Santa Maria Novella, Florence.

Hindu India

In India the beauty and richness of physical fertility and eroticism has always been emphasized as an expression of the gift of life. This can be seen in direct contrast to European concerns about sensual temptation and the emphasis on earthly suffering in religious experience. As such, southeast Asian art has generally combined human with natural forms. Some of the earliest supernatural figures date from around the first century CE, for example a female nature spirit called a *yakshi* ▶ **fig. 2.18** who manifests the very landscape of India. Her undulating pose, called *tribhanga* due to the three points of knee, waist, and elbow, suggests that she is organic and supple like the mango tree from which she draws flowers. Her form appears both among the earliest developments in the Indian subcontinent and in the imagery of Hinduism and Buddhism.

The intimate poses of Hindu gods and goddesses have long sustained their popularity with viewers. The figures of Siva and Parvati in this twelfth- or thirteenth-century sandstone relief carving from Orissa, for example, not only gaze into each other's eyes, but their elegant bodies interlock ▶ **fig. 2.19**. Like Apollo and Christ, Siva is portrayed with a youthful and strong body, in the full flower of manhood; but his pose is usually curved, with a softness to the modeling of his muscles and a much more sensuous appearance to match that of his female partner. Being the earliest, and some say supreme, god of an Indian male Trinity, Siva carries many forms and titles that emphasize his sexual energy and his important union with the goddess Parvati, also called Kali or Shakti, the female spirit of the universe. In the myths, this divine couple had two sons, one of whom, Ganesha, is easily recognized since he is represented with an elephant's head and a child's body ▶ **fig. 2.20** (and see inset, opposite).

2.18 *Yakshi* bracket figure from the east gate of the Great Stupa, Sanchi, Madhya Pradesh, India, early Andhra period, 1st century BCE. Stone, height c.5ft.

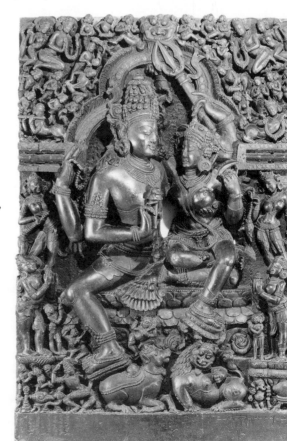

2.19 *Siva and Parvati*, Orissa, India, 12th–13th century. Schist relief. British Museum, London.

One of Siva's best-known guises is as the Lord of the Cosmic Dance, Nataraja ▶ **fig. 2.21.** Usually (though not shown here) surrounded by the flaming aureole signifying the cosmic light of the sun, the god is given multiple arms to allow numerous symbolic gestures, or *mudras*. One of the most common, the "fear not" gesture, can be identified by the presence of the raised right hand, palm turned out. His right leg gracefully supports the vibrant movement of the dance. He crushes a small figure who symbolizes ignorance under his foot. Siva is balanced yet dynamic, embodying his delicate power both to create and to destroy. During the Chola dynasty (888–1267), many of these bronze statues were made for use in a daily ritual that involved pouring oil from above. If the figures were properly aligned, the oil would flow down and drip off the big toe.

Representations of the god Siva embody the Indian fascination with the sensual body, just as images of Christ reflect Western preferences for a powerful ruler. When Buddhism emerged in India in the fourth century BCE, visual depictions of the enlightened teacher were slow in appearing. The next section describes the dual influences of East and West as the image of the Buddha slowly developed.

Siva and Ganesha

Ganesha probably existed as a tribal totem before being incorporated into the Hindu pantheon. His hybrid appearance is explained by the myth of his birth, according to which he was brought to life by Parvati without Siva's seed and was born while Siva was away from home. By the time Siva returned, Ganesha had grown to a young man and Siva was suspicious of his presence. He challenged Ganesha, who had no reason to recognize Siva as his father. In the fight that ensued, Siva cut off Ganesha's head. Once Parvati had explained that he was their son, Siva ordered a servant to bring him the head of the first creature he met so that he could restore Ganesha to life. The servant quickly found an elephant and brought its head back, thus incorporating one of the most beloved animals of India into the "Holy Family" of Parvati and Siva. In recognition of his brave defense of his mother's doorway, images of Ganesha abound in the entrances of Indian homes.

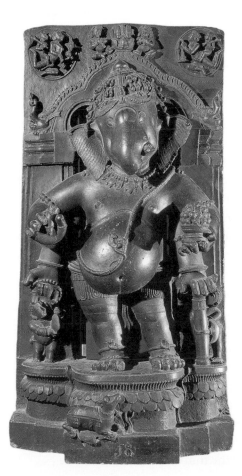

LEFT **2.20** *Ganesha*, Orissa, India, 13th century. Schist. British Museum, London.

RIGHT **2.21** *Siva as Nataraja*, India, later Chola period, 13th century. Bronze, 2ft 10¼ins × 2ft 3½ins × 1ft 1in. Nelson-Atkins Museum of Art, Kansas City.

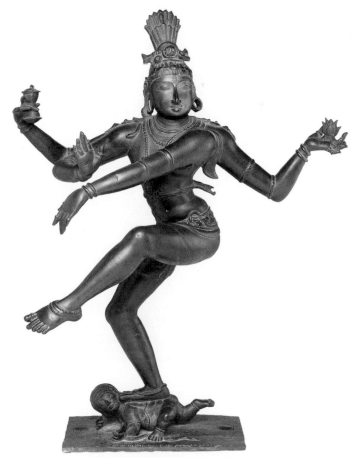

Buddhist India and East Asia

Siddhartha Gautama was an Indian prince who began teaching a reformed version of Hinduism in the sixth century BCE. Rejecting his privileged life in the palace, he became a wandering ascetic teacher whose wisdom and popularity earned him the title Buddha, or Enlightened One (see inset, opposite). Buddhism was established five hundred years before Christianity and its precepts influenced Christian ideas about suffering, a savior, judgment, and new levels of existence after death. For instance, similar to Christian hopes for an afterlife, the Buddha believed that suffering in this life will lead to a higher level of existence in a process called reincarnation (*samsara*). In the final enlightenment, the Buddhist achieves a state of pure being without physical distractions, or *nirvana*. The Buddha's own existence in this state was portrayed in painting and sculpture as a divine condition. Thus, although primarily a teacher and model, Buddha had a status that quickly grew to that of a god and pictorial conventions were adapted from representations of Hindu deities. The challenge in Buddhism, however, was to express Buddha's spiritual form without privileging the physical body. This concern affected the development of his eventual characteristic representations.

As with Early Christian symbols representing Christ, Buddha was not at first shown in human form. Only aniconic (non-figurative) references to his presence are made by objects important in his life, such as the tree where he had his *bodhi* or revelation ▶ **fig. 2.22**. Many of these objects had also been important in earlier Indian religions and their traditional associations thus brought richer significance to his symbols.

The style of representing the physical Buddha begins with influences from imported Western sculpture. Since Buddhism began in the northern area of India, many cultural influences were available to artists through traveling merchants. In fact, the contemporary work of the neighboring Hellenistic Empire, formed when Alexander the Great (356–323 BCE) conquered Greece, brought Western approaches to the sculpted figure to Indian artists. In a Buddha from the northwestern Gandharan region, mostly in present-day Pakistan ▶ **fig. 2.23**, one can see similarities to Greco-Roman sculpture. Despite the figure's height of 7½ feet, its human proportions and monumental sensibility are related to Greek developments, including the regular fold patterns in the drape of his monk's robe (*sanghati*) and the places where the pressure of his body smooths them out. Serene in his lowered gaze and with the symmetry of a figure balanced evenly on both legs or the pyramidal seated yoga position(see fig. 2.24), the Buddha's inner peace is conveyed through outer form much like the self-control of the *kouroi* (see fig. 2.4). At the same time, the style is not entirely derived from foreign sources, for a fleshier and more rounded body is clearly visible under the thin drapery in spite of the

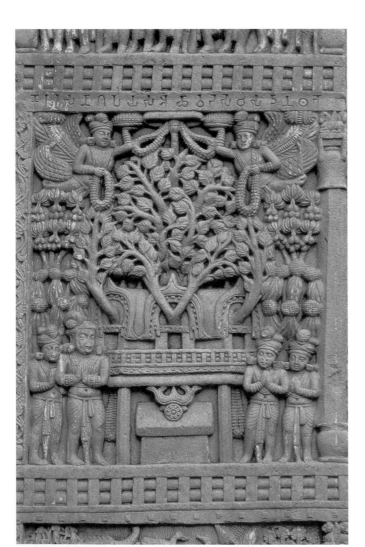

2.22 *Adoration of the Bodhi Tree*, detail of east gate, south pillar, from Torana, Great Stupa, Sanchi, Madhya Pradesh, India, 2nd or 1st century BCE. Stone.

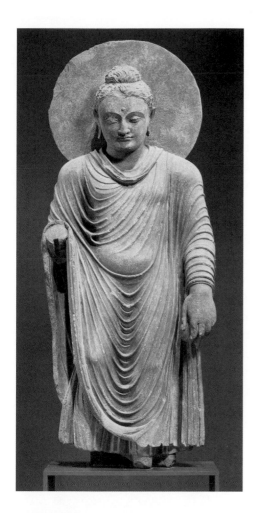

regulated folds. The Buddha shows his origins in Indian sculpture and reminds the viewer that he was a beautiful, young Hindu prince.

Iconographic features identify this figure as the Buddha, much as a king can be recognized by his crown. There are thirty-two such characteristics or *lakshanas*. For instance: Buddha's earlobes are stretched into long loops symbolizing the heavy jewelry he removed when he left his father's palace. His head swells with the *unisha*, a cranial knob indicating his great wisdom and divine energy. He also has a tuft of hair between his eyes, the *urna*, or third eye, by which he sees the meaning of life. His hair is formed in "snail curls" that resemble the tight patterns in Persian hair and beards (see fig. 3.8).

Under the Gupta dynasty (320–647 CE), highly skilled artists produced religious art. Even though this was a Hindu imperial family, its members sponsored some of the most beautiful images of the Buddha. These figures owe much to earlier sculptural styles from the region around the Ganges River and have been called the "classical" version of Buddha, namely, the form of the Buddha that became standard both because it seemed to achieve an ideal balance between form and content and because it was exported in this form to China and Southeast Asia. Two examples are characteristic.

2.23 *Standing Buddha*, from Takht-I-Bahai, Gandhara (modern-day Pakistan), c.2nd or 3rd century BCE. Slate, height 7½ft. Museum für Indische Kunst, Berlin.

The Buddha

The legend of Siddhartha Gautama begins around 560 BCE in Nepal with his miraculous birth to his mother, Queen Maya. A prophecy told that he would either be a great ruler or teacher. Raised in a rich, courtly household, he seemed destined to rule until one day, when he was twenty-nine, he took a walk outside the palace and discovered three things that woke him to human misery: disease, old age, and death. He decided to leave the comfortable world of royal privilege, even his wife and newborn son, so that he could ponder the meaning of life and take on the role of a wandering monk. He deprived himself of every comfort, even food, for six or seven years as he wandered, but found this only led to pride in his austerity. He decided to adopt a more moderate lifestyle and finally, one day, achieved the ability to distinguish between temptation and good intention, thus finding enlightenment or *nirvana*. The tree under which he was meditating has since been named the tree of enlightenment or *bodhi*. He fulfilled his destiny after this, preaching his understanding of the "Wheel of Life" and became a great enlightened teacher, or Buddha.

The basic tenets of the Buddha's teaching revolved about reforming the intense strictures of the social caste system in place during his lifetime. Building upon the best philosophies of Hinduism, he taught a circular law (the "wheel") that life is suffering because people desire worldly pleasure through ignorance; to have true happiness and peace, a person must meditate on denying desire and understanding the self. He advocated the eight-fold way to salvation, the *dharma*: (1) to be filled with proper understanding; (2) to resist evil deeds; (3) to be discreet; (4) to behave respectfully toward others; (5) to follow a constructive vocation; (6) to keep away evil thoughts; (7) to control emotions; and (8) to strive for complete concentration. Since one's deeds in each consecutive life determine one's position in the next (*karma*), it is only after breaking the attachment to earthly things that one could be freed from the cycle of reincarnation and suffering. The first sermon on these things took place in a deer park, and the Buddha is often represented seated with deer about him as a reference to the historic moment.

The Buddha's recognition that the life of hermits may not encourage the best social goals led to the formation of the first monastic communities, where monks lived together and practiced the spiritual rules he taught. Most Buddhist art in India was made for these communities. The Buddha, or *Shakyamuni* (wise man of the Shakya clan), lived a long life, dying around 480 BCE.

In a sandstone sculpture from Sarnath, Buddha is shown preaching his first sermon in the Sarnath Deer Park at Benares ▶ **fig. 2.24**. He is seated in the meditating yogi posture with his hands in a position called *dharmachakra*, or "turning the wheel of the law" (*dharma*, "law" and *chakra*, "turn"). The drapery of the cushion is shaped to resemble the lotus flower, a symbol with many associations in Indian art. Here it stands both for the purity of Buddha's thought and his place in the universe. Although represented giving his sermon, he seems to be more a model for his own teaching than actively engaging his audience. His heavily lidded eyes serve to turn his gaze inward and the smoothness of his drapery enhances a slender, elegant figure whose grace expresses an inner quiet as well as the flexibility of a serious practitioner of yoga. On the base, the wheel representing the *dharma* is centered between two deer (now broken off) to show both the subject and the location of the sermon. Abstracted lion-griffins appear on the throne sides, signifying the Shakya clan from which Siddhartha Gautama came and the authority of the Buddha's teaching. Behind him a large disk functions like a halo, representing the wheel of the sun shining around him. It is decorated with vegetal forms reminiscent of early Indian organic fertility motifs.

The standing figure, also from Sarnath, is covered with drapery that is only suggested by its edges, allowing the graceful and sensual body to express Buddha's spiritual union with nature ▶ **fig. 2.25**. The edges of the neckline, wrist, and hem echo the roundness of the wheel behind him as well as the curves of his egg-shaped head—a reference to the shape of the universe from which all is begun; the lines around his neck (*trivali*) are a sign of beauty. His face has moved further away from the Western naturalism of the Gandharan example (fig. 2.23), becoming more abstract and iconic. His forehead and nose are flatter planes with sharp edges and his hooded eyes are enlarged to exaggerate his inner vision. Buddha's hair is again made up of "snail-curls." The reassuring *mudra* of his right hand is the same as that of Siva (see fig. 2.21) and also recalls the later blessing gesture of Christ as the *Beau Dieu* (see fig. 2.15).

2.24 *Seated Buddha Preaching the First Sermon*, Sarnath, Uttar Pradesh, India, Gupta period, 5th century CE. Sandstone, height 5ft 3ins. Archeological Museum, Sarnath.

RIGHT **2.25** *Standing Buddha*, Sarnath, Uttar Pradesh, India, Gupta period, 474 CE. Sandstone, height 6ft 4ins. Archeological Museum, Sarnath.

2.26 *Great Bodhisattva,* from Cave 1, Ajanta, India, c.600–650 CE. Wall painting.

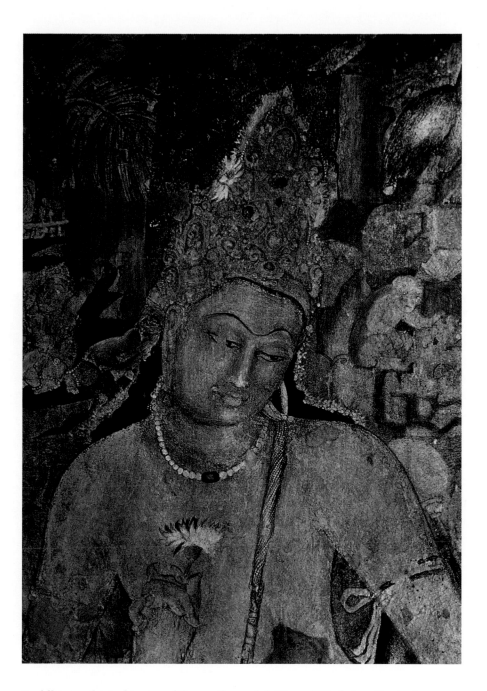

Buddhism adopted many of the myths and deities of Hinduism. For instance, moralistic Hindu fables and folktales of animals achieving understanding (*jatakas*) were adapted to represent the previous lives of the Buddha before he became Prince Siddhartha. The popular imagery of these stories was retained in Indian Buddhist art. Similarly, many of the Hindu gods and goddesses reappear as royal disciples of the Buddha who delay their own *nirvana* in order to guide their people. They are called *bodhisattvas* and, unlike the early simple appearance of the Buddha, their forms indulge the rich decorative traditions of Indian deities in portraying beauty, rich garments, and jewelry, as can be seen in the fresco from Cave 1, Ajanta ▶ **fig. 2.26**. The sensuous and princely *bodhisattvas* directly recall the god Siva, invoking the early Indian emphasis on male fertility and power.

This distinction between the enthroned introspective Buddha and his worldly devotees developed more fully as Buddhism spread from India to Southeast Asia and China. As Indian craftsmen created the first imagery for Chinese and Indonesian shrines, their foreign style added an element of the exotic to royal commissions. Local artists then adapted the new subject matter to fit the physiognomy of their own populations as, for instance, at the great pilgrimage site of Buddhist shrines at the Longmen Caves in Luoyang ▶ **fig. 2.27**. Here, thousands of gigantic Buddhas were carved into rock caves as devotional shrines by workers employed by imperial Chinese dynasties. In the cave shown, the Buddha has begun to appear Chinese in his facial features (rounder head, slanted eyes, flatter nose and cheeks) as well as conveying the spiritual quiet of the *Vairocana Buddha* (cosmic Buddha), which sets him apart from the infinite number of worlds over which he looms. Ultimately, the presentation of Buddha and his court was meant to reflect the wealth and position of the royal donors.

2.27 *Vairocana Buddha and Attendants*, Longmen Caves, Luoyang, Henan Province, China, c.665–75 CE. Natural rock, height c.49ft.

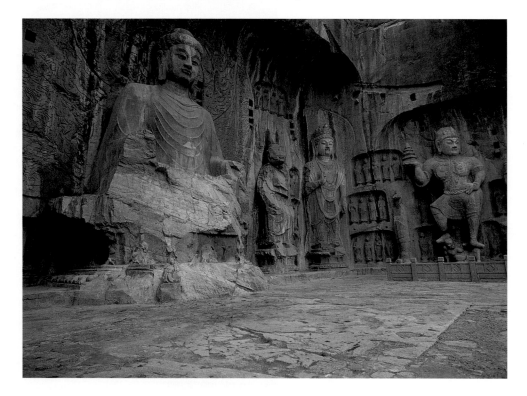

Some of the cliff faces have eroded so much that the shrines are now exposed, but they were originally enclosed and could be visited only by entering the caves. The carved and painted Buddha figures are placed within spaces of varying depth that include *bodhisattvas* on either side. The central Buddha occasionally has a ▸mandorla◂, or flame-like aura filled with multiple smaller buddhas surrounding his body. From about the fourth century onward Buddhism was sponsored by various dynasties in northern China in order to unify their political territories, so it is appropriate that these settings give the general impression of a royal court with retainers around a ruler.

The central Buddha figures are the largest of the compositions and stand or sit with no suggestion of movement or interaction other than a possible identifying *mudra*.

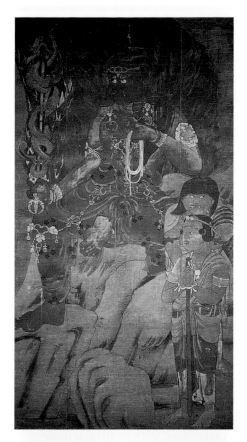

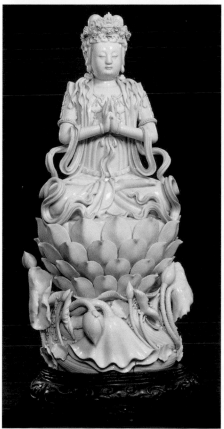

Buddha's asceticism is stressed by the simplicity of his form set against the detailed richness of his retainers. The seated figures are in the pyramidal lotus position while the standing ones rest solidly on vertically static drapery. Their monumentality is reinforced by a style that brings the eye repeatedly back to the center, whether through circular forms and patterns to create the Buddha himself or the gestures and drapery of the surrounding princes. The faces show change over the centuries from the long, ascetic face of an Indian monk to a rounder, weightier head with Chinese features. Opulent decoration surrounds them, on the ceilings and in the intricate lines of the flowing drapery on their attendants. Buddhist art in China had developed a unique style, far from its Indian origins. The adoption of Buddhism in other countries had similar results and the figure of the Buddha changed according to the cultural conventions under which it was adopted.

By the time Japan imported Buddhism from China in the seventh century, the religion as practiced in India or Southeast Asia had been assimilated with Chinese esoteric philosophies. Having spawned myriad sects, myths, and mysteries throughout Asia, Buddhism as it entered Japan was quickly adopted by a population practicing an indigenous religion based on nature-spirit worship, called Shintoism. Icons of the Buddha in elaborate temple shrines, surrounded by dramatic retinues, are portrayed in a style of fierce ▸realism◂. These expressive figures were easily appreciated in the context of the politics of the Kamakura period (c.1185–1333), with its shoguns (petty princes) and Samurai warriors. One of the gods developed from the fierce aspect of Hinduism's Siva into esoteric Buddhism is the ferocious Fudo Myo-o ▶ **fig. 2.28**. He wields a sword and noose out into the viewer's space, his body is stocky, and his deeply lined face sprouts fangs and bulging eyes. In spite of this display of raw power, he was actually revered as a protective figure.

One of the most beloved gods in Buddhism is known as Kuan-yin in Chinese or Kwannon in Japanese. Originally this deity was the *bodhisattva* named Avalokiteshvara in India, revered as the greatest incarnation of mercy, protector of travelers and rulers, and savior of souls. These qualities are portrayed in the richly clad figures with soft features and nurturing poses, so that there is some ambiguity about whether the god is male or female. There are fine depictions of the deity in Chinese porcelain of the Ming dynasty (1368–1644), of which ▶ **fig. 2.29** is a seventeenth-century example.

ABOVE LEFT **2.28** *Fudo Myo-o*, Japan, early Kamakura period, Myo-o-in, Koysan, Wakayama prefecture, Japan, c.1185–1333. Color on silk, height 5ft 1½ins.

LEFT **2.29** *Bodhisattva Kuan-yin of the South Seas*, Dehua Ware, China, Late Ming dynasty, 17th century. Porcelain with white glaze, height 1ft 5¾ins. The Norweb Collection, Cleveland Museum of Art.

Aztec Mexico

So far this chapter has considered how the human figure has been taken as the model with which representations of divine figures can most easily be associated. Many cultures devised different forms of gods as animals or fantastic non-human creatures. Yet often, to convey their divine power, these portrayals are still given anthropomorphic expressions; in other words they convey some human physical characteristics along with animal forms. MesoAmerican societies, as rich in mythic traditions as those discussed above, also merged natural events with supernatural characters. Although separated in time and place, the various settlements and peoples in Mexico and the Caribbean shared many deities and stories. The last great Mexican empire, that of the Aztecs, incorporated elements of earlier beliefs as sacred history, producing figures of gods in highly developed forms. The images are anthropomorphic and their symbols are important keys to identification.

2.30 *Coatlicue*, Tenochtitlán, Mexico, Aztec period, c.1500 CE. Stone, height 8ft 6ins. Museo Nacional de Antropologia, Mexico City.

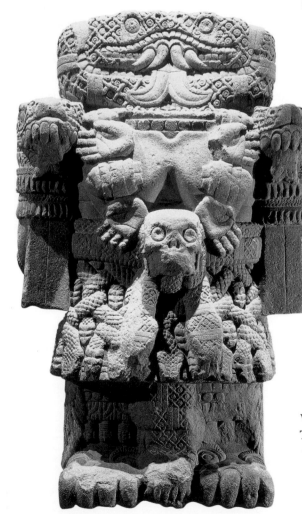

The earth goddess Coatlicue ▶ **fig. 2.30** is based upon a concept of a powerful, repulsive appearance, similar to the Greek Gorgon Medusa (see fig. 2.7). This version of Coatlicue is a terrifying creature with eight limbs, two rattlesnake heads, and a skirt of twisted snakes (her name means "she of the serpent skirt"). Originally brightly painted, like nearly all MesoAmerican art, her large size and horrifying aspect would have made a chilling greeting at the entrance to the Templo Mayor, or "Great Temple," in present-day Mexico City, then the Aztec capital called Tenochtitlán. Because women brought babies into the world they were agents of life, but that very life required death in order to make room and to feed the living. For this reason, women were also associated with death and none more so than Coatlicue, whose breasts lie directly above a belt ornament of a skull tying her both to the good, nurturing earth of fertile Mexico and to the consuming earth of burial and decay. Coatlicue's children are the sun god Huitzilopochtli and the moon goddess Coyolxauhqui, whose great battle is re-enacted daily in the changeover between light and darkness.

Two legends about Coatlicue's family tie together older MesoAmerican myths with the history of migrations some time before the fifteenth century. (It has not been established exactly when the people known as Mexica moved into the valley, but they are recorded as important rulers by this time.) These stories come from age-old oral traditions that were recorded by Spanish monks who accompanied the conquistadors in the sixteenth century. In the first, Coatlicue is an old priestess who becomes magically pregnant through some feathers collected while sweeping the temple floor. She already has four hundred sons and one daughter, Coyolxauhqui, all of whom become jealous and believe that their mother has shamed them. They plan to kill her but the unborn son, Huitzilopochtli, calls out that he will avenge her. He is then born with his weapons at the ready and chases them all, capturing and killing Coyolxauhqui. The characters are traditionally identified with natural phenomena. As Coatlicue was the earth goddess, her children are of the sky: the daughter is the moon of

the four hundred star-sons, while Huitzilopochtli is the sun god who banishes them every morning.

The second legend relates the story of the Mexica before they moved to Tenochtitlán: in this version Huitzilopochtli is the leader who recommends that they leave where they were living, while Coyolxauhqui defends the people who were afraid and wanted to stay. Again, the two fight and Huitzilopochtli decapitates Coyolxauhqui, implying that enemies of the Aztecs would be reduced to shreds because they were weak, "like women."

Among the most famous Mexican reliefs, one of the largest Aztec monuments ever uncovered, at about 10 feet in diameter, represents Coyolxauhqui chopped into pieces after doing battle with her sun-brother ▶ **fig. 2.31** (and see inset, p. 48). Her name means "she of the golden bells," so she is identifiable through the disk-shaped bells on her cheeks. She also wears the traditional ornaments of the fire god on her ears, and her hair is adorned with feathers. Appearing within the round outline of the moon, her limbs, which are in profile and have bones coming from their ends, are broken away from her naked torso, shown frontally. Nudity in Aztec culture was considered a form of humiliation and here the goddess is seen like a captive who has lost her social identity after losing an important battle. Significantly, the stone was set into the floor of Huitzilopochtli's temple on the main square of Tenochtitlán, where sacrificial victims landed after rolling down from the altar. Rather than depicting a model hero, whose strength or spiritual sophistication suggested that of the individual ruler (as seen in the Greek, Christian, Hindu, and Buddhist examples above), Coyolxauhqui stands as a figure subjugated to Aztec authority.

2.31 *Dismemberment of the Moon Goddess, Coyolxauhqui*, Tenochtitlán, Mexico, Aztec Late Post-Classical period, 1325–1521 CE. Stone relief, diameter 11ft 6ins. Museo del Templo Mayor, Mexico City.

The other temple on the main square, also part of the Templo Mayor complex, was dedicated to the rain god Tlaloc, whose cult had been adapted from earlier societies in the regions near Tenochtitlán. Sun and water are vital elements in Aztec worship; Tlaloc's name means "he who makes things grow," showing the importance of water to the fertility of agriculture in a hot climate. He also presided over an afterlife inhabited by people who had drowned, and his cult included sacrifices of sick children whose mothers' tears were said to forecast fruitful rain. Tlaloc was believed to live in the mountains surrounding Tenochtitlán, up where the rainclouds formed. His sister, Chalchiuhtlicue ("Jade Skirt"), was associated with the water already on earth in the form of lakes, oceans, and rivers. Although he was generally seen as benevolent, Tlaloc's storms could also bring destruction to growing crops as well as devastating floods or he could withhold his gifts for years at a time.

Representations of Tlaloc include images from such water creatures as snakes, frogs, fish, and mollusks to the lightning of thunder storms. Many of the objects dedicated to

Under the Great Temple in Mexico City

It was while digging a tunnel for a subway under the street near Mexico City Cathedral in 1978 that workmen found the great relief stone of Coyolxauhqui. This may seem ironic, but in fact the cathedral was deliberately built over the razed remains of seven successive temples of the Aztecs in what had been their capital city of Tenochtitlán. After the conquistador Hernando Cortés had forced the Aztecs into becoming part of Spain's New World empire in 1519–21, Christian missionaries quickly set about erasing all evidence of the powerful rituals that had been enacted in the central square. They expressed horror at the practice of human sacrifice, whereby public offerings were made to the sun god Huitzilopochtli, considering it barbaric and using it as a justification for violent conquest by Europeans. For many people nowadays, it is difficult to reconcile how Christians could abhor ritual sacrifice yet condone the massacre of non-Christians who would not convert or give away their resources to outsiders. In turn, the Aztecs were offended at the Spanish worship of a weak god who was not only unable to avoid being put to death, but whose executioners were so primitive as to make it take hours rather than a few, merciful seconds—like their own highly developed technique of swiftly removing the victim's heart.

him at Templo Mayor were riches taken from surrounding areas as the Aztecs became a great imperial power in the fifteenth and sixteenth centuries. Thus Tlaloc's cult came to signify the continuation of earthly fertility and prosperity as provided by powerful conquering Aztec kings. The most common article on which Tlaloc was represented was a vessel that could hold water, his life-giving substance. One of the vessels from the temple shows his face with two serpents forming the eyes and mouth ► **fig. 2.32**. The headdress he wears shows heron feathers held in place by a net of clouds. Since he was blue, the perceived color of water in the sea, the vessels were also often colored blue. Performers who appeared as Tlaloc in religious festivals often wore masks covered with blue turquoise.

During the dry season, around the beginning of May, Aztecs undertook a special procession in which kings would lead the participants away from the city and up the 12,000-foot heights of Mount Tlaloc. There they set up camp, donned elaborate costumes, and performed complex prayer rituals in an elegant wooden temple; a stone effigy of Tlaloc took center stage, surrounded by those of the gods of lesser mountains. The kings each presented Tlaloc's effigy with new garments and rich jewelry, as well as a bounteous feast of prepared foods in newly made dishes and baskets. Sacrifices were performed in honor of both Tlaloc and the lesser gods, the blood being given as symbolic of the nourishing fluid that Tlaloc gave back through rain. The mountain was the key geographic element upon which Tlaloc's cult linked the rain of the sky with the fertility of the earth. The kings ensured the change of seasons by their acts, and the proof appeared about a month later when rainclouds would form around these very mountains and the valley would be replenished and renewed.

2.32 Mask of Tlaloc, from Templo Mayor, Mexico, Aztec period, c.1500 CE. Painted terracotta vessel, with mother of pearl and green stone beads on the interior, 1ft 1¼ins × 1ft ⅝in × 1ft ⅝in. Museo del Templo Mayor, Mexico City.

As explored in this chapter, rulers of many different societies often bolstered their authority through religious imagery: the perfect god could reflect qualities of the best rulers. In fact, most of the gods' visual characteristics were taken from royal ►iconography◄. However, leaders did not always have complete control over religious ideas. In a more direct use of art and monuments to influence both public opinion and documented posterity, kings and chiefs could sponsor images and buildings that epitomized their claims to broad social and political control. This theme is the subject of chapter 3.

Further Reading

T.R. Blurton, *Hindu Art* (Cambridge, MA, 1993), chapter 3, pp. 76–110

R. Cormack, *Byzantine Art* (Oxford, 2000), "Iconoclasm," pp. 86–102

J.C. Harle, *The Art and Architecture of the Indian Subcontinent* (New Haven, 1986), chapter 5, pp. 87–110

Kenneth Lapatin, *Mysteries of the Snake Goddess* (Boston/ New York, 2002)

E. Matos Moctezuma, *The Great Temple of the Aztecs* (London, 1988), pp. 37–86

J. Munsterberg, *Art of India and Southeast Asia* (New York, 1970)

M.K. O'Riley, *Art beyond the West* (London, 2001; New York, 2002), pp. 65–93, 126–135

R. Osborne, *Archaic and Classical Greek Art* (Oxford, 1998), pp. 75–85

J. Pedley, *Greek Art and Archaeology* (Englewood Cliffs, NJ, 1993), pp. 166–181, 198–212

J.J. Pollitt, *Art and Experience in Classical Greece* (Cambridge, 1972), pp. 27–36

B. Rowland, *Art and Architecture of India* (Harmondsworth, 1953), chapters 9 and 10, pp. 75–100

R.F. Townsend, "The Renewal of Nature at the Temple of Tlaloc," *The Ancient Americas: Art from Sacred Landscapes* (Chicago and Munich, 1992)

J. Welch Williams, *Bread, Wine, and Money: The Windows of the Trades at Chartres Cathedral* (Chicago, 1993), chapter 3

Source References

pp. 26–7 "Inanna spoke …"
D. Wolkstein and S.N. Kramer, *Innana Queen of Heaven and Earth: Her Stories and Hymns from Sumer* (New York, 1983), pp. 36–37

p. 28 "They were men of Argive race …"
Herodotus, *History*, trans. D. Grene (Chicago, 1987), p. 46

Discussion Topics

1. Compare and contrast Buddha and Christ. Pick out elements of their representations that show similarities and differences.

2. How has Hinduism retained some of the religious ideals of very early societies? How is this evident in its artwork?

3. Are iconoclastic claims that no one should represent the supreme being justifiable? Do you have a mental image for your personal conception of a god? Has it been influenced by visual art?

4. Do myths and legends help you understand visual art? Which stories told in this chapter seem to call for the same types of figures or scenes?

5. Can you begin to see how the religious art and practices of the Aztecs supported their imperial political aspirations? How do you think visitors to the capital would have viewed most of the imagery they saw in the main square?

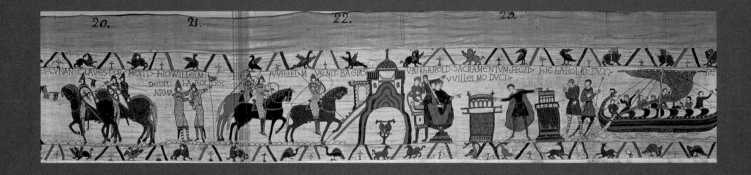

The Art of Rulers

Art and architecture have served to express the power and ambitions of rulers throughout history. Large, imposing buildings and sculptural monuments or finely wrought items of luxury reveal not only the wealth and technical prowess of a particular civilization or society, but are also an expression of the importance of the patron who instigated their creation. Often these works are dedicated to an event or to the memory of an illustrious person, reflecting well upon whoever commissioned them. Many royal patrons worldwide commissioned elaborate artworks throughout the centuries that evoked the memory of successful ancestors by using visual references to the works of the past, and thereby reinforced their own claims to contemporary power.

Even today, assertions of political strength are supported by visual means. We have daily reminders of our contemporary leaders, who appear on billboards, in newspaper features, or as sponsors of commercial and municipal facilities. One timeless method of reinforcing personal or state control continues in nearly every country of the world—images of the monarch, leader or state-founder appearing on the currency are easily distributed, reaching people who are unable to visit populous centers, where rulers like to site larger monuments to themselves. As a historical record, currency has particular value as coins survive better than most other visual records (see fig. 2.10).

The frequency with which images of rulers appear should not necessarily be read as a sign of their strength. The building of monuments, statues, palaces, and an insistence on the ubiquitous presence of their portrait have often been the resort of rulers whose power is shaky. The same is true of those tyrants and despots who have had to preserve their rule through fear, rather than good governance. Examples abound of rulers who have employed such techniques, from antiquity to the great masters of twentieth-century propaganda, Stalin and Mao, or the former dictator Saddam Hussein, whose image appeared in every Iraqi town and village, on every television set, and even on the face of a wristwatch. In more liberal societies, such a personal item might carry the image of a popstar or model, and indeed to a Westerner, a Saddam—or Mao—wristwatch might seem deliberately kitsch, rather than awe-inspiring. Thus, context is important when viewing all ruler images.

This chapter considers some major projects of rulers from across the world who sought confirmation of their powerful role in visual images. The messages that they convey seem strikingly similar, despite the vast span of time and place that separates them.

3.1 Bayeux Tapestry, detail of *Ubi Harold Sacramentum Fecit*. Harold swears an oath at Bayeux that he will accept William as king of England), probably Canterbury, England, c. 1073–83. Wool embroidery on linen, height 1ft 8ins. Bayeux Tapestry Museum, by special permission of the city of Bayeux.

Key Topics

Art and architecture used as projections of power over the past three millennia.

▶ Conquerors: Assyrians and Persians used architecture and decorative art to emphasize their superiority over subject peoples.

▶ Cult of divine kingship: ancient Egyptian rulers reinforced their authority by claiming to be gods, and pyramids reflected their individual importance.

▶ Divine kingship in Africa: expressed in naturalistic portraits on bronzes in Benin, ceremonial stools in Asante, and *ndop* statues in Kuba.

▶ Technical advances: the ancient Roman use of concrete and the arch resulted in a plethora of new forms projecting imperial authority.

▶ Continuity: medieval Germans adopted Roman practices to assert legitimacy, and the Normans produced the Bayeux Tapestry to justify claims to the English throne.

▶ Divine approval: early Southeast Asian dynasties commissioned monumental religious art to enhance authority.

The Middle East

The Middle East has always been an area of intense conflict over limited resources. Rulers who succeeded in holding fertile land or strategic territory had to use every means at their disposal to assert their control. Tensions with which modern readers are familiar in the form of wars between Iran and Iraq or the troubles in nearby Afghanistan can be traced back over five thousand years. For this reason, the reinforcement of ruling power through visual imagery has long been a motivation in Middle Eastern art production.

Mesopotamia

The area between the Tigris and Euphrates rivers, which empty into the Persian Gulf, was known as Mesopotamia (Greek for "[land] between rivers"), and was the site of several ancient civilizations (it is now modern Iraq). When the Assyrians brutally consolidated their power in the region around 1000 BCE, they were already part of a long line of successive groups to take it by force. Following the Sumerians, Babylonians, and Hittites, they inherited strong architectural engineering skills to make fortified structures and a rich vocabulary of figural representation. In an area where building material was produced by making bricks of the soil itself, as there were no natural quarries or forests, they secured their citadels, or defensive palace complexes, with thick walls and massive gateways ▶ **fig. 3.2**. At the entrances were prodigious winged bulls or lions with heads of men wearing elaborate headdresses, one type of which is called *lamassu* ▶ **fig. 3.3**. Their intimidating size was intended to suggest to the visitor that the ruler living inside wielded the physical strength of the bull and agile vigilance of the hawk. In order to render the legs as naturalistically as possible in both front and side views, the sculptors gave the animals five legs each.

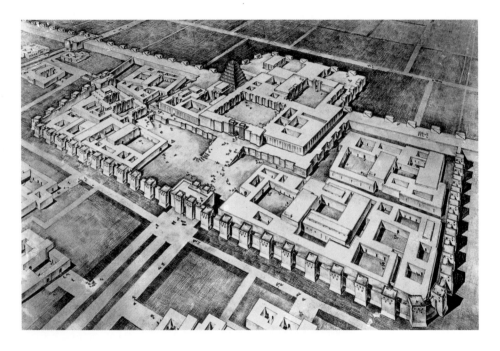

3.2 The citadel and palace complex of Sargon II, Dur Sharrukin (Khorsabad, Iraq), c.721–706 BCE. Reconstruction drawing after Charles Altman.

Long alabaster reliefs on the walls of the palace reinforced the impression of grandeur with scenes of the king victorious in battle and in the hunt ▶ **fig. 3.4**. Though carved in ▸low relief◂ (a technique requiring delicacy in achieving shapes through shallow carving), the narrative scenes are full of action. Hunting scenes were important to the king's reputation as a virile and courageous leader. The most fearsome animal to hunt was the parallel "king" of the animal world, the lion. In scenes depicting King Ashurbanipal of Nineveh, dead lions litter the ground behind the royal party's chariot, making the message of the ruler's dominance obvious. As a way of stressing this point even further, the artists rendered the bodies of the humans in superhuman terms, while the depictions of the lions shows greater naturalism ▶ **fig. 3.5**. Although the king

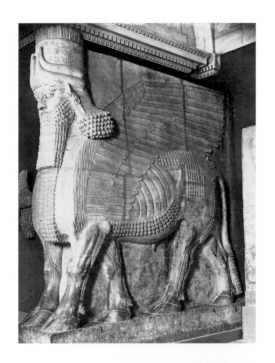

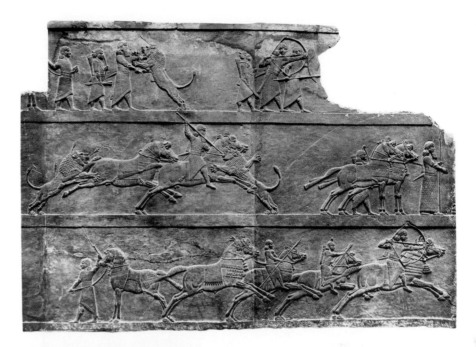

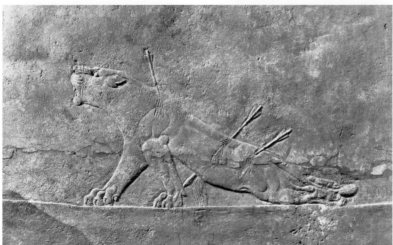

ABOVE LEFT **3.3** *Lamassu* (human-headed winged bulls) guarding the gateway of the Palace of Sargon II, Dur Sharrukin (Khorsabad, Iraq), c.720 BCE. Limestone, height 13ft 10ins. Musée du Louvre, Paris.

ABOVE RIGHT **3.4** Lion-hunting scene from the Palace of Ashurbanipal, Nineveh (Kuyunjik, Iraq), c.668–630 BCE. Limestone, height c.1ft 11ins. British Museum, London.

LEFT **3.5** *Dying Lioness*, from the Palace of Ashurbanipal, Nineveh (Kuyunjik, Iraq), c.650 BCE. Limestone, height c.2ft. British Museum, London.

is aiming his bow and arrow, he does so in such a way that the strain of human effort is diminished and the dignity of authority maintained. By contrast, the lions have powerful muscles and tendons, huge paws with long claws, and massive heads with open mouths suggesting loud roars. They struggle with death, dragging themselves valiantly in spite of fatal wounds. This realistic treatment of the animals intensifies both the danger that the king faces and the nobility of the royal hunt.

Persia

After the Assyrians, the Persian emperors built an even greater empire, the largest in the world, during the fifth century BCE (the remains of which make up modern Iran). They adopted Mesopotamian building and pictorial traditions for representing power. Among the many palaces built in the center of their territory was one at Persepolis, to which an annual New Year's festival brought delegates from all over the empire

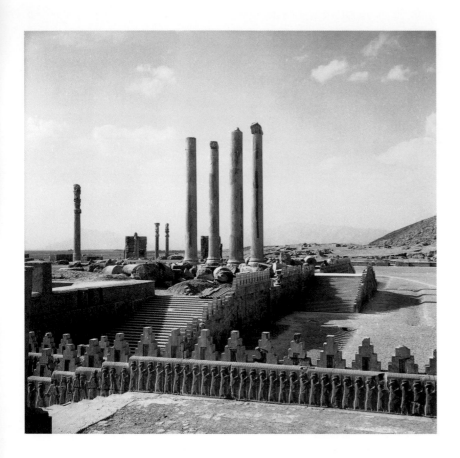

3.6 Palace of Persepolis, Iran, c.500 BCE.

bearing tribute to their ruler. The palace complex expanded under successive generations as the treasures secured inside increased over the years. Buildings comprised audience halls, storage rooms, private apartments, and generous military quarters—apparently as housing for the guards needed to protect the riches kept on site. The entire layout demonstrates the contemporary concern with procession and formal ceremony. Wide staircases lead out and back at right angles to large landings (called a "bent-axis" approach) ▶ **fig. 3.6**. The square audience halls were built in hypostyle fashion, with regular rows of columns holding up the roof over large spaces. One was 250 feet square, 60 feet high, and could accommodate 10,000 people.

The Persians designed a unique architectural form to embrace international artistic elements. Columns were fluted like those of the Greeks, with bases resembling Egyptian foliate devices, and ▶capitals◀ in the shape of powerful Mesopotamian animals such as paired bulls. As they incorporated the resources of great cultures around them by trade and conquest, the Persians' architectural programs began to reflect decorative influences from these peoples.

Reliefs on the staircases, doors, and walls of the buildings at Persepolis reinforce both the function of the site and the position of the emperor as ruler over vast lands ▶ **fig. 3.7**. Visitors who processed up the steps would find themselves next to long lines of soldiers, dignitaries, or other subject people, all like themselves bearing tribute. These reliefs were originally painted and gilded, which would have enhanced the festive atmosphere of the holiday event. Repetitive elements increase the impression of endless numbers of indistinguishable subjects and the common condition of all peoples under the Persian yoke. The figures are rendered in a flat, formulaic fashion, even though evidence points to their rendering by Greek craftsmen who had practiced a freer approach in their previous work for other sponsors.

Within the strict formula of the procession reliefs, iconographic details clearly identify the different cultural groups of figures. Yet the treatment of the drapery on the Persian

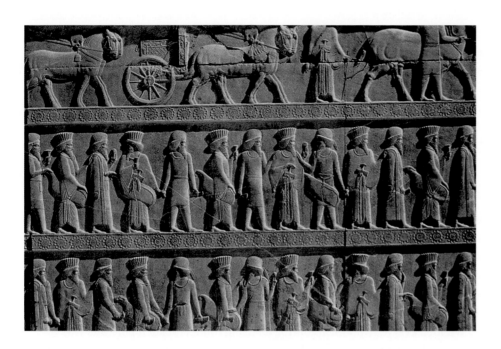

3.7 Reliefs from staircase up to audience hall, detail of procession of tribute-bearers, Persepolis, Iran, c.500 BCE.

figures gives a more naturalistic suggestion of bodies underneath. This could remind the viewer of the Assyrian distinction between humans and animals, showing that style can be used quite deliberately to convey content. In this case, the Persians are the dominant representatives of the emperor; their corporeality gives them stronger "presence" than the duller outsiders. Even the trees have a strict regularity; nature itself is controlled by imperial design.

A number of reliefs show the ruler enthroned or holding audience. ▶ **fig. 3.8** shows Darius I (r. 521–486 BCE) seated while his heir, Xerxes (r. 486–465 BCE), stands behind. Both their heads rise above the level of the other figures, but Darius would be even taller if he were to stand, thus creating a multi-level hierarchical scale within the set height of the ▸frieze◂. He is attended by bearers, in official uniforms for their roles, and royal guards. Facing Darius is an important retainer giving a report—probably the commander-in-chief of the imperial bodyguard. He bows slightly and covers his mouth

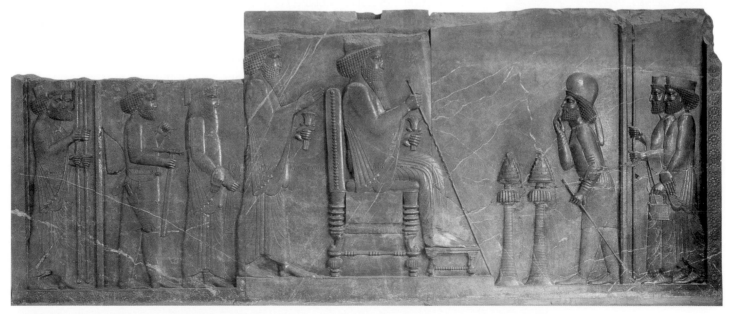

3.8 Darius I holding audience with Xerxes behind him, from the palace complex of Darius and Xerxes, Persepolis, Iran, Achaemenid Persian era, c.510–330 BCE. Limestone relief, height 8ft 4ins. Archeological Museum, Teheran.

with his hand, indicating his inferior position, which limits his right to speak. The right angles of the stiff bodies are repeated by the sharp lines of the throne and the guards' staffs, giving the impression of strict conventions that regulated all movement.

This presentation of the emperor's control through the standardization of visual forms followed a long tradition in the Middle East. Although other cultures did not emphasize the repetition of identical figures to quite the same extent as the Persians, we will see that it has been quite common to use art to reinforce authority in many other world societies.

Africa

Ancient Egypt

The most common view of ancient rulers expressing power through monumental art, at least in the West, is that of the Assyrian and Persian emperors posing as warriors and orators, gods, and monarchs. In ancient Egypt, the rulers were known as pharaohs, and they were thought to incarnate gods—become their living, physical forms—even as they wielded everyday political control. A strong model for such portraits was introduced in the early dynasties of the so-called "Old Kingdom" (c.3100–c.2155 BCE). Pharaohs were patrons of architecture and monuments that immortalized their memories, much like those produced in Mesopotamia.

Statues of any given pharaoh were made throughout his lifetime as proxy representations of his presence throughout the long, narrow country. When he died, many of his statues were gathered into his tomb, along with other treasures, to continue his identity and prove his legitimacy in the afterworld. One early example of an enthroned Egyptian pharaoh from the Old Kingdom can be found in the large fourth-dynasty statue of Khafre ▶ **fig. 3.9**. It is carved in a clean, smooth style from a block of very hard stone called diorite, a material in which details are difficult to execute. The restraint of his posture and the simplicity of his form combine to convey a quality of authority and control termed the "Old Kingdom style." In this representation, Khafre is associated with Horus, the sky god, a falcon who wraps his wings protectively around the ruler's head. The pharaoh is seated with a straight back, feet planted side by side on the ground, arms resting symmetrically on the throne, and large, almond-shaped eyes looking slightly up and away from the earthly realm. The body is sufficiently modeled for the viewer to acknowledge its size and muscular strength without being distracted by surface details or imperfections. A quality of stability is inherently communicated in the work since the figure is not wholly carved away from the stone block and thus retains some of the balancing bulk and solidity of the raw material. At the same time, the highly polished surface suggests a regal richness and refinement of workmanship. The Old Kingdom style's reserved, upright pose conveys both an elevated importance of a god incarnate and the powerful authority of the human ruler.

3.9 Statue of Khafre from Giza, Egypt, Dynasty IV, c.2500 BCE. Diorite, height 5ft 6⅛ins. Egyptian Museum, Cairo.

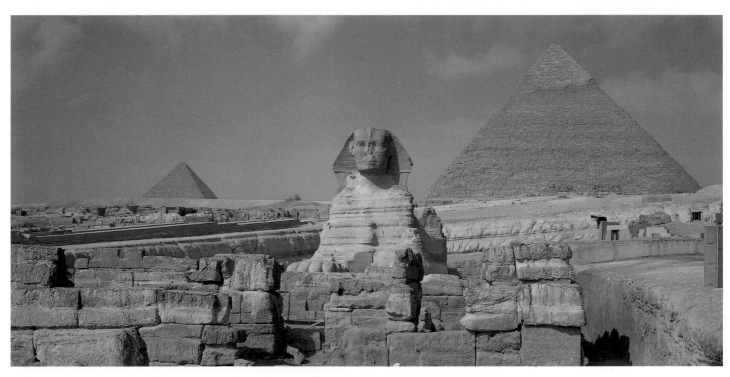

3.10 Sphinx and Pyramid of Khafre, Giza, Egypt, Dynasty IV, c.2650 BCE.

3.11 Valley temple of the Pyramid of Khafre, Giza, Egypt, Dynasty IV, C.2500 BCE.

Archeological evidence points to niches for fifty-four statues of Khafre in his elaborate funerary complex found in the ancient necropolis (city for the dead) of Giza outside Cairo ▶ **fig. 3.10**. Because there was limited habitable area in Egypt, and land near the Nile flooded annually, burials were made in the desert to the west. Giza contained other areas with streets and more modest tombs. The three pyramids from the Old Kingdom were built by successive rulers, each pyramid smaller than the one before. Khafre's is in the center, and although it appears to be the largest, its circumference is actually less than that of his father, Khufu; its greater height is on account of its higher base. These pyramids were only one part of a series of structures that began in the valley near the Nile and served processional needs by including a covered causeway that led to a mortuary temple just outside the protective wall surrounding the pyramid. The valley temple, easily visible to people near the Nile, was a statement of stability and permanence, being constructed of massive square granite pillars in an impressive repetitive ▸post-and-lintel◂ arrangement ▶ **fig. 3.11**. Large statues like the one of Khafre discussed above were lined up along the walls.

The shape of the pyramid was silhouetted against the sky and the setting sun in the west. Its form even resembled the *ben-ben*, a pyramidal stone symbol related to the sun cult. When first

3.12 Diagram of north–south cross-section of Pyramid of Khufu (Cheops, Egypt). Drawing after L. Borchardt.

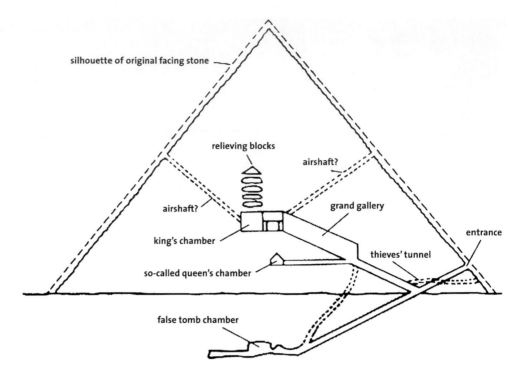

silhouette of original facing stone

relieving blocks

airshaft?

airshaft?

grand gallery

king's chamber

entrance

thieves' tunnel

so-called queen's chamber

false tomb chamber

completed, the polished white limestone veneer of the smooth sides would have gleamed, reflecting light and becoming a sort of cosmic architecture, connecting the realm of the sky gods to the human landscape. On a more pragmatic note, the sheer scale was meant to impress viewers with the king's ability to obtain the materials as well as a large enough labor force with the necessary skills for such exacting construction. The entire monument was made of such accurately cut stones that no mortar was needed to fit or hold them together.

As the pyramids were meant to contain valuable goods, architects had to provide security. Besides great walls, which limited access, they were also fitted with devices to stop thieves from removing objects. The interior of the largest pyramid, that of Khufu, demonstrates how complex these systems could become ▶ **fig. 3.12**. The entrance was on the north side, 49 feet above ground level, hidden behind the original veneer. Within the solid block structure, approximately 775 feet square at its base, interior ramps that led to the burial chamber included false leads, empty rooms, and massive blocking stones designed to discourage penetration. The burial chamber itself was protected from the weight of the stones above it by "floating headers," or vertically spaced ceiling stones, which compress when the structure settles. Nevertheless, all these precautions did not deter looters for whom the lure of the riches was greater than the dangers. During Antiquity, the tomb was emptied of its contents.

Outside the central pyramid of Khafre rests the huge Sphinx (see fig. 3.10). With the body of a lion and the head of a pharaoh (probably Khafre), this resembles the powerful, protective figures also made in Mesopotamia (see fig. 3.3). The Sphinx did not originate with the fourth dynasty. The body of the lion had evidently been sculpted out of the limestone bedrock many centuries before. In reusing the form and giving it a

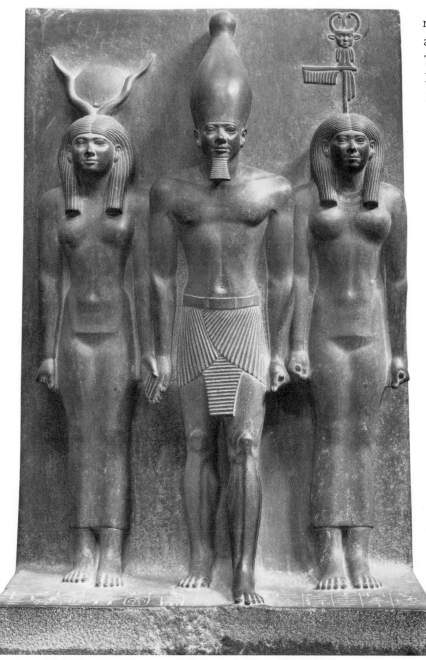

new head, Khafre was linking his reign to that of ageless Egypt herself. About 1100 years later Thutmosis IV (1419–1386 BCE) removed the sand that had covered it again and repaired its battered form. He made additions, including a small relief of a pharaoh and a shrine in front. This shrine was extended by Ramses II (1279–1213 BCE), continuing the tradition of linking himself with successful kings from the past.

The third pyramid belonged to Khafre's son, Menkaure. His pyramid is smaller and his statues often include the figure of his wife, Queen Khamerernebty II. Menkaure's reign was fraught not only with civil and defensive wars, but with the economic effects of his predecessors' lavish building programs. Although he matched their monuments as far as he could afford, the construction of pyramids subsequently fell out of favor, partly because they were obvious targets for thieves.

A statue of Menkaure serves to introduce an important difference in Egyptian images of authority. In it, he stands between Khamerernebty and Hathor ▶ **fig. 3.13**. In ancient Egypt, the pharaoh ruled the political state based upon his kinship or marriage with the blood ruler, the queen. In other words, this was a matrilineal society where blood lines were traced through the mother. The Egyptian queen, in turn, incarnated the most important female deities. Thus, when appearing as the goddess Hathor, the queen wears her "Hathor wig," or strictly divided hair pulled to the front over her shoulders. The queen might also don a headpiece that cradles the sun disk within

3.13 Triad of Khamerernebty, Menkaure and Hathor, from Giza, Egypt, Dynasty IV, c.2500 BCE. Diorite, height 3ft 1⅜ins. Egyptian Museum, Cairo.

the horns of a cow. Note that the divine female figure (Hathor) in this relief statue is identical with the human representation (Khamerernebty) since, while the queen was the incarnation of the goddess, the goddess looked exactly like her. This statue places Menkaure in close association with the queen/goddess incarnate. She presents Menkaure as her legitimate choice for pharaoh, thus publicly supporting a ruler whose position, for political reasons, was weaker than his forebears'.

If she chose, the queen could rule on her own, though this happened only rarely. In the case of Hatshepsut, of the New Kingdom period (c.1500–1162 BCE), the queen combined

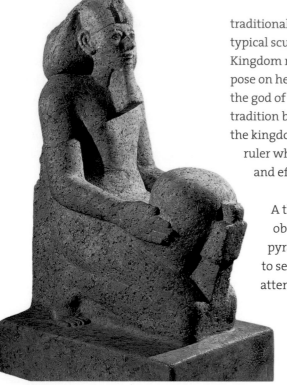

traditional male and female imagery as a means of conveying power ▶ **fig. 3.14**. In a typical sculpture intended for the royal tomb, which must be compared with such Old Kingdom models as Khafre's portrait (see fig. 3.9), she is seated in the same upright pose on her throne wearing the traditional pharaonic beard and headdress of Osiris, the god of the dead. Hatshepsut (r. 1486–1469 BCE) borrows these traits from the male tradition because queens ordinarily placed the day-to-day political and military rule of the kingdom in the hands of the pharaoh. For this reason, normally it was the male ruler who needed to convey powerful public images of his wealth, personal courage, and efficient government administration.

A third type of monument commonly associated with ancient Egypt is the obelisk, a tall single block of stone that narrows toward the top, ending with a pyramidal shape. Obelisks were made to commemorate the reigns of rulers and to serve as gifts to the gods whose temples they adorned. Their height was an attempt to send the inscribed messages to the heavens, so tying them to the tradition of prehistoric sun worship in Egypt. The shape of the obelisks was also said to be reminiscent of a shaft or ray of sunlight. Hatshepsut had four obelisks built in Luxor at the temple of Karnak, dedicated to Amon-Re, the sun god, to be placed near those of her father, Thutmosis I. Only one of those four obelisks remains standing; at almost 100 feet, it is the tallest ever erected in Egypt. It contains an inscription that links Hatshepsut's kinship with her father to the god he incarnated: "Amon, Lord of the Thrones of the Two Lands . . . I am his daughter in very truth, the glorifier of him" ▶ **fig. 3.15**.

3.14 Kneeling figure of Hatshepsut, New Kingdom, Deir-el-Bahari, Egypt, Dynasty XVIII, c.1490 BCE. Red granite. Egyptian Museum, Berlin.

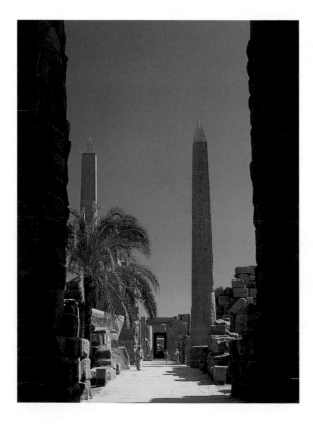

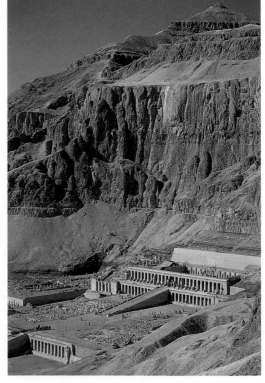

LEFT **3.15** Standing obelisk of Hatshepsut, r.1486–1469 BCE (with obelisk of Thutmosis I in background), at Luxor, Karnak, Egypt. Red granite, height 97ft.

RIGHT **3.16** Funerary temple of Hatshepsut at Deir-el-Bahari, Dynasty XVIII, c.1480 BCE.

Hatshepsut's funerary temple projects some of the same grandiose splendor as the complexes at Giza, but in a different form ▶ **fig. 3.16**. Her actual burial chamber was not on site, but with those of other pharaohs in the Valley of the Kings necropolis. By this time the major monumental focus had shifted to the mortuary temple, where three terraces step back and up against the cliffs. In a barren landscape, it would have presented a stunning site with lush gardens and lavishly decorated sculpture. The ability to keep tropical plants, fruit trees, and flowers alive in the extreme climate was not merely for the benefit of the gods worshiped within. It also projected Hatshepsut's control over nature and her ability to bring plenty to her land as both political ruler and life-giving goddess-queen (compare inset).

The Most Famous Tomb in the World

Probably as well known today as any of the Egyptian pyramids is the famous burial monument, the Taj Mahal, at Agra in Uttar Pradesh, India ▶ fig. 3.17. Popular legend has it that it was built by a grieving widower out of love for his dead wife, but another look at the story reveals something rather different.

In the latter part of the seventeenth century, Shah Jahan (fifth emperor of a Mughal empire that extended over northern India and Afghanistan), used the extraordinary wealth built up by the dynasty of which he was a part to construct a vast mausoleum for his favorite of three wives, Mumtaz Mahal, who died in 1630. Built of white marble, and inlaid with mosaic work and semi-precious stones, it is an elaborate and unusual tribute for an Islamic emperor to pay to his wife, however boundless his love and unquenchable his grief.

Closer examination of Shah Jahan's ambitions for his dynasty reveals that the building was perhaps less to do with Mumtaz herself than its reputation as "the greatest monument to love" would suggest. It becomes apparent that Mumtaz's function was to serve the dynasty. In life she had borne Shah Jahan all his fourteen children and in death her monument celebrated her part in continuing the successful dynasty. Even the name of the building, Taj Mahal, generally taken to be a shortening of her name, in fact translates from Persian as "Crown Palace." And more than that, the very fabric of the building and its complex attempts to link the dynasty with the divine. The luxurious gardens and perpendicular canals are based upon descriptions of the rivers and flora of Paradise in the Qur'an, lines of which are inlaid over the entrances. The elaborate octagonal towers of the mausoleum suggest the architecture of celestial mansions, and the shape of the dome echoes that of the Mughal ceremonial crown and hourglass throne. In short, Shah Jahan's royal regalia, in the shape of this building, has found its place within an allegorical Paradise.

The building also served a useful practical function for the Mughal court, as a place to make daily handouts to the poor. Rather than underlining the disparity between rich and poor, this may have helped establish the sympathetic reading of the building as a tribute to Mumtaz, who was believed to have exerted a good influence over her husband.

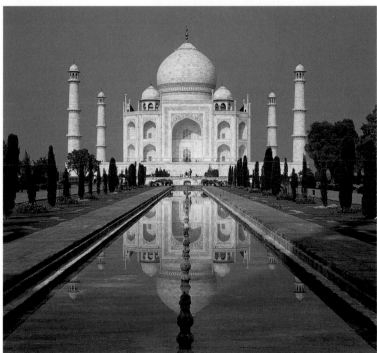

3.17 Taj Mahal, exterior view with garden, Agra, Uttar Pradesh, India, 1632–47.

Sub-Saharan Africa

Benin. From about 800 CE, the Edo people began to dominate the West African kingdom of Benin (modern Nigeria). About 1300, a marriage was arranged between an Edo chief's daughter and the son of the Ife king in the nearby Yoruba area. Since the Ife had long been associated with the divine kingship of the peoples living in the land comprising the Bight of Benin, this union legitimized the subsequent dynasty of Benin. Their king, or *oba*, was able to consolidate power through successive generations, becoming the leader of a great warrior empire during the fifteenth and sixteenth centuries.

Bronze casting and the cult of divine kingship were introduced to the Benin kingdom by the nearby Ife peoples in the mid-fourteenth century. Among the Ife, the practice of creating naturalistic portrait heads had already reached a considerable level of technical sophistication ▶ **fig. 3.18**. The process was further developed in Benin, especially after Portuguese traders introduced rings of brass, called *manillas*, as trading currency. Heads were made to commemorate ancestor kings, while plaques of kings, court officials, and ceremonial symbols adorned the palace walls (see fig. 3.20).

Each *oba* erected an altar to his forebears with brass heads denoting their legacy of power and wealth. The very material suggested incorruptibility and permanence. The Edo people in Benin practiced a more abstract style than the Yoruba Ife, combining the symbol of the head (as the center of thought, judgment, and perceptions) with the regalia of rulership ▶ **fig. 3.19**. Coral necklaces and coral and agate beaded caps, and, later, elaborately carved elephant tusks, were made using valuable resources that only kings could possess and distribute. These heads became the *oba*'s link to the royal line of legitimate rulers. Figurines of the *oba* with the queen mother, who validated his legitimate lineage, were also made. Elaborate ceremonials involving the veneration of both the queen mother and her son, as well as the *oba*'s rare appearances before his people, reinforced acknowledgment of the king's divinity.

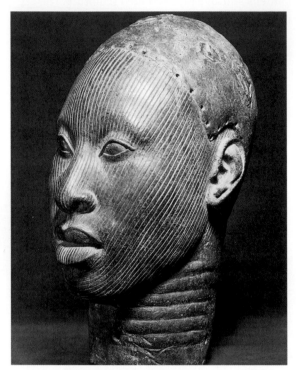

3.18 Head of an *oni* (king) of Ife, Yoruba (modern Nigeria), 12th–15th century. Zinc and brass, height 1ft ½in. Museum of Ife Antiquities, Ife.

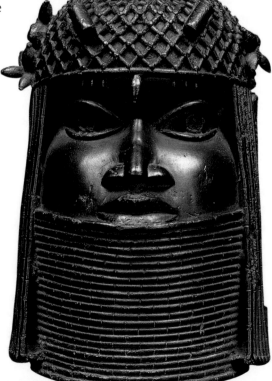

OPPOSITE **3.19** Head of an *oba* (king), from Benin (modern Nigeria), mid-period, 16th–17th century. Brass, height 10¾ins. British Museum, London.

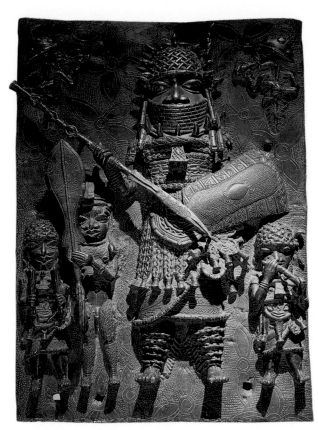

3.20 Plaque with figure of an *oba* (king) and dignitaries of Benin (modern Nigeria), c.late 16th–early 17th century. Brass. Museum für Volkerdunde, Berlin.

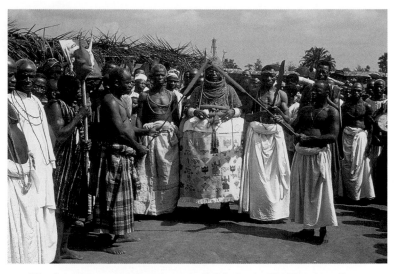

3.21 Ritual ceremony showing *oba* and officials, Benin City, Nigeria, 1960s.

Plaques commemorated the events of the *oba*'s reign. The figures were arranged in ritual hierarchical scale, with the king attended by court officials. The plaques were originally hung in an order that reflected status, but now only some of the figures in single scenes can be identified. In the plaque reproduced here, the *oba* stands tall and centered, carrying the insignia of his position: coral necklace, bracelets, anklets; coral headdress; leopard teeth on his collar and bell on his chest ▶ **fig. 3.20**. Many of these symbols are still worn today in the reconstituted kingdom of Benin now in the Republic of Nigeria ▶ **fig. 3.21**. His retainer carries a broad ceremonial sword, while he holds the spear and shield. On the plaque the *oba*'s two large attendants wear many similar items, denoting their great importance as court dignitaries, possibly even military commanders. The small figure to the right is a musician, a formal member of the *oba*'s court.

Asante. A type of ceremonial throne or stool has been a key status symbol of many West African rulers since long before the first contact with Europeans. Important members of tribes are seated according to their social status above common ground-level seating. Local areas produce distinctive styles of chairs and stools encoded with cultural meaning. In the legends of the Asante, an Akan tribal group now living within the nation of Ghana, a consolidation of independent city-states into a confederate kingdom took place at the beginning of the eighteenth century. At that time, all the regalia of the member states was destroyed and a new set of symbols was created. The first and foremost of these objects was the Golden Stool, a symbol of the seat of authority with magical origins. The stool is associated with supernatural powers that preserve the Asante people and is given due honors. It is made from solid gold and exhibited only on state occasions.

In turn, all members of the Asante aristocracy have their own stools. The design of each stool reflects the personal identity and role of its owner in society ▶ **fig. 3.22**. Asante kings not only commission and design their own stools, upon which they sit only when exercising the powers of their office, but also keep those of their ancestors as state treasures. Asante stools in Ghana tend to be rectangular with a slightly concave curve. They are carved from single pieces of wood and have four corner legs, sometimes curved inward so that they meet, as well as a central post. The amount of decoration denotes hierarchical importance. After a king's death, his stool is blackened to signify his absence and is placed with the others in the state shrine. It is believed to continue to house his soul and is therefore treated with the respect due his person while alive.

Symbols on the stools are comparable with those on other items of royal regalia, such as sunshades, swords, staffs, and metal vessels. Any type of design whose iconography suggests a meaning consistent with the personal goals of the owner can be fashioned on these objects. For instance, the carvings that top royal ceremonial sunshades or staffs can represent human activities; animals, birds, or fish; fruit or other plant forms; or even celestial bodies ▶ **fig. 3.23**. They can refer to the diplomatic, military, social, or religious intentions of the leader, as known through fables, historical tales, or common symbolic associations. When a powerful figure appears during a ceremonial ritual, surrounded by his or her regalia, as well as retainers who carry their own, the effect is to reinforce a commanding presence. The

3.22 Stool associated with the royal house, Asante, Ghana, 1953. Carved wood with silver veneer, height 16⅛ins. British Museum, London.

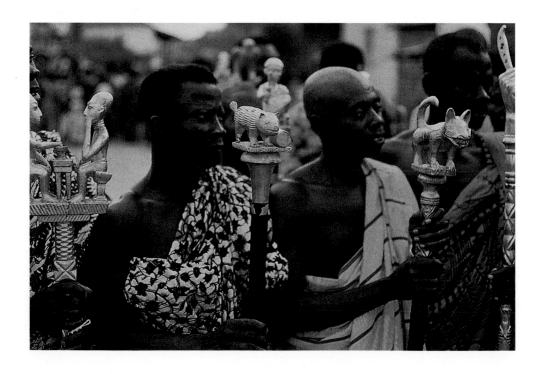

3.23 Fante linguists (counselors/spokesmen of the king) with staffs, Fante region, Ghana, 1974.

higher a person's rank, the more rights he has to commission and display formal regalia. In this regard, the king's objects, as well as his jewelry, incorporate a great deal of gold. Gold carries many levels of association for the Asante, ranging from status, wealth, and the control over resources of regions that hold gold, to its color, signifying the life-sustaining powers of the sun.

Clothing is another element of the regalia that identifies people in authority but which, like rugs and wall hangings, has not survived the centuries as well as other artistic products. Since the seventeenth century, the Asante people have woven a special cloth called *kente* ("cloth that will not tear") to signify status. The process of densely weaving threads in contrasting colors is ritually regulated and the patterns are named, again with symbolic meanings attached to the usage of the fabric. Material of lesser quality, such as cotton, is widely available but the patterns may still relate to specific formal occasions or social position. More labor-intensive types of precious fabric, such as silk, can be worn only by very high officials and royalty. The strips of repetitive geometrical decoration are very elaborate. In traditional weaving they are produced on narrow looms, then stitched together. Many yards are worn by those of the highest status, wrapped around the body a number of times. Men traditionally cover their left shoulder and arm, keeping their right arm free for sword usage and to protect the left, more vulnerable, side. Receiving a gift of the best *kente* cloth is a high honor, as was paid to the former United States president and first lady Bill and Hilary Clinton, shown here clad in gift *kente* cloth during an official state visit in 1996 ▶ **fig. 3.24**.

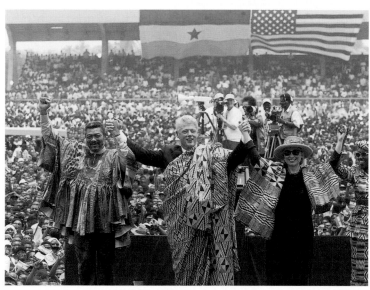

3.24 Ghanaian president Jerry Rawlings and Mrs Nana Rawlings with Bill and Hilary Clinton wearing *kente* cloth, Accra, Ghana, 1998.

Kuba. Within the Democratic Republic of Congo in Southwestern Africa, the Kuba kingdom has a unified, stable history. In the seventeenth century the concept of individual wooden king statues, or *ndop* sculptures, was introduced into a society that had always been prolific in the production of artistic forms (see fig. 3.25). The figures combine idealized features while also being invested with portrait-like associations. In the standardized *ndop* form, the kings are shown facing forward and seated cross-legged in repose on a box-shaped throne/platform. Their eyes are closed and their hands rest on their upper legs, the left holding a short ceremonial dagger with the blade pointing toward their back. Each king is crowned with a distinctive flat and square headdress on a head that is proportionately larger than the body. This privileging of the head over the body is found in much African imagery, usually referring to the primacy of spirit or intellect over physical strength. Yet, like the Egyptian pharaoh portraits described above (see fig. 3.9), the similarity of features among the various portraits suggests that the office of king was more important than the individual's personal appearance. A certain amount of standardization helps to reinforce authoritative ideals, just as the symmetrical, dignified pose conveys authority and wisdom.

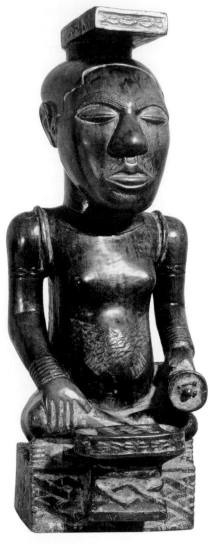

3.25 *Ndop* (king figure) sculpture made for Shyaam a Mbula-Ngoon, Kuba (Democratic Republic of Congo), 18th century. Wood, height 21⅝ins. British Museum, London.

In front of each king on their *ndop* is a small object, the *ibol*, which represents his personal symbol—often the only way that he can be securely identified. Every Kuba king's *ibol* is different and, like Asante regalia symbols, is often a complex reference to his personal goals or preferred identity. The king announced his choice of *ibol* during his coronation and enthronement as a sort of programmatic prediction for his reign. The *ndop* illustrated here was probably made in the eighteenth century to commemorate King Shyaam the Great ▶ **fig. 3.25**. He is shown with a *lele* game, a board game that can be compared with chess in the strategic and analytical skills required to play it. Apparently, Shyaam had become familiar with *lele* when traveling outside his kingdom and brought it back as a way to help determine the best leaders. It is also a direct reference to his own skills in wresting control of the throne away from the previous dynasty and his subsequent wise rulership.

During his lifetime, the *ndop* was treated as a proxy for the king's presence. As it was important to believe that a king could never die, when a king was near death, his advisors would strangle him while pressing his *ndop* against his mouth to capture his final breath. Once the successor was chosen, he was isolated in complete secrecy with this statuette to facilitate the transfer of the previous king's powers and wisdom. However, unlike the Asante tradition in which the blackened stool was believed to house the soul of the deceased king, the Kuba king was considered divine and his soul did not stay earthbound. Therefore once this process was completed, the *ndop* of a dead king was believed to be empty and seen merely as a memorial of his existence, not the residence of his continuing spirit. Made of hardwoods, these works have been protected with oil. However, they are still subject to deterioration and are sometimes replaced by replicas that convey the same commemorative attributes. There are many fake replicas as well, but they do not have the sacred value of authentic reproductions. The presence of authentic *ndops* in Western collections suggests they were acquired by force, trickery, or theft.

As shown in this chapter so far, there are many (perhaps surprising) similarities between small tribal groups and large empires in the tradition of art commissioned for and by royalty. As most of these cultures were isolated from each other, there could have been little cross-influence of ideas. It is therefore important to note the seemingly universal need for visual projection of rulers' powers.

The West

Roman and Byzantine Empires

The Romans inherited the ambitions and hybrid culture of their immediate predecessor, Alexander the Great (356–323 BCE). Alexander had himself incorporated great empires of the ancient world, including those of Mesopotamia and Egypt, into his "Hellenistic," or Greek-oriented, empire. Over a period of approximately six hundred years the Romans also reached out aggressively to assemble an empire out of conquered land, which eventually stretched from the border of Scotland to the Persian Gulf, from the North Sea to the Sahara Desert. They controlled all the territory surrounding the Mediterranean Sea. Over time their emperors developed a vast repertoire of imperial imagery from which to choose their symbols of power.

Images of conquest and technological superiority went hand in hand, as the Roman army trained both soldiers and engineers. Among the booty brought back from conquered territories is an Egyptian obelisk—first taken to Alexandria by Emperor Augustus (r. 27 BCE–14 CE), then brought to Rome during the reign of Emperor Caligula (37–41 CE), and now standing in St. Peter's Square. But the Romans also created new records of their own technical expertise. The Column of Trajan, which commemorates Emperor Trajan's conquest of the Dacian territories (a large part of Eastern Europe), includes scenes of troops building bridges and fortifications just as often as it does battles or sieges ▶ **fig. 3.26**. For Trajan (98–117 CE) the column demonstrated the belief that Romans brought progress to outlying territories, which was one way of justifying their aggression ▶ **fig. 3.27**. That the Roman presence was formidable from the Dacian point of view is evident from other scenes of mass suicide and abject submission. The emperor appears fifty-three times on the column, always in a commanding position.

The column was part of a much larger complex, or ▸forum◂, which Trajan had built in Rome (see fig. 3.28). The forum was paid for by the riches looted from conquered territories. Following a victory in battle, Roman soldiers would erect a wooden column, *tropaion* or trophy, on which to hang booty and beneath which prisoners would be tied. From here allocations were made to soldiers based

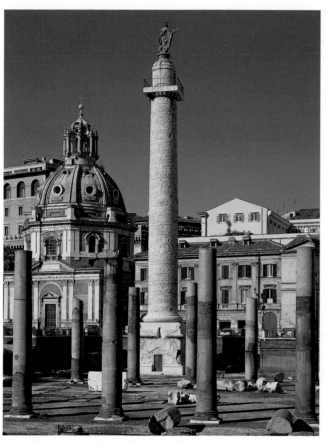

3.26 Column of Trajan, Forum of Augustus, Rome, Italy, late 1st century BCE.

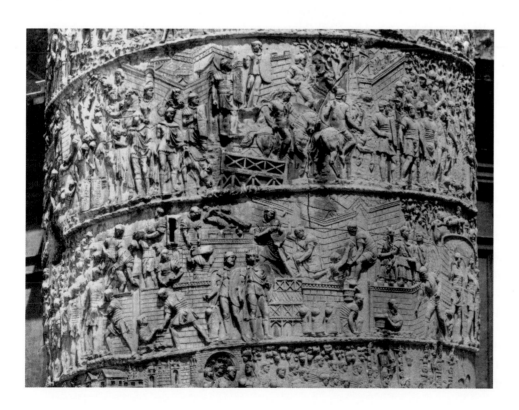

3.27 Column of Trajan, detail showing scenes from the Dacian campaign, the river god and the crossing of the Danube, Forum of Augustus, Rome, Italy, late 1st century BCE.

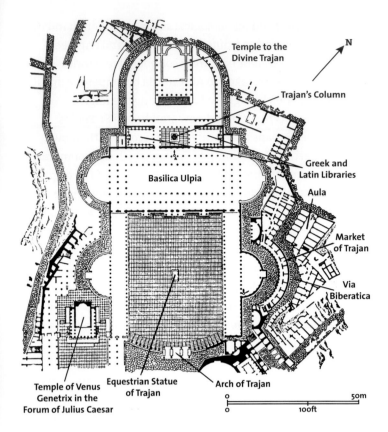

3.28 Forum of Trajan, Rome, Italy, 100–112 CE. Reconstructed plan.

upon rank and performance. On Trajan's Column's the booty is shown on the literal stone base and signifies the economic base from which the construction of the forum was possible. The campaign scenes curve up the column in a continuous frieze and could be partly viewed from the upper stories of the two buildings on either side.

In front of the column a large building, 200 by 400 feet long, and an even larger open courtyard, 400 foot square, served as assembly spaces. The building was in the form of a traditional Roman public assembly hall or ▸basilica◂ and was known by Trajan's family name, the Ulpia ▶**fig. 3.28**. Two-story side aisles supported by arches flanked a high central aisle, or ▸nave◂, which was lit by windows above the aisle roofs. The nave ended in semicircular extensions called ▸apses◂, which provided good acoustics for speakers or performances. The main doors into the basilica were from the courtyard side. Relief panels and sculptures appear on the various entrances and walls and reinforce the victory theme.

To build this open forum, Trajan's architect, Apollodorus of Damascus, had to clear a sizeable section of the closely packed downtown area in Rome. He provided space for the displaced merchants with an innovative architectural project that terraced the previously unused hillside through the use of the arch (see inset, p. 70) and ▸concrete◂ vaults (lower right area of fig. 3.28). Contrary to other emperors, who simply took property away from people when they wanted to build, Trajan ensured the economic stability of the city as well as the inhabitants' support for his rulership by providing more and better retail spaces for the merchants affected by the forum plan.

Even more innovative, Trajan's successor, Hadrian (r. 117–38 CE), traveled the empire, getting to know the varied languages and cultures of its peoples; he was particularly fascinated by architectural design. His greatest achievement was the Pantheon, a temple whose name means "all gods" and which brought Roman technological prowess to an unprecedented peak ▶**fig. 3.29**. The Romans were tolerant of other religions, and gods from many parts of the empire were worshiped in Rome. This tolerance heightened the impression the city gave as a cosmopolitan crossroads, gathering the whole world under one capital. Hadrian's Pantheon replaced an earlier Greek-style temple from the reign of Augustus's son-in-law, Agrippa. The new building reconstituted the original façade and, from the enclosed court originally leading to it, appeared to consist of the traditional rectangular structure behind.

Visitors entering the doors of the Pantheon are still awestruck by the vast open space of the huge ▸rotunda◂ ▶**fig. 3.30**. Exploiting the design of the arch and the properties of concrete, Hadrian and his engineers covered the largest uninterrupted space yet

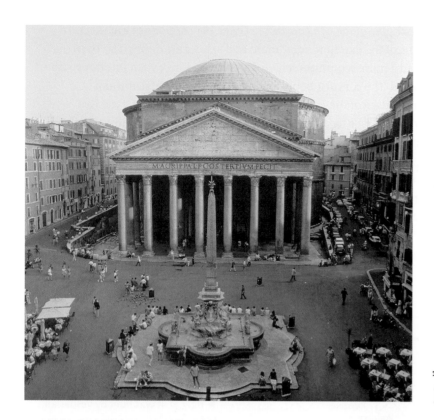

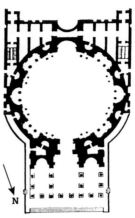

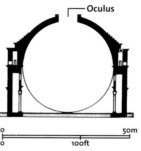

FAR LEFT **3.29a** Pantheon, exterior, Rome, Italy, 118–28 CE.

LEFT & BELOW LEFT **3.29b** Pantheon, plan and cross-section, Rome, Italy, 118–28 CE.

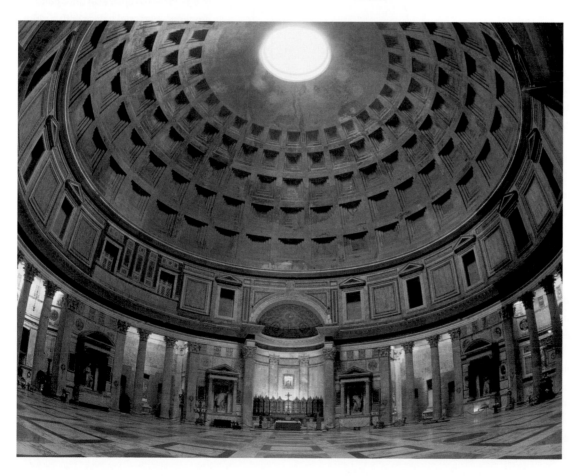

3.30 Pantheon, interior, Rome, Italy, 118–28 CE.

attempted with a single ▶dome◀. In contrast to Greek conceptions of architecture, where the aesthetic of the exterior is dominant and spaces are defined by barriers, Hadrian introduced a more sculptural sense of architecture in which interior space appears to be molded. The contrast between the planar exterior façade and voluminous interior space of the Pantheon points up the difference in the two concepts. The Parthenon (see fig. 4.9) is an example of the type of building that would have originally stood behind the Pantheon's façade.

The Romans mixed concrete with different materials in order to make the foundation and lower walls heavier and the dome lighter. The crucial point where the 360° arch meets the wall was reinforced with stepped bands. The 20-foot-thick walls hid four huge relieving arches set on eight powerful ▶piers◀. This allowed for large and small niches on the interior, which were originally filled with statues of deities.

Arches

The Romans did not invent many things, but they improved upon nearly everything they found in the lands they controlled. One architectural form they found in Mesopotamia, the arched doorway, was to become among their most successful building features. There are many different types of arch, but the "true" arch is constructed of stone wedges called voussoirs, which are larger at the top of the span but narrow at the bottom to form the inner curve ▶ fig. 3.31. Once the stone at the center top, called the keystone, is inserted it begins to assert a downward thrust that is carried through each voussoir and into the supporting piers. The keystone thus locks in place all the other stones, which, due to their shape, cannot fall inward.

When these arches were reinforced with concrete, they became the basic components for massive structures. Arches that are linked side to side form ▶arcades◀. Arches that are sandwiched together form barrel vaults; they can also be crossed to form ▶groin vaults◀, which take greater pressure from above. The Colosseum in Rome is one of the best-known examples of a very

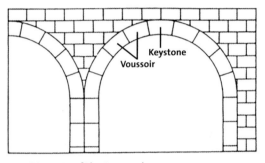

3.31 Diagram of the true arch.

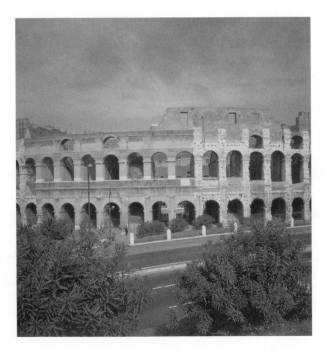

large version of the common form of ▶amphitheater◀ that Romans constructed in most of their cities ▶ fig. 3.32. It was built by Vespasian (r. 69–79 CE) to replace an unpopular emperor's personal palace with a public entertainment space. This was part of the Roman administration's method of appeasing the poor and unemployed, the so-called "bread and circuses" cited as being the common people's only interests by the satirist Juvenal in the first century CE. For in addition to arranging popular sporting events, the administration handed out food, hoping in this way to avoid protests and riots by the discontented populace. Arches in amphitheaters allowed construction of arcaded corridors leading to tunnels under the seating sections. The floor was set above a network of cells and pens for prisoners and animals, and dressing room and storage areas for performance needs. It was so well supported by barrel and groin vaulting that it could be flooded for the performance of mock naval battles.

3.32 Colosseum, Rome, Italy, c.70–82 CE.

At the top of the dome, a 30-foot span was left open to the sky. This oculus let in light (and rain); it also enabled the designers to give the dome its low profile, as it prevented the need to support a nearly horizontal area. The fact that the building's profile seems much steeper from inside than from outside is due to the use of coffering, or sunken insets, which reduce in size as the dome circumference decreases. These coffers have triple frames set closer at the top of each square. The optical effect moves the eye upward and stretches the flat outlines. When the sun shines, a round spot of sunlight moves around the marble-inlaid interior, changing place over the course of a day and according to the time of year.

The overall dimensions of the interior are highly symbolic, comprising the shape of an orb, or sphere, nearly 150 feet high and wide. The orb was a symbol of universal rule (emperors are often shown holding one in their hand when enthroned), and the Pantheon's dedication to all the gods demonstrated the Roman emperors' aspirations to bring all religions under their control. The inside of the Pantheon's dome was originally painted light blue and there were gold rosette bosses inside each coffer, resembling stars. The overall effect was that of a self-contained cosmos, further enhanced by the way rain, sunlight, or fog could change the air coming through the oculus. The Pantheon stands not only as an architectural masterpiece, but as an enduring monument to Hadrian's stature as an imperial ruler.

Equestrian Statues

In the middle of Trajan's Forum, a bronze statue of the emperor mounted on his horse was erected to celebrate his active participation in military campaigns. Many such equestrian portraits, intended to commemorate victorious rulers, have since been melted down. That of Marcus Aurelius (r. 161–80 CE) has survived ▶ fig. 3.33. It stood for some time at the center of the Piazza del Campidoglio in Rome, redesigned by Michelangelo in the sixteenth century, and is now in the Museo Capitolino. Reminiscent of the images of Trajan on his column (except in terms of scale), the over-lifesize Marcus Aurelius gestures toward an enemy about to be crushed under his charger's raised hoof. In contrast to the superhuman quality of the overall form, the portrait face of this emperor breaks with tradition. Marcus Aurelius chose to be memorialized as burdened with his care of the empire. His face is thus lined and his expression sad. It has been said that his intelligence and interest in philosophy caused him to feel troubled by the suffering his conquests brought. He wears the beard and curly hair made popular by the emperor Hadrian, a Greek characteristic suggesting the wisdom of old age. The style is extremely naturalistic, adding to the majestic appearance of the fine horse he rides, though its relatively small stature enhances the emperor's dominance. According to legend, this statue survived because during the Middle Ages it was mistakenly believed to be a portrait of Constantine, who is generally credited as the first Christian emperor.

However valuable accuracy might be in portraiture, naturalism is not necessarily a goal in representations of rulers. During hard times when luxury objects are scarce and craftsmen few, or when individual personalities have little to do with power, a more abstract style can be equally effective, as discussed in the context of early Greece (see figs. 2.4, 2.8) and ancient Egypt (see

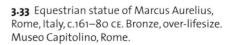

3.33 Equestrian statue of Marcus Aurelius, Rome, Italy, c.161–80 CE. Bronze, over-lifesize. Museo Capitolino, Rome.

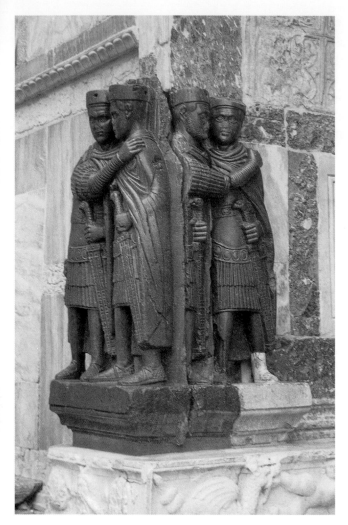

3.34 *The Tetrarchs*, exterior corner of St. Mark's, Venice, Italy, c.305 CE. Diorite, height 4ft 3ins.

figs. 3.9, 3.13). Individual portraiture was clearly not a concern in the design of the four unknown tetrarchs, a statue now attached to the wall of St. Mark's in Venice ▶ **fig. 3.34**.

During the late third century, the empire faced increasing threats from both inside and out. Emperors came and went, sometimes more than one ruling at a time. In 284 a general was proclaimed emperor by his troops who decided that only drastic plans could save the empire: Diocletian militarized the government while imposing reform measures. The most important of these was the decision to divide the empire into East and West with two sets of rulers in each — a tetrarchy, or rule of four. Both sides had an Augustus assisted by a Caesar. Diocletian became Augustus of the East and he appointed fellow army generals to the other positions. The statue of the tetrarchs (fig. 3.34) made around 305 is not large, only about 4 feet high, and the only distinguishing characteristic among the men is that each set has one bearded and one clean-shaven face (the elder Augustus and junior Caesar respectively). Otherwise, the emphasis on unified leadership without recourse to personal status is conveyed by their identical appearance. Three features stand out. First is the gesture of the right arms, which links each set into a single shape. (The right figures' arms are not visible in this photograph, but they come around from behind their companion to clasp their left shoulders.) They show solidarity in the face of all the intrigues and corruption of recent Roman history. Their left hands grasp the hilts of their prominent swords, which are shaped like eagle heads—the symbol of the Roman army. From this gesture it is clear that they rule by the sword and will keep order by force if needed. Finally, their piercing gazes are made possible by the use of a drill to suggest the pupils of their eyes. This feature underlines their awareness of all that goes on under their administration.

The bodies are no longer modeled upon Classical Greek ideals. They are short and stocky, while detail is limited to the articulation of their military garb. Made out of diorite, the material used by Egyptian pharaohs (see fig 3.9), modeling is conditioned by the medium. Their faces have the lines of responsibility seen on Marcus Aurelius (see fig. 3.33), but none of the pensive qualities of a conflicted thinker. They simply look resolute and anonymous. Diocletian also copied the Egyptians by erecting new obelisks to commemorate important predecessors. He had two matching ones placed outside the mausoleum of the emperor Augustus, whose rule by Diocletian's time was often referred to as "golden."

Diocletian's system began to restore order and he even tested the tetrarchy by retiring, in 305, along with the Augustus of the West, allowing their Caesars to succeed them. But long-established attitudes change slowly and not everyone could accept joint

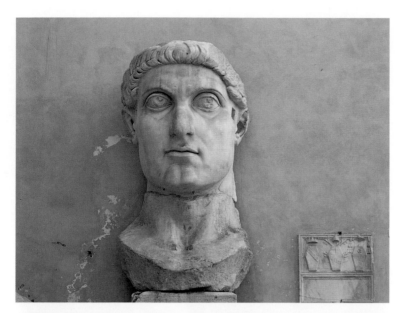

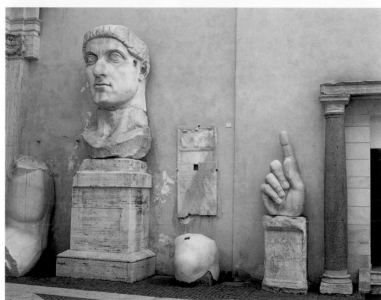

3.35 Head of colossal statue of Constantine, Rome, Italy, c.313 CE. Marble, height of head 8ft 6ins. Palazzo dei Conservatori, Rome.

3.36 Head, hand, arm, and knee fragments of colossal statue of Constantine, Rome, Italy, c.313 CE. Marble. Palazzo dei Conservatori, Rome.

rulership or give up blood succession: in 306 the son of the Western tetrarch Constantius Chlorus, named Constantine, was raised by his troops to become an Augustus, thereby invalidating the new process. Many political tangles ensued. The outcome was civil war, in which Constantine took on all the legitimate rulers and won. By 312 he was sole ruler of the West, and in 324 he took control of the East as well.

One of the projects left unfinished in Rome by the legitimate Augustus whom Constantine defeated, named Maxentius, was a huge basilica much like the one Trajan had built in his forum (see fig. 3.28). It had one large apse in the west in which Constantine now placed a giant statue of himself ▶ **figs. 3.35–36**. The statue was constructed of diverse materials and only the marble parts that comprised the limbs and head have survived. The head reveals a compromise between the naturalistic portrait tradition and the harsh abstraction of the tetrarchs. As part of imperial

3.37 Bas relief on the north side of the Arch of Constantine, Rome, Italy, 322–25 CE. Marble.

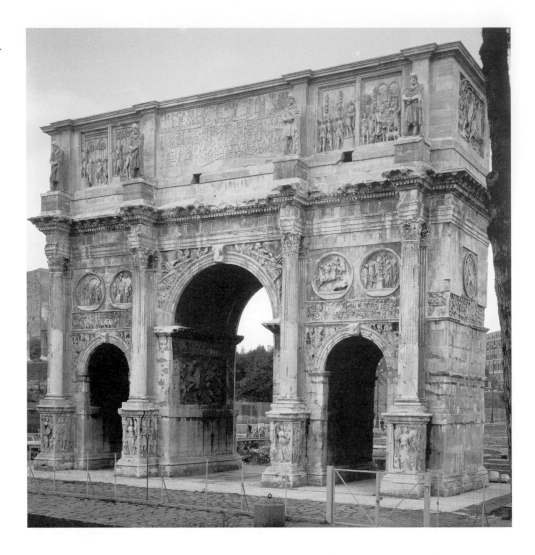

propaganda, many such heads were sent around the empire to be attached to locally constructed bodies. Like those of Egyptian rulers, they served to stand for the emperor himself whenever he was elsewhere. Over 8 feet high, this head would have topped a seated body, totaling overall at least 25 feet. Some of Constantine's facial features are clearly rendered: his sharp chin, crooked nose, thick and muscled neck. These personal elements are overshadowed, however, by the intensity expressed in his eyes, which are not only large, but further accented by being deeply set with thickly defined lids—both upper and lower—and eyebrow lines that point down the long nose.

The marble has been employed effectively to leave flecks where the eyes' reflection would glisten. They stare upward, away from the viewer in the basilica, following elaborate court ritual that did not acknowledge subjects. One of Constantine's biographers has claimed that this pose showed the emperor's divine inspiration and preoccupation with matters of higher order. The size of the eyes suggests that he is all-seeing, while the calm and authority of his expression makes his massive presence seem god-like and omnipotent. If the head is seen from the side, however, some of the magic disappears. Now it becomes clear that enough marble was used to carve only

the front of the head for viewing straight on. Without the weight of the back of the head to balance it, the nose would have exerted an enormous pull downward. The square holes visible in the temples are evidence that brackets were used to attach the head to the wall behind it. The powerful image essentially turns out to be only a mask.

Another major monument erected for Constantine similarly shows how first appearances can be deceptive. After he came to power, a commemorative victory arch was erected next to the Colosseum (see inset, p. 70) ▶ **fig. 3.37** . Unlike the traditional single entryway, the Arch of Constantine features a triple arcade. Victory arches had long been erected in Rome to document the greatest successes of the Roman army. Constantine placed his defeat of Maxentius on the same level, even though in reality it was during a civil war that gained the empire neither land nor external security. The arch looks grand upon first viewing and seems to meet the high standards of Roman imperial public sculpture. But the monument is actually a pastiche of ▸roundels◂ and panels, columns and statues pulled from the works of previous rulers (Hadrian, Trajan, and Marcus Aurelius). The high-quality workmanship that seems to match standards of earlier periods gives a false impression, since it is nothing more than ▸*spolia*◂, reused pieces. The only sections that were carved new for this monument are the small friezes over the two side arches. The subjects of the scenes that appear on the four faces are traditional: two show successful battles and two show Constantine performing his public role in Rome. In one, he appears at a huge racetrack, where an annual series of athletic games was held ▶ **fig. 3.38**. At the time of this grand entertainment, a symbolic "bread and circuses" act had become annual imperial practice. Emperors would fling gold coins to the crowd, which, as one can imagine, went wild. Constantine wanted to record his largesse (*donatio*) for posterity, so he is shown throwing out coins with his right hand, some of them being caught in a nearby figure's cloak. In fact, Constantine would have had little in his treasury to pay for such gestures.

3.38 *Donatio* frieze, detail, Arch of Constantine, Rome, Italy, 322–25 CE. Marble, height 3ft 4ins.

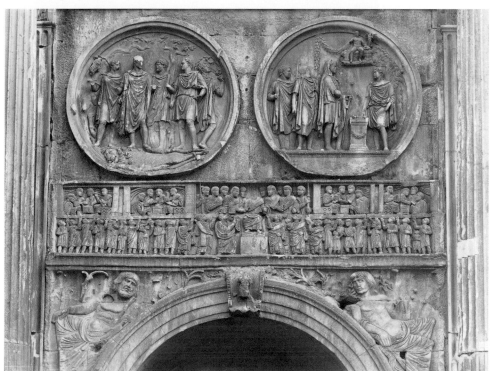

The figures in this *Donatio* relief contrast sharply with those of the earlier works. None of the fluid naturalism or complex compositional arrangements reappears here. Instead, two rows of nearly identical figures are stacked one above the other. Bodies are stumpy, recalling those of the tetrarchs. Drapery is incised rather than modeled and eyes are drilled. Despite his imperial stature, Constantine (whose head was carved separately out of marble and has since been lost) is seated

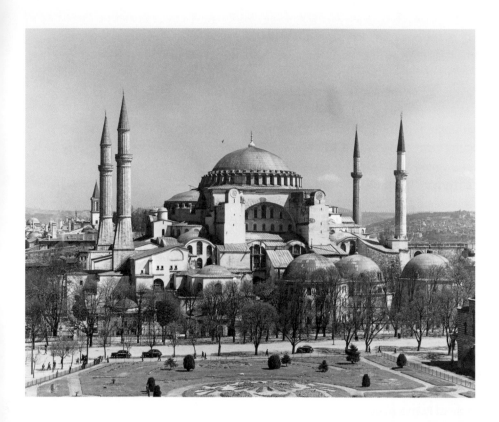

LEFT **3.39** Hagia Sophia, Constantinople (modern Istanbul, Turkey), 532–37 CE.

BELOW LEFT **3.40** Plan of Hagia Sophia, Istanbul.

BELOW RIGHT **3.41** Hagia Sophia, Istanbul, 532–37 CE.

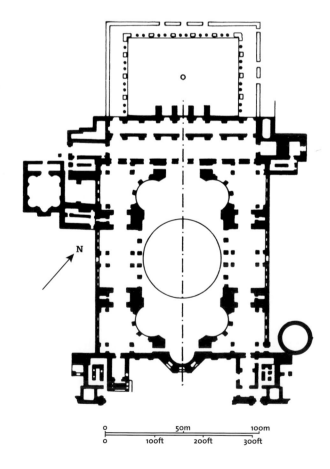

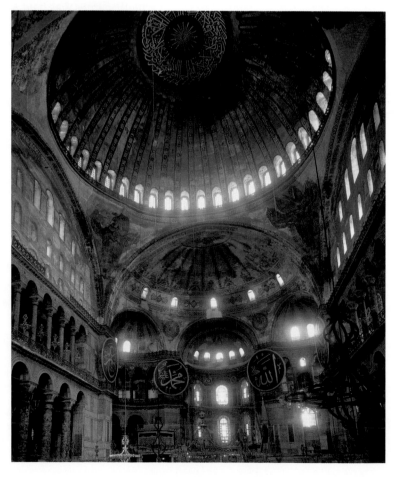

awkwardly, with none of the subtlety used to elevate Trajan's role in the narrative scenes on his column. Craftmanship had clearly declined.

Like the colossal statue in the basilica, the Arch of Constantine was designed to proclaim the legitimacy of the new sole emperor. Yet the realities of civil war renewed all the problems Diocletian had been trying to alleviate, and funding for many of Constantine's grandiose projects must have been difficult to find. His monuments betray his empty claims and hint at the real misery his policies caused. In spite of this, by the sixth century, Constantine was remembered primarily as the first emperor to allow the Christians legal status (although he was not baptized until shortly before his death). For that, his importance grew throughout the predominantly Christian period of the Middle Ages.

During the next two centuries, the Eastern half of the empire under the capital at Byzantium (renamed Constantinople by Constantine when he defeated the Augustus of the East) diminished in size as both the Persians from the east and the Germanic tribes from the north pressed upon the borders. Thus the policies of the ruler who came to power in 527, Justinian, were entirely centered upon defense and reconquest. He wanted to be a second Constantine, reconstituting a whole empire out of lost territories.

Beginning his rule in the midst of riots, needing to find employment for masses of poor and income for imperial industries, Justinian immediately took control. He rebuilt one of the buildings burned during the riots as a means of putting people to work and nationalized the factories that made the necessary materials. In the design of his new Church of Hagia Sophia in Constantinople (modern Istanbul), Justinian took the Pantheon as his model, stretching the interior space to form the longitudinal axis needed for Christian ceremonial. The church's architects, Anthemios and Isidorus, exceeded the largest amount of uninterrupted interior space previously built ▶ **figs. 3.39–40**. They adapted the concept of giant arches, and in Hagia Sophia calculated how to suspend one giant dome and two half-domes over four heavily ▸buttressed◂ piers. Windows at the bases of the full and half-domes let in streams of light ▶ **fig. 3.41**.

Ottoman Tributes to Justinian's Achievement

When Constantinople fell in 1453 to the Ottoman Turks, they claimed more than just a large city. They were taking the last capital of the old Roman Empire with all its monuments and history. The greatest building in their territory was now Hagia Sophia and, far from wanting to destroy this evidence of Justinian's glory, they wished to emulate it. The great sultan Suleyman (r. 1520–66) asked his chief architect, Sinan, to build mosques that copied the grand design. One result in the same city is the Suleymani mosque ▶ fig. 3.42 (lower building complex in photograph). To the main building Sinan added a whole complex, including a university, hospital, shops, and gardens, as well as his own and the emperor's tombs. By creating a huge domed masterpiece, Suleyman was consciously linking himself with Justinian's claims to universal rule and suggesting that his wars of conquest would prevail, as Justinian's reconquest of the West had done.

3.42 Aerial view of the Suleymani mosque, 1550–57, Istanbul, with Hagia Sophia in the background.

The engineering of the dome was not flawless. The first design gave it too low a profile and it collapsed in 558. The second, steeper, arc was completed in 563 along with a number of other structural modifications to support it. In 989 part of the dome fell again, the rest following in 1346. The minarets at the four corners were added after the Ottoman Turks conquered Constantinople in 1453 and turned Hagia Sophia into a mosque. Today it is a museum that preserves some Christian and some Islamic decoration.

Richly colored marbles cover the floor and lower walls, and make up the columns at all levels, which are topped by intricately carved capitals of complex foliage motifs. Interior walls are covered with reflective gold and colored glass mosaics as well as inlaid mother-of-pearl. Silver screens, golden lamps, rich fabrics, and heavy incense originally accompanied elaborate ceremony. In Justinian's time, the church building was believed to be a reflection on earth of the paradise inhabited by Christ and his saints in heaven, and it also provided an impressive stage for the emperor to announce victories and military plans and to pronounce on thorny Church issues of the day.

When Justinian's general, Belisarius, managed to regain territory in Italy, the capital of the Western Empire was no longer in Rome, but Ravenna—a more easily defended city to the northeast. Here a tiny version of Hagia Sophia's central plan was built in the mid-sixth century over the grave of the city patron, St. Vitalus (in Italian, San Vitale). Inside, a mosaic image of Justinian appears near the altar, where only clerics and the

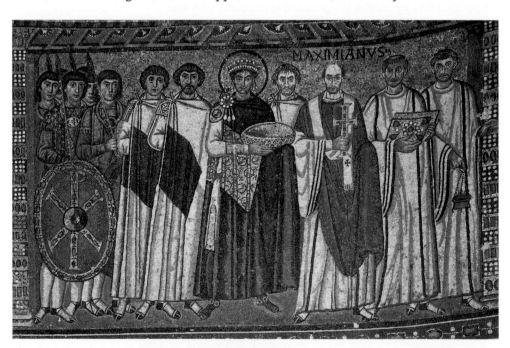

3.43 *Bishop Maximianus with Justinian and his Retinue,* in the apse of San Vitale, Ravenna, Italy, c.547 CE. Mosaic.

emperor were allowed ▶ **fig. 3.43**. As Justinian never set foot in Italy, this serves as the traditional proxy image for the absent emperor, similar to the commemorative portraits of Egyptian and Kuba kings discussed above. He appears in the center of the short frieze with his military guard on his right (the viewer's left). They are identified as high officials by the *tablion*, or patch of purple fabric, under their right arms on their

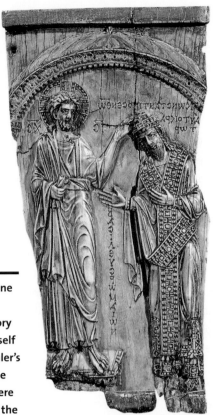

3.44 *Christ Crowning the Emperor Constantine VII*, Constantinople (modern Istanbul, Turkey), c.945. Ivory plaque, 7⅜ins x 3¾ins. Pushkin Museum, Moscow.

Divine Approval

The coronation of a Byzantine emperor was often commemorated with an ivory plaque showing Christ himself placing the crown on the ruler's head. A good example is one from the tenth century, where Constantine VII is shown in the imperial *loros*, or decorated stole, inclining his head toward Christ, who stands above him in a ceremonial fashion ▶ fig. 3.44. They appear under a dome, which may place them in Hagia Sophia—the usual location of such ceremonies. The plaque is inscribed with titles that identify Constantine as sole ruler. This formula, often used in the East, was copied by Western rulers who claimed the same authority. When the Norman counts took over the island of Sicily in the 1140s and proceeded to make it a small kingdom along with territories from southern Italy, they produced propagandistic art that spoke to their Western and Eastern Christian subjects as well as the Muslim population living there. One of the churches they built contains a mosaic made around 1145 by skilled craftsmen brought in from Constantinople ▶ fig. 3.45. It shows the Norman king Roger II, wearing full imperial Byzantine regalia, being crowned by Christ in a similar fashion to Constantine VII. Although Roger II himself would not have worn such garments, and although his kingdom had nothing like the strength of the Eastern empire, he considered himself a third major power in Europe, in competition with the German and Byzantine emperors.

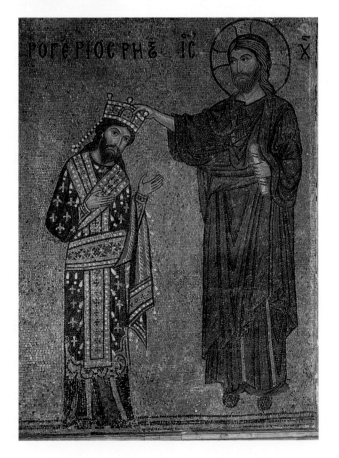

3.45 *Christ Crowning Roger II*, from La Martorana, Palermo, Sicily, c.1145. Mosaic.

white *chlamis*, or robe. The emperor also wears a *tablion*, but his is richly embroidered with gold thread. The way in which the figures overlap makes it clear that the group is processing, with Justinian in the lead. To his left (the viewer's right) are the clergy, the religious equivalents of military leaders, in front of the architecture, with soldiers behind; all are coming into the central space under the dome with their gifts for the offering, a formal part of the service.

The soldiers carry a shield with the monogram formed from the first two Greek letters of Christ's name, the Chi-Rho, associated with the legend of the miraculous conversion of Constantine on the eve of his battle with Maxentius for Rome. The local bishop of Ravenna, Maximianus, who presided over the church's dedication, brings a golden cross, studded with gemstones, as a gift. Another cleric carries a richly decorated gospel book. The emperor himself offers a golden bowl for the bread, the paten, needed in the most important part of the Christian ceremony when Christ's sacrifice is commemorated through the offering of bread as a symbol of his body and wine as a symbol of his blood. The cup for the wine, the chalice, is carried by Empress Theodora, who is shown in a companion mosaic. This ritual presentation of ceremonial vessels by the Byzantine ruling couple symbolizes the distant city of Ravenna being pulled back into the ruler's immediate sphere.

Justinian, as self-styled head of Church and State, surrounds himself with the two most powerful arms of his government, the clergy and the army. Claiming to be Christ's representative on earth, he brings gifts for the altar to show his devotion. His role as both Christian ruler and conqueror is related to that of Constantine. He is dressed in a rich imperial purple cloak clasped at the shoulder with a huge brooch of pearls and gemstones. His crown is equally exaggerated in size, while his face compares well with that of Constantine's colossal statue in Rome. Justinian's features, however, more closely resemble the traditional face of authority inherited from the Mesopotamian and Egyptian traditions. His nose forms a very long straight line down the center of his face, descending from two strong eyebrows that begin the curve of the eye sockets that are the dominant element of the face (compare the statue of Khafre, fig. 3.9). Dark lines draw the upper and lower lids; large black pupils give him a penetrating stare. The subtlety of the mosaic technique suggests that the work was probably done by artists brought in from Constantinople. Other decorative elements in the church came out of imperial workshops, such as the intricately carved column capitals that match those in Hagia Sophia. Although relatively small, the church provided evidence of the high-quality artwork produced at Justinian's court to those who had never been there.

Western Europe in the Middle Ages

The Germanic tribes who settled across Europe as the Roman Empire declined had been eager to hold on to the luxuries and power of their illustrious predecessors. As petty kings began to control larger tribal areas and carve out definitive political boundaries, they looked to the visual arts for confirmation and legitimacy. The first powerful ruler in the West during the Middle Ages was Charlemagne, or Charles the Great. Crowned Emperor of the West in Rome on Christmas Day, 800, Charlemagne copied all the imperial imagery he could afford in reduced circumstances. His palace

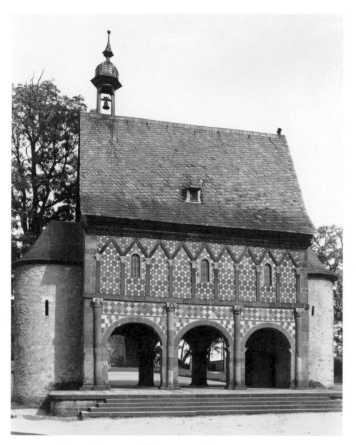

ABOVE **3.46** Gatehouse to abbey at Lorsch, Germany, 768–74.

RIGHT **3.47** Back cover of *Lorsch Gospels*, German, early 9th century.
Ivory. Victoria and Albert Museum, London.

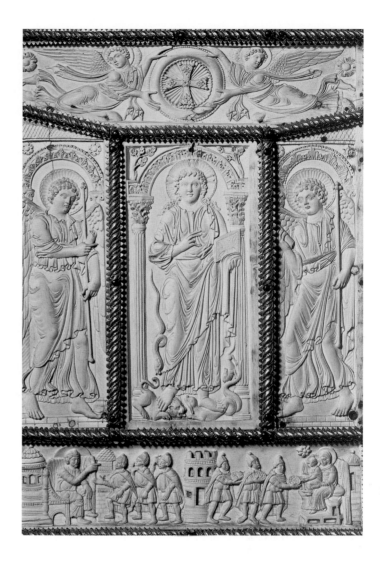

chapel at Aachen was modeled after San Vitale in Ravenna, even using antique *spolia* from the same city. He brought in experts on Classical techniques to illuminate manuscripts, carve ivory, and produce other works of art in workshops at his court. His descendants, called Carolingians after his name in Latin—Carolus—carried on these traditions. Triple arches, reminiscent of Constantine's symbol of victory, were used not only in architecture at the imperial abbey of Lorsch ▶ **fig. 3.46**, but as decorative elements, for example on an ivory cover for a gospel book produced at the same location ▶ **fig. 3.47**. Christ stands in victory over his enemies in the center of the scene, illustrating the verse from Psalm 91 that reads "you shall tread safely on snake and serpent." His position under the central arch mirrors that of the visiting emperor making his ceremonious entry through the gateway of the abbey.

One of Charlemagne's three grandsons, Charles the Bald (named for his lack of land, not hair) fought with his brothers all his life for control of parts of his grandfather's empire. Even managing to get the pope to crown him emperor in 875, two years before his death, he struggled to maintain an appropriate image of himself as heir to the great Charlemagne. He is portrayed in splendor in a miniature that covers two folios

3.48 Codex Aureus of St. Emmeram, folios showing Charles the Bald enthroned, Court School of Charles the Bald, probably Reims, c.870. Manuscript. Bayerische Staatsbibliothek, Munich.

of the Codex Aureus, or Golden Book, of St. Emmeram ▶ **fig. 3.48**, a manuscript made by Charles's court artists about 870. The folios are dyed imperial purple, and chemically dissolved gold was used for much of the design and lettering. On the left-hand folio, Charles sits in regal robes covered with gems on an equally richly decorated throne. Following the Early Christian tradition of borrowing Roman imperial imagery (compare fig. 2.12), Charles is flanked by his sword- and shield-bearers, with Classical female personifications of plenty behind him. God's hand, indicating divine approval, appears from above, over a cloth of honor and under a canopy set over four marble Corinthian columns.

On the next page is a celestial vision from the Book of Revelation, in which St. John the Divine reports seeing the lamb of God adored by twenty-four elders. The lamb symbolizes Christ, whose death was seen by Christians as the final Judaic sacrifice of a living creature. The dome over the palace chapel at Aachen was originally painted with this design, and Charlemagne's wide, straight throne, which was placed in the second level there, is also recognizable. Although the four columns of the canopy over Charles appear to support a single arch, they also allow the sides to form two smaller arches in which crownlights hang. The arrangement of the arches in front of the throne lodge at the Aachen chapel is also triple, following the model of San Vitale.

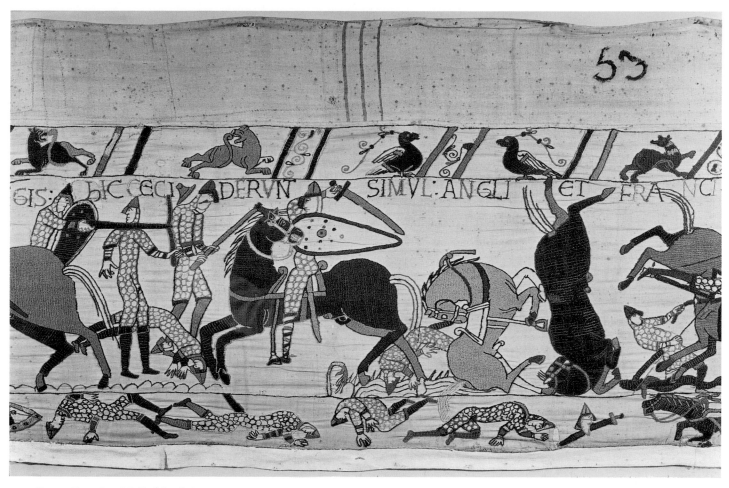

3.49 Bayeux Tapestry, detail of *Angli et Franci in prelio* (French and English fall side by side in battle), probably Canterbury, England, c.1073–83. Wool embroidery on linen, height 1ft 8ins. Bayeux Tapestry Museum, by special permission of the city of Bayeux.

It appears that this is no abstract idea of an enthroned Charles, but refers to his actual position on his grandfather's throne in Aachen, a town held nearly continually by his brother Lothair. Like the Byzantine emperors, the Carolingian rulers claimed to be Christ's representatives on earth. Charles's need to express divine approval made him turn to his grandfather's potent legacy. He sits under the dome of heaven with God's hand blessing his rule. The richness of the decoration implies his own wealth and power, a fiction even greater than that created by Constantine about himself.

Another illustration of complex claims to political power was worked into a continuous narrative scene on what is now called the Bayeux Tapestry. It is a visual record of the conquest of England by William of Normandy in 1066. Although it has been labeled a tapestry, the decoration was not actually woven on the loom; it is, rather, a frieze-like embroidered linen strip, one foot eight inches high and 230 feet long, its narrative scenes offering vivid details of medieval life ▶ **fig. 3.49**. The main story is sewn into the middle band of the linen, and includes countless references to scenes on Roman monuments, Old Testament illustrations, and medieval artworks. The upper and lower borders also contain emblems and secondary registers of figures with allusions to literary sources and contemporary designs. The form of the long, narrow series of images celebrating a military victory had been established in scrolls

and such monuments as Trajan's Column (see fig. 3.27). Here, the story of the conquest is told from the viewpoint of Norman chroniclers—not surprisingly, since history is almost always written by the victors. However, it appears that the work was commissioned by William's half-brother and vassal Odo, the Bishop of Bayeux, after he had been rewarded with the earldom of Kent, and that it was embroidered in Kent by Anglo-Saxons. Needlework of this kind was called *opus Anglicanum*, "English work," and was commissioned by wealthy people throughout Europe. Such a huge commission brought prestige to the owner; Odo possibly planned it as a gift to William after he had fallen from favor. Scholars have pointed out details in some scenes that suggest that the defeated Anglo-Saxons subtly inserted their interpretation of the conquest. The general purpose of the embroidery, however, was to illustrate a justification of the Normans' act.

The overall story concerns the succession to the throne of England. It begins with the aged Anglo-Saxon king Edward the Confessor determining who should rule after his death. A number of powerful Anglo-Saxon families had eligible sons but he was afraid they would squabble among themselves once he was gone. He turned instead to his boyhood companion and relative, with whom he had grown up in exile, William, Duke of Normandy. In the narrative of the Bayeux Tapestry, Edward sent Harold, Earl of Wessex, one of the most likely Anglo-Saxon successors to the throne, to the Continent to promise the position to William. A series of events took place while Harold was there, the meaning of which varies in differing accounts, but it seems clear that, whether he freely made an oath or was captured while traveling on the Continent and forced to make one, Harold stood by the saints' relics in Bayeux Cathedral and swore to support William's claim to the throne ▶ **fig. 3.1** (see p. 150). This scene thus sets Harold up as a perjurer if he fails to help William later become king of England. To the right, his companions appear to have their feet in water and one turns toward the ship already starting to cross the Channel, perhaps underscoring the Anglo-Saxon opinion that once Harold had complied with William's demand, he got out of Normandy and sped home as fast as possible.

On Edward's death, Harold was crowned king, thus breaking his oath, and William prepared to invade, claiming that the throne was his and that Harold must be punished. In the tapestry the battle is presented as a civil war, in other words, an internal conflict between "rebellious" and "loyal" subjects (see fig. 3.49). The Latin inscription *Angli et Franci in prelio* refers to the combatants by names that William used only later in his legal documents (*Angli* are the Angles, or English; *Franci* are the Franks, or French; *in prelio* means "in battle"). In Normandy, William would not call his people "French," since the Normans saw the French as their reluctant foreign hosts. It was in England that he employed the term "Franci" to refer to his continental subjects. In this scene both armies are losing men, although it has become difficult to tell the two sides apart. This points to the fact that the Anglo-Saxons had long been buying their armor and horses from the Normans. More importantly, the soldiers' similarities reinforce Norman denials that this contest over the succession to the English throne was an invasion by foreigners. The Anglo-Saxon designers, while trying to follow their Norman patron's concern that none of William's future subjects

be shown as crushed barbarians in the manner of Roman triumphal imagery, labeled the battle scene with the form of address they knew from the king's Anglo-Norman decrees. In the last surviving scene (the end of the cloth is damaged), Odo's own vassal is shown killing Harold, reinforcing the assistance that William's loyal bishop provided for the conquest. The cause of Harold's death was not known, so a symbolic event, his blinding, is used to underscore the Norman attitude that his defeat was divine retribution.

Southeast Asia

Of countless possible examples, two massive shrines in Southeast Asia serve to illustrate the way in which early dynasties commissioned monumental religious art to convey their suitability as rulers. Both temples were built according to religious beliefs originating in India; merchants and other travelers passed through Southeast Asia on one of the trade routes going to China. During the fifth century, Hindu missionaries from India brought the cult of Siva (see chapter 2), while Buddhist missionaries brought the classical form of the Buddha as realized in statues made under the Gupta dynasty (see figs. 2.26–27). Both Hinduism and Buddhism could be easily adapted to the local religions of the common people. In Java and Cambodia, the imagery and ceremonial captured the imagination of the ruling nobility, who built enormous religious monuments that represented their personal power as well as suggesting the approval of the gods whose blessings benefited their people. The earliest major monument in this area is one of the most sophisticated sacred sites in the world. Borobudur, on the island of Java (Indonesia), was begun as a small Hindu shrine about 775 CE, but around 800 became an elaborate Buddhist pilgrimage destination ▶ fig. 3.50. Following the Javanese tradition of placing shrines on sacred mountains, Borobudur is situated on a hill that has been elaborated into a mountain-shaped temple. It was built by the powerful kings of the dynasty called Shailendra, or "mountain lords."

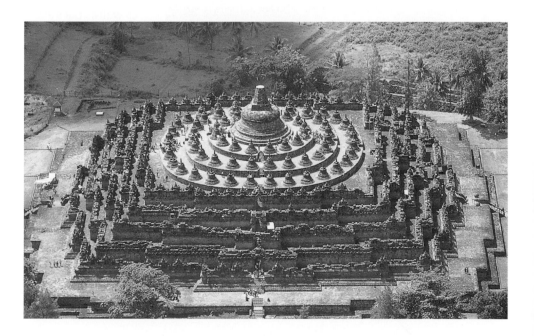

3.50 Aerial view of Borobudur, Java, Indonesia, late 8th century.

It is not clear whether the royal family created a specific ceremonial performance to project their own power at this site. In any case, the monument stands as evidence of their patronage of Buddhism as the official religion of the state as well as their devotion in providing pilgrims with a physical means of following the path to *nirvana*. In this sense, they were functioning like *bodhisattvas* in helping their people reach enlightenment.

The entire design was conceived in terms of religious doctrine. Not a hollow structure like a pyramid or Roman temple, Borobudur was built in the tradition of the Indian ▸stupa◂, a solid high mound marking a sacred site and visited by pilgrims who walked around (circumambulated) it in meditation and prayer. Stupas often had more than one level. Borobudur has many, all made of volcanic stone joined together without mortar. It is set upon a square base, which was greatly expanded later to reinforce it, with five terraces that step back and upward. The sides of every level are not straight, but jut out twice to meet at the center. Three more circular levels top these squares, making nine in all. Each side has a long set of steps that together lead all the way from the ground to the top level. From above, the overall design resembles a ▸mandala◂, a graphic symbol of the infinite. Each of the terraces is designed to exhibit narrative sculptural reliefs against both the main wall of the structure and the protective parapet, so that visitors have to go around twice to see it all. (The base platform was added later for structural purposes and actually covers the lowest wall of scenes.) On the first of the four gallery levels, the imagery appears in two registers, thus requiring four circuits. Ten tours are required to see all the images, relating to stages of transformative Buddhist ritual. These scenes cover all the important stories of Buddhism, totaling nearly 1500 panels: Buddha's life and his past lives, as well as tales about others' search for enlightenment. As pilgrims make their progress up and around the symbolic mountain, the scenes become less physical and increasingly spiritual, a metaphorical path toward awareness. The tour is not easy, involving long and steep climbs.

By the time the visitor reaches the highest level, open to the sky, the reliefs have ended and three-dimensional portrayals of seventy-two eternally meditating Buddha figures, free from distraction, sit inside small stupas with bell-shaped domes pierced by diamond-shaped holes that make the figures within barely visible ▶ **fig. 3.51**. They symbolize the state of near-enlightenment for which the pilgrim has striven. The style is smooth and self-contained, exuding complete stillness. In the center is a monumental stupa that may have held sacred relics associated with the Buddha at one time. It sits at the apex of the entire structure, an earthly

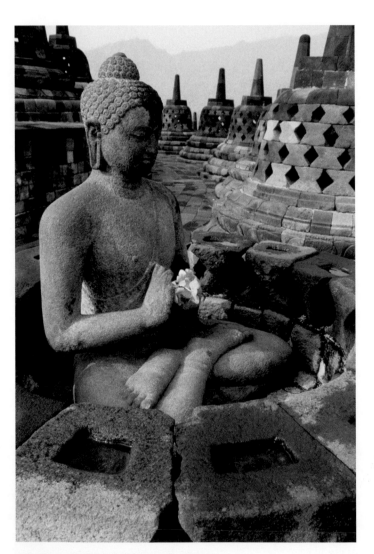

3.51 View of top level of Borobudur, Java, Indonesia, late 8th century.

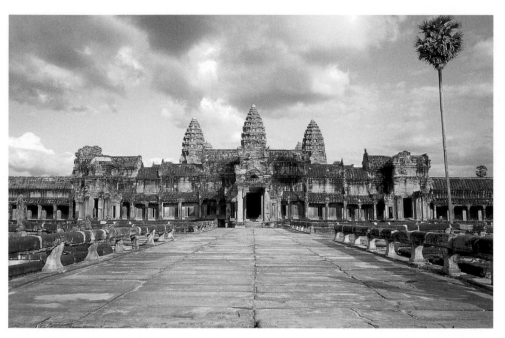

3.52 Angkor Wat, Cambodia, first half of 12th century.

representation of the cosmic Mount Meru, believed by both Hindus and Buddhists to be at the center of creation.

A twelfth-century temple complex built at Angkor, Cambodia, was also structured to recall the world mountain and may have been directly modeled upon Borobudur ▶ **fig. 3.52**. Here the surrounding land is part of the overall plan. Just after 800, a Khmer ruler by the name of Jayavarman II established a central power in Cambodia and emulated the Shailendra dynasty with a royal cult linked to the Indian cult of Siva. His descendants extended the Khmer empire, continued the tradition of building elaborate temples, and founded the city of Angkor with its vast irrigation system that provided rice for the entire empire. Over a thousand temples and palaces attested to the importance of Angkor both as a political capital and spiritual center of Khmer control; the complex was oriented according to plans intended to symbolize the symmetry of the universe. Sculptural imagery depicted the stories and luxuries of Hindu deities.

These designs culminated in the largest Hindu temple in the world, built between 1120 and 1150 by Suryavarman II. Angkor Wat, which simply means "temple of the capital," is set within a rectangular moat 2½ miles long and approached from the west by a wide road. It was dedicated to the Hindu god Vishnu and contained Suryavarman II's tomb. The plan encloses a series of cruciform buildings set within concentric rectangles that build up levels of shrines with *sikharas*, or spires, to a central point symbolizing the mountain at the center of creation. The central tower is over another shrine, this one dedicated to Siva, and is set within a walled enclosure cornered by four companion towers. All five are shaped to resemble flower buds, so that each layered story and final crown seem to grow up out of the one below.

The amount of carved sculptural relief at Angkor Wat is immense. Nearly every surface of its long galleries is articulated in lavish narrative scenes of classical Hindu legends. Although the reliefs are quite shallow throughout, the compositions are complex, their overlapping, repeated, and sinuous lines yielding a rich sense of movement and elegance. At times the legendary imagery is fused with contemporary aspirations in figures whose attire would have been recognizable to visitors of the day, similar in approach to that of the Syphnian Treasury frieze (see figs. 4.3–4).

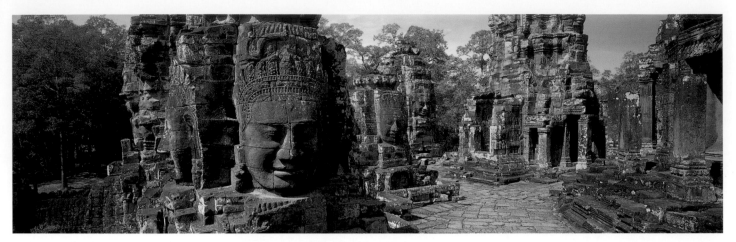

3.53 Head of ruler, Bayon, Angkor Thom, Cambodia, c.1200.

Suryavarman II initiated the Khmer royal cult of the *devaraja*, or "god-king," whereby the ruler incarnated the god, either Vishnu or Siva. At the end of the twelfth century, Jayavarman VII replaced the Hindu cult with Buddha, styling himself the "Buddha-raja," or enlightened ruler prince in the manner of the *bodhisattvas*. In this role he undertook a great number of social projects and built civic architecture for his people's welfare. At Angkor Thom, another temple complex near Angkor, the central mountain temple of Bayon portrays Jayavarman VII's features on the four compass points of over two hundred *sikharas* as the beautiful, ideal king who helps his people obtain *nirvana* ► fig. 3.53.

Hawaii

The leaders of the Polynesian islands, east of Java in the Pacific, had particular signifiers of status to assert their authority. In Hawaii until the mid-nineteenth century, for example, only one class was allowed to wear the color red, those of royal blood, or *ali'i*. From this class came the supreme chief whose authority was based not only on his kinship, but also on his personal abilities. His rank denoted both spiritual and political authority, which was identified by his wearing of cloaks (*'ahu 'ula*) made of precious feathers given in tribute ► fig. 3.54. Similar cloaks were also made in other areas of Polynesia such as Tahiti and New Zealand. Besides the royal red, yellow feathers of the mamo bird were the most highly prized feathers in Hawaii, due to the nearly impossible labor it took to obtain them. Their number on the cloaks indicated the status of the wearer. Feathers were said to be the covering of the gods, and therefore linked their owners with divine authority. Feather cloaks for the highest-ranking officials were woven by men who chanted the genealogy of the destined wearer in order to weave his prestige symbolically into the garment. The patterns in which the feathers were woven into the coconut fiber of the cloaks underscored the significance of the materials. Basically semicircular in form with a circular neckline, the cloak was worn with the opening in the front, so any central design would fall against the wearer's back, while imagery on the outer sides would meet in the front. Although the size and decoration of every *'ahu 'ula* was different, crescent patterns appear on nearly every example of the approximately 160 extant cloaks. The crescent referred to the rainbow, a legendary sign of rank in Hawaii that clearly symbolized pure royalty and its unique kinship prerogatives.

3.54 *'Ahu 'ula* (known as the Kearny cloak), Hawaii, c.1843. Red, yellow, and black feathers on fiber netting, 5ft 9ins x 9ft 6ins. British Museum, London.

Monuments to Power

Many powerful images of past cultures still permeate the modern perception of leadership. Ancient Egyptian obelisks, for example, represented such authority that for centuries after Egypt's rule colonial powers from all over Europe coveted them and shipped them back home as symbols of their own greatness. Ten of the seventeen obelisks standing in present-day Rome are such *spolia*. One was begun new in 1938 on the instructions of Benito Mussolini (1883–1945), the Fascist dictator notorious for his aggressive foreign policy, who also took possession of an ancient obelisk from Ethiopia. The Egyptian obelisk on the Place de la Concorde in Paris ▶ **fig. 3.55** did not reach the city until 1836, but its acquisition was based upon an original goal of the French emperor Napoleon (r. 1804–15) in his earlier wars of conquest. The obelisks in London and New York ▶ **figs. 3.56–57** were originally part of a set from the reign of Thutmosis III (fifteenth century BCE), which Cleopatra later transferred to the city of Alexandria. They were dubbed "Cleopatra's needles" by the English who shipped one to London in 1877–78 with great trial and tribulation (it was nearly lost in a gale in the Bay of Biscay); it now stands on the Embankment of the Thames. The other, given to the United States by the ruler of Egypt in 1869 in gratitude for the completion of the Suez Canal, was erected on a knoll in Central Park in Manhattan. The Washington Monument (1848–84) ▶ **fig. 3.58** is shaped like an obelisk, a combination of Old World form with American technology (it has an elevator inside); with an observation deck at its summit, it was designed to represent a progressive ideal

ABOVE **3.55** Egyptian Obelisk, Place de la Concorde, Paris, France (first erected by Thutmosis III, r.1483–1425 BCE). Red granite, height 74ft.

RIGHT **3.56** Cleopatra's Needle, Thames Embankment, London, England (first erected by Thutmosis III, r.1483–1425 BCE). Red granite, height 69ft.

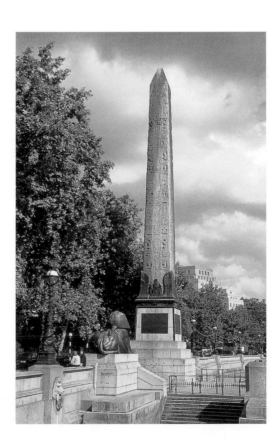

of the vast opportunities available in a new, open country. One might see the modern corporate skyscraper as an heir to such architectural statements of optimism and wealth ▶ **fig. 3.59**. Certainly their association with the ideology of the American way of life reached an unprecedented pitch when the World Trade Center towers in New York were attacked on September 11, 2001.

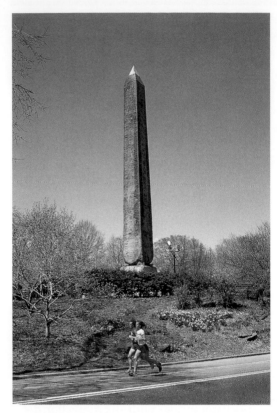

LEFT **3.57** Cleopatra's Needle, Central Park, New York City (first erected by Thutmosis III, r.1483–1425 BCE). Red granite, height 71ft.

3.58 Washington Monument, Mall, Washington, D.C., built 1848–84.

3.59 Skyline before September 11, 2001, with World Trade Center towers, New York City.

Further Reading

W.E. Begley, "The Myth of the Taj Mahal and a New Theory of Its Symbolic Meaning," *Art Bulletin*, 61 (1979), pp. 7–37

D. Bernstein, *The Mystery of the Bayeux Tapestry* (Chicago, 1986)

S.P. Blier, *Royal Arts of Africa* (London, 1998), chapter 1, "The Benin Kingdom: Politics, Religion, and Natural Order"

R. Cormack, *Byzantine Art* (Oxford, 2000), chapter 2 "In the Shadow of St Sophia," pp. 37–73

T. Cummins, "Kinshape: The Design of the Hawaiian Feather Cloak," *Art History*, 7:1 (1984), 1–20, also in: *The Arts of Africa, Oceania, and the America: Selected Readings*, ed. J. Berlo and L. Wilson (Englewood Cliffs, NJ, 1993)

C. Holt, *Art in Indonesia* (Ithaca, NY, 1967), chapter 2 "The Impact of Indian Influences," pp. 35–65

M. Klokke, "Indonesian Art," in M. Girard-Geslan, et.al., *Art of Southeast Asia*. (Paris, 1994/New York, 1998), pp. 342–354

R. Krautheimer, *Early Christian and Byzantine Architecture* (Harmondsworth, 1965 and 1979), chapter 9 "The Hagia Sophia and Allied Buildings," pp. 215–249

N. Luomala, "Matrilineal Reinterpretations of Some Egyptian Sacred Cows," *Feminism and Art History: Questioning the Litany* (New York, 1982)

J. Miksic, *Borobudur: Golden Tales of the Buddhas* (Jakarta, 1990), Part II "Architecture and Symbolism," pp. 39–57

J. Munsterberg, *Art of India and Southeast Asia* (New York, 1970)

M.K. O'Riley, *Art beyond the West* (London, 2001; New York, 2002), pp. 83–98

O.K. Werckmeister, "The Political Ideology of the Bayeux Tapestry," *Studi Medievali*, 3rd series, 17 (1976), pp. 535–95

T. Zéphir, "Khmer Art," in M. Girard-Geslan, et.al., *Art of Southeast Asia* (Paris, 1994/New York, 1998), pp. 187–196

For websites on obelisks, visit http://www.mhhe.com/frames

Source References

p. 60 "Amon, Lord of the Thrones ..."
E. A. Wallis Budge, *Cleopatra's Needles and Other Egyptian Obelisks* (London, 1990), p.222

Discussion Topics

1. Consider some of the stylistic features in artworks of this chapter that contribute to the claims of divine kingship.

2. Are there any analogies between modern travel brochures, advertisements for merchandise, or movie trailers that make false claims in the way that Constantine did in the artwork he commissioned? What devices do designers use to convey their messages?

3. Look again at the mosaic of Justinian in San Vitale. Can you tell how Justinian's claims to be sole ruler of Church and State might have been challenged by the bishop in this image? What does the hierarchical scale suggest? How does the overall composition divide into two parts?

4. Consider the architecture of southeast Asia in relation to the layout of Teotihuacán as described in chapter 1. How do they refer to religious beliefs about the center of the universe? How do they compare with the way the Pantheon embodies Roman claims to universal rule?

5. Compare the iconographic features of the *oba* in the brass plaque of Benin with Charles the Bald in the Codex Aureus. What visual devices are used to affirm them as kings? How do their retainers reinforce this impression?

6. What other grand architectural or sculptural projects described in this book are associated with the political leaders under whose terms they were built? How did their patronage affect the style and technology of the projects?

7. How do the upright, symmetrical, still postures of formal royal portraits described in this chapter contribute to the impression of authority?

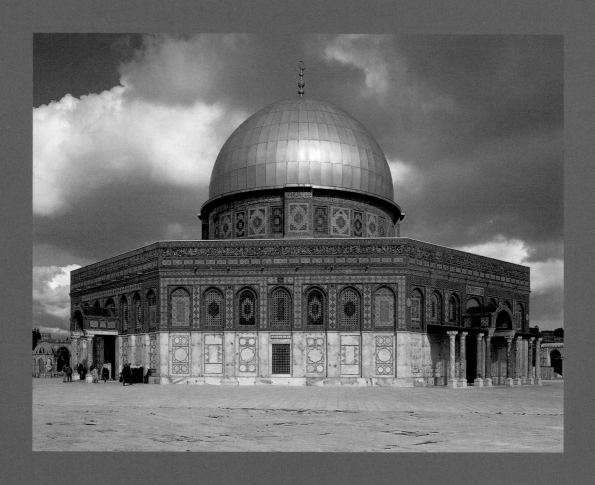

Pilgrimage

Traditionally, one of the principal reasons that people choose to travel has been to visit holy shrines. Over many centuries, pilgrims have undertaken arduous journeys in the belief that a visit to a certain site would guarantee their spiritual, physical, or mental well-being.

Even in today's increasingly secular Western world, people speak of making a pilgrimage to popular tourist attractions. In the United States, for instance, nearly every family with children travels to one of the Disney theme parks. A more religious fervor pervades other sites such as Graceland, the former home of Elvis Presley near Memphis, Tennessee. His celebrity as a rock and roll singer, combined with his charisma and intensity earned him countless fans and immense wealth. His house at Graceland is filled with possessions that now serve as precious relics of his life. There is a deeply pentecostal, evangelical aspect to Elvis's cult, linked partly to his own beliefs, partly to the popular style of religion in the southern United States, and partly to the continual fascination of this topic among tabloid newspapers who have dubbed his followers "Presleytarians."

This chapter looks at historical pilgrimage sites, opening with a discussion of destinations in ancient Greece, focusing on the holy shrines of Delphi, Olympia, and the Athenian Acropolis. As each pilgrimage destination became known and attracted increasing numbers of visitors, the possible routes towards their goal proliferated, and inns, stables, stores, and other travel services were opened to serve the travelers by enterprising business people. Competition to attract pilgrims and their custom often motivated civic and religious leaders to build bigger and more innovative monuments than their neighbors, and their claims of the efficacy of holy shrines were often underscored by the richness of the decoration they commissioned.

The most widely documented period of pilgrimage in the West was during the Middle Ages, when churches were designed to accommodate ever-greater crowds, as reflected in architectural styles beginning with the solid, symmetrical and "Roman-like" Romanesque and continuing with the airy spaces and complex heights of the Gothic. And Islam, the only religion to require pilgrimage as a basic religious duty, continues to draw millions of people annually to shrines dating back to the seventh century CE.

4.1 Dome of the Rock (al-Aqsa mosque), late 7th century, from the south. Jerusalem, Israel.

Key Topics

Pilgrimage as a religious quest and the development of sacred architecture.

▶ Spiritual and political goals: reflected in the sophisticated architecture at sacred sites in ancient Greece and in shrines celebrating the power of the guardian deities.

▶ Medieval pilgrims: shrines housing holy remains attracted the first Christian pilgrims, in many respects the forerunners of modern tourists.

▶ Sacred architecture: new architectural forms developed in response to an increased flow of visitors, seen particularly in the plans of Romanesque churches.

▶ Ambition: religious building projects in the Gothic era imposed a burden on taxpayers, creating a sense of alienation with the Church.

▶ Mecca: the city toward which daily prayer is directed and the birthplace of Mohammed is the supreme site of pilgrimage in Islam.

▶ Convergence: Jerusalem as the site of rivalry between Jewish, Christian, and Muslim faiths, reflected in the city's architectural history.

Greek Shrines of Antiquity

The ancient sites of Delphi and Olympia on the Greek mainland were considered sacred sites ▶ **fig. 4.2**. Like the mounds and henges discussed in chapter 1, they were set in striking landscapes. By 700 BCE, sanctuaries at Delphi and Olympia were dedicated to the gods Apollo and Zeus (see chapter 2). Apollo was credited with killing a great dragon at Delphi, thus ending matriarchal, primitive practices and ushering in a new era of patriarchy and intellect. It was here that the most famous oracular shrine, or place of prophecy, was maintained by powerful priests. Visitors were drawn to festivals in honor of Apollo, held every four years, which included contests in poetry, sports, and music. Along the hill path leading up to the standard large temple to Apollo, each Greek city-state, or *polis*, built small enclosures to serve as treasuries and storage lockers for the valuable objects dedicated to the celebration of the cult. One of these treasuries at Delphi is notable for its decoration, in which the priests were able to insert details that gave traditional scenes conveying general moral messages a secondary and contemporary political meaning ▶ **fig. 4.3**.

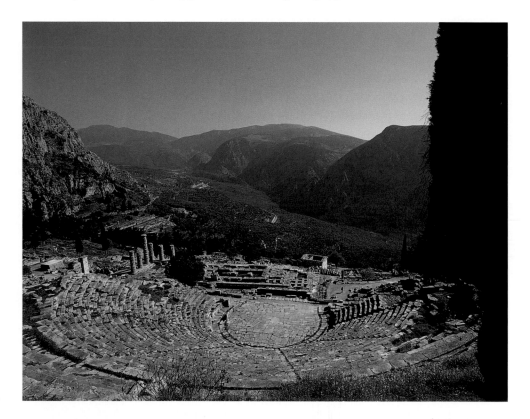

4.2 Overview of Delphi, Greece.

To understand the intersection of religion and politics in Greece, one need only know the phrases associated with the sanctuary at Delphi: "Know thyself" and "Nothing in excess." Although different forms of government ruled the various city-states, most Greeks believed that a unified body of individual citizens with strong wills, self-control, and a sense of order would keep the larger, threatening world at bay. Potential dangers ranged from the world of mythical and supernatural mysteries to the physical world of predatory empires, such as the Persians. Thus, Apollo, as the god of reason and intellect, beauty and knowledge, arts and diplomacy, represented an ideal to which all citizens (free, native-born adult males) should aspire. Knowing their own limits, and restricting

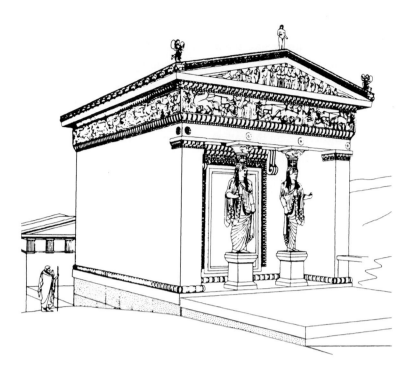

4.3 Syphnian Treasury, Delphi, Greece, c.530–525 BCE. Reconstruction drawing.

both pleasure and work, prevented people from becoming arrogant and complacent. It was expected that governments would be just, whether ruled by kings or elected representatives, and that citizens would take part in making decisions as well as remaining discreet about publicly voicing disapproval.

This philosophical outlook is manifest in some of the details on the treasury building that people from the island of Syphnos erected at Delphi (c.530–525 BCE). As a miniature version of larger temples, it was built in the ▸Ionic◂ style of Asia Minor and the Aegean islands, in which an unbroken horizontal lintel is supported by delicate columns, which sometimes take the form of a *kore* (see chapter 2). On the building's north frieze, the story of the battle between the gods and the giants is illustrated with references to contemporary life in Greece in the sixth century BCE and was clearly intended to send a message to the pious guests climbing the hill at Delphi ▶ **fig. 4.4**. Although in general the story was a universal lesson in brains versus brawn, in this case the giants have been identified as the allies of the tyrant Peisistrates, who controlled Athens at that time, while the gods stand with Apollo. The horizontal space of the frieze prevents the giants from looking tall, so the designer chose to place full-face helmets over their heads, making their expressions fierce, with emblematic symbols on the top of some that relate to specific city-states in Greece. In contrast, the gods appear quite delicately human, with clothing or weapons through which they can be identified.

The space within the architectural frieze was long and narrow and had, in the past, often led to the use of boring, repetitive subjects. On the Syphnian Treasury, the sculptors grouped the figures according to their respective activities, arresting the viewer's eye and turning it back to "read" the entire layout like words in a sentence.

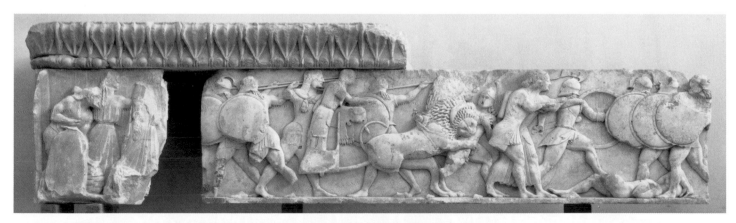

4.4 Syphnian Treasury, north frieze, Delphi, Greece, c.530–525 BCE. Marble, height of frieze 2ft 4/5in. Delphi Museum, Greece.

In the battle scene, the figures were made to overlap in complex poses suggesting that the gods and giants not only stood side by side, but also occupied space layered in depth from back to front. The detail at fig. 4.4 shows a lion mauling a giant who falls back, away from the viewer. The giant's helmeted head is in low relief, while the leg that juts out toward the viewer was so deeply cut away from the surface in ▸high relief◂ that it was vulnerable to breakage. The Greek use of painted colors (usually a deep blue background with bright hues on the relief) and bronze, wooden, or leather accessories, served to enhance this effect.

Like Delphi, the site of Olympia, in the Peloponnese in southern Greece, was developed around the cult of a god and regular athletic contests. Here the supreme god, Zeus, oversaw the Olympic Games held, then as now, every four years. The architectural style of the main temple is ▸Doric◂, the style of mainland Greece. Typical of large Greek temple design, interior space was not the primary objective ▶ **fig. 4.5**. Most of the rectangular form is taken up by a long ▸colonnade◂ that surrounds the inner sanctuary, or ▸cella◂. Steps at the east end indicate that the foundation was above ground level, making the columns appear even taller than they really were. The whole structure was designed to create a majestic backdrop to outdoor ceremonies, much as groves of trees would have served to define sacred locations in nature for the Classical Greeks' ancestors.

The visitor would face a giant Doric façade complete with sculpted ▸pediment◂ and a frieze of square relief ▸metopes◂ placed on the second inner wall of the sanctuary. When the giant doors were open, the 40-foot, seated statue of Zeus was revealed. On the east pediment, statues were placed within the triangular space, forming a scene centered on Zeus ▶ **fig. 4.6**. (The west pediment on the back of the building is discussed in chapter 2, fig. 2.8.) Other scenes on the temple are derived not only from his legends, but from stories underlining the competitive nature of the Olympic Games.

Control of Olympia, and all the income from visitors that it represented, was contested for many years between the two neighboring cities of Elis and Pisa. This ultimately led to war in 470 BCE, when Elis was victorious over Pisa and built this temple in thanksgiving. The cities' struggle is mirrored in the story, on the temple's east pediment, of a tragic chariot race whose outcome would echo down through multiple generations of gods and mortals. The contestants were the legendary king of Pisa, representing old age, and Pelops, a suitor for the king's daughter, representing youth. They stand on either side of Zeus, who presided as judge. Because the king had been given a prophecy that his son-in-law would cause his death, he had challenged all his

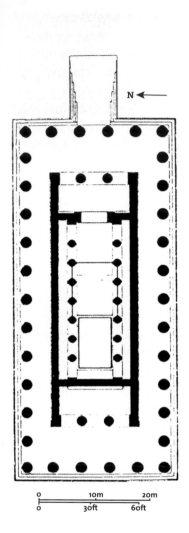

4.5 Plan of Temple of Zeus at Olympia, Greece, 465–457 BCE.

4.6 Reconstruction drawing of the preparation for the chariot race between Oinomaos and Pelaps, from the east pediment, Temple of Zeus, Olympia, Greece, 465–457 BCE.

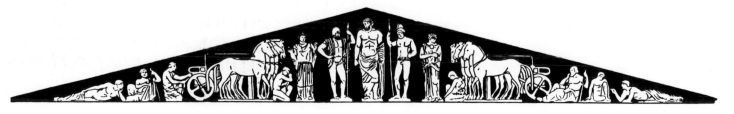

daughter's suitors to a chariot race in order to win her hand, confident in the belief that his special chariot was unbeatable. Pelops, however, was cleverer than previous suitors and he made a deal with the king's charioteer, Myrtilus, to cause the death of his royal master during the race. Pelops thus triumphed over the Pisan king, also winning the most popular and dangerous type of race held at the Olympic Games. However, instead of paying Myrtilus, Pelops drowned him. Thus, by marrying the king's daughter through treachery, he brought down retribution upon his descendants, as chronicled in the cycle of myths dramatized in the fifth century BCE by Aeschylus as the *Oresteia*.

The figures of the pediment are not engaged in any of the story's action, but are shown at rest, as if preparing for the start of the race. On either side of the two men are their women, the queen by the king and his daughter next to the suitor who would win her. As the triangular pediment decreases in height, so do the figures. Thus the horses come next, four for each chariot, heads to the center and lower rumps to the outside. Beyond them are figures seated and reclining in the corners. Of these, one on the far right is probably the old blind prophet, leaning on a staff, who had told the king of his fate. His gesture of horror, hand raised to his bearded face, reflects his awareness of the tragic future and stands as an ambiguous warning to viewers.

In the twelve metopes that appear on the east and west porch friezes of the temple, the hero Herakles (the Roman Hercules) performs his famous labors. The son of Zeus by a mortal woman, Herakles is primarily associated with the attributes of strength and courage. Unfortunately, during a fit of madness, these also proved to be his undoing as he killed his own children. To atone for this deed, the king of Argos assigned twelve impossible tasks, each one the subject of a metope. Being in the form of self-contained squares, the scenes were a challenge to design with figures large enough to read from below yet active enough to convey the story. As at Delphi, the most skillful sculptors were hired for the work. Since Greek visitors knew the story of the twelve labors well, only minimal references to participants or locations were necessary. Nonetheless, making a square with one, two, or three figures visually compelling was another matter, and the solutions that were adopted are instructive. There is room here for only two examples.

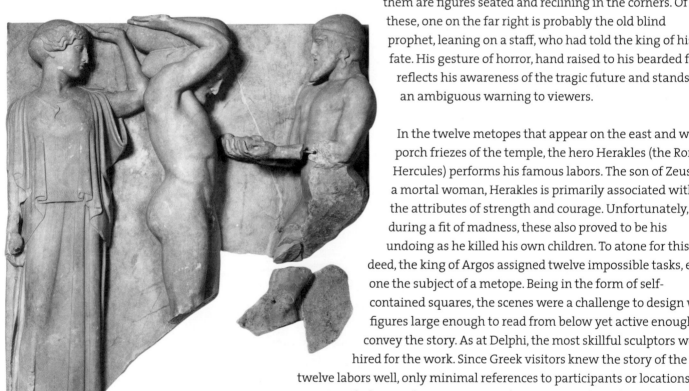

4.7 Metope showing Herakles with Atlas and the golden apples, from Temple of Zeus at Olympia, Greece, c.460 BCE. Marble, approx. height 5ft 3ins. Olympia Archeological Museum.

The most straightforward presentation of vertical figures in a row is on the east façade in the tenth labor, when Herakles had to obtain the golden apples of the Tree of Life from the Hesperides. He persuaded Atlas, the giant who was believed to hold up the world, to get them while he took his place. The metope shows the moment when Atlas has returned with the apples ▶ **fig. 4.7**. Herakles is still supporting the world with his hands at the very top of the lintel, thus placing them directly under the line of the pediment and the entire weight of the roof. Athena, his protector goddess, helps him

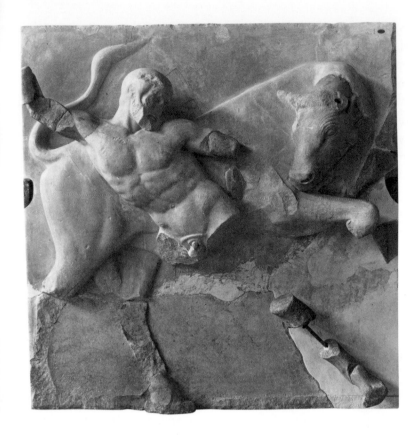

with one hand. The viewer's eye is directed from her gaze across to Atlas, down to his arms, which reach across to Herakles to offer the apples. The "V" shape of Herakles' arms moves from Athena's hand down his body and the direction of his gaze to the apples, which in turn lead back to Atlas. In this way, wherever one starts to look at the scene, the sculptor ensured that all the figures would be seen. Athena's frontal pose allows for an orderly portrayal of the heavy *peplos*, the garment preferred by mainland women at this time. Her severe facial expression alludes to Atlas' reluctance to resume his burden; he required her divine persuasion. The two male bodies—one in profile, the other three-quarters— exemplify the development of muscular modeling and complex poses that followed from earlier *kouroi* sculptures (see chapter 2).

The second example, from the west façade, shows the seventh labor and involves only two figures, Herakles and the huge, fire-breathing bull of Crete, which he had to capture ▶ fig. 4.8. Besides

4.8 Metope showing Herakles with the Cretan Bull, from Temple of Zeus at Olympia, Greece, c.460 BCE. Marble, height 5ft 3ins. Olympia Archeological Museum.

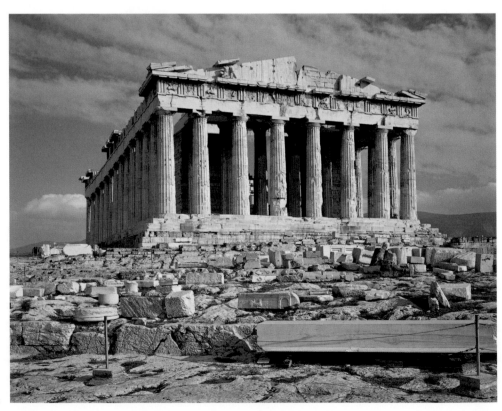

4.9 View of the Parthenon from the northwest corner, showing frieze of cavalcade in preparation, Athens, Greece, 447–438 BCE. Marble, height of frieze 3ft 6ins.

accommodating both vertical and horizontal elements, the design problem here was to avoid creating a simple "T" as well as to fit some action into such a tightly packed space. The sculptor set up the effect of a struggle by opposing the two figures in a diagonal arrangement. The relief was also layered to add depth and use the area most efficiently; Herakles appears in front of the bull. While his left foot stretches from its anchor in the bottom right-hand corner, his right arm reaches out in a striking gesture with his club. The club, in turn, points toward the head of the bull, whose body is extended from bottom left to top right. Since the bull's tethered head is dragged around toward Herakles, the composition becomes circular.

The Persian War

The Greeks lived in small, disciplined city-states that emphasized the arts, intellect, restraint, and physical fitness—a great contrast with those living in the empire of the Persians, who reveled in wealth, luxury, and power over many cultures and subject peoples (see chapter 2). Everywhere the Persian emperor traveled, even in war, thousands of people, animals, furniture, documents, and treasures moved with him. Unlike the Greek belief that "less is more," to the Persian ruler "more" was a public sign of the vastness of his holdings. By the fifth century BCE, Darius I (r. 521–486 BCE) (see chapter 3) already controlled Greek cities situated on Asia Minor. However, their inhabitants had risen up against their Persian governors and had been helped by mainland forces from Athens and Eretria. As punishment, the emperor decided to annex the Greek islands of the Aegean and invaded the mainland. There seemed little doubt that Darius, whose innumerable armies included legions of conquered slaves and whose boundless wealth had been extended with the resources of hundreds of subject kingdoms, would quickly overcome the much smaller Greek forces.

Instead, no one was more surprised than the Greeks, when, after years of losses and destruction by the Persian armies, an Athenian-led army of about ten thousand was victorious against much greater numbers at the battle of Marathon in 490 BCE. Some six thousand Persians were killed in contrast to only around two hundred Greeks. Darius's successor, Xerxes (r. 486–465 BCE), led another campaign against the entire Greek region in revenge. However, after the Greeks suffered many more grievous losses and the destruction of Athens, a great victory at the naval battle of Salamis in 480 BCE assured Greek independence. The Greek philosopher Aristotle (384–322 BCE) wrote that this success gave the Athenians a political confidence they had previously lacked. They certainly saw themselves as leaders of the Greek allies and defenders of Greek culture over "barbarians" (literally meaning those people who did not speak Greek). The Athenians moved on to colonize former Greek city-states that had allied with them against the Persians. The Parthenon project (see fig. 4.9), largely funded by these allies, can therefore be seen as standing for a renewed sense of Athenian self-confidence.

The largest and most elaborately decorated temple from the Greek Classical period, the Parthenon on the Acropolis in Athens, continues the lessons learned at Olympia ▶ fig. 4.9. Dedicated to Athena, the city's patron goddess, the Parthenon replaced two earlier temples that had been destroyed by the Persians. It was designed to become another universal pilgrimage shrine for all Greeks to visit. Presenting themselves as the saviors of Greece during the Persian War (see inset), the Athenians felt that Athena warranted devotion from more than just her own citizens. Furthermore, a shrine that would draw crowds as large as those that visited Delphi and Olympia would be a worthwhile economic investment. The Athenian leader Perikles (c. 495–429 BCE) offered to pay for the rebuilding out of his own pocket, but the citizens rejected this because they did not want the temple associated with his family. Instead, the council voted to take the funds remaining in the allies' defense treasury on the island of Delos. The confederated city-states, called the "Delian League" after the site of their finances, wanted to keep the money there even after the defeat of the Persians in case of further invasion. The Athenians forced the issue by insisting Athena be honored and simply claiming the funds.

Situated at the top of the highest hill in Athens, the Acropolis (formerly the site of a Mycenean palace), the Parthenon was part of a complex of buildings set over sacred ground. The temple was dedicated to Athena's later incarnation as Parthenos, or virgin, and the name possibly also referred to the virgins who were an intrinsic part of her ritual cult. Construction began after a peace had been concluded with the defeated Persians. Initiated by Perikles, who believed that Athens could have a golden age, the project went ahead, despite Delphic warnings about pride and excess and ongoing clashes with Sparta leading to the Peloponnesian War. The accepted formulas for Greek temples had to be abandoned

4.10 West frieze on the Parthenon, Athens, Greece, 447–438 BCE. Marble, height of frieze 3ft 6ins.

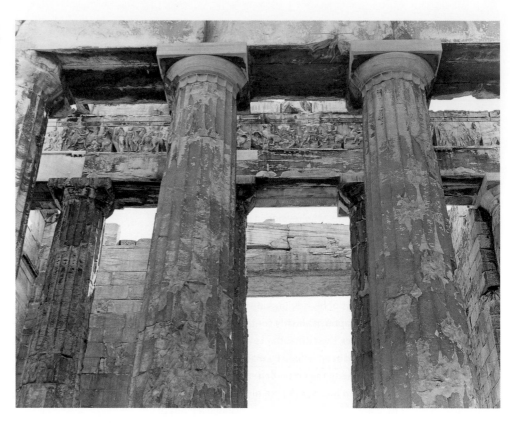

in the Parthenon, since its vast scale required more columns and a much more ambitious sculptural program.

The result remains formidable, particularly when seen from the entrance to the Acropolis. It was laid out to be viewed from this ideal vantage point—below and at an angle, allowing a full panorama of one end and one side: a Doric building with eight columns across the end and seventeen down each side, all 34 by 6 feet; over twenty-five three-dimensional statues in the pediments; ninety-two sculpted metopes in the outer frieze; and an inner decorated Ionic frieze (for the first time on a Doric building) of 3 feet 7 inches high by nearly 600 feet long. The subjects of all the decoration are related to the Greek victory—whether in a general sense about order triumphing over chaos or specifically about Athenian importance. Visitors would have recognized the stories of the Lapith and the Centaurs (see chapter 2), the Gods and the Giants (see figs. 4.3–4), the birth of Athena from Zeus' head, or her appearance with Poseidon as patrons of Athens. The narrative on the Ionic inner frieze, however, would have been less familiar, as this was its first appearance on temple decoration. Most scholars believe that it shows the Panathenaic procession, an annual festival held in Athens honoring Athena on her birthday, with special emphasis every fourth year ▶ **fig. 4.10**. The parading figures that appear in the various scenes of the frieze are neither divine nor mythological; they probably stand for contemporary citizens who are shown moving through the city and up the Acropolis to the Parthenon.

Beginning on the southwest corner of the cella wall and leading away in two directions, the frieze records the various categories of citizens taking part in the daylong festival.

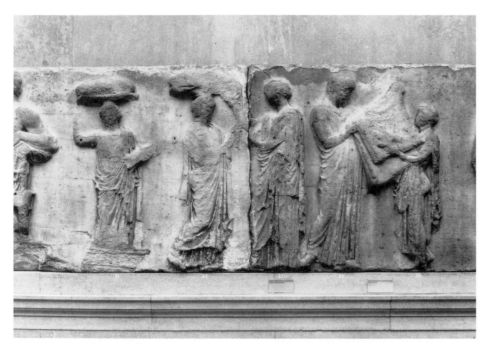

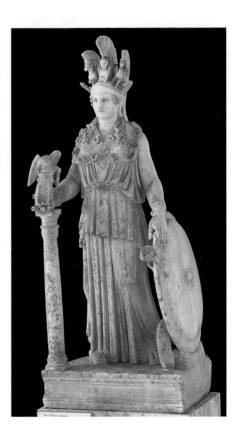

ABOVE **4.11** Inner frieze on the Parthenon, detail of *peplos* offering, Athens, Greece, 447–438 BCE. Marble, height of frieze 3ft 6ins. British Museum, London.

RIGHT **4.12** Statue of Athena Parthenos, 2nd century CE. Roman copy of original made in gold and ivory by Phidias in 438 BCE. Roman version marble, height 3ft 5½ins (with base). National Museum, Athens.

A major portion of the space is dedicated to young athletes, most on horses, which suggests that their numbers were exaggerated beyond their probable participation in the festival; instead, they may commemorate the heroes of the battle of Marathon, a turning-point in the Greek defense against the Persians. This frieze, positioned 40 feet above visitors' heads, was the most ambitious relief work yet produced, following years of experimentation. Figures are grouped and no two groups are alike. As at Olympia, the frieze's background was painted a dark blue and the figures were brightly colored. The relief levels were varied to suggest depth, but here account was also taken of the shadows under the roof, and the top area along the frieze is in higher relief than the bottom so that it can be seen more easily from the ground. Also allowing for distance, drapery is deeply carved to help convey energetic bodily movement.

The procession meets over the eastern doorway, the entrance to the sanctuary ▶ **fig. 4.11**. Here the scene has been interpreted in differing ways, but is most commonly thought to represent citizens presenting a new *peplos*, woven by temple virgins, to the ancient olive-wood statue of the goddess Athena whose taller divine colleagues are seated, watching from Mount Olympus. This innovation of placing contemporary citizens on sacred architecture was seen by many as a deliberate act of arrogance on the part of the Athenians.

Inside the cella was a huge statue of Athena ▶ **fig. 4.12**, made of ivory and gold, much like the later one of Zeus at Olympia. In fact, it was sculpted by the same artist, Phidias (c. 500–c. 432 BCE), who coordinated the entire sculptural program at the Parthenon.

This is a perfect example of how images can encourage travel, since both the astounding size and amazing technical abilities demonstrated in the execution of this statue and building drew curious visitors to Athens, much as they are still drawn today. But as construction went on, so did the war with Sparta. Funds became more scarce, Perikles' rule less popular, and thoughtful citizens less certain of the validity of their city's policies. Today, hindsight makes it possible to see the Parthenon not only as the quintessential accomplishment of the Greek's golden age, but also as an expression of misguided pride, which led to the Athenians' ultimate ruin when they lost the Peloponnesian War and exposed themselves to conquest by Alexander the Great of Macedon.

Christian Pilgrimage in the Middle Ages

By the mid-tenth century, Europe was recovering from the severe economic and political troubles that stemmed from the breakup of the Roman Empire about five hundred years earlier (see chapter 3). Boundaries between countries were relatively stable, although in some regions borders were to remain fluid for centuries, even to the present day. Trade routes through the Byzantine territories, the last remnant of the great Roman Empire, had begun to reopen, making the riches of Eastern Europe and Asia available once again in Western Europe. Gradually, in-kind barter gave way to the reintroduction of the coinage systems used during the Roman era. People could again go on the road with easily portable cash, an economic factor that gave a new impetus to religious pilgrimages. Money did not spoil like fresh produce or require hauling like wine or pigs, and it allowed people to travel further and still pay for their board and lodging. Coins also spread the portrait of the ruler and reminded citizens of the government's wide influence. To trade at the local village market or at the grand seasonal fairs of recovering cities, people traveled from home with animals, fresh produce, and crafts. They traded for the products and currency of other regions, the riches of the East, and even for the holy remains ("relics") of the Christian saints. The latter were valuable for their supernatural powers, having been part of, or close to, the bodies of blessed individuals. Like Chinese ancestors, Christian saints were expected to help the most pious of their devotees still on earth.

Around the year 1000, technological advances in agricultural methods and tools began to increase crop yields and streamlined the processing and distribution of food throughout Europe. The old Roman plow, designed to turn the shallow and dry topsoil of the Mediterranean-bordering regions, was improved for use in the heavy, damp, northern dirt. Deeper furrows not only allowed better drainage and access to richer soil, but new methods of three-year crop rotation (corn/wheat/fallow) also kept the soil productive. By harnessing the power of water, medieval engineers were able to replace manual technologies with more efficient industrial systems such as mills driven by water wheels. As yields increased, especially of superior flour, markets could reach beyond local needs. Old Roman roads were repaired, allowing heavy carts to be used for transporting goods with the incidental advantage of making travel easier for pilgrims.

The motives of the new travelers varied considerably and were not always strictly religious. Some went in search of goods not available at home such as dyes, spices,

precious metals, or medicines, while others hoped to escape from injustice or unemployment. But this was a period of intense religious belief in the power of the saints. Equally strong was the belief in the power of sacred places, or *loci sancti*, to bring earthly and heavenly realms together. There was no doubt in the minds of most Christian pilgrims that making an arduous journey and leaving an offering at a shrine would increase the chances of a saint interceding on their behalf when they were judged by God at the end of time.

Not all pilgrimages were undertaken voluntarily. A pilgrimage to distant religious sites was often prescribed by the Church as a form of penance and atonement for wrongs committed. In this way, the traveler was pursuing absolution (forgiveness) in this life along with salvation in the world beyond. These goals were comparable with those of voluntary pilgrims in search of healing from illness or other worldly plights. For most religious pilgrims, however, travel to sacred sites was a public demonstration of the depth of their faith.

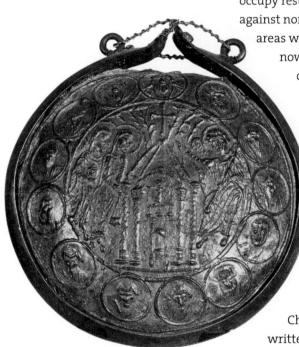

4.13 Souvenir flask showing scene of the three Marys at Christ's tomb, Syria, c.600 CE. Lead. Monza Cathedral Treasury.

Pilgrimages could also be assigned by the Christian Church to punish poor clerics or occupy restless knights. The latter were also occasionally organized into fighting forces against non-Christians. The most famous of these were the crusaders who went to the areas where Christ had lived in the Middle East, or the "Holy Land," to reclaim lands now held by the Muslims. Many of the lands that the Islamic rulers had conquered around the Mediterranean Sea had been part of the old Roman Empire and were also important sites in Christian history. Beginning in the eleventh century, intermittent crusades were organized by kings or popes as military expeditions; the word "crusade" is derived from the Latin *crux* ("cross"), and crusaders were considered to be soldiers of Christ. Returning soldiers often brought back with them stolen booty that included holy relics, Early Christian or Islamic artifacts, and colorful stories of adventures in the East, just as pilgrims did. Being in the same places visited by Christ and the saints was believed to bring great spiritual benefits, but it was also simply thrilling—inspiring the same awe that travelers to historic sites often seek today. Then as now, it was common to return with some kind of souvenir, often incorporating scenes from the New Testament; the little flask showing the three Marys at Christ's tomb dates from early in the seventh century ▶ **fig. 4.13**. Travelers' written accounts of their experiences were used as sources by artists who illustrated Christian sites in the Holy Land. An Anglo-Saxon manuscript, for example, dating from around 1100, included an image of the church on the Mount of Olives from which Christ ascended to heaven, based on the eighth-century description by a pilgrim named Arculf ▶ **fig. 4.14**. Only the disappearing feet of Christ are visible, as if the viewer were standing under the dome and looking up in the manner of his disciples who witnessed the miracle.

European pilgrims had three primary destinations. These were the sites from Christ's life in Palestine, the catacombs and Basilica of St. Peter in Rome, and the Cathedral of St. James in Compostela, Spain. Other shrines could be visited along the way.

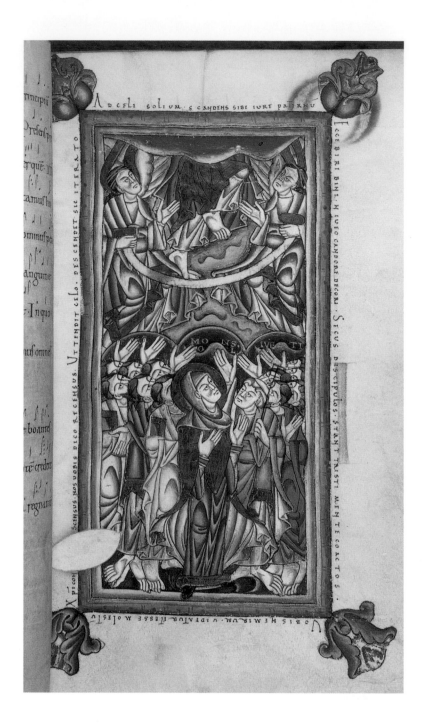

4.14 Scene of the Ascension of Christ from the Mount of Olives, English c.1100. Manuscript, from the Caligula Troper. British Library, London.

The Holy Land

The Early Christian shrines in the Holy Land were mostly built by the emperor Constantine when he recognized Christianity as a legitimate faith in the early fourth century (see chapters 2 and 3). He financed churches on sites in Palestine, two of which became models for building types in medieval Europe: the basilica and the mausoleum.

In the town of Bethlehem, where Christ was born, a rocky grotto was said to have been the site of the stable where Mary and Joseph took shelter. Various small buildings

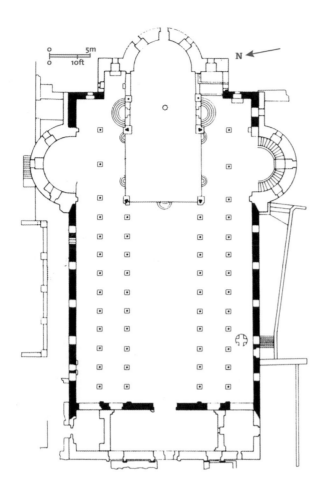

4.15 Plan of the Church of the Nativity, Bethlehem, Israel, 4th century.

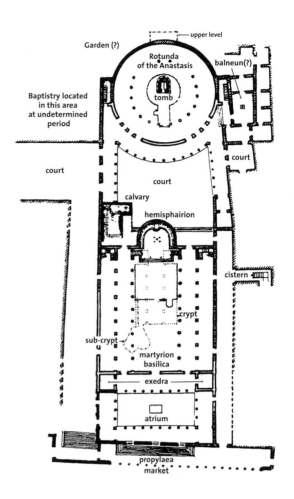

4.16 Plan of the Church of the Holy Sepulcher, Jerusalem, Israel, 4th century.

covered the spot until the year 333, when a full-scale basilica, or Roman public assembly hall, was completed to hold the crowds of visitors ▶ **fig. 4.15**. At the east end, behind the altar, the basilica structure was joined to a large octagonal structure over the holiest area. The octagon's floor was raised by seven steps and an opening was made in the floor through which visitors could look down into the grotto.

A similar set of structures commemorated the sites of Christ's crucifixion and burial at the Church of the Holy Sepulcher, begun in 328 ▶ **fig. 4.16**. The apse, or rounded projection, of a large basilica marked the place where Christ's cross was believed to have been rediscovered. A doorway opening at the end of the north aisle led into another sanctuary associated with the spot on the hill of Golgotha where the cross was originally set into the ground. Finally, a domed canopy covered the rock cave in which he was entombed. At the end of the fourth century, this was elevated to a grand two-story rotunda with a circular walkway. Like the octagonal structure at Bethlehem, the form recalled the standard Roman central-plan burial structure, or mausoleum. Artists

sometimes copied this form to depict the tomb from which Christ was believed to have risen on Easter morning ▶ **fig. 4.17** (see also fig. 4.13). Such anachronistic elements were intended to help the viewers at the time of the art's production to recognize places or events. During the Middle Ages, Christ's tomb was the most popular pilgrimage destination in Palestine. The entire area around all three shrines was enclosed and guided tours were led from a monumental gateway.

Taking Ship

The *Boke of Margery Kempe*, the memoirs of an English pilgrim dating from the 1430s, includes vivid details of the difficulties involved in only a small portion of the journey from England to Jerusalem. This is an excerpt from Louise Collis's biography of this mystical woman:

> Sailings [from Venice] were twice a year, in spring and autumn . . . The general cabin for pilgrims was the hold under the rowing deck. There were no portholes. Light and air came only in through the hatchways. A berth consisted of a space big enough to lie down in chalked on the boards. This would be one's only private place during the voyage. Here, one spread one's mattress, piled one's luggage at its foot and tried to sleep through the noise of snoring, cursing, talking, the sailors running about overhead, the animals in pens on deck stamping, all the creaking and movement of a ship at sea. The heat and smell were horrible.

> It was a good thing to have it in writing that the meals were to be fit for human consumption and regularly served. Should the pilgrims wish to bring their own chickens, space must be reserved for coops on deck; and they must have the right to go into the cookhouse and do their own cooking, as there were those who couldn't stand Italian food day after day. Continual salads dressed with oil were found particularly unappetizing.

> On account of seasickness, overcrowding, rats, lice, fleas, maggots, foul air and general debility, travellers often fell ill. One should try to provide for such times: the captain must definitely concede the right to come up on deck for air at any hour and to remain there until revived. If the worst happened and one died, one's belongings were not to be seized from those to whom one had willed them. Also, a proportion of the passage money ought to be returned. It might not be possible to get him to agree to carry one's body to the nearest land for proper burial, because a corpse on a ship was considered unlucky by sailors. They preferred to pitch it overboard forthwith.

> It remained only to visit those churches dedicated to saints likely to take a benevolent interest in one's journey over the sea and through the Holy Land . . . At last the time came to hire a boat and row to the galley with one's bedding, pots and pans, food, medicine and hens. Fortified by having kissed a hundred relics and prayed to all the saints, one clambered aboard on the last leg of a journey which was to give one not only social status in the material world, but also a reserved seat in heaven. The flags of the Pope, the captain and the city of Venice were hoisted. The pilgrims sang an appropriate hymn. The sailors chanted orders and responses. The oarsmen sang their rowing song as the ship moved out of harbour and caught the wind in its sails.

Although Margery Kempe could not read or write, she dictated her adventures at the end of her life to record her piety. She had a reputation for being quite a fanatic: some thought her to be a victim of religious mania (she had a habit of screaming when praying and displaying arrogance about being personally selected by God); others believed her to be a genuine mystic.

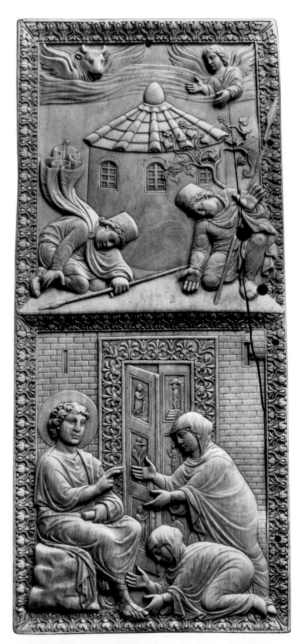

4.17 *Holy Women at the Tomb*, c.400. Ivory, 2ft 2³/₈ins x 5³/₁₀ins. Castello Sforzesco, Milan, Italy.

Europe

Rome, where the Pope usually resided, was the center of the Church's power and one of the two main destinations for pilgrimages from Western Europe. It was also the location of the graves of saints Peter and Paul and hundreds of other martyrs in the catacombs (see chapter 2). Here Constantine, considered the first Christian emperor, located his huge Basilica of St. Peter. Rome's historical attraction for Christians has remained constant through the ages.

The other main destination was in Spain, more accessible than Rome or Jerusalem for the inhabitants of the British Isles and France, in the town of Santiago de Compostela. Its patron saint Iago, or James, was one of Christ's twelve apostles; in fact, the one often considered his "human brother." Legends abound about how his remains came to be in a northwestern corner of Spain. In one version, the coffin containing the dead apostle was placed on a ship in Jerusalem bound for another city in the eastern Mediterranean. During the voyage, a storm destroyed the ship and killed the crew. Miraculously, the coffin survived the sinking of the ship and floated west across the entire expanse of the Mediterranean Sea, through the Strait of Gibraltar adjoining the continents of Africa and Europe, into the Atlantic Ocean, and up the coast of present-day Portugal to the northwest corner of the Spanish peninsula in the kingdom of Galicia. In the seventh century, after the Church became dominant in the area, the coffin was rediscovered and proved impossible to budge from its location in Compostela. St. James was honored with a Christian sanctuary over this location. His bones, along with those of St. Peter in Rome, were advertised as being the only remains in Western Europe of a saint who had known Jesus Christ.

Pagan Origins for Christian Symbols

The sanctuary built over the relics associated with St. James was on the site of a former pagan shrine to the sea goddess Brigit. Ironically, her symbol, the scallop shell—also an attribute of Venus, recalling her birth from the sea—then became an attribute of St. James. The word "scallop" derives from the Norse term for vulva, *skalpro*, relating to the shape of certain kinds of mollusk. Thus, a common fertility symbol for female deities became inextricably linked with the cult of St. James and the pilgrimage to Compostela. As a distinctive badge of the pilgrim, the shell is found on clothing or knapsacks in Romanesque sculpture and painting (see fig. 4.23).

Although the relics are still venerated in Compostela, the story is generally discredited. However, their presence generated strong faith among pilgrims, increasing the potency of the prayers offered to St. James and sometimes making subsequent events appear miraculous.

Most pilgrims to Compostela used one of four land routes through France, which converged in Spain at the bridge in the town of Puenta la Reine, and followed a single path to Compostela. Along these routes there were many other sanctuaries and shrines. Church authorities found that they had increasing numbers of travelers to be housed and fed, have their supplies replenished, and often be nursed through illnesses. In return, pilgrims made generous offerings to the shrines. Enterprising people at every stop saw a good opportunity for profit and catered to pilgrims' needs. Those churches that housed a saint's relics were able to lavish further funds on increasingly large reliquary boxes and buildings. Impressive services were held at the saint's feast day and the local market fairs were often set for the same dates. Expanding shrines provided a new impetus for devotional arts and architecture. Thus the cult around saints' relics grew hand in hand with the economic recovery of France and northern Spain in the Middle Ages.

Romanesque Churches. In response to the increased numbers of visitors, a new church ground plan was developed to incorporate better spaces for the flow of pilgrims from the west entrance of the church, around the shrine in the east end, and back out. Churches built according to the "pilgrimage plan" survive throughout France. At the abbey church of Conques (c. 1035–60), a small town along a rocky mountain road in the southern region, requiring a difficult climb much like that encountered by Greek visitors to Delphi, the layout was quite small in order to fit the limited flat area on the side of the mountain ▶ **figs. 4.18–19**.

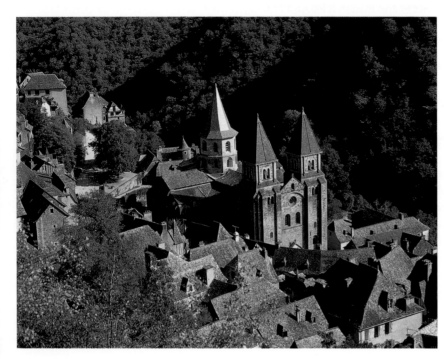

4.18 Abbey church of Sainte Foy, Conques, France, c.1035–60.

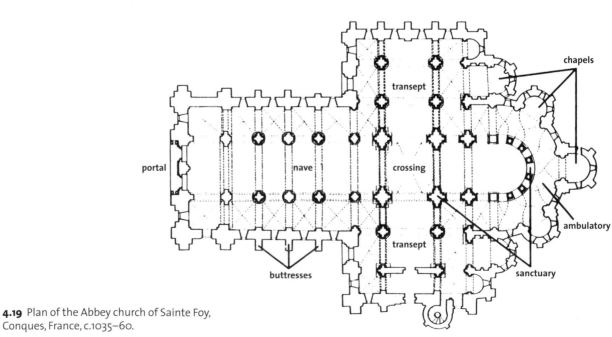

4.19 Plan of the Abbey church of Sainte Foy, Conques, France, c.1035–60.

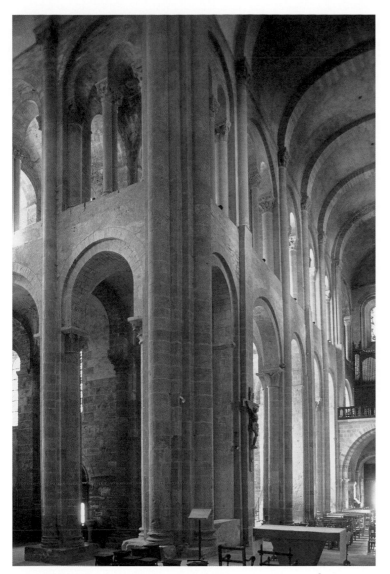

4.20 Interior view toward east, abbey church of Sainte Foy, Conques, France, c.1035–60.

Through fortunate decisions of government architects in the late nineteenth century, the church at Conques has been restored and is again a thriving tourist destination. As a typical example of the Romanesque style in architecture, it has structural components reflected throughout the surface articulation of the building ▶ **fig. 4.20**: both the interior and exterior design make use of large piers topped by round arches, creating symmetrical divisions of space. The spaces between the piers form "bays," which are here covered by simple rounded ceilings, descriptively called "barrel vaults." The barrel vault over the nave, or central aisle, offered ideal acoustics for the performance of chant.

The interior side aisles begin at the two western doors flanking the central entrance. They lead down the main body of the church, around the ▸transepts◂, or arms, and into the sacred east end where they become the ambulatories, allowing access to the altar area on the main level. The ultimate goal of pilgrimage churches, the saint's remains, were originally on display here at Conques; now, as in many other Romanesque churches, they are kept in the crypt below, which is entered by staircases descending off the ▸ambulatory◂ on either side of the main altar.

Often at the far east end of Romanesque churches, in the half-circle projection of the apse, stood other altars with devotional objects. On days of heavy traffic, people could enter in the west, pass around the upper and lower east end, and exit through a transept (side) door without doubling back. This design avoided many of the accidents of suffocation and trampling that occurred in older churches on major feast days. Large numbers of people, their emotions heightened by crowd mentality and sometimes desperate at the end of long and often harrowing journeys, rushed into the sanctuaries when the doors were opened. Now, pilgrims could move more easily in and out of the church, without causing a catastrophic jam at the entrance.

The cult of Sainte Foy ("foy," or, in modern French, "foi," means "faith") in Conques can be seen as characterizing the medieval attitude to relics. The remoteness of Conques made it difficult to reach with supplies, one result being that the population did not grow as quickly as in other towns. However, the remains of Sainte Foy became an "attraction," one designed to draw people and their wealth. Significant relics were

necessary to establish the reputation of the place as a worthy site for pilgrims. In the late ninth century, the monks at Conques, having no special remains of their own, stole the body of a young female martyr from a rival neighboring monastery. How the relics were secured is uncertain, but according to two eleventh-century accounts researched by historian Patrick Geary, one of the monks pretended to join the other monastic community and spent many years gaining the confidence of its members. Finally, he was appointed to guard the church treasure, thus affording him an opportunity to break open the tomb, steal Sainte Foy's remains, and take them back to Conques. It appears from other accounts that these were not the only relics that the monks at Conques attempted to obtain furtively, and they were hardly alone in such endeavors. That their plan worked is evident, for by the end of the eleventh century, the numbers of pilgrims visiting Conques exceeded the capacity of the Carolingian structure and the new, larger church was planned.

The new owners of Sainte Foy's remains began to create an impressive presentation site for them ▶ **fig. 4.21**. Around the year 980, the skull was placed in an elaborate container modeled, according to local custom, after lifesize enthroned figures of the Madonna. The remaining bones were buried under the main altar of the church. Originally made of wood with a golden head refashioned from a Roman parade helmet, the 3-foot-high statue was heavily studded with countless jewels donated over time by wealthy visitors to the shrine. Especially if seen in the dark crypt, illuminated by the light of flickering candles, the statue of Sainte Foy, with her enamel eyes, golden crown, and high-backed throne, would have appeared truly impressive.

Sainte Foy's cult was fostered by the monks at Conques through the chronicles relating her acquisition. Furthermore, she was given credit for performing many miracles, both at home and when taken on the road to provide protection in disputes or during the "relic tours" undertaken for fundraising. Since the stories about Sainte Foy were well known, one might wonder how people reconciled this golden bejeweled figure with a young girl who was martyred for her faith. Clearly, the statue does not represent Sainte Foy's earthly form. Instead, she has been given the dazzling appearance of an enthroned saint in heaven. Her piercing eyes stare at otherworldly visions, and her precious throne, clothing, and crown heighten the apparent value of her holy remains. In strong contrast to the drabness of life in an eleventh-century provincial French town, the glittering statue was intended to raise hopes of sharing in the glory of God's kingdom.

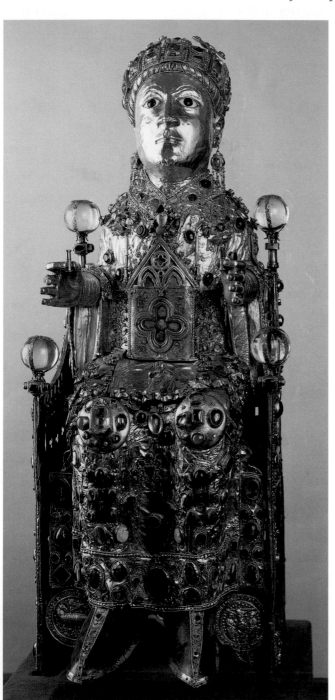

4.21 Reliquary statue of abbey church of Sainte Foy, Conques, France, c.1035–60. Gold and silver over wooden core, height 2ft 9⅛ins. Conques Abbey Treasury.

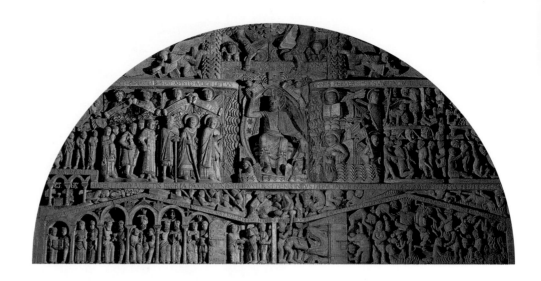

4.22 Tympanum of the west façade, abbey church of Sainte Foy, Conques, France, c.1130.

On the west façade, over the doors through which pilgrims entered the church, was a sculpted relief of the Last Judgment, or Apocalypse, a reminder of the very purpose of the pilgrimage—an attempt to save one's everlasting soul. In the central tympanum, above the main door, a large image of the enthroned Christ, judge of the living and dead at the end of time, towers over figures on either side ▶ **fig. 4.22**. Rendered in the stiff and abstract style characteristic of sculpture done in France and northern Spain in the early twelfth century, he looks unbending and authoritative.

Canterbury

Around the 1370s and 1380s, Geoffrey Chaucer wrote *The Canterbury Tales*, one of the most celebrated literary works of medieval England. It recounts the stories told by a group of pilgrims as they travel from an inn near London toward Canterbury. After Thomas Becket, Archbishop of Canterbury, was murdered in 1170 for resisting King Henry II's power over the Church, his tomb at Canterbury Cathedral became an important pilgrimage site. A special chapel for his veneration was added to the east end of the church, beyond the altar area, called the Corona ▶ fig. 4.23, signifying the crown of martyrdom. The space was shaped in a rotunda, like Roman mausoleums. Becket's tomb was in the center while, all around, stained-glass windows told the story of his life and the miracles pilgrims witnessed after his death.

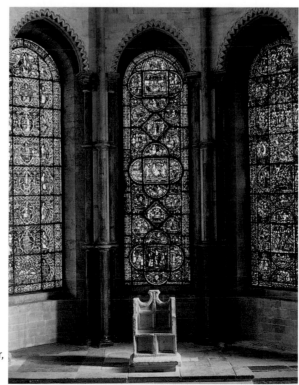

4.23 The Corona and St. Augustine's chair, Canterbury Cathedral, Canterbury, Kent, England, 12th century.

To Christ's right are figures of those who will be granted permission to enter his kingdom for eternal salvation. They are the ones who were "good" while on earth. The figures include monks, pilgrims, even a king; the prevalence of staffs and walking sticks draws attention to the act of pilgrimage, emphasizing the piety of the those who have undertaken it. By contrast, on Christ's left are the souls who are to be condemned to everlasting torment. Devilish figures torture them and one of them forces the damned into the mouth of hell ▶ **fig. 4.24**. He looks over his shoulder to make eye contact with a figure on the other side of a wall who, holding tightly to the

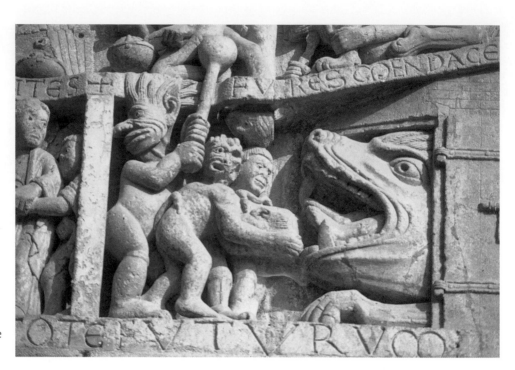

4.24 *The Jaws of Hell*, detail of the damned from the west façade, abbey church of Sainte Foy, Conques, France, c.1130. Stone.

hand of the person behind, waits to be welcomed into the gates of heaven where Christ sits enthroned with his "elect." The sculpture was originally brightly painted and, for those visitors who could read, carried an excerpt from the Scriptures that reinforced the threatening nature of the sculpted scenes.

The didactic potential of the imagery is evident, and there are also many texts that corroborate this function of Romanesque sculpture. For instance, in a medieval guidebook to Santiago de Compostela written by a righteous French traveler, a description of a scene now on the Puerta de las Platerias, at the south entrance to the cathedral, includes such admonitions as:

> Nor ought we to forget the female figure set near the Temptation of Our Lord: she holds in her hands the rotting head of her lover, cut off by her husband, who forces her to kiss it twice each day. What a great and admirable judgment upon an adulterous woman, which should be recounted to everyone!

A pilgrimage plan church, similar to the one at Conques, was eventually built at Compostela early in the twelfth century; although larger and more elaborate, it was meant to accommodate the same kind of traffic. Having been remodeled many times over the centuries, the church now has only small medieval portions left.

The Gothic Style. As travel and trade contributed to the improved economy in medieval Europe, towns gradually turned into cities, with flourishing commerce in industrial centers. Secular and religious leaders competed for political power and initiated building projects that reflected their stature. The great cathedrals were both

Our Lady of Guadalupe

The waning of the Middle Ages did not mark the end of belief in the miraculous powers and divine provenance of particular images. For several centuries, one of the most important objects of pilgrimage in the New World has been the Virgin of Guadalupe, a sixteenth-century painting currently housed in the New Basilica of Our Lady of Guadalupe in Mexico. For the faithful, the painting of the Virgin Mary is of miraculous origin, and is linked to several apparitions of the Virgin to a Mexican peasant, Juan Diego, in 1531. She instructed him to pick flowers and to deliver them to the bishop. The appearance of the flowers was itself miraculous because they were either out of season or of a kind not found in the region. When Juan delivered the flowers as instructed, an image of the Virgin appeared on his mantle or *tilma*, shown here in an eighteenth-century interpretation ▶ fig. 4.25. Even modern investigators have been moved to believe that the painting must be of divine origin the unprimed *tilma* has not rotted and because there is no evidence that the painting was created by separate brushstrokes as one would expect if the artist were mortal. (In Christianity, there is a long tradition of images from miraculous sources: *acheiropoieta*, a Greek term meaning "not made from human hands.") Some claim that the reflection of Juan Diego can still be seen in the Virgin's eye, as if the painting directly captures the moment when Mary appeared to him.

In terms of Christian iconography, the painting belongs in the tradition of the Virgin's "Immaculate Conception," a doctrine that had been slowly gaining ground in the Middle Ages, according to which the Virgin was born without the taint of Original Sin. Such details as the moon on which Mary stands are taken from the Book of Revelation. However, the Virgin of Guadalupe is an image that has exceeded conventional art-historical

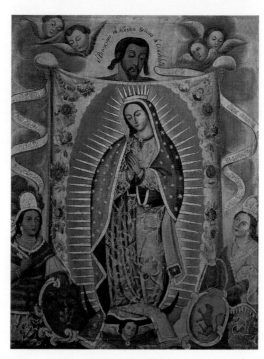

4.25 Anonymous, *Virgin of Guadalupe*, 1746. National Palace, Mexico City, Mexico.

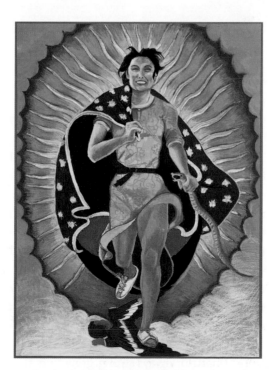

4.26 Yolanda M. López, *Portrait of the Artist as the Virgin of Guadalupe*, part 3 from the Guadalupe Triptych, 1978. Oil pastel on paper, 2ft 6ins x 2ft. Collection the artist.

status and has become a national symbol of great power. In some ways the painting is a Mexican equivalent to the Statue of Liberty in the United States or the Eiffel Tower in France, and like these monuments it attracts millions of visitors annually (20 million according to one source). Some historians have even credited the painting with having helped to reconcile tensions between Mexican Indians and Spaniards: the fact that the mother of the Christian god appeared to a humble Nahua Indian seemed to make it easier for the Aztecs to accept Christianity; furthermore, her apparition to Juan Diego took place in the area of the sacred Aztec shrine to Tonantizin, "Our Mother." Yet at the time of Juan Diego's canonization as a saint of the Catholic Church on July 31, 2002, there was controversy surrounding the opinion that he had been made to look "too European" in certain images. Some felt that a Mexican Indian was being "Westernized" in order to gain entrance to the elite of the Church. On the other hand, the Virgin of Guadalupe has inspired several artists, including the Mexican-American Yolanda López (b. 1942), because the painting synthesizes the rich lore of Catholicism, Mexican history, and issues of ethnic identity. López made a three-piece painting, a triptych, featuring three generations of women in her family in the guise of the Virgin of Guadalupe: her grandmother, her mother, and herself ▶ fig. 4.26. Each figure is surrounded by the star-covered cloak and aura of light that surrounds the traditional figure. They also each have a snake—a symbol of male power and the first sin, but also of knowledge. López herself runs toward the viewer in sports shoes holding the snake in her hand like a tool. She treads on a *putto*, the cherub that often accompanies saints in religious scenes. This one, with its tricolor wings, refers ironically to the "angel" role assumed by the United States over the years in Mexico.

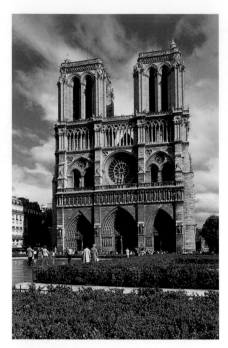

4.27 Façade of Notre Dame Cathedral, Paris, France, 1210–15.

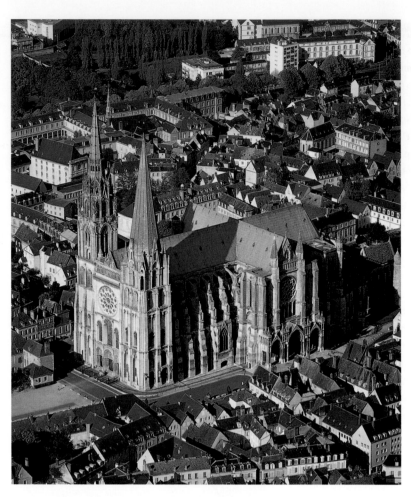

4.28 Aerial view of Chartres Cathedral, Chartres, France, mainly 1194–1225.

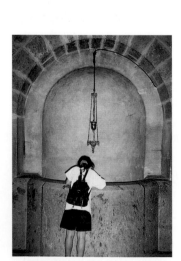

4.29 Present-day visitor at well in crypt, Chartres Cathedral, Chartres, France.

seats of spiritual authority and symbols of a city's material wealth and technological prowess, a combination still reflected in Notre-Dame in Paris ▶ **fig. 4.27**, despite the changes brought about by nineteenth-century restoration.

The cathedral at Chartres, about 50 miles southwest of Paris, is closer to its original condition than Notre-Dame and is an outstanding example of the early development of the Gothic style ▶ **fig. 4.28**. The site had been sacred since time immemorial: chroniclers recorded that a pre-Christian virgin was worshiped at a natural spring there. Legend also has it that, during the period when the area was controlled by Romans, a governor's daughter converted to Christianity against her father's will and was martyred for her faith when she was thrown down a well into this same spring. As early as the eighth century the Virgin Mary was venerated there. Later, a fragment of Syrian silk believed to be from a garment worn by Mary during Jesus' birth was sent from Byzantium to Europe. It was given to Chartres by the king Charles the Bald (see chapter 3) in the year 876 for the dedication of a new church on the site. Thus, the ritual cult at Chartres, always strong, grew from that of a virgin goddess to the ultimate virgin, the Christian Queen of Heaven. Chartres Cathedral became Mary's palatial shrine. Visitors can still see the well in the crypt under the east end of the cathedral ▶ **fig. 4.29**.

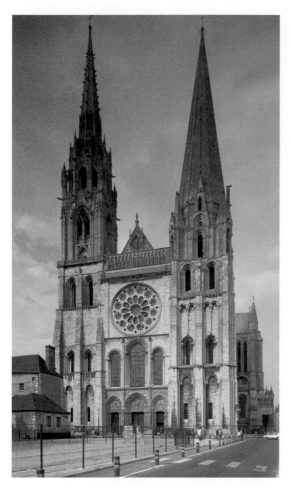

4.30 West façade, Chartres Cathedral, Chartres, France, c.1150.

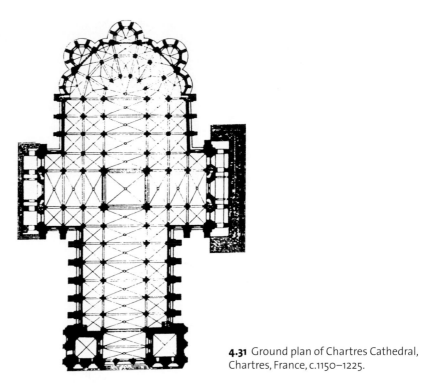

4.31 Ground plan of Chartres Cathedral, Chartres, France, c.1150–1225.

As Mary's cult increased in importance in medieval Europe, Chartres began attracting large crowds of pilgrims. When parts of the Romanesque church burned in 1134, the western façade was replaced with the newest style of sculptural decoration and large stained-glass lancets, or round-topped upper-story windows ▶ **fig. 4.30**. This portion of the church escaped damage during another fire in 1194 and was incorporated into the present building. One of the first rose windows (with tracery suggestive of the shape of a rose) was added to the level above the central portal. Chartres Cathedral was the first church to be constructed entirely on the new Gothic structural principles of pointed, ▸ribbed vaulting◂ with detached, external buttressing. The building was essentially complete by 1220, an extraordinary feat of speed and overcoming adverse circumstances. Nevertheless, social conflict repeatedly erupted in the town due to the economic burden of funding it.

Although experimental in design, many of the architectural features found at Chartres, including the extraordinary height of the nave, were achieved through engineering principles used in other twelfth-century churches around northern France. The layout follows the familiar Romanesque pilgrimage plan ▶ **fig. 4.31**. The novelties occur in the superstructure, where high vaulting is formed by crossing pointed "ribs" of stone which are then covered by a thin layer of concrete. The increased pressures of gravity and wind forces exerted by these high arches could be contained within their supporting piers only if the walls were very thick and the piers were close together.

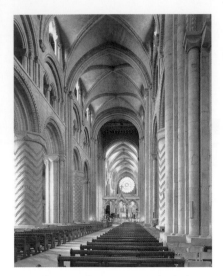

4.32 The Nave facing east, Cathedral (former abbey church) of Durham, England, 1093–c.1133.

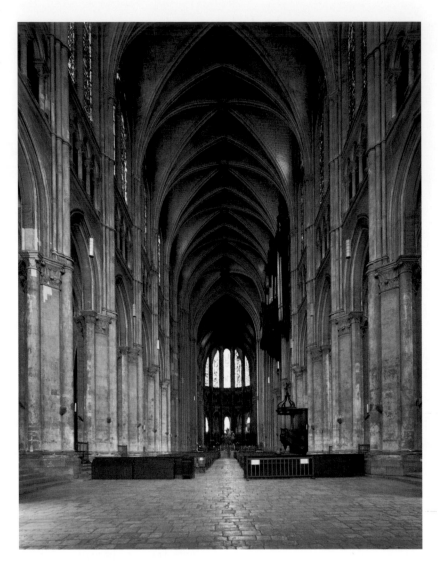

4.33 Interior view of nave and choir looking toward apse, Chartres Cathedral, Chartres, France, c.1194–1225.

Pointed rib vaulting, as well as buttresses that take some of the weight and help secure the arch, had been used by Norman architects in such monumental statements of strength as the abbey churches at Caen in France and Durham in England ▶ **fig. 4.32**. There, however, the buttresses are incorporated into the outer aisle walls and the "flying" connectors that link the buttress to the nave wall are hidden in the vaulting of the gallery (second-story) roof. The way in which both inside and outside walls are articulated make Caen and Durham clear examples of the structural principles of Romanesque style. On the other hand, the Gothic style of Chartres is based on the illusion that the walls are made of glass ▶ **fig. 4.33**. This is only possible to imagine from the interior, of course. But by the time the High Gothic cathedrals were realized, the linearity of the upward thrust in the nave vaulting is echoed by the repeated lines of delicate ▸flying buttresses◂ around the outside of the walls and a perforated, lacy effect is achieved.

Chartres saw the first full-scale application of this engineering concept and there is a great contrast between interior and exterior. Outside, the huge amounts of stone used

4.34 Detail of exterior buttressing on the south front, Chartres Cathedral, Chartres, France, c.1194–1225.

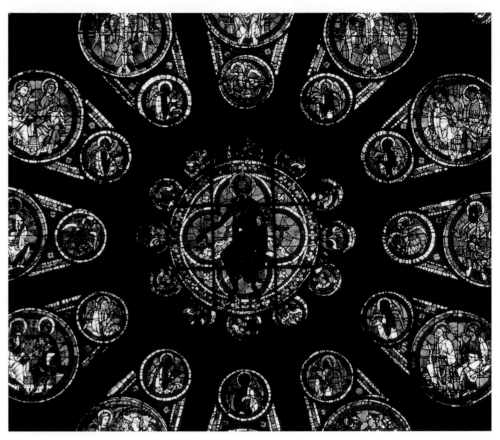

4.35 Detail of Christ from west rose window, Chartres Cathedral, Chartres, France, c.1220.

in the buttresses and flying buttresses create a massive, narrow effect of solid support ▶ **fig. 4.34**. Inside, the deep rich colors of the earliest stained glass mimic the appearance of precious gems. The faithful enter the building, which symbolically stands for heaven, and windows filled with narrative scenes that were dark and unreadable from the outside become visible and glowing. Thus, visitors move from ignorance to knowledge, from darkness to light, from the secular everyday world to the sacred world of promised salvation.

Chartres provided the first opportunity for the use of such grand amounts of stained glass. All the scenes commonly used in sculpture and manuscript illumination were employed in the window decoration and more were developed just to help fill the new amount of space. The earliest set of three large lancet windows, in the west façade, from the thirteenth century, represents Mary's lineage, the early events of Christ's life when she was present, and his Passion, or story of the events surrounding his death. In the center of the rose window above he offers his body and the flowing blood he shed for the salvation of the faithful ▶ **fig. 4.35**. Many of the other windows celebrate the Virgin Mary as well, while important products of the region, which helped pay for this undertaking, were also incorporated into the religious illustrations.

Certainly the presence of the *Sancta Camisia*, a relic from the Virgin believed to be the tunic she wore when Christ was born, was a major economic factor in the ability of

Chartres to afford such a cathedral. Similarly, the bread and wine used in the church services not only related symbolically to Christ's body and blood, they also reflected the income from surrounding wheatfields and vineyards. Bread and wine were the most important sources of income for the bishop and canons who ran the cathedral. (The latter were the cathedral's equivalent of an abbey's monks. However, their lives were not dedicated to the private work of a monastic order; rather, as members of the cathedral "chapter," they were primarily concerned with maintaining the property around the cathedral area and all the appropriate religious services of a public church throughout the year.) They owned fields and vineyards and their sales of grain and

Modern Versions of Medieval Piety

Medieval notions of intense piety are not dead. They have been emulated by such television evangelists as Reverend Schuller, who raised funds for Philip Johnson and John Burgee's Crystal Cathedral in Garden Grove, California ▶fig. 4.36. According to art historian, Jane Welch Williams:

> In 1978, with construction well-advanced, Schuller was faced with a lack of funds. He orchestrated a modern reenactment of the twelfth century Cult of Carts, urging people to deposit whatever money they could spare into wheelbarrows and cement mixers. The so-called Cult of Carts occurred twice at Chartres, in 1144 and again in 1194, when people of all classes of society, but apparently primarily the poor serfs of the countryside, pulled carts by ropes over their backs to the construction site, spontaneously contributing and delivering materials necessary to continue the work. Like the Cult of Carts at Chartres, Schuller's reenactment served not only symbolically to broaden the base of support for the construction project, but, more importantly, provided a profoundly moving appeal to the super-rich for donations. Schuller's prime-time religion had brought him star evangelist status, and even the *National Enquirer* listed a star-studded Hollywood following ... The Crystal Cathedral is what the architects of Chartres would have built if they had known how—an entire building of glass.

Modern cults reach far wider than those of the past: construction design for the Crystal Cathedral included wiring for television broadcasts of the services held there. Yet visitors are not restricted to those who tune in on television and radio (3.5 million weekly in 1984); thousands of devotees travel from far away to witness Schuller preach in his "walls of glass."

4.36 Philip Johnson and John Burgee, Crystal Cathedral, Garden Grove, California, 1978–80.

wine were very profitable. In addition, the place of both wine and bread in the form of taxes, tithes, and donations to the cathedral are recorded many times in the windows and sculptures, two of the most famous being the St. Lubinus window in the north aisle (wine) and the figures under the *Beau Dieu* on the central portal of the south transept (bread) ▶ **fig. 4.37**.

In contrast to the portrayal of Christ as a harsh judge in the Romanesque tradition, as at Conques (see fig. 4.22), in Gothic art he is often shown as a *Beau Dieu*, or benevolent lord (see fig. 2.15). The Last Judgment on the tympanum of the south portal at Chartres ▶ **fig. 4.38** is full of hope, showing Christ between his mother and St. John, who intercede for the faithful being judged. The sculpture is carved in a realistic style with a pleasant expression, making a gesture of blessing and carrying the gospel book that records his words offering salvation to believers.

Other tradesfolk are also illustrated in the windows, such as cobblers, farriers, wheelwrights, butchers, blacksmiths, and drapers ▶ **fig. 4.39**. The team of masons producing figural sculptures in the St. Cheron window ▶ **fig. 4.40** is among the images of artisans working on the church fabric, suggesting that the windows were dedicated by confraternities, or guilds, of these workers. This interpretation would link the swift construction progress to communal support and generous donations on the part of the inhabitants of Chartres. In fact, thirteenth-century

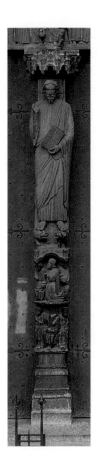

LEFT **4.37** Detail, figures on lower trumeau of central portal, south transept, Chartres Cathedral, Chartres, France, c.1194–1225.

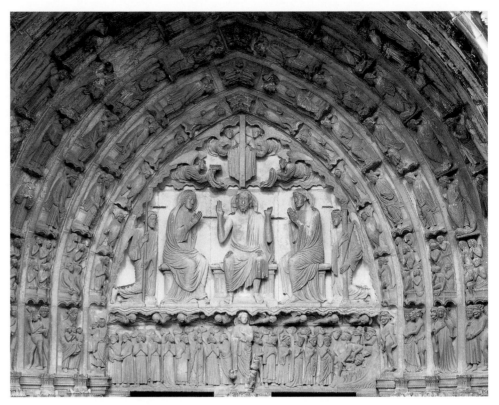

ABOVE **4.38** Tympanum of Last Judgment, south portal, Chartres Cathedral, Chartres, France, c.1150.

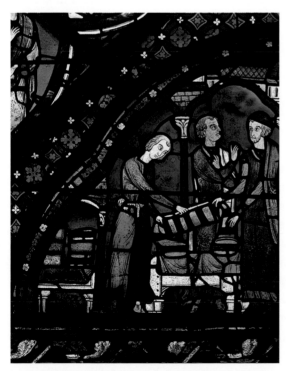

4.39 Window of St. James, no. 37, panel 2, donors detail —drapers, Chartres Cathedral, Chartres, France, c.1220.

4.40 Window of St. Cheron, Bay XL11, north apse, detail of sculptors, Chartres Cathedral, Chartres, France, c.1220.

chronicles record that Chartres was unable to secure rights for town councils or trade guilds from the king. The heavy economic burdens imposed by the count, bishop, chapter, and monarch upon the common people meant that they were already too strapped to respond generously to a new building campaign (see also inset, p. 118). After an initial period of substantial contributions by aristocratic supporters, including a pledge by the bishop and chapter of a large percentage of their agricultural income for three years, fundraising became more desperate, the bishop and canons quarreled, and the townspeople began to ally against the cathedral, sometimes abetted by the count.

In 1210 the life of the dean, or head, of the chapter was threatened when a mob vandalized his house. During the 1960s, the German art historian Jan van der Meulen found evidence in the eastern half of the cathedral structure that the canons took protective measures to ensure their security. Wooden bridges were constructed above the street area that led from their various residences and subsidiary buildings as well as the bishop's palace to interior gallery corridors near the lower windows. In 1253 the situation worsened when the cantor (choral director) was killed on the steps of the south entrance. The entire chapter fled Chartres for four years, returning only under the protection of the king's troops and with his legal demand for retribution from the townspeople.

Other cities suffered similar trials and tribulations. The construction of Reims Cathedral was halted in 1233 when rioters attacked the archbishop's castle and dragged stones from the cathedral to use as street barricades. In Laon, the bishop was assassinated and the cathedral burned. Certainly, the stresses of these huge projects were not meekly endured by the local populations. Nonetheless, the fact remains that these immense buildings were eventually completed and funds were found. For, in the midst of all the conflict, the towns depended upon what the cathedral represented: a draw for pilgrims, a center for market fairs, and a concentration of wealthy clergy offering employment, resources, and a connection to the powers that ruled everyone's lives. The more one knows about the oppressive realities of life in thirteenth-century France, the more one must be impressed by such a coherent and efficient achievement as Chartres Cathedral.

Islamic Pilgrimage

In many traditions, worshipers faced east when praying, in the direction of sunrise. This accounts for the verb to "orient" oneself, orient also connoting "east" from the medieval French *oriri*, meaning "to rise." In geographical terms, the Orient is the eastern hemisphere, whose land mass comprises the continent of Asia. Among members of the Islamic faith, or Muslims, the direction faced when praying to God depends upon where a person is in relation to the city of Mecca, the birthplace of Mohammed (570 CE). Mecca contained the traditional sacred precinct of the Quraysh tribe, of which Mohammed was a member, in the shrine called the Ka'bah, or House of God, in the Grand Mosque ▶ fig. 4.41. Believed to have been built by Abraham, the Ka'bah holds a black stone in its side "sent from God." Frequently restored, it is decorated to be an earthly reflection of the Divine Temple in heaven following the accompanying Qu'ran inscription describing it as "adorned like a bride." The arcaded

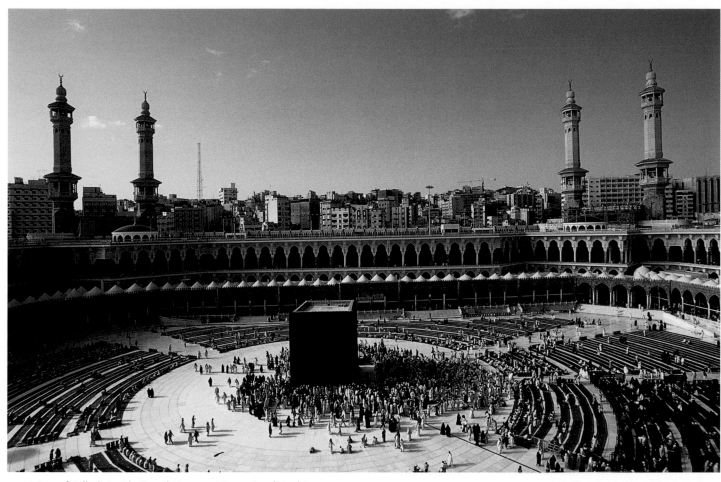

4.41 View of Ka'bah, inside Grand Mosque, Mecca, Saudi Arabia.

courtyard around the Ka'bah is 600 by 800 feet. An extension built in 1995 allows one million people to pray inside the holy precinct.

The five requirements or "pillars" of the Muslim faith include prayer (five times daily) and pilgrimage. Each member of the faithful must make the *hajj*, or journey to Mecca, at least once in his or her lifetime if at all possible. As Islam has spread across the world over the centuries, this sacred journey has brought together people of diverse cultures for a unifying religious purpose. Only Muslims may enter the sacred city, and approximately 1.25 million do so every year during the prescribed time for pilgrimage, which falls between the eighth and thirteenth day of the last month of the Muslim year. During the 1950s the government of Saudi Arabia began building roads, hotels, health clinics, and other services for this event, which brings in about $50 million a year to Mecca, keeping the city's economy separate from the oil-based finances of the rest of the country.

Although a building is not essential to the performance of prayer, Muslim law does require a state of physical cleanliness, enough space to bow the head to the ground, and correct directional placement toward Mecca. Thus, a prayer carpet can serve for the entire worship space just as well as a huge mosque (a term derived from the European

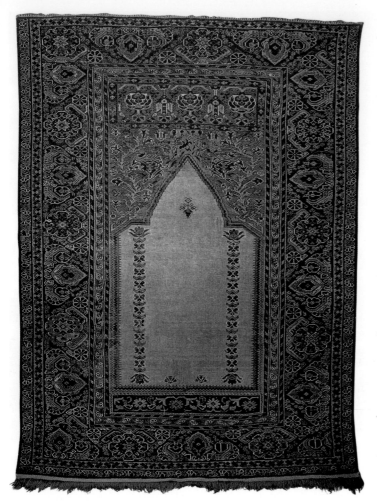

4.42 Gheordez prayer rug showing white *mihrab* (prayer niche) with two Turkish floral columns and stylized mosque lamp hanging from top of *mihrab*, Turkey, 18th century. Wool. Museum für Angewandte Kunst, Vienna.

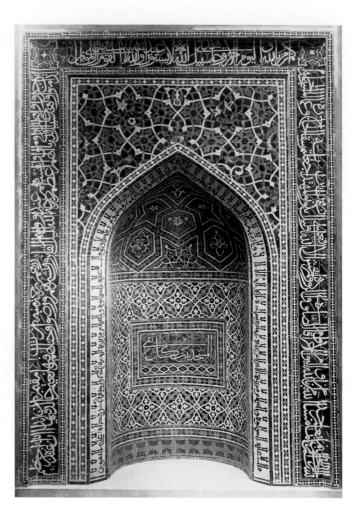

4.43 Mosaic *mihrab* (restored), from the mosque of Madrasa Imami, Isfahan, Iran, c.1354. Monochrome-glaze tiles on composite body set on plaster, 11ft 3¹/₁₆ins × 9ft 5¹¹/₁₆ins. The Metropolitan Museum of Art, New York.

pronunciation of *masjid*, meaning a place for bowing down) ▶ **fig. 4.42**. The primary structural basis of mosque architecture centers on the need for sufficient open floor space. In order to help the faithful ascertain the correct direction towards which to bow, however, the ▸*qibla*◂ or prayer wall in a mosque is fitted with a ▸*mihrab*◂ ▶ **fig. 4.43**. This is an empty vertical niche toward which the faithful pray, standing in for the slab of commemorative marble on the wall in the Prophet's own house from where he was accustomed to lead prayer. The prayer rug pictures the *mihrab* in the asymmetrical woven design, standing in for the mosque location.

Jihad, or holy struggle waged on behalf of Islam as a religious duty, expanded the Muslim empire soon after Mohammed's death (632 CE). The Middle East once again became the center of a new religious power that took advantage of pre-existing city centers in what is now Saudi Arabia and the strength of early political dynasties. As elsewhere, sites already sacred to other faiths were adopted and pilgrims often visited

for more than one reason. Since Islamic rulers, or caliphs, were considered to be successors of Mohammed, they held both political and religious control and could promote their own power through decisions about the form of worship ceremonies and the buildings in which they were held. The architectural traditions of Arabia were greatly broadened as Muslims encountered the Persian and Greco-Roman buildings of Iraq and Syria during the conquests of the Umayyad and Abbasid dynasties (661–1258).

In the city of Jerusalem, Islamic rulers were acutely aware of the strength of previous traditions among their subjects. One of the earliest surviving mosques was built on Mount Moriah in 691 by the Umayyad dynasty caliph 'Abd al Malik, whose treasury had been swollen by the sudden financial influx from Arab conquests across the eastern Mediterranean ▶ **fig. 4.1** (see p. 92). Called the "Dome of the Rock" because the central dome covers a rocky crest where many important religious events were believed to have taken place, this structure was built before a rectangular courtyard form became the standard mosque design. As such, it must be seen as atypical of Islamic architecture. (In fact, shaped like the central plan of a Roman mausoleum: see The Holy Land, pp. 104–106), the Dome of the Rock recalls important Christian monuments around Jerusalem, including one commemorating Christ's own ascension into heaven on the Mount of Olives [see fig. 4.14].) 'Abd al Malik was not in control of Mecca when he built the Dome of the Rock. He needed a city to embellish as his capital, but he was a religious leader as well as a prince so he also required a place rich with sacred associations.

Among the events believed by Jewish medieval tradition to have occurred on the rock was the creation and later burial of the first man, Adam (Genesis 2–5). This was also where Abraham (considered the ancestor of the Arabs) attempted to sacrifice his son, Isaac, but was stopped by God (Genesis 22). Mohammed's night journey with the archangel Gabriel (Qu'ran 17.1) and even his final *Mi'raj*, or ascension, have been associated with this spot. The mosque is built upon the foundation of the great Jewish temple, destroyed by Roman armies in 70 CE, which was believed to have been built in its original form by King Solomon according to God's detailed instructions. Another mosque was built later in the same complex, next to the Dome of the Rock, specifically dedicated to Muhammed's ascension: the *qubbah al mi'raj*.

A tenth-century resident of Jerusalem, al-Muqaddasi, said that 'Abd al Malik had the Dome of the Rock built as a sign of his triumph over Christianity and to draw attention away from the fourth-century Church of the Holy Sepulcher (see fig. 4.16). It seems clear that it was the Early Christian architectural design that most influenced decisions about the form of the mosque. In fact, the two domes are virtually identical in circumference (as is the alternation of piers and columns) and both interiors allow visitors to walk around an opening in the central floor to the rocky area visible on the natural ground (as also in the Church of the Nativity, Bethlehem; see fig. 4.15). Christian authors had transferred Jewish traditional locations for the navel or *omphalus* of the earth, Adam's birthplace and burial, and Abraham's sacrifice of Isaac from the rocky peak of Mount Moriah to the site of the Holy Sepulcher, where the hill of Calvary and Christ's tomb were commemorated. The caliph might have been trying to reassert

Mohammedan associations when he had a long text inscribed on the inside of the dome, proclaiming the oneness of the godhead against Christian claims of a trinity (see fig. 4.44).

The building was covered with contemporary mosaic decoration, the skill of which suggests that it was done by artists from the Byzantine capital of Constantinople (modern Istanbul). Both interior and exterior walls were decorated with either marble or mosaic, though the exterior was refurbished with tile in the sixteenth century. Because of the Muslim preference for religious art devoid of figuration, artists adapted the vegetal and symbolic imagery that had formerly been part of larger Christian narrative scenes ▶ **fig. 4.44**. The rich flora of gardens and overflowing vases recall Christian descriptions of heavenly paradise, an especially fitting concept for people from arid desert regions. The representation of jeweled objects reinforces 'Abd al Malik's lavish royal program and may even refer to the submission of rival empires. Finally, the elegantly scripted quotations from the Qu'ran show the origins of an Islamic artform that would increase in importance for a thousand years, especially under the Mughal rulers of India.

The Dome of the Rock was built in the holy city of both Jews and Christians. The monument was meant to be visited by Muslims and non-Muslims alike, helping to strengthen the faith of the former while warning the latter that their dominance had been superseded. Today Islamic visitors to Jerusalem join throngs of pilgrims from other faiths. Just as medieval pilgrims were drawn to holy shrines around the time of the first millennium, Jerusalem became the destination of choice for millions of faithful during commemorations of the year 2000.

4.44 Interior of the Dome of the Rock (al-Aqsa mosque), showing late-7th-century mosaic decoration. Jerusalem, Israel.

Further Reading

E. Dahl, "Heavenly Images: The Statue of Ste. Foy of Conques and the Signification of the Medieval 'Cult-Image' in the West," *Acta ad Archeologiam et Artium Historiam Pertinentia*, 8 (1978), pp. 175–91

R. Ettinghausen and O. Grabar, *The Art and Architecture of Islam: 650–1250* (Harmondsworth, 1987), chapter 2

P. Fehl, "Gods and Men in the Parthenon Frieze," in: Vincent J. Bruno, ed., *The Parthenon*, New York, 1974

O. Grabar, *The Formation of Islamic Art* (New Haven, 1973), chapters 3 and 5

R. Hillenbrand, *Islamic Art and Architecture* (London, 1999), chapter 1

K.A. Marling, *Graceland: Going Home with Elvis* (Cambridge, MA, 1996)

R. Meiggs, "The Political Implications of the Parthenon" in: Vincent J. Bruno, ed., *The Parthenon*. New York, 1974

L.V. Watrous, "The Sculptural Program of the Siphnian Treasury at Delphi," *American Journal of Archeology*, 86 (1982), pp. 159–72

J. Welch Williams, "The Crystal Cathedral in Garden Grove, California and Chartres Cathedral, France: A Television Evangelist's Adaptation of Medieval Ideology" *Medievalism in American Culture*, eds., Rosenthal and Szarmach, New York 1981, 251–287

Source References

p. 106 "Sailings [from Venice]..."
L. Collis, *Memoirs of a Medieval Woman: The Life and Times of Margery Kempe* (New York, 1964), pp. 70–75

p. 112 "Nor ought we..."
C. Davis-Weyer, *Early Medieval Art 300–1150* (Englewood Cliffs, NJ, 1971; reprinted Toronto, 1986), p. 151

p. 118 "In 1978, with construction..."
J. Welch Williams, "The Crystal Cathedral in Garden Grove, California and Chartres Cathedral, France: A Television Evangelist's Adaptation of Medieval Ideology," in *Medievalism in American Culture*, ed. B. Rosenthal and P.E. Szarmach (Binghamton, NY, 1989), pp. 251–87

Discussion Topics

1. How do objects and architectural monuments motivate people to travel? Do they represent an economic benefit or hardship for the local population?

2. In what ways are the preparations, precautions, and regulations involved in travel today similar to those experienced by medieval pilgrims?

3. Why do you think Sainte Foy was such a powerful embodiment of saintly powers for eleventh-century people?

4. What do such modern building projects as the Crystal Cathedral in California have in common with Gothic cathedrals?

5. What kinds of art and architecture are at stake in the continuing bitter struggles over boundaries and access in the city of Jerusalem?

6. Describe your reactions to the miraculous qualities associated with the Virgin of Guadalupe.

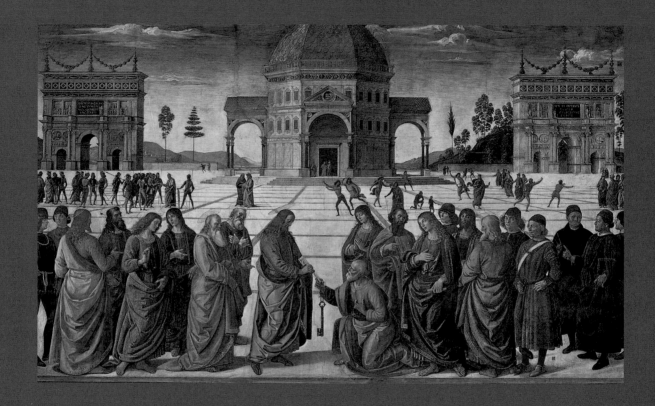

Patrons and the Role of the Artist

Since the sixteenth century, art historians have often celebrated the singular achievements of individual artists. Monographs, or books devoted to one artist's life and work, continue to form a large part of the art historical literature. Likewise, museum exhibitions often focus on the biographical details of a given artist's life. In recent decades, popular movies have also sought to explain the history of art through the examination of an individual career. Successful films, such as *Frida* or *Pollock*, highlight the emotional turmoil and troubled personal lives of famous artists. In a rejection of this tradition of interpreting art through biographical detail, some art historians have asserted that studying artists' lives is not the most effective tool for interpreting art. They argue that, while often making for compelling stories, artists' lives have been over-emphasized at the expense of an understanding of the broader cultural milieu in which art is produced. The core of this argument is to be found in the idea that individuals are "culturally over-determined," meaning that the major aspects of their life are affected more by broader societal concerns, such as the economic situation, political ideals, and social mores, than by singular events in their lives.

With these ideas in mind, this chapter attempts to analyze a portion of the history of art through a consideration of two issues, artistic patronage and the professional status of artists, which are in turn central to an understanding of the life of any individual painter, sculptor, or architect. This chapter extends chronologically the discussion begun in chapter 3 about rulers and their efforts as patrons to commission works that would extend an impression of authority. However, the focus here is on how patronage intersected with artists' attempts to redefine their profession. While patrons employed artists to enhance their reputations, artists themselves found new strategies whereby patronage would improve their own status.

The time span extends from 1000 to around 1700, centuries during which the societies under discussion defined what being an artist or patron could mean. Examples are drawn from fifteenth-century Benin, and from the Northern and Southern Song dynasties (960–1260) and the Ming dynasty in China (1368–1644). After an exploration of the Italian Renaissance (1400–1580), and as a striking contrast to the populous art centers of Europe, the role of the artist and patrons in New Ireland (now part of Papua New Guinea) in the Melanesian islands is assessed. The chapter concludes with a consideration of art under two powerful patrons, the Mughal emperor Akbar of India (r. 1556–1605) and Louis XIV, King of France (r. 1643–1715).

Key Topics

The interrelationship of patron and artist, and the evolution of artistic expression.

▶ Royal patronage: the living conditions and freedom of artists in Benin, West Africa (c.1400–1700), determined by their standing with the king, or *oba*.

▶ The art academy: created in ninth-century China, was an important governmental tool for training professional artists, and for dictating style and subject matter.

▶ Mutual benefit: the Renaissance brought an end to artist anonymity, and an increase in important commissions from secular, as well as religious, patrons. The prestige of all parties was enhanced.

▶ Patronage and innovation: even under a centuries-old system of patronage, artists in Papua New Guinea have exercised creative control.

▶ The enduring legacy of patronage: Mughal and French art academies, founded by powerful patrons, influenced their respective artistic traditions for centuries.

5.1 Pietro Perugino, *Giving the Keys to St. Peter*, 1481. Fresco, 11ft 5½ins × 18ft 8½ins. Sistine Chapel, Vatican, Rome.

Benin

This discussion of the Edo people of Benin, whose West African empire was at its height between 1400 and 1700, overlaps with that in chapter 3. The royal art of Benin serves mainly to glorify the courtly splendor and military prowess of its patriarchal rulers; art at court was not aimed at a general audience. The oral historians of the Edo empire passed on the story that royal patronage of the arts began with the *oba*, or king, called Ewuare, who ruled during the late fifteenth century. His desire for a newly refurbished capital caused him to order the complete destruction by fire of Benin City, the government center where as many as 120,000 people had made their home. During the lavish rebuilding process that followed, he not only had the royal precincts at its center embellished, but divided the city into districts according to a hierarchy of the artists and artisans who served the royal court. Members of these guilds lived and worked in specific areas of the city, their proximity to the royal palace serving as an indicator of status.

Brass relief sculptures of the *oba* tend to emphasize his strength and fearsomeness. The rigid pose and blank, staring features project a sense of determined purpose and powerful will that was at the heart of maintaining a warrior kingdom. Note also that images of the king of Benin always show him young and in the prime of life. There is a traditional story that the elderly King Ewuare requested woodcarvers and brass casters

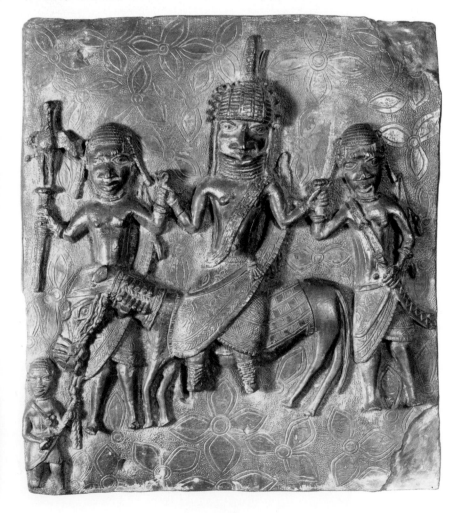

5.2 Plaque of the *oba* (king) Esigie, Benin, 16th century. Brass, height 1ft 4⁷⁄₈ins. British Museum, London.

to portray him. While the woodcarvers showed the king naturalistically as a man of advanced years, the brass casters produced an image of idealized youthful vitality, for which King Ewuare rewarded them handsomely. From then on, brass became the medium of choice at the royal court. The brass casters' workshops were moved closer to the palace in recognition of their new, exalted social status.

During the sixteenth century two of King Ewuare's grandsons, Esigie and Arhuaran, fought a war over their elevation to the kingship. When Arhuaran moved with his followers to the distant city of Udo in an effort to set up a competing government in exile, he took with him a group of artists that were immediately required to start producing royal artworks to rival those made for Esigie in Benin City. When Arhuaran was defeated, the new King Esigie moved quickly to consolidate artistic production in the royal quarter of Benin City. Hence, the brief period of brass casting in Udo came to an abrupt end.

More than nine hundred plaques decorated the palace built under their grandfather King

RIGHT **5.3** Saltcellar, with figures of Portuguese noblemen around the base and lid surmounted by Portuguese caravel with crows' nest lookout, Benin, 16th century. Ivory, height 1ft. British Museum, London.

Ewuare. Art historians continue to debate the exact period of their production. The plaque shown here narrates the story of King Esigie's resounding defeat of a neighboring people, the Igala ▶ **fig. 5.2**. Oral history relates that the king had defied a supernatural "bird of prophecy" in heading into battle, an act of courage that led to his victory. King Esigie had the bird slaughtered and its image cast into a staff (held by a courtier in the left side of the plaque). The king's authority is conveyed not only by size, but by symmetry: he is not only the largest figure, but the central one.

Benin's artistic production was long influenced by its trade relationship with the European kingdom of Portugal. Portuguese ships had first appeared along the west coast of Africa some time in the 1480s, and the two peoples quickly developed a mutually beneficial economic relationship, trading brass, coral beads, and armed mercenaries for ivory, human slaves, and cloth. While the Portuguese mainly wanted raw materials from the Edo people, they also bartered for artworks, particularly ivory carvings. The example shown here is an elaborately detailed saltcellar; salt was a valuable commodity for preserving food, and such decorative containers were prized by Europeans at this time ▶ **fig. 5.3**. The saltcellar features mounted Portuguese noblemen, symbolic of the military might of these key allies of Benin. The role of the artist in Benin remained tied to royal patronage until the last king was exiled in 1897.

Chinese Painting

At the core of the past four thousand years of Chinese painting is respect for continuity and tradition. United by a written language, yet divided by hundreds of local dialects, Chinese culture found a unifying force in its writing; the written Chinese language, rendered with calligraphic line, is also at the heart of artistic production. For all the additional subtleties of color, texture, and composition, the rendering of form through line is crucial to the aesthetics of Chinese art. One Chinese critic famously wrote, in reference to the astonishing tonal range of ▸monochrome◂ ink paintings, that black ink contains all the color you need. ▸Calligraphy◂ was deemed so important that it was an accepted idea among the Chinese elite that the quality of an artist's drawing was directly linked to the quality of his character.

The philosophical model provided by the work of Confucius is central to an understanding of how artists and patrons in China viewed the visual arts (see also

inset, this page). The essentially conservative attitude of Confucian thought has a reverential respect for tradition and emphasizes a strict code of conduct, order, etiquette, and structure, called *Li*. Another essentially Confucian concept is that of *wen*, which refers to the arts and the humanities: he decreed that the sophisticated study of culture was paramount to a civilized society. As part of this ideology, the Confucian "scholar-officials" who made up the political and economic elite dedicated themselves to producing, interpreting, and collecting art objects.

Confucius

The life of the philosopher Confucius (551–479 BCE) has been super-imposed with countless myths and legends. Only the simplest facts are verifiable. Confucius (Kung fu Zi) was born in the state of Lu, now part of the Shandong province. Living in a region beset with corrupt and inefficient government, Confucius challenged the authorities to provide moral leadership, which led to his being labeled a troublemaker. His career in government service was restricted to minor positions. In his later life, however, he was surrounded by numerous disciples who shared his vision of reform.

Artists were expected to display Confucian precepts through their work. Those who aspired to significant government roles (doled out on the basis of a series of examinations on Confucian philosophy) had to implement Confucian thought in their own lives. Followers of Confucius compiled an influential anthology of his aphorisms known as the *Analects*. Often contradictory, it is the source of "Confucius said..." philosophical statements, for example "What is the right thing to do? The gentleman is as concerned about what is right as the petty man is about what is profitable."

Northern Song

During the Northern Song dynasty (960–1127), a fundamental change occurred in the make-up and outlook of the ruling classes. In 960 a chaotic, decentralized political era had ended when the emperor Tai Zu was able to weaken the power of the "Great Families," the name given to the military–aristocratic associations that had fractured China into disparate regional kingdoms. In little more than a century, a new

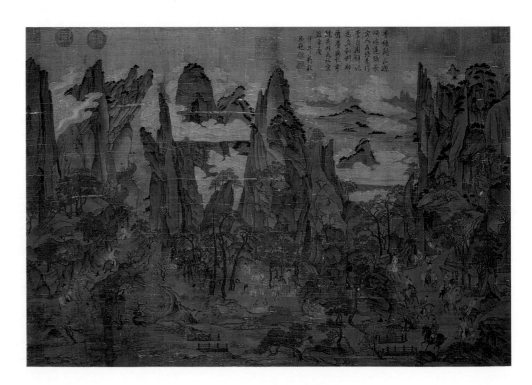

5.4 Anonymous, *The Emperor Ming Huang's Journey into Shu*, late 11th-century copy of 8th-century Tang dynasty composition. Short handscroll, ink, and colors on silk. National Palace Museum, Taipei.

centralized imperial government was able to bring order to a population of over 100 million.

An essentially conservative, Confucian dynasty, the Northern Song aimed to revive the courtly splendor of a bygone age: the Tang dynasty that had thrived between 618 and 906. The new government consolidated the visual arts under its management, establishing an academy, called the Bureau of Painting, in 984 (the establishment of an imperial academy of painting was itself in deference to the original Tang academy). The academy maintained near-total control over the careers of artists, dictating styles and appropriate subject matter. While this was in some ways restrictive, it also offered tremendous benefits in the form of institutional prestige and lavish patronage. The artists considered here were professionals, meaning that they painted in order to earn a living.

Often associated with the imperial court, patrons demanded that artists revive older Tang styles, such as blue-green landscape painting. Furthermore, artists were instructed to make *mo fang* images, or exact copies, of famous Tang paintings. Such copies were often achieved with the help of tracing; conceptually, it has at its core the respect for tradition and the high standard of conduct central to Confucian thought. A fine example of such a work is *The Emperor Ming Huang's Journey into Shu* ▶ **fig. 5.4**, a *mo fang* of a Tang landscape (the original of which is no longer extant), which tells the story of the emperor's abdication in three episodes, to be read from right to left. Ming Huang, himself an important patron of the arts and founder of the imperial academy, had been forced from power by an army that had tired of his (extremely un-Confucian) amorous obsessions. The stylistic features derived from Tang painting include the continuous sense of space, yet the scale and spatial relationships are undefined. It has crisp, long contour lines filled in with flat washes of blue and green.

Other landscape artists of the Northern Song sought to show the natural structure of the world that underpinned human society as governed by the concept of *Li*. Fan Kuan's monochrome ink hanging scroll *Travelers Amid Mountains and Streams* ▶ **fig. 5.5**, for example, consists of a landscape of monumental grandeur that completely dominates the two figures in the right foreground. The mountain and water symbolize the harmonious order of both the natural world and Chinese civilization, while the pine trees are symbolic of endurance and strong character. The two travelers (whose brief earthly life pales in comparison to the eternity of natural forces) are barely visible. Fan Kuan's stylistic innovations include a variety of tonal washes and the textured brushwork called *tsun* (compare Fan Kuan's textures with the flat color of *The Emperor Ming Huang's Journey into Shu*, fig. 5.4).

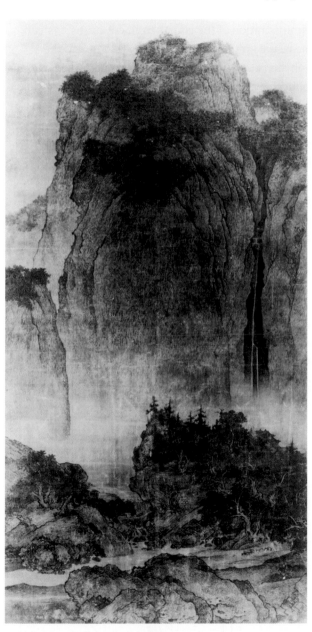

5.5 Fan Kuan, *Travelers Amid Mountains and Streams*, Northern Song dynasty, c.990–1030. Hanging scroll, ink on silk, height 6ft 9¼ins. National Palace Museum, Taipei.

Among the many Song figure paintings concerning the affairs of imperial courts is an anonymous twelfth-century work called *Breaking the Balustrade* ▶ **fig. 5.7**. It recounts the story of a famous test of loyalty and Confucian etiquette under the emperor Chengdi during the ancient Han dynasty. The figure on the left, who is being restrained by guards, had overstepped his authority in criticizing another member of the court, who is shown to the right of the enthroned emperor. Sentenced to a quick execution, he proves his fealty to the emperor by the courageous way in which he accepts the punishment, while a figure in the foreground simultaneously pleads for his life. The picture dramatically displays the tension and intrigue of the imperial courts.

The last Northern Song emperor, Huizong, ruled from 1101 to 1126 at the capital Kaifeng, and was notorious for his poor administration of the court's military affairs. Instead, Huizong poured resources into the visual arts, consolidating their study into the Institute of Painting and Calligraphy in 1104. During his reign the imperial collection grew to a total of 6,396 works produced by over two hundred artists.

Huizong's collection was among the first to include examples of bamboo painting, a genre that appealed to the most conservative artists (bamboo artists snidely categorized painting into three types: calligraphy, bamboo, and everything else). Because the bamboo plant symbolized the graceful elegance and adaptable resilience of the idealized Confucian scholar, bamboo paintings highlighted the connection between the character of an artist and the quality of his line. An example by Wen Tong, ▶ **fig. 5.8**, shows how the art of calligraphic line depends on varying the pressure on the brush.

Chinese Painting Formats

Fig. 5.6 outlines the three different formats of the Chinese paintings illustrated in this section. Album leafs are simple rectangular pages, sometimes bound into volumes. Hanging scrolls have a vertical axis and often remain open, hung on a wall. Handscrolls feature a horizontal axis and are often not seen all at once. Instead, they are unrolled from right to left, revealing a steadily changing succession of views.

5.6 Chinese painting:
◀ Album leafs
 Hanging scrolls ▶
 Handscrolls
 ▼

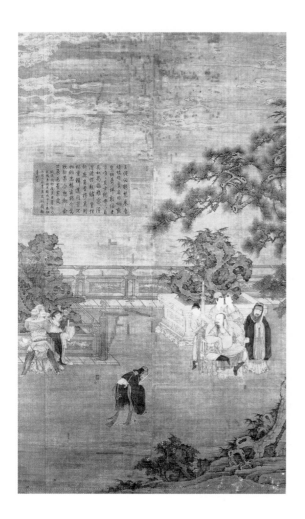

Venerating the courtly style of the Tang, Huizong himself painted a *mo fang* called *Ladies Preparing Newly Woven Silk* ▶ **fig. 5.9**, which features an idealized imperial world, with elegant women preparing (putting the finish on) the luxurious fabric according to age-old ritual. There is no attempt to convey character, drama, or allegory; rather, the picture enunciates social roles and the polished decorum of palace life. The logic, order, and secular piety of the simple composition is imbued with the values of imperial leadership.

During the Northern Song dynasty a new manner of painting, called *wen-jen hua*, or "literati painting," arose. This was the province of amateurs, but not just any amateurs. The literati artists came from the most elite segments of Chinese society, men who were well versed in politics and economics as well as in poetry, philosophy, and literature. In terms of the role of the artist and the patronage of the arts, literati artists distinguished themselves from the professionals of the imperial academy. Because they

5.7 Anonymous, *Breaking the Balustrade*, Northern Song dynasty, 12th century. Hanging scroll, ink, and colors on silk, 5ft 8½ins × 3ft 4⅛ins. National Palace Museum, Taipei.

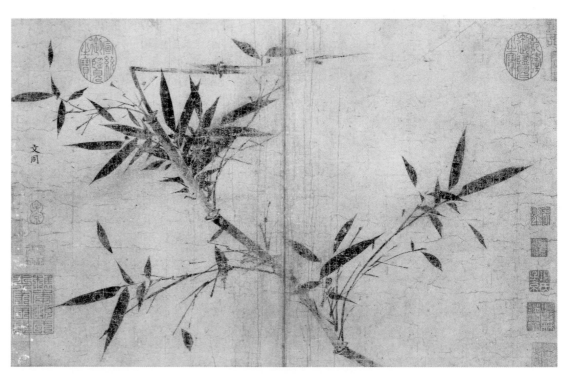

5.8 Wen Tong, *Bamboo*, Northern Song dynasty, c.1070. Hanging scroll, ink on silk, 4ft 2ins × 3ft 5½ins. National Palace Museum, Taipei.

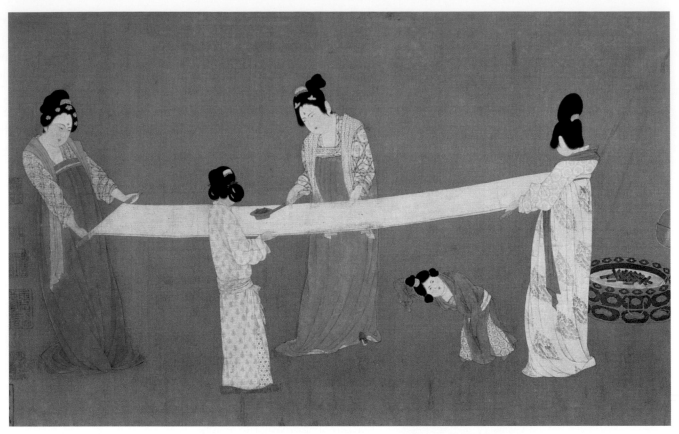

5.9 Attrib. Emperor Huizong, *Ladies Preparing Newly Woven Silk*, Northern Song dynasty, early 12th century. Section of a handscroll, ink, color, and gold on silk, detail 1ft 2⅝ins × 4ft 9⅛ins. Museum of Fine Arts, Boston.

were wealthy and important officials in Chinese society, the literati considered it beneath them to sell paintings. Instead, they exchanged artworks with one another as gifts. Art was not a profession for them, but just one of many ways of expressing themselves; these scholars also wrote poetry and music. Literati looked down on the artists of the imperial academy, whom they considered to be lacking in the poetic sensibility that was the focus of literati art. For these reasons, there were no patrons for literati works other than the artists themselves. The literati, initiated by the scholar-official and art connoisseur Su Shih around 1050, successfully combined the roles of artist, patron, collector, and critic into one person.

Literati painters criticized the stylistic rigidity and lack of individual expression in the academic painting of the imperial court. They shared the academic artists' concern for Confucian values, but had a different philosophy of art. For them, Confucianism supported the idea that personal expression, which did not factor into professional painting, *was* a significant factor in art. While academic poetry in Chinese society had developed a tremendous range of expression, the literati felt that painting had been denied such a role in the official academy, especially because of the academic artists' commitment to the realistic rendering of forms. Literati artists thought that this style was unsophisticated and restrictive. Su Shih wrote, "Anyone who talks about painting in terms of likeness, deserves to be classed with children."

Writing on Art (Literally)

There is a tradition in Chinese painting that artists and collectors write their personal thoughts, usually in the form of inscriptions, directly onto a painting. This tradition, which continues to this day, began with the convention of basing paintings on poetry, which was considered to be the greatest of the literary arts. In linking themselves with poets, painters thus raised the status of their works. The fourth-century painting by Gu Kaizhi, *The Nymph of the River Luo* ▶fig. 5.10, for example, is a visual interpretation of an anonymous third-century poem. Artists sometimes also copied poems or added personal commentaries onto such paintings as an excuse to display the quality of their calligraphy, to which collectors (often artists themselves) might add a further inscription. Collectors would more commonly stamp their personal seals on to the surface of an artwork, documenting the painting's ownership, as in Zhao Mengjian's album leaf *The Three Friends of the Cold Season* ▶fig. 5.11. The rectilinear style and geometric placement of the seals, combined with their red color, provides a beautiful complement to the organic complexity of shape and monochrome finish of the image itself.

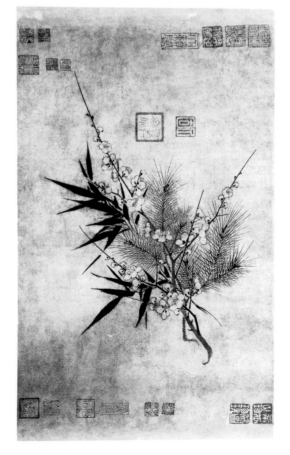

ABOVE **5.10** *The Nymph of the River Luo*, Southern Song dynasty, 12th- or 13th-century copy of Gu Kaizhi (c.344–406). Detail of handscroll, ink, and color on silk, entire scroll 10ft 2ins × 9½ins. Freer Gallery of Art, Smithsonian Institute, Washington, D.C.

LEFT **5.11** Zhao Mengjian, *The Three Friends of the Cold Season*, Southern Song dynasty, 13th century. Album leaf, ink on paper, 1ft ⅝ins × 1ft 8⅞ins. National Palace Museum, Taipei.

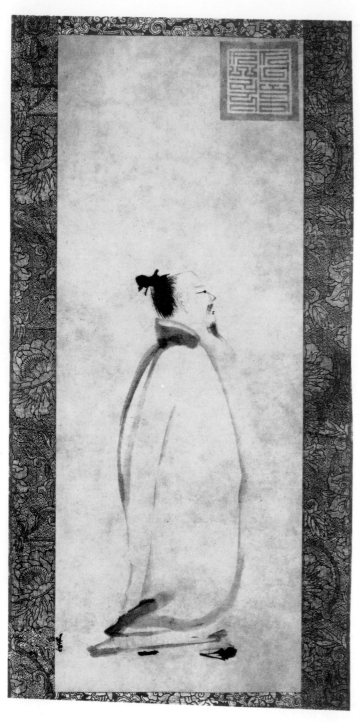

5.12 Liang Kai, *Li Po Chanting a Poem*, Southern Song dynasty, 13th century. Hanging scroll, ink on paper, 3ft 6⅞ins × 1ft ⅛in. National Museum, Tokyo.

In order to unleash their expressive powers, literati artists developed a free technique with the brush. Building upon the past stylistic experiments of the so-called "untrammeled" artists (eighth-century painters who had found little success in their own time), the Northern Song literati rendered forms using a type of reductive abstraction, eliminating most naturalistic details. Unfortunately, few works by the original group clustered around Su Shih have survived. But later paintings, like Liang Kai's thirteenth-century portrait of the famous Chinese poet Li Bai, are still fine examples of the literati style ▶ **fig. 5.12**. Liang Kai was a fugitive of sorts from the imperial academy, where he had attained the highest honor, the Golden Belt. Later in his career he left the academy because of its restrictive style and bureaucracy. He developed a purposely "amateurish"-looking style, lacking the sophisticated polish of academic artists (the literati were "amateurs" in the literal sense; *lovers* of art). Furthermore, there is a sense of exuberance in Liang's freehand brushwork that is lacking in the precise contours of academic painting. Taking advantage of his paper medium, in *Li Bai Chanting a Poem* Liang Kai has spread ink so as to create a remarkable tonal range.

Southern Song

The Northern Song court's emphasis on artistic culture, and the concomitant production of elegant pictures featuring tranquil subjects, in many ways belied the realities of the early twelfth century. For during this time the empire was under increasing threat from the north. Despite a standing army of over one million soldiers, the Song emperors had relied on their wealth to provide peace through the payment of tribute to their northern neighbors, the Liao people. In a belated policy change, Chinese forces joined with their Jurchen neighbors in 1118 to form an alliance that crushed the Liao. However, the Jurchens then turned upon their Chinese allies and defeated the main Song forces. By 1127, Huizong was captured, the capital Kaifeng had been sacked, and thousands of scholar-officials had gone into exile in the south of China.

In southern China, the emperor Huizong's son, Gaozong, in 1138 reassembled an imperial court, called

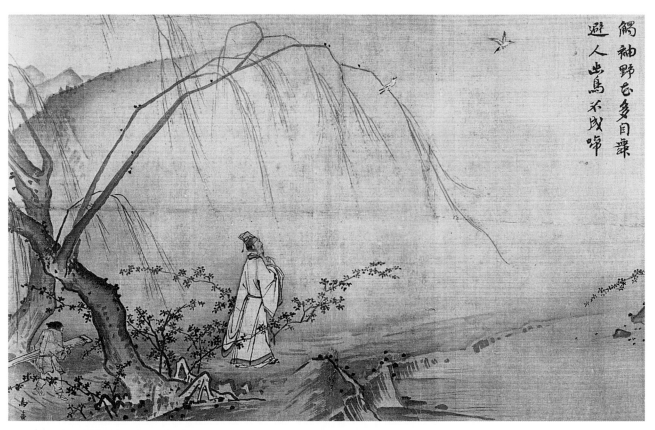

5.13 Ma Yuan, *Walking on a Mountain Path*, Southern Song dynasty, artist flourished c.1190–1230. Album leaf, ink, and colors on silk, 10¾ins × 1ft 5ins. National Palace Museum, Taipei.

the Southern Song dynasty, along with its attendant painting academy at a new capital, Hangzhou. Here, imperial patronage continued to dominate, with academic artists still producing serene images. Many pictures extoll the harmony of figures in a landscape—the new court, like the old, desired escapist fantasies from their artists; no works display the anxiety of a Southern Song population under the near-constant threat of conquest by the Jurchens.

Landscape painting at the Southern Song academy reached a zenith in the second half of the dynasty, some time after 1200, when the artists Ma Yuan and Xia Gui came to the fore. Later called the Ma-Xia school, these two artists developed a type of intimate landscape painting that contrasts with the monumental grandeur of Northern Song artists. Their sentimental landscapes, often painted on small album leafs, display a natural world that is tame and idealized, a refuge for the weary, as in Ma Yuan's *Walking on a Mountain Path* ▶ **fig. 5.13**. Replete with the ideal harmony of nature seen through Daoist philosophy, the image shows a scholar-official (the probable patron of this type of work) who has been transported to a higher realm of feeling by his experience of the natural world, the harmony of which stands as a metaphor for the harmony of a correctly ordered society. At least half of the painting is empty, creating a dualism of solid and void akin to the familiar "mountain and water" reference of earlier landscapes. Ma Yuan's frequent use of this type of composition earned him the moniker "Ma the Corner."

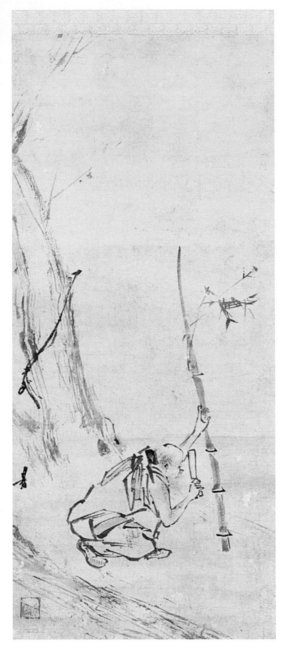

5.14 Liang Kai, *The Sixth Patriarch Chopping Bamboo at the Moment of Enlightenment*, Southern Song dynasty, 13th century. Hanging scroll, ink on paper, 2ft 4¾ins × 1ft½in. National Museum, Tokyo.

During the later years of the Southern Song dynasty, another "amateur" challenge to academic orthodoxy arose through Chan Buddhist artists (Chan Buddhism is more familiar to English-speakers under its Japanese title, Zen Buddhism). Their work is similar to literati painting in its reliance on the expressive character of virtuosic brushwork as well as its lack of official patronage. Chan Buddhists' religious practice emphasized meditation as well as sudden flashes of intuition as a path to enlightenment. As discussed in chapter 2, *nirvana* is the ideal state sought by practicing Buddhists, a purification of all earthly desires. Unlike the professional artists at the academy in Hangzhou, Chan artists were monks who practiced their art in the monasteries surrounding the capital.

Like the literati, Chan Buddhist artists worked in monochrome ink, allowing it to spread with freehand brushwork that dissolves forms and breaks up contour lines. One of the most famous Chan works, *The Sixth Patriarch Chopping Bamboo at the Moment of Enlightenment* ▶ **fig. 5.14**, was made by Liang Kai, discussed earlier as an exemplar of literati style. After Liang left the Southern Song academy, he developed a style called "abbreviated brushwork," resulting in a degree of improvisation that was forbidden at the academy. *The Sixth Patriarch* shows one of the founders of Chan Buddhism at the moment of reaching *nirvana*. It is notable that the patriarch is chopping a branch of bamboo. Because the segments of bamboo stems reflect logical order, bamboo sometimes symbolizes the orderliness of Confucian society. Therefore, an attack on bamboo represents a rejection of the norms of Chinese society; in the same manner, Liang's free style is a rejection of the style, artistic roles, and patronage systems of academic painting.

The Ming Dynasty: Revival and Breakdown of Tradition

China's Ming dynasty (1368–1644) is renowned for its recreation of the splendors of earlier imperial courts, especially those of the Tang (618–907) and Northern Song (960–1127). This revival was strongly nationalistic, rejecting the Mongol-influenced culture of the previous Yuan dynasty, when China had been conquered by Mongol armies. While imperial patronage was renewed under the aegis of the government at the Ming Academy, it was during the Ming that "amateur" literati painting became widely established as a more profound alternative to the court art that the scholars scorned. The fluid, calligraphic brushwork of Wen Zhengming's *Seven Juniper Trees* ▶ **fig. 5.15** is a fine representative of Ming literati work, combining the attributes of many Yuan and Song techniques.

It is possible that the new-found popularity of scholar's painting during the early Ming led to its subsequent breakdown. The career of the painter Tang Yin (1470–1524) demonstrates the collapse of the traditional standards of scholar's art during the Ming. Tang, who had been disgraced after cheating on the Confucian-inspired civil service exams, was still able

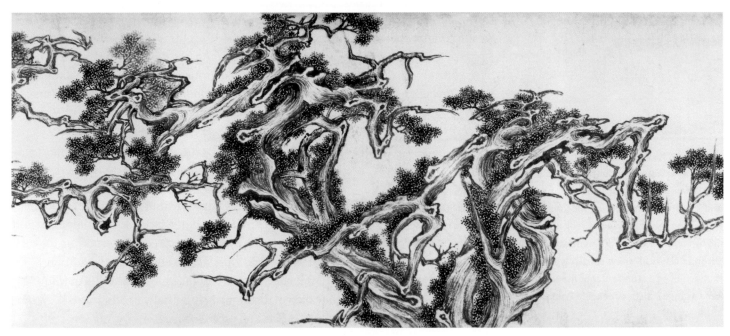

5.15 Wen Zhengming, *Seven Juniper Trees*, Ming dynasty, 1532. Detail of handscroll, ink on paper, entire scroll 11ft ⅛ins × 11ft 10½ins. Honolulu Academy of Arts, Hawaii.

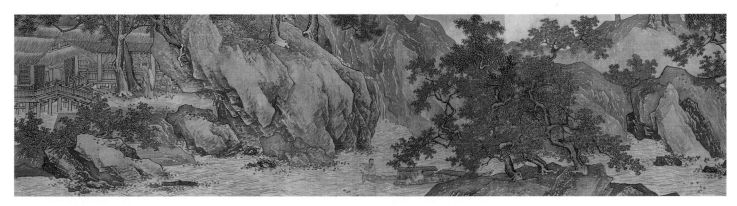

5.16 Tang Yin, *Secluded Fishermen on an Autumn River*, Ming dynasty, inscribed 1523. Section of handscroll, ink, and color on silk, height 11½ins. National Museum, Taipei.

to build a career as a painter in both the academic and the literati styles. As he was not a poet, a calligrapher, or a scholar, his success shows the breakdown of the literati ethical standard that "the quality of the painting reflects the quality of the man." Tang's *Secluded Fishermen on an Autumn River* ▶ **fig. 5.16** combines elements of both literati and academic traditions. For scholar-painters, "amateur" style had been inseparable from aristocratic lineage, elite education (focusing on poetry and the other literary arts), and personal character. With Tang Yin, artistic roles changed, and a centuries-old connection was broken as literati painting became separated from the lives of the noble amateurs who practiced it. From this point on, "amateur" painting was absorbed into the art market that was anathema to the literati, as they found their work appropriated to meet the needs of the professional artists.

The Italian Renaissance

During the centuries of the Ming dynasty in China, thousands of miles away, across the barren country that made up the silk route—a trade highway between East and West—a pivotal landmark in European history was beginning: the Italian Renaissance. Funded by a relatively small group of patrons, consisting of princely families, cardinals, and popes, Renaissance artists attempted to revive the grandeur of the Classical past (see inset). The term "Renaissance," French for "rebirth," was coined to celebrate this revival of the arts of antiquity.

The Greco-Roman Classical Tradition

The term "Classical" and its variants had two important, and, for most artists, overlapping, definitions. First, it referred broadly to Greek and Roman artworks of antiquity and the aesthetic theory that underpinned them. (During the Renaissance, there was little or no distinction made between Greek and Roman art; only in later centuries did historians work to differentiate the "Greco" from the "Roman.") Second, "classical" (now usually with a small "c") meant an artwork that achieved a standard that other artists wanted to emulate. For Renaissance artists, Greek and Roman art was "Classical" in both senses of the word.

At the beginning of the Italian Renaissance, artists found themselves professionally constrained by the guild system, a medieval economic structure that favored the corporate interests of a company over the individual. Guilds exercised near-total control over artists' careers, determining for whom they could work and at what price. In addition, guilds tended not to recognize specialized skill or training; they did not distinguish, financially or otherwise, between trained artists and unskilled laborers. During the Renaissance, artists attempted to establish their individual careers outside the guild system. Meanwhile, wealthy patrons developed a taste for complex, magnificent artworks, usually with the goal of glorifying themselves. Thus, the desires of the patrons intersected with those of the artists trying to break away from the economic and aesthetic strictures of the guild system.

Renaissance Florence

During the fifteenth century, the Tuscan town of Florence established itself as an economic and artistic capital. The city's wealth and influence, derived from international banking as well as textile manufacture, had been steadily increasing since the late 1100s. Patrons committed substantial resources to the decoration of public spaces, churches, and personal homes. Florentines believed that they were the inheritors of the Classical tradition, a "New Athens." While Florence had in fact been carved out of a malarial swamp by Roman legions in the distant past, many of the supposed links between Florence and the Classical era were historically inaccurate: for example, many Florentines thought that their baptistery had been built in antiquity, when in fact it was a more recent medieval structure. Regardless, during the fifteenth century patrons of the arts were determined to remake Florence in imitation of the Classical past.

The Italian Renaissance benefited from an economic prosperity that created new collectors and patrons. In Florence the foremost patrons were the Medici family of bankers. This patrician family had attained a high degree of prosperity under Giovanni (1360–1429), whose son Cosimo Il Vecchio (1389–1464) established the family as *the* leading political power (essentially ruling Florence for over three hundred years) and patron of the arts. Giovanni poured money into a vast library and established a humanist academy at his home. He further supported the scholar Marsilio Ficino in establishing a school of Neoplatonic thought (see inset). An astonishing number of early Renaissance artists, including Filippo Brunelleschi, Lorenzo Ghiberti, Leon

Intellectual Trends: Humanism and Neoplatonism

One major aspect of Renaissance culture was its embrace of "humanism," a term applied to a philosophical outlook according to which human values have greater significance than religious belief. In contrast to the medieval period's focus on the divine, thinkers during the Renaissance emphasized the important accomplishments of philosophers, poets, mathematicians, scientists, and other learned people. The development of humanism provided an intellectual environment in which artists could justify higher social status than before; by training in the humanities, artists sought to put themselves on the same intellectual level as their wealthy patrons, and to separate the visual arts from their history as menial crafts.

A major part of the humanist tradition was a revival of Greek and Roman scholarship. Intellectuals naturally turned to Plato (427–347 BCE), the foremost philosopher of the ancient Greek world. Plato dealt with nearly every major question surrounding human existence and had developed a systematic philosophy of the "art of living." The study of Plato's work by Renaissance scholars was called "Neoplatonism."

Battista Alberti, and Paolo Uccello, received Medici support. Cosimo's grandson, Lorenzo "The Magnificent," along with Lorenzo's cousin, Lorenzo di Pierfrancesco, continued the tradition of artistic patronage; Sandro Botticelli and Michelangelo were among their stable of artists. Later, Lorenzo's son Giovanni ruled the Christian church as Pope Leo X (see p. 154) while his nephew Giulio became Pope Clement VII in 1523. The sometimes difficult relationship between the Medici and the other citizens of Florence also influenced the family's collecting habits: central to their patronage was a need to burnish the image of the family investment-banking business, as so-called "moneylending" had an uncertain reputation in this era.

One of the most erratic artistic careers of the Renaissance in Florence funded by the Medici was that of Filippo Brunelleschi (1377–1446). Brunelleschi first came to the fore as a finalist along with Lorenzo Ghiberti (1378–1455) in the competition to design new relief sculpture for the east doors of the Florence Baptistery (public competitions such as this were controlled by the same small group of wealthy families that offered private commissions). The panels, to be based on stories from the Old Testament, would face the cathedral's main entrance. The finalists were each given a year to sculpt and gild a composition depicting the sacrifice of Isaac ▶ **figs. 5.17–5.18**. The finished panels were judged in 1403 by a group of prominent citizens, including Giovanni de' Medici. Brunelleschi lost the competition. While his work arguably had a clearer composition,

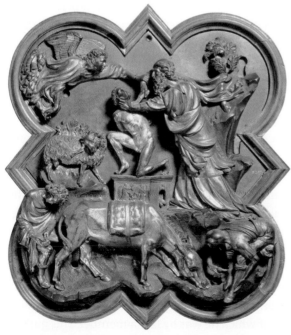

5.17 Filippo Brunelleschi, *Sacrifice of Isaac*, 1403. Gilt bronze, 1ft 9ins × 1ft 5½ins. Museo Nazionale del Bargello, Florence.

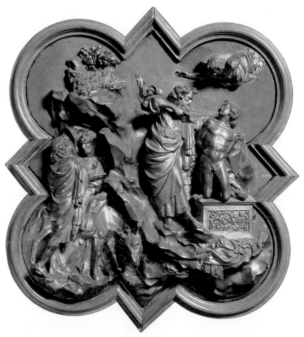

5.18 Lorenzo Ghiberti, *Sacrifice of Isaac*, 1403. Gilt bronze, 1ft 9ins × 1ft 5½ins. Museo Nazionale del Bargello, Florence.

Ghiberti's figures appeared more elegant and natural to many critics. Ghiberti's technical ability, especially the fact that he cast his panel in just one piece, also may have tipped the balance in his favor.

A desire to rival the accomplishments of antiquity was a motivating force for the Renaissance patrons and artists who depended on Classical prototypes. Because of its earlier importance in Rome, architecture was considered the most prestigious artistic profession in Renaissance Italy. In 1419, Brunelleschi entered another competition, to design a dome for Florence Cathedral, Santa Maria del Fiore. The cathedral had originally been designed in the late thirteenth century by Arnolfo di Cambio (1245–1302), and a bell tower designed by the painter Giotto (1301–37) had been added after 1334. The need to complete the cathedral dome was partly symbolic, because the dome represented the most visible form of architectural achievement of the Romans (see the Pantheon, figs. 3.29–30).

One of the most delightful anecdotes of the contest for the dome commission, which illustrates Brunelleschi's clever attempt to win over a group of patrons by showing up the other entrants, is the story that he challenged his competitors to stand an egg on its end as proof of their competency (an impossible task). After scorning their efforts, Brunelleschi smashed an egg down so that the end crumpled and it remained in place. When told by the assembled group that they too could imitate Brunelleschi's technique, the architect claimed that they too could build the dome if he divulged his entire plan to the committee. Brunelleschi's octagonal plan for the dome included not only aesthetic qualities, notably its elegant ribbed design, but imaginative practical details: construction without the use of expensive scaffolding that would have obstructed the central spaces of the cathedral ▶ **fig. 5.19**.

Renaissance artists steeped themselves in written works and aesthetic theory, a crucial extension of learning strictly from practical application or apprenticeship. The basis of art and architecture was increasingly defined by its practitioners as an intellectual pursuit with roots in Classical learning (see inset). Artists based their demands for greater respect and wages largely on the distinction that they drew between themselves and the artisans who had served in medieval guilds. Brunelleschi's career is a case in point. He was able to envision a design for the new dome before construction had begun because of his theoretical knowledge. Traditionally, buildings had been planned during construction by the most experienced foreman at the site, who would also have a flair for administration and design. Most buildings were designed as the project advanced. Brunelleschi was thus partly responsible for the elevation of architectural practice to its status of intellectual, as opposed to manual, labor.

In 1434 Brunelleschi also struck a decisive blow against the economic control of the guild of stonemasons and carpenters, of which he was by law a member. This guild

Vitruvius

It is likely that Brunelleschi had studied the architectural theory of the Roman engineer Marcus Vitruvius Pollio, called Vitruvius. Vitruvius had worked for both Julius Caesar and the emperor Augustus late in the first century BCE. His book *On Architecture* was the only surviving text during the Renaissance that detailed Classical building practices and aesthetic theories. For this reason, Vitruvius' book was republished over eighty times in the fifteenth century and became a bible for such Renaissance architects as Brunelleschi.

5.19 Filippo Brunelleschi, *Dome of Florence Cathedral*, 1420–36.

had almost absolute control over the building professions and the careers of its members, most of whom were laborers. In the middle of the construction of the dome, at a time when Brunelleschi had become indispensable to its completion, he refused to pay his annual dues and sought to sever his relations with the guild. This act threatened the economic control of the guild and Brunelleschi was quickly imprisoned. After several weeks a compromise was reached at the behest of the Medici, who were determined to see the dome completed. Brunelleschi was able to use his patrons' need as a personal lever. The philosophical challenge that Brunelleschi presented to the guild was paramount in raising the status of the artist in the Renaissance; he asserted that his individual achievement superseded the institutional prerogatives of the guild system.

The dome was finished and consecrated in 1436. A decade later, Brunelleschi was granted posthumous honors, unprecedented for an artist—he was buried beneath his own aesthetic and engineering marvel, only the second person to be interred in the cathedral (the other was St. Zenobius, first Bishop of Florence and a local patron saint). This community ritual recognized that the status of architects had reached new heights.

Alberti and Fifteenth-Century Painting. Leon Battista Alberti (1404–72), perhaps the most influential figure in the history of fifteenth-century painting, was not a painter himself, but an architect and humanist. Scion of a wealthy banking family who had been exiled from Florence in one of the numerous political intrigues of the era, Alberti supported the arts throughout his life. His book *On Painting* was intended to convince a generation of artists and patrons that painting was a sophisticated, intellectual endeavor that deserved their utmost attention. Published in 1435 in Latin and translated by the author himself into Italian in 1436, *On Painting* was aimed at two audiences: the Latin version at the educated patrons that Alberti hoped to attract; and the vernacular Italian one at less-educated artists in particular and the broad public in general. To promote the art of painting, Alberti relied upon his own education in the humanities and the Classics; nearly every argument he presents in *On Painting* is

buttressed by examples drawn from the practices of antiquity. He hoped to convince painters that by adopting his rigorous standards, based on Classical models, they could improve their work and gain social status. Alberti's treatise proved so popular with painters that most copies of the Italian version had been worn out through repeated readings by the end of the Renaissance.

In *On Painting*, Alberti elaborated on three concepts — ▸*disegno*◂, allegory, and ▸*istoria*◂ — that would form the conceptual kernel of European painting, as well as form the basis of its high status, for many centuries. The term *disegno* can be translated as both "drawing" and "design." In terms of drawing, Alberti made the case that this skill was fundamentally intellectual, the work of the mind, not simply the work of the hand. This was an important distinction, as manual labor of any sort was viewed with contempt by the educated upper classes during the Renaissance. The major drawing skills that Alberti promoted included ▸linear perspective◂ (the first third of the treatise was devoted to the technical details of perspective), anatomy drawing, and a concern for Classical systems of proportion. The "design" aspect of *disegno* refers to skills in composition, the ability to take a set of characters and a scene and combine them into a meaningful whole. *Disegno* in this sense is a type of visual problem-solving.

Alberti's second concept, allegory, a literary genre to which fifteenth-century painters frequently alluded, was the device most consistently used by artists to assert the newly elevated status of their profession. Allegory functions in artworks in three ways: personification, simile, and metaphor. Personification is most apparent in the Renaissance predilection for picturing Greco-Roman gods and goddesses, all of whom personify certain qualities (for example, Athene/Minerva personifies Wisdom); metaphor (for example, "the ship of state") and simile (for example, "solid as a rock") are figures of speech that artists transposed into the visual arts.

Perhaps Alberti's most significant contribution to the theory of Renaissance art was his concept of *istoria*, often translated as "history painting," though Alberti intended the term to have a broader, more exalted meaning. To bring out the narrative aspect of a painting effectively, Alberti argued that it was necessary to aspire to a level of education not previously available to artists. In order to convey the complex stories of Christianity and the Classical past in a way that would appeal to sophisticated patrons, artists should expand their knowledge to match that of a humanist. For Alberti, an *istoria* was a picture that did not simply tell a story clearly and logically, but also "moved the soul" of the viewer to a contemplation of a work's religious and humanist values.

Alberti's ideas were pursued by virtually all the best-known artists of the Italian Renaissance. Piero della Francesca (1415–92), for example, developed Alberti's theories of linear perspective and used them with consummate skill in his paintings. The entire composition of his *Flagellation of Christ* ▶ **fig. 5.20**, which depicts Jesus being punished in front of the Roman governor Pontius Pilate, derived from his mastery of the perspective grid. Note the way in which both the ceiling and the floor map out the complicated succession of spaces. The space was plotted so accurately that historians have been able to make ground plans of Piero's imaginary palace.

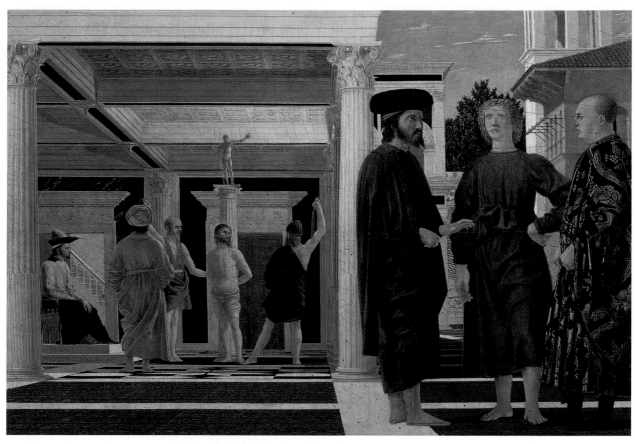

5.20 Piero della Francesco, *Flagellation of Christ*, 1460. Oil and tempera on panel,
1ft 11ins × 2ft 8ins. Galleria Nazionale delle Marche, Urbino.

Other painters paid less attention to spatial illusions and focused on Alberti's call for good figure drawing. Antonio Pollaiuolo's *Martyrdom of St. Sebastian* ▶ **fig. 5.21** is an exemplary treatment of the human body in a multitude of positions, almost like an anatomical textbook. Pollaiuolo (1431–98) evidently took one model and put him through his paces; the crossbowmen strain to load, aim, and fire their weapons. The rugged muscularity of their bodies is contrasted with the idealized smoothness of St. Sebastian's body. In contrast to the attention lavished on the human figures, Pollaiuolo created the background out of stock fifteenth-century elements: a simple swath of countryside adorned with Roman ruins and a winding river.

Another way of responding to Alberti's codification of painting and of displaying specific marketable skills is evident in the work of Sandro Botticelli (1444–1510), who was particularly close to the Medici family. His *Primavera* ▶ **fig. 5.22** at first seems to violate the Albertian norms of illusionistic space and well-modeled anatomy drawing in favor of elegant line. It is arguable, however, that Botticelli chose to display his intellectual skills more than manual ones; the subject matter of *Primavera* is a complex humanist allegory involving allusions to both Classical thought (particularly the Neoplatonic humanism that was at the forefront in the Medici academy run by Marsilio Ficino), and contemporary Christian ideas. The central figure combines

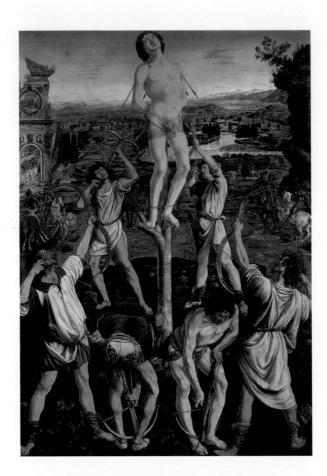

5.21 Antonio Pollaiuolo, *Martyrdom of St. Sebastian*, 1475. Tempera on panel, 9ft 7ins × 6ft 8ins. National Gallery, London.

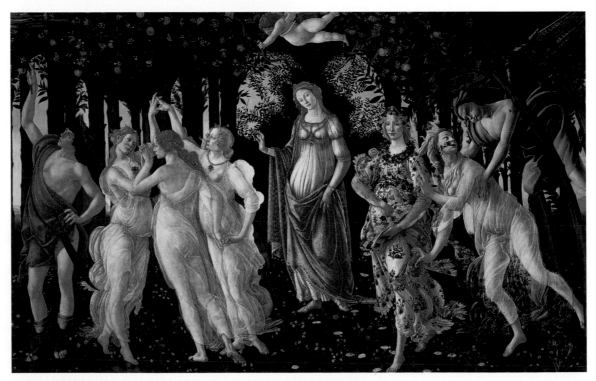

5.22 Sandro Botticelli, *Primavera*, c.1482. Tempera on wood, 6ft 8ins × 10ft 4ins. Galleria degli Uffizi, Florence.

elements from the Classical past with those of a recognizably Christian Virgin, a joining of forces known as syncretism. She stands for both the Virgin Mary *and* the Roman goddess of spring. Botticelli, as an active humanist, was striving to ensure that artists would be acknowledged as much as philosophers, poets, and orators.

Among Botticelli's many fine portraits, one of 1480–85 is thought to be of Simonetta Vespucci ▶ **fig. 5.23**, mistress of Giuliano de' Medici. Vespucci is shown in half-length profile, a view that became fashionable in emulation of portraits on Roman coins. Her mien is serious, perhaps to accord with Alberti's dictum that proper young patrician women should have "a grave demeanor" (akin to the notion of *gravitas*, denoting a weighty solemnity). Vespucci's beauty in the picture is itself an allegory: the circle of humanists in the Medici household asserted that there was a complex hierarchy of the beautiful, ranging upward from the earthly component of physical beauty to immaterial divine beauty.

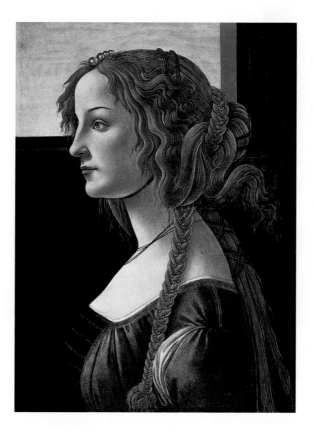

5.23 Sandro Botticelli, *Profile of a Young Woman* (*Simonetta Vespucci*), 1480–85. Tempera on poplar panel, 3ft 9 ⅝ins × 1ft 1¾ins. Gemäldegalerie, Berlin.

The art historian Michael Baxandall has investigated painting contracts from the early Renaissance and concluded that a gradual shift can be discerned from a valuation based on the materials that make up the work to one based on the artist's skill. Earlier contracts specify the price mainly in terms of how much gold leaf and ultramarine blue (a rare pigment whose powder was worth twice its weight in gold) were to be used in the painting. Artists were paid based on a standardized wage-labor scale. It was accepted that they would supplement their incomes through skimming off some of the expensive materials where they could. Later contracts specify the amount of

work that the named artist will himself perform as opposed to members of his workshop or studios. This suggests that patrons were increasingly aware of the individual skills of specific artists.

Florence's Two Davids. Sculpture became an increasingly prominent feature of the public spaces and private homes of the wealthy in Renaissance Florence. Patrons sought to supplement their collections of Classical sculpture with new works of the highest quality. The two most famous Florentine sculptors, Donatello (1386–1466) and Michelangelo (1475–1564), each made a work based on the story of the young Israelite warrior David, who triumphed over Goliath and later became a powerful king. Donatello's *David* ▶ **fig. 5.24** was made for the Medici family's private sculpture garden. Its proportions and the twisted pose (▶*contrapposto*◀) reflect a broad Classical influence. The sculpture was in fact one of the first free-standing nudes to be made since antiquity. Donatello's *David* remains controversial; the warrior appears both arrogant and sexualized, toying with the head of Goliath at his feet. Some scholars assert that the Neoplatonic theory of Ficino's academy lies behind the work's complex levels of meaning. Homo-sexuality was widely practiced in ancient Greece and Rome, and Plato himself extolled the educational value of homoerotic relationships. The sexual suggestiveness of this work fits the context of its commission for a private collection.

ABOVE **5.24** Donatello, *David*, 1440. Bronze, height 5ft 2¼ins. Museo Nazionale del Bargello, Florence.

RIGHT **5.25** Michelangelo, *David*, 1501–04. Marble, height 14ft 3ins. Galleria dell'Accademia, Florence.

In contrast, Michelangelo's *David* ▶ **fig. 5.25** was destined for a public space. It remains the most widely admired statue of a male nude. The citizens of Florence saw David as a courageous figure who had fought and defeated a more powerful enemy and therefore as an allegory of their own

struggles. Michelangelo was able to carve his *David* from an expensive single piece of marble that had been abandoned by several earlier sculptors, a task that was no small feat technically. The work was completed soon after the expulsion of the sometimes tyrannical Medici, who were exiled in 1494 (they would return to power in 1515), and has the mature, powerful physique and confident self-awareness that made it an icon of the Renaissance ideal. There is a certain irony in the fact that Donatello's statue of David was thrown over by the mob that ransacked the Medici palace on their defeat.

Leonardo da Vinci. Leonardo da Vinci (1452–1519), often credited as the abiding genius of the Renaissance, spent his entire career as a supplicant to one patron after another. (Like most people without aristocratic pedigrees, Leonardo had only one name. "Da Vinci," indicating the village where he was born, which was later added as an honorific.) After an apprenticeship in Florence with Andrea del Verrocchio (1435–88), as well as attempts at educating himself in science and engineering, Leonardo at the age of thirty wrote a letter to the Duke of Milan, Lodovico Sforza (1451–1508), requesting a position. The Sforza ruling family were not bankers in the Medici mold, but had gained their duchy through service as *condottieri*, mercenary soldiers, and were in a near-constant state of war. Leonardo's letter to Lodovico therefore outlined his ten best "secrets," in the hope that their military applications would be accepted by the Sforza. His second point is typical: "I know how, when a place is under attack, to eliminate the water from the trenches, and make an endless variety of bridges." At the end of his letter, almost as an afterthought considering his patrons' needs, Leonardo wrote: "I can execute sculpture in marble, bronze, or clay, and also in painting I can do the best that can be done, and as well as any other, whoever he may be." This initial petition to Lodovico was turned down, but, through persistent appeals, Leonardo finally attained a retainer at the Sforza court.

While working there between 1482 and 1499, Leonardo executed some of his best-known works. Many of these, like the copy of "Vitruvian Man" in one of his notebooks, attempt to lay claim to the Classical system of proportion that was an important part of artists' new intellectual status ▶ **fig. 5.26**. In the same notebook Leonardo wrote: "Let no man who is not a mathematician read my work." However, the popular view of Leonardo the Renaissance genius and scientist, which Leonardo himself took pains to

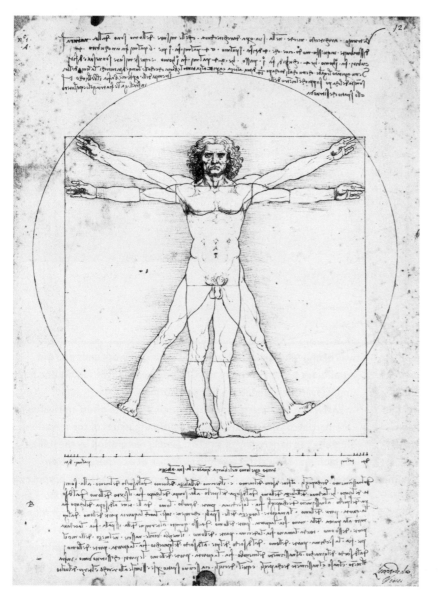

5.26 Leonardo da Vinci, *Proportions of the Human Figure* ("Vitruvian Man"), 1485–90. Pen and ink, 13½ins × 9⅝ins. Galleria dell'Accademia, Venice.

promulgate, is not entirely valid. Leonardo did not have access to a quality formal education, and it is doubtful that he was acquainted with the most advanced mathematical and scientific theories of the day; most of his work in these fields was either whimsical or simplistic. Leonardo's notebooks were saved by his contemporaries more for their astounding drawings than for their scientific wisdom. His attempts to promote himself as a scientist might be another example of a Renaissance artist trying to associate himself with more exalted bodies of knowledge.

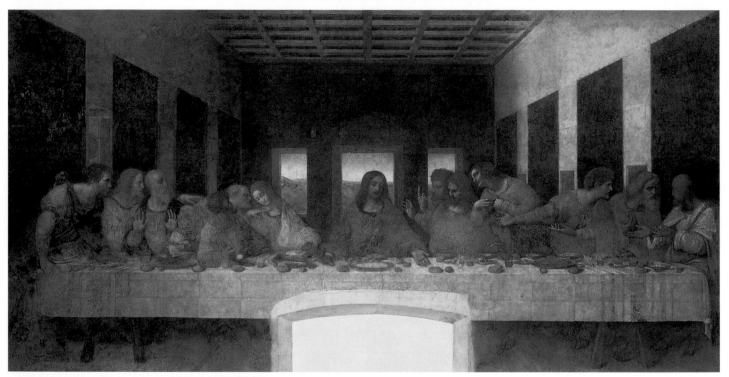

5.27 Leonardo da Vinci, *Last Supper*, c.1495–98. Mural painting, 15ft 1⅛ins × 28ft 10½ins. Santa Maria delle Grazie, Milan.

Disputes over the Restoration of Leonardo's *Last Supper*

As early as the 1550s, Giorgio Vasari (see p. 157) noted that the condition of the *Last Supper* had deteriorated to the extent that it had become an "indistinct smudge." Recently, there has been an escalation in the rhetoric over the proper care of artworks. The painstaking conservation of the *Last Supper* by the Italian conservator Pinin Brambilla Barcilon between 1979 and 2000 has provoked admiration as well as outrage. The process removed so much pigment from the wall that the work was dramatically altered, the changes immediately evident even to the untutored eye. Restorers have argued that none of the pigment they removed was originally applied by Leonardo. Rather, they assert that the work is more meaningful now that layers of repainting by other artists over nearly five centuries have been eliminated. The historian James Beck, one of the founders of Artwatch International, a group that opposes most restorations, argues in turn that Barcilon has no

way of knowing conclusively where Leonardo's work ends and the repaintings begin. For this reason, he believes that the restoration has unnecessarily endangered a fragile painting.

Artwatch also insists that restorations are more often motivated by commercial considerations than by legitimate issues of conservation. They cite the bankrolling of the *Last Supper* restoration by the Italian conglomerate Olivetti as a *prima facie* case of a corporate patron attempting to attach its name to an artwork for advertising purposes. It is completely understandable that Artwatch decries the curators and administrators who agree to unnecessary and damaging restorations for the sake of money and publicity. However, there is an undeniable irony in a patron's desire for prestige through an association with the arts being blamed for the *destruction* of paintings when this same motivation was, in the Renaissance, responsible for their *creation*.

The Duke of Milan commissioned Leonardo to paint a fresco (he in fact did the work in an experimental medium of his own devising [see also inset, opposite]) for the refectory of a local monastery, Santa Maria delle Grazie. In the *Last Supper* ▶ **fig. 5.27** Leonardo abandoned the tradition of differentiating Judas from the other apostles in placing him on the far side of the banquet table. Instead, he increased the dramatic tension by focusing on facial expression and body language.

Leonardo's last two patrons were Cardinal Giuliano de' Medici in Rome (brother of Pope Leo X) and the King of France, Francis I. In 1517 Leonardo went to live in a château at Cloux, near the royal court in Amboise. There he died in 1519, and became the subject of a story guaranteed to increase his posthumous status: according to Vasari (see below)—a notorious distorter of the truth—Leonardo won the great honor of dying in the arms of the king.

Rome: Julius II and Leo X

In Rome during the sixteenth century, artists and popes developed mutually beneficial relationships: the artists benefited from the vast sums of money spent on artworks, while the papacy used the arts to glorify the church and inspire the faithful. The patronage of Pope Julius II (Giuliano della Rovere, 1443–1513) was central to the careers of Donato Bramante (1444–1514), Michelangelo, and Raphael (1483–1520). Julius, nephew of Pope Sixtus IV, was elected to the papacy in 1503. He almost immediately began a series of military campaigns, first against the Venetians and then the French, which were designed to enlarge and secure the Papal States. His ambitious military plans were complemented by a desire to remake the city to the standards of his Roman imperial forebears.

Julius was, in fact, only one of a series of popes who, beginning around 1440 upon the return of the papacy from its temporary headquarters in Florence, sought to consolidate the papacy's power and revive the economic and aesthetic life of Rome. Through the early fifteenth century, and partly because of the political volatility of the papacy's relationship with European monarchs, Romans had not been successful in reclaiming their city's past splendor and political clout. While Florence had prospered, Rome had remained undistinguished as a Renaissance city. Where Florence had Brunelleschi's great new cathedral dome, Rome languished, surrounded by the magnificent ruins of a lost empire. Julius's uncle Sixtus IV had worked with some success at reviving the city, his achievements culminating in the construction of the Sistine Chapel, which includes frescos by some of the most noted artists of the time. That by Pietro Perugino (1450–1523), *Giving the Keys to St. Peter* ▶ **fig. 5.1** (see p. 126), illustrates the satisfying ties between popes and artists that were then developing. The fresco features a typical fifteenth-century scene, in which the background consists of a symmetrical assemblage of *faux*-Classical architecture, including a fashionable circular temple based on Vitruvius; note the perspective in the lines of the plaza setting. In the foreground Jesus rewards the apostle Peter with the symbolic keys to the Christian Church. The popes traced their authority back directly to Peter, often referred to as the "first pope." Perugino was not only showing off his skill in *disegno* in this papal commission, but dramatizing the link between the popes and the founders of Christianity.

When Julius became pope, even the main church over which he presided, St. Peter's, was an ancient relic, leaky and in need of structural repairs (see chapter 4). Originally constructed under Emperor Constantine in the early fourth century, St. Peter's stood as a testament to the lowly state of the city and the papacy, long in the shadow of an empire. One of Julius's first acts as pope was to order plans for a new, grander church, for which he chose Bramante as architect. Having built fortifications for Julius in Latium, Bramante was then working on the Tempietto for the Spanish monastery of San Pietro in Montorio across the river from Rome in Travestere ▶ **fig. 5.28**. Commissioned in 1502, it demonstrated his commitment to Classical prototypes, and reflects the idealized geometry put forth by Vitruvius. The Tempietto marked a location significant to the worship of the popes' "ancestor" St. Peter: the place where he was executed by the Romans.

In April 1506, Julius and Bramante presided over the laying of the cornerstone for the new St. Peter's, to be built at the same time that the Constantinian edifice was being dismantled. The completed church differed significantly from Bramante's plan. He had envisioned the church as a symmetrical shape built outward from a perfect circle in the form of a central plan ▶ **fig. 5.29**. However, by the time the building was completed, almost a century after Bramante's death, the necessity of having a large nave in which pilgrims could congregate had superseded his vision of a central-plan church.

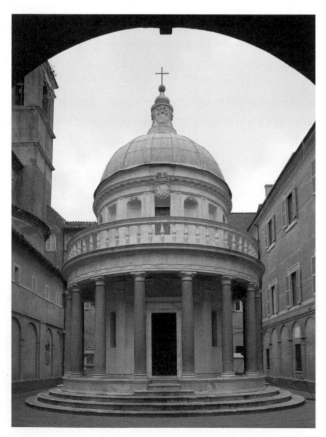

5.28 Donato Bramante, *Tempietto*, façade of San Pietro in Montorio, Rome, 1502–03.

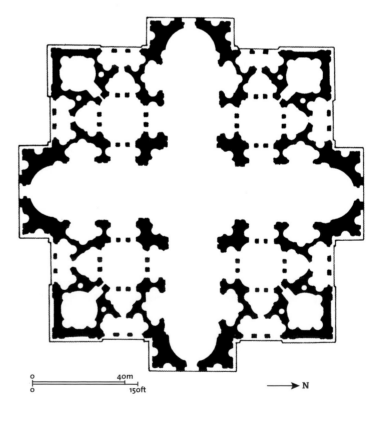

5.29 Donato Bramante, plan for St. Peter's, Rome, 1505–06.

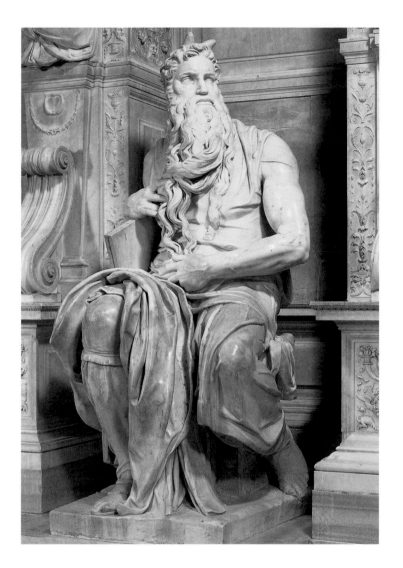

5.30 Michelangelo, *Moses* from the Tomb of Pope Julius II, Church of San Pietro in Vincoli, Rome, 1516. Marble, height 7ft 8½ins.

At a time when it was customary for the pope to act and live like a prince, Julius used his position to direct extensive artistic programs that would both embellish his apartments and glorify his reign. In pursuit of these aims, Julius demanded the presence of Michelangelo and Raphael. In 1505 Michelangelo was commissioned to begin work on a lavish tomb for the pope, to be placed under the crossing of the new St. Peter's, a task that would preoccupy him for over thirty years. Michelangelo spent eight months in the Carrara region personally selecting blocks of marble for the project. The scheme was to have forty figures on the tomb, but this ambition was never realized. Among the statues that Michelangelo completed was that of Moses ▶ **fig. 5.30**, eventually erected in the church of San Pietro in Vincoli (St. Peter in Chains). Intended to emphasize his spiritual intensity, the prophet was also made to resemble the pope. Note the massive hands and the sculptural bulk of the hair. (Incidentally, the small horns on Moses' head are an iconographic mistake: when the first five books of the Old Testament—the Pentateuch—were translated into Greekduring the Hellenistic period, the Hebrew word for "beams of light" shining from Moses' head was mistranslated as "horns.") According to legend, when Michelangelo finished the sculpture, he struck it with a hammer, and, impressed with its naturalism, cried, "Now speak!"

In 1508 Julius decided that Michelangelo should abandon the sculptures for the papal tomb. Finding a painter to decorate the ceiling of the Sistine Chapel was now the pope's main concern. Michelangelo had not yet undertaken a project of such magnitude, certainly not as a painter. He accepted the commission reluctantly, and it took nearly four years to complete. The narrative scenes are derived from the book of Genesis, and it is small wonder that their creator came to be called "the divine" by his contemporaries. Drawn with the sensibility of a sculptor, the massive figures on the ceiling illustrate Michelangelo's belief that the human body was the most expressive form available to an artist ▶ **fig. 5.31**. Few works could have done more to secure Julius II's reputation as a visionary patron of the arts.

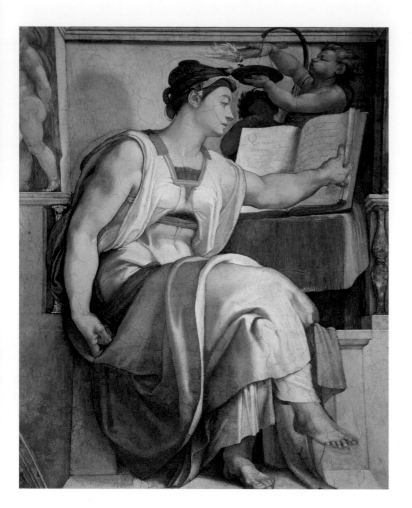

5.31 Michelangelo, *Eritrean Sybil*, detail of ceiling, Sistine Chapel, Vatican, Rome, 1508–12. Fresco.

Meanwhile Raphael had been decorating the pope's private apartments at the Vatican since 1509, starting with the reception room known as the Stanza della Segnatura (Room of the Signature). This is where Julius would sign and seal documents, exercising his control over events both religious and secular. Raphael chose to decorate the room with a series of allegorical frescos that represent the themes of Justice, Poetry, Theology, and Philosophy, the most celebrated of which is *The School of Athens* (Philosophy) ▶ **fig. 5.32**. The room was originally a library, and all four frescos include prominently displayed books. The *School of Athens* itself shows an idealized philosophical academy, situated in an imaginary elevation of Bramante's new St. Peter's. The left side of the picture, featuring a portrait of Leonardo in the guise of Plato, is dedicated to theoretical knowledge, while the right side is populated with empirical philosophers led by Aristotle. The whole stands as testimony to Raphael's humanist knowledge and as a glorification of the intellectual culture of the papal court.

During the reign of Julius II's successor, the Medici pope Leo X (1513–23), a courtier remarked: "Everything pertaining to art the pope turns over to Raphael." Raphael was certainly the favorite artist of the pope. He was given numerous further responsibilities, ranging from overseeing the continuing construction of St. Peter's after Bramante's death, to a position as keeper of antiquities, and the designs for tapestries in the Sistine Chapel. The pope's scholarly leanings are astutely captured in Raphael's portrait of him with the cardinals Giulio de' Medici and Luigi de' Rossi ▶ **fig. 5.33**. He is seated at an angle to the picture plane, a format Raphael had learned from Leonardo da Vinci in Florence. His corpulence comes across with the *gravitas* of a Roman emperor. By 1515 Leo X's lavish lifestyle had already depleted the funds secured by Julius II's military successes. It was said mockingly that in the following two years he spent the entire funds of the next pope!

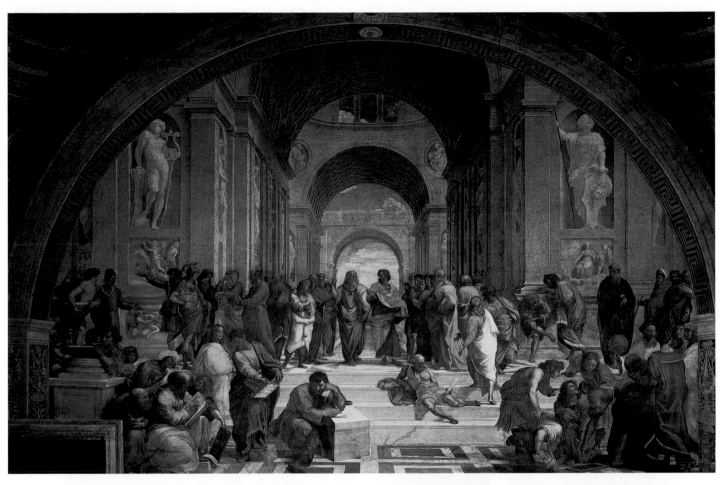

5.32 Raphael, *The School of Athens*, 1509–11. Fresco, 26ft × 18ft.
Stanza della Segnatura, Vatican, Rome.

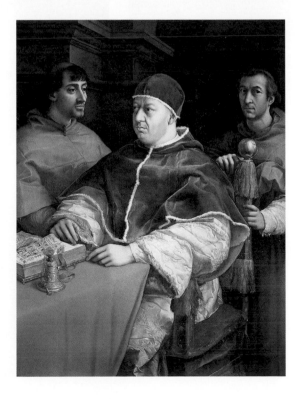

5.33 Raphael, *Leo X with Cardinals Giulio de' Medici and
Luigi de' Rossi*, c.1517. Panel painting, 5ft ½in × 3ft 11ins.
Galleria degli Uffizi, Florence.

Titian in Venice

The painter Titian (Tiziano Vecellio, 1480–1576) spent most of his life in Venice, whose wealthy rulers were his earliest patrons. There he also met Pietro Aretino, a humanist remembered in the history of Western art for initiating the idea of Venetian ▸colorito◂ painting as a distinct alternative to central Italy's emphasis on Albertian *disegno*. Titian's portrait of him ▶ **fig. 5.34** is characterized by broad, ▸painterly◂ brushwork that builds up layers of oil glazes in brilliant coloristic effects. Titian's friendship with Aretino served him well, as Aretino recommended him to princes and other patrons.

Titian was the first European artist to find international fame. While working at the court of the Gonzaga family in Mantua in 1532, he was noticed by the Holy Roman Emperor Charles V (1500–58), of the Habsburg family. First for Charles V, and later for his son Philip II (1527–98, King of Spain), Titian made a series of works that established the norms for aristocratic portraiture in Europe. His *Charles V on Horseback at the Battle of Mühlberg* ▶ **fig. 5.35** is a full-length portrait again remarkable for its handling of *colorito* (note the rich color in the background piece of sky); Titian's patron is in the guise of a Roman emperor commanding his troops.

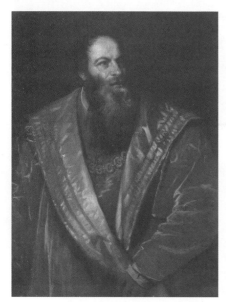

ABOVE **5.34** Titian, *Pietro Aretino*, 1540. Oil on canvas, 3ft 2ins × 2ft 6¼ins. Palazzo Pitti, Florence.

RIGHT **5.35** Titian, *Charles V on Horseback at the Battle of Mühlberg*, 1548. Oil on canvas, 10ft 10⅝ins × 9ft 1⅞ins. Museo del Prado, Madrid.

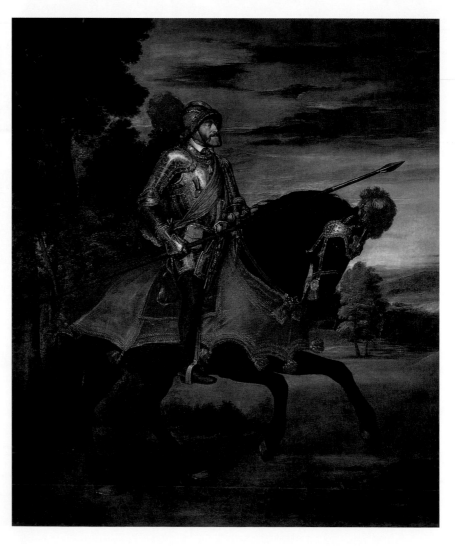

5.36 Titian, *Danae*, 1545–46. Oil on canvas, 3ft 10⅛ins × 2ft 3⅛ins. Museo di Capodimonte, Naples.

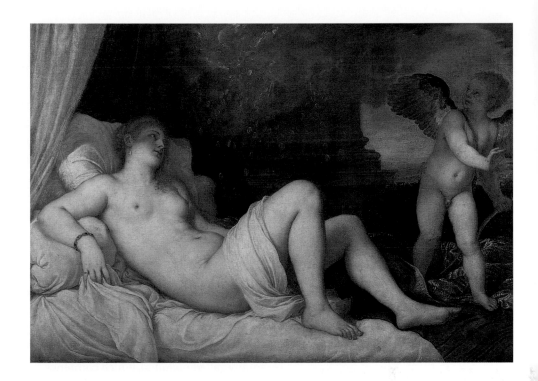

Titian's paintings that exemplify his status as a knowledgeable humanist include *Danae* of 1545–46 ▶ **fig. 5.36**. This is based on a myth as retold by the Roman poet Ovid (43 BCE–18 CE): Danae's father, Acrisius, having heard a prophecy that his grandson would kill him, had his daughter locked away in a tower so that she could never conceive; but Zeus visited her there in the form of a shower of gold (the moment captured by Titian as a rain of coins from the sky), and she later gave birth to Perseus. The prophecy was fulfilled when Perseus unknowingly killed his grandfather.

Giorgio Vasari and Grand Duke Cosimo I

In the 1550s the Florentine painter and architect Giorgio Vasari (1511–74) first published his controversial (and entertaining) book *Lives of the Artists*. The book, which established the importance of an artist's biography in the Western academic discipline of art history, was substantially revised and republished in 1568. Having been apprenticed to Michelangelo, Vasari went on to spend most of his career under the patronage of the Medici Grand Dukes, including Cosimo I. Vasari's concept of artistic genius, as revealed in his *Lives of the Artists*, was to prove highly influential in enhancing the status of artists. Of his erstwhile master, Michelangelo, Vasari wrote this reverent account:

> While industrious and choice spirits ... strove to show the world the talent with which their happy stars and well-balanced humours had endowed them, ... the great Ruler of Heaven looked down and, seeing these vain and fruitless efforts, ... resolved, in order to rid him [humanity] of these errors, to send to earth a genius universal in each art, ... so that the world should marvel at the singular eminence of his life and works and all his actions, seeming rather divine than earthly.

For centuries to come, Vasari's description of Michelangelo provided artists with a touchstone from which they could promote the exalted status of the visual arts. The idea behind the book, that artists' lives were both interesting and worthy of attention, represented a fundamental change in the way artists were perceived in Italian society. And the prolific Vasari was not only a painter and architect, but also co-founder (with Cosimo) of the first academy of the fine arts in Europe, Florence's Accademia del Disegno. Modeled on Ficino's fifteenth-century Platonic academy, the Accademia del Disegno was dedicated to providing an institutional framework through which Renaissance artists would be professionally recognized. While still beholden to the rich and powerful, artists were succeeding in breaking away from the medieval system of anonymous labor. Vasari probably had more than an inkling that the future of European art would be dominated by such academies and that his *Lives of the Artists* would endure.

New Ireland

Far away from Renaissance Italy, we now look briefly at the different practices of artistic patronage associated with ceremonial arts on the South Pacific island of New Ireland, now part of Papua New Guinea. For centuries the islanders have performed a ceremony called *malagan*, which combines a memorial festival for the recently deceased with an initiation ritual for young men. It features a series of carved wooden sculptures, the design of which combines anthropomorphic with complex abstract elements ▶ **fig. 5.37**. For the duration of the ceremony, the brightly painted sculptures are placed in an enclosure that is also home to ancestral remains. The spirits of the deceased are thought to reside in some sculptures.

The system of artistic patronage that developed around the *malagan* ceremony is unknown anywhere else. In order for sculptors to make one of the commemorative works, they must first "rent" the right to use certain traditional imagery. Historically, specific families own the rights to each type of *malagan* sculpture, and the artist is free to make a specific sculpture only after paying for the privilege. The sculptures are not preserved after the ceremony, but are either burned or left to disintegrate. This leasing

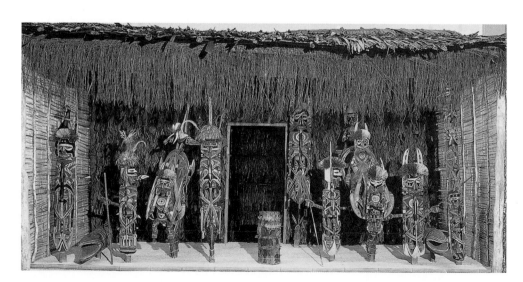

5.37 *Malagan* tableau, New Ireland, Melanesia. Bamboo palm, crotan leaves, and painted wood, 8ft 6ins × 16ft 6ins × 10ft. Museum der Kulturen, Basel.

RIGHT **5.38** Tatanua Mask, New Ireland, Papua New Guinea. Wood, fiber, shell, lime, feathers, height 1ft 5½ins. Otago Museum, Dunedin.

system does not limit the artist's ability to exercise creative control over his work, because the lease outlines the subject matter only in broad terms. *Malagan* sculptures therefore show a tremendous range of stylistic innovations even while maintaining ritual specificity.

These economic roles are somewhat reversed in the *malagan* dance known as Tatanua. For this ceremony, the artists control the production of ritual objects, because the dancers generally "rent" the masks from the sculptors who created them. The masks are worn by young male dancers whose movements celebrate the strength, aggression, and vigor of warriors in the prime of life ▶ **fig. 5.38**. In vibrant colors, the masks also feature a long row of hair running up the middle of the head, akin to the "Mohawk" style.

Two Patrons: Akbar and Louis XIV

This consideration of patronage ends with brief accounts of two major patrons of the arts, one in Asia and one in Europe, both of whom influenced the production of art for many centuries after their reigns: the Mughal emperor Akbar (1556–1605) in northern India and Louis XIV, King of France (1643–1715).

Akbar

In 1526 the Mughal leader Babur (r. 1483–1530), who traced his ancestry back to the conquerors Timur and Genghis Khan, established an empire throughout much of India. The Mughals were Muslims from Central Asia who conquered the Hindu peoples of northern India and synthesized a new culture out of both traditions. Babur's descendants, especially his grandson Akbar, were determined to create a cosmopolitan capital rich in the visual arts in order to enhance his empire's prestige. Akbar's father, the emperor Humayan (r. 1530–56), had previously assembled a small group of Indian artists and appointed Persian painters as leaders and teachers, so, with Akbar's expansion of imperial patronage, the painting of the Mughal court combined elements of both Persian and Indian traditions. The resulting work is powerful in its depiction of narrative and complex in its tension between linear and dimensional elements. Mughal architecture, including the palace complex at Fatehpur Sikri, represents a similar sophisticated blend of disparate aesthetic traditions.

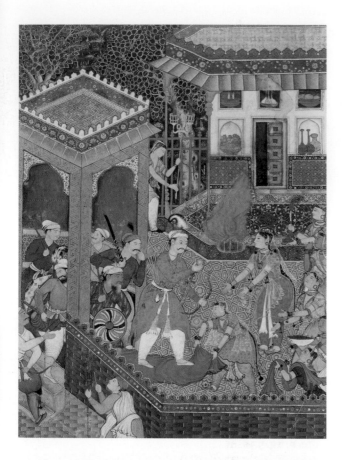

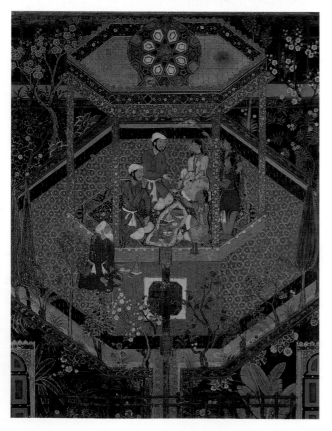

One of the most important institutions of the court was the painting academy, part of the imperial library. Overseen by Akbar himself, the academy employed 145 Hindu and 115 Muslim painters at its height. Artists were remunerated on a military pay scale that was continually adjusted to reflect their level of achievement. According to Abul Fazl's biography of the emperor: "Each week, the several superintendents and clerks submit before the emperor the work done by each artist, and His Majesty gives a reward and increases the monthly salaries according to the excellence displayed." At the academy, artists were grouped by particular talents, such as drawing, and by acquired specialties in illustrating certain themes. Because many of the paintings were intended to illustrate manuscripts, painters were expected to develop skills in certain types of subject matter (battles, court life, and so on). Works of art were generally collaborative, with one artist producing the contours in Indian red over a white priming coat, while a second would fill in the color; sometimes a third artist who specialized in portraiture would add the faces, especially if the scene illustrated the emperor or other prominent members of the court.

Two of the most important works of the imperial academy were the illustrated manuscripts *Hamzanama* and the *Akbarnama* (the suffix *-nama* means "history of"). Amir Hamza, a legendary figure based partly on an uncle of Mohammed, was much admired at court. The artists of the *Hamzanama*, overseen by the Persian painter Abd-us-Samad, painted more than 1,400 pictures during fifteen years of work in order to dramatize the life of Hamza and his family. The image of *Senowbar Banu* ▶ **fig. 5.39** shows a red carpet being placed in front of two victorious warriors. Note the tension between the two-dimensional planes of color and unmodeled figures, and the sense of three-dimensional space created by the architectural elements. In *Rustam and Mihrufuz Converse in a Garden Pavilion* ▶ **fig. 5.40**, the image is divided into three registers that are stacked vertically, a typical compositional device in Mughal manuscript illuminations. The central register features the main scene. Here, Hamza's family is portrayed sitting in a pavilion surrounded by nature.

ABOVE LEFT **5.39** Unknown, *Heroes Being Given Refuge By Senowbar Banu and Omar*, folio from the *Hamzanama* (Tales of Hamza), c.1570. Opaque watercolor and gold on cloth, 2ft 7ins × 2ft7⁄8in. Los Angeles County Museum of Art.

LEFT **5.40** Anonymous, *Rustam and Mihrafuz Converse in a Garden Pavilion*, from the *Hamzanama*. Paint on cloth. Victoria and Albert Museum, London.

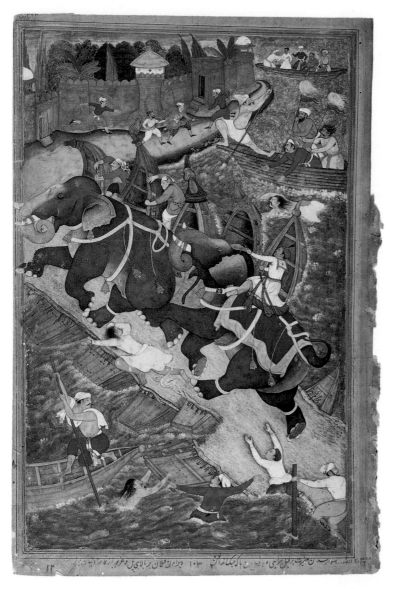

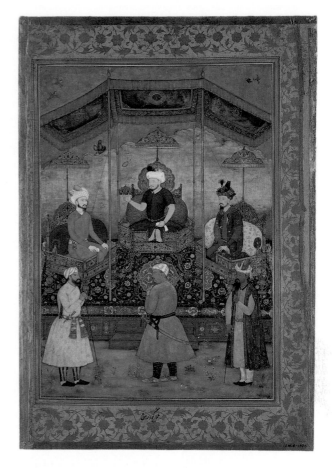

5.42 *Timur Hands his Crown to Babur*, from the Minto Album (inscribed 'The work of Govardhan'), c.1630. Gouache on paper, 11½ins × 8ins. Victoria and Albert Museum, London.

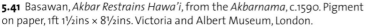

5.41 Basawan, *Akbar Restrains Hawa'i*, from the *Akbarnama*, c.1590. Pigment on paper, 1ft 1½ins × 8½ins. Victoria and Albert Museum, London.

Akbar's adventurous exploits were vividly captured by the artists of the *Akbarnama*. The scene *Akbar Restrains Hawa'i*, for example, shows the emperor riding his favorite elephant, named Hawa'i ▶ **fig. 5.41**; the elephant is rutting and therefore dangerous and unpredictable in his behavior toward other elephants. Hawa'i, with the emperor guiding him, is chasing the other elephant across a rickety pontoon bridge. The scene glorifies Akbar's courage and poise at a perilous moment.

Artists at the imperial court were also instructed to pursue the art of portraiture, with the focus on creating accurate likenesses of the sitter. The Mughal emperors always emphasized their exalted ancestry, which included Timur and Genghis Khan. The portrait of Timur shown here ▶ **fig. 5.42**, is a fine example of imperial portraiture designed to emphasize this lineage. Scholars often doubt the accuracy of the titles of

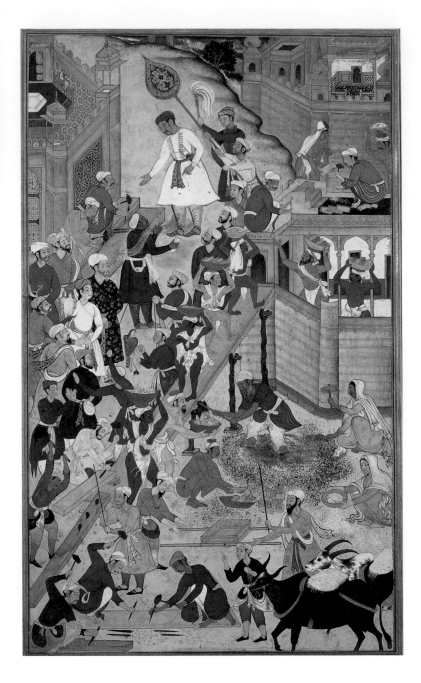

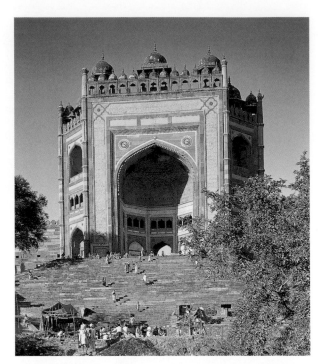

LEFT **5.43** Basawan, *Akbar Overseeing the Construction of Fatehpur Sikri*, from the *Akbarnama*, c.1590. Pigment on paper, 1ft 1½ins × 8½ins. Victoria and Albert Museum, London.

ABOVE **5.44** Buland Darwaza gate, Jama Masjid, Fatehpur Sikri, India, 1569.

these portraits; this one may have been retitled so that a minor prince at some later date became the great leader Timur, thus enhancing the picture's value.

In 1569 Akbar decided to move the court about 20 miles outside the capital of Agra to a new city, Fatehpur Sikri (called the City of Victory, it was abandoned in 1584 in favor of Lahore, apparently because of a problem supplying it with fresh water). The emperor chose this site for a new capital in order to celebrate the life of the Muslim saint Shaikh Salim Chishti, who had correctly predicted the birth of Akbar's heir, Jahangir. At Fatehpur Sikri, Akbar established a new court complex built of red sandstone. In this image from the *Akbarnama*, the emperor is shown overseeing the construction of the

5.45 View of central throne column, Divan i-Khass, Fatehpur Sikri, India, 1570s.

city ▶ **fig. 5.43**. Aesthetically, Fatehpur Sikri shows the same synthesis of Muslim and Hindu styles that is typical of Mughal painting. Terraced balconies of Hindu origin stand comfortably next to domes inspired by Muslim architecture. The ceremonial entrance to the city was called the Gate of Victory, or Buland Darwaza ▶ **fig. 5.44**. Flanked by enormous statues of elephants, it symbolizes the power and stability of the emperor. Among the most spectacular buildings is Akbar's audience hall, the Divan i-Khass ▶ **fig. 5.45**. In its center stands a carved column, like a minaret, surmounted by a circular throne upon which Akbar would sit to receive supplicants.

Louis XIV

Louis XIV, who came to the throne in 1643, was the first French king to break the power of the nobility and centralize the administration of the state in his own hands. His lavish patronage and authoritarian control of the arts proved influential throughout Europe, as his court set the standard for how art should function in the service of the government.

The Royal Academy of Painting and Sculpture was first established in Paris in 1648 under the patronage of the king's advisors Chancellor Séguier and Cardinal Mazarin, at a time when the king was only ten years old. Modeled on Italian academies, it aimed to give French artists the opportunity to pursue the ideals of the Classical tradition of the Greeks, Romans, and the Italian Renaissance. In quick succession, Louis XIV was instrumental in establishing like-minded academies of science, architecture, and music, as well as the Paris Observatory. Under the leadership of Charles LeBrun (1619–90), the painting academy set out to establish an atelier with royal patronage, allowing artists to work for the king outside the control of the guild system. The academy's importance increased substantially after 1662, when LeBrun became a favorite of Louis XIV and was given new authority to manage the production of art for the good of the king. In an address to the academy, Louis XIV explicitly stated its purpose: "Gentleman, I am entrusting you with the most precious thing on the earth, my fame." In 1666 he established a satellite academy in Rome in order to enable artists to study the Classical tradition and the Renaissance. The rigorous curriculum at the Paris academy was codified, centering on the completion of years of complex drawing exercises and copying of older artworks. Biannually, an exhibition was held in the Palais du Louvre, at which the members of the academy displayed their work in the hope that the government would buy it.

5.46 Charles LeBrun, *The Family of Darius Before Alexander*, c.1660. Oil on canvas, 5ft 4½ins × 15ft 1in. Châteaux de Versailles et de Trianon.

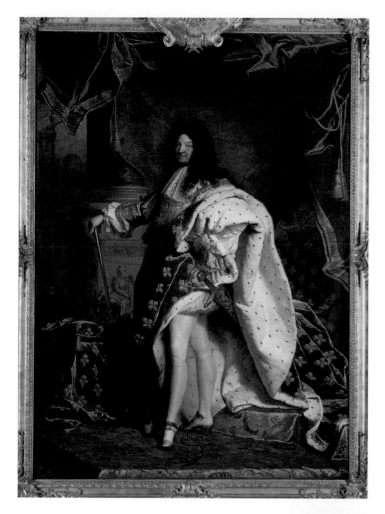

For over two hundred years, the academy represented the only route through which an artist could achieve a successful career in France. Its professors believed that the Classical tradition had established a clear hierarchy of painting subjects, with narrative history painting at the pinnacle. For this reason, only the top artists were allowed to pursue large-scale history paintings, in a style exemplified by Charles LeBrun's first royal commission, *The Family of Darius Before Alexander* ▶ **fig. 5.46**. The Hellenistic general and emperor Alexander was one of Louis XIV's favorite historical figures. This painting focuses on Alexander's beneficence, as he pardons the family of the conquered Persian general Darius III. It draws on the Renaissance tradition of strong drawing and design (*disegno*), with its storytelling based on a language of gesture and facial expression (LeBrun would later write a book codifying specific expressions to show each emotion).

Portraiture was also a steady source of commissions for the artists at the academy. Hyacinthe Rigaud's *Louis XIV* ▶ **fig. 5.47**, for example, shows the king in a ballet pose that accentuates his calves. Louis XIV was an excellent dancer and designed a type of high-heeled shoe for men that became immensely fashionable at court.

ABOVE **5.47** Hyacinthe Rigaud, *Louis XIV*, 1701. Oil on canvas, 9ft 1in × 6ft 4⅜ins. Musée du Louvre, Paris.

RIGHT **5.48** Garden Façade of the Palace of Versailles, Versailles, France, 1661–88.

5.49 Garden with Apollo Fountain and canal at the Palace of Versailles, Versailles, France, 1688.

In 1682 Louis XIV moved his court to a new palace about 20 miles outside Paris, in the small village of Versailles. The king's architectural board, made up of Louis Le Vau, J. H. Mansart, and LeBrun, were still overseeing the construction of a vast new complex ▶ **fig. 5.48** (begun in 1661 and completed 1688). At Versailles, Louis XIV consolidated his power by gathering the French nobility together, away from Paris, under his watchful eye. The palace provided a space for the entire court, as well as demonstrating the centralized control of the monarchy. Its architectural style shows the same concern for a Classical aesthetic as the standardized painting of the academy. The extensive gardens, designed by André Le Nôtre (1613–1700), also display the symmetry and logical order of a Classical manner, with nature, like the kingdom, firmly under control ▶ **fig. 5.49**.

Most royal courts in Europe attempted to emulate the model espoused by Louis XIV, the "Sun King." Many years and many rulers would pass before artists were able to break away from the control of government institutions.

Further Reading

E. Barker, et al., *The Changing Status of the Artist* (New Haven, 1999), part 1, pp. 27–102

R. Barnhart, et al., *Three Thousand Years of Chinese Painting (The Culture and Civilization of China)* (New Haven, 1997), pp. 87–138

R. Berger, *A Royal Passion: Louis XIV as a Patron of Architecture* (Cambridge, 1997), chapter 10, pp. 107–142

M. Blackmun Visonà, et al., *A History of Art in Africa* (New York, 2001), pp. 310–325

M. Brand and G. Lowry, *Akbar's India: Art from the Mughal City of Victory*, exh. cat., Asia Society Galleries (New York, 1985), chapter 2, 35–56

A. D'Alleva, *Arts of the Pacific Islands* (New York, 1998), pp. 70–79

P. Duro, *The Academy and the Limits of Painting in Seventeenth-century France* (Cambridge, 1997)

P. Girshick Ben-Amos, *The Art of Benin* (Washington, D.C., 1995), pp. 20–36

D. Kent, *Cosimo de Medici and the Florentine Renaissance: The Patron's Oeuvre* (New Haven, 2000)

D. Mateer, *Courts, Patrons, and Poets* (New Haven, 2000), pp. 3–18

J. Rawson, *The British Museum Book of Chinese Art* (London, 1997)

S.P. Verma, *Art and Material Culture in the Paintings of Akbar's Court* (New Delhi, 1978), pp. 7–26

Source References

p. 130 "What is the right thing to do …"
C. Hucker, *China's Imperial Past An Introduction to Chinese History and Culture* (Stanford, CA, 1975), p. 78

p. 134 "Anyone who talks about …"
Su Shih, quoted in J. Cahill, *Chinese Painting* (Geneva, 1960), p. 91

p. 149 "I know how, when a place is …"
Leonardo, in *The Italian Renaissance Reader*, ed. J. Conaway Bonadella and M. Musa (London, 1987), p. 187

p. 149 "Let no man …"
Ibid., p.194

p. 157 "While industrious and choice spirits …"
Vasari, *Lives of the Artists*, trans. J. Conaway Bonadella and P. Bondanella (Oxford, 1991), p. 414

Discussion Topics

1. How did literati and Chan Buddhist artists challenge the status quo in China?

2. What was the influence of poetry on Chinese and Italian Renaissance artists?

3. What were the skills that Alberti wanted Renaissance artists to learn?

4. How did the professional status of the artist change during the Renaissance?

5. Why is narrative painting so important to patrons such as Louis XIV?

6. What was the influence of the academic institutions discussed in this chapter on the role of the artist?

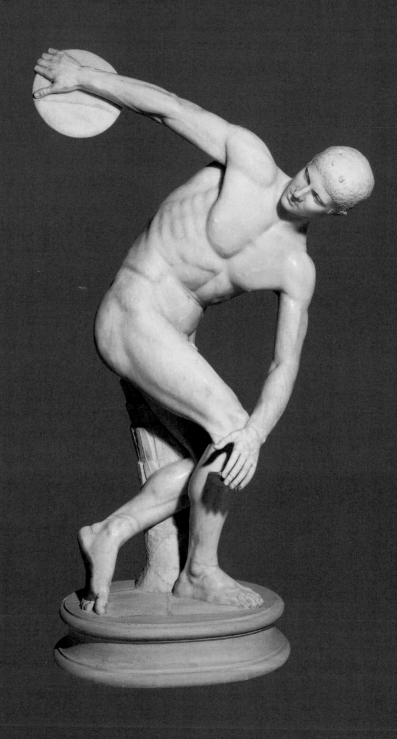

Art and Collecting

The history of art is the history of the appreciation and collection of the art object. This chapter examines two broad types of art collection. First, those made by collectors who commission objects to suit their taste. Second, collections formed by the selective purchase of pre-existing objects such as antiques, contemporary crafts, and so on. This second type may reflect a collector's personal taste as much as does the commissioned collection, but other factors, such as the collector's public image or financial speculation, tend also to play a part. That art, whether commissioned for private or public purposes, is something that can be collected as a sign of social status has had a considerable influence on the making of art and the writing of art history. And it is a fact that countless artworks have been preserved simply because of their place within a collection.

Works of art were among the earliest "collectibles." Much of what is known about Greek art, for example, is derived from the Romans who collected Greek sculpture as part of the plunder from their conquests of the Mediterranean area. Indeed, the Romans took the best artwork from all over their empire back to the capital, making Rome an enduring center of classical artifacts. Many original Greek statues have been lost, such as the famous fifth-century BCE bronze *Discobolus*, or "Discus Thrower," by Myron. It is known only through the collection of differing marble versions found in or near Rome ▶ **fig. 6.1**, all of which date from at least a century after the creation of the original. Restoration of the broken parts of the *Discobolus* became a controversial subject among eighteenth-century collectors who disagreed on the original position of the figure: some copies have the head facing downward rather than back as in the version illustrated here.

A renewed fashion for collecting antiquities flourished from the eighteenth century onward, creating the need for "experts" to identify and date the objects. Aristocratic patrons sponsored catalogs of engravings that documented various collectors' holdings for the sake of

comparison, read articles positing theories about the subject matter of classical sculpture and painting, and encouraged scholars to devise systems for dating and measuring the quality of artworks. One of the results was the rise of a new academic discipline, art history.

6.1 Myron, *Discobolus*, Roman copy of a c.450 BCE Greek bronze original. Marble, height 5ft 1in. Museo Nazionale delle Terme, Rome.

Key Topics

The role of collectors and collecting in the history of art. Collections founded on both commission and purchase.

▶ Aristocratic commissions: medieval European commissions of illuminated manuscripts acted as visible demonstrations of status.

▶ Commercial prosperity: the mercantile middle-class amassed collections, many inspired by the new spirit of scientific enquiry, especially in the Netherlands (c.500–1750).

▶ Treasures of the past: well-born Enlightenment travelers in Europe brought examples of ancient art home; many of these private collections later formed the basis of national museums.

▶ Emulating Europe: nineteenth-century American industrial barons started important collections of their own, some of which are open to the public today.

▶ Collecting by force: war provides an opportunity for the victor's cultural enrichment through looting.

▶ Cross-fertilization: artists benefit from collecting, as seen in the influence of Japanese prints on nineteenth-century French art, and of Europe on Japan.

▶ Profit: the rise of the modern art market and a new kind of collector.

Commissioning Illuminated Manuscripts

During the Middle Ages in Northern Europe, royalty continued the tradition of Roman aristocrats by exchanging rare and valuable gifts. These objects formed the basis of the collections of ruling families. Books were among the household and decorative objects most often presented. Members of the Valois dynasty (1328–1589) in France were particularly avid bibliophiles. They used books to support their claims to legitimacy as successors of the Capetian kings (987–1328), to profess their knowledge of classical texts, to reinforce their appearance as pious Christian rulers, and to record the luxury and ritual by which they lived their privileged lives. Few people in the Middle Ages could read, so series of narrative pictures, or cycles, that could tell the story contained in the text played a vital role in transmitting the message of the books, whether they were religious or politically propagandistic in content.

The official chronicle of the kings of France, the *Grandes Chroniques*, was begun by Philip III (r. 1270–85) at the abbey of St. Denis to document the life of his pious father, Louis IX (r. 1226–70), who was canonized St. Louis in 1297. His descendants claimed the title of "the most Christian of kings" and, by the time of the Valois dynasty, Louis IX had become a symbol of the French kings' ability to merge religion and politics. The third Valois king, Charles V (r. 1364–80), reinforced his associations with his illustrious forebears by having a copy made of the chronicles to add to his collection. Yet it was not an exact copy: Charles V had changes made to make the French kings appear at their best in history and to support the legitimacy of the Valois line. There are many other instances throughout history where collectors changed the artworks they collected to better fit their notions of why they valued them.

In Charles's *Grandes Chroniques* one cycle illustrates the life and legend of St. Louis. Another introduces the events of Charles's own reign: it includes a full-page miniature designed to project a sense of court luxury and royal hospitality ▶ **fig. 6.2**. A central group of figures is set against blue fleur-de-lis canopies. Charles V (far left) entertains the Holy Roman Emperor Charles IV (center)

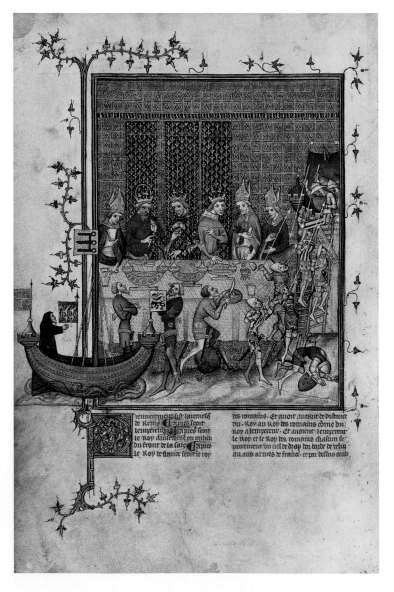

6.2 Scene showing a state dinner, folio 473v, from the *Grandes Chroniques de France*, 1378–80. Manuscript, 7½ins × 7½ins. Bibliothèque Nationale, Paris.

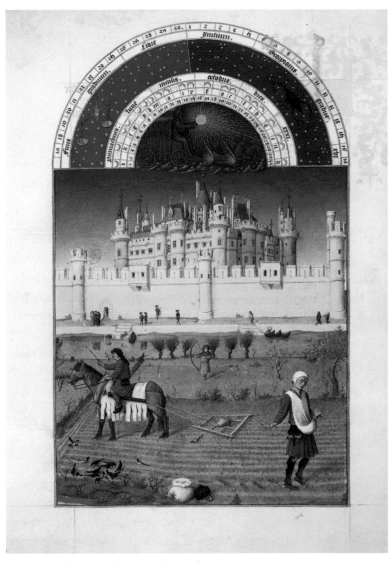

6.3 The Limbourg Brothers, *October*, scene showing sowing the winter grain, from the *Très Riches Heures*, c.1413. Vellum, 8¾ins × 5⅚ins. Musée Condé, Chantilly.

with his eldest son, Wenceslas (right), in the grand hall of the Palais de la Cité in Paris at a state dinner held in 1378. The background is covered by a dense textile pattern, which flattens the space and enriches the decorative quality of the page. On the right, a troupe of actors re-creates the siege of Jerusalem from the First Crusade (1095–99), a scene that might refer to the French king's role in future crusades. Although these characters and props are in the foreground, they are represented in hierarchical scale, and thus appear smaller than the leaders behind the table. The whole scene is set within vine leaves like a huge decorated initial from early medieval manuscripts. The book's lavish display of precious materials, including gold, was intended to draw attention to the dynasty's wealth and the tireless labor of its artists.

Charles's brother Jean, Duke of Berry (1340–1416), also had many elaborate manuscripts made for his formidable library. The most famous are his numerous Books of Hours, prayer books intended for use at home each day, including a calendar of feasts of the year accompanied by richly detailed illustrations of the twelve months. The *Très Riches Heures*, or "Very Rich Hours," around 1413 by the three Limbourg brothers; Paris was attracting ▶illuminators◀ from all over Europe at this time, and these painters were particularly renowned for their attention to minute detail in translucent, glowing colors.

The miniature for the month of October in the *Très Riches Heures* shows the Duke of Berry's view of the Palais du Louvre from his residence in Paris ▶ **fig. 6.3**. It is so precise in detail that architectural historians have used it to produce models reconstructing the lost building. The reflective surface of the water with shadows cast upon it is rendered by a combination of pigment and silver gilt. In the foreground are the fields that still surrounded Paris at this time, showing the peasants whose work supported the lifestyle of the royal residence. At the time of this commission, the Hundred Years' War between France and England was raging and, in addition, in 1413 the people of Paris rose up in rebellion against the policies of Charles V's brothers (including the Duke of Berry) who were ruling as regents behind the throne of his young son,

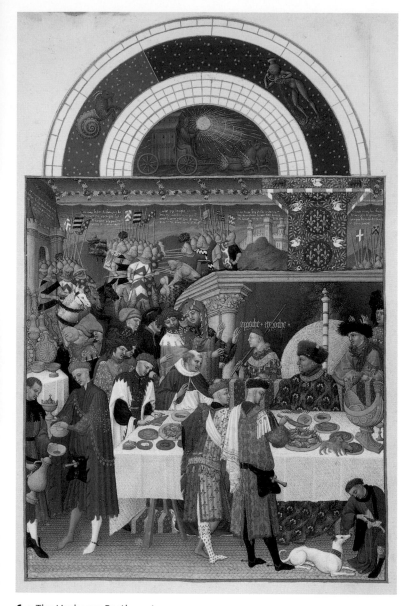

6.4 The Limbourg Brothers, *January*, scene showing banquet, from the *Très Riches Heures*, c.1413. Vellum, 8¾ins × 5⅝ins. Musée Condé, Chantilly.

Charles VI. In tune with the intended contemplative use of devotional books, this idyllic scene of October harvest creates a view of contemporary life far removed from the world of political intrigue.

For January, the artists produced a scene of a banquet crowded with people and a rich array of objects from Jean's personal collection ▶ **fig. 6.4**. The duke is seated to the right of center in a heavily patterned garment against a carpeted banquette, both executed in the two most expensive pigments, blue and gold. All the details eloquently profess Jean's love of luxury: the heavy gold chain and pendant around his neck; the fur hat on his head; above, the cloth of honor with his coat of arms; the huge, busy tapestry covering the walls behind; the carved capitals on the fireplace opening; the dog in the foreground; the lavishly dressed servers and courtiers, some taking out their knives to select from the mounds of food on golden plates; the giant ship-shaped *nef* (a functional vessel, probably a gift from afar); and the cupboard burdened with hanging vessels. The duke stands out against the fire screen, but everyone else is absorbed into the riot of color that would warm the coldest January.

Although the Duke of Berry's library included older books made by others, his own commissions enriched his collection with pictorial evidence of his lifestyle, family and associates, property and castles. His support also allowed the miniature painters of the day to improve their craft.

Netherlandish Collections

As the interest in collecting objects grew, so did the desire to make records of their form. Skilled illustrators often worked for scientists researching and cataloging plants and insects, for example. Artists found new patrons among wealthy merchants who wanted paintings of rich vessels, foods, antiques, or various symbolic objects. Some painters who collected such things included them in their own compositions. Certainly the widening interest in objects influenced the subject matter and symbolism of painting at a time when public appreciation for art was also increasing.

The port cities of the Netherlandish countries, largely untouched during the Hundred Years' War, developed into huge commercial centers during the fifteenth century under the Duke of Burgundy (the most powerful of Charles V's brothers and the one who acquired these lands through marriage). He encouraged long-distance trade and, throughout the next two centuries, the concomitant growth in seafaring exploration occasioned the collection, analysis, and cataloging of natural phenomena. Throughout Europe, flora, fauna, and natural treasures such as local shells and rocks as well as the exotic specimens from newly discovered lands abroad were displayed in "curiosity cabinets," or *Wunderkammer*. Possession of large collections served to represent the wealth, knowledge, and social status of the collector. In addition, scientific investigation intensified in response to the Protestant Reformation. Scholars began to look more to empirical observations than to divine dogma for the explanations of natural phenomena. The results were Dutch lenses for telescopes and microscopes and better trade routes through Dutch navigational advances.

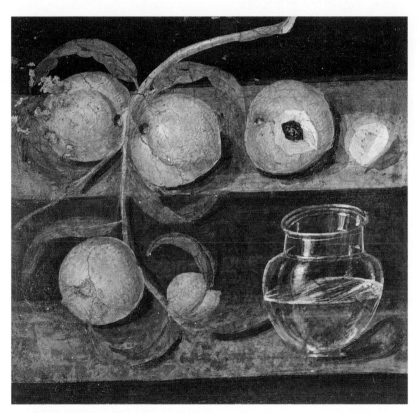

6.5 *Peaches and Glass Jar*, from Herculaneum, Italy, c.50 CE. Wall painting, 1ft 2ins × 1ft 2ins. National Archeological Museum, Naples.

By the seventeenth century, the Dutch were reveling in hard-won political and economic freedom after centuries of oppressive taxation and ravaging territorial wars under Burgundian, German, and Spanish dynastic houses. This change of circumstances meant secure housing and the accumulation of material possessions; full larders of imported foods were highly prized as symbols of independence and financial success. As an artform in Europe, the genre of "still-life" painting had gradually emerged in the Low Countries during the sixteenth century. Among its precursors, Greek and Roman wall painting had used illusionistic devices to suggest a continuation of real space, whether on dramatic stage sets or in household guest rooms, where items of food offered signs of welcome ▶ **fig. 6.5**; the technique of using ▸perspective◂ or ▸foreshortening◂ to achieve such effects is known as ▸*trompe-l'oeil*◂, or "deceive the eye." Such tricks can be seen in contexts ranging from medieval book illuminations with detailed botanical borders to Renaissance altarpiece doors rendered as ▸illusionistic◂ cupboards. Fifteenth-century Northern European altarpieces focused on mundane, everyday articles as paths to understanding the presence of God in all the things of this world. Moral lessons were inherent in this tradition, known as *devotio moderna*—thus, for instance, realistic flower paintings could bring beauty into the domestic sphere even as they commented upon the temporal quality of all living things. The Dutch Republic's growing merchant economy could be recorded in ▸still-life◂ compositions of objects and luxury goods found within the homes of newly affluent middle-class people who were able to profit from the thriving exchange of merchandise. Such a genre, centering

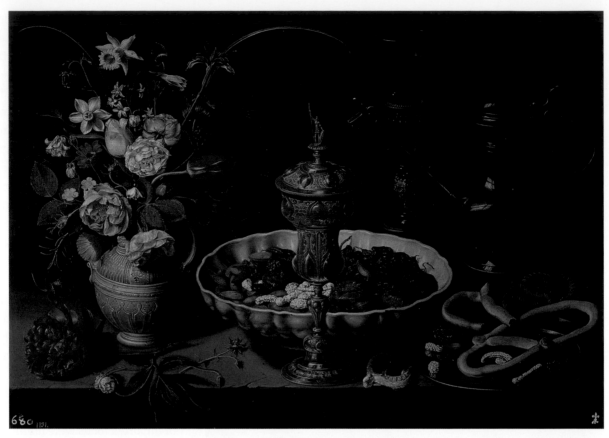

6.6 Clara Peeters, *Breakfast Piece*, 1611. Oil on panel, 1ft 8½ins × 2ft 4¾ins. Museo del Prado, Madrid.

on easily available subject matter, appealed to male as well as female painters; the artist could work at home on small canvases and sell them at reasonable prices to the new middle-class market.

The rise in sales of still-life paintings, including flower compositions, provided an opportunity for women to become professionally recognized as artists, something quite rare before this period. Women had first practiced the still-life genre when they were employed as illuminators to color botanical books. As the flower industry grew with the increasing European thirst for scientific observation, colonial importation, and exotic curiosity collecting, women's opportunities in the visual arts expanded. Equating the skills of accurate botanical representation with fine needlework, male artists were willing to grant female artists limited recognition as "decorative painters." Comparable with the realm of portraiture, still-life and flower images depicted the tiny details of domestic existence.

Women learned to paint from fathers, brothers, and husbands, often as they were assisting them in their own painting by mixing pigments or filling in skies and backgrounds for them. Working from subjects in their own homes made their craft possible as women were denied all other training or, for example, access to nude models. A few women were well positioned to take advantage of the situation.

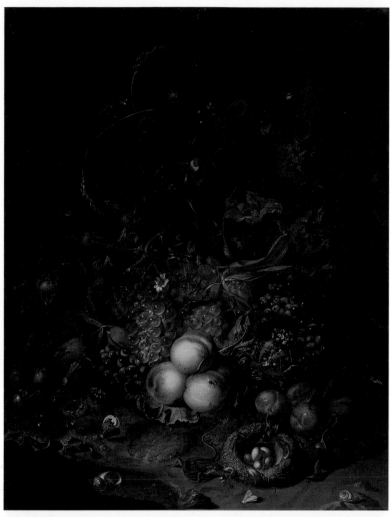

6.7 Rachel Ruysch, *Flowers, Fruit, and Insects*, 1716. Oil on canvas. Palazzo Pitti, Florence.

One of the earliest, Clara Peeters (active 1611–21), was a Flemish painter born in Antwerp whose work codified in visual form the popular sixteenth-century fascination with object collecting. Her work includes the earliest examples of still-life compositions based on "meal themes," such as the fish piece, the game piece, and this *Breakfast Piece* ▶ **fig. 6.6**.

The elements of Peeters's *Wunderkammer* imagery, marvels of nature and human artisanship, are matched by her capacity to render visual and tactile qualities in paint. She often added a self-portrait in the reflection of a shiny vase or goblet. These works are key products of Peeters's time and place: she advertises her skills at the same time as indicating her gender, a combination sure to evoke interest. Signing her works at the age of only fourteen, Peeters stands as the first known professional female still-life painter in an enduringly popular tradition.

The market for still-life paintings corresponded to a new access to luxury or semi-luxury goods on the part of individuals at all income levels as well as a fascination with detailed realism. The objects depicted were chosen to feed buyers' love of rich materials with exquisitely worked precious metals, porcelain, hybrid flowers, and exotic natural objects such as sea shells, olives, and artichokes. Even if they did not own such things, they could hang realistic renditions of them on their walls. In some cases, collecting reached fever-pitch in seventeenth-century Holland, as in the fashion for collecting tulip bulbs (now called "Tulipmania"), when whole fortunes were made and lost over the purchase and cultivation of the flower during the 1630s. The market was driven to impossibly high prices through speculation and sales on bulbs still in the ground, on the search for the elusive black tulip, and on land purchases for growing flowers. Although the government attempted to regulate trading, it was unsuccessful against the attraction of quick riches and the desire to own the rarest specimens. The crash came in 1637 when sales faltered and panic caused sellers to flood the market.

Flower compositions became a specialty among still-life painters. One of the leading exponents of the genre was Rachel Ruysch (1664–1750), who produced at least 100 works of this kind; another 130 have been attributed to her. She usually incorporated elaborate details of insects, reptiles, and small mammals, learned from her father who was a professor of botany and anatomy ▶ **fig. 6.7**. This approach reflects the Dutch preference for "naturalia," a category used to denote specimens in collections of insects, shells, fossils, and so on. Ruysch used artistic license in choosing to group her

6.8 Maria van Oosterwyck, *Vanitas (Still Life)*, 1668. Oil on canvas, 2ft 5ins × 2ft 11ins. Kunsthistorisches Museum, Vienna.

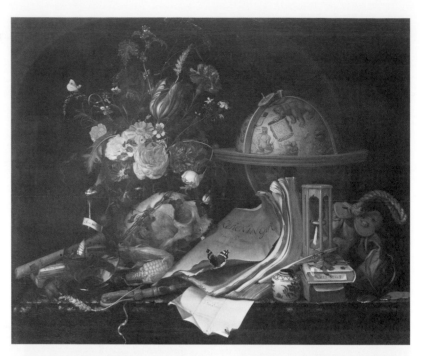

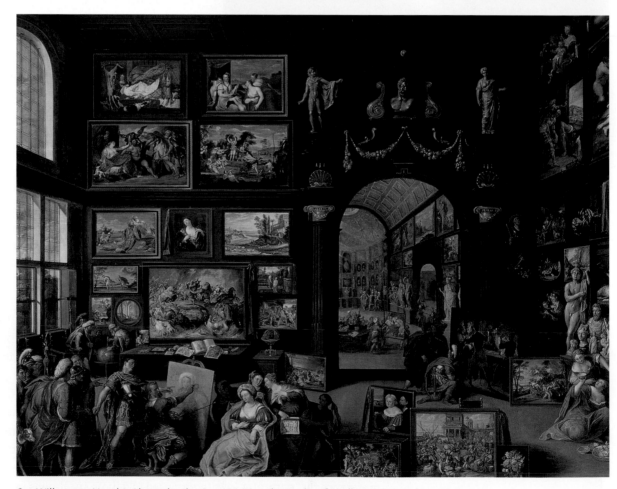

6.9 Willem van Haecht, *Alexander the Great Visiting the Studio of Apelles*, 1628. Panel painting, 3ft 5³⁄₈ins × 4ft 10⁵⁄₈ins. Royal Cabinet of Paintings, Mauritshuis, The Hague.

subject matter in botanically impossible situations: flowers that bloom in different seasons are arranged together, or they might appear in the painting at the same time as their fruit.

Ruysch was directly concerned with scientific observation (however loose its application), and many of her works were commissions to record the select flower hybrids of her wealthy customers. At the same time, many sober Dutch Protestants saw moral symbolism in the brevity of beauty and pleasure. An outgrowth of *devotio moderna* notions, images of flower, fruit, and empty shells were interpreted as recording brief lives mirroring the temporality of all on earth, while the hourglass, pipes, and musical instruments show the impermanence of entertainment—hence the label *vanitas*, "vanity" ▶ **fig. 6.8**. Still-life paintings became popular on the open market as reminders among the industrious Dutch middle class that pleasurable activities used both money and time better spent in work.

Artists producing works under commission also recorded patrons' extensive collections of the latest fashionable objects. Some of the more successful artists became so wealthy that they were able to establish large art collections themselves. As a hugely successful artist, the Flemish painter Peter Paul Rubens (1578–1640) invested much of his earnings in the acquisition of both antique and contemporary art. Rubens collected for several reasons, not only to raise his social status, but to supplement his income, to support his diplomatic career, and to further his art practice. Rubens's own painting shows the influences that collecting had on his compositions, while his artistic interests naturally dictated some of his collecting habits. He is exemplary for this chapter: he made paintings desired by other collectors; his home became a huge exhibition space for his personal collection; and the art he collected influenced or even appeared in his own work.

Born to a successful upper middle-class family, Rubens spent much of his career endeavoring to gain wealth and prestige for his family. He spent the years 1600–08 in Italy, absorbing elements from different European traditions into his artistic technique. By 1610 he had secured a reputation at the court in Brussels and was free to develop a large workshop of assistants, which substantially increased his income. In 1618 Rubens had acquired enough money to make a major purchase of over ninety antiquities from Sir Dudley Carleton, English ambassador to Venice at the time. In order to house his new collection, Rubens had an extension built on to his palatial home in Antwerp. This new gallery, called the "Pantheon" by the artist because of its circular shape and ceiling oculus (compare figs. 3.29–30), gave Rubens the type of collection—and exhibition— space that had previously been available only to nobility. Willem van Haecht's painting *Alexander the Great Visiting the Studio of Apelles* (1628) is thought to include a view of Rubens's Pantheon in the background on the right ▶ **fig. 6.9**. Showing the Greek warrior appreciating an artistic collection, the subject encapsulates the European view of collecting as an exalted, aristocratic endeavor.

A collaborative painting by Rubens and another Flemish painter, Jan Brueghel the Elder (1568–1625), ▶ **fig. 6.12**, shows what money could buy in the early seventeenth

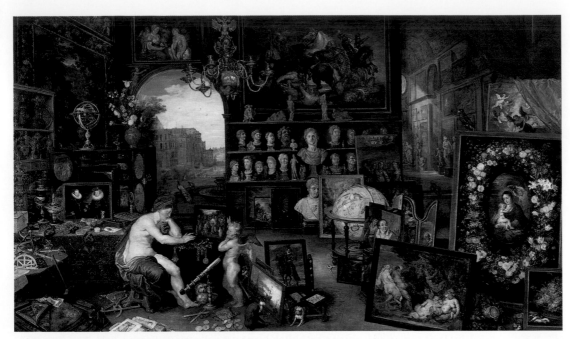

6.10 Jan Brueghel the Elder and Peter Paul Rubens, *Allegory of Sight*, 1617. Oil on panel, 2ft 1⅝ins × 3ft 7ins. Museo del Prado, Madrid.

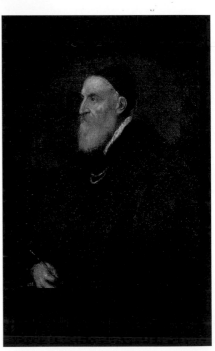

6.11 Titian, *Self-Portrait*, 1567. Oil on canvas, 2ft 9⅞ins × 2ft 1⅝ins. Museo del Prado, Madrid.

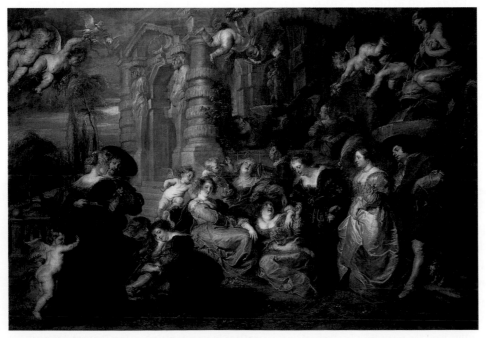

6.12 Peter Paul Rubens, *The Garden of Love*, c.1638. Oil on canvas, 6ft 6ins × 9ft 3⅜ins. Museo del Prado, Madrid.

century. Marble heads and paintings, gold vessels, coins and jewels, naturalia, and scientific instruments are displayed on shelves and in cabinets, as well as strewn across the floor, of a room which also offers an architectural vista and a view of a second room, equally filled. One of a series of five representations of the senses, the *Allegory of Sight*, with anachronistic aplomb, has Venus and her son, Cupid, in the center looking at a painting of Christ curing a blind man. Another collaboration between Rubens and Brueghel appears in the large framed painting to the right, the Madonna surrounded by flowers.

In 1626 Rubens sold a large selection of antiquities and other artworks to the English aristocrat George Villiers, Duke of Buckingham—probably an attempt to raise funds to buy other works for his own collection, but probably also a venture with diplomatic ramifications. As he was involved in negotiations between the monarchy in Spain and in England, it is thought that through this sale Rubens might have been trying to influence Buckingham to favor an English–Spanish alliance.

Having been ennobled by the court at Brussels in 1624, Rubens went on to receive a knighthood from Charles I in England and a landed title from Philip IV in Spain. Titian, the first artist to receive this honor, had been ennobled by the Spanish monarch and Holy Roman Emperor Charles V, and included his gold medal (an honorary knighthood from King Charles I) in a *Self-Portrait* ▶ **fig. 6.11**; Rubens bought this prestigious work for his own collection, which eventually included over three hundred works, including paintings by most of the masters of the Italian and Northern renaissances. Twenty-six of them are from Venice, all in the *colorito* style of which Titian was supreme master (see chapter 5). The impact of the Venetian approach to color on Rubens was strong, as can be seen in his late works. Having settled in a large château outside Antwerp, Rubens portrayed his own family at leisure in luxurious, yet pastoral, settings. His *Garden of Love*, for example, shows the artist leading his new bride, Helena Fourment, into an allegorical realm of decorous flirtation ▶ **fig. 6.12**. The painting includes the broad, painterly brushwork and complex graduated tones that caused the followers of *colorito* in France to become known as "Rubenistes." Images of aristocratic grandeur, such as the *Garden of Love*, would influence an entire generation of French artists in the eighteenth century.

The Grand Tour

During the eighteenth-century Enlightenment (see chapter 7), a rising interest in history and the origins of Western civilization spurred travel from Northern Europe to Mediterranean countries. It was considered essential education for young European gentlemen to travel to more "exotic" lands before settling down. Sons of English aristocrats would follow a prescribed path across the Continent to Eastern Europe in a journey of exploration that came to be called the "Grand Tour." Setting out to observe the surviving remains of the great civilizations of the past, these young men would cross the Channel to France and spend months on a broad cultural itinerary through Italy and Greece, perhaps going as far as Hagia Sophia in Istanbul (see figs. 3.39–41) or the pyramids in Egypt (see fig. 3.10). The "Wonders of the World" worked their magic on the imagination of this wealthy elite. Visits to such sites also made the tourists want to

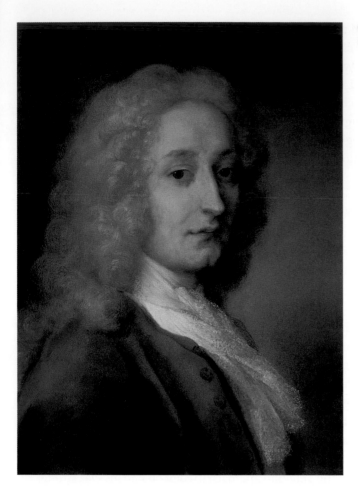

6.13 Rosalba Carriera, *Antoine Watteau*, 1721. Pastel. Museo Civico de Treviso.

take home evidence of their experiences in the form of souvenirs. Having large manorial halls to fill and boundless budgets, many an eighteenth-century nobleman began to collect ancient art or have drawings made of significant places and monuments, while others sat for their portraits by Italian painters to document their stay in the lands of classical culture. Some artists were kept busy year round with this trade, such as the portrait painter Rosalba Carriera (1675–1757) ▶ **fig. 6.13**. She was able to accommodate a large number of commissions by perfecting the ▸pastel◂ medium, a quick technique that lent itself to the portrayal of the soft, lacy, and rich clothing of well-dressed European gentlemen. Another painter who specialized in outdoor views (called *vedute*) of the most picturesque spots in Venice was Canaletto (1697–1768). His work was so popular with English tourists that he used the British consul as a sort of dealer. Many of his popular paintings were also engraved and sold in print editions, making them widely available for purchase ▶ **fig. 6.14**. Canaletto's scenes of Venice emphasize the light sky, varied architecture, and open expanses of water of this unique sea-bound city. He employed one-point perspective to portray the buildings lining the canals accurately, probably using a *camera obscura* (a box with a lens that casts a reflective image of the view, allowing the artist to trace it).

Probably the most famous souvenirs taken back to England from the Eastern Mediterranean are the marble sculptures from the Parthenon (see figs. 4.9–11). Claimed in 1801 by Thomas Bruce, 7th Earl of Elgin, while he was English ambassador to Turkey, the marbles were then under the control of the Ottoman Turks who had occupied Greece in 1453. The Parthenon had been partly destroyed by the Venetian bombardment of Athens in 1687, and the site was left in ruins, with many of the sculptures that had adorned the building now lying about on the ground. Art collectors of several countries were interested in their fate; in fact the French already had artists on the Acropolis drawing them *in situ*. However, Lord Elgin pestered the local authorities until they gave him permission to pack up the fragments and remove them to ships. He also dismantled large portions of the ▸entablature◂ to acquire the lion's share of both the Doric and Ionic friezes. Although one ship he purchased for transport sank with all these treasures, much of the best artwork made it back to his ancestral home. After

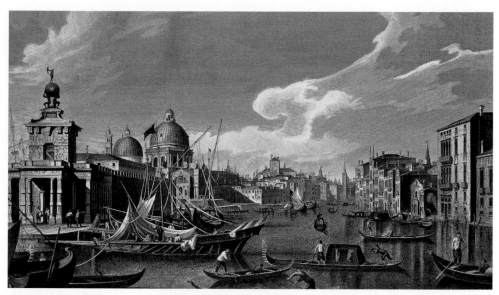

6.14 Visentini (after Canaletto), *Entrance to Grand Canal*, 1742. Engraving. Museo Correr, Venice.

long deliberations at the end of his life when he was ill and bankrupt, the British government purchased the entire collection in 1816. It is now housed in a special wing of the British Museum in London.

In 1829 Greece gained independence from the Turks and requested that the British return the "Elgin marbles," or Parthenon sculptures, to their home country. The controversy is still ongoing and the British government now maintains that the artworks were legally acquired and that returning them would set a precedent that could empty all museums with treasures from other countries. The case has garnered widespread interest. Was Elgin a thief who used the Turkish indifference to Greek treasures to feed his obsession for collecting? Or did he perform a service to art history by rescuing masterpieces that were deteriorating from neglect? Has the British Museum protected a priceless treasure for nearly two centuries, making it accessible to the world without charge seven days a week? Or did the conservators irremediably damage the works by scrubbing them free of all vestiges of original coloring in order to present them as the pure, white works that Victorians believed Greek sculpture to be? Controversy continues over Greek plans for a museum near the Acropolis that could hold the marbles, over a loan of the entire collection to Athens for the 2004 Olympics, and over numerous other Parthenon sculptures currently unseen in storerooms in Athens after removal in 1995 for restoration of the building. The ethics of collecting is an issue that is intrinsic to the study of art and that is further explored later in this chapter.

A more varied collection of antique sculpture, also housed in the British Museum, is in a gallery first opened in 1808 to display the collection of Charles Townley ▶ **fig. 6.15**. Townley was an avid collector who not only undertook the Grand Tour many times himself, but established business relations with British excavators, restorers, and

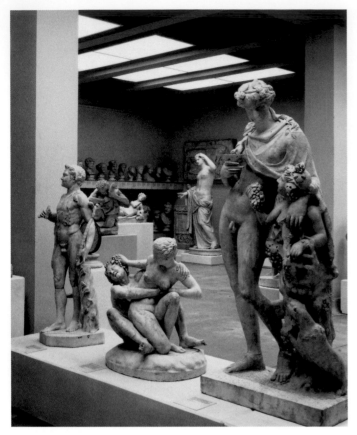

6.15 General view of the Townley collection, British Museum, London.

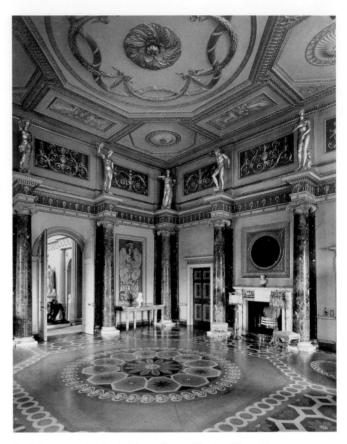

6.16 James and Robert Adam, the vestibule of Syon House, Middlesex, England, 1762–69.

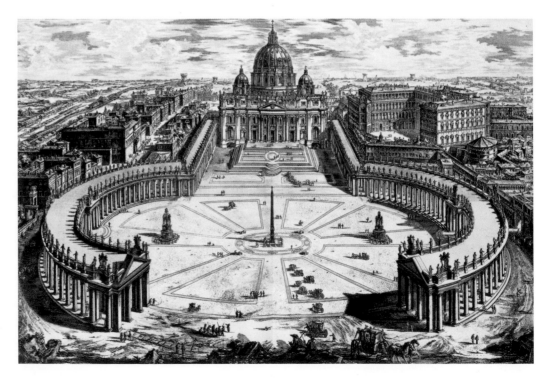

6.17 Giovanni Battista Piranesi, *St. Peter's Rome with the Colonnades and St Peter's Square*, c.1750. Copperplate engraving. Private collection.

dealers in Italy. They saved prized objects for him and often found ways to smuggle particularly valuable pieces through customs in ways that lowered his tariffs. Collectors like Townley, with their high level of financial investment, made the huge antiquities industry of this period possible. Townley housed his many hundreds of sculptures in a home much like the preserved Syon House ▶ **fig. 6.16**, a medieval and Jacobean building extensively remodeled by James and Robert Adam in the 'antique style' between 1762 and 1769 for the Duke of Northumberland. The interior was designed to complement a rich display of antique sculpture by providing simple, classically derived room decoration with open niches and wall surfaces. Townley competed with other active collectors and compiled catalogs of his holdings to increase the collection's value. He also purchased catalogs of works he did not own and ▸engravings◂ of sites from which his pieces had been taken, so that he could visualize

Winckelmann and the Origins of Art History

Johann Joachim Winckelmann (1717–68) was a German archeologist whose interest in art and literature led him to begin identifying the subjects of antique sculptures by linking them with classical texts. With scholarly rigor, he formulated lists of characteristics that could be used to aid in the determination of the themes of artworks. As many of the collectors who referred to his works were trying to establish the value of their own collections, Winckelmann also described the qualities of the "best" or "highest" classical art as a yardstick by which to measure the worth of unidentified finds. This resulted in an interpretation of Greek art of the fifth century BCE that elevated it to a pinnacle of appreciation during the Enlightenment and inspired the revival of classical architecture, a style later labeled Neoclassical.

Winckelmann's categories of art have determined the course of art history and the arrangement of museums ever since his book, the *History of the Art of Antiquity*, was published in 1764. He proposed a conception of art history as a continuous developmental cycle from primitive trials to highly accomplished masterpieces and back to weak or overdeveloped copies of the best work. His concentration on Greek Classical art (fifth century BCE) as the peak of achievement in the ancient world and the ideal against which to measure all art that came after is still at the root of Western art history.

Winckelmann's theories have been repeatedly challenged in the contemporary era by scholars who propose other explanations for the history of visual art.

them in their original settings; Giovanni Battista Piranesi (1720–78) produced hundreds of etchings that fulfilled such needs, especially of Rome ▶ **fig. 6.17**. Townley managed to obtain one of the copies of Myron's *Discobolus*, but the grain on the marble matched only if the head was made to face downward (see fig. 6.1). It worried Townley that this discrepancy with the earlier copy found in 1781 made his work less authentic. However, he had obtained the statue in spite of great pressure from Pope Pius VI to procure it for the Vatican collection; when the pope managed to secure another copy, the Roman restorer replaced the head to match Townley's version. Townley had the *Discobolus* added to a portrait of himself and his friends in the midst of his objects and catalogs ▶ **fig. 6.18** in a painting by Johann Zoffany (1733–1810) comparable with that by Brueghel and Rubens a century and a half earlier (see fig. 6.10). Townley's patronage extended to such scholars as Johann Winckelmann (see inset), whom he urged to help identify the unknown figures in artworks he purchased and authenticate their value as true antiques.

An even more eclectic collector of antiquities from all over the ancient world was the architect Sir John Soane (1753–1837). In 1813 and 1824 Soane purchased two adjacent houses in Lincoln's Inn Fields, London, to house his collection. He indulged his greatest architectural fantasies in remodeling the structures to include classical decoration, elevated ceilings, even a dome with a light well to the basement. Yet this space was barely large enough to contain all the Egyptian tomb finds, classical statuary, gems and cameos, contemporary painting, and other artworks he acquired. He left his house to the State on condition that no entry fee would be charged to visitors ▶ **fig. 6.19**. The collection on display at Sir John Soane's Museum still seems crammed into quarters meant more for people than for the monumental, often exotic, curiosities.

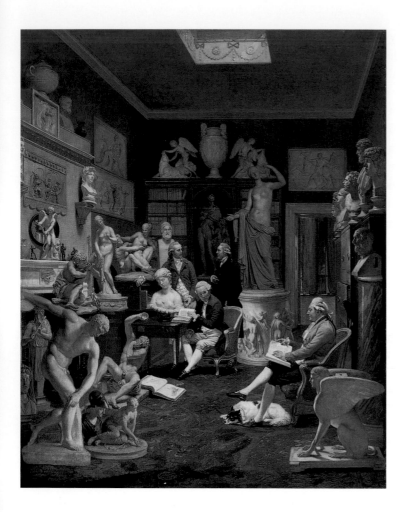

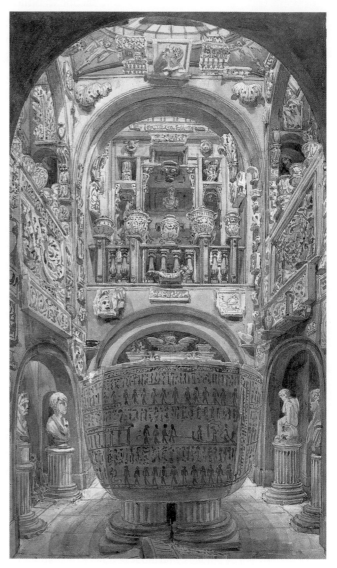

6.18 Johann Zoffany, *Charles Townley and his Friends in the Park Street Gallery, Westminster*, 1781–83. Oil on canvas, 4ft 2ins × 3ft 3ins. Towneley Hall Art Gallery and Museums, Burnley.

6.19 Joseph Michael Gaddy, view of the Dome area in Sir John Soane's Museum, seen from the crypt, with the sarcophagus of the Egyptian Pharoah, Seti I in the foreground, 1 September, 1825. Drawing. Sir John Soane Museum, London.

Elgin, Townley, and Soane were among the private collectors who would provide the resources for British cities to develop public museums. Unlike France (see p. 188, below), where public museums house treasures forcibly appropriated through revolutionary political policies, Britain slowly acquired public collections through the donation or purchase of private estates. The idea of a universal museum with artifacts from wide-ranging locations and historical periods, so familiar to us today, grew out of these Enlightenment collectors, who used their unbridled intellectual curiosity and wealth to put the displacement and assemblage of art on a parallel with the ancient Romans whose treasures they sought.

The American Nouveau Riche

During the nineteenth century, wealthy Americans sought to emulate the luxurious style and elegance of the houses of the European aristocracy. In many cases, the tycoons of the steel and railroad industries had far more ready cash than their European counterparts. Industrial barons like Andrew Carnegie, J.P. Morgan, Andrew Mellon, and Henry Clay Frick were among those to use their newly acquired riches (hence the term "nouveau riche") to acquire artistic objects. Perhaps the most engaging of them was Henry Clay Frick (1849–1919), son of a farmer, who became a millionaire by age thirty; he accumulated his fortune by purchasing and running the ovens at coal mines near Pittsburgh to produce coke, a vital element in the production of steel. Frick later became chairman of Carnegie's steel company, which was building America's railroad system.

Frick was driven to collect works of art more by his personal and emotional associations with the subject matter than by theories of artistic value. As his life was full of traumatic events he also turned to collecting for comfort. He suffered the deaths of two children: his favorite daughter, Martha, at age six after a long and painful illness; and his namesake, Henry Clay Frick, Jr., shortly after. Furthermore, in 1891 and 1892 Frick was responsible for the ruthless suppression of two industrial strikes, which led to his attempted assassination by Alexander Berkman and his seemingly miraculous survival (attributed to

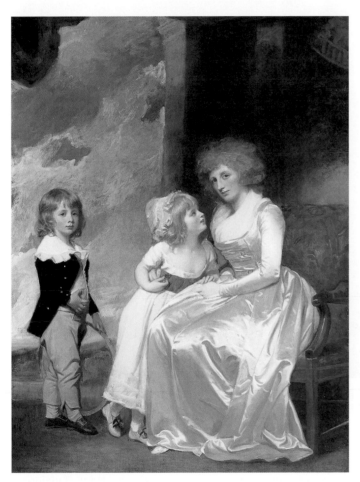

6.20 George Romney, *Henrietta, Countess of Warwick, and Her Children*, 1787–89. Oil on canvas, 6ft 7¾ins × 5ft 1½ins. Frick Collection, New York.

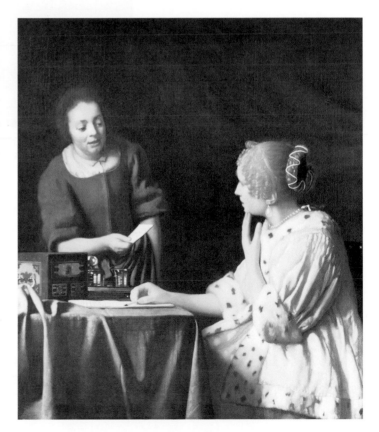

6.21 Johannes Vermeer, *Mistress and Maid*, 1665–70. Oil on canvas, 3ft × 2ft 7ins. Frick Collection, New York.

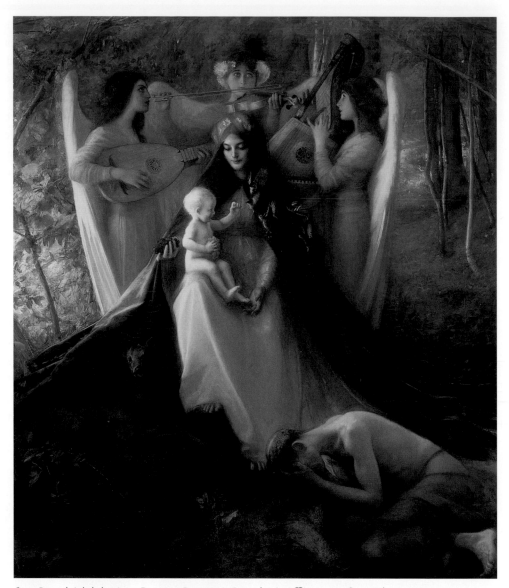

6.22 Pascal-Adolphe-Jean Dagnan-Bouveret, *Consolatrix Afflictorum*, 1899. Oil on canvas. Frick Art and Historical Center, Pittsburgh.

a vision of his dead daughter). Portraits that reminded him of family members, landscapes similar to his home region in Pennsylvania, spiritual evocations of visions and peace—whether by Old Masters or contemporary artists—these formed the basis of the collection that hung in the family homes, first at Clayton House in Pittsburgh and later on Fifth Avenue in New York. For instance, George Romney's portrait *Henrietta, Countess of Warwick, and Her Children* ▶ **fig. 6.20** was probably chosen for its evocation of Old World dynasties, which not only added a feel of history to his own newly built mansions, but suggested how his children might have appeared if they had survived. In 1919 Frick was incredibly lucky in obtaining Vermeer's *Mistress and Maid* ▶ **fig. 6.21**; according to his great-granddaughter Martha Frick Symington Sanger, Frick bought this painting because of its content, the letter being passed between concerned women and the small silver box in the picture, expressions and objects that

American Loot and the Invention of Ethnographic Museums

Rather than the riches of classical antiquity preferred by Enlightenment gentlemen of Britain, by the end of the nineteenth century many American collectors were turning their attention to objects on their own continent. Reactions against Church dogma had once again spurred a passion for science. In the United States, one form of study was the anthropological investigation of native peoples. As missionaries struggled to convert non-Christians and Westernize their cultural mores, explorers and scientists searched for authentic inhabitants in remote areas and recorded their cultural practices. In some cases, the same investigators became avid collectors of native crafts and artworks, even as they watched the often ruthless suppression of native independence for the sake of Westerners' access to natural resources, trade, or converts. Most of those ethnographic collections were donated to or purchased by museums, such as Native Northwest Coast art in the Smithsonian National Museum in Washington, D.C., or the American Museum of Natural History in New York, where examples of the national diversity in the Americas is documented by objects that were once part of a rich lifestyle of gift-giving and complex religious drama (see figs. 9.9–10). The same debate about who owns the Parthenon marbles (see p. 181) can be applied to many of these holdings, and lawsuits abound in which Native American tribes struggle to regain their cultural heritage (see p. 344, below).

he associated with his daughter's illness and death. Similarly, Frick commissioned *Consolatrix Afflictorum* ("Consolation of the Afflicted") ▶ **fig. 6.22** from painter Pascal-Adolphe-Jean Dagnan-Bouveret (1852–1929), who specialized in religious imagery and a spiritual connection with his patrons. Here the Madonna, whose face is that of Frick's wife, Adelaide, appears as a sort of nature goddess in a green wood surrounded by music-making angels; she is holding the Christ child on her lap in the form of a portrait of Frick's dead infant son. Various flowers and animals appear as both religious symbols and personal mementos for Frick. The man lying at the Virgin's feet represents Frick in his grief. This huge canvas was incorporated into a false wall, covering the dining-room fireplace of Clayton House, Pittsburgh, where Frick spent some of his most melancholy hours after the tragedies of 1891–92. Frick's home in New York, which cost him $5 million, was expressly designed to house his collection, with a view to making it a gift to the city for the cultural education of the public. The curators of the Frick Collection have added about forty-five paintings to the original 131 since its donor's death.

Spoils of War

Sometimes collections were the result not of methodical purchases but of war spoils. Battle campaigns often targeted areas where the booty might be greatest, for example churches. Not only did this give the army the opportunity of looting for treasures to take home, but it was also demoralizing for the enemies to see their nation's precious goods being callously carted off. During the French revolutionary wars of 1789–99, when France declared hostilities on all the nations in Europe still under monarchical rule, troops rolled across northern Italy, shipping everything of value back to Paris on trains. The breadth of the collection of Italian medieval and Renaissance paintings still held in Paris at the Louvre is one result of this frenzied despoiling. Napoleon continued the same policies in other countries once he became supreme commander of the army.

During World War II, the German army had orders from both Adolf Hitler and Gestapo chief Hermann Goering to ship any art of value back to Germany. To protect the superiority of German holdings, monuments that could not be transported were to be

destroyed. This resulted in forceful takeovers of all the objects in private collections and national or municipal museums that could not be hidden. The destruction was particularly great in Russia, where vandalism was encouraged by military superiors to obliterate the cultural holdings of a people whom the Germans considered less than human. Over 400 museums and nearly 1,700 Orthodox churches were obliterated in a campaign that also ruined more than 70,000 factories, 100,000 farms, and 70,000 villages, and caused the deaths of an estimated 49 million people.

At the end of the war, Russians responded to these atrocities with some fervent looting of their own. Hundreds of thousands of artworks were sent from Germany to the East, whether they had come from there originally or not. Some are maintained to this day in the Hermitage Museum, St. Petersburg, but, unfortunately, Stalin's interest in creating a huge national museum of Western art was never realized and many of the works that were stored in uncontrolled environments have not survived or are greatly damaged. The armies of other countries also looted. Although an international task force of American and British officers tried to find and record art

The First National Museum

The Louvre in Paris was the first national museum to make former possessions of elite patrons available to the public view through the nationalization of aristocratic property, and it led the way for other countries to acquire former private collections to open to public exhibition.

The organization of the museum into rooms where objects are grouped in chronologically related settings was initiated by a man who tried to save French patrimony from destruction at the hands of zealous revolutionary vandals. Alexander Lenoir became interested in obtaining some of the objects being destroyed during the French Revolution because he was himself an artist and amateur collector. Although not a supporter of the *ancien régime*, Lenoir could appreciate the fine workmanship in monuments that others considered to be ideological atrocities. In his Museum of French Monuments, opened in 1795, most of the works displayed had associations with the aristocratic privilege that was frowned upon by the revolutionaries ▶ fig. 6.23. Many of the works being destroyed were less highly prized than the Classical antiquities for which Winckelmann had established a widespread preference. In addition, all religious subject matter was considered to be a corrupt expression of the former autocratic domination of the Church.

Lenoir worked for the revolutionary government as the guardian of the spoils being brought into the capital from châteaux and churches all over France. Eventually, the temporary holding depot at the former abbey of the Petits-Augustins in Paris was overflowing, and Lenoir requested permission to display some of the best pieces. In order to justify their preservation, Lenoir emphasized the value of these objects as historical documents of French national accomplishments, rather than as artworks. Lenoir's task was a difficult one, for on the one hand he wanted to keep his job in a government system determined to reject all vestiges of the feudal past, while on the other he wanted to contribute to the republic's enlightened appreciation of its citizens' technical skills. His proposal was accepted and the museum opened to the public, possibly serving to assuage some of the guilt of a nation that had turned on its own heritage.

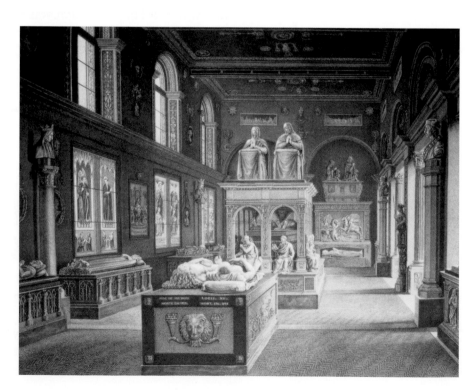

6.23 Fifteenth-century room in the Louvre, from Jean-Baptiste Réville and Lavalée, *Vues pittoresques et perspectives des salles du Musée des monuments français*, Paris, 1816.

Hiding the Louvre

During World War II, one of the most ambitious evacuations of art to protect it from the ravages of a foreign occupation occurred at the Louvre in Paris. The experience of the French authorities during World War I had made them fear another conflict that threatened their collection. As early as 1937, they began making lists both of artworks and possible hiding places throughout France. Thousands of packing cases were prepared for paintings, sculpture, and other *objets d'art*. Along with other museums, the Louvre eventually closed its doors on August 25, 1939 and a massive packing and documenting operation was undertaken. Employees of the post office and large department stores as well as experts in transportation and construction were called in to help. Soon packers were sleeping in the galleries for only a few hours between shifts. In blackout conditions truckers had to drive without headlights on unfamiliar roads crammed with a fleeing population. Yet by November, most of the important works were carefully tucked away in remote country châteaux where curators took up residence, while lesser artworks continued to be removed from Paris or packed away in cellars.

When the Maginot Line of defense failed to hold the Germans outside France in June 1940, all the art hidden in repositories in northern France had to be rushed to the south before bridges across the Loire were destroyed. The trips were again complicated by jammed roadways and inexperienced volunteer drivers. The German officer placed in charge of French cultural patrimony in Paris after the occupation was an art historian who successfully protected the hoards from being looted.

Similar operations were undertaken in England, where the holdings of the British Museum, National Gallery, Tate Gallery, and other institutions were moved to remote castles and underground mines in northern Wales. It was a good thing too, as London was badly bombed during 1941.

and monuments affected by the war, this proved impossible and much naturally went unnoticed. American troops billeted in French châteaux vandalized the valuable interiors. Comparable with the Elgin controversy between Britain and Greece, legal cases in the United States involve private collections containing valuable items "acquired" by American soldiers, or public museums found holding property purchased from questionable dealers after the owners died in concentration camps.

This discussion of collections affected by war ends with the vicissitudes of the Nissim da Camondo Museum in Paris, originally the private collection of the Camondo family, Jewish bankers who had prospered in Italy and the Ottoman Empire. By 1868, they had moved their business to Paris and participated in the ambitious rebuilding of the city under Baron Haussmann (see chapter 7). In the next generation, Isaac da Camondo amassed a huge collection of Japanese prints and Impressionist paintings (see p. 191, below) while his cousin, Moïse, built a townhouse near the fashionable Parc Monceau in 1911. Moïse attended all the big auctions, acquiring not only French aristocratic objects of the eighteenth century but also many of the royal spoils that Napoleon had brought out of Russia and surrounding countries.

Moïse's goal was to create a family memorial. After a scandalous divorce early in his marriage, Moïse made his children the center of his life. However, in 1917, his son, Nissim, a French reconnaissance pilot in World War I, was shot down and killed. Moïse decided to invest the entire remaining family fortune in acquiring the best objects for his collection in order to endow a museum in Nissim's memory. When he died in 1935, his daughter, Béatrice, carried out his wishes for the completion of the planned conversion of the house. She was a Catholic convert whose family had been at the center of Parisian cultural life for nearly a century. During World War II, she remained in Paris, apparently feeling safe from German persecution. Yet unlike the family collection, which miraculously escaped German appropriation, she and her family all perished at Auschwitz in 1943. The private museum, one of the many small collections administered by the city of Paris comparable with those of Frick in New York and Soane in London, remains as Moïse originally instructed, though it commemorates a greater family tragedy than he could have imagined.

African Artifacts and Souvenirs

The manner in which Western nations have acquired their non-Western artifacts parallels the stories related in this chapter about collectors on the Grand Tour and in times of war. Another pattern of collecting developed during the centuries of colonial history, when Western nations took over non-Western countries for access to their natural resources. On the west coast of Africa, first the Portuguese and later the British, French, and Dutch traded with such native societies as the Benin kingdom (see chapters 3 and 5). Rich in goods brought from the interior to the coast, the *oba*, or king, of Benin sold ivory, cotton, pepper, and slaves to Europeans in return for brass.

Missionaries arrived in the wake of the merchants and tried to force the local population to give up their own religious culture, and friction inevitably followed. Increasingly demanding more export goods in return for lower prices, the British soldiers became a burden to the inhabitants of Benin City. After brutally suppressing an insurrection, in 1897, the British set out on a "punitive expedition": Benin City was burned, and the army looted a huge collection of carved ivory tusks, brass ancestor heads and altars, coral beaded ornaments, weapons, and other items of social and sacred significance ► fig. 6.24. All were loaded on to ships bound for England, where the items were sold into private and public collections. The Benin king was kept in captivity in southeastern Nigeria until his death in 1914. Many of these items can now be seen in public ethnographic museums in New York, London, and elsewhere. However, like the Native American artifacts held in such museums (see chapter 9), these pieces are separated from their original context and often have little meaning for viewers.

During the late nineteenth century and throughout the twentieth, trade in native arts and crafts of Africa became so popular among Europeans that artisans often found it profitable to produce copies of traditional designs. This led to what is now termed "airport art," an industry producing inexpensive copies of traditional craftwork, sold as souvenirs and taking little account of the originals' value in terms of their ceremonial or symbolic associations.

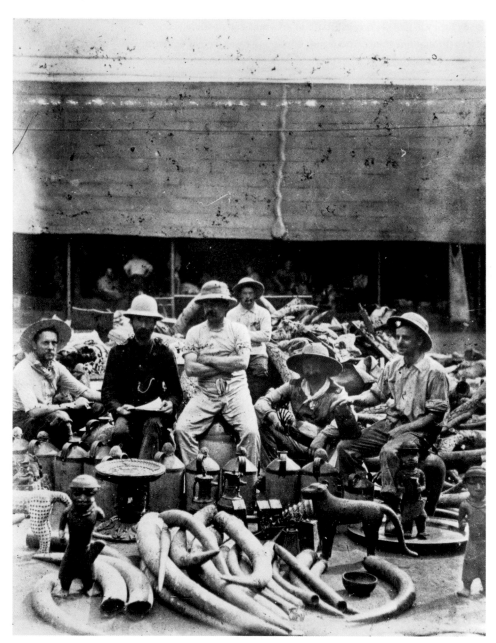

6.24 Photograph of British Punitive Expedition, 1897.

Cross-influences in Collecting: Japan and France

During the eighteenth and nineteenth centuries, the Japanese developed a type of popular ▸print◂ aimed at middle-class collectors that showed an awareness of European prints that some Japanese artists had collected. Later, this style of Japanese print became highly desirable among French collectors and strongly influenced the compositions of the French Impressionists.

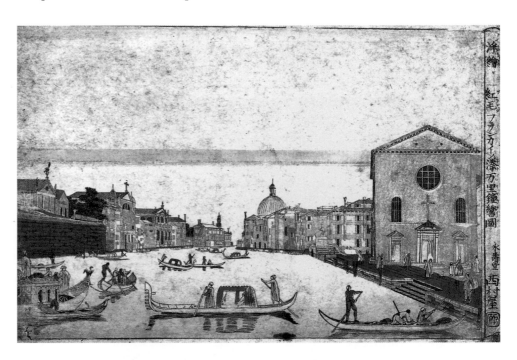

6.25 Utagawa Toyoharu, *The Bell that Rings for Ten-thousand Leagues in the Dutch Port of Frankai*, c.1770. Hand-colored woodblock print. Private collection.

Japanese artists became familiar with European painting techniques through eighteenth-century Chinese books on the subject and through trade with the Dutch. The Dutch were the only Westerners allowed to trade in Japan until the mid-nineteenth century; Japanese studies of European learning were therefore called *rungaku*, or Dutch studies. Japanese artists began incorporating European techniques such as perspective to give the illusion of three-dimensionality. Their prints contrasted with the steeply angled viewpoint of traditional Japanese pictorial space where humans appeared in hierarchical scale irrespective of Western perspective relationships of distance within the ▸picture plane◂. A lower viewpoint with blurred contours on objects further away from the viewer introduced spatial distance. At the same time, strongly outlined forms in the foreground drew the main scene sharply to the viewer's attention. Utagawa Toyoharu (1735–1814) applied these techniques to the popular print known as ▸*ukiyo-e*◂ (see p. 192). He studied one-point Western perspective drawing and applied it to Japanese subjects, developing a "perspective print" or ▸*uki-e*◂. An early example of his approach is his view of the Dutch port of Frankai ▶ **fig. 6.25**, a scene that shows its reliance upon European models through its similarity to Canaletto's *vedute* (see fig. 6.14).

Ukiyo-e prints were introduced after the sixteenth century, when a renaissance of visual arts occurred under the ruling shogun (military governors). Entertaining illustrated manuscripts were commissioned both by the shogun and by the wealthy

merchants who served them. Shifting away from the aesthetic elite of the imperial ruling family whom the shogun had subjugated in the twelfth century, the subjects of these books were simple stories of romance and valor. A new theater form, Kabuki, was similar in content and became the only public entertainment considered both fashionable and acceptable for respectable women to frequent.

Whole books were expensive and time-consuming to produce, so around 1650 the traditional technique of carving and printing in ink from woodblocks was applied to popular new scenes sold as single sheets. Because the distribution of loose prints depended upon a large and accessible clientele, the genre flourished in the cities, especially Edo (renamed Tokyo in 1868), where the population exceeded one million. Called "Edo prints" (after the Edo period, 1615–1868), these prints are also known as *ukiyo-e* or "pictures of the floating world." This term, originally named by Buddhists priests as a temptation, implies pleasure and impermanence, or being free from care. As the *chonin*, or city artisan and lower merchant classes, became financially secure, they also became consumers of every available pleasure: collection of these single, and thus affordable, prints was one. Courtesans, the theater, and, later, travel were favorite subjects.

Among the courtesans in their special district (the Yoshiwara) just outside the city of Edo were famous beauties, whose faces were available in special *ukiyo-e* called *bijin-ga* or "beautiful women" prints. One printmaker whose career became associated with defining an ideal canon of female beauty was Kitagawa Utamaro (1753–1806). Working after the introduction of color to the *ukiyo-e* block printing technique, and in competition with the most accomplished artists of his day, Utamaro became the most sought-after master of the popular print in the late eighteenth century ▶ **fig. 6.26**.

6.26 Kitagawa Utamaro, *The Courtesan Hana-Murasaki ("Violet flower")*, from the series Six Jewel-Rivers, 1793–94. The British Library, London.

The artist for the Edo print produced only the drawing, which was then traced by an engraver onto woodblocks, one for each color. This meant that the lines defining the overall scene had to capture the essence of the form with little precise information being included. In this sense, *ukiyo-e* is clearly indebted to the intellectual artistic tradition of both China and Japan that preceded it. Utamaro's success came from a combination of his knowledge of this tradition and the popularity of his subject matter.

Kabuki theater had evolved since the seventeenth century using only male actors, who played all the parts, and these stars were featured on another type of popular print, collected like modern movie posters ▶ **fig. 6.27**. Kunisada (1786–1864), a member of the Utagawa family, was a prolific producer of these prints. Another approach to the popular print, which reanimated *ukiyo-e* for another hundred years, was a new interest in landscape. Increasing public desire for travel and knowledge of the world outside the city caused a surge in popularity of this subject in the nineteenth century. Of the masters who represented outdoor scenes, the greatest were Katsushika Hokusai (1760–1849), and his follower and rival Ando Hiroshige (1797–1858). Both were greatly indebted to the developments in perspective that had been introduced by Toyoharu (see fig. 6.25).

Although still working in what can be termed the ▸genre◂ aspect of *ukiyo-e*, in other words the combination of human figures in their daily settings, Hokusai's primary contribution was the introduction of outdoor views that incorporated the traditional Japanese sense of nature as a sacred subject with the latest techniques in popular ▸woodcut◂ prints. As he matured, he also became increasingly interested in Western imagery, especially Dutch landscapes. Hokusai innovatively fused the foreign perspective with his own training in these works. While doing research for his best-known series, Thirty-six Views of Mount Fuji (early 1830s), Hokusai traveled all over Japan, seeing remote countryside locations little known in Edo. His sensitive presentation of the varying lifestyles and physical environment of rural areas greatly expanded the pictorial vocabulary of *ukiyo-e*.

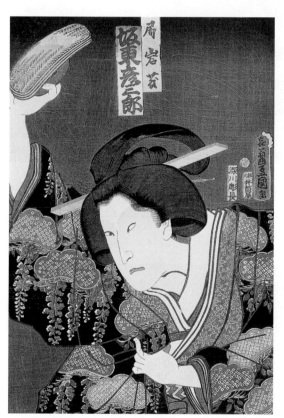

6.27 Kunisada Utagawa, *The Actor Bando Hikosaburo*, published 1850. Color woodblock print. Private collection.

Hokusai used Mount Fuji, which can be seen from many areas in Japan, as the focus of his series, but the mountain was the primary subject of few of the prints. Most of the compositions have a foreground scene that makes its presence appear merely incidental, as in *The Great Wave off Kanagawa* ▶ **fig. 6.28**, where small boats are threatened by the high sea, or in the sensitive and somewhat humorous representation of an old barrel-maker working with his tools in front of dried rice fields ▶ **fig. 6.29**. Hokusai repeated visual motifs, such as the juxtaposition of circles and triangles, as seen in both the pointed boats under the rounded wave and the green barrel hoops on the ground bisected with a wooden pole. In the latter print, Mount Fuji itself serves as a triangular counterpoint to the huge circular barrel that frames it. The view inside the barrel, with the energetic man in the foreground and the fields and mountain behind him, is set off like a separate scene within the print. In *The Great Wave*, the small repeated curves denoting the breaking edge of the wave suggest the threatening claws of a giant monster hanging over the desperate rowers. The dominance of the color blue, a characteristic Hokusai feature, reinforces the impression of the entire scene being engulfed by water.

Hokusai went on to publish ten further prints in this series, making a total of forty-six, and then began another series entitled One Hundred Views of Mount Fuji, published in 1834. The popular demand of collectors for images of the venerated mountain as

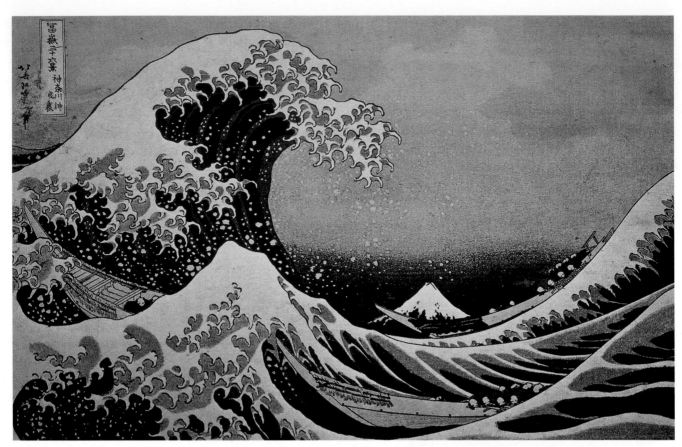

6.28 Katsushika Hokusai, *The Great Wave off Kanagawa*, from the series Thirty-six Views of Mount Fuji, Edo period, early 1830s. Woodblock print, ink and color on paper, 10⅛ins × 1ft 2¾ins. Claude Debussy Centre, St. Germain en Laye.

6.29 Katsushika Hokusai, *Fuji Seen through a Barrel on the Plain of Fujimihara in the Province of Owari*, from the series Thirty-six Views of Mount Fuji, Edo period, early 1830s. Woodblock print, ink and color on paper, 10⅛ins × 1ft 2⁹⁄₁₆ins. Allen Memorial Art Museum, Oberlin.

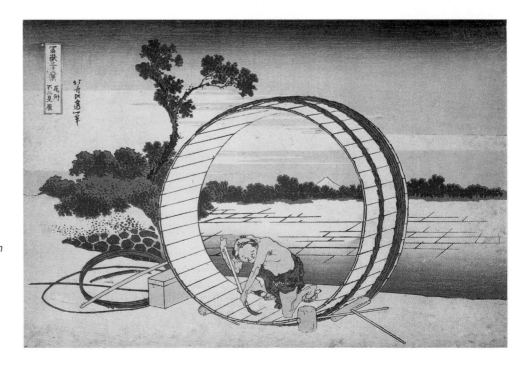

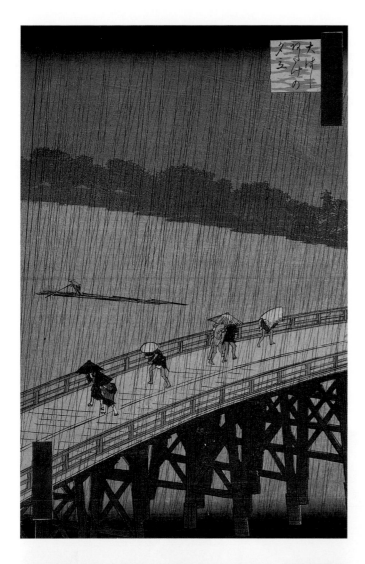

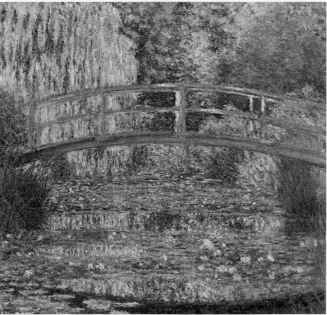

well as for travel scenes led Hokusai to produce ever more ingenious compositions. Meanwhile his rival Hiroshige was to benefit equally from this demand: his series of prints on the route between Edo and Kyoto were an overnight hit in 1857 ▶ **fig. 6.30**. Hiroshige incorporated more humor into his work and contrasted Japanese traditional pictorial techniques with Western styles within the same scenes. He also emphasized a stronger element of romance than Hokusai had in his *ukiyo-e*.

It was Hokusai, however, whose work first astounded the French ▸avant-garde◂ painters of the mid-nineteenth century when Japanese prints were shown at the International Exposition of 1867 and then became available for purchase at new shops in Paris offering "Oriental" goods (see chapter 8). In particular, they were captivated by the simple lines and vivid colors and began to collect these prints as avidly as the Japanese public to whom they were first marketed. Many of the French artists thought that Edo prints offered a perfect antidote to the stultifying European academic tradition as represented by Titian or Rubens (see figs. 6.11–12). In their work from the 1860s and 1870s, Edouard Manet (1832–83), Edgar Degas (1834–1917), and Claude Monet (1840–1926) showed the influence of Japanese compositions by the use of steep perspectives, sharp contours without shadows, and flat patterns of bright color. They also introduced Japanese subject matter such as fans and kimonos or techniques such as figures being cut off by the frame (see figs. 6.34, 6.37). Monet himself amassed a huge collection of Japanese prints, many of which are still on view in his house in Giverny, now a museum. The gardens there included a waterlily pond with a Japanese bridge ▶ **fig. 6.31**. Mary Cassatt (1844–1926), an American painter in the French Impressionist group, developed an innovative technique of color ▸etching◂ designed to give the

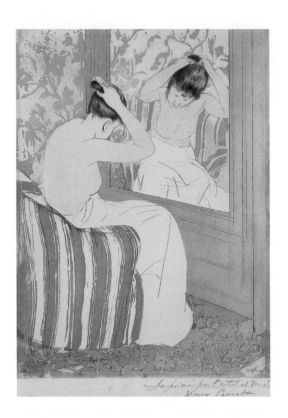

LEFT **6.32** Mary Cassatt, *The Coiffure*, 1891. Color print with drypoint etching, soft ground, and aquatint, 1ft 2½ins × 10½ins. Cleveland Museum of Art (bequest of Charles T. Brooks).

BELOW **6.33** Edouard Manet, *Olympia*, 1865. Oil on canvas, 4ft 3ins × 6ft 2ins. Musée d'Orsay, Paris.

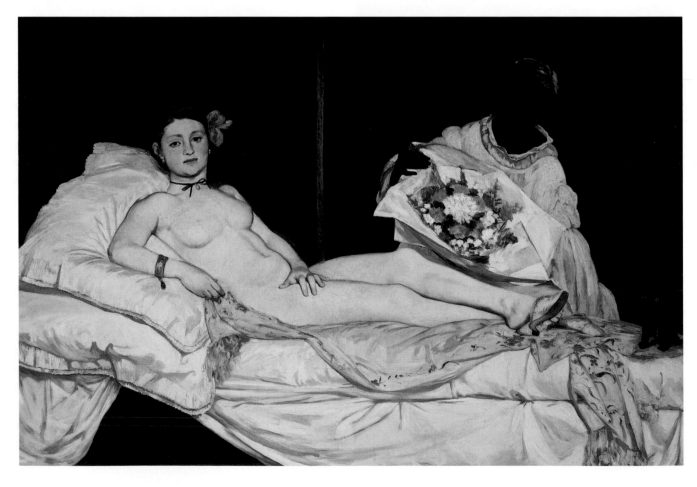

effect of *ukiyo-e* prints. In *The Coiffure* ▶ **fig. 6.32** she captured not only the angle, patterning, and line of the Edo print, but also the feeling of the intimate views of courtesan life popularized by artists like Utamaro (see fig. 6.26).

The stress in traditional Japanese art on the natural landscape, as well as the restrained use of line and shading, made sense to these artists, who were challenging the standard academic procedure whereby sketches made outdoors were considered unfinished until reworked in the studio. The Impressionists' interest in optical science, in working directly from nature (which they called *plein-air*, or outdoor, painting), and in simplifying the clues by which three-dimensional subjects were rendered on two-dimensional surfaces turned the Parisian art market upside down in the second half of the nineteenth century.

Perhaps more importantly, the collection of *ukiyo-e* prints made exotic subject matter more familiar in Europe, especially in France. Avant-garde artists were trying to break away from the traditional privileging of historical and mythological scenes in painting. The appearance of courtesans, workers, country landscapes, and nightlife in the Edo prints corresponded to the subjects that the French Impressionists were painting and that their contemporaries in literature were depicting in novels and poetry. Charles Baudelaire (1821–67), a friend of many of the Impressionist painters, was an influential writer who called for realist subjects and whose poetry collection entitled *Les Fleurs du mal* ("Flowers of Evil"), published in 1857, uses lyricism and irony to evoke the quest of modern man to find an ideal within tawdry city life. Composers, too, were affected by the prevalence of Japanese imagery: Claude Debussy (1862–1918) claimed to have written his innovative "impressionist" orchestral work *La Mer* after seeing Hokusai's *Great Wave off Kanagawa* (see fig. 6.28).

It was the portrayal of everyday details in Impressionist paintings that many members of the public found shocking. For instance, *Olympia* ▶ **fig. 6.33**, Manet's painting of a prostitute receiving flowers from a customer, is not a radical deviation from the long pictorial tradition of the full-length reclining female nude that he knew from the work of Titian (see fig. 5.36), Rubens and Velázquez. The difference came in the treatment of the subject. While Titian's nudes were anonymous, allegorical figures suggestive of the classical Venus, Manet's model Victorine Meurent was clearly identifiable, especially to other painters for whom she had modeled. Although surrounded by standard references to erotic experience, with her black maid, erect cat, and casual slipper, Olympia's look is less seductive than confrontational. In defiance of European pictorial conventions, Manet used a deliberately flat technique, reducing his forms to linear patterns that caused contemporaries to call his rendering awkward. He was clearly influenced by his interest in Japanese prints, but scholars have also suggested that Manet's emphasis on the two-dimensional quality of his medium (paint on canvas) rather than on the illusion of a three-dimensional space (window onto another world) was a metaphor for the superficiality he perceived in Paris during the 1860s. Manet's work may reflect the social posturing he observed in the city while it was being rebuilt under the supervision of Baron Haussmann (see chapter 7). In place of small neighborhoods, the opening up of streets, for example, meant that people increasingly

depended on appearance rather than acquaintance to convey their social status. In these terms, Olympia's naked body caricatures the elaborate system of signs that clothes could convey; her gaze challenges the viewer to pass judgment on her "status." Olympia's body is certainly not inviting: she was unfashionably slender, and the lighting harshly reveals her skin's imperfections. Manet's later painting *Nana* ▶ **fig. 6.34**, derived from one of Zola's *Rougon-Macquart* novels (see inset, opposite), has a man present at the right edge of the picture; by contrast, in *Olympia* the viewer is implicated as an anonymous, perhaps prurient presence. Yet rather than reading sly seduction, male visitors to the exhibition of this work felt that Olympia/Victorine was mocking them. The discomfort that this caused to the nineteenth-century public hardly qualified the work for inclusion in private collections of either beautiful nudes or technical *tours de force*.

In his work as an art critic, Zola applauded avant-garde artists to such an extent that he lost his job. When Manet painted a portrait of Zola to thank him for his support, he included some of the objects from Zola's own art collection to establish his close identity with this avant-garde world ▶ **fig. 6.35**. A print of *Olympia* (see fig. 6.33) hangs above his desk, along with an *ukiyo-e* actor print. Behind the writer stands a Japanese screen. He is posed holding an illustrated catalog while copies of his essays, the top one on Manet, are arrayed on his workspace.

Edgar Degas was also strongly influenced by Japanese printmaking. His compositions often show the same steep angles and cut-off figures of the Japanese print as well as *ukiyo-e* themes of the private world of women or the theater. He liked to make studies of women who, rather than confronting the viewer, posed as if they were unaware of being watched, as in many of his paintings of ballerinas ▶ **fig. 6.36**. Degas visited rehearsals and sketched dancers at work, combining scenes of daily work with the allure of the stage. He would often also set up his models with props for bathing, which allowed him to paint the female nude in a context reminiscent of the beauty preparations of Edo courtesans.

6.34 Edouard Manet, *Nana*, 1877. Oil on canvas, 5ft ⅝in × 3ft 9¼ins. Kunsthalle, Hamburg.

In European collecting, value was measured not only by technical prowess, but also by the subject matter. Collections were meant to elevate the viewer and refine his taste (most collectors were men). Most French dealers were initially horrified by the Impressionists' supposed decadence. But a few enterprising men found a quality in

Emile Zola

Emile Zola (1840–1902) was a writer and art critic who collected paintings by his friends (Manet did a portrait of him; see fig. 6.35) as well as the popular Japanese prints. In 1868 he embarked on a series of novels that would form a collection of interrelated stories, a vast undertaking eventually completed in 1893. In the twenty novels that make up *Les Rougon-Macquart*, Zola aimed to write about contemporary life much as his friends Manet and Cézanne painted it. His work is the most successful product of the movement now called "naturalism," which was literature's answer to Impressionism.

Zola's series follows two branches of a family, the Rougon (legitimate) and the Macquart (illegitimate), through their generations; in so doing, the novels offer a documentary panorama of everyday life during Napoleon III's Second Empire (1852–70), stressing economic and social change. Many of the Macquart characters are impoverished and Zola's treatment is direct, often raw. In this way, he responds to Baudelaire's model in *Les Fleurs du mal*.

The most autobiographical work of the series is *L'Œuvre* (*The Masterpiece*) of 1886; its hero, Claude Lantier, is modeled on Zola's painter friends; another central character, the novelist Pierre Sandox, is a thinly disguised self-portrait of a writer aspiring to produce a collection of related novels. Lantier's doubts about his work and the difficulties of living outside the official Academy lead him to commit suicide, hanging himself in front of his incomplete painting of a naked woman. Just as one can see detailed aspects of late nineteenth-century Paris in Impressionist paintings, so Zola's series of novels offers insights into urban and rural lives that would formerly not have been considered worthy subject matter for literature.

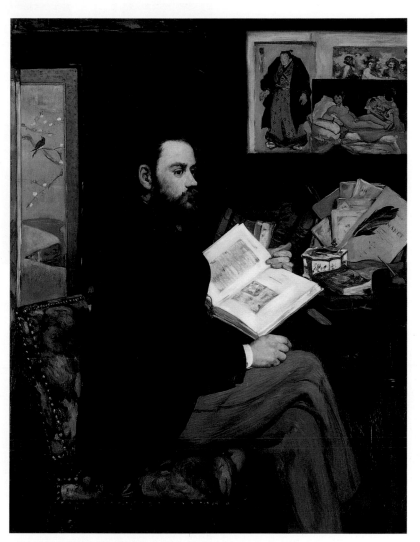

6.35 Edouard Manet, *Portrait of Emile Zola*, 1868. Oil on canvas, 4ft 9½ins × 3ft 8⅞ins. Musée d'Orsay, Paris.

many of their paintings that they believed would eventually change the art market. They began collecting works from the painters, often at pitiful prices. Nonetheless, for some of the artists this was the only means of financial survival. The support of these dealers proved to be the glue that held the movement together and led to the great success of those who lived to see their work fetch prices as high as those of the academic painters. The dealers would buy unknown artists' works in quantity and then create a market for them through carefully orchestrated exhibitions; this procedure changed the relationship of artists to buyers, and the "middleman" has

6.36 Edgar Degas, *The Rehearsal*, c.1878–79. Oil on canvas, 1ft 6¾ins × 2ft. Frick Collection, New York.

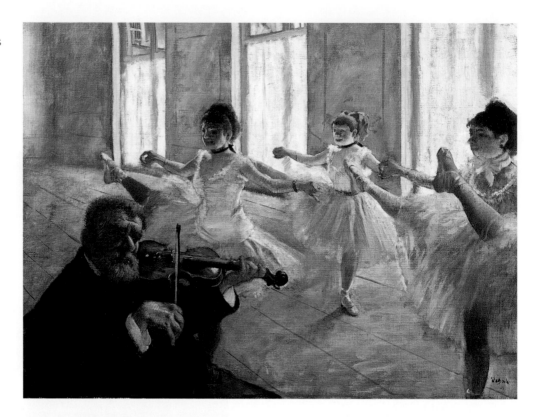

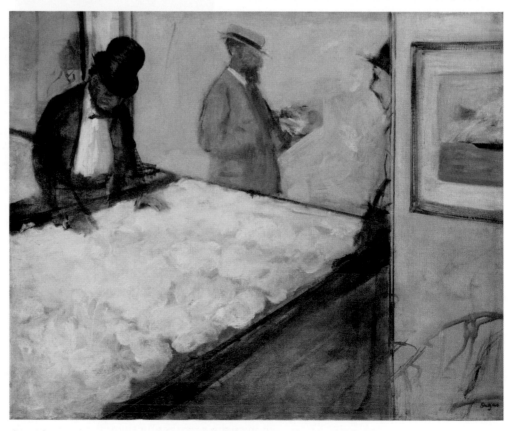

6.37 Edgar Degas, *Cotton Merchants in New Orleans*, 1873. Oil on linen, 1ft 11¼ins × 2ft 4³⁄₈ins. Fogg Art Museum, Harvard University.

remained the essential link in the current art market. The exhibitions in Paris were among the first to allow artists to show outside official government circles. Collectors who took the chance to sponsor such events became partners in the growing success of the capitalist system of industrialized France.

The collector who became the biggest dealer of Impressionist paintings, Paul Durand-Ruel (1831–1922), was himself the son of a successful art dealer in Paris. The latter collected and sold the paintings of the Barbizon School, a group of painters who worked in the Barbizon Forest southwest of Paris and who, in many respects, paved the way for Impressionist ideas about art. The younger Durand-Ruel inherited both the family business and a substantial stable of academic painters who brought steady sales as well as some of the most innovative paintings in France. He followed family tradition by using the assured income from sales of traditional painting to support the work of the newest artists of his generation. In particular, during the Franco-Prussian War, when many avant-garde artists fled Paris, Durand-Ruel met them in London, purchasing and exhibiting their work to help them meet their financial needs.

Upon returning to France in 1872, in spite of the fact that he could not sell much Impressionist work, Durand-Ruel visited Manet's studio and purchased all twenty-three paintings he found there, returning later for more. In the same year he purchased twenty-nine paintings from Monet and made similar investments in the work of Degas, Camille Pissarro (1830–1903), Alfred Sisley (1839–99), Auguste Renoir (1841–99), and others. As his collection grew, so did his efforts to create an audience for the new style. Besides their refreshing subject matter, many of these paintings could be appealing because they were small, unlike the giant canvases showing ambitious subjects designed for government competitions. This helped Durand-Ruel find buyers since the works were easy to ship and affordable for middle-class patrons.

The exhibitions that Durand-Ruel organized in the United States came by invitation after intense lobbying efforts on the part of Mary Cassatt. Cassatt had long been encouraging wealthy Americans visiting France to take home Impressionist paintings and thereby create an interest in the movement on that side of the Atlantic. In 1886 the first show opened in New York, with three hundred canvases, to more enthusiastic acclaim than a simultaneous exhibition in Paris of the same artists' work. Such American collectors as Henry Clay Frick (see pp. 185–87) already trusted Durand-Ruel's judgment for his previous offerings of the popular Barbizon School painters and felt that the Impressionists' work was both interesting and stimulating. Degas' studies of his family's cotton market offices in New Orleans, for example, depicted the sort of people to whom hardworking American collectors like Frick could easily relate ► fig. 6.37. Works sold and the show was extended for an extra month. The Impressionist group began to thrive and members were able to begin to establish independent reputations.

The next artistic generation, given the name "Post-Impressionists" by English critic Roger Fry, held similar interests in light, color, spontaneity, and modest subjects. The influence of Japanese prints on their work and on that of other avant-garde artists

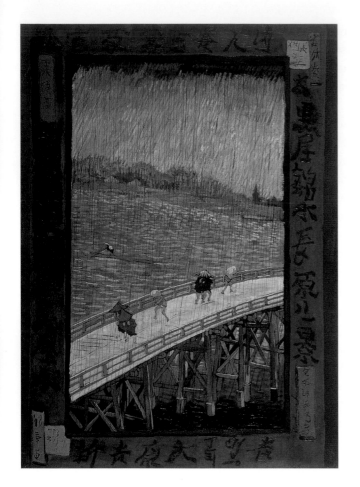

6.38 Vincent van Gogh, *The Bridge in the Rain*, 1887. Copy after Ando Hiroshige. Oil on canvas, 2ft 4¾ins × 1ft 6¼ins. Van Gogh Museum, Amsterdam.

remained high. Vincent van Gogh (1853–90) had a brother, Theo, an art dealer who put him in touch with the latest movements even when he was not resident in Paris. Through Theo, van Gogh had access to artworks that he copied as a way of experimenting with technique. In *The Bridge in the Rain* (after Hiroshige) ▶ **fig. 6.38**, for example, van Gogh copied the original woodblock print into an ▸oil painting◂. He intensified the color and added a strong horizontal pattern in the water to the striking vertical strokes of rain found in Hiroshige's work (see fig. 6.30).

Paul Durand-Ruel and Theo van Gogh were among the founders of the modern art market. Their encouragement of innovative, even radical, artists helped foster change as a crucial factor in the success of all the modern arts. It had been fairly common for artists to supplement their income as collectors and dealers (as did Rubens, see p. 177), but after 1900, collectors would take ever greater risks: they tried to forecast the direction of the art market and to maximize their profits by acquiring and then selling works when their commercial value had risen, often relying upon the predictions of trusted dealers. Such critics as Zola could also play an important role in helping establish young artists' reputations. Collectors could team up with critics who might play a part in causing the commercial value of artworks to rise or fall.

Modern Collections

Peggy Guggenheim (1898–1979) was among the twentieth-century collectors to support emerging artists. A disaffected member of the wealthy Guggenheims of New York (her uncle, Solomon Guggenheim, also devoted large sums of money to the collection and maintenance of modern art), she became interested in young artists while living in Europe in the late 1930s. Moving in avant-garde circles, she was briefly married to the Surrealist artist Max Ernst. She had friends make lists of artists they knew who were doing strong, innovative work and went to visit their studios and buy from them.

During World War II, Guggenheim returned to New York and opened a gallery in which to exhibit her collection. She named it "Art of This Century." It was in this gallery that Guggenheim introduced young American artists to the European exiles who had fled the war in Europe (see chapter 9). She held group and solo exhibitions, commissioned artworks, and even handed out monthly stipends to her favorites in return for the pieces they made.

Many of the American artists whose work Guggenheim collected and exhibited became successful and she has been credited with a key role in establishing New York as the new center for Western art after the war. One artist whom she promoted was Jackson Pollock. Guggenheim acquired a large number of Pollock's works in return for steady financial assistance and gave him four solo shows in her gallery, where he had initially worked as a janitor. His status as an artist was heightened by a commission he received from Guggenheim to make an Abstract Expressionist ▸mural◂ for her apartment. This controversial painting was hung in Guggenheim's entry hall, an area traversed by most of New York's art world when they attended Peggy's famous parties. But Guggenheim soon tired of New York, and in 1947 moved to a new home in Venice.

In Venice, Guggenheim bought a palazzo on the Grand Canal where she installed her collection. These works came to the notice of the Italian public in 1948, when they were featured at Venice's modern-art exhibition, the Biennale. In 1949 Guggenheim opened her home to visitors, thus again introducing the work of European artists and lesser-known Americans to a new public. Guggenheim bequeathed her collection to the care of the Solomon R. Guggenheim Foundation created by her uncle. At the time of writing, there are plans to expand the Peggy Guggenheim Museum in Venice.

Peggy Guggenheim acquired artworks without any intention of making a profit. Even during the years of her cleverest purchases, the volatile art market, particularly the modern-art market, would not have been a wise investment choice. Considering unpredictable changes of taste, the purchase of expensive paintings and sculptures was a dangerous venture that few reputable financial institutions would support. In the 1980s in the United States and Europe, however, prices at art auctions, fueled by booming Asian economies, seemed on a permanent upward trend. For the first time in history, large lending institutions such as Citibank accepted artworks as collateral for loans while also setting up art investment firms.

The new glamor and riches that became a part of the art market in the 1980s have given rise to a new type of profit-driven collector, of whom the British advertising magnate Charles Saatchi (born 1943) is a particularly successful example. Saatchi made his fortune through the advertising firm he created with his brother Maurice in 1967, Saatchi & Saatchi. The firm expanded through the acquisition of other agencies, and came to public attention through the advertisements it designed for Margaret Thatcher's election campaign to become Prime Minister of Great Britain in 1979. Charles Saatchi's style of collecting, exhibiting, and selling modern art depended on his purchase of the entire output of young, unknown artists in order to gain financial control of their work. This was intended to be beneficial to both artist and collector.

In 1988 Saatchi acquired a work by Damien Hirst (born 1965) at an independent exhibition of recent British college graduates. Hirst's work was controversial and quickly won wide notice among art critics. Saatchi then began buying works from a variety of young unknown artists and exhibiting them at his private gallery in London. This campaign culminated in 1997 when Saatchi's collection was shown at the Royal Academy of Arts in London at an exhibition named Sensation, which had a second

showing at the Brooklyn Museum in New York in 1999. In both cities, the exhibition created an uproar. Among the works most negatively received was Chris Ofili's *Holy Virgin Mary*, a painting with elephant dung and snippets of pornographic pictures stuck to its surface. Ofili, a British artist of Nigerian descent, believed that the pictures of genitals celebrated fertility while the dung had sacred associations from African traditions. But because he applied the dung to the Madonna's breast as a further sign of fertility (Ofili is himself Catholic), some visitors misunderstood the reference and thought he meant the material as an insult to Christianity. During the Brooklyn Museum run, after someone threw white paint on the painting in protest, it had to be protected by guards and Plexiglas. The Sensation show also raised the question of private versus public collection and exhibition. For all the outcry about the appropriateness of Saatchi's private collection being put on public view or the manner in which two venerable arts institutions allowed themselves to get caught up so obviously in the financial gain of a private individual, the exhibition ultimately served to increase the artists' publicity and drew yet more attention to Saatchi.

Many American corporations also collect art on a grand scale. Their artworks are usually displayed in corporate offices and occasionally also exhibited as public-relations events. Decisions about which works to purchase can reveal something of the character of a company's president or board of directors. Their ideas about art and the artists whose work they consider to be worthwhile investments can vary the shape of collections throughout the country. Most companies invest in art as a way of giving back to the community as well as burnishing their public reputation. Some companies prefer Old Master painting; others collect modern American icons; still others support emerging artists in the hope of appearing "hip" to the general public.

Although few collections can ever rival the size of those held by national museums such as New York's Metropolitan Museum, some companies have amassed substantial numbers of artworks. Notable corporate collections include the Art Gallery of Chase Manhattan Bank, begun by David Rockefeller, another member of a very wealthy American family. UBS Paine Webber, an investment firm, has a significant collection and also, via the merger with UBS Warburg, is a major sponsor of the Tate Modern and Tate Britain galleries in London.

Clearly many artists would not have been able to afford to practice their craft and many works would never have been created or been lost without the commissions, acquisitions, and conservation of objects by collectors throughout history. Their objectives were not necessarily a long-term service to art history, as can be recognized in retrospect; often they removed works from their original context, often from the sacred associations of their originating societies. Many times the collectors themselves were greedy or corrupt and some of the restorations they had made to artworks irreparably damaged the original. Yet the fact remains that, as a result of their efforts, many collections are now open to the public, and continue to be appreciated for their educational value. In the current climate of increasing contact and interdependence among diverse societies, many people place great importance upon access to information and the value of cross-cultural exposure and appreciation.

Further Reading

B. Buettner, "Past Presents: New Year's Gifts at the Valois Courts," *Art Bulletin*, 83:4 (2001), 598–625

W. Chadwick, *Women, Art, and Society* (London, 1990) chapter 4 "Domestic Genres and Women Painters in Northern Europe"

T.J. Clark, *The Painting of Modern Life: Paris in the Art of Manet and His Followers* (Princeton, 1984), chapter 2, pp. 79–146

A.D. Hedeman, *The Royal Image: Illustrations of the "Grandes Chroniques de France,"* 1274–1422 (Berkeley, CA, 1991)

E. Lipton, *Alias Olympia* (New York, 1992, reprinted 1999)

P. Mason, *History of Japanese Art* (New York, 1993), "Ukiyo-e, Pictures of the Floating World," pp. 304–322

A. McClellan, *Inventing the Louvre: Art, Politics, and the Origin of the Modern Museum in 18th-century Paris* (Berkeley, CA, 1994)

C. Moorhead, *Lost and Found: The 9000 Treasures of Troy* (London, 1994), chapters 15 and 16

L.H. Nicholas, *The Rape of Europa: The Fate of Europe's Treasures in the Third Reich and the Second World War* (New York, 1994)

M. Simon, *The Battle of the Louvre: The Struggle to Save French Art in World War II* (New York, 1971)

M.F. Symington Sanger, *Henry Clay Frick: An Intimate Portrait* (New York, 1998)

B. Thompson, *Impressionism: Origins, Practice, Reception* (London, 2000)

T. Vettros, *The Elgin Affair: The Abduction of Antiquities Greatest Treasures and the Passions it Aroused* (New York, 1997)

For websites of featured museums visit:
http://www.mhhe.com/frames

Discussion Topics

1. Think of someone you know who collects. Does the collection consist of stamps, teddy bears, teapots, postcards, beer cans, or other treasured objects? How does the collection help define the collector's character?

2. Do you think Britain should give the Parthenon sculptures back to Greece? What are the important considerations in this issue? Can you think of other art that such an act might affect?

3. Does it make sense that art is often a victim of war? Can you think of other instances beyond those cited in this chapter?

4. Why are *ukiyo-e* prints "popular" art? To what can they be compared today?

5. Consider the personal possessions you would depict in a still-life painting. What significance do they have for you? For your audience? Do your choices tap into contemporary issues that would help scholars of the future contextualize your work?

6. What is the responsibility of a public museum director if a visitor becomes offended at an artwork on exhibit in their institution?

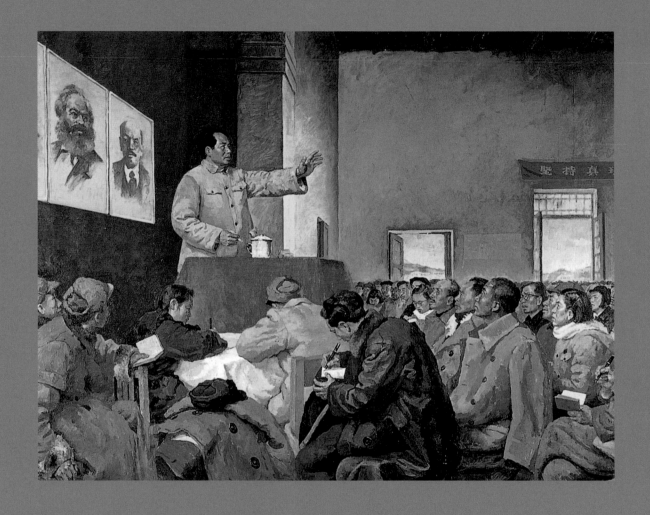

Art and Revolution in the Modern World

The broad sweep of European history from the late eighteenth century can be characterized by a move toward democracy and away from repressive monarchies. The overthrow of monarchies was both sudden and unexpected, through revolution. However, a revolution is not simply a change in government, rather it implies that the changes that occur are momentous and often part of a total re-evaluation of the way people view their society. The term revolution is also currently used in order to indicate any of several dramatic types of cultural, economic, or social changes that have altered the basic worldview of a people, with or without a change in government. Artists, whose work has the power both to influence and be influenced by political thought, have played key roles in the revolutionary process.

This chapter considers the history of art during times of social upheaval and revolution between 1760 and 1960. It first examines the French Revolution (1789–99) through the work of the Neoclassical painter Jacques-Louis David and his circle. It continues with a discussion of the United States beginning at the time of the American Revolution (1775–83), especially the idea of the fledgling republic as a "Promised Land" and its leaders as martyrs and saints. The chapter then explores a series of internal conflicts in France from the 1830s onward, including the relationship between Georges Haussmann's rebuilt Paris, the Franco-Prussian War (and subsequent Commune of Paris), and French Impressionism. In addition, the new art of graphic design, a product of the Industrial Revolution in Europe, made its impact in the late nineteenth century. Finally, in the twentieth century, the forces of revolution spread from Europe and the United States into Latin America and Asia. We look at how the revolutions in Mexico, Russia, and China challenged artists to participate in the rebuilding of their nations under a Communist system of government. The chapter concludes with those conflicts, which inspired a new generation of artists to grapple with a sudden and radical change in society.

7.1 Luo Gongliu, *Mao Zedong Reporting on the Rectification in Yan'an*, 1951. Oil on canvas, 5ft 4⅝ins × 7ft 8⅞ins. Museum of the Chinese Revolution, Beijing.

Key Topics

The role of the artist in the political revolutions that have characterized the last two centuries worldwide.

▶ Artistic shift: in revolutionary France artistic styles changed from the sumptuous Rococo to the more spartan Neoclassicism, in line with the overthrow of the absolute monarchy and the aristocratic artforms associated with it.

▶ A new country: Neoclassicism was adopted as the style for architecture in the new American republic, and artists developed a style to suit the "Promised Land."

▶ The democratic impulse: kept alive by artists in nineteenth-century France, this gave rise to the new style of realism in art; Impressionism can be seen as an escapist response to the continuing turmoil.

▶ In the service of the revolution: artists in Mexico revived the ancient art of mural painting to glorify a new Communist regime.

▶ Varying fortunes: in Russia the Constructivists' radical abstraction, designed to serve the new industrial state, was later outlawed by Stalin.

▶ Nation-building: Communist China prescribed didactic art and its artists contributed to the personality cult of Chairman Mao.

The French Revolution

At the time of the French Revolution (1789–99), which resulted in the overthrow and execution of the French monarchy, a style called "Neoclassicism" (or "new classicism") predominated in the arts of France. As its name implies, this style was based on a revival of Classical Greek and Roman art as well as the ideals of the Italian Renaissance.

In the decades before the ascendance of Neoclassicism, the dominant ▸Rococo◂ style in art catered to the tastes of the royal family and aristocrats who ruled the French state, with much of it depicting their leisure time. The word Rococo (derived from the French *rocaille*, "rock-work") was initially applied to a style of interior decoration. Its characteristic curves, irregular shell-like shapes and sense of playfulness were soon absorbed by painters including Antoine Watteau (1684–1721). His *Pilgrimage to Cythera* ▶ **fig. 7.2**, for example, was shown in 1717 at the annual exhibition in Paris sponsored by the royal government, called the ▸Salon◂. This painting has many typical Rococo qualities: colorism based on a richness of tone and hue; loose brushwork, and an asymmetrical composition. It is essentially a *fête galante*, a scene usually depicting an outdoor garden party of the aristocratic class. Here, the flirtatious couples who are embarking from Cythera, an allegorical island of love, are deep in conversation; aristocrats prided themselves on their education, particularly their knowledge of several languages, hence the genre of Rococo paintings known as "conversation pieces."

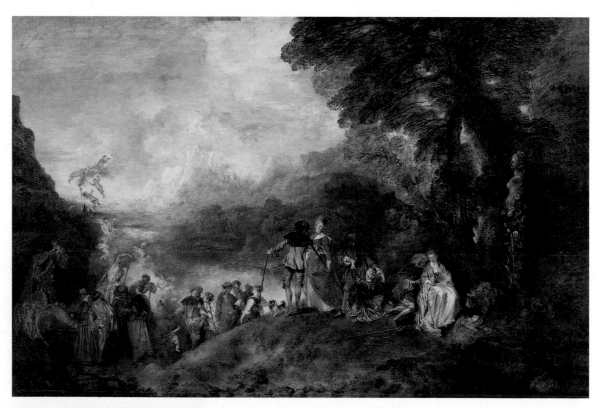

7.2 Antoine Watteau, *Pilgrimage to Cythera*, 1717. Oil on canvas, 4ft 2¾ins × 6ft 4⅜ins. Musée du Louvre, Paris.

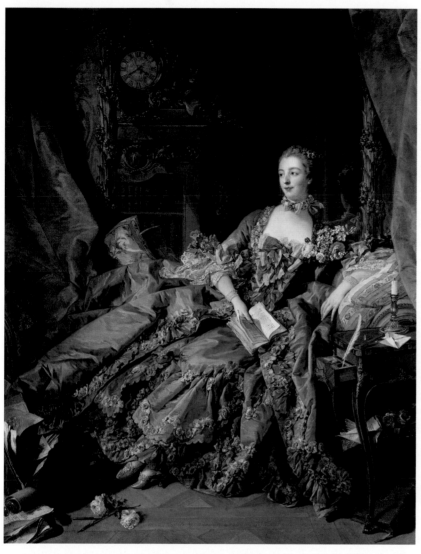

7.3 François Boucher, *Madame de Pompadour*, 1756. Oil on canvas, 8ft ¼in × 5ft 1¾ins. Alte Pinakotheck, Munich.

The portrait of Madame de Pompadour ▶ **fig. 7.3** by François Boucher (1703–70) shows one of King Louis XV's mistresses reclining on an elegant sofa, all entirely Rococo in style: her elaborate hairstyle, her fashionable dress, the furniture, lavish decorative details captured in exuberant color. Men and women of the aristocratic class spent hours each morning attending to their appearance, including not only flamboyant dress but elaborate cosmetics.

The series of four paintings titled *The Progress of Love* was commissioned from Jean-Honoré Fragonard (1732–1806) in 1771 by Louis XV's last mistress, Madame du Barry, to decorate her country retreat. Recounting the courtship of a young aristocratic couple, the series represents such a sumptuous climax of the Rococo style that it also became caught up in its decline, which was almost as sudden as its ascendance. One of the series, *Loveletters* ▶ **fig. 7.4**, shows the amorous couple flirting on the balcony of a country estate. By the time that Fragonard finished the pictures in 1773, Madame du Barry no longer wanted them in her home. Eventually, the four paintings found their way to the United States, where they joined the Frick collection (see chapter 6). Madame du Barry rejected the pictures because the Rococo had started to become unfashionable in artistic circles in favor of the Neoclassical style.

There are two major reasons for this change in taste. First, a series of archeological finds spurred a new interest in the Classical past and its artistic styles. The initial event that stirred artists to represent scenes from Classical history was the discovery in 1709 of the buried Roman city of Herculaneum. In 1739 the Frenchman Charles de Brosses, who sent a report on the excavations to the French government, helped to popularize the discovery across Europe. This historic coup was followed in 1748 by an even more spectacular find uncovering the buried Roman city of Pompeii, which had been destroyed by the same Vesuvian eruption that had destroyed Herculaneum in the year 70 CE. These discoveries, especially after the publication of Francesco Valletta's eight-volume *An Account of the Antiquities of Herculaneum* (1757–1792), ignited widespread interest in the lives of the Romans. Artists developed a deepening interest in producing Neoclassical works that drew upon both the Greco-Roman past and the classicism of the Italian Renaissance. As a result, many upper-class British men were motivated to undertake the "Grand Tour" (see chapter 6).

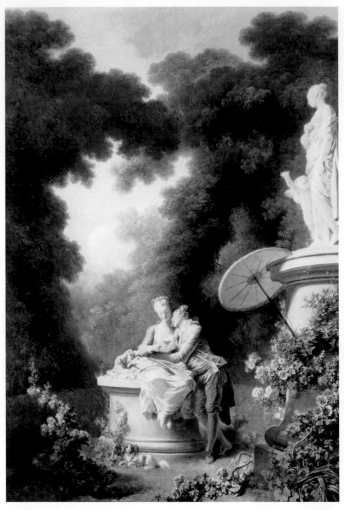

7.4 Jean-Honoré Fragonard, *Loveletters*, from the series The Progress of Love, 1771–73. Oil on canvas, height 10ft 5ins. Frick Collection, New York.

Second, as the Rococo was strongly associated with aristocratic society, the change in taste was a reflection of changing political attitudes. During the eighteenth century, the hereditary rule of the king and the aristocracy in France as well as the power of conservative religious institutions was challenged by a burgeoning intellectual trend in Europe, the "Enlightenment." In general terms, Enlightenment thinkers asserted that human society should be based on the common good, and that turning to logic and reason would lead people to a better, more equitable society. Enlightenment philosophers elevated the powers of human reason to new heights: "I think, therefore I am," wrote the French philosopher René Descartes (1596–1650). Enlightenment thinkers delighted in knowledge for its own sake. In fact, the French art critic Denis Diderot (1713–84) wrote the first encyclopedia during the 1750s and 1760s, attempting to assemble all the knowledge of the world in one place. (See also inset.)

The Enlightenment led to many significant changes in European society, such as the emancipation of Jewish Europeans as well as the eventual end of the African slave trade. Enlightenment thought also represented a clear rejection of the hereditary rule and economic disparities of France under Louis XV. The concept of an entire society existing to serve the whims of a single class, as well as the idea that France was nothing more than a "kingdom" — the property of one absolute ruler—was challenged by the Enlightenment's emphasis on liberty and equality. Espousing democratic values, Enlightenment writers envisioned kingdoms being replaced with a society based on loyalty to a nation that was established for the benefit of all citizens.

The Social Contract

The French philosopher Jean-Jacques Rousseau (1712–78) was a leading social theorist during the Enlightenment. His books *The Social Contract* and *Emile* (both 1762) described the obligations between people and society at large. The latter, although a novel, was described by its author as a treatise on human nature; its subtitle is *On Education*. Rousseau often used examples from Greek and Roman history to illustrate his concept of citizenship based on moral responsibility, such as the following quote from *The Social Contract*.

> Good social institutions are those that know best how to strip man of his nature, to take from him his real existence and give him one which is only relative, and to add his personality to the common unity; to the end that each individual will no longer think of himself as one, but as a part of the whole, no longer a thinking being except in the group. A Roman citizen was neither a Caius nor a Lucius: he was a Roman. A woman of Sparta had five sons in the army and awaited news of the battle. A messenger arrived and she asked for news, trembling. "Your five sons have been killed." "Ignorant slave, did I ask you that?" "We are victorious!" The mother ran to the temple and gave thank-offerings to the gods. There is your citizen.

The theme of self-sacrifice for the good of society was an Enlightenment theme that was taken up by many Neoclassical painters, especially Jacques-Louis David. By doing so, painters like David implicitly contrasted the sacrifices made by Classical figures with the self-indulgence of the ruling aristocracy shown by Rococo artists.

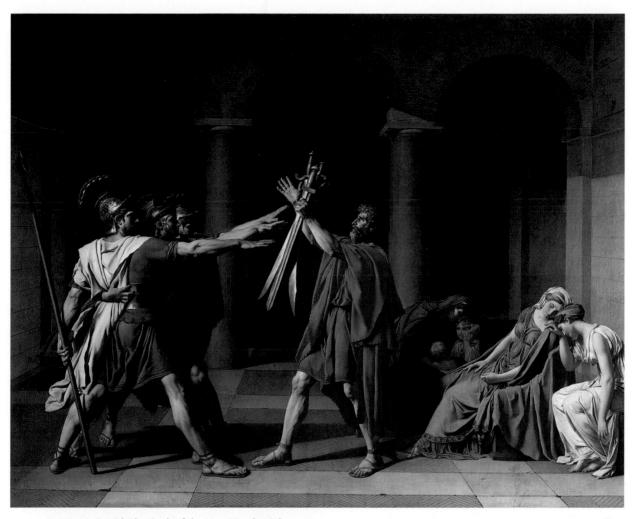

7.5 Jacques-Louis David, *The Oath of the Horatii*, 1784. Oil on canvas, c.14ft × 11ft. Musée du Louvre, Paris.

Enlightenment cultural critics viewed the Rococo—both its subject matter and its style—as representative of the corrupt, immoral values of French aristocratic society. In 1763 Diderot wrote, "I should gladly sacrifice the pleasure of seeing attractive nudities if I could hasten the moment when sculpture and painting ... will compete in promoting virtue and purity of morals." Diderot and others argued that the complex spatial illusions, asymmetrical compositions, and broad brushwork of Rococo painting were symptomatic of a corrupt society. An art that instead visualized the order, logic, and reason of the Enlightenment was needed as a corollary to social and political change.

The work of the French Neoclassical painter Jacques-Louis David (1748–1825), beginning with *The Oath of the Horatii* ▶ **fig. 7.5**, exemplifies a cultural shift that set the stage for the French Revolution: an embrace of Enlightenment moralism as well as a related rejection of Rococo frivolity in the arts. Enlightenment reformers such as David often modeled their artworks on the deeds of leaders in the Classical past, particularly actions that demonstrated self-sacrifice; for the good of the nation, one might sacrifice one's own life, or a son's life, in war. *The Oath of the Horatii* displays the

resolve of the Horatii clan to defend the fledgling Roman Republic against another family, the Curiatii. The conflict is heightened by the fact that the Horatii are closely allied with the Curiatii, and the two families are linked by marriage. The painting captures the moment when the Horatii sons swear allegiance to their father and his republican cause; the grief of the family's women draws attention to the ensuing personal tragedy. Stylistically, the painting is beholden to Neoclassical principles stemming from Roman low-relief sculptural panels. In a shallow rectangular space, the figures are placed in simple groups, each figure displaying a clear emotional state through gesture and facial expression. There are no Rococo effects; the color is flat with little tonal range, the space is symmetrical and plainly decorated, without any visible patches of painterly brushwork. The representation of women in *The Oath* is partly related to the artist's rejection of the Rococo, which David regarded as a "feminine" style, its color and illusionistic feats symbolic of women's deceitful nature, while he saw the simple clarity of Neoclassicism in masculine terms. The passive female members of the Horatii clan serve as a foil to the reason, power, and control of the Horatii men. The scapegoating of women was prevalent in France not only in painting, but also in the real events of the French Revolution. Until her death at the guillotine in 1793, the Queen of France, Marie Antoinette, was a central focus for the people's disgust with the government, even though she was little involved in its economic problems.

Spain: Francisco de Goya

The art of Francisco de Goya (1746–1828) bore witness to the lives of both the Spanish aristocracy (he was made "Painter to the King," Charles IV, in 1786) and the *pueblo* (the people) during the time of the Enlightenment. From the fashionable world of the *majo* (female *maja*) or "attractive" folk, to the nationalism of the *pueblo*, Goya chronicled many aspects of life in Spain. Goya's first success was a series of prints called Los Caprichos ("The Caprices"), which dealt with the ambiguities of artistic production and romantic inspiration during the Enlightenment, or "Age of Reason," and also poked fun at the aristocracy and clergy in Spain. *The Sleep of Reason Produces Monsters* ▶ fig. 7.6 exemplifies Goya's eerie imaginative powers. In this etching, a sleeping man (a self-portrait? a personification of reason?) is surrounded by a nightmare vision of bats, which may symbolize ignorance. Goya was possibly suggesting that Enlightenment reason stands guard against ignorance and folly, or perhaps he was celebrating the sinister yet evocative power of an artist's imagination when it is released from the stifling control of the intellect. This latter interpretation corresponds to the Enlightenment idea of the artist as an inspired visionary. Enlightenment thinkers embraced both the intellectual achievements of reason as well as its seeming opposite—irrational, inspired creativity.

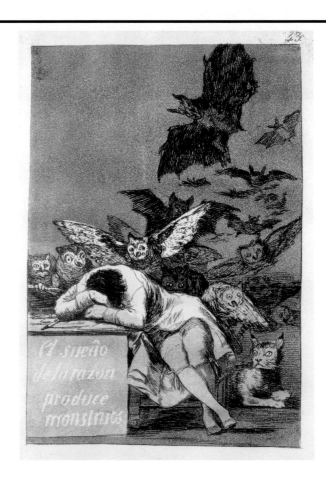

7.6 Francisco de Goya, *The Sleep of Reason Produces Monsters,* from the series Los Caprichos, 1799. Etching and aquatint, 8½ins × 6ins. The Metropolitan Museum of Art, New York.

The French Revolution remains a topic of complex debate. One influential view asserts that the revolution represented an attempt by members of the upper-middle class, the bourgeoisie, to gain greater economic and political power for themselves. At the start of the revolution, an increasingly corrupt and inept aristocracy that was determined to hold on to its power controlled the French government. Allied with the conservative clergy, these two groups together owned the vast majority of property, bankrupted the treasury, and yet paid no taxes. The bourgeoisie allied themselves with oppressed and heavily taxed working people in order to address these inequities. When political compromise failed, working people turned to violence in desperation. On September 10, 1792, the monarchy was abolished by a group of revolutionary leaders, and the next day the new French Republic was founded. Clearly, most revolutionary principles were rooted in the critique of aristocratic power initiated during the Enlightenment.

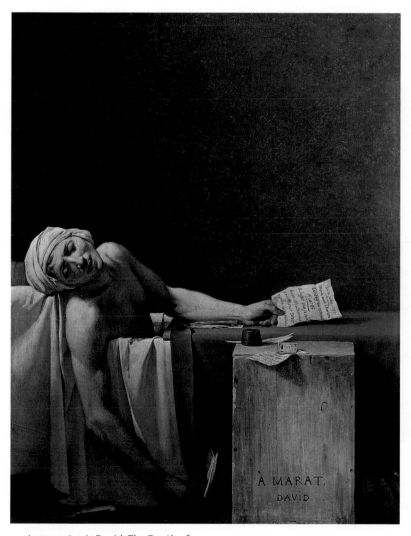

7.7 Jacques-Louis David, *The Death of Marat*, 1793. Oil on canvas, c.5ft 5ins × 4ft 2⅜ins. Musées Royaux des Beaux-Arts de Belgique, Brussels.

David became a major cultural and political figure during the Revolution, serving as a parliamentary representative in the National Convention, administering the republic's artistic institutions, and even voting for the death of King Louis XVI in 1793. Painted at the height of the Revolution, David's *Death of Marat* ▶ **fig. 7.7** underscored the ascendance of the more radical forces within the revolutionary movement with whom the painter was allied at the time. Led by Maximilien Robespierre, this faction fomented the Reign of Terror, which began with the execution of Louis XVI and Marie Antoinette in January 1793 (they had been imprisoned since 1792), and continued until Robespierre's own execution, which was engineered by his more moderate political enemies in the summer of 1794. The story of *The Death of Marat* reinforces the theme of women's deceit that was a major part of revolutionary rhetoric. Jean-Paul Marat was a doctor who began publishing an infamous journal during the Revolution. Confined to his bath by a painful skin disease, he was killed by a young aristocrat named Charlotte Corday, who hoped that his death would end the Revolution. Again, David's painting places a powerfully modeled figure in a shallow space, with dramatic lighting and simple color to dramatize Marat's death as a "martyr" of the Revolution. The picture has been seen as drawing a parallel between Marat's murder and the death of Jesus as a Christian martyr, an attempt to create a popular image of revolutionary leadership and sacrifice. Marat's lack of clothes and modest bathroom are used as a means of commenting against the fashionable wealth of the aristocrats as seen in portraits like that of Madame de Pompadour.

One of David's final revolutionary paintings, *The Intervention of the Sabine Women* ▶ **fig. 7.7**, is also Neoclassical in style, but this time shows women in strong, active roles. While the composition is crowded, it still has clarity of form, space, and gesture. The subject matter suggests that David wanted to distance himself from the violence of the Reign of Terror. Having escaped with a short prison sentence for his radical alliances with Robespierre and Marat, David attempted to reinvent himself through this painting as a political moderate. In the Roman legend, the Sabine women demand an end to the cycle of violence between the Romans and the Sabines. (David revered the French painter Nicolas Poussin, 1594–1665, who had painted a scene from the beginning of the conflict, when the Romans first kidnapped the Sabine women at a festival.) Along with *The Oath of the Horatii* and *The Death of Marat*, *The Intervention of the Sabine Women* tracks David's politics throughout the revolution. The fact that women in the third of these works act neither as passive weaklings nor as deceitful villains might owe something to David's royalist ex-wife, Charlotte Pécoul: she had divorced him because of their political differences, but was instrumental in saving him from further imprisonment and possible execution.

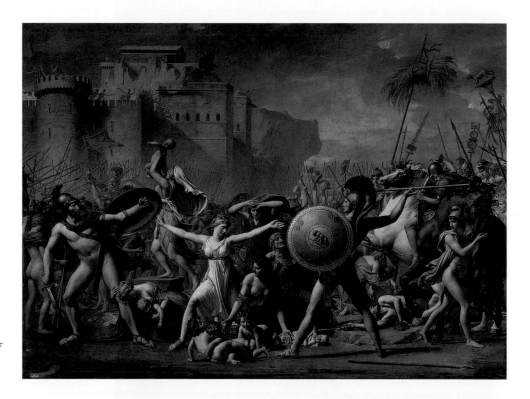

7.8 Jacques-Louis David, *The Intervention of the Sabine Women,* 1799. Oil on canvas, 12ft 8ins × 17ft 2ins. Musée du Louvre, Paris.

The revolution led to many changes in the manner in which artistic culture was regulated in France. In 1793 the Académie Royale de Peinture et Sculpture was abolished under David, who replaced it with a new academy to be administered by the Republic—yet it performed the same educational and exhibition functions as before. In essence, everything had changed yet everything had remained the same. (The Académie Royale was re-established in 1816 upon the restoration of the Bourbon monarchy.) As early as 1750, Louis XV had opened parts of the royal collection to public viewing at the Palais Luxembourg. The king had even ordered that plans be made to

England and the Grand Manner

It is important to recognize that the Neoclassical style was neither uniquely French nor inherently expressive of revolutionary ideals. Indeed, it became just as popular in England as it was in France, even at a time when the English government was vehemently opposed to the French Revolution. Neoclassical history paintings were referred to as being in the "Grand Manner" in England, where one of the foremost painters of this genre was the Swiss artist Angelica Kauffmann (1741–1807). Kauffmann arrived in London in 1766 after extensive study of Classical and Renaissance artworks in Italy. In London she established her reputation as a painter of the Grand Manner with works such as *Zeuxis Selecting Models for his Picture of Helen of Troy* ▶fig. 7.9. The Greek painter of antiquity, Zeuxis, was said to have painted an image of Helen of Troy (the story is told in Pliny's *Natural History*). Because no single woman met his exalted standard, Zeuxis based Helen on a collage of body parts from various local young women, illustrating the classical belief that artworks should portray an ideal world, more perfect than any real person—a far cry from Enlightenment ideas. However, in later historical painting, Kauffmann's choice of subject matter echoes the views of Enlightenment thinkers. *Cornelia, Pointing to her Children as her Treasures* ▶fig. 7.10 represents a Roman matron entertaining a female friend who has come to show off her jewels. When Cornelia is asked to show hers, she sends for her children. Like the Horatii patriarch depicted by David (see fig. 7.5), Cornelia is more interested in the greater social good—mainly her children's contribution to society as virtuous citizens—than the individual pleasures of frivolous wealth. Kauffmann's message also reinforces Enlightenment calls for mothers to care for their own children (as opposed to the practice whereby children were given first to wetnurses, then boarded out or raised by tutors). Kauffmann went on to enjoy a successful career in London: she was a founding member of the Royal Academy of Art in 1768. She settled in Rome in 1782 and throughout her career enjoyed the patronage of European royalty and nobility.

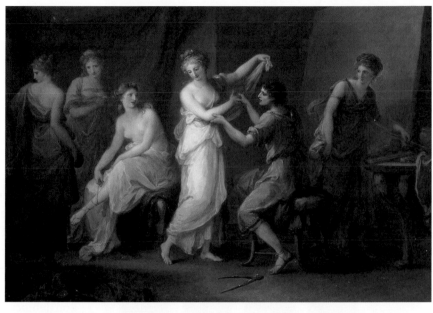

7.9 Angelica Kauffmann, *Zeuxis Selecting Models for his Picture of Helen of Troy*, c.1765. Oil on canvas, 2ft 7ins × 3ft 7ins. Brown University Library, AnnMary Brown Memorial Collection, Providence, Rhode Island.

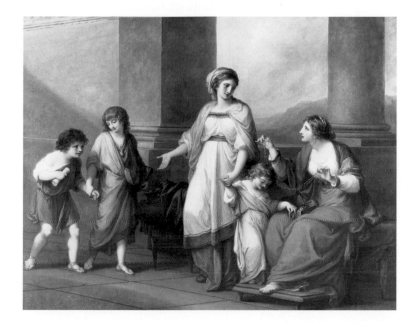

7.10 Angelica Kauffmann, *Cornelia, Pointing to her Children as her Treasures*, c.1785. Oil on canvas, 3ft 4ins × 4ft 2ins. Virginia Museum of Fine Arts, Richmond.

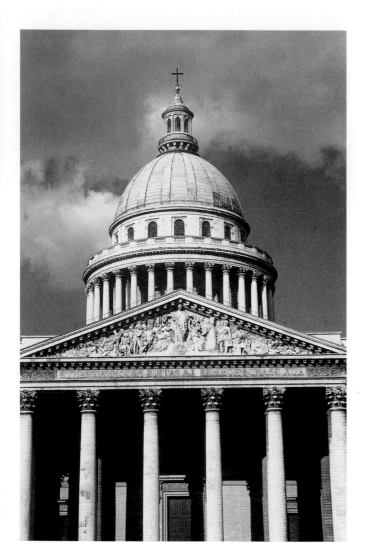

7.11 Exterior view of Jacques-Germain Soufflot's Panthéon, Paris, France, 1755–91.

renovate space in the old Palais du Louvre for a permanent display. Under the revolutionary government, this plan was adopted under the guise of demonstrating the new democratic principles of the republican government. David oversaw the opening of a new museum at the Louvre, called the Musée Central des Arts, on August 10, 1793, a date chosen to drive home the point that the new government was more open and democratic (August 10 was the first anniversary of the imprisonment of the now deceased king and queen). The new museum opened with two exhibitions, one being the annual Salon of contemporary art, the other a selection of nearly six hundred works from the royal collection, as well as those confiscated from churches and aristocratic estates. Thereafter, the museum was open on a rotating schedule that allowed artists to work undisturbed most of the time copying famous paintings, interspersed with three-day viewings for the general public every twelve days. The revolutionary government apparently viewed the establishment of the museum as an important public-relations exercise, pouring money into the project at a time when the country's finances were in dire straits.

When he fell ill in 1744, Louis XV had vowed that if he recovered he would fund the restoration of a half-ruined church at the Abbey of Sainte Geneviève. Renamed the Panthéon after the Revolution, this Neoclassical church is based on a Greek plan of the type favored in Renaissance Rome, featuring colossal Corinthian columns and an enormous dome ▶ **fig. 7.11**. Construction began in 1757 under the supervision of Jacques-Germain Soufflot (1713–80) and was eventually completed in 1791. Its rather hybrid style was intended to synthesize the rational clarity of the Classical style with the light proportions of the French Gothic. Soufflot thus addressed patriotic sentiment as well as the love of reason that was a key feature of the Enlightenment. After the Revolution, the church became a mausoleum intended to honor French intellectuals in a quintessentially Enlightenment shift of reverence from the divine to the secular, an idea that particularly appealed to the bourgeoisie. An inscription on the building, "For

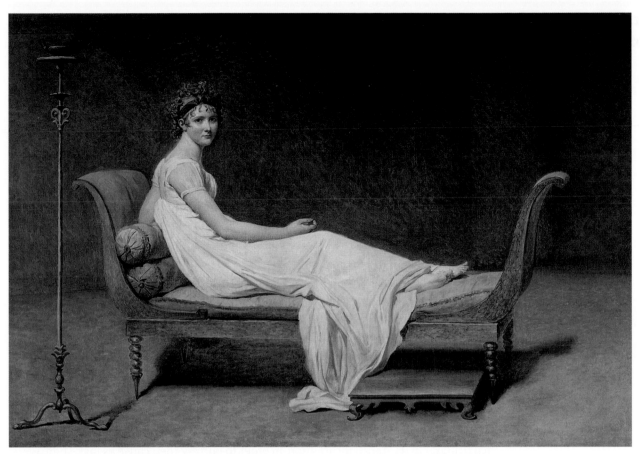

7.12 Jacques-Louis David, *Madame Juliette Recamier*, 1800. Oil on canvas, 5ft 8ins × 7ft 8ins. Musée du Louvre, Paris.

Great Men a Grateful Homeland," summarizes the Enlightenment's glorification of knowledge (and men). The Panthéon hosted some of the pageants and festivals that David designed in his role as an arts administrator, including the transfer there of Voltaire's ashes in 1791; no other French philosopher could more strongly embody Enlightenment thought than Voltaire (1694–1778).

In portraiture, the Neoclassical details of David's *Madame Juliette Recamier* ▶ **fig. 7.12** make an interesting comparison with the Rococo flourishes of Boucher's *Madame de Pompadour* (see fig. 7.3). Juliette Recamier was the most celebrated woman in Parisian society, renowned for her beauty, the circle of intelligentsia that gathered at her home, and for her liaisons with men such as the ▸Romantic◂ author François-René Chateaubriand (1768–1848). Recamier's simple hairstyle and plain costume are in tune not only with David's severe painting style, but also with the fashionable chaise longue, an item of furniture based on a Roman design. Wealthy Romans would recline in social situations such as mealtimes and Recamier's pose and general air of relaxation recall that atmosphere. By 1800, when this painting was finished, the French Revolution had ended inconclusively, and France was again led by an absolute ruler, General Napoleon Bonaparte. After the Revolution, Neoclassical painters would serve the wealthy and powerful, as Rococo artists had done before them.

The American Revolution

Even before the onset of revolution in the 1770s, artists had portrayed the struggles of American colonists against the repressive policies of Great Britain in religious terms. American artists composed history paintings that pictured the American Revolution as a biblical conflict akin to the battle of early Christians against the Roman Empire. Major history painters such as John Trumbull and Benjamin West pictured the United States as a land of destiny, while others developed a visual imagery of portraiture that made heroes of revolutionary leaders and militiamen who lost their lives in battle. Several decades later, the landscape painting of the nineteenth-century Hudson River School reinforced the idea of the new republic as a "Promised Land."

The American War of Independence was fought between 1775 and 1783 as the colonies struggled to break their historic ties with Great Britain. The roots of the revolution were essentially economic: a series of taxes imposed by Britain in the 1760s and early 1770s were rejected by colonists who felt they were exploitative. Violence first erupted in the "Boston Massacre" of 1770, soon followed by full-scale conflict beginning on April 19, 1775. After a series of early defeats and stalemates, the fledgling country started receiving naval support, military supplies, and troops from France in 1777, an arrangement that was formalized by treaty in 1778. More than a decade before the onset of the French Revolution, France allied itself with the Americans as part of its long-standing enmity with Great Britain. The combined strength of Franco-American armies finally favored the United States. In 1783, war ended with the Treaty of Paris.

American revolutionary politicians relied on the ideas of the Enlightenment, particularly in its French incarnation, in order to portray their cause as just. There were in fact large numbers of "Loyalist" supporters of Great Britain during the revolution, and it was necessary for the new country's founders to provide a credible rationale in order to influence public opinion. The Declaration of Independence, published on July 4, 1776, stated clearly: "We hold these truths to be self-evident, that all men are created equal." Later, the United States Constitution (ratified in 1783) further conveyed the ideals of the

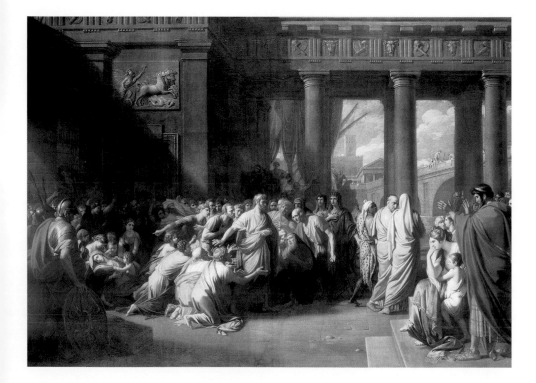

7.13 Benjamin West, *The Departure of Regulus from Rome*, 1769. Oil on canvas, 7ft 4¼ins × 10ft. The Royal Collection © 1999, Her Majesty Queen Elizabeth II.

Enlightenment: "We the people, in order to form a more perfect union, establish justice and tranquility, provide for the common defense, promote the general welfare and hence, secure the blessings of liberty, for ourselves and our posterity, do ordain and establish this constitution for the United States of America." The words and events of the American Revolution would inspire the leaders of the French Revolution several years later, and it is perhaps ironic that the French monarchy's support of the Americans—support that saw Enlightenment words put into action—helped bankrupt the French state and hastened its own downfall.

Because of their close ties to European society, most professional American painters from the era of the American Revolution traveled to Europe to study painting. There, many of them were strongly influenced by the Neoclassical style as well as the philosophical arguments of the Enlightenment. The most successful of these émigré artists was the Pennsylvania-born history painter, Benjamin West (1738–1820). In 1760 West persuaded his patrons to send him to Europe, where he completed a Grand Tour (see chapter 6) and finally settled in London in 1763. In Europe, West quickly adapted to the contemporary fascination with Neoclassical history paintings that illustrated the Enlightenment ideal of virtuous conduct. In 1769 he produced the *Departure of Regulus from Rome* ▶ **fig. 7.13**, a large-scale narrative painting drawn from the history of the Roman Republic's wars with the North African empire of Carthage. West's painting

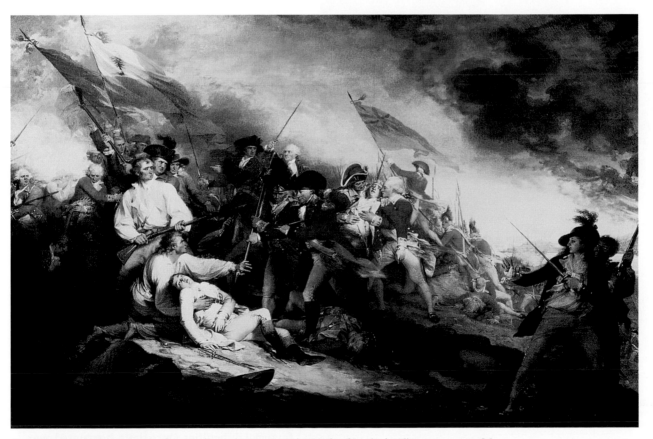

7.14 John Trumbull, *The Death of General Joseph Warren at the Battle of Bunker's Hill, June 17, 1775*, 1786. Oil on canvas, 2ft 1in × 2ft 10ins. Yale University Art Gallery, New Haven.

dramatizes the self-sacrifice promoted by the Enlightenment philosophers. Regulus, a Roman general, is shown leaving Rome to face certain death at the hands of the Carthaginians. Having been imprisoned in Carthage, he was sent back to Rome in order to negotiate on behalf of his captors in exchange for his life. Regulus chose to sacrifice himself by disobeying his captors and warning the Roman government of the impending peril of a Carthaginian attack. West's painting is set in a shallow space, with dramatic gestures and historical accuracy characteristic of the Grand Manner (see inset, p. 215), capturing the moment when Regulus leaves Rome on his way to meet his fate. *The Departure of Regulus* secured West's reputation in Britain, and he went on to enjoy a long career as a favorite of King George III. While in England he was among the founding members of the Royal Academy of Arts in London, as well as a teacher and benefactor of many American artists, including John Trumbull and Gilbert Stuart.

7.15 Gilbert Stuart, *George Washington (Lansdowne Portrait)*, 1796. Oil on canvas, 8ft × 5ft. The Pennsylvania Academy of the Fine Arts, Philadelphia.

Unlike Benjamin West, the history painter John Trumbull (1756–1843) served in the Revolutionary army under George Washington, devoting himself to art only toward the end of the war. In 1780 he moved to London and eventually studied at West's studio, remaining there until 1789 when he returned to the United States. In 1786 Trumbull painted *The Death of General Joseph Warren at the Battle of Bunker's Hill, June 17, 1775* ▶ **fig. 7.14**, a painting that shows West's influence in its depiction of contemporary events with a Neoclassical style. Trumbull's paintings of the Revolution, like those of David in France, are so manipulative of the viewer's emotions that they could almost qualify as propaganda images. *The Death of General Joseph Warren* depicts the fallen officer as a Christian martyr, much as David would do with his *Death of Marat* (see fig. 7.7). While the composition features the geometric clarity typical of Neoclassicism, its fiery palettes of warm colors, the sense of movement, and the exaggerated lighting also gesture toward the ▶Baroque◀ style of Rubens (see chapter 6).

Gilbert Stuart (1755–1828), who had sat out the American Revolution in England and Ireland, also studying for a period with West, returned to the United States in 1793 because of continuing financial difficulties. Once there, he painted over one hundred portraits of George Washington, the

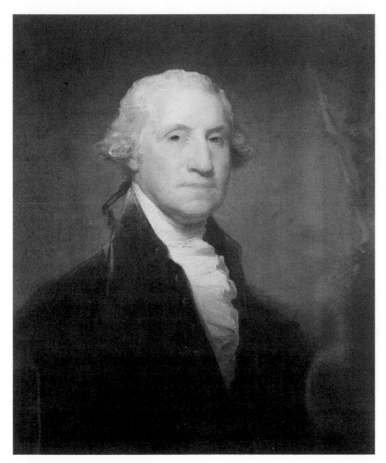

7.16 Gilbert Stuart, *George Washington (Vaughan-Sinclair Portrait)*, 1795. Oil on canvas, 2ft 5⅛ins × 2ft ⅛in. Andrew W. Mellon Collection, National Gallery of Art, Washington, D.C.

first President of the United States. One of these, the *Lansdowne Portrait* ▶ **fig. 7.15**, named for its original owner, the Marquis of Lansdowne, dates from 1796 and clearly shows the influence of French aristocratic portraiture; it is apparently based on Hyacinthe Rigaud's portrait of Louis XIV (see fig. 5.47). Here, Washington is shown formally in a full-length composition, his haughty demeanor and the arm gesture denoting declamatory speech recalling Roman imperial portraiture. Probably because of its reliance on the tropes of aristocratic portraiture, Stuart's *Lansdowne Portrait* met with limited success. In contrast, the *Vaughan-Sinclair Portrait* of 1795 ▶ **fig. 7.16** and the *Atheneum Portrait* of 1796, in both of which Washington appears humbler, and his pose more intimate and casual, became the most popular work of Stuart's career. He kept the original version of the *Atheneum Portrait* in his own studio while churning out lucrative copies of it for wealthy American patrons throughout the rest of his life; this is the portrait that appears on the one-dollar bill in reverse.

The French Neoclassical style and the Enlightenment also influenced American architects at the time of the founding of the republic. For example, the United States Capitol Building, as well as the plan of the entire city of Washington, D.C., rely on Neoclassical architecture to epitomize the outlook of an enlightened government standing for liberty and justice. During the presidency of George Washington (1789–97), the new capital city was designed under the supervision of the Secretary of State, Thomas Jefferson. Jefferson, a devoted Neoclassicist ever since his European sojourn of 1785, commissioned the French architect Pierre L'Enfant (1754–1825) to devise a plan for the new city ▶ **fig. 7.17**. This combined a grid of streets that was intended to signify the clear logic and reason behind the new nation with a series of radiating avenues that would serve as a setting for grand processions. It may seem ironic that L'Enfant's plan was based on the layout of the grounds at the Baroque French palace of Louis XIV at Versailles, one of the most famous manifestations of monarchical power (see chapter 5). However, L'Enfant reinvented the visual language of an absolute monarch so that it became symbolic of an Enlightenment government. For example, the radiating avenues in the grounds of Versailles, arguably symbolic of the king's

7.17 Pierre L'Enfant, *Plan for Washington, D.C.*, 1790.

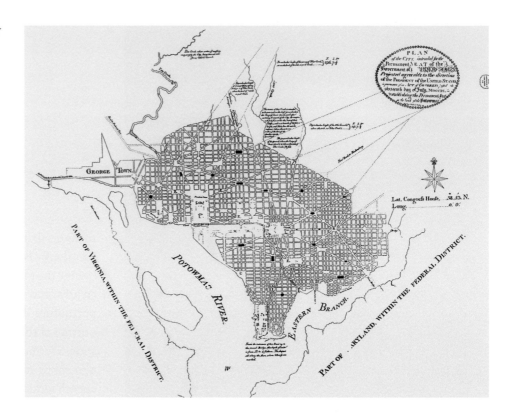

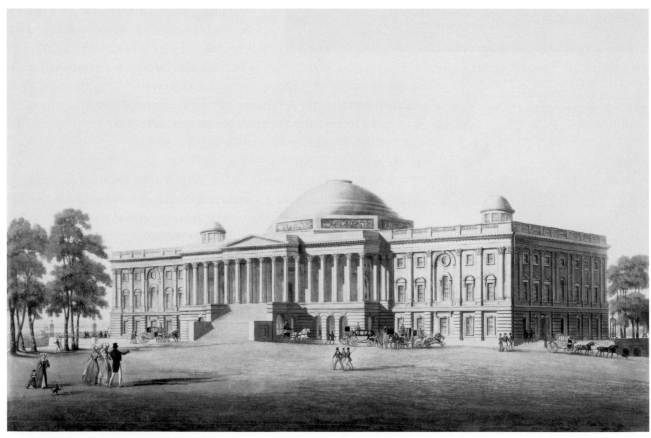

7.18 Exterior view of William Thornton and Benjamin Henry Latrobe's United States Capitol Building, c.1808. Engraving by T. Sutherland, 1825. The New York Public Library.

omnipotent reach, are, in Washington, transformed into representations of the philosophical space opened up by an enlightened government. The Capitol Building ▶ fig. 7.18, designed and redesigned over several decades by three different architects, William Thornton (1759–1828), Benjamin Henry Latrobe (1764–1820), and Charles Bullfinch (1763–1844), stakes an American claim to the Classical style. The architects replaced some of the traditional decorative elements with typical "American" iconography, including corncobs and tobacco leaves. Also, its derivative forms (as well as the sheer eclecticism of combining elements of Greek, Roman, British, Italian, and French Classical traditions) are in many ways symbolic of the origins of the new country. In the United States, the Neoclassical style was employed after a revolution in order to represent a new nation's principles and institutions.

Ongoing Revolution: France in the Nineteenth Century

Following the final defeat of Napoleon by the allies at the Battle of Waterloo in 1815 and the subsequent restoration of the Bourbon monarchy, France again came to be ruled by a repressive monarchic government. The outlook worsened in 1824, when the second Bourbon king since the restoration, Charles X, was enthroned. By 1827, his reactionary government had enacted harsh legislation that curtailed, and eventually abolished, freedom of the press (which had been a key element of Enlightenment liberty). Political and social harmony in France was again destabilized by the threat of social insurrection or even revolution, which indeed erupted in the violent outbreaks of 1830, 1848, and 1871.

Political Strife in the 1830s

In 1830 a series of strikes, followed by open rebellion, especially in Paris, led to the abdication of Charles X. His successor, Louis Philippe, was at first a moderately liberal ruler, under whom the government promised to provide better economic opportunity and political rights for its non-aristocratic citizens, especially the wealthy bourgeoisie. For a time, censorship laws were relaxed and publishers founded several new journals that provided a forum for criticism of the government. However, in a few years the government once again started to depend on censorship and force to sustain its rule. Artists, who valued freedom from censorship all the more because it was an issue that struck to the heart of their profession, often inserted themselves into the middle of controversies over free speech. One such artist and influential critic of the regime was Honoré Daumier (1808–79), whose ▸lithographs◂ for the journal *L'Association Mensuelle* eventually led to his imprisonment. In *Rue Transnonian* ▶ fig. 7.19, Daumier memorialized an attack by government-controlled military forces on French civilians in 1834. The soldiers had run amok after shots were fired at them from an apartment building. Here, the Christian story of the Massacre of the Innocents is invoked in a modern setting: an entire family is slaughtered in their sleep.

The lithographs of Daumier were among the first products of the "realist" movement. It is important to understand this word ▸realism◂ in terms of its original context: rather than being eye-witness accounts of particular incidents or representing "real" people, such works as *Rue Transnonian* feature iconic victims who are broadly symbolic of the consequences of state-sponsored violence. For Daumier, "realism" made sense

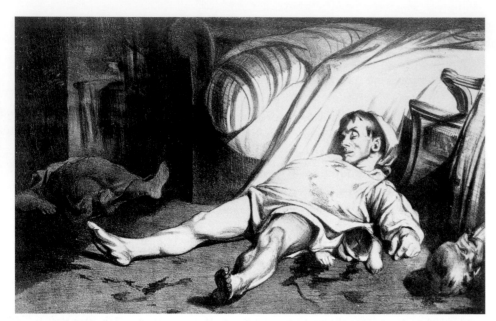

7.19 Honoré Daumier, *Rue Transnonian*, illustration in *L'Association Mensuelle*, July 18, 1834. Lithograph. Private collection.

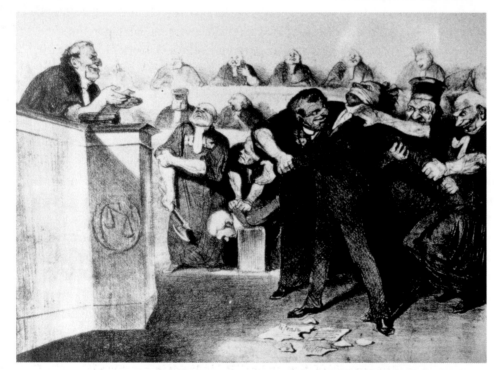

7.20 Honoré Daumier, *Vous avez la parole, expliquez-vous . . .* (You have the chance to speak, explain yourself . . .), published in *La Caricature*, May 14, 1835. Black and white lithograph, 10¼ins × 1ft 1¾ins. Private collection.

only in contrast to officially sanctioned French art, whose production was controlled by the government and dwelt upon the "unreal" world of idealized history. In his *You have the chance to speak* ▶ **fig. 7.20**, which satirizes the deplorable state of the French judiciary, Daumier was exploring one of his favorite themes from the real, everyday world. It shows a judge with a cynical grin telling a defendant that he is free to speak, while the defendant is gagged and bound by court officers. Near the defendant's hands, a document titled "The Defense" has been torn to shreds, symbolic of his lack of civil rights under the repressive regime.

The Fall of the French Monarchy, 1848

Following an economic downturn in 1846, uprisings in Paris led to a series of revolts across the whole of Europe in 1848. In February Louis Philippe, the last King of France, abdicated after three days of rebellion in Paris. These insurrections again led to the French military under the control of the monarchy attacking French civilians. Eventually, open elections (in which over nine million citizens voted) led to the establishment of a second French Republic. This democratic government was short-lived, however, as a new emperor, Louis Napoleon (nephew of Napoleon I) rose to power within the republic in December 1851. Louis Napoleon proved a more enlightened ruler than the monarchs who had preceded him, and oversaw an era of rapid industrial and urban growth in France.

Under the government of this new emperor, Napoleon III, the painter Gustave Courbet (1819–77) worked to establish the new realist painting style, partly in response to the upheavals of 1848. Courbet felt that the realist style was representative of the dispossessed people who had suffered under the monarchy. Courbet's political sympathies are evident in *The Stonebreakers* ▶ **fig. 7.21**. This painting shows two peasant laborers clearing stones from a road, not only backbreaking, but poorly paid, work. As one critic commented, the man is too old for this sort of work, and the boy is too young. The hardships of these two peasants appeared all too "real" to many art critics, and Courbet was roundly criticized for his glorification of the poor and its implicit condemnation of French society. Similarly, the realist style of the work was thought to be awkward and ungainly, crudely rejecting the officially sanctioned polish of Neoclassicism.

7.21 Gustave Courbet, *The Stonebreakers*, 1849. Oil on canvas, 5ft 2⅝ins × 8ft 6ins. Formerly Gemäldegalerie, Dresden (now destroyed).

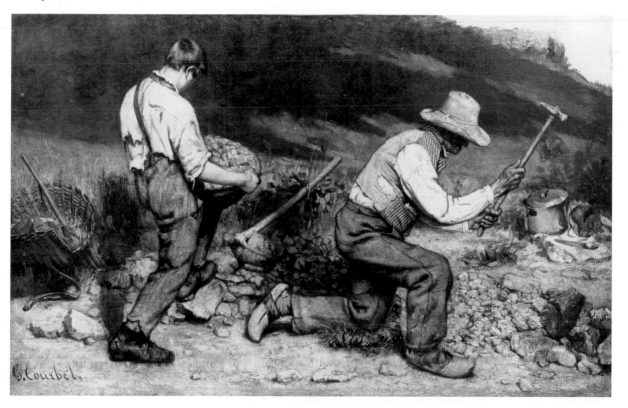

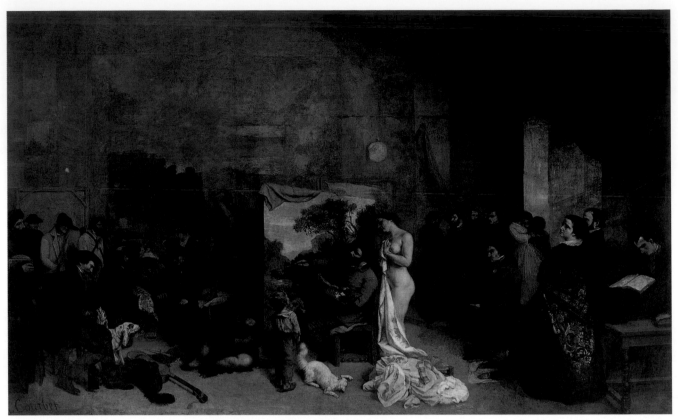

7.22 Gustave Courbet, *The Interior of My Studio, A Real Allegory Summarizing My Seven Years of Life as an Artist*, 1854–55. Oil on canvas, 11ft 9ins × 19ft 7ins. Musée d'Orsay, Paris.

In 1855 Courbet exhibited a painting titled *The Interior of My Studio, A Real Allegory Summarizing My Seven Years of Life as an Artist* ▶ **fig. 7.22** at a private exhibition space he called the "Pavilion of Realism." The title's reference to "seven years" took the viewer back to 1848, when the people had overthrown the king. What did Courbet see as the connection between his realist painting and the revolution of 1848? (It is much harder to see the connection between art and revolution in Courbet than it is with polemical artists like David, Trumbull, or Daumier.) Possibly, Courbet felt that traditional painting was tainted by its association with repressive governments, and that his realist style, rejecting the polished brushwork and stagey compositions of the French academy, served as a more democratic alternative. He may also have felt that images that presented peasants and workers without sentiment—even at times as ugly and threatening, as he did in many pictures—served to memorialize the roles that they played in French revolutionary politics. Not much in *The Interior of My Studio* is truly "realistic." The central figure of Courbet himself is surrounded, on the left, by generic types—the peasants, peddlers, and workers who served as the "cast" for most of his paintings—while on the right there are portraits of "real" people who had supported his career in Paris. For Courbet, like Daumier before him, the term "realism" signifies a separation from the ideal, romanticized world of traditional history painting. The musical instrument placed on the floor to his left, as if thrown away by the artist, is intended to suggest that Courbet has discarded the trappings of traditional painting.

Renewal and Destruction, 1851–74

Despite the problems in French society, it is undeniable that under Napoleon III's government, Paris thrived as it never had before. The emperor appointed a civil servant, Baron Georges Eugène Haussmann (1809–91), to oversee a grand series of improvements to the city's infrastructure and public spaces. Haussmann spent huge sums to build new sewer and drinking-water systems, wholesale markets, and broad tree-lined avenues. He also established many new public parks, and supervised the construction of grand monuments including a new opera house and the Palais des Tuileries, which finally completed the sixteenth-century master plan for the Louvre complex. Critics contended that Haussmann's rebuilding of Paris, which made it into the picturesque city it is today, also resulted in the razing of entire neighborhoods and the displacement of thousands of poor families, who could no longer afford to live in the expensive new apartment buildings that became a hallmark of "Haussmann's Paris." In place of formerly depressed areas, new fashionable neighborhoods were built that catered to the expanding bourgeoisie who had become wealthy during the Industrial Revolution.

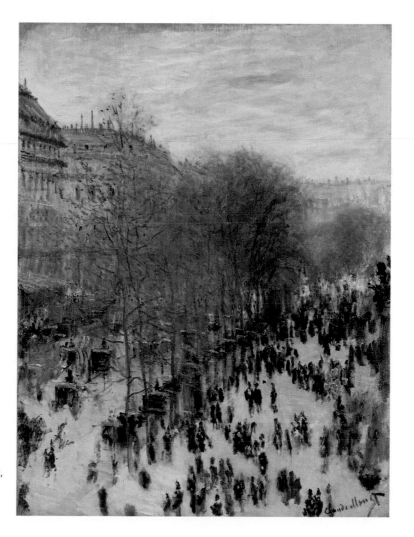

7.23 Claude Monet, *Boulevard des Capucines*, 1873–74. Oil on canvas, 2ft 6⅝ins × 1ft 11¾ins. The Nelson-Atkins Museum of Art, Kansas City.

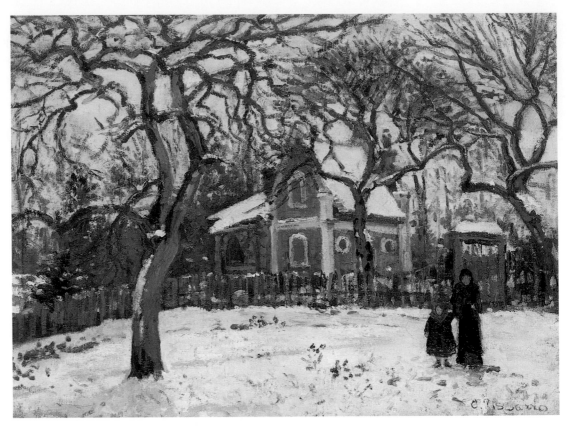

7.24 Camille Pissarro, *Chestnut Trees at Louveciennes*, c.1872. Oil on canvas, 1ft 4⅛ins × 1ft 9¼ins. Musée d'Orsay, Paris.

In 1871 an insurrectionary government, the Paris Commune, was established following the country's humiliating defeat in the Franco-Prussian War. This utopian attempt by some of the residents of Paris to secede from France and create a new socialist government was quickly defeated. The revolt culminated in the "bloody week" in May, when French troops under the command of the government attacked the rebellious citizens of Paris and 40,000 people were killed. During the battle for the city, many of its most beautiful monuments, including the new Palais des Tuileries, were destroyed by fires, many of which were set by the insurrectionists in order to delay the troops and destroy monuments that served the rich and powerful.

Immediately following the collapse of the Commune and the end of civil war, Parisians sought to escape its troubling memory. Impressionist painters sought to portray the French cityscape and countryside as idyllic places for bourgeois leisure, free from the struggle and strife of a century of revolution. Two of the movement's most prominent painters, Claude Monet (1840–1926) and Camille Pissarro (1830–1903), had taken refuge together in London, away from the revolutionary violence. After the Commune, Monet and Pissarro, as well as most of the other Impressionists, were united in a desire to erase the memory of the recent past's humiliations and bloodshed. At the same time, they hoped that the new republic, France's third in a century, would finally fulfill the ideals of the French Revolution. Monet painted several scenes in the years after the Commune that show Paris as a glamorous backdrop for bourgeois leisure. His

Boulevard des Capucines ▶ **fig. 7.23**, for example, a work that was featured in the first Impressionist exhibition in 1874, shows one of the city's grand thoroughfares teeming with life. In *Chestnut Trees at Louveciennes* ▶ **fig. 7.24** Pissarro celebrated the countryside as a peaceful and harmonious place, free of strife. These are essentially escapist paintings, completed at a time when the French were still suffering the results of war and insurrection.

The Industrial Revolution in France and the Rise of the Poster

The Industrial Revolution had its roots in eighteenth-century Britain, with the gradual development of new technologies made possible by the exploitation of steam, coal, and iron, thus transforming the nature of manual labor. This was a process of incremental, rather than violent or sudden, change, and resulted in both the creation of great wealth and the condemning of European peasantry to arduous lives spent toiling in factories. In the nineteenth century, one of the most visible manifestations of the Industrial Revolution was the rise of the modern city. Urban centers such as Paris and Vienna were rebuilt at this time in order to provide attractive living spaces for the burgeoning bourgeois population that had been enriched by new industries. Artists could equally use the new technologies, especially those artists who were drawn to exploring the printing industry. The mass-reproduced, accessible art of the poster, for example, became popular in these expanding cities, whose bustling life provided ideal subject matter, notably for the poster artists of Paris.

Among the most celebrated of these during the period after the Commune was Jules Chéret (1836–1932). His *La Loïe Fuller* ▶ **fig. 7.25** is one of the many posters he produced as an advertisement for a popular show. Graphic design developed as a profession to cater for the consumerist need for newspaper advertising, packaging, and especially posters that were pasted all over the new cities.

7.25 Jules Cherét, *La Loïe Fuller*, 1897. Lithograph, 11³/₈ins × 1ft 3³/₄ins. Stapleton Collection.

Mexico

When the longtime dictator Porfirio Díaz was overthrown in 1910, Mexico embarked on a ten-year odyssey of struggle. In 1920, at the end of a tumultuous decade during which different factions vied for power, a stable government with a Communist ideology came to the forefront. Out of the revolutionary period arose a group of nationalist artists, known as "Los Tres Grandes": Diego Rivera (1886–1957), David Alfaro Siqueiros (1896–1974), and José Clemente Orozco (1883–1949). Each dedicated himself to portraying the glory of the Mexican Revolution. Working mainly under the sponsorship of the state, between 1920 and 1935 they sought to revive the defunct art of mural painting. Not simply propaganda, their works offered a new way in which later artists could represent revolutionary politics.

Diego Rivera sat out the Mexican Revolution in Europe, where he was part of a large circle of expatriate artists experimenting with new abstract styles such as Cubism and Fauvism (see chapter 8). When he returned to Mexico City in 1921, Rivera chose as subject matter for several paintings the "heroes of the revolution," such as Emiliano Zapata, as well as subjects from the Mexican society of the Pre-Columbian period. Like other nationalist artists in Mexico, he chose to revive the tradition of mural painting because of its association with ancient Mexican cities such as Teotihuacán (see chapter 1). Later, as members of the Mexican Communist party, Rivera and his colleagues began to see public murals as a populist art of the people, while oil paintings made on an easel (like the ones Rivera himself had made in Paris) became tainted in the public's mind by their association with capitalist society. In 1922 the three artists helped form an artists' union and signed a manifesto written by Siqueiros, called "A Declaration of Social, Political, and Aesthetic Principles." It stated: "We repudiate easel painting and all ultra-intellectual, drawing-room art as

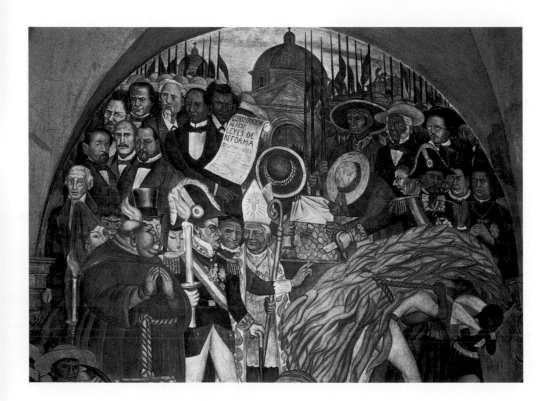

7.26 Diego Rivera, *History of Mexico* (detail), 1930. Mural on the main staircase of the Palace of Fine Arts, Mexico City.

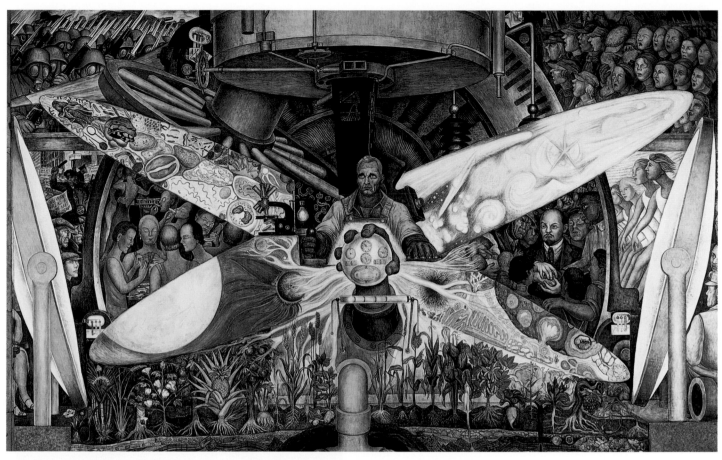

7.27 Diego Rivera, *Man at the Crossroads Looking with Hope and High Vision to the Choosing of a New and Better Future*, 1934. Mural, Palace of Fine Arts, Mexico City.

aristocratic, and we uphold the manifestations of monumental art because of its public usefulness." In his fresco entitled *History of Mexico* ▶ **fig. 7.26**, Rivera devised a complex iconographic program that depicts an idealized version of ancient Mexico. Stylistically, the painting is a hybrid of realist style and the advanced abstract techniques, mainly Cubist, that Rivera had practiced in Europe. The land is shown as an idyllic place populated by honest workers. These figures of ancient Mexican people is comparable to the later Socialist Realist tradition in the U.S.S.R. of depicting inspirational worker-heroes. Rivera's works thus encapsulate a vision of Mexico as a future Communist utopia and an idealization of the Mexican past.

Diego Rivera made an extended tour of the United States in 1931. While there, he was commissioned by the Rockefeller family to decorate the atrium of their newly built business complex, the Rockefeller Center in New York. The resulting mural, *Man at the Crossroads Looking with Hope and High Vision to the Choosing of a New and Better Future* ▶ **fig. 7.27**, was explicit in its celebration of proletarian revolution. An allegorical worker is shown steering an industrial world into the future; next to him stands a figure clearly identifiable as the Russian revolutionary Vladimir Lenin. This portrait proved too provocative for Rivera's patrons, and the mural was destroyed (Rivera eventually re-created it in Mexico).

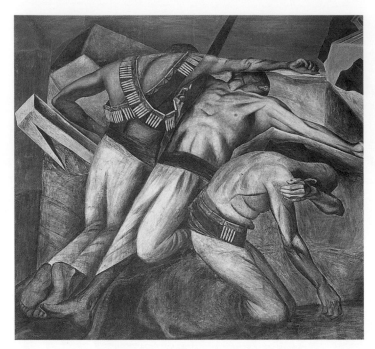

ABOVE **7.28** José Clemente Orozco, *The Trench* (detail), 1926. Mural. Escuela Nacional Preparatorio San Idelfonso, Mexico City.

RIGHT **7.29** David Alfaro Siqueiros, *The Elements* (detail of kneeling woman), 1923. Mural on the stairwell ceiling, Escuela Nacional Preparatorio San Idelfonso, Mexico City.

Like Rivera, José Clemente Orozco also wanted to inspire a political, spiritual, and cultural renewal in Mexico through his art. In *The Trench* ▶ **fig. 7.28**, a mural in fresco commissioned by the government for the Escuela Nacional Preparatario (National Preparatory School), he used an ▸expressionist-naturalist◂ style to depict the Revolution in the language of Christian martyrdom: the Trinity is made up of three iconic revolutionaries; the one in the center appears to have been crucified. Orozco tended to place less emphasis than Rivera and Siqueiros on direct social change and Communist politics, and more on political change motivated by spiritual awakening.

David Siqueiros was the most politically active of Los Tres Grandes. The only one of the three to have fought in the Mexican Revolution, in 1937 he commanded a squad that unsuccessfully tried to assassinate Leon Trotsky (1879–1940), who had been exiled from the Soviet Union by Joseph Stalin in 1929 and had sought asylum in Mexico City (where he was eventually assassinated by those who felt he had betrayed Stalin). Orozco's belief in art as political expression had been clear since 1918, when he organized a group called the Congress of Soldier Artists. Siqueiros argued that post-revolutionary art in Mexico must uphold Communist principles favored by the government and address the peasants and industrial workers who had traditionally

been marginalized in a Mexican society dominated by an elite of mainly European lineage. Nevertheless, Siqueiros looked to European Renaissance narrative paintings, notably Michelangelo's Sistine Chapel ceiling, as a guide for his art. His mural *The Elements* ▶ **fig. 7.28** contains an allegorical figure (a kneeling woman with wings) with Christian connotations that fits comfortably within the European tradition.

In the 1930s Rivera, Siqueiros, and Orozco all settled in the United States, where they had a mixed reception, as their Communist politics rankled with many American critics. In 1933 the *Chicago Daily News* denounced Rivera in no uncertain terms: "He has scorn for every rung of society except that of the industrial worker … How long will Americans blind themselves to the sincerity of those people who are working for the downfall of our inherited form of government?" Of these three, Siqueiros had the most substantial influence on American artists through his use of industrial paints and spray guns, and in experimenting with abstract forms in large-format pictures. The future Abstract Expressionist painter Jackson Pollock (see chapter 9) was among those that Siqueiros tutored in New York.

Russia

In 1903 a group within the Russian Social Democratic Party reached a majority, for which the Russian word is "Bolshevik." The Russian Revolution of 1917 that finally brought the Bolsheviks, led by Vladimir Ilyich Lenin (1870–1924), to power was in fact made up of two separate incidents, known as the February Revolution and the October Revolution. The first of these, springing from the corrupt and ineffectual leadership of Tsar Nicholas II and the imperial government, was sparked by the massive losses that Russian forces suffered at the hands of Germany in World War I. The abdication of the tsar was followed by several months of political jockeying and the return of Lenin from exile abroad, which resulted in a coup by the Bolshevik-sponsored Soviets (workers' councils) against the provisional government, the "October Revolution." At this point the Second All-Russian Congress of Soviets formed a new government in St. Petersburg (which had been renamed Petrograd in 1914 and became Leningrad in 1924) and gave Lenin the leadership. Perhaps the most influential group of Russian artists to serve the new Soviet state were the Constructivists, especially El Lissitzky and Vladimir Tatlin.

The Constructivists wanted to ally their art with industrial production, and often worked to design practical goods such as workers' clothes and government buildings as well as more traditional artworks. They used elementary forms, simple geometric compositions, and the tools of the engineer. They did not seek to make art serve as simple propaganda for the government, but wanted to make art that was in harmony with the goals of Soviet ideology. However, the Constructivists were over-optimistic in that they assumed a level of industrial progress that was completely out of reach for the industrially undeveloped, agrarian economy of the U.S.S.R.

The career of the typographer, illustrator, and painter El Lissitzky (1890–1947) summarizes the fate of modern art in the new country. His geometric poster *Beat the Whites with the Red Wedge* ▶ **fig. 7.30** is typical of the abstract yet propaganda-driven work of the Constructivists. It shows a red triangle, symbolic of Lenin's Reds,

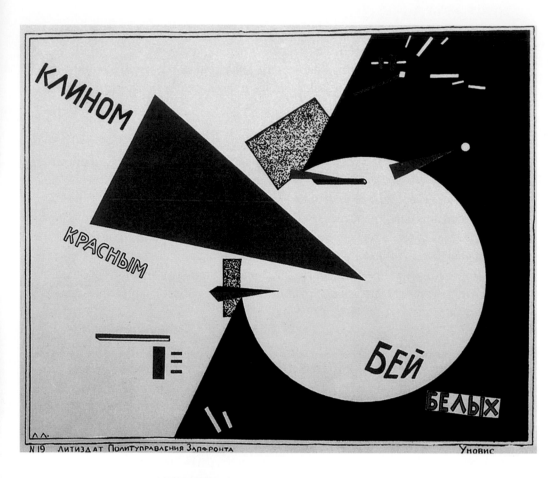

7.30 El Lissitzky, *Beat the Whites with the Red Wedge*, 1919. Poster, 1ft 11ins × 1ft 7ins. Van Abbemuseum, Eindhoven.

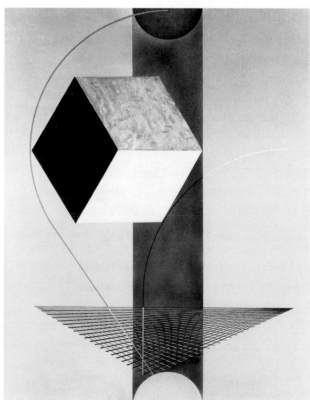

puncturing a white circle, symbolic of anti-Communist counter-revolutionaries (known as "white Russians," they were finally defeated by the Bolsheviks in 1920). This type of allegory was not enough to keep the Constructivists in favor with government authorities for very long, because the abstract style of the work appeared inaccessible and elitist. In 1919 Lissitzky began a new series of paintings and prints that he called Proun, an acronym for a Russian phrase that roughly translates as "Project in Affirmation of the New." Reiterating Constructivism's embrace of the machine aesthetic, the image from the series shown in ▶ **fig. 7.31** features an engineer's T-square and a piece of Plexiglas, emblematic of the new materials favored by Constructivist "artist-engineers." At the end of 1921, after the Soviet government had turned hostile toward abstraction, Lissitzky left the country and settled in Berlin, where he influenced many artists, including László Moholy-Nagy (see chapter 8), to embrace Constructivist concepts.

7.31 El Lissitzky, *Proun 99*, 1923–25. Water-soluble and metallic paint on wood, 4ft 2ins × 3ft 3ins. Yale University Art Gallery (gift of the Sociéte Anonyme).

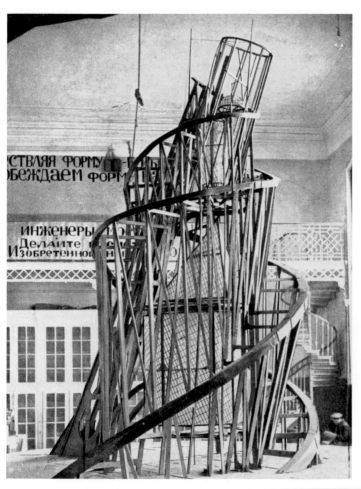

7.32 Vladimir Tatlin, *Project for the Monument to the Third International*, 1919–20.

One of the most ambitious and influential Constructivist projects designed to further the revolutionary goal of spreading Communism worldwide was Vladimir Tatlin's *Monument to the Third International* ▶ **fig. 7.32**. The Third International, set up in 1919 by Lenin, was an organization dedicated to promoting the overthrow of capitalism throughout the world. Tatlin (1885–1953) wanted to create an appropriately innovative monument to the new Communist state in Russia and to the expected triumph of Communism everywhere. He also wanted to synthesize utility with pure abstract forms, and dreamed of a functioning monument to the future. The building consisted of a skeleton of structural steel, within which government offices, designed as pure geometric forms sheathed in glass, were strung vertically up the central axis of the tower. A cube at the bottom housed the legislature, a pyramid at the second level was the office of the International Executive Committee and other executive groups, and a sphere at the top was devoted to a propaganda bureau. The enormous monument, planned to be more than 1,300 feet high, was intended to rotate slowly, each level turning at a different speed (the top level once per day, the second at the rate of once per month, and the ground floor once per year). The rotation of the parts was not only intended to symbolize political change, but to suggest that the Soviet revolution was in harmony with the very movement of the planets, a distant cousin of the medieval religious ideal of the harmony of the spheres. Despite its renown, Tatlin's plan was too ambitious for the resources of the new state and was never realized (only a small-scale mock-up was built).

As early as 1921 the authorities in the Soviet Union had questioned whether any art that did not directly serve the state was in fact tainted by "Western bourgeois aesthetics." Serving the state required that the works be accessible to everyone, so abstract works were suspect. With Lenin's death in 1924, a five-year internal battle for power developed in Moscow. In 1929 Joseph Stalin (1879–1953)—he himself selected this surname, which means "Steel"—had secured a dictatorial control of the state, which he would maintain until his death in 1953. Much like Hitler in Germany, Stalin suppressed any art production that did not meet the requirements of "agitation and propaganda." He denounced the use of abstraction, and favored figurative artworks devoted solely to nationalist subject matter such as the "heroes of the Soviet Union." Stalin, in fact, had dogmatic views about appropriate subject matter similar to those espoused by Rivera in Mexico. However, Stalin was in a position to force all artists to accept his point of view. A typical example of this Socialist Realism is Alexander Gerasimov's *Joseph Stalin and Voroshilov at the Kremlin* ▶ **fig. 7.33**. Employing a retrograde naturalist style, Gerasimov (1881–1963) shows Stalin and Voroshilov, leader of the Red Army, striding purposefully, while in the background the nationalistic

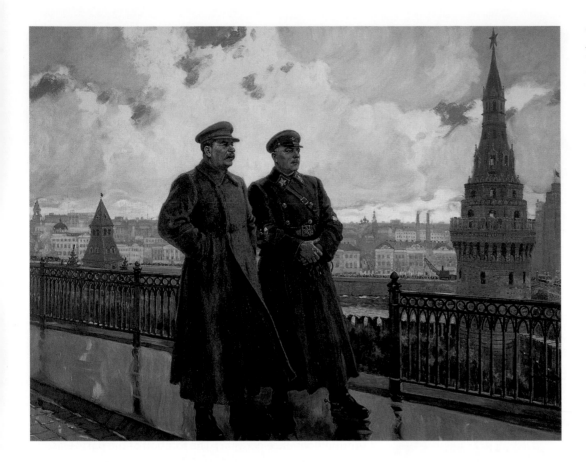

7.33 Alexander M. Gerasimov, *Joseph Stalin and Voroshilov at the Kremlin*, 1938. Oil on canvas, 9ft 10ins × 12ft 10ins. Tretyakov Gallery, Moscow.

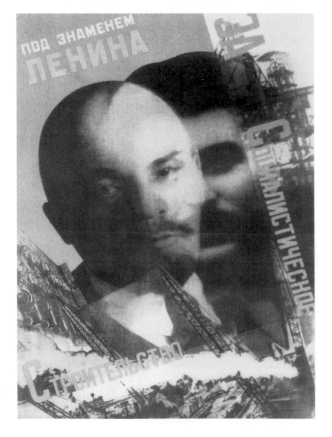

LEFT **7.34** Gustav Klutsis, *Under Lenin's Banner Toward Socialist Construction*, 1930. Poster. Private collection.

imagery includes familiar older structures alongside modern factories. Soviet Socialist Realism would later be exported to China when that country allied itself with the U.S.S.R. after its own Communist revolution in 1949.

Stalin also wanted to turn the art of graphic design toward propagandistic realism. Artists used striking combinations of text and photographs to idealize the industrial might of the U.S.S.R. under Stalin's Five-Year Plans. Gustav Klutsis's (1895–1944) *Construction* ▶ **fig. 7.34** is much more accessible than Lissitzky's Constructivist abstraction. It declares the triumph of Soviet economic power in simple, forthright terms. In later decades, the association of realistic painting with brutal dictatorships like those of Stalin and Hitler would help to undermine its credibility as a legitimate artistic style, both in the fine arts and in the commercial realm.

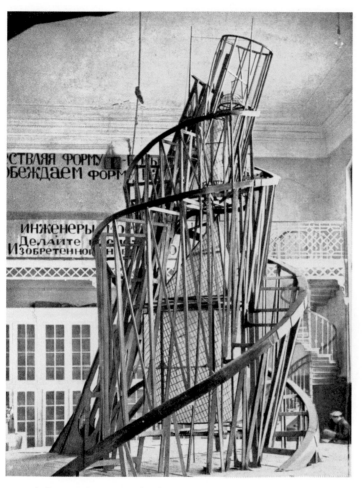

7.32 Vladimir Tatlin, *Project for the Monument to the Third International*, 1919–20.

One of the most ambitious and influential Constructivist projects designed to further the revolutionary goal of spreading Communism worldwide was Vladimir Tatlin's *Monument to the Third International* ▶ **fig. 7.32**. The Third International, set up in 1919 by Lenin, was an organization dedicated to promoting the overthrow of capitalism throughout the world. Tatlin (1885–1953) wanted to create an appropriately innovative monument to the new Communist state in Russia and to the expected triumph of Communism everywhere. He also wanted to synthesize utility with pure abstract forms, and dreamed of a functioning monument to the future. The building consisted of a skeleton of structural steel, within which government offices, designed as pure geometric forms sheathed in glass, were strung vertically up the central axis of the tower. A cube at the bottom housed the legislature, a pyramid at the second level was the office of the International Executive Committee and other executive groups, and a sphere at the top was devoted to a propaganda bureau. The enormous monument, planned to be more than 1,300 feet high, was intended to rotate slowly, each level turning at a different speed (the top level once per day, the second at the rate of once per month, and the ground floor once per year). The rotation of the parts was not only intended to symbolize political change, but to suggest that the Soviet revolution was in harmony with the very movement of the planets, a distant cousin of the medieval religious ideal of the harmony of the spheres. Despite its renown, Tatlin's plan was too ambitious for the resources of the new state and was never realized (only a small-scale mock-up was built).

As early as 1921 the authorities in the Soviet Union had questioned whether any art that did not directly serve the state was in fact tainted by "Western bourgeois aesthetics." Serving the state required that the works be accessible to everyone, so abstract works were suspect. With Lenin's death in 1924, a five-year internal battle for power developed in Moscow. In 1929 Joseph Stalin (1879–1953)—he himself selected this surname, which means "Steel"—had secured a dictatorial control of the state, which he would maintain until his death in 1953. Much like Hitler in Germany, Stalin suppressed any art production that did not meet the requirements of "agitation and propaganda." He denounced the use of abstraction, and favored figurative artworks devoted solely to nationalist subject matter such as the "heroes of the Soviet Union." Stalin, in fact, had dogmatic views about appropriate subject matter similar to those espoused by Rivera in Mexico. However, Stalin was in a position to force all artists to accept his point of view. A typical example of this Socialist Realism is Alexander Gerasimov's *Joseph Stalin and Voroshilov at the Kremlin* ▶ **fig. 7.33**. Employing a retrograde naturalist style, Gerasimov (1881–1963) shows Stalin and Voroshilov, leader of the Red Army, striding purposefully, while in the background the nationalistic

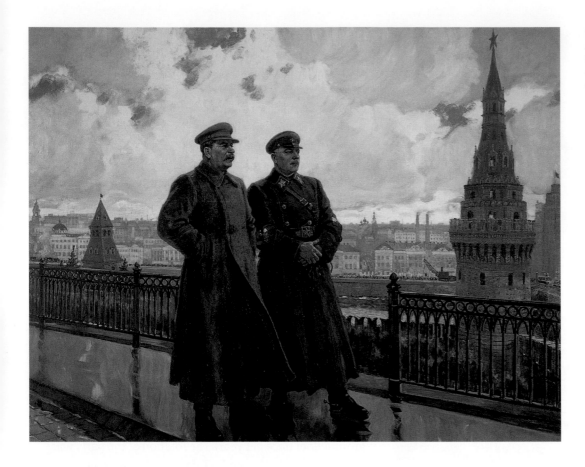

7.33 Alexander M. Gerasimov, *Joseph Stalin and Voroshilov at the Kremlin,* 1938. Oil on canvas, 9ft 10ins × 12ft 10ins. Tretyakov Gallery, Moscow.

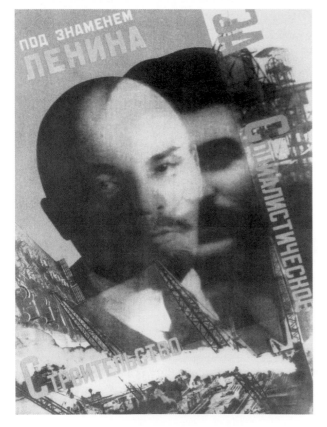

LEFT **7.34** Gustav Klutsis, *Under Lenin's Banner Toward Socialist Construction,* 1930. Poster. Private collection.

imagery includes familiar older structures alongside modern factories. Soviet Socialist Realism would later be exported to China when that country allied itself with the U.S.S.R. after its own Communist revolution in 1949.

Stalin also wanted to turn the art of graphic design toward propagandistic realism. Artists used striking combinations of text and photographs to idealize the industrial might of the U.S.S.R. under Stalin's Five-Year Plans. Gustav Klutsis's (1895–1944) *Construction* ▶ **fig. 7.34** is much more accessible than Lissitzky's Constructivist abstraction. It declares the triumph of Soviet economic power in simple, forthright terms. In later decades, the association of realistic painting with brutal dictatorships like those of Stalin and Hitler would help to undermine its credibility as a legitimate artistic style, both in the fine arts and in the commercial realm.

China

In China the internal conflict between the nationalists and the Communists, exacerbated by Japanese invasion in the 1930s, would not be resolved until after World War II ended in 1945. In 1949 the nationalist forces were eventually defeated and fled to Taiwan, while mainland China was united under the Communist dictatorship of Chairman Mao Zedong. Modeling his new society on the U.S.S.R. under Stalin, Mao quickly implemented tight governmental control of the arts. He defined the ideas behind art in the new People's Republic of China as follows:

> In the world today all culture, all literature and art belong to definite classes and are geared to definite political lines. There is in fact no such thing as ... art that is detached from or independent of politics. Proletarian literature and art are part of the whole proletarian revolutionary cause; they are, as Lenin said, cogs and wheels in the whole revolutionary machine.

In 1950 a Central Academy of Fine Arts, which emphasized a doctrinaire Socialist Realist style, was established in Beijing. The central Beijing academy also controlled the curriculum of lesser regional art schools. The People's Republic mandated that art must be didactic and accessible, easily understood, and able to influence the great masses of China's peasant population. In fact, part of the government's policy was to train peasants to produce amateur art with political themes.

This new vision appealed particularly to young artists who wanted to participate in the nation-building process; many older artists, however, especially those who had studied European modernist styles, were shunted out of the mainstream, their careers in tatters. The new academy forbade the making of modernist abstractions, as well as almost all traditional Chinese painting and religious artworks. The resulting works are generally explicit in their message. Luo Gongliu (born 1916), who specialized in a naturalistic style based on Soviet Socialist Realism, came to prominence in the early 1950s. His painting *Mao Zedong Reporting on the Rectification in Yanan* ▶ **fig. 7.1** (see p. 206) shows the Communist leader at a makeshift rostrum, backed by pictures of Lenin and Karl Marx. It depicts an imaginary scene from around 1942, when China was still occupied by Japan, and the Communist army had a single stronghold in Yanan,

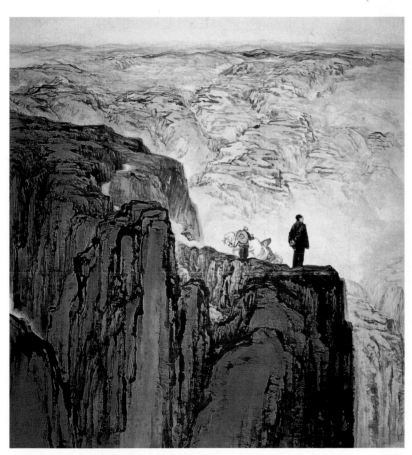

7.35 Shi Lu, *Fighting in Northern Shaanxi*, 1959. Ink and color on paper, 7ft 9¾ins × 7ft 1in. Museum of the Chinese Revolution, Beijing.

a town whose resilience would later make it become sacred to the People's Republic. At this time, in a series of lectures later compiled as *Talks at the Yanan Forum on Literature and Art* (quoted above), Mao set out his theory of art's place in the service of the common peasants who would form the backbone of the Communist revolution.

In the painting, Mao's body language and gesture effectively communicate his ability to move listeners; they, in turn, take notes with rapt attention.

Mao's economic campaign, the "Great Leap Forward" of 1957–60, which was intended to continue to build upon the revolution's economic successes, ended in starvation for millions of Chinese and political disruption in Beijing. Because Mao's strategy was to break the Soviet–Chinese alliance, artists soon found that Socialist Realist art also had to adapt. There was a new call by the government for artists to add subject matter as well as stylistic elements that were recognizably Chinese. This nationalistic trend resulted in works such as *Fighting in Northern Shaanxi* by Shi Lu (1919–1982) ▶ **fig. 7.35**, a painting that combines Soviet Socialist Realism with textured mountain strokes reminiscent of China's great landscape painting tradition. In addition, the placement of Mao, alone in an awesome natural scene (except for some smaller servants or soldiers), resonates with the Southern Song tradition of showing scholars meditating amidst natural beauty (see chapter 5).

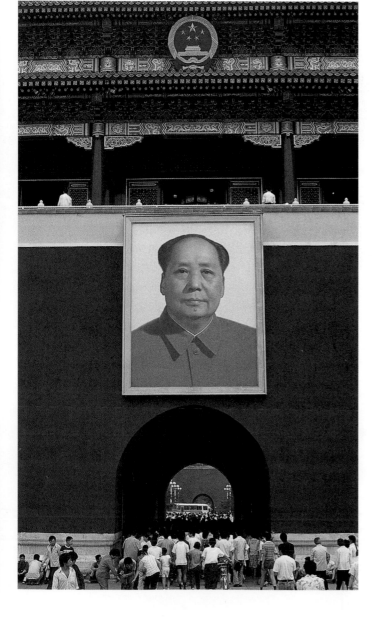

Between 1966 and 1977 Mao's "Cultural Revolution" led to some additional changes in the way that politics and art were practiced in China. First and foremost came a greater expansion of his personality cult. His poetry became compulsory reading for all Chinese citizens. The visual arts also served to enhance Mao's status: soon after the revolution, for example, a giant portrait of him was hung from Gate of Heavenly Peace in Tiananmen Square, next to the tower from which he had proclaimed the establishment of the People's Republic in 1949 ▶ **fig. 7.36**. During the Cultural Revolution, when Mao and his allies mobilized millions of young people to fight against the huge Communist bureaucracy that had begun to limit Mao's power in China, this portrait became an icon to his Chinese supporters. Reproductions numbered in the tens of millions; they could be found in almost every home, business, or government building.

In this chapter we have attempted to elucidate the way in which various regimes, whether repressive or revolutionary and forward-looking, have employed artists who work in realistic styles to achieve their goals. The theme is taken up again in chapter 10, where contemporary artists with staunch political commitments are discussed.

7.36 Photograph of Chairman Mao, displayed at the Gate of Heavenly Peace in Tiananmen Square, Forbidden City, Beijing, China.

Further Reading

J.F. Andrews, et al., *A Century in Crisis: Modernity and Tradition in the Art of Twentieth-century China*, exh. cat., Guggenheim Museum (New York, 1998), pp. 228–277

S. Barron and M. Tuchman, *The Avant Garde in Russia 1910–1930*, exh. cat., Los Angeles County Museum of Art (Boston, 1980), pp. 92–101

D. Bjelajac, *American Art: A Cultural History* (London, 2001), pp. 127–141

T. Crow, *Painters and Public Life in Eighteenth-Century Paris* (New Haven, 1985), pp. 211–254

S. Faunce and L. Nochlin, *Courbet Reconsidered*, exh. cat., Brooklyn Museum (New York, 1988), pp. 17–42

L. Folgarait, *Mural Painting and Social Revolution in Mexico, 1920–1940* (Cambridge, 1998), chapter 3, pp. 33–85

Great Utopia: The Russian and Soviet Avant-Garde 1915–1932, exh. cat., Guggenheim Museum (New York, 1992), pp. 1–24

R.L. Herbert, *Impressionism: Art, Leisure and Parisian Society* (New Haven, 1988), pp. 1–32

L. Hurlburt, *The Mexican Muralists in the United States* (Albuquerque, NM, 1989), pp. 159–174

J. Plax, *Watteau and the Cultural Politics of 18th-century France* (Cambridge, 2000)

F.K. Pohl, *Framing America: A Social History of American Art* (London, 2002)

P. Powell, *Mao's Graphic Voice: Pictorial Posters from the Cultural Revolution*, exh. cat., Elvehjem Museum of Art (Madison, 1996)

Source References

p. 210 "Good social institutions are those ..."
Rousseau, quoted in R. Lamm, *The Humanities in Western Culture* (Madison, 10/1996), vol. 2, p. 240

p. 211 "I should gladly sacrifice the pleasure ..."
Diderot quoted in L. Eitner, *An Outline of 19th Century European Painting* (London, 1992), p. 4

p. 230–31 "We repudiate easel painting ..."
Siquieros, quoted in *Art in Theory 1900–1990: An Anthology of Changing Ideas*, ed. C. Harrison and P. Wood (Oxford, 1992), p. 388

p. 237 "In the world today all culture ..."
Mao Zedong, "Talks at the Yanan Forum on Literature and Art," *Selected Works* (Shanghai, 1967), vol. 3, p. 86

Discussion Topics

1. How is the term "revolution" used in this chapter to denote both political movements and artistic change? How have the two overlapped in history?

2. How did Neoclassical style and subject matter reinforce each other?

3. Cite some examples not discussed in the text of American buildings that show a Classical influence.

4. Why is abstract art not often suitable as revolutionary art?

5. Do you know of any artists involved in revolutionary politics today? Describe their work.

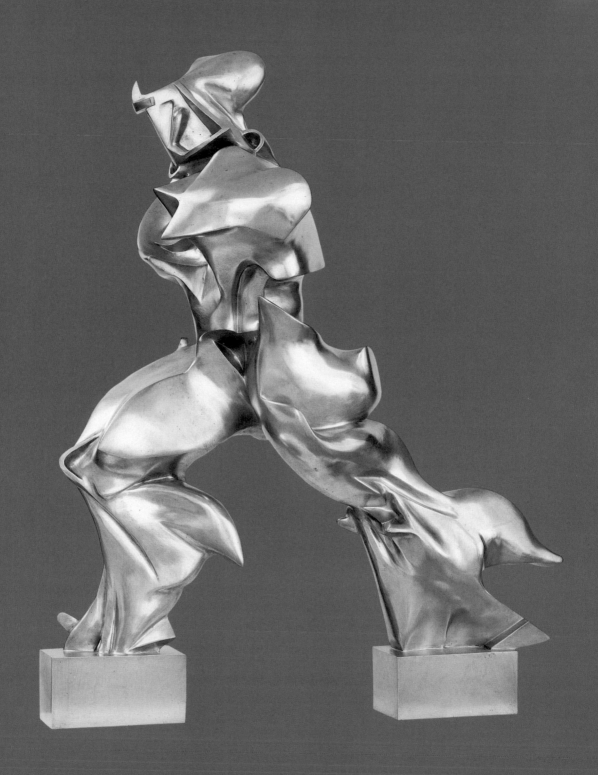

Utopia and Dystopia

The word "utopia" was coined by the English statesman Sir Thomas More (1478–1535) for his book of that title, published in 1516. The word was derived from the Greek for "nowhere" (*ou*, "not"; *topos*, "place"). For More and other thinkers who built upon his idea, utopia could represent an ideal society that did not yet exist. Many European writers and artists who were dissatisfied with the economic and political injustices of their own era used the theme of utopia to express their desire for substantial social change, which they hoped would result in a society more just and equitable than their own. By the late nineteenth century and into the early twentieth, there was a general feeling of being on the cusp of a new, utopian age. Those who felt that European society was corrupt and artificial often sought solace in a vision of a new, better world that was just around the corner.

This chapter opens with a consideration of the Neo-Impressionists, for whom science would lead to both aesthetic innovations as well as a more just society. Other artists sought refuge in images of humanity's primeval past, a time before modern civilization had corrupted human society. In some cases, this escapist philosophy manifested itself in an attachment to "primitive" art. In the section on Paris in the early twentieth century, we focus on two artists who are central to the development of modern art, Pablo Picasso and Henri Matisse. This is followed by discussions of German Expressionism and artists of the Futurist group in Italy and Britain. Our exploration of early twentieth-century American art draws attention to the artists who sought to imagine the future through an abstract language of color. While experimenting with the traditional medium of oil painting, they also endeavored to create an art of the future that employed new electrical technologies. As a parallel, American corporations took up the theme of utopianism in presenting the public with a new world of material plenty.

"Dystopia" is the antonym of "utopia," and denotes an imaginary place that is evil and corrupt. The concluding section of this chapter delves into post-World War I visions of the future in Germany, where some artists expressed deep fears related to the future and humanity's place in a technologically sophisticated world. Other German artists at the Bauhaus continued to enjoy an optimistic attitude, believing that the machine world could lead to a utopian age.

8.1 Umberto Boccioni, *Unique Forms of Continuity in Space*, 1913. Bronze (cast 1931), 3ft 7⅞ins × 2ft 10⅞ins × 1ft 3¾ins. The Museum of Modern Art, New York (acquired through the Lillie P. Bliss Bequest).

Key Topics

The varying responses of artists to the beginnings of the "modern age" after 1880.

▶ Divergent trends in Paris: some artists adopted scientific progressivism, while others fled the industrial landscape to seek succor in a utopian primitivism.

▶ A medieval utopia: Expressionist artists in twentieth-century Germany were inspired by the collective ethic of the guild system; the potential moral effects of architecture were explored.

▶ In celebration of technology: Italian Futurists developed an art to mirror the speed and physical brutality of the modern world.

▶ A colorful future: in America the Synchromists produced color-saturated abstractions that influenced industrial design.

▶ Machine war: World War I produced a crisis in the arts, as in every other field of endeavor in the West. In Germany, many artists responded with a dystopian, disordered vision of the world; others, more positively, proposed a fresh start for the arts in its aftermath.

French Art After Impressionism

The French painters Georges Seurat (1859–91) and Paul Gauguin (1848–1903) both initiated new styles based on, but departing significantly from, Impressionist painting techniques. Seurat's "Neo-Impressionist" style was indebted to his study of modern optical science, while most of his subject matter was drawn from contemporary life. Seurat looked toward the future, believing that his scientifically devised color harmonies served as a metaphor for a coming age of social harmony. In contrast, Gauguin's style and subject matter reveal a vision grounded in an idealized, primitive past, a past he looked for outside the hustle and bustle of European cities. Unlike the scientific progressivism of Seurat, Gauguin sought inspiration in folk-art motifs to reinforce his bold painting style.

In 1886, at the opening of the eighth (and last) Impressionist exhibition in Paris, Seurat exhibited his monumental painting *Sunday Afternoon on the Isle of the Grande Jatte* ▶ **fig. 8.2**. Seurat and his main supporter, the critic Félix Fénéon, argued that the new style used in *The Grande Jatte*, which combined tiny, tightly structured brushstrokes (▸pointillism◂) with experimental color theory ("divisionism"), inaugurated a new type of scientifically regulated Impressionism. Seurat's painting technique is indebted to the Impressionists' bright palette, juxtaposition of complementary colors, and novel compositions. However, Seurat based his technique not on the intuitive decisions of

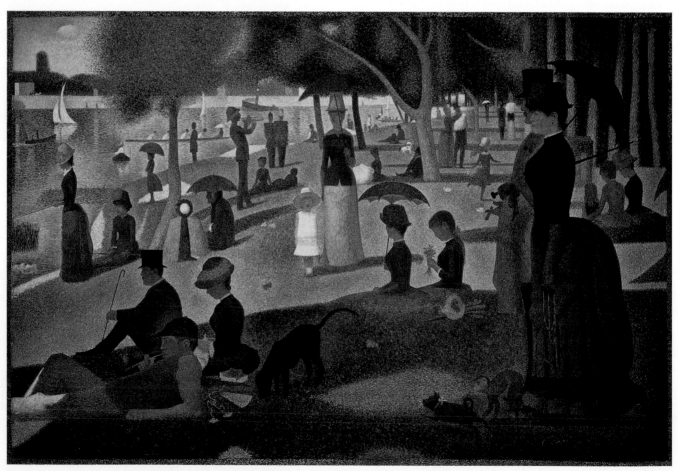

8.2 Georges Seurat, *Sunday Afternoon on the Isle of the Grande Jatte*, 1884–86. Oil on canvas, 6ft 9½ins × 10ft 1¼ins. The Art Institute of Chicago.

the Impressionists, but on the modern science of optics, studying the work of scientists such as Michel-Eugène Chevreuil and Henry Ogden Rood, who published *Modern Chromatics* in 1879. Seurat attempted to find a way of making colors mix in the viewer's perception, not through mixing pigments. (For example, a painter traditionally makes green paint by mixing the primary colors blue and yellow together. Seurat attempted to juxtapose small amounts of blue and yellow on his canvases that would form a vivid green in the viewer's eye when the painting was seen at the appropriate distance.) When *The Grande Jatte* was first shown, some critics complained that the grass was muddy and dark.

Seurat's vision for the future was an essentially utopian one connected to his embrace of scientific knowledge and progressive politics. A quiet man with little taste for public life (Degas called him "The Notary"), Seurat had an unwavering belief that science would lead humankind toward a more just and harmonious future society. Charles Darwin's theory of evolution was the most high-profile scientific concept of the day; it is possible that the monkey in *The Grande Jatte* may be an oblique reference to the theory of evolution and its socialist interpretation (see inset).

The imagery of *The Grande Jatte* at first glance seems straightforward: a cross-section of Parisian society enjoying a relaxing day in the park, a typical scene in terms of recent Impressionist subject matter. However, contemporary French viewers would have recognized that the painting was not at all what it seemed. Any Parisian would know that this was not the world of Monet's *Boulevard des Capucines* (see fig. 7.23). The island of *The Grande Jatte* was never a peaceful place of bourgeois leisure, but rather a seedy spot on the fringe of Paris near the outflows of the city's new sewer system. In addition, the island was renowned for being particularly raucous on Sunday afternoons, when factory workers blew off steam during their one free afternoon of the week. With this in mind, it is possible that Seurat was parodying similar Impressionist scenes; he hoped that the corrupt "present" would give way to

Two Visionary Thinkers: Charles Darwin and Karl Marx

Among the most world-shattering ideas was the concept of evolution introduced by Charles Darwin (1809–82). His book *On the Origin of Species by Means of Natural Selection, or The Preservation of Favoured Races in the Struggle for Life*, first published in 1859, was in its sixth printing in 1872. In asserting that the natural world operated by a set of scientifically deducible rules, that species changed because of environmental circumstances, and, most controversially, that human beings were part of a "family tree" that could be traced back to include other primates, Darwin undercut humanity's view of itself as superior to the rest of creation. Implicit in his work was a vision of the future as one of continual progress toward an as yet undefined but superior world.

Karl Marx (1818–83), co-author of the *Communist Manifesto* (1848), devoted his career to a consideration of the economic issues of modern industrial society, particularly the struggle between factory workers and the capitalist owners of the means of production. Marx saw inevitable conflict between these two groups, whose interests he felt were irreconcilable. While Marx envisioned a brighter future for working men and women through revolution (see chapter 7), much of his intellectual work was rooted in an assessment of the past. Marx claimed to have discovered inevitable evolutionary patterns in history, patterns that enabled him to make "scientific" predictions about the future of European society. In 1848 he set the stage for his predictions of a future workers' state when he wrote in *The Communist Manifesto*: "The history of all hitherto existing society is the history of class struggles." His final published work, *Das Kapital* ("Capital"), known as the "working man's bible," was first printed in 1867 and was as widely read as Darwin's greatest success. In Marx's system, the coming of a socialist, classless state was as inevitable as Darwin's evolutionary change.

8.3 Paul Signac, *In the Time of Harmony*, 1893–95. Oil on canvas, 10ft 2¾ins × 13ft 5⅜ins. Montreuil Town Hall.

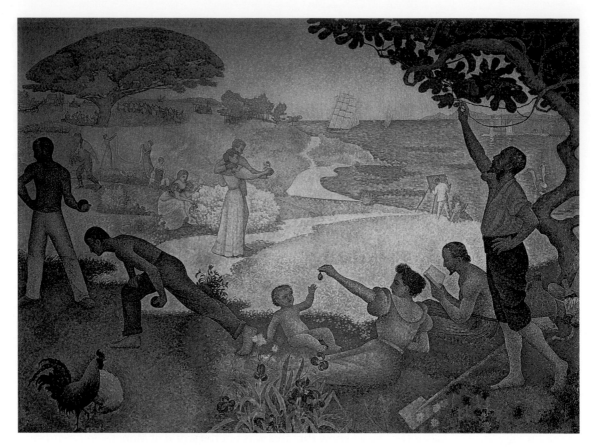

a more just society. The stiffness of the figures has also been interpreted as a sign of an uncomfortable social mix among the wide range of classes that met in the park.

Seurat's ironic commentary on the present contrasts pointedly with *In the Time of Harmony* ▶ **fig. 8.3**, a beguiling vision of a future utopian society painted by Seurat's protégé, the French artist Paul Signac (1863–1935). The mural combines themes of modern leisure activities as painted by the Impressionists with Classical allusions to the tranquillity of early, mythic Greek history. Thus, while looking backward, it also evokes a future in which most people can devote their lives to the joys of art, literature, sports, and love.

The most strikingly modern-looking element of the Parisian cityscape built during Seurat's lifetime was the Eiffel Tower, an iron-framed structure nearly 1,000 feet high, built in 1889 for the Universal Exposition ▶ **fig. 8.4**. The tower, like the exposition itself, was designed to celebrate the centenary of the French Revolution. Some critics viewed it as fitting into the Classical tradition of triumphal arches. Still, its exposed iron beams, which look comfortably familiar to contemporary viewers, represented a startling departure from the dominant styles of the time. While popular with the average visitor to the exposition, of which there were 28 million during the summer of 1889, the Eiffel Tower was widely denounced by artists, art critics, and other intellectual elites. The visionary "futurist" look of the tower offended conservative taste. As early as February 1887 a petition signed by notable French authors and others,

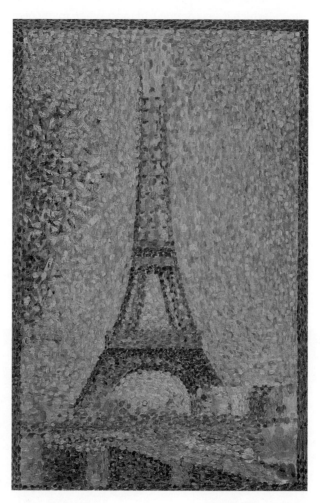

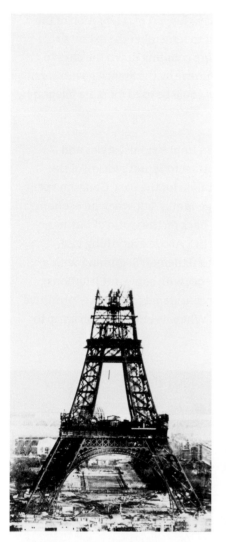

ABOVE **8.4** Photograph of Eiffel Tower under construction, October 14, 1888. Photograph taken from the East tower of the Palais du Trocadéro.

ABOVE RIGHT **8.5** Georges Seurat, *Eiffel Tower*, c.1889. Oil on panel, 9½ins × 6ins. Fine Arts Museums of San Francisco.

"A Protest Against the Tower of Monsieur Eiffel," was published in the newspaper *Le Temps*.

> We come, we writers, painters, sculptors, architects, lovers of the beauty of Paris which was until now intact, to protest with all our strength and all our indignation, in the name of the underestimated taste of the French, in the name of French art and history under threat, against the erection in the very heart of our capital, of the useless and monstrous Eiffel Tower.

Despite their protestations, a contract stipulated that the Eiffel Tower must not only be built, but would remain standing for twenty years. Among the signatories of the protest letter was the writer Guy de Maupassant (1850–93), who joked later that he ate lunch in the Eiffel Tower restaurant nearly every day in order to avoid looking at its "metallic carcass."

Seurat was one of the few artists at the time who welcomed the tower for its futuristic qualities. In 1889 he completed his painting *Eiffel Tower* ▶ **fig. 8.5**, which shows the monument in a near-finished state as an icon of modern urban life, rising up in

magnificent splendor, a tower of futuristic light. Today, this sort of celebration of the Eiffel Tower appears commonplace, so it is important to remember the extent to which it was derided. In 1909, when many people were counting down the days to its destruction, the tower was given a last-minute reprieve by the French government: with war looming, it was saved because its antennae could be used for radio telegraphy, thus facilitating military communication.

Like Seurat, the French painter Paul Gauguin drew on Impressionist styles and techniques in his early works. However, in stark contrast to Seurat's vision of the future, Gauguin's mature paintings focused on nostalgia for the past. Gauguin spent his early adult life as a stockbroker supporting a large family, but when an economic downturn in 1883 led to his dismissal, he turned his back on the world of business (and his family) and began to build a career as an artist. Above everything else, Gauguin sought to use his painting to explore spiritual themes. Beginning with a sojourn in the French countryside of Brittany (1886–90, with some interruptions), Gauguin chose to live and work in a fashion that he considered to be more "primitive" than life in industrialized European cities like Paris. When he embarked on a trip to

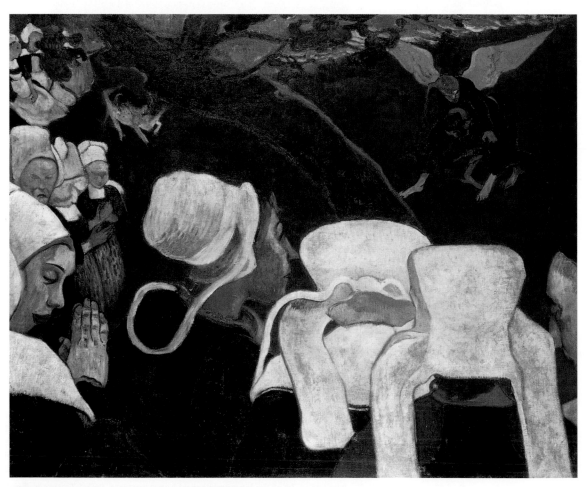

8.6 Paul Gauguin, *Vision After the Sermon*, 1888. Oil on canvas, 2ft 4¾ins × 3ft ¼in. National Gallery of Scotland, Edinburgh.

Panama and Martinique in 1887, Gauguin exclaimed: "I am off to live like a savage." The terms "primitive" or "savage" have negative connotations, but for Gauguin, a "primitive" life was in many ways more authentic and meaningful than life spent in the "civilized" city. To embrace the primitive was to reject contemporary European culture, based in cities. The term "primitivism" is still applied to the style of European artists who utilized non-Western sources in the late nineteenth century.

Basing himself in Pont-Aven, a quaint village in Brittany, Gauguin searched for a spiritual utopia, a place where he could find meaning and fulfillment. This region was inhabited by people who lived according to past traditions, untainted by the modern world. In the 1880s, those who lived in the French countryside felt little allegiance to the French nation, and identified themselves primarily with their region. Few people in rural areas outside Paris spoke standard French, having instead a local dialect or "patois." Gauguin reveled in the folk dress, arts, and simple lifestyle of the "primitive" people of Brittany. It was in Pont-Aven that he painted *Vision After the Sermon* ▶ **fig. 8.6**, which includes a small group of women in traditional dress standing next to a preacher. A tree cuts across the composition, separating them from a scene of the biblical patriarch Jacob in his struggle with an angel (the story is told in Genesis 32: 22–32). Gauguin wanted to emphasize the extreme piety of these peasant women (a piety not common in modern Parisian society). By creating a powerful religious vision, he connects them directly to the biblical story. Several formal elements in *Vision After the Sermon*, many related to its two-dimensional emphasis, were derived from Gauguin's awareness of Japanese woodblock prints, a form that was taking Paris by storm during the late nineteenth century (see chapter 6): the heavy black contour lines; the uptilted horizon line; flat areas of color; and dramatic cropping of the image. Of course, in Gauguin's European-centered view, even the sophisticated art of cosmopolitan societies like Japan's were "primitive" in their unfamiliarity.

While taking account of contemporary trends, however, Gauguin also looked to the past in his use of techniques derived from Breton folk art. Impressionist painting had encouraged Gauguin to break from using natural-looking color, but he went even farther than most Impressionists in his use of abstract color, which he used less to evoke *place* than *feeling*. His unnatural-looking field of red is intended to shock the viewer. The way in which flat planes of color are "stitched" together with heavy black outlines shows his appreciation of the Breton folk art of *cloisonné* jewelry; in this style of decorative art, metal borders are filled with flat areas of colored enamel (the verb *cloisonner* means "to partition").

In 1891 Gauguin set out for the South Pacific, aiming initially for Papeete, the capital city of the Tahitian islands. Neither Brittany nor Tahiti was as far removed from the French society he was trying to escape as they might seem. Pont-Aven was home to a large community of artists, and had attracted many Parisians away from the city. Tahiti had been made a French protectorate in 1843, and a colony in 1880, so for some time French naval officers had been using the city of Papeete as a port of call, and many of the native inhabitants became service-workers and prostitutes to meet their demands.

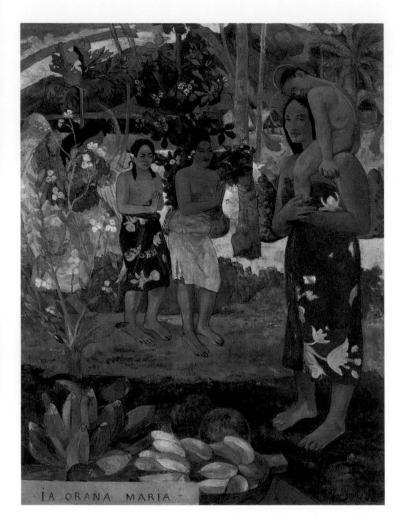

IA ORANA MARIA

8.7 Paul Gauguin, *Ia orana Maria* (Hail Mary), 1891–92. Oil on canvas, 3ft 8¾ins × 2ft 10ins. The Metropolitan Museum of Art, New York. Bequest of Sam A. Lewisohn, 1951.

Gauguin spent most of the final twelve years of his life in Tahiti and the nearby Marquesas islands. There, he continued to make art that expressed spiritual feelings, often combining Christian imagery with pagan elements, as in *Ia orana Mary* (Hail Mary) ▶ **fig. 8.7**, which shows native people arranged in imitation of a scene of the Virgin and Child. Use of this type of subject matter is called "syncretism," meaning that two disparate traditions are combined into one. For Gauguin, the Tahitian people seemed to live like primitive Adams and Eves, existing in a tropical garden paradise out of the past.

Paris in the Early Twentieth Century

The synergy that developed between artists, collectors, and art dealers in the early twentieth century made Paris a mecca for artists from across Europe, America, and Asia. The list shown (see inset, opposite) gives an idea of the range and sheer number of artists who left their countries of origin to gather in the city that offered them the best professional opportunities in the Western world.

Artists in Paris during this period were determined to make stylistic advances and consistently invented new ways of seeing and representing the modern world. Paradoxically, many, including Pablo Picasso (1880–1973), often sought to advance modern painting through the study of "primitive" art, believing it could help them in breaking out of the constraints of European tradition. Born in Málaga, Spain, Picasso finally settled in Paris in 1904 after several previous visits. He soon made the acquaintance of the American expatriate Gertrude Stein, an author and collector who provided Picasso with support long before he became famous. In 1905 she sat for a portrait. The resulting work ▶ **fig. 8.8** shows the first elements of the Cubist style. The assertively flat plane of the side of Stein's nose contests the three-dimensional shape of her face. Picasso subtly transformed her face into a physical impossibility; a viewer would not be able to see her face both in profile and frontally at the same time. Picasso

Paris: Capital of the Art World

Over a period of some forty years, the appeal of Paris proved irresistible to the following artists.

Arrival in Paris	Name	Country of Origin	Arrival in Paris	Name	Country of Origin
1893	Filippo Marinetti	Italy	1911	Ossip Zadkine	Russia
1895	Franz Kupka	Czechoslovakia	1911	Antoine Pevsner	Russia
1897	Kees van Dongen	United Dutch Provinces	1912	Piet Mondrian	United Dutch Provinces
1904	Pablo Picasso	Spain	1913	Chaim Soutine	Lithuania
1904	Constantin Brancusi	Romania	1913	Naum Gabo	Russia
1904	Gertrude Stein	U.S.A.	1913	Tsuguharu Foujita	Japan
1905	Marie Vassilieff	Russia	1914	Leopold Zborowski	Poland
1906	Gino Severini	Italy	1914	Hans Arp	Germany
1906	Juan Gris	Spain	1914	Michael Larionov	Russia
1906	Lionel Feininger	U.S.A.	1914	Natalya Goncharova	Russia
1906	Morgan Russell	U.S.A.	1917	Le Corbusier	Switzerland
1906	Amedeo Modigliani	Italy	1919	Tristan Tzara	Romania
1907	Stanton Macdonald-Wright	U.S.A.	1920	Juan Miró	Spain
1907	Daniel-Henry Kahnweiler	Germany	1921	Man Ray	U.S.A.
1908	Alexander Archipenko	Ukraine	1924	Brassaï	Transylvania
1909	Diego Rivera	Mexico	1924	Sophie Taeuber-Arp	Switzerland
1909	Jacques Lipchitz	Russia	1926	Alexander Calder	U.S.A.
1909	Sonia Delaunay	Ukraine	1927	René Magritte	Belgium
1910	Marc Chagall	Russia	1929	Salvador Dalí	Spain
1911	Giorgio de Chirico	Italy	1933	Wassily Kandinsky	Russia

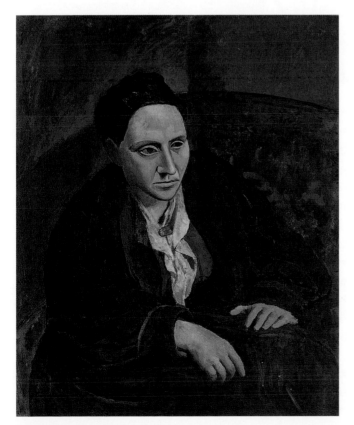

8.8 Pablo Picasso, *Gertrude Stein*, 1905. Oil on canvas, 3ft 3³⁄₈ins × 2ft 8ins. The Metropolitan Museum of Art, New York. Bequest of Gertrude Stein, 1946.

based his abstract formal elements on the collections of non-Western art that he saw at the Trocadéro Museum in Paris, whose display included ceremonial masks with similarly multiple simultaneous viewpoints.

Picasso's *Les Demoiselles d'Avignon* is considered by most art historians to be the first Cubist painting ▶ **fig. 8.9**. Picasso's colleague and Cubist collaborator Georges Braque (1882–1963) said about its creation that Picasso was "drinking gasoline and spitting fire." Stylistically, the picture maintains the innovative form-building first seen in his portrait of Gertrude Stein, combined with some elements of traditional French painting. Five women are grouped around a table, most in poses taken from French academic art (especially the women second and third from the left). This reverence for tradition is counteracted by the aggressive way in which the women's faces and bodies have been nearly turned inside out. The face of the woman seated on the far right has been broken down into an assortment of flat planes (called facets), which are based on African visual

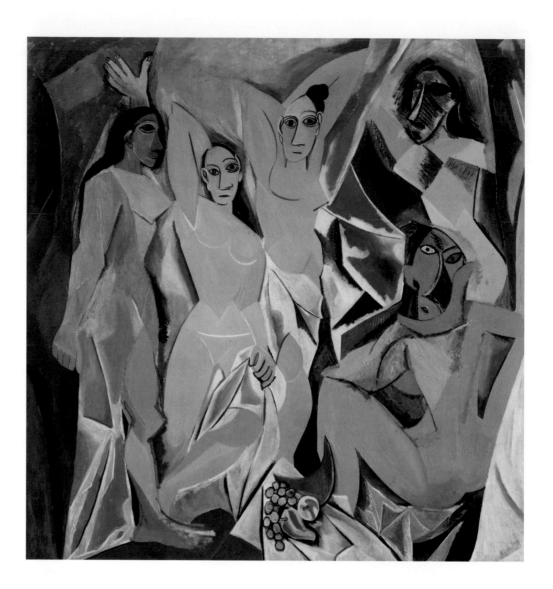

8.9 Pablo Picasso, *Les Demoiselles D'Avignon*, 1907. Oil on canvas, 8ft × 7ft 8ins. The Museum of Modern Art, New York (acquired through the Lillie P. Bliss Bequest).

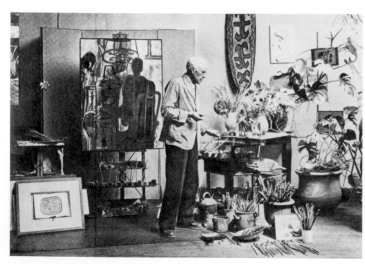

8.10 Georges Braque in his studio, c.1950.

sources as well as the abstract work of Paul Cézanne (1839–1906). (Cézanne, an artist from the Impressionists' generation, had been memorialized with a large retrospective at the Salon d'Automne held in Paris in 1907.) Working from these sources, Picasso transformed the body of the woman on the right so that it is impossible to describe its position; it can look forward or backward, or even somewhere in between. Stylistically, Cubism became one of the most influential artistic movements of all time. For generations to come, European artists sought to explore the possibilities for representing abstract forms opened up by Picasso's work.

European artists like Picasso often identified with what they perceived to be the irrational, pre-civilized (and therefore more authentic than that of urban European

society) power of non-Western objects. A photograph of Braque in his studio ▶ **fig. 8.10** shows the artist surrounded by an assortment of objects gleaned from a variety of African cultures. For the Cubists, these were not the sort of artworks that needed "professional" study of their original historical context. Rather, they resounded powerfully as "primitive," magical images from a faraway time and place. In *Les Demoiselles*, Picasso's vague references to African and Iberian masks provided a means of exploring his own fears and desires. He later recalled a trip to the Trocadéro Museum (see inset) in 1907 as a formative experience in the completion of *Les Demoiselles*: "When I went to the old Trocadéro, it was disgusting. The Flea Market. The smell. I was all alone. I wanted to get away. But I didn't leave. I stayed. I stayed. I understood that it was very important: something was happening to me, right?" The women in his painting are prostitutes; Picasso was exploring his ambivalent feelings about sexuality, exoticism, and morbid fear of disease, especially venereal disease.

While Picasso and Braque based their Cubist art on the manipulation of forms, the French painter Henri Matisse (1869–1954) was building a career based on the manipulation of color. Matisse combined abstract colorism with a profound respect for the academic tradition and a utopian vision of humanity's primitive past. Matisse's paintings, along with those of several colleagues, became known as "Fauvist" in 1905,

The Universal Exposition (1900) and the Trocadéro Museum in Paris

A series of European world fairs and exhibitions that celebrated Western colonial power's "destiny" in Africa, Asia, and Oceania culminated in the Universal Exposition of 1900, held in Paris and showcasing elements of both future technology as well as a "primitive" past. Over 57 million visitors flocked to see such marvelous inventions as electric light displays, the telegraph, escalators, and moving sidewalks.

A highlight of the fair was its colonial section, where European powers displayed the riches gained through conquest ▶ fig. 8.11. The French section presented the people and artifacts of two African cultures, Algeria and Dahomey. Algeria had been occupied by France in 1830, the Dahomey lands (modern-day Benin) only seven years before the exhibition, in 1893. In the Dahomey section, the French government showcased not only objects, but Dahomey people, who were put on display like

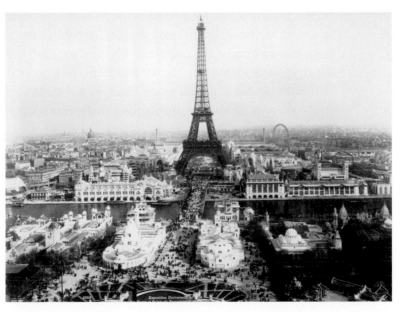

animals. Such dehumanization characterized the attitude toward Africans of many European artists, part of the imperialist tradition that viewed non-Western cultures as uniformly "primitive," natural, and uncontrolled.

The ethnographic collections shown at the exposition later became part of the Trocadéro Museum, a dark, unkempt building where the objects were grouped helter-skelter in cases with little attention to curatorial order. For example, one case might have objects all made of wood; the case might contain everything from the crudest tools to the most splendid masks, and were often from cultures that lived thousands of miles apart. Because of the resulting confusion for visitors, most Europeans had their preconceptions of African culture as uncivilized, disorderly, and repugnant confirmed by the lowly surroundings and chaotic display techniques.

8.11 The Colonial Section at the 1900 Universal Exposition in Paris.

8.12 Henri Matisse, *The Joy of Life*, 1905–06. Oil on canvas, 5ft 9⅛ins × 7ft 10⅞ins. Barnes Foundation, Merion, Pennsylvania.

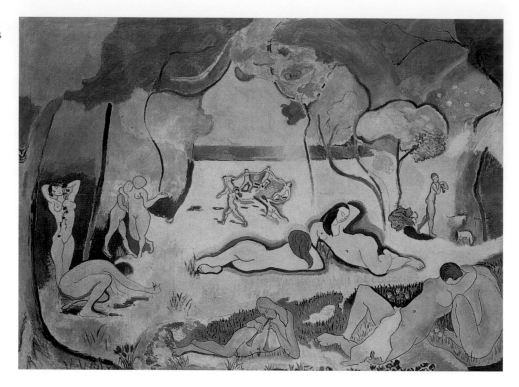

when a critic described them unfavorably as "fauves," or "wild beasts," because of their extremely reductive paint handling and brilliant colorism. This term stuck, despite the fact that Matisse's innovative abstract style was used, for the most part, to portray conventional subject matter, including landscapes, still lifes, and portraits. In 1906 Matisse had a solo show in which he displayed *The Joy of Life* ▶ **fig. 8.12**. The painting's style is heavily influenced by Japanese prints, particularly in the way flat areas of color are separated from one another by strong black contour lines. Most of the figures are nude women, and the work conveys longing for a world untainted by modern technology and industry, much as Gauguin's work had done. However, unlike Gauguin, rather than translate his interest in the primitive through non-Western cultures, in this painting Matisse chose subjects straight from the Classical tradition: *The Joy of Life* suggests an Arcadia, the traditional idealized rural setting of ancient Greek and Roman poetry absorbed into Renaissance literature and iconography, a land of idyllic calm and harmony, a place of perfect peace. Matisse's picture is filled with Arcadian references: the god Pan with his flute, shepherds, and dancers, all in pleasant surroundings.

In 1906 Matisse traveled to the French colony of Algeria. In making this trip he was following in the footsteps of the great French colorist Eugène Delacroix (1798–1863), for whom a visit to North Africa had been a revelation. Matisse's two-week sojourn made the phrase "soak up the local color" a literal fact. Matisse saw Algeria through the eyes of the French Empire; his viewpoint was influenced by the idea that the "primitive" world was a world of rich sensual color. This idea paralleled the conventional stereotype that Algeria's atmosphere and folk arts, as well as its people, were both literally and figuratively colorful. The painting that best represents Matisse's "primitivist" approach to color is *Blue Nude* ▶ **fig. 8.13**. Compositionally, the viewer

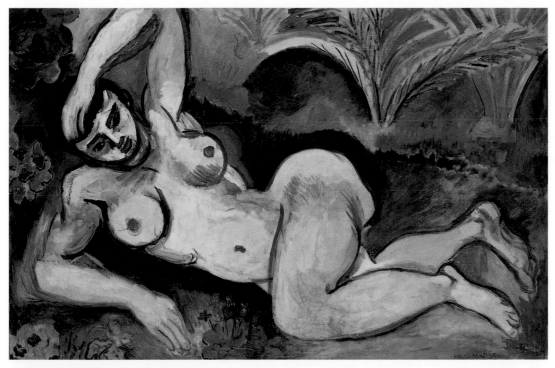

8.13 Henri Matisse, *Blue Nude, (Memory of Biskra)*, 1907. Oil on canvas, 3ft ¼in × 4ft 7¼ins. Baltimore Museum of Art.

is faced with a traditional reclining female nude, but now transformed into an exotic, primeval-looking creature. It is hard for a present-day viewer to imagine how shocking the *Blue Nude* was to contemporary audiences who revered the polished rendering of academic artists. In 1913, when the painting toured the United States as part of an exhibition of European art, students and faculty of the Art Institute of Chicago held a protest at which they burned a crude reproduction of Matisse's picture.

German Expressionism

"Expressionist" art is that in which forms and colors are deliberately exaggerated or distorted; the intention is not to represent anything realistically, but to convey emotional impact. One of the most influential of the German Expressionist groups of the early twentieth century was Die Brücke (The Bridge), which sought to re-create the medieval workshop system. The members of this short-lived group (1905–13) therefore worked collaboratively, without individually signing their works. They are chiefly associated with the revival of the woodcut and other graphic arts. Ernst Ludwig Kirchner (1880–1938), the only fully trained artist in the group, can be seen as representing its aims in using Gothic script to signify Germany's ties to the past in an untitled woodcut produced in 1906 for the title page of the Die Brücke manifesto, even while the text refers to the future: "With faith in progress and in a new generation of creators and spectators we call together all youth. As youth, we carry the future and want to create for ourselves freedom of life and of movement against the long established older forces." Die Brücke was founded in Dresden, which had its own major ethnographic museum, comparable with the Trocadéro in Paris. Members of the group sought their own "primitive" inspiration in this collection of objects looted from non-Western cultures.

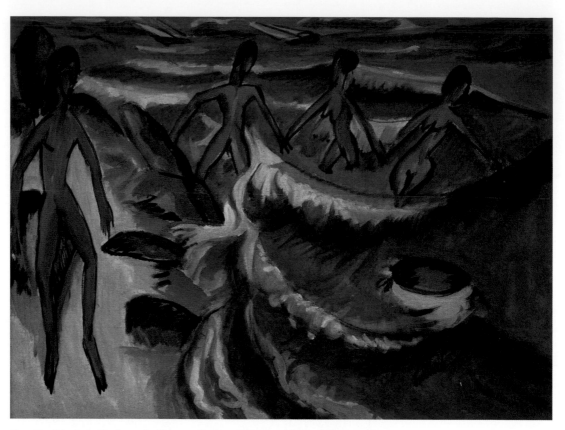

8.14 Ernst Ludwig Kirchner, *Bathers on the Beach (Fehmarn)*, 1913. Oil on canvas, 2ft 5⅞ins × 3ft 3⅜ins.

The group often made trips to local ponds in Moritzburg, where they combined their "collective" art production with an attempt to live a free and unfettered existence. Their version of an Arcadian idyll consisted of harmony based on male dominance, as Die Brücke artists treated their female models as domestic servants and/or sexual diversions. Kirchner's *Bathers on the Beach* ▶ **fig. 8.14** celebrates this vitalist utopian spirit of a primitive life spent amidst the natural world. The spiky forms of the women are drawn from Kirchner's two sources of inspiration: the figures in German medieval woodcuts and the Pacific Island artworks in the Dresden ethnographic museum.

A striking example of German Expressionist architecture was presented in 1914 at an exhibition of the design arts held in Cologne, for which Bruno Taut (1880–1938) erected a glass pavilion ▶ **fig. 8.15**. This polygonal building created an interior environment suffused with color and light; its fourteen-sided exterior featured quotes from an obscure spiritualist author, Paul Scheerbart, mostly about the capacity of glass and crystals to create a harmonious environment. The pavilion's crystalline and prismatic dome combined with an interior waterfall and a kaleidoscope, again contributing to the theme of color and light. Taut believed that the evocative effects of stained glass symbolized the possibility of transforming society, since the color and light of the medieval past could serve as a model for a future, vaguely spiritual, utopia. His nostalgia for the past was complemented by a concern with the future as Taut made use of the most up-to-date technology.

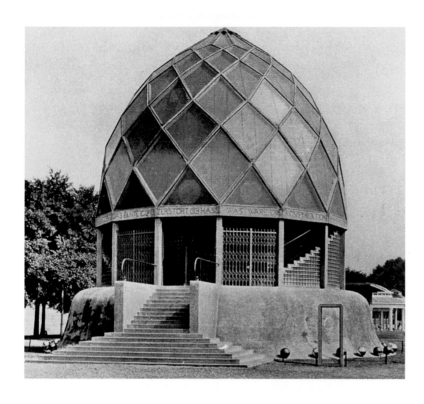

8.15 Bruno Taut, Glass House, Cologne, Germany, 1914.

Taut believed that architecture could have a real moral and religious effect on people's lives. Following Scheerbart, he wrote: "Glass architecture that turns the humble dwellings of men into cathedrals will exert the same beneficial influence over them." He joined two artists' groups that shared his way of thinking: an informal association of architects called Die Gläserne Kette (the Glass Chain; glass was the main material in their—mostly unbuilt—works); and the Arbeitsrat für Kunst (Workers for Art), a group of utopian socialists whose political ideals focused on the promise of a new, just society (compare inset).

Le Corbusier and the Classical Future

In contrast to Taut's view of architecture as symbolic of his mystical, religious aspirations for society, the Swiss-French architect Le Corbusier (1887–1966; his real name was Charles-Edouard Jeanneret) felt strongly that classical tradition could become the aesthetic basis of a modern architecture of the future. His Villa Savoye ▶fig. 8.16 features innovations including the use of tubular steel, ribbon windows, pylons, and Cubist-inspired geometric living spaces, while at the same time taking account of the qualities central to classical theory, such as proportion and balance. None of the villa's exterior surfaces is ornamented; there are no stone coursings, eaves, balustrades, or anything that would disrupt its clean form. While the building looks rather stark and artificial because of this lack of ornament, Le Corbusier in fact intended that the inhabitants could better enjoy the natural world through its large windows and outdoor living spaces. Le Corbusier viewed his creations as "machines for living in," and envisioned a utopia of machine functionalism founded on the aesthetic principles of the past.

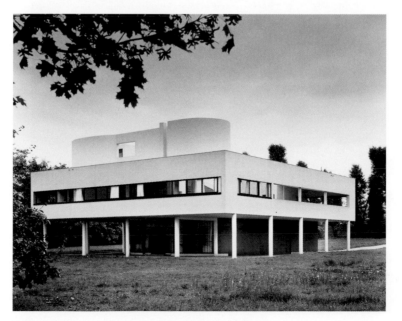

8.16 Le Corbusier, Villa Savoye, Poissy, France, 1928–30.

Italian Futurism

The poet Filippo Tommaso Marinetti (1876–1944), initiator of the philosophy of Italian Futurism, aimed to effect rapid change in Italy, a country that had fallen behind other European nations in terms of industrial progress and economic prosperity. Arguing that Italy needed to charge full throttle into the modern world, he based his ideas on anarchist revolution, nationalist yearnings, and contemporary French aesthetics. Marinetti published the original *Futurist Manifesto* in 1909, presenting a poetic vision of Italy as a modern nation churning with industrial forces:

> We will sing of great crowds excited by work, by pleasure, and by riot; we will sing of the multicolored, polyphonic tides of revolution in the modern capitals; we will sing of the vibrant nightly fervor of arsenals and shipyards blazing with violent electric moons; greedy railroad stations that devour smoke-plumed serpents; factories hung on clouds by the crooked lines of their smoke; bridges that stride the rivers like giant gymnasts, flashing in the sun with a glitter of knives; adventurous steamers that sniff the horizon; deep-chested locomotives whose wheels paw the tracks like the hooves of enormous steel horses bridled by tubing; and the sleek flight of planes whose propellers chatter in the wind like banners and seem to cheer like an enthusiastic crowd.

A group of artists formed around Marinetti in Milan, and gathered momentum as an activist nationalist group intending to completely redefine Italian society. They scorned their nation as little more than a giant museum dedicated to the long-dead cultures of the Romans and the Renaissance. Ironically, yet pragmatically, Marinetti published the *Futurist Manifesto* in *Figaro*, a French, not Italian, newspaper, because Paris was the dominant cultural center of Europe.

One of the most prominent Futurists was the painter and sculptor Umberto Boccioni (1882–1916). His painting *The City Rises* ▶ **fig. 8.17**, with its bright colors and mechanical

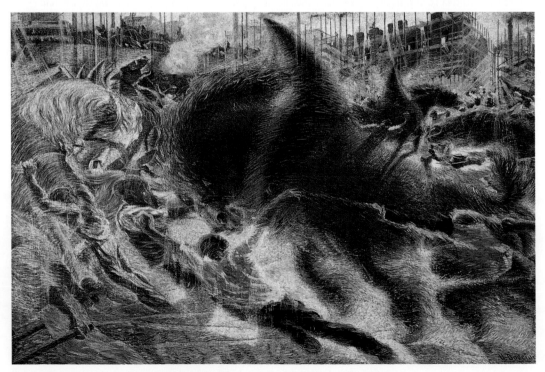

8.17 Umberto Boccioni, *The City Rises*, 1910. Oil on canvas, 6ft 6½ins × 9ft 10½ins. The Museum of Modern Art, New York.

brushwork, shows a modern Italian city bursting with the energy of new construction. The horse, a traditional symbol of physical strength, signifies the new city's power and might. The figures are aligned according to a diagonal scheme, creating dynamic compositional "lines of force" to represent the potential of modern technology. Yet, *The City Rises* displays an arguably dated nineteenth-century Neo-Impressionist technique in its attempt to look toward a world of the future.

Boccioni would soon adopt a new style for his later Futurist works: Cubism, a style that he and others in the movement would reinvent. Boccioni's *Charge of the Lancers* ► **fig. 8.18** exemplifies the way in which the Futurists changed their artistic language

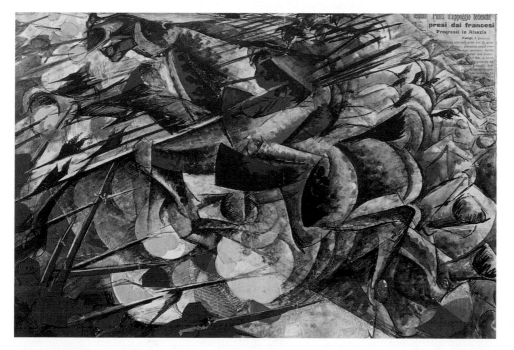

around 1911, trading in the pointillist technique of the Neo-Impressionists for the fractured, faceted planes of Picasso's Cubism. Whereas Picasso had sought to explore form in a state of rest, Boccioni added elements of Futurist dynamism to create a new, more vital form of the Cubist style. In *Charge of the Lancers*, Boccioni again used the traditional motif of the horse as a symbol of military power. Ironically, Boccioni himself died after falling from a horse during World War I.

Boccioni also developed a Futurist aesthetic based on Cubism in his sculpture. In *Unique Forms of Continuity in Space* ► **fig. 8.1** (see p. 240) for example, a mechano-

8.18 Umberto Boccioni, *Charge of the Lancers*, 1915. Oil and collage on cardboard, 1ft ⅝in × 1ft 7⅝ins. Formerly in the collection of Dr Ricardo Jucker, Milan.

morphic man (a man who has the form of a machine) is striding into the future. Here, Cubist facets serve to give the sculpture the appearance of movement. The figure stands as a personification of a vision of the future, while the medium (bronze) and subject matter (a heroic man) are rooted firmly in the Classical past. The Futurists saw the world in starkly gendered terms. They were outspoken in their sexism and overall contempt for women, and envisioned their utopia in the strongest masculinist terms.

The Italian Futurists advocated a European war as a means of leading Italy into the future. Marinetti wrote: "We will glorify war—the world's only hygiene—militarism, patriotism, the destructive gesture of freedom-bringers." However, many members of the Futurist movement were either killed or badly injured during World War I and the country did not experience the renewal and modernization that the Futurists had hoped for. In fact, the continued weakness of the Italian economy, combined with the popularity of nationalist politicians, led to the rise of Fascism (Mussolini was a friend of Marinetti's). The Fascist slogan "To believe, to obey, to combat" underlines the authoritarian and militaristic nature of its ideology.

The United States: Color and the Future

A large number of artists influenced by Matisse's colorism (discussed above), as well as by Cubist form-building techniques, thought of color as an essential element in their visions of the future. This group, including not only the French artist Robert Delaunay (1885–1979) and his Ukranian-born wife Sonia Delaunay (née Terk, 1885–1979), but the Americans Morgan Russell (1886–1953) and Stanton Macdonald-Wright (1890–1973), used abstract visual languages to express their dreams for the future. Robert Delaunay's *Homage to Blériot* ▶ **fig. 8.19** is a tribute to the French aviator who was the first to fly an airplane across the English Channel in 1909. In contrast to many artists of late nineteenth-century Paris who had denounced the Eiffel Tower as a vulgar industrial monstrosity, Delaunay and his friends saw it as an authentic monument of an exciting new world. Together with Blériot's monoplane, the tower served as a symbol of French leadership in technology and design.

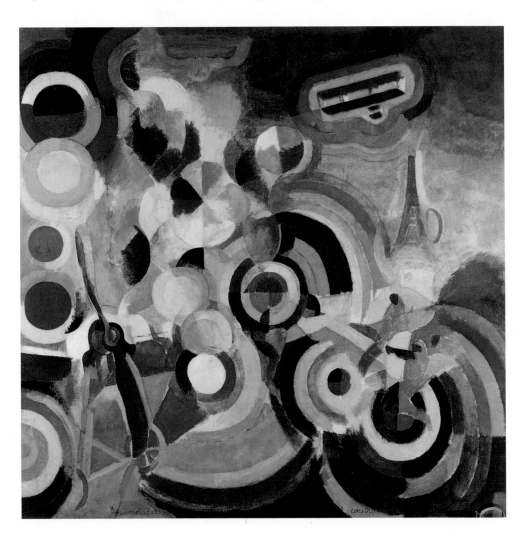

8.19 Robert Delaunay, *Homage to Blériot*, 1914. Oil on canvas, 6ft 4½ins × 4ft 2ins. Kunstmuseum, Basel.

While they were in Paris, Morgan Russell and Stanton Macdonald-Wright attended the color-theory classes of the Canadian émigré artist Ernest Percyval Tudor-Hart (1873–1954) and were further inspired by the colorism they saw in works by the Delaunays and Matisse. In 1912 Russell coined the term "Synchromism," meaning "simultaneous color," to describe the color-saturated abstractions he was producing

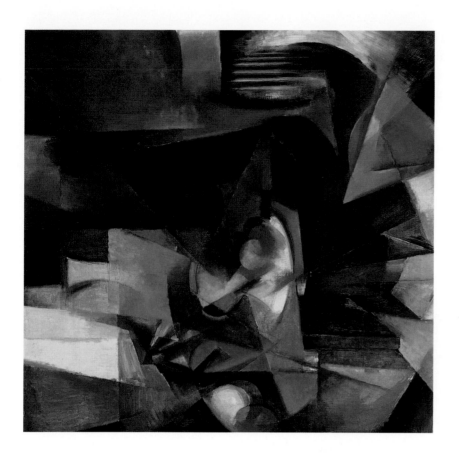

8.20 Stanton Macdonald-Wright, *Synchromy No. 3*, 1917. Oil on canvas, 3ft 3ins × 3ft 1¾ins. Brooklyn Museum of Art, New York.

with Macdonald-Wright. After successful exhibitions in Munich and Paris in 1913, their work was sent to the United States, where it had a considerable impact on other American artists as well as on the popular press. Macdonald-Wright's *Synchromy No. 3* ▶ **fig. 8.20** features abstract, swirling bands of bold color. The critic Willard Huntington Wright (Macdonald-Wright's brother) asserted that such works responded directly to the modern age:

This new art of color is striving for an intensity of effect which the older painting does not possess. The world today demands more powerful aesthetic stimuli than it did in the past. The reason for this is to be found in the new conditions of modern life … Modern life has been markedly increased in intensity as a result of mechanics, densely populated areas, the flooding of the mind with a vast amount of knowledge of events through the perfecting of means of collecting news, the rapidity of travel, the world's swiftly moving panorama, the discoveries in brilliant artificial light, etc.

Russell and Macdonald-Wright attained their greatest American success at the Forum Exhibition of Modern American Painters, which was shown at New York's Anderson Galleries in 1916. Organized by Willard Huntington Wright, the Forum Exhibition presented Synchromism as an "art of pure color" that eclipsed the colorism of Parisian modernists like the Delaunays because it was completely abstract (see also inset).

In 1923, in a book called *The Future of Painting*, Willard Huntington Wright wrote that the Synchromists had done all that could be done in oil painting, and that the future for the visual arts lay in the realm of projected light. "Already the future of the art of color is evident. The medium of the new art will be light: color in its purest, most intense form." Wright was far from alone in believing

Abstraction

Since the late nineteenth century, artists in Europe had been experimenting with abstract styles. Gauguin, for example, was among those to leave out certain details from their scenes, presenting the viewer with only a broad depiction of figures and landscapes. The Synchromists' paintings were among the first in modern art to be "completely abstract," or "non-objective." "Non-objective" means that there are no recognizable objects represented in the painting, the opposite of "representational" art, which tries to portray figures and space as they would appear in real life. Macdonald-Wright's *Synchromy No. 3* (see fig. 8.20) has no reference to objects in the observed world; furthermore, his colors do not appear in nature.

that colored electric light would become an artistic language capable of supplanting the art of painting. As the technology of electricity and illumination advanced, several practitioners of "mobile color" in the United States proffered their art as a successor to painting. This medium was often called "color music" because the instruments that produced it looked like the organ.

Colored light is intended to be part of any performance of the orchestral work *Prometheus: Poem of Fire* by the Russian composer Alexander Scriabin (1872–1915). First played in Moscow, in 1911 (but without the color), it was performed at New York's Carnegie Hall in 1915. Mobile color was projected onto different layers of a small (8-by-10-foot) screen constructed of gauze. A projection machine, the "chromola," had been devised for this performance by engineers at New York's Edison Laboratories. This novelty had a mixed reception, most critics responding better to the color than to the music: "To harmonize with such a score, the colors thrown on the screen should therefore be equally hideous, whereas they are really beautiful."

The most successful artist of colored light in the United States was Thomas Wilfred (1889–1968), whose work was praised by established art critics, collected by major museums, and performed throughout the United States. Wilfred spent a lifetime developing and refining his instruments and elaborating his beliefs in an art of personal expression based on the manipulation of color and light. He called his art "Lumia" and the instrument he invented the "clavilux" (or "light played by key"). Such color organs typically consisted of one or more light projectors with variable focal lengths directing their beams through an assortment of prisms, colored gels, and slides mounted on electric rotation devices. The artist also used custom-shaped light filaments in order to create forms with a direct beam. Lumia works, such as *Vertical Sequence II*, featured an abstract drama of moving forms. Born in Denmark, Wilfred had immigrated to the United States in 1916. After his first public performance in New York on January 10, 1922, Wilfred's popularity soared and he toured continuously with his clavilux through 1933, when he established the Art Institute of Light in New York. His success in America was complemented by a European tour in 1925; that year Lumia was the only American art presented at the World Exposition in Paris.

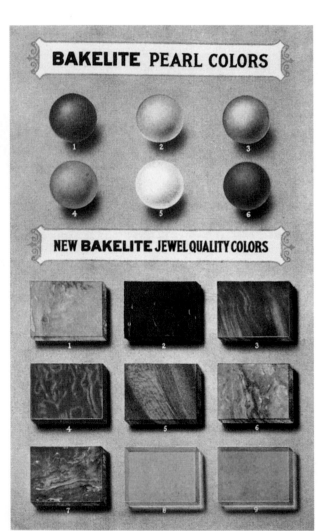

8.21 Color chart from *Gifts to Treasure*, a 1924 catalog of Bakelite jewelry from the Embed Art Company.

Wilfred and the Synchromists were all correct in arguing that color would prove to be the basis of the future, at least the future of American industry. The first issue of the influential magazine *Fortune* in 1930 featured a long article entitled "Color in Industry," drawing attention to the ubiquitous use of color in consumer goods in the 1920s: "For during the past few years a great pail has up-ended itself over the American scene, has splashed our household goods and gods with a rich, warm stream of flat, bright color." According

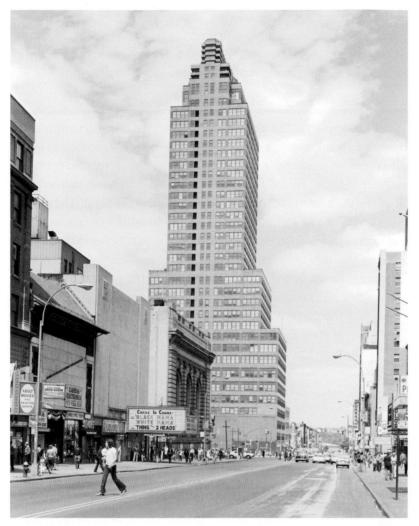

8.22 Raymond Hood, *McGraw-Hill Building*, New York, 1931.

to *Fortune*, the earlier American home had been filled with pots and appliances, all in natural wood stains or black, "or some dull, dark color allied to blackness." The home of 1928, however, was a veritable symphony of color. "Here so utilitarian an object as a sink was purchased from a color range of T'ang Red, Orchid of Vincennes, Royal Copenhagen Blue, Ivoire de Medici, St. Porchaire Brown, Rose du Barry, Ionian Black, Clair de Lune Blue, Ming Green and Meissen White." Thermoplastics, such as Bakelite, allowed designers to introduce color in a variety of new products ▶ **fig. 8.21**. The magazine writer listed several product packages that had been chromatically redesigned in the late 1920s and had secured "gratifying sales increases." Lifebuoy soap, Bokar coffee, Kotex, and Packer's shampoo had all used colored packaging to secure larger shares of the consumer marketplace. In 1928 Macy's had introduced the Red Star iron, a bestseller because of its red molded plastic handle. At this time also dyed fuels were introduced, such as red Socony Special gasoline or Pure Oil's blue motor oil. Not only automobiles and their associated products, but also trains (New York's Blue Comet, Chicago's Red Bird) and planes were touting new color schemes.

By the 1930s, colorful buildings could be found in the major cities of the United States. The color of the terracotta for the McGraw-Hill Building in New York ▶ **fig. 8.22** was obsessively watched over by the architect Raymond Hood (1881–1934). Hood was determined to create a color harmony of perfect synchromy:

> The blue-green glazed surface of the terracotta responds readily to the changing sky colors. Under a bright blue sky the color is correspondingly bright and blue. In the light of dawn, it picks up opalescent tints that change radiance with the rising of the sun … There seems to be some relationship between the blue-green color and the many sky colors, resulting in its color always being a harmonious complement.

Further complementing the blue-green body of the building, Hood designed the main entrance to include blue horizontal strips. After World War I, the United States,

militarily strong with its cities and industries intact, was ideally situated to pursue a utopian future of capitalist affluence based on a world of splendid color and light. In contrast, the destruction that had been visited on the European continent would there engender dramatically different views of the future.

Dystopian Visions in Germany After World War I

World War I (1914–18), also known as the "Great War," showed the unexpectedly lethal effects of modern military technologies, especially when fed by mass production at a level that dwarfed previous "industrial revolutions." The Great War featured the first widespread use of machine guns, poison gas, and mechanized infantry; it was truly a machine war. Between the assassination of the Austrian Archduke Ferdinand in Sarajevo in June 1914 and the European armistice in 1918, eight million people were killed, and twice as many wounded. An international influenza outbreak in 1918 killed millions more. So many died that the notion of a lost generation, "the generation of 1914," became a European truism. To add to the agony, many of the wounded were horribly mutilated (the first serious attempts at reconstructive cosmetic surgery, much of it with gruesome results, date from the Great War) or shell-shocked, a form of neurological illness resulting from traumatic experience.

While even the victorious countries such as Italy struggled to find stability after the war, the situation in Germany, a defeated and starving country, was more desperate. In 1918 German agricultural production was down 50 per cent from prewar figures, while coal production was down 81 per cent. Many Germans did not know how they would eat or keep warm in the winter of 1918–19. German nationalists irrationally blamed the failures of the war on democratic and socialist groups, while left-wing groups blamed the militarism and aggressiveness of Germany's imperialist outlook. For a brief period even a Communist revolution based on the Bolshevik success in Russia seemed possible. However, this rebellion was eventually crushed by Fascist elements, particularly the Freikorps, a militia organized by ultra-nationalistic military officers. The economic situation in Germany was exacerbated by the terms of the Versailles Treaty of June 1919, a punitive treaty that further humiliated and impoverished the country through the imposition of crippling reparation payments. In February 1919 a new parliamentary-based government was installed in Berlin. The "Weimar Republic," named after the historic German town where the new constitution had been ratified, survived a series of crises until 1923, when the German currency finally steadied and a short period of relatively stable prosperity began. However, the "golden twenties" would end abruptly with the severe economic depression that struck both the United States and Europe in 1929.

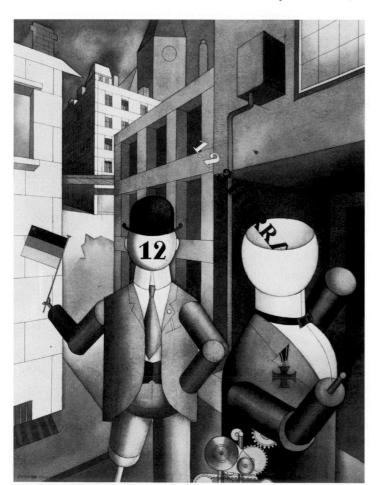

8.23 Georg Grosz, *Republican Automatons*, 1920. Watercolor, 1ft 11⅝ins × 1ft 6⅝ins. The Museum of Modern Art, New York.

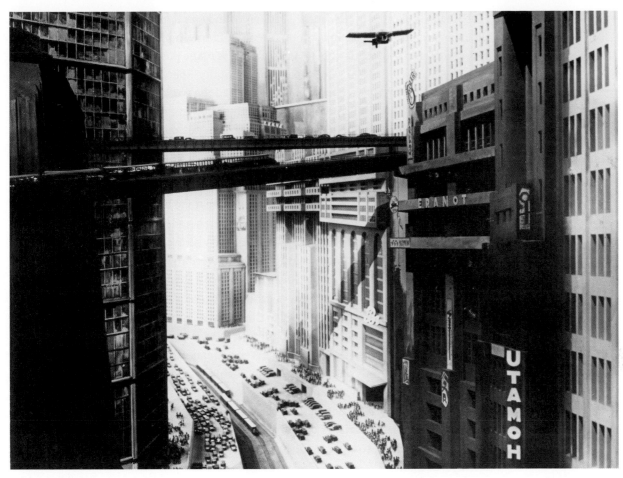

8.24 Photographic still from the film *Metropolis*, 1926.

For George Grosz (1893–1959), an artist who made a specialty of satirizing German war profiteers and corrupt military officers, the idea of machine–human combinations was a vision of dystopia. His ▸watercolor◂ *Republican Automatons* ▶**fig. 8.23** shows two well-dressed men, one waving a German flag, the other spouting stenciled patriotic nonsense. Their faces are empty globes; their limbs are smooth machine-like cylinders. A mechanical contraption made up of gears and belts is superimposed on one man's body. Robots and other machine imagery are thus connected with the horrors of mechanized warfare—one man has an amputated leg—and with the greed of "patriotic" industrialists who have profited from the slaughter.

In Germany after the war, the film industry flourished. Among works exploring some of the technological fears and fantasies of German society at the time was the 1926 film *Metropolis* ▶**fig. 8.24**, directed by Fritz Lang (1890–1976) (see inset, p. 264). *Metropolis* featured some of the most stunning set designs of this era, including a futuristic skyline of soaring skyscrapers inspired by the director's visit to New York in 1924. Lang's subject is the moral and social price of technology in Metropolis, an urban dystopia run not by any recognizable form of democratic government, but by a corporate chieftain, John Frederson, with the aid of a visionary scientist, Rotwang. In *Metropolis*, Rotwang (on Frederson's orders) has created a mechanical woman,

a robot who is planted in the workers' underground city to replace the young heroine and labor organizer, Maria. In a famous scene, Rotwang transfers the human Maria's appearance and soul to his Robot-Maria, a process made possible by the still-exciting technology of electricity. Robot-Maria, a futuristic Eve, is programmed to goad the workers into open revolt so that Frederson can bring them more fully under his autocratic control. Robot-Maria is "tested" at an elegant party and easily dazzles the sophisticated men of Metropolis with her beauty and erotic dancing. This scene fuses two male anxieties of this period in Germany. It suggests that both machines and women are to be feared as being beyond the direct control of men and act as destabilizing, corrupting forces. The vision of Robot-Maria as a corrupting machine-woman was an element of the backlash against the so-called "New Woman" movement that was a prominent part of the political landscape in Germany in the 1920s. As German women fought for a future in which they would have the right to vote, to own property, and to make basic life decisions for themselves, many men in Germany portrayed this quest for equality as something dangerous and unpredictable. The flesh-and-blood Maria in *Metropolis* is a compromise vision. While she works as a labor organizer and leader of men, her leadership is based less on aggressive activism than on her saintly, nurturing, "feminine" qualities. "Maria" is, of course, a name derived from the Virgin Mary, and thus a reassuring counter to the image of the robot-woman as a temptress and destroyer of men.

After her début among the men of the ruling class, Robot-Maria stirs up the passions of the workers and leads them into a violent and futile rebellion that almost causes their children's death in a flood. After the flood, the film ties up all of its loose ends neatly. The children are saved, Rotwang and Robot-Maria are destroyed, Maria marries John Frederson's compassionate son, and tranquillity reigns. However, despite the tidy conclusion to the film (required by the producers), the machines of *Metropolis* are portrayed overall as the basis of a dystopic society. The film creates a vision of the future that combines factory owners' greed and malevolence, deadening industrial labor, and barren, hostile cityscapes. *Metropolis* represented an especially grim view of the coming machine age.

Fritz Lang

Lang had a prestigious career in the German film industry during the 1920s and early 1930s. However, after emigrating to the United States in 1937 (where his success continued), Lang recounted a harrowing story of his last days in Germany under the Nazis. His film *The Testament of Dr. Mabuse* had been banned in 1933, and Lang was summoned to meet Joseph Goebbels, the director of the National Ministry for Public Enlightenment and Propaganda. Filled with dread, Lang went to the appointment, at which he was told that Hitler greatly admired his work and would like him to work for the National Socialist Party. Goebbels promised to overlook Lang's Jewish ancestry. Lang fled Germany for France the same day.

Counterpoint: Utopian Visions in Germany After World War I

Paradoxically, the destruction that was visited on the European continent during World War I engendered in Germany some optimistic views of the future. While many German artists despaired of any sort of future for their country, let alone a utopian one, the artists of a new school of art and architecture, the Bauhaus (or "House of Building"), strove against this pessimism to create an industrial future of elegantly designed buildings and products. They sought to rebuild Europe as a sleek machine world of chromium and steel. In Weimar on April 1, 1919, soon after the formation of the Weimar Republic, the Berlin architect Walter Gropius (1883–1969) became director

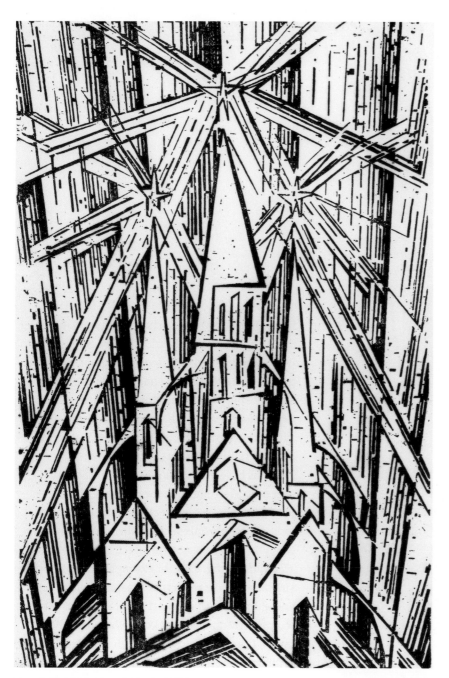

8.25 Lyonel Feininger, *Cathedral of the Future/Socialism*, from the cover of the Bauhaus manifesto, 1919. Woodcut. Bauhaus-Archiv, Berlin.

of the Bauhaus. The school, formed by combining the old Grand Ducal Academy of Fine Art and the Grand Ducal Saxon School of Arts and Crafts, had clear utopian overtones. Gropius envisioned a future where the schism between "arts" and "crafts," indeed between exalted theoretical "artists" and laboring workers, "artisans," would be healed. He wrote in the "First Proclamation of the Weimar Bauhaus":

Let us create a new guild of craftsmen, without the class distinctions that raise an arrogant barrier between craftsman and artist. *Together let us conceive and create the new building of the future*, which will embrace architecture and sculpture and painting in one unity and which will rise one day toward heaven from the hands of a million workers like the crystal symbol of a new faith. [Emphasis added.]

This statement is echoed on the cover of the Bauhaus manifesto, a woodcut by Lyonel Feininger (1871–1956) entitled *Cathedral of the Future/Socialism* ▶ **fig. 8.25**. Consciously dependent upon traditional Christian imagery, the woodcut is equally influenced by modernist abstraction and the Futurists' "lines of force," while its purposeful crudeness and "obsolete" medium were intended to recall a time of pre-industrial harmony: the Middle Ages in Europe. The Bauhaus was at first as much dedicated to spiritual harmony as to artistic production.

From 1919 to 1925 the teachers at the Bauhaus worked to build upon the ideal of a

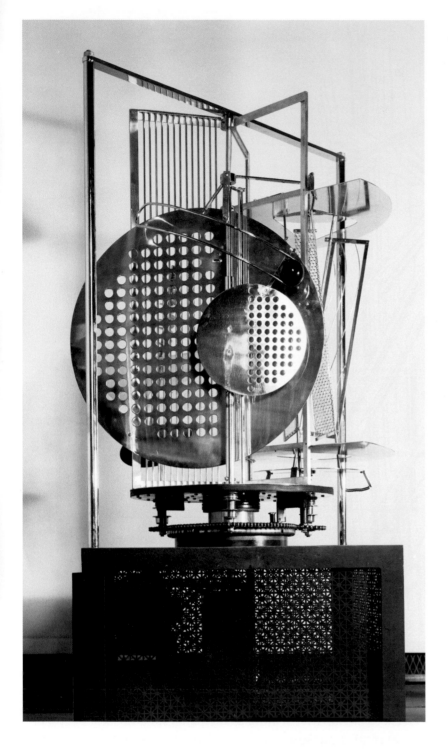

8.26 László Moholy-Nagy, *Light Prop for an Electric Stage: Light-Space Modulator*, 1922–30. Aluminum, steel nickel-plated brass, other metals, plastic, wood, and electric motor, 4ft 11½ins × 2ft 3⅝ins × 2ft 3⅝ins. Busch-Reisinger Museum, Harvard University.

future harmony in the arts and industry. When the Hungarian artist László Moholy-Nagy (1895–1946) joined the faculty in 1923, however, there was a substantial change of approach. Moholy-Nagy was adamantly opposed to the Expressionist spiritualism of Bauhaus artists such as Feininger and Johannes Itten (1888–1967), and he successfully advocated a new program for the Bauhaus based on an exploration of the artistic uses of modern industrial materials. Moholy-Nagy promoted a "machine aesthetic," advocating that industrial materials such as plastic or aluminum could be used to beautiful effect. His *Light-Space Modulator* ▶ **fig. 8.26**, for example, is a moving ▸installation◂ of reflectors, plastic, electric motors, and aluminum that is part-machine, part-abstract sculpture. Moholy-Nagy later worked on the sets for the film *Things to Come* (1936, directed by William Cameron Merzies and based on the book *The Shape of Things to Come* by H.G. Wells), designing futuristic buildings to project architecture into the year 2055. When the Bauhaus was forcibly closed in 1935 by the Nazis, who considered it a hotbed of anti-Fascist politics, Moholy-Nagy spent a couple of years in London. In 1937 he emigrated to Chicago, where he set up a school to promote Bauhaus teachings in the United States.

Gropius felt that the true aims of the Bauhaus could be expressed most effectively through architecture, the field in which he was trained. In 1924, when the school at Weimar was dissolved—partly because of its "radical" image and lack of financial

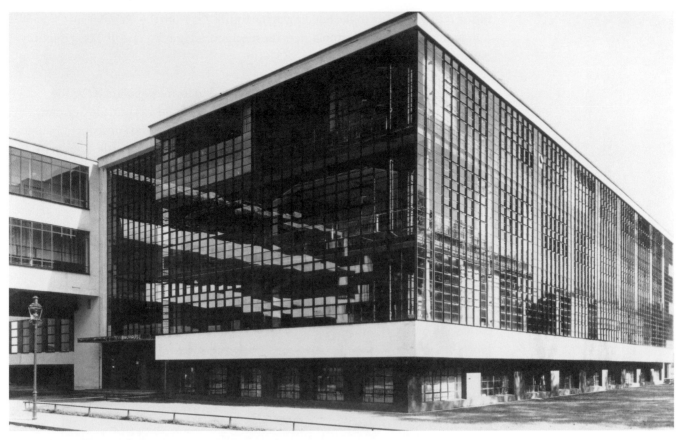

8.27 Walter Gropius, *Bauhaus Buildings*, Workshop wing, Dessau, Germany, 1925–26.

success—Gropius orchestrated a move to another German provincial town, Dessau, where the local authorities provided funds for the construction of a new complex of buildings ▶ **fig. 8.27**. Designed by Gropius himself, these encapsulated the machine aesthetic in architecture. They feature horizontal strips of glass, called ribbon windows, and showcase the structural steel that had traditionally been hidden by decorative stone in monumental building projects. Furthermore, the main building's shape, when seen from the air, is that of a propeller, a gracious reference to the airplane factory that was a key part of Dessau's economy.

Women at the Bauhaus

While there were several women faculty members and women students were allowed to enroll at the Bauhaus, they were barred from working in the "exalted" areas of architecture and painting. Most were shunted into the workshops that specialized in traditional areas of "women's work" such as textiles, led by Gunta Stölzl (1897–1983). Some of the most remarkable works made at the Bauhaus, such as the coffee- and teapots by Marianne Brandt (1893–1983), or the abstract textiles of Anni Albers (1899–1994), were not given much recognition by their male colleagues. Clearly the Bauhaus dreams of equality were limited in their scope to equality among men and the bias that made "crafts" inferior to "fine art" was maintained through gendered associations.

The Bauhaus sculpture and stagecraft professor Oskar Schlemmer (1888–1943), who taught at the Bauhaus from 1920 to 1929, was also active as a painter. His *Bauhaus Stairway* ▶ **fig. 8.28** shows students on the stairwell of the Dessau Bauhaus. The figures have the smooth tubular shapes and upright poses of robots. They appear purposeful, striding into the future like Boccioni's robot-man, and the bright color scheme adds an additional layer of optimism to the scene. They are the students of the

future busily working in the building of the future. Far from the "Republican Automatons" of Grosz's dystopia, here the mechanized humans are working mightily toward an industrial utopia.

The "honest" attitude toward industrial materials and forms popularized by the Dessau Bauhaus was to prove enormously influential on the arts outside Germany, especially in the United States, where Moholy-Nagy, Gropius, and subsequent Bauhaus director Ludwig Mies van der Rohe (1886–1969) would eventually settle. Known in America as the International Style, the architectural language formulated at the Bauhaus, along with Moholy-Nagy's pioneering basic course in modern materials and design concepts, would become a staple of American art and design.

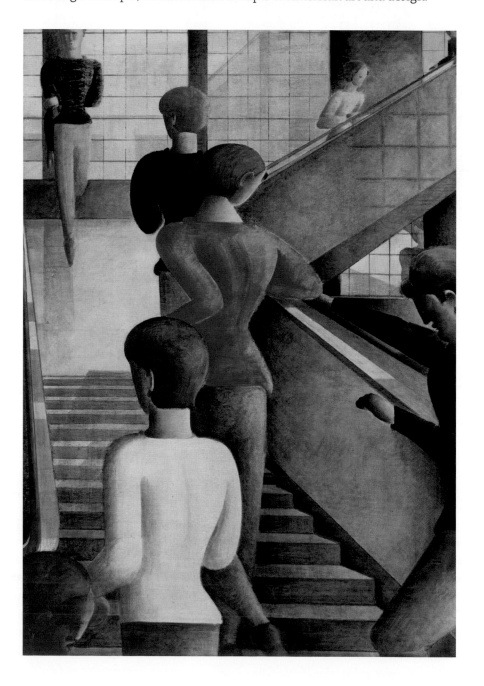

8.28 Oskar Schlemmer, *Bauhaus Stairway*, 1932. Oil painting, 5ft 2⅞ins × 3ft 9ins. The Museum of Modern Art, New York.

Further Reading

T. Benson, et al., *Expressionist Utopias: Paradise, Metropolis, Architectural Fantasy*, exh. cat., Los Angeles County Museum of Art (Los Angeles, 1993), pp. 62–83

G. Berghaus, *Futurism and Politics: Between Anarchist Rebellion and Fascist Reaction, 1909–1944* (Berlin, 1996)

D. Cottington, *Cubism* (Cambridge, 1998), pp. 6–31

M. Droste, *Bauhaus 1919–1933* (New York, 1998)

J. Halperin, *Félix Fénéon: Aesthete and Anarchist in Fin-de-siècle Paris* (New Haven and London, 1988), pp. 73–91

C. Harrison, et al., *Primitivism, Cubism, Abstraction: The Early Twentieth Century* (New Haven, 1993), pp. 46–61

G. Levin, *Synchromism and American Color Abstraction 1910–1925* (New York, 1978), pp. 27–36

J. Lloyd, *German Expressionism: Primitivism and Modernity* (New Haven, 1991)

R. Marchand, *Advertising the American Dream: Making Way for Modernity 1920–1940* (Berkeley, CA, 1985), chapter 5, pp. 117–163

B. McCloskey, *George Grosz and the Communist Party: Art and Radicalism in Crisis, 1918 to 1936* (Princeton, 1997)

Source References

p. 243 "The history of all hitherto existing society …"
Marx, in *Selected Writings*, ed. D. McLellan (Oxford, 1977), p. 222

p. 245 "We come, we writers …"
"Protest against the Tower of Monsieur Eiffel," *Le Temps* (February 14, 1887)

p. 251 "When I went to the old Trocadéro …"
Picasso, quoted in J. Richardson, *A Life of Picasso*, 2 vols. (London, 1996), vol. 2, p. 24

p. 253 "With faith in progress and in a new …"
Kirchner, quoted in *Art in Theory 1900–1990: An Anthology of Changing Ideas*, ed. C. Harrison and P. Wood (Oxford, 1992), pp. 67–68

p. 256 "We will sing of great crowds …"
Marinetti, quoted in ibid., p. 147

p. 259 "This new art of color is striving …"
W.H. Wright, *The Future of Painting* (New York, 1923), p. 24

p. 259 "Already the future of the art of color …"
Ibid., p. 50

p. 260 "To harmonize with such a score …"
Scriabin, "Untitled," *The Nation* (March 25, 1915)

p. 260 "For during the past few years …"
"Color in Industry," *Fortune* (February 1930), pp. 85–94

p. 261 "The blue-green glazed surface …"
A. North, "But … Is It Architecture?" *American Architect*, 141:2603 (January 1932), pp. 28–31

p. 265 "Let us create a new guild of craftsmen …"
Gropius, First proclamation of the Weimar Bauhaus, quoted in J.-L. Ferrier, and Yann le Pichon, *Art of Our Century: The Chronicle of Western Art, 1900 to the Present*, trans. W.D. Glanze (Englewood Cliffs, NJ, 1988)

Discussion Topics

1. Why is modern art equated with progress, and traditional art with the status quo, or even regression?

2. Why did so many artists focus on the "primitive" past? How did these visions relate to the present?

3. What new technologies did artists find fascinating in the early twentieth century? Why?

4. What forces shape today's visions of the future?

5. How do you envision the future? Does "progress" always bring good things?

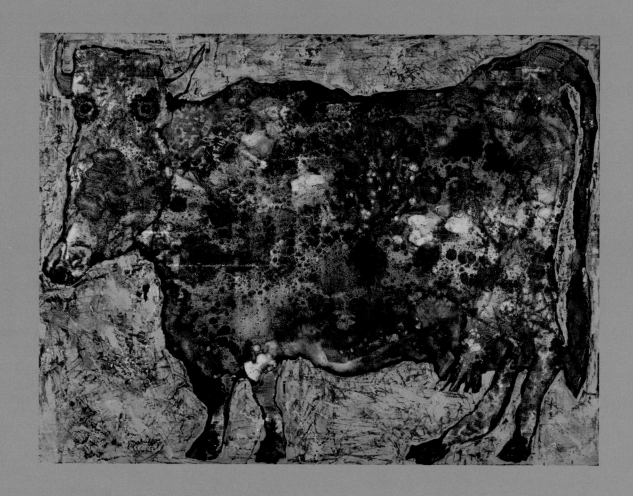

Art, the Spirit World, and the Inner Mind

A large number of artists have sought to represent the external world through their works. The word "represent", in fact, means to "re-present," or "present again" a slice of the world. The tradition of Western art since the Renaissance, in particular, has highlighted artists' ability to recreate a convincing illusion of the external world through their work. Likewise, many people consider realistic representation to be the core rationale for the production of art. In spite of this prevailing sensibility, an investigation of the art of Western and non-Western cultures shows that, in many artistic traditions, the focus has not been on portraying the external world, but on representing intangible aspects of human experience. Artists in a variety of cultures have thus taken up a practice that creates a paradox; how do you "re-present" a supernatural spirit, a feeling, or a vision, when the subject of your work was never physically "present" in the first place? When an artist attempts this type of representation, they are taking on a different sort of challenge, one in which they must themselves "present" a spirit or a feeling for the first time.

This chapter first considers works of art that grapple with representations of supernatural spirits, focusing on non-Western art, with examples drawn from the Aborigines (the indigenous people of Australia), the Yoruba people of West Africa, and several Native American peoples, including the Hopi and Navajo of the Southwest as well as Northwest Coast communities. In the second section we explore the influence of the psychoanalytic theories of Sigmund Freud on Western artists' representations of the inner mind, focusing on Austrian and German Expressionist artists and the Dada artists of Zurich and New York. After World War I, the French Surrealists attempted to create an aesthetic of the subconscious based directly on their own reading of Freudian psychoanalysis. In the 1920s, a distorted theory arose that dubbed modern art "degenerate" and profoundly affected German art policy under the Nazis. Next, we consider the place of Karl Jung in relation to the American abstract painting movements that flourished after World War II, concluding with a discussion of the impact of existentialist philosophy on postwar art in Europe.

9.1 Jean Dubuffet, *Cow with the Subtile Nose*, 1954. Oil and enamel on canvas, 2ft 11ins x 3ft 9¾ins. The Museum of Modern Art, New York.

Key Topics

The attempts of artists worldwide to portray states and ideals that can have no physical form.

▶ Primeval forces: the perennial concern with the spirit world and relationship with the earth seen in the art of peoples such as Aborigines, Yoruba and Native American tribes.

▶ Dreams and desires: late-nineteenth-century artists began to explore through expressionist art the significance of dreams and the role of the subconscious in everyday life.

▶ Unreason and chance: Dada and Surrealist artists tapped forces beyond their conscious control.

▶ Reaction: these new tendencies in art were condemned as "degenerate" by Nazis, leading to the flight of artists to America.

▶ Questions: World War II prompted an exploration of existentialism as artists approached the question of humanity's place in the universe.

▶ The return of representation: Pop artists rejected the spiritual anxiety of abstract artists, embracing representation and the semi-ironic glorification of the consumer society.

Aboriginal Art

The culture of the Aboriginal people of Australia is rooted in a custodial relationship with the land. Aborigines believe that the land cannot be owned, and that changes to the terrain made by humans, for example through road-building, mining, or quarrying, amount to physical violence toward their spirit-gods and themselves. Beginning in 1788, with the arrival of Europeans from Great Britain, the Aborigines have found their land and culture under continual attack. Today, Australian Aborigines number around 300,000, down from one million in the eighteenth century, making up about 1.5 per cent of the total population of Australia. Traditionally, Aboriginal communities are fairly small; over three hundred survive, maintaining distinct identities. Yet, although separated by vast distances (Australia is about the size of the United States) and different languages, these communities share certain long-standing spiritual convictions and stories of mythological origin. Over the past two centuries, Aboriginal people have adopted the word "Dreaming" to express the primeval age when ancient gods and goddesses walked the earth. All traditional Aboriginal art is an expression of a particular artist's relationship to the Dreaming as determined by his ancestry, as well as his social and religious status. The concept has nothing to do with actual dreams and a great deal to do with mythology. It connects all Aborigines with the supernatural world experienced by their ancestors, and artists play an important role because their images reveal this hidden knowledge to their community.

Perhaps the most evocative images that express the continuing tradition of the Dreaming are those made by the artists of the Arnhem Land in the northeast part of Australia. Prominent among these are bark paintings, made out of flattened pieces of bark from the stringwood tree. The anonymous painting *Mimih Spearing a Kangaroo* ▶fig. 9.2 is basically naturalistic, despite the proportions being offset by the reductive abstraction of the forms; note also the "X-ray" style, in which the internal structure of the figures is visible through their skin. *Mimihs* are a type of trickster spirit in Aboriginal cosmology. They are usually depicted with elongated bodies and are credited with having made ancient rock paintings as well as with teaching the Aboriginal people how to paint. In this image, the *Mimih* is hunting a kangaroo, an action that has both prosaic and sacred meanings: on the one hand, hunting and cooking are two of the most basic actions in life; on the other, the killing of kangaroo has a number of esoteric associations. Peter Marralwanga's bark painting *Ngalyod, The Rainbow Serpent* ▶fig. 9.3 displays the densely patterned cross-hatching called *Rarrk*. These patterns and colors are valued for their intricate beauty as well as their symbolic meanings. The Rainbow Serpent is pictured here in a tight coil, completely covering the pictorial field. Its whirlpool shape probably represents it resting in wetland during the dry season. The Rainbow Serpent is the fundamental creator-figure in Aboriginal belief. A complex, androgynous deity, it appears and reappears in many different incarnations in the Aboriginal spirit world. The Rainbow Serpent's age-old process of swallowing and then regurgitating other ancestral spirits is one of the fundamental processes of the Dreaming. This systematic transformation of other beings is said to have resulted

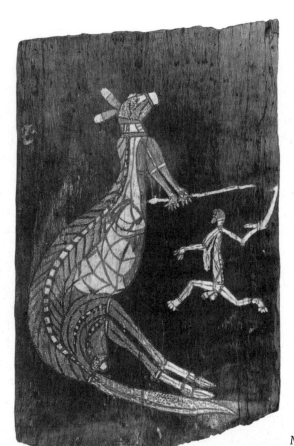

9.2 Anonymous, *Mimih Spearing a Kangaroo*, Oenpelli, Arnhem Land, Australia, c.1912. Paint on bark, 4ft 3ins x 2ft 8ins. Museum Victoria, Melbourne, Australia.

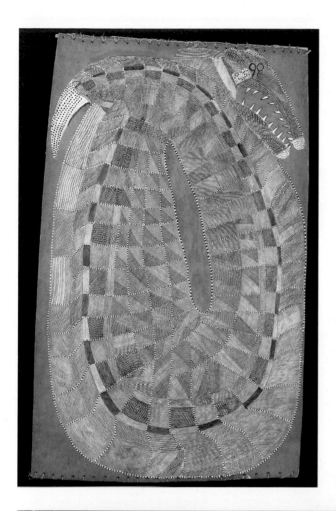

9.3 Peter Marralwanga, *Ngalyod, The Rainbow Serpent*, 1981. Natural pigment on bark. National Gallery of Australia, Canberra.

in the establishment of sacred places in primeval days, but also serves as an allegory of spiritual growth and transformation for an individual person. In the desert regions of central Australia, teams of artists have produced ephemeral ground paintings since time immemorial. The artists apply *wamulu*—a mixture of chopped plants and bird feathers, mixed with ochre, sometimes held together with an oil binder—to a prepared piece of ground. Because of their unstable medium and ties to spiritual practices, few records of historic works survive. In Aboriginal society, a man becomes an artist not primarily on the basis of technical skills but because of his status as a spiritual and societal leader. *Yarla* ▶**fig. 9.4**, a collaborative ground painting produced for an exhibition in Paris in 1989, consists of a series of abstract geometric patterns that fill the space without overlapping. The work contains elements of many stories from the Dreaming, of which the artists have personal and private interpretations, depending on their ancestry and religious status. Such paintings should not be considered puzzles for the Western art historian to decode, because protecting their secrecy to keep the meaning sacred is a key part of Aboriginal heritage. Contemporary Aboriginal artists often speak of "inside" and "outside" meanings to their works. This refers to the "outside" facts about a ground painting—like the circles that may mean a local well in the artists' hometown—that can be disclosed to the general, even non-Aboriginal public, and the "inside" knowledge that can be revealed only to an initiate.

9.4 Paddy Jupurrurla Nelson, Paddy Japaljarra Sims, Paddy Cookie Japaljarri Stewart, Neville Japangardi Poulson, Francis Jupurrurla Kelly, Frank Bronson Japsamarra Nelson, *Yarla*, 1989. Earth pigments, mixed media, 13ft x 33ft. Ground painting as installed in Le Halle de la Villette, Paris, in Magiciens de la Terre exhibition, 1989, organized by Centre Georges Pompidou (CNAC).

Yoruban Art

The ten million Yoruba people of sub-Saharan West Africa, modern-day Nigeria, have a long and fabled history. During the last millennium vast Yoruba kingdoms have risen and fallen, at times uniting a large swath of West Africa under one king. In the eighteenth century, the capital city of Oyo was one of the premier cities in Africa. As a result of invasions from Islamic and European forces, especially Great Britain, the centralized Yoruba government declined, and by the end of the nineteenth century, the Yoruba had been dispersed throughout the lands that formed the British Empire.

9.5 Yoruba woman with *ere ibeji* ("twin's figures"), 20th century. Height 7⅞ins.

Despite having been undermined by Islamic and Christian proselytizers, the traditional spiritual beliefs of the Yoruba have survived repeated attempts at destruction. In small communities of Yoruba people throughout Nigeria, spiritual practices are an integral part of everyday life. One important part of Yoruba belief relates to the high rate of twin births in their society, reportedly as high as 4 per cent. When twins are born, they are called *emi alagbara*, "powerful spirits," and their mother, family, and village all participate in a celebration in their honor. At this celebration the *iyabeji*, "mother of twins," composes and sings a song praising her offspring. Throughout their lives, the twins will be honored with small gifts, clothes, performances, and special meals. When a twin dies, regardless of age, his or her spirit is reinvested in a sculpture. Carved from a special wood from the native ire ona tree, the resultant artwork, *ere ibeji*, "twin's figure" ▶fig. 9.5–6, is the responsibility of a professional artist and a priest who together ensure that the sculpture is made according to the correct ritual. Appeasement of the dead twin's spirit is at the root of this process, as well as in later generations a sense of duty toward one's ancestors. Because living twins were powerful spirits, able to influence human events, it is important that the spirit invested in the sculpture is continually honored so that the deceased twin does not cause any disaster to befall the community. The sculpted figure (or figures) is ritually praised, dressed, adorned, washed, fed, and generally cared for, enjoying the same honors that the living person enjoyed. The responsibility

Frobenius and the Ife Heads

In 1910, the German ethnographer Leo Frobenius (1873–1938) found a treasure trove of Yoruba memorial heads dating back to around 1400, when the capital city of the Yoruba people was called Ife. Frobenius was astounded by the idealized naturalism of the heads, cast in bronze, technically accomplished, and modeled with the same degree of proficiency as ancient Greek works. Naïve in his belief that lost-wax casting was a strictly European technology, Frobenius declared that he had found artworks from the mythical lost continent of Atlantis! Yoruba sculptors had shifted styles from an art of idealized naturalism, as seen in the Ife heads (see fig. 3.18), to one of expressive abstraction, as in the twin's figures, a style that many centuries later would come to inspire such artists as Picasso and Matisse (see chapter 8).

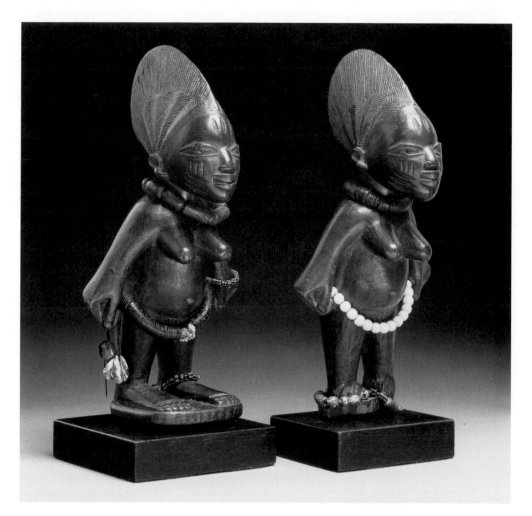

9.6 *Ere ibeji* ("twin's figures"), Yoruba culture, Nigeria, 20th century. Wood, height 7⅞ins. University of Iowa Museum of Art, Iowa City.

of caring for the *ere ibeji* does not stop with one generation, but continues in perpetuity, so that some families with a high rate of twin births have several sculptures to care for. *Ere ibeji* made after 1500, first during the time of the Oyo kingdom and later during the colonial period, feature a type of expressive abstraction in which a human body is built up of softly swelling, but not protruding, forms. These are structured with a clear sense of symmetry, balancing the rounded forms with strict compositional lines. The key issue for Yoruba artists is not to capture a naturalistic likeness, but rather to create a sculpture that bears only an indirect resemblance to the human twin. The only elements that distinguish the individual traits of a given twin's figure (remember, the figure has been invested with the spirit of the deceased) are the lineage lines on the face formed by scars, and in some cases the hairstyle.

Native American Art

The term "Native American" is used to identify collectively the diverse peoples who settled in the United States long before European colonists arrived in the seventeenth century. Those considered here are the Navajo, Hopi, and Northwest Coast peoples. They are all guided by the spirit world in their everyday lives, while special occasions are marked through ritual and art.

Navajo. During the sixteenth century, the fifty clans that make up the Navajo people abandoned their nomadic way of life and settled in what is now New Mexico in the southwestern United States. There, they formed long-standing relationships, and sometime rivalries, with the Hopi and other Native American peoples. But New Mexico was occupied by the United States in 1846, resulting in two decades of war and the almost complete destruction of the Navajo people in the 1860s. There are now almost 250,000 descendants of the Navajo survivors of the war with the United States, most of whom live on a 16 million-acre reservation within the states of New Mexico, Utah, and Arizona. The sand paintings that are made by a Navajo priest, or *Hataalii*, along with his assistants, as part of certain religious ceremonies are among the most compelling images produced by this people. The commonly used term "sand painting" is less accurate than "dry painting," because the artists often include elements other than sand, such as crushed rock, corn meal, pollen, charcoal, and tobacco to enrich the picture's surface. During the traditional healing ceremony, the *Iikaah*, which lasts for two to nine days, four or five groups of paintings made. The aim is to restore the ill person's spiritual balance, as imbalance is viewed as the root of sickness. In traditional Navajo belief, priests have the right to make these sacred paintings so as to summon the assistance of beneficent spirits, known collectively as the *Yei*, or "Holy People." The painting is just one small part of a ceremony that includes other rituals such as prayers and dances. The paintings are destroyed at nightfall in accordance with religious law. The dry painting, captured here in a wool ▸tapestry◂, *Hosteen Klah Whirling Log Ceremony* ▶**fig. 9.7**, is one of a type used in a specific ritual prayer called the Nightway Chant. The parameters are defined by an image of the body of the Rainbow Goddess, whose figure wraps around the central composition, leaving an opening to the east. Inside this ring, the priest has created a radial design with two perpendicular lines crossing in the middle. The four lines pointing toward the cardinal directions

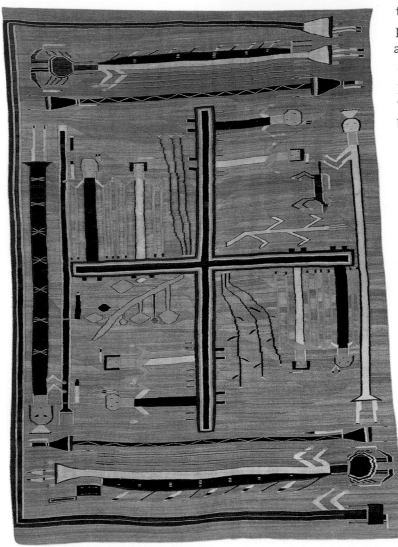

9.7 *Hosteen Klah Whirling Log Ceremony,* Navajo culture, c.1925. Sandpainting tapestry by Mrs Sam Manuelito. Wool, 5ft 5ins x 5ft 10ins. Heard Museum, Phoenix.

have representations of spirits placed at their ends, while four pairs of human beings and their crops inhabit the box-like inner spaces. The entire composition is set up orthogonally, that is, the interior elements are all structured along perpendicular lines. The symbolism of the subject matter is known only to the Navajo, for whom secrecy is a vital aspect of spiritual power.

Hopi. The Hopi, traditional rivals of the Navajo, are a *pueblo* people (meaning they live in small villages) of the southwestern United States whose name translates as "little

people of peace." Beginning in the sixteenth century, the Hopi resisted repeated Spanish incursions and forced conversions to Christianity. Like the Navajo, they were eventually decimated by the American military in the nineteenth century, and forcibly settled in 1888 into a small reservation on the Colorado plateau, which is surrounded by the larger Navajo reservation. Each Hopi village features a central ceremonial space that is used during the first half of the year for ceremonies dedicated to agricultural fertility. *Katsinas*, a group of over two hundred spiritual beings who are believed to reside in the mountains, play a central role in these ceremonial festivals. In their traditional belief, the Hopi people lived with the *Katsinas* in the underworld, then left them behind for this world. The *Katsinas* taught the Hopi people rituals so that they could call upon them when in need. In contrast to the Navajo vision of the *Yei*, *Katsinas* are not worshiped as deities by the Hopi people; rather, they are appealed to as powerful spirits who have the ability to help the members of the community. Male and female, these spirits have a vast number of characteristics embracing everything from physical prowess to moral conduct; their individual qualities thus help to explain the world and what is expected of the members of Hopi society. Beginning at the winter solstice in December, and continuing through the seven-month agricultural season, *Katsinas* are represented by masked individuals, traditionally men from the Badger clan. These men visit Hopi *pueblos* to perform ceremonies on behalf of the community, with much of the focus on the need for rain to grow healthy crops.

9.8 Unsigned, *Tukwunangwu Cumulus Cloud Katsina*, Hopi culture, Arizona. Watercolor, 10½ins x 1ft 4¾ins. National Museum of the American Indian, Smithsonian Institution, New York.

Apart from the masks used at ceremonies, Hopi artists also sculpt *Katsina* figures out of cottonwood for use in the instruction of children in the spirit world of the *pueblo*. In turn, these figures have been transformed into artistic commodities, mainly by American collectors who value Native American tradition. Such sculptures as the *Tukwunangwu Cumulus Cloud Katsina* ▶**fig. 9.8** (reproduced here in a painting) traditionally appear at mixed *Katsina* dances as well as the Salako ceremony. This *Katsina*, part of the appeal for good summer rains, is wearing a mask with a geometric design as well as feathers representing clouds around its head. The figure stands straight and symmetrical, an icon of agricultural fertility.

Northwest Coast. Among the Northwest Coast peoples, elaborate masks were used at ceremonies by priests to portray great spirits of the supernatural world. For example, a nineteenth-century mask, *Bella Coola*, represents Komokoa, chief of the undersea world ▶**fig. 9.9**. Oral tradition lies at the heart of the history and identity of each cultural group. At feasts, ceremonies, and meetings, leaders recounted long passages from legends and often assumed the form of the most important characters in dance. In order to involve his audience in the story being enacted, the leader used noisemakers, various woven garments, and wore multiple masks, some of which had

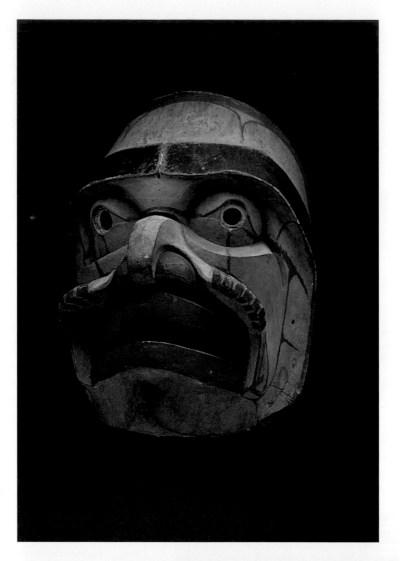

9.9 *Bella Coola*, mask representing Komokoa, chief of the undersea world, Talio, 19th century. Painted wood, 1ft 7½ins x 1ft 2ins. American Museum of Natural History, New York.

9.10 *Kwakiutl*, mask depicting a man inside a sea raven inside a bull head, Drury Inlet, 19th century. Wood, 2ft¼in x 1ft 9½ins. American Museum of Natural History, New York.

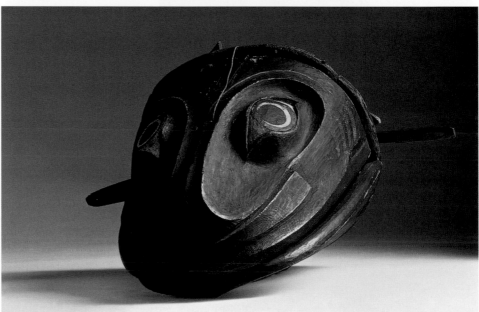

three different forms that opened up one inside the other, as in the nineteenth-century *Kwakiutl* mask of bull, raven, and man ▶**fig. 9.10**. The exaggerated features of the mask were used in the evocative dances inside village homes.

The Northwest Coast peoples saw life as encompassing constant movement and change: in birth and death, in growth and aging. Animals in Northwest Coast legends are capable of metamorphosis, or changing forms; many stories were enacted with masks that look like two or more creatures at once. Similarly, blankets and tunics were woven in abstract designs that could be read as differing animal forms, depending upon the positive or negative spaces; the changing forms on the fabric would be enhanced by the dancer's movements. To produce such complex patterns as that shown in the Chilkat blanket of the Tlingit tribe ▶**fig. 9.11** would require a weaver particularly skilled in creating curved designs from the warp and weft, or vertical and horizontal strands, of the fabric. The word "blanket" is actually inaccurate, because this textile would most often be worn, by a man, about the shoulders like a cloak, or used to decorate the wall of a house. Textiles like this were made in a collaboration between husband and wife; the man would prepare the design on a pattern board, and the wife would weave the finished work. This particular blanket features a design based on a bear, an animal that was special to the Tlingit

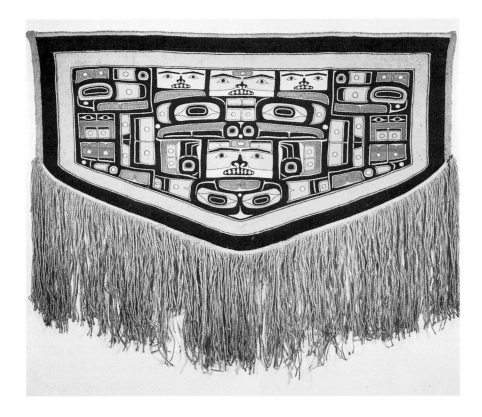

9.11 Chilkat blanket, depicting a brown bear, Tlingit culture, collected 1907, Cape Prince of Wales, Alaska. Goats wool with cedar bark base, 4ft 7ins x 5ft 4ins. National Museum of the American Indian, New York.

because of its human-like qualities. The design is highly abstract, consisting of a central image based on a frontal view of the bear's face, which is flanked by two symmetrical images of the bear's profile. At a formal dance ceremony, the fringes on the bottom of the textile would highlight the rhythmic movement of the man's body.

We now move for the remainder of this chapter to a discussion of Western artists of the twentieth century who did not seek to represent supernatural spirits, but rather the realm of the inner mind.

Sigmund Freud and Expressionism

With the publication of various works, especially *The Interpretation of Dreams* in 1900 and *Three Essays on the Theory of Sexuality* in 1905, the Viennese psychoanalyst Sigmund Freud (1856–1939) inadvertently became a touchstone for Western artists throughout the twentieth century. Specifically, Freud argued for a model of consciousness that emphasized the importance of subconscious, primarily sexual, desires and dream imagery as well as the rational, conscious mind. While Freud did

not have a direct causative impact on many artists, his work popularized the formal study of the mind and provided a framework through which artists could gain access and give expression to irrational, fantastic subject matter. Several artists sought to represent their inner, emotional lives, and explore feelings that were inappropriate in terms of the strict conventions of bourgeois society. Artists concerned themselves with their conscious emotional states, but also with their subconscious, meaning the dreams, memories, and desires that influence behavior without the conscious mind becoming aware of it. In pursuit of this type of work, artists often used an Expressionist style, meaning that they distorted ►form◄ and color in order to create intense emotional effects (see Gauguin, chapter 7). Expressionist artists believed that subjective experience served as the primary basis for the visual arts.

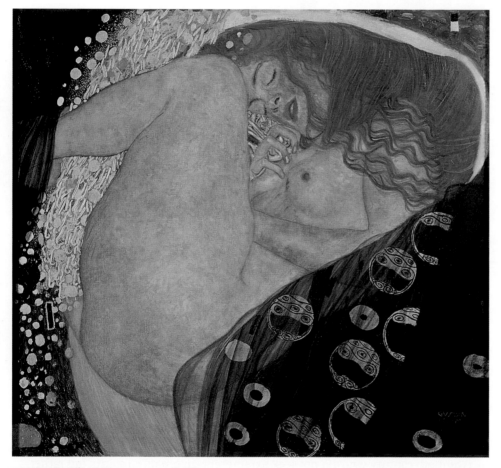

9.12 Gustav Klimt, *Danae*, 1907–08. Oil on canvas, 2ft 6¼ins x 2ft 8⅝ins. Private collection.

Freud's fellow residents in Vienna during the early twentieth century included the Austrian painters Gustav Klimt (1862–1918), Egon Schiele (1890–1918), and Oskar Kokoschka (1886–1980). Each of these artists, in their own way, examined Freudian issues of sexual anxiety, repression, and psychological introspection in their work. Each was influenced by Freud's view regarding the inextricable links between sexual and creative behavior. Schiele and Kokoschka also broached disturbing issues of childhood and adolescent sexuality that resonate with Freud's revolutionary investigations. Gustav Klimt came to the fore of the Austrian avant garde in 1897 as a founding member and first president of the Vienna Secession. The artists of the various Secession groups proclaimed their withdrawal from the constraints of what they saw as the stiflingly conservative attitudes of the government-controlled art academy in Vienna. They were well funded by a dedicated group of bourgeois patrons with progressive artistic tastes. In some ways, however, artists in the Secession movement adhered to a rather conservative taste in art, and their revolution was less to do with style than the then-shocking themes of overt sexuality that characterized their work. This compromise between academicism and erotic provocation can be seen in Klimt's *Danae* ►**fig. 9.12**, for example. On the one hand, Danae, one of the lovers of Zeus discussed by the Roman poet Ovid, was a canonical subject in the Western art tradition, and had been depicted

9.13 Egon Schiele, *The Self Seer II (Death and the Man)*, 1911. Oil on canvas, 2ft 7⅝ins x 2ft 7½ins. Private collection.

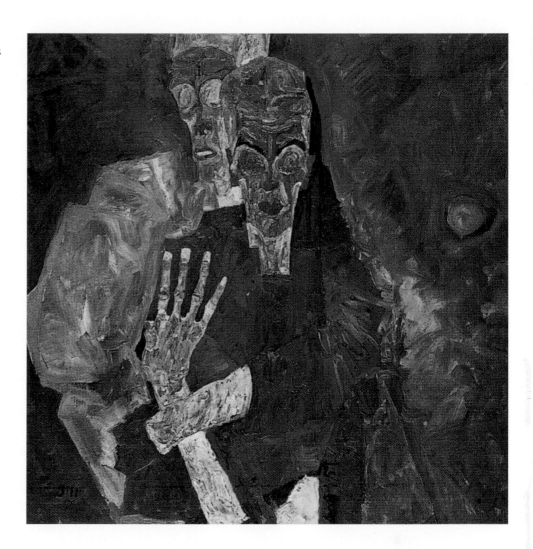

by many artists from the Renaissance onward. However, her explicit pose in Klimt's painting, insinuating recent coitus, combined with the convincingly rendered naturalism of her face, clearly represents a contemporary Viennese woman (not a historical figure) and is therefore more compellingly erotic than earlier paintings of this subject by artists such as Titian (see fig. 5.36). The overt sexuality is cloaked in the trappings of the Art Nouveau style, a richly decorative style that emphasized two-dimensional ornament. By placing his very real-looking figure in a dream-like world of fantasy, Klimt was able to deflect any potential charge of pornography, while perhaps indicating knowledge of Freud's investigations into how repressed sexuality can be played out through dreams and fantasies. Klimt's protégé Egon Schiele had trained at the Vienna Academy of Fine Arts, after which he came under the influence of the Secession groups. Schiele initially embraced the decorative linear effects of Art Nouveau, but around 1910 he started using a less decorative, Expressionist style. While Schiele made a large number of explicitly sexual images of women and adolescents (he was imprisoned briefly on pornography charges in 1912), even more telling are his self-portraits. Schiele's *The Self-Seer II* ▶**fig. 9.13** is rife with the sort of sexual anxiety that so interested Freud. It is a double portrait of Schiele as an emaciated man: the image in the foreground conveys a sense of a conscious, rational self, but seemingly

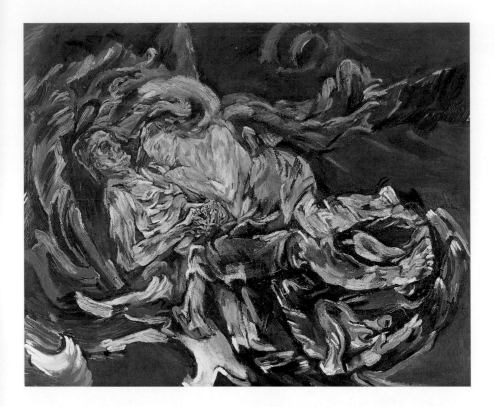

9.14 Oskar Kokoschka, *Bride of the Wind (The Tempest)*, 1914. Oil on canvas, 5 ft 11¼ins x 7ft 2⅝ins. Kunstmuseum, Basel.

haunted by a second image, a ghost that probably represents the artist's subconscious. The androgynous nature of the body, suggestive of both male and female characteristics, amplifies the mood of angst of indecision, and fear. Oskar Kokoschka also worked initially in the circle grouped around Klimt. However, like Schiele's, his style became less decorative and more personally expressive. His painting *Bride of the Wind (The Tempest)* ▶**fig. 9.14** draws upon the emotional turmoil of his recently terminated affair with Alma Mahler, wife of the composer. The lovers are shown embracing on a bed metaphorically shown as a raft upon a stormy sea. Kokoschka allows the viewer a glimpse into his inner world, a sense of the storm and stress of a tempestuous sexual liaison.

Outside Vienna, especially in the artistically progressive city of Munich, artists also sought to explore their inner minds. For Wassily Kandinsky (1866–1944), an expatriate Russian who had settled in Munich, Freudian concerns with the unconscious mind intersected with his desire to express spirituality through art. "I value only those artists who really are artists, that is, those who consciously or unconsciously, in an entirely original form, embody the expression of their inner life; who work only for this end and cannot work otherwise." After participating in a series of Secession movements (Kandinsky was actually the first artist to secede from a Secession movement!), in December 1911 he founded a group called Der Blaue Reiter ("The Blue Rider") along with his German-born colleague Franz Marc (1880–1916). Members of this loosely associated group were united in their belief in the spiritual content of art, transcending questions of style and representation (Kandinsky saw blue as a spiritual color, while Marc's love of animals stemmed from his view that they represented purity). In contrast to Schiele's sense of the unconscious as something angst-ridden and even threatening, for Kandinsky the inner mind was a repository of spirituality, uncorrupted by the crass materialism of European bourgeois society. Kandinsky wrote a pioneering essay, *Concerning the Spiritual in Art* (dated 1912, though it appeared in 1911), whose first part outlines his ideas "About General Aesthetics," while its second,

9.15 Wassily Kandinsky, *Improvisation No. 30*, 1913. Oil on canvas, 3ft 7¼ins x 3ft 7¼ins. Art Institute of Chicago (Arthur Jerome Eddy Memorial Collection).

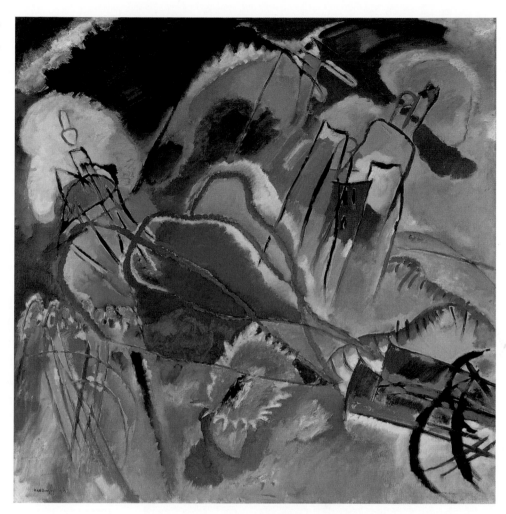

"About Painting," includes discussions of the psychology of colors as well as the language of form and color. He felt that paintings such as *Improvisation No. 30* ▶**fig. 9.15** sprang from impulses of his subconscious mind. Paradoxically, the decision to paint and make an "improvisation" could be said to be an act of the conscious mind, not the subconscious. Kandinsky's series of improvisations pass through abstraction to a nearly ‣non-objective‣ state.

World War I and Dada

"The beginnings of Dada were not the beginnings of art, but of disgust," wrote the group's founder, Tristan Tzara (1896–1963), in 1916. A group of young people sought to escape the devastation of World War I while also expressing horror at the pointless loss of life. That year in Zurich, Tzara, Emmy Hennings (1885–1948), Hugo Ball (1886–1927), Hans Arp (1886–1966), and others formed a loose association that they called "Dada" for its nonsensical childlike sound. They met at a nightclub they called the Cabaret Voltaire, where they would perform satirical skits and poems, exhibit artworks, and in general proselytize against the war. Performances at the Cabaret Voltaire, including Hugo Ball's recitation of a "Sound Poem" ▶**fig. 9.16**, exemplify the Dada program of anti-rational exploration, or, in other words, tapping into the recesses of the

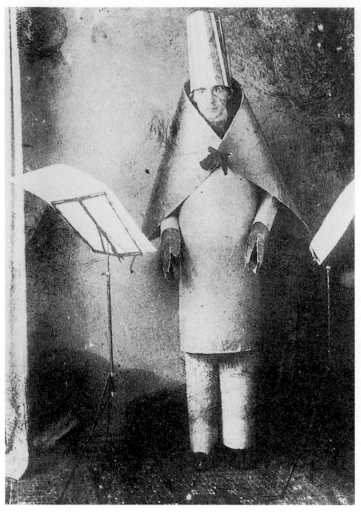

9.16 Hugo Ball, *Sound Poem*. Photographed at Cabaret Voltaire, Zurich, 1916.

unconscious mind. On this occasion, Ball, dressed in a tin costume (satirizing the clergy of his Catholic childhood), read a number of his Sound Poems (*Lautgedicht*), including one called *Caravan*: "Karawane Jolifanto bambla o falli bambla grossiga m'pfa habla horem egiga goramen." This is not gibberish, as many English-speakers assume. Rather, many of the words have resonance, if obscurely for a German-speaker. Ball intended to liberate language, particularly verbs, from the stifling confines of syntax and logical exposition. At the same time he indulged his love of the absurd, mocking the studied formality of the German language. For the Dadaists, as well as for Freud in a different context, humor was a powerful weapon against the oppressive control of the "rational" mind. Freud had in fact written a treatise in 1905 in which he argued that jokes allowed people to express repressed desires from their unconscious mind.

In the visual arts, too, the Zurich Dadaists wanted to connect with creative forces beyond the artist's conscious control. Arp, in *Collage Arranged According to the Laws of Chance* ▶**fig. 9.17**, for example, simply allowed pieces of paper to fall indiscriminately onto a larger surface. He then used that pattern as a building block for an abstract collage. Similarly, Tzara cut out all the words from a printed text, put them in a hat, and pulled them out again at random to create a poem. The Dada movement in Zurich inspired a number of artists to establish satellite associations, of which the most notorious was perhaps the circle centered around the French artist Marcel Duchamp (1887–1968) in New York. Duchamp's early paintings owe something to Cubism. He always had a flair for the theatrical, and had attracted both admiration and mockery in 1913 when his *Nude Descending a Staircase* was exhibited at New York's Armory Show of European modern art. Like the Dada artists in Switzerland, Duchamp chose to spend the war in a neutral country (the United States did not join the conflict until 1917; he was exempted from military service for reasons of health). In New York, Duchamp worked continually to undermine traditional notions of art and creativity, in particular through his use of "readymades," everyday objects that Duchamp acquired and then offered up as "completed" works. Through this ▸iconoclastic◂ gesture, he negated the element of conscious control over a work's production and at the same

9.17 Hans Arp, *Collage Arranged According to the Laws of Chance*, 1916–17. Torn and pasted papers on gray paper, 1ft 7⅛ins x 1ft 1⅝ins. The Museum of Modern Art, New York.

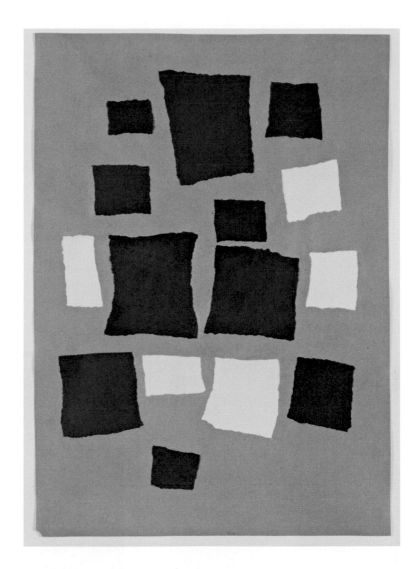

time indulged a Dadaist love of provocation and absurdity. In 1917, Duchamp exhibited his most notorious readymade, *Fountain* ▶**fig. 9.18**, a urinal that he submitted under the pseudonym R. Mutt to the Society of Independent Artists for its first exhibition in New York. Duchamp succeeded in drawing attention to the hypocrisy of the show's organizers when his *Fountain* was rejected by an exhibition that claimed to have no criteria for selection and no jury! In a final compromise, it was allowed into the show but placed discreetly behind a curtain, in order to avoid offense (purportedly to women and children). *Fountain* was not simply a puerile prank, but intended as a challenge to artistic tradition; Duchamp drew attention to the pre-eminence of the work of the mind in conceptualizing an artwork, as opposed to the work of the hand in making it. Duchamp greatly enjoyed the absurdity of this scandalous episode, and made the most of it in print under his own name with an "analysis" of the Mutt case.

Back in Paris after World War I, Duchamp created another Dadaist sensation, this time an "assisted readymade." An "assisted readymade" differs from a "readymade" in that the artist at some point intervenes to alter the original object, which in this case was a poster of Leonardo da Vinci's *Mona Lisa*. Duchamp has "assisted" the poster by drawing

a mustache on the face and writing the potentially enigmatic inscription "L.H.O.O.Q." along the bottom ▶**fig. 9.19**. Pronounced letter by letter in French, more or less "Elle a chaud au cul," it actually means "She has a hot ass." The work was a deliberate satire of Freud's essay on Leonardo, published in 1915, in which Freud examined Leonardo's career in terms of the emotional life of his childhood. Employing his theory of infantile sexuality, Freud asserted that Leonardo's neglectful father and doting mother had combined to create a circumstance whereby Leonardo developed homosexual tendencies. For example, Freud sought to explain Leonardo's interest in scientific research through a consideration of his psychosexual development. According to Freud, there was a

concurrence in Leonardo of his overpowerful instinct for research and the atrophy of his sexual life (which was restricted to what is called ideal [sublimated] homosexuality) . . . The core of his nature, and the secret of it, would appear to be that after his curiosity had been activated in infancy in the service of sexual interests he succeeded in sublimating the greater part of his libido into an urge for research.

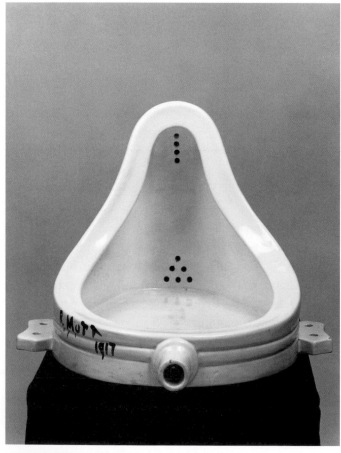

ΛBOVE **9.18** Marcel Duchamp, *Fountain*, 1917. Readymade, height 2ft. Courtesy Sidney Janis Gallery, New York.

RIGHT **9.19** Marcel Duchamp, *L.H.O.O.Q.*, 1919. Altered color lithograph of Mona Lisa. Galleria Pictogramma, Rome.

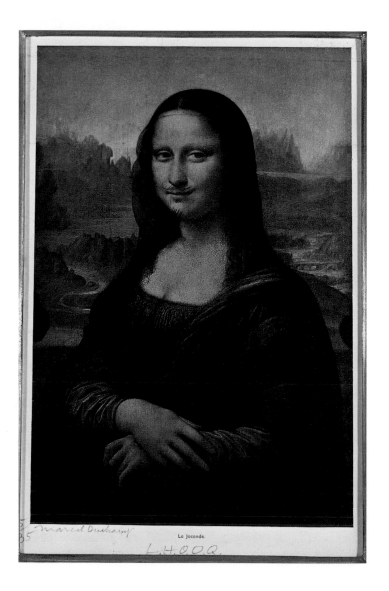

Freud's work on this subject remains controversial, and his suggestion that homosexuality was pathological is offensive to many people. However, Freud's essay provides a necessary context in which to understand Duchamp's alterations to the poster of the *Mona Lisa*. The inscription, taken together with the mustache and goatee beard, male attributes drawn on to a virtually fetishized female portrait, refers to Leonardo's ambiguous sexuality as well as to the rumor that he had modeled the portrait on his own face. In typical Dada fashion, Duchamp incorporated references to Freud's work with consciously irreverent humor.

Surrealism

It was, apparently, by pure chance that a part of our mental world which we pretended not to be concerned with any longer—and, in my opinion, by far the most important part—has been brought back to light. For this we must give thanks to the discoveries of Sigmund Freud ... The imagination is perhaps on the point of reasserting itself, of reclaiming its rights.

These words were written by André Breton (1896–1966) in his *Surrealist Manifesto* of 1924; they touch on several of the key themes of Surrealist art, the first artistic movement to be directly responsive to Freud's work. Breton had appropriated the term "Surrealism" from the author Guillaume Apollinaire, who coined it in 1917 to describe the fantastical elements of his own poetry. Note the reference to "pure chance" for sparking an interest in the subconscious mind, as well as for the founding of psychoanalysis. As discussed above, the exploitation of random elements was fundamental to the form of expression favored in Zurich by the Dadaists, who reassembled in Paris in 1920. Breton initially conceived of Surrealism as an elaboration of the principles that had been promoted by the Dadaists, but he insisted on a clearer program and a proper leadership structure. The conscious way in which Breton would maintain tight control over Surrealism and its adherents for over two decades was antithetical to Dadaist ideas and contradicted its embrace of "pure chance." Breton also indicated in the *Manifesto* that the reassertion of the "imagination" would be a guiding force in Surrealism. More than any other artistic movement, Surrealists actively attempted to organize their art along the lines of psychoanalytic theory. The Freudian model of the mind provided a basic structure for Surrealist thought. Freud had in a sense pushed the conscious mind off its metaphorical pedestal, by asserting that seemingly meaningless dreams and fantasies were central to an understanding of psychology. The discipline of psychoanalysis was still in its infancy, and it was causing animated conversation in intellectual circles throughout Europe; the Surrealists were among those to look to it for concepts that supported their view of art and life.

Breton, like the Futurist movement's founder Filippo Marinetti (see chapter 8), was a poet, not a visual artist. He encouraged fellow Surrealists to release the subconscious by playing games with words. For example, the sentence "The exquisite corpse will drink the young wine" was the result of a group of people each writing a word or phrase without knowing what anybody else was writing (the parlor game became known as "exquisite corpse"). Creating such sentences depended on chance selection of words. The Surrealists valued such games as a means of exploring the subconscious world of the imagination.

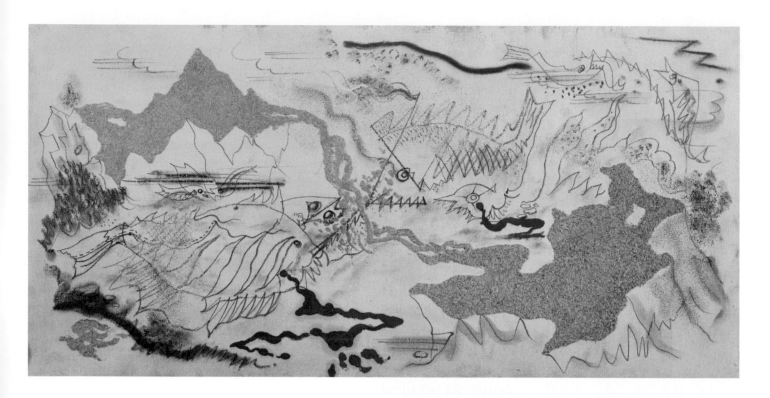

ABOVE **9.20** André Masson, *Battle of Fishes*, 1924. Sand, gesso, oil, pencil, and charcoal on canvas, 1ft 2¼ins x 2ft 4¾ins. The Museum of Modern Art, New York.

RIGHT **9.21** Joan Miró, *Birth of the World*, 1925. Oil on canvas, 8ft 2⅞ins x 6ft ¾in. The Museum of Modern Art, New York.

Breton overcame his initial reluctance to accept the visual arts as a suitable vehicle for Surrealist expression, on condition that artists would embrace his concept of "psychic automatism." In the *Manifesto*, Breton defined Surrealism as "pure psychic automatism, by which it is intended to express, either verbally or in writing, the true function of thought. Thought dictated in the absence of all control exerted by reason, and outside all aesthetic or moral preoccupation." Like the Dadaists, Breton believed that "reason" was a false concept, one that had been hopelessly undermined by the corrupt European regimes that ruled in its name. Breton had worked as a medical officer during World War I, during which he witnessed at first hand the unspeakable horror that "rational" societies could produce. For him, the rejection of artistic control was more than an aesthetic choice; it was a political statement.

It is hardly surprising that no Surrealist artist ever relinquished aesthetic concerns as completely as Breton's manifesto demanded. When the French painter André Masson (1896–1987) made his first works incorporating "psychic automatism," he was immediately faced with a paradox akin to that which Kandinsky had faced in his series of improvisations. How could he make an artwork without exercising some control over it, while remaining true to the principles of pure and unmediated automatism? Simply deciding to make an artwork begins a process based to a large degree on conscious control. Clearly, for Surrealist artists the practice of their art was in many ways less "pure" than the movement's theoretical underpinnings. Masson's *Battle of Fishes* ▶**fig. 9.20** shows an elegant compromise solution. Masson began the work using automatist principles; he poured glue on the canvas in a (fairly) random fashion, then scattered sand across it to create a basic composition. Using this initial "automatic" composition as a foundation, he then worked it up into a finished painting. While obscure enough to conform to the Surrealist expectation of conveying altered states of consciousness, the subject matter and its warlike imagery had a very real, personal resonance for Masson. He had been seriously wounded in World War I and continued to suffer psychological trauma (see also inset). The *Battle of Fishes* can be understood as an expression of his revulsion at European civilization's capacity for destruction.

In the 1920s, Masson worked in the same studio building in Paris as Catalan-born painter Joan Miró (1893–1983), who was among those to sign the first *Surrealist Manifesto*. It was Miró who notoriously poured contempt on fellow artists, even though Surrealism, too, belonged to the "School of Paris"—the congregation of artists, collectors, and dealers in Paris after the war. "I shall break their guitar," he said in 1924, when he and Masson abandoned the Cubist style and its typical still-life subject matter featuring musical instruments. Miró's painting *Birth of the World* ▶**fig. 9.21**

Shell Shock

> Shell Shock. How many a brief bombardment had its long-delayed after-effect in the minds of these survivors, many of whom had looked at their companions and laughed while the inferno did its best to destroy them? Not then was their evil hour, but now, now, in the sweating suffocation of nightmare, in paralysis of limbs, in the stammering of dislocated speech.

In this passage the English poet Siegfried Sassoon (1886–1967), who served in the trenches during World War I, was reflecting on the often delayed responses to the horrors of battle. The war produced hundreds of thousands of cases of "shell shock," the equivalent of contemporary post-traumatic stress disorder. Freud's outlining of how the mind suppresses unpleasant experiences, often leading to neurotic states, served as a model for psychiatrists such as William Rivers (1864–1922), who ministered to soldiers at the Craiglockhart hospital in Scotland. Rivers's treatment of his patients relied extensively on Freudian techniques, including dream interpretation. Both Sassoon and fellow poet Wilfred Owen (1893–1918) were at Craiglockhart in 1917. Owen was killed after being returned to the front. Sassoon's poetry written in the trenches is noted for its bleak realism. One of the verses from *Does It Matter?* (in his collection *Counter-Attack and Other Poems*, 1918) reads:

> Do they matter?—Those dreams from the pit? . . .
> You can drink and forget and be glad,
> And people won't say that you're mad;
> For they'll know you've fought for your country
> And no one will worry a bit.

9.22 René Magritte, *The Menaced Assassin*, 1926. Oil on canvas, 4ft 11¼ins x 6ft 4⅞ins. The Museum of Modern Art, New York.

exemplifies the Surrealist love of primeval themes. It is a haunting vision of creation in which a few abstract, biomorphic forms float in a wash of gray atmosphere. Like Masson, Miró worked through a combination of automatic drawing followed by free association in order to build a finished work. Miró's and Masson's works formed the centerpiece of the first Surrealist art exhibition, held in Paris in 1925. The following year Breton oversaw the opening there of the first gallery devoted exclusively to Surrealism. In the later 1920s, Breton decided to shift the focus of Surrealist art away from psychic automatism and toward the representation of dream imagery. While Breton had signaled this interest in the first *Surrealist Manifesto*, he did not translate his beliefs into concrete policy until after 1927:

> Freud very rightly brought his critical faculties to bear upon the dream. It is in fact, inadmissible that this considerable portion of psychic activity . . . has still today been so grossly neglected. I have always been amazed at the way an ordinary observer lends so much more credence and attaches so much more importance to waking events than to those occurring in dreams.

This change in focus was codified in the second *Surrealist Manifesto* (1929) and resulted in a considerable turnover of members of the movement; some artists, including Masson, were banished by Breton, while others joined the group as new members. In this second wave of Surrealism, artists produced works containing fantastical subject matter but executed in a truly banal, realist style, which the average viewer found relatively accessible. It is easier to grasp the meaning of Dalí's "melting clocks," for instance, than the murky realm of Miró's *Birth of the World*.

The Belgian painter René Magritte (1898–1967), who first became associated with the movement in 1925, moved to Paris in 1927. His *The Menaced Assassin* ▶**fig. 9.22** is in the hyperrealist style of second-wave Surrealism. The painting apparently shows the aftermath of a murder and features a series of enigmatic middle-class men: they could be either detectives or perpetrators and are dispersed seemingly at random across the scene. It is important to consider this painting in terms of the long tradition of narrative artworks in Europe. *The Menaced Assassin* opens up a dream world that consciously undermines the stage-managed storytelling of such paintings as David's *The Oath of the Horatii* (see fig. 7.5). In the Magritte, it appears at first that there is a story, even a mystery, which can be worked out by the viewer. But closer examination reveals that the narrative has collapsed, the clues do not add up, and one is denied the feeling of closure that comes with understanding a story. Instead, there appears to be an undefinable irrationality, or evil, lurking beneath the surface.

Thanks in part to his impressive skills at self-promotion, another Catalan-born painter Salvador Dalí (1904–89) became the best known of all the Surrealist artists, especially in the United States, where he lived between 1941 and 1948. Like Magritte, Dalí specialized in a realistic style based on such traditional illusionistic devices as linear perspective and clearly delineated forms. However, his subject matter featured hallucinatory visions of a world torn by conflicted sexual desires. Freud had written in *The Interpretation of Dreams*, "The content of dreams, however, does not consist entirely of situations, but also includes disconnected fragments of visual images, speeches, and even bits of unmodified thoughts." Among other characteristics, Freud found that dreams featured "displacement," meaning that one object in a dream can

9.23 Salvador Dalí, *Birth of Liquid Desires*, 1931–32. Oil and collage on canvas (unvarnished), 3ft 1⅞ins x 3ft 8¼ins. Peggy Guggenheim Collection, Venice (The Solomon R. Guggenheim Foundation, New York).

9.24 Salvador Dalí and Luis Buñuel, *Un chien Andalou*, 1929. Film still.

represent another because of an unconscious psychological connection, and "condensation," through which multiple images can be concentrated into a single one. Dalí was determined to provide images that could be traced back to real dreams and to his psychosexual anxiety as a child. Realistic paintings such as *Birth of Liquid Desires* ▶**fig. 9.23** are filled with cryptic references to Dalí's inner life. He claimed to be putting on to canvas a factual record of a dream.

Dalí also helped to expand the Surrealist repertoire to include film. In 1929 he teamed up with the Spanish director Luis Buñuel (1900–83) to create the short film *Un chien Andalou (An Andalusian Dog)* ▶**fig. 9.24**. Rejecting narrative almost entirely, the film consists of twenty-four minutes of loosely connected events and imagery, none of which concerns the dog of the title (Andalusia is a region in southern Spain). The film is probably best remembered for the special-effects shot of a woman's eye being slit open, an image that can still make the unprepared viewer gasp with horror. Other typical Surrealist elements include a man with ants running over the palm of his hand, which in colloquial French would mean he is "itching to kill." One extended sequence shows a woman accosted in her home and threatened with sexual assault. Surrealism as a movement saw liberation in sexual terms, but this liberation almost always cast women in the role of passive sexual objects, or conversely as threatening *femmes*

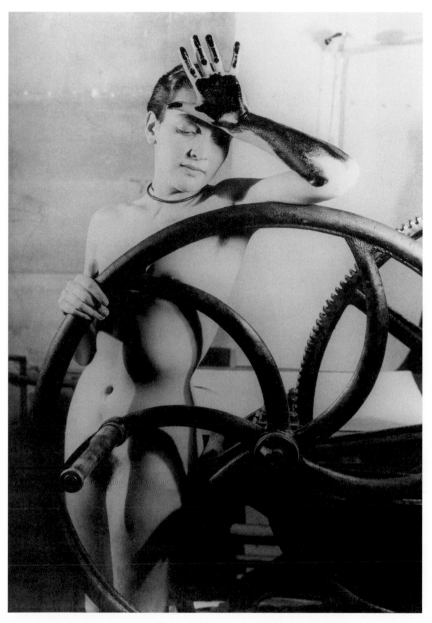

9.25 Man Ray, *Veiled Erotic*, 1933. Photograph.

fatales, roles not dissimilar to those promoted by the conservative European societies that the Surrealists held in contempt.

Paradoxically, the Surrealists' focus on the creative power of the unconscious mind allowed them to indulge the sort of male sexual fantasies that, far from liberating sexuality from repressive forces, reinforced the most traditional views of women. Such attitudes can be seen in the work of the American photographer Man Ray (1890–1976), who met Duchamp in New York during the war and soon emigrated to France. In his *Veiled Erotic* ▶**fig. 9.25**, for example, the organic shape of a female nude body is juxtaposed with the wheel of a mechanical printing press, ink covering her left arm and hand; the woman was the artist Meret Oppenheim (1913–85) (see fig. 9.27). The wheel partially masks her nudity in a traditional gesture toward modesty, while Oppenheim's pose, one hand at her head, resonates with that of traditional images of Venus. The wheel's handle forms the most provocative part of the composition, as it projects into space, suggesting an aroused penis. The handle can be read as an extension of Oppenheim's body, emphasizing the male organ, and women's "lack" of it, which is an important topic in Freudian sexual theory. It may also be read as a simple allusion to penetration. For all its artistry, the image teeters on the brink of plain erotica.

The next phase of the Surrealist movement (see also inset p. 295) culminated in two exhibitions, one in London in 1936, the other in New York in 1937. Focusing on "Surrealist objects," both events featured constructions and installations made out of everyday materials showing a renewed interest in dream-like juxtapositions of unrelated things. Breton had often quoted the French prose poet Isidore Ducasse (1846–70), who wrote under the pseudonym the Comte de Lautréamont and made

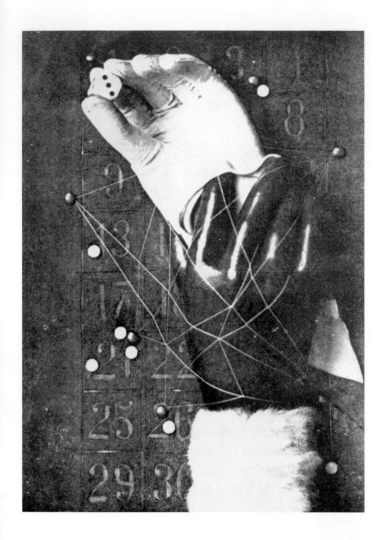

9.26 Valentine Hugo, *Untitled (Object of Symbolic Function)*, endpapers of *La Révolution surréaliste 3*, December 1931. Assemblage.

the celebrated simile "As beautiful as a chance encounter of a sewing machine and an umbrella on an operating table." By constructing artworks out of found objects, artists were able to realize surreal juxtapositions in such a way as to make them more immediate to the viewer than paintings or photographs. It also showed the Surrealists' continuing debt to the Dada movement. The *Untitled (Object of Symbolic Function)* ▶**fig. 9.26** by Valentine Hugo (1887–1968), in which two rubber gloves are trapped in a spider's web, typifies this phase of Surrealism. One of the gloves penetrates the other with explicit sexual innuendo. A die introduces an edge of instability, reminding the viewer of the random forces of chance while suggesting that a game is to be played.

Meret Oppenheim's *Object* (known as *Luncheon in Fur*) ▶**fig. 9.27** caught the attention of many Americans in 1936, encapsulating the Surrealist love of sexual suggestiveness combined with an embrace of the bizarre. The work's shape

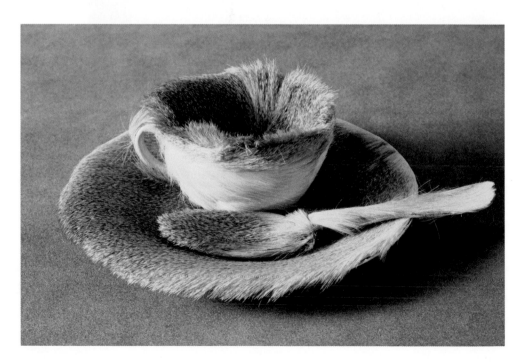

9.27 Meret Oppenheim, *Object*, 1935. Fur-covered cup, saucer and spoon: cup 4³⁄₈ins diameter; saucer 9³⁄₈ins diameter; spoon 8ins long; overall height 2⁷⁄₈ins. The Museum of Modern Art, New York.

Breton and Surrealism in Mexico

Because of his strong commitment to revolutionary Communist politics, André Breton formed a natural alliance with Mexican artists and intellectuals dedicated to similar causes. As mentioned in chapter 7, in the 1930s Mexico was briefly the home of the exiled Leon Trotsky, whom Breton visited during an extended trip there in 1938. The two thinkers collaborated on an essay called the *Manifesto for an Independent Revolutionary Art*, which asserted that there were strong commonalities between artistic and political revolution. The manifesto concluded: "Our goals: the independence of art for the revolution; the revolution for the liberation of art once and for all."

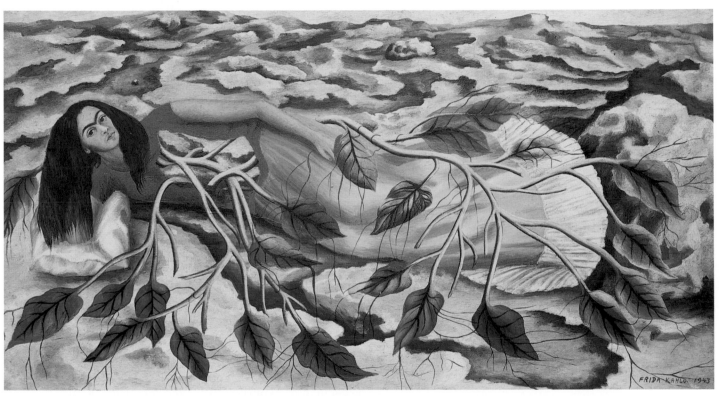

9.28 Frida Kahlo, *Roots*, 1943. Oil on sheet metal, 11³/₄ins x 1ft 7⁵/₈ins. Private collection.

Breton's visit helped to further a Surrealist consciousness in several artists, notably Frida Kahlo (1907–54) and her husband Diego Rivera (see chapter 7), with whom Trotsky was living at the time. Kahlo's representational painting style conveys not only the tragedies of her personal life, but her commitment to the Marxist struggle and her Mexican heritage. Most of her works are self-portraits; *Roots* ▶fig. 9.28, for example, in the organic growth from her body, symbolizes both personal renewal and a renewal of her native land. She wears Mexican costume and her body is marked by the scars of the numerous surgical operations she endured after a streetcar accident when she was a teenager. Although Kahlo lived and worked in Mexico, she visited France and participated in some of the Surrealist exhibitions in the United States.

and tactile qualities offer several sexual readings, but it is the elegant transformation of a cold, hard object—a china teacup—into a warm, richly textured one that makes *Object* the supreme statement of Surrealist principles. An extremely ordinary object has been altered to invoke the mysteries of the unconscious. Yet, while Surrealist artists could investigate their inner thoughts, and take their dreams and hopes and fears seriously, Surrealism itself placed men in charge as the creators and women as their sidekicks. Oppenheim was the prototype of the *femme-enfant* ("woman-child"), a muse with both sexual allure and passive innocence for the male Surrealist. Oppenheim herself had been "found" on the streets of Paris by male members of the movement as a fifteen-year-old runaway. Although some of them encouraged her artistic activities, there was never any question of equal billing. In sum, the Surrealists opened up new avenues through which artists could explore their inner lives, yet in many ways they remained bound by the traditions of European society.

Degenerate Art

In Germany in the 1920s, the public had a healthy appetite for progressive modern art. Government funding supported the collection and exhibition of contemporary works in Berlin as well as in the provinces. Away from Paris, cities such as Munich, where Kandinsky had settled, were among the most influential art-making centers in the world. However, the architect Paul Schultze-Naumburg and others propounded a disturbing theory of modern art and the mind that would influence the arts policy of Nazi Germany in the 1930s. Schultze-Naumburg asserted that modern art was the work of degenerate, immoral radicals bent on corrupting German culture. Notoriously, his essay *Art and Race* (1928) made explicit comparisons between European Expressionist paintings and photographs of people with severe mental illness or facial deformities ▶**fig. 9.29**. Schultze-Naumburg intended to convince people that modern art not only represented deformity, but was itself the work of "diseased" minds. This concept of immoral art was further informed by a twisted view of race as well as virulent anti-Semitism. The Expressionist fascination with "primitive" sources (see chapter 8) further inflamed Schultze-Naumburg. His desire for a wholesale eradication of these "diseased" works and artists came to fruition in the 1930s.

After the Nazis seized power in 1933, Joseph Goebbels, who later held the title of Government Minister for National Enlightenment and Propaganda, set about enforcing a specific artistic and cultural policy. He sought to create an artistic culture that celebrated and validated Nazi rule, eliminating artworks that did not fit this vision. He confiscated thousands of examples of modern art from German private and public collections, fired "non-Aryan" museum curators, and stopped the collecting and display of modern art. Sometimes the government would gather modern artworks and exhibit them in a format called "Chamber of Horrors of Art." The overall intent was to "purify" German society of art that the state found threatening or that clashed with its racist view of the world.

This national policy culminated in two exhibitions held in Munich in 1937. The first, the Great German Art Exhibition, was opened on July 18 at the House of German Art, which was the first large-scale public building completed by the new regime. Viewers

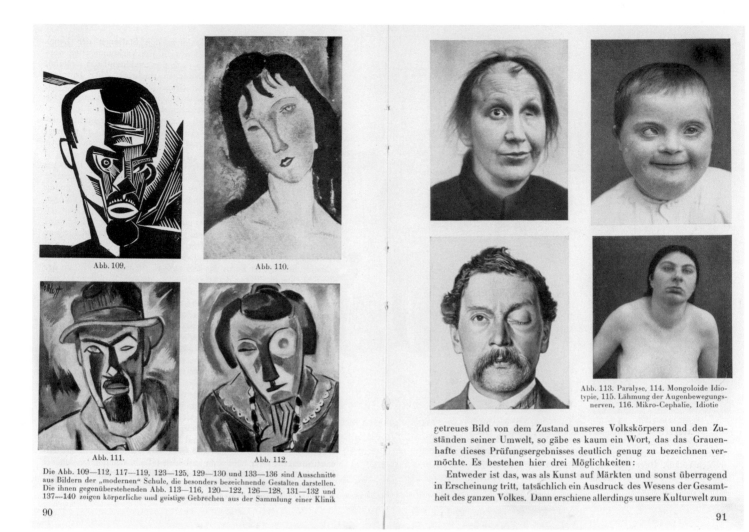

Abb. 109,

Abb. 110.

Abb. 111.

Abb. 112.

Die Abb. 109—112, 117—119, 123—125, 129—130 und 133—136 sind Ausschnitte aus Bildern der „modernen" Schule, die besonders bezeichnende Gestalten darstellen. Die ihnen gegenüberstehenden Abb. 113—116, 120—122, 126—128, 131—132 und 137—140 zeigen körperliche und geistige Gebrechen aus der Sammlung einer Klinik

90

Abb. 113. Paralyse, 114. Mongoloide Idiotypie, 115. Lähmung der Augenbewegungsnerven, 116. Mikro-Cephalie, Idiotie

getreues Bild von dem Zustand unseres Volkskörpers und den Zuständen seiner Umwelt, so gäbe es kaum ein Wort, das das Grauenhafte dieses Prüfungsergebnisses deutlich genug zu bezeichnen vermöchte. Es bestehen hier drei Möglichkeiten:

Entweder ist das, was als Kunst auf Märkten und sonst überragend in Erscheinung tritt, tatsächlich ein Ausdruck des Wesens der Gesamtheit des ganzen Volkes. Dann erschiene allerdings unsere Kulturwelt zum

91

9.29 Paul Schultze-Naumburg, photographs from *Art and Race*, 1928.

were confronted with a selection of idealized, representational paintings and sculptures that glorified the regime and its narrow view of German culture. Hitler, who had unsuccessfully pursued a career as an artist when he was a young man, took a personal interest in selecting works for the show ▶**fig. 9.30**. At the opening he declared: "From now on we will wage an unrelenting war of purification against the last elements of putrefaction in our culture." The second exhibition, a hastily assembled survey of modern art from German public collections alluded to in Hitler's speech, opened the following day under the title Entartete Kunst (Degenerate Art). The German word *Entartete* has scientific overtones of mental and physical mutation, as well as its common English sense of moral decline. Like the curators of ethnographic collections who exhibited "primitive" African art in most major European capitals, the curators of the Degenerate Art show, led by Adolf Ziegler, hung the works helter-skelter so as to create a sense of alienation and confusion in the viewer ▶**fig. 9.31**. The 650 works from over thirty public collections were loosely grouped according to thematic

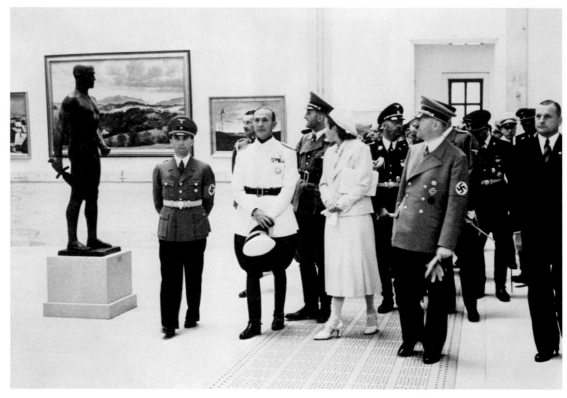

9.30 Hitler Shows Off "Purged Art." Original caption July 25, 1939, Berlin, Germany: "Germany's 'purged' art shown off by Fuehrer. Purged by modernism, impressionism, cubism and other 'isms', and with only the 'Good Germanic Art' left, a National exhibit of German art is shown to heads of Foreign Missions in Berlin, by Der Fuehrer in person (at right in front) and his Minister of Propaganda Dr. Goebbels (at left)."

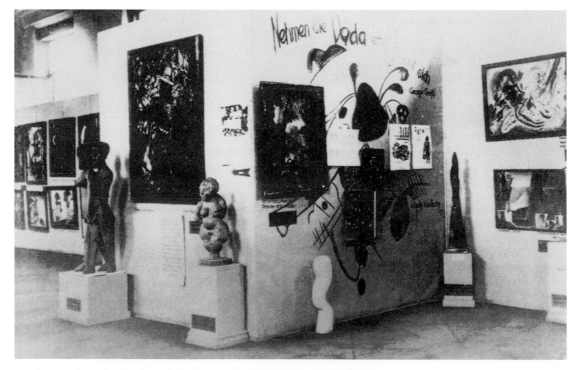

9.31 Room 3, including Dada wall, in Degenerate Art Exhibition, Munich, 1937.

labels, three of which emphasized the "diseased" minds of the artists: "Madness becomes method," "Crazy at any price," and "Nature as seen by sick minds." The third category was used to defame a group of landscapes by the artists of Die Brücke (see chapter 8). The slogan "Crazy at any price" was written under a selection of watercolors by Kandinsky. This slogan represents part of Ziegler's strategy to inflame the public by claiming that outrageously high prices had been paid out of public funds for these "degenerate" works. Two other members of the Der Blaue Reiter group, Franz Marc and Auguste Macke, both of whom had received their country's highest military honor while fighting, and dying, for Germany during World War I, were similarly maligned by inclusion in the exhibition. Inevitably, Expressionist artworks that depicted emotional turmoil and sexuality played a large role in the display. For example, Oskar Kokoschka's *Bride of the Wind* (see fig. 9.14), which had been bought by an art museum in Hamburg, and which is a rather tame painting by modern standards, was included in the show along with numerous other Expressionist artworks.

Degenerate Art, free to the public, was a blockbuster success. Over two million people visited during its four-month run in Munich, while another million saw the traveling version over the next three years. Its success in terms of raw numbers is well documented, yet the evidence is ambiguous as to the show's effectiveness in convincing the German public to accept such a distorted view of modern art. In 1939, however, any such speculation was irrelevant as Europe had once again plunged into war.

Postwar Abstraction

In the United States after World War II, American artists working under the influence of the émigré Surrealists established a new model of "painting from the unconscious" based on the work of Freud's disciple Karl Jung (1875–1961). Jackson Pollock (1912–56), who had undergone Jungian psychoanalysis as part of his treatment for alcoholism and depression, as well as other Abstract Expressionists such as Adolph Gottlieb (1903–74) and Mark Rothko (1903–70), demonstrated a knowledge of Jung's model of the "collective unconscious" in their paintings. They explored the unconscious in a novel manner that demonstrated their immersion in postwar American ideology.

One of the keys to the ascendance of an American school of painting based largely on expressing the unconscious mind was an influx of European immigrant artists in the 1920s and 1930s. The French Surrealists figured prominently in the group of exiles that set up shop in New York to sit out the war. American artists had already been exposed to Surrealist ideas through several exhibitions in the United States, as well as the gallery dedicated to Surrealism between 1932 and 1936. Then, after Paris fell to the Nazis in 1940, an expatriate cadre of Surrealists grouped themselves around Breton in New York. But they remained rather aloof from American artists: several even chose to emphasize their transient status by refusing to engage with English-speakers. However, three exhibitions held in 1942 increased the Surrealists' visibility in New York. The show entitled First Papers of Surrealism made a large splash when it opened at the Whitelaw Reid mansion. The most provocative work, Duchamp's installation *16 Miles of String*, transformed the gallery space into a giant spider's web, suggesting the tangled world of dreams and fantasies in which the Surrealists reveled. In the same

year, Peggy Guggenheim opened her Art of This Century gallery devoted to modern European art (see chapter 6), and the dealer Pierre Matisse held an exhibition called Artists in Exile. The latter show brought attention to Masson's automatist drawings (Masson and Breton had by then been reconciled and Masson brought back into the Surrealist fold). Furthermore, the Surrealists published two journals in New York, *View* and *VVV*, which brought their ideas to the attention of a new and wider public.

Many American artists were drawn to the branch of psychoanalysis begun by Freud's follower Jung, known as analytical psychology. Jung's work stressed the fact that images found in individuals' dreams and fantasies often found a corollary in images produced in a variety of religious, folkloric, and mythological systems. Jung considered this anecdotal correlation to be evidence of a "collective unconscious," an underlying storehouse of images that all human beings share. This theory opened up several major new avenues of thought for artists. In the United States, it provided a new rationale for an American embrace of primitivism in art: the artist was now free to explore Native American and non-Western imagery in terms of its being part of the collective unconscious to which all people could universally relate. Jung's theory also provided a comforting view of humanity at a time when the Western world had recently torn itself apart with hatred and killing. The collective unconscious supplied a model of universal human connection that underlies Abstract Expressionist art.

The painter Adolph Gottlieb, trained in New York and Paris, expressed a belief in the power of non-Western and unconscious imagery to represent the anxiety of the postwar world: "Today when our aspirations have been reduced to a desperate attempt to escape from evil, and times are out of joint, our obsessive subterranean and pictographic images are the expression of the neurosis which is reality." Gottlieb felt that the collective unconscious could serve as a vehicle through which the individual psyche could be healed and as a means of expressing a more universal experience. His *Pictograph* ▶**fig. 9.32**, one of a series of similar images, illustrates his working method: he painted a grid in order to create a basic structure, then filled its internal spaces with a variety of abstract and representational forms. The organic forms create a strong contrast with the rectilinear structure of the grid outlining them. The painting is not designed to serve as a mystery with one set of definitions, but has myriad disconnected shapes that represent Gottlieb's search for universal healing. In a sense, the expressionist element in Abstract Expressionism is much less clearly defined than in, say, the works of Schiele some thirty years earlier (see fig. 9.13). Schiele clearly plotted out his personal fears and anxieties while making many images of people that were important to him, including himself and his spouse, all psychobiographical in content. In contrast, Gottlieb and other Abstract Expressionists saw their art in less personal terms, reaching out to the whole of humanity.

Jackson Pollock's life and work intersected with a number of key aspects of the new American abstract painting. Embarking on Jungian treatment in 1937, he became aware of the Surrealists' explorations of the unconscious and automatism around the same time. The painting *Guardians of the Secret* ▶**fig. 9.33** is typical of Pollock's Surrealist-influenced work, combining some indistinct representation with fields of

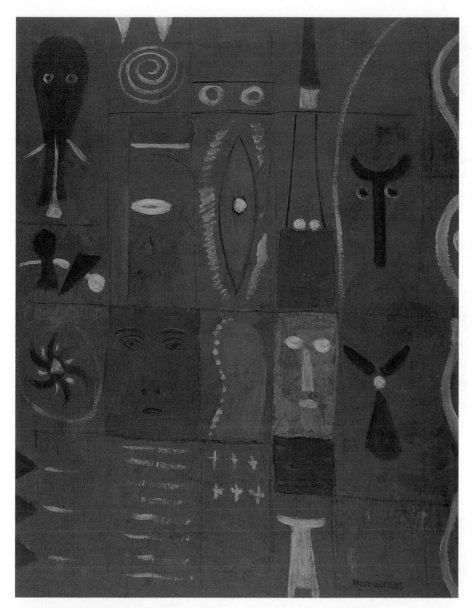

9.32 Adolph Gottlieb, *Pictograph*, c.1946. Oil on canvas, 2ft 10ins x 2ft 2ins. Gottlieb Foundation, New York.

automatic drawing in a fluid, ▸gestural◂ style. The obscure title and imagery—what looks like a Roman sarcophagus and a dead wolf are at the center—suggest some of the universality of Jung's collective unconscious. The wolf, for example, may suggest a Native American link, as Pollock was particularly interested in Navajo dry painting (see p. 276) as a source for primitivist iconography. Pollock made his most influential work during a period of sobriety between 1947 and 1950, while living and working on Long Island, New York. He developed a technique whereby he rolled out enormous unstretched and unprimed canvases on the floor of his studio. Walking around the studio, he would apply a variety of pigments, including industrial paints. He would work by dripping, pouring, and splattering the paint, resulting in such works as *Autumn Rhythm No. 30* ▶**fig. 9.34**. The picture thus became, to an extent, a record of the physical activity of making it, particularly the movements of the artist's hand. Pollock's automatist style was termed "gestural abstraction," and represents one of the two main trends in Abstract Expressionist painting. A set of photographs taken by Hans Namuth and first displayed in *Life* magazine in 1951 vividly documented Pollock's working process. It has been argued that these pictures, which show Pollock absorbed in what almost constitutes a performance, have been more influential to future generations of artists than the works themselves.

Pollock's work is often considered to convey aspects of a uniquely American ideology. Born in Cody, Wyoming, he cultivated the "cowboy" image—individual, tough, self-sufficient, stoic—associated with the American West. One of the first artists to paint

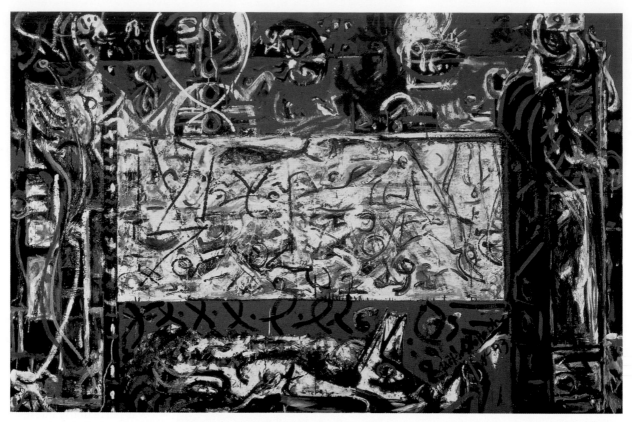

9.33 Jackson Pollock, *Guardians of the Secret*, 1943. Oil on canvas, 4ft ³/₈in x 6ft 3³/₈ins. San Francisco Museum of Modern Art.

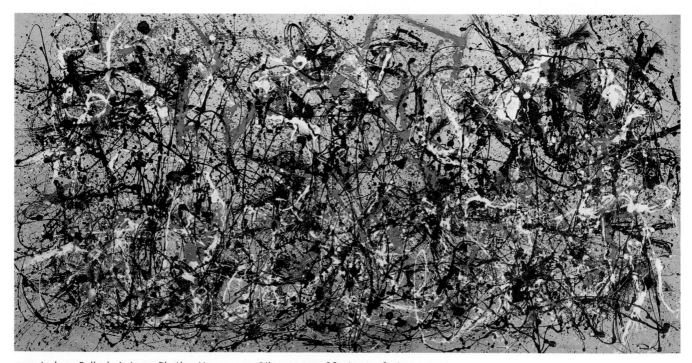

9.34 Jackson Pollock, *Autumn Rhythm No. 30*, 1950. Oil on canvas, 8ft 9ins x 17ft 3ins. The Metropolitan Museum of Art, New York (George A. Hearn Fund, 1957).

publicly in casual clothes, especially cowboy jeans, he invariably worked on a large scale, producing paintings evocative of the grandeur of the American West. The critic Harold Rosenberg introduced the term "action painting" in 1952, in an article that does not specify individual artists, but he was referring primarily to Pollock and Willem De Kooning (1904–97). The term resonates with a specifically American sense of energy and heroic achievement.

Pollock, probably unintentionally, set up a comparison between the "masculine" qualities of his work and the so-called "feminine" weakness of traditional French modernism. This sexist gendering of gestural abstraction was expressed through a number of implicit comparisons: Pollock's works were big and unrefined, while French paintings were small and polished; Pollock used industrial paints, French artists used expensive fine art supplies; Pollock wore simple clothes, French artists were renowned for their sartorial elegance. In addition, the comparison can be extended to the realm of the political: the United States was militarily strong and was a victor in World War II, France was weak and had been overrun by Germany;

The Irascibles

On January 15, 1951, *Life* magazine published a photograph by Nina Leen of a group of Abstract Expressionist artists, including Gottlieb, Pollock, and Rothko, calling them "The Irascibles" ▶fig. 9.35. The group had been formed in protest at their art not being included in the Metropolitan Museum of Art's exhibition American Painting Today—1950. This informal association, and particularly the photograph of the artists together, was an important factor in causing people to see Abstract Expressionism as a coherent body of work. It also represents one of the first times that American artists successfully portrayed themselves as "avant-garde," a French military term that denotes the most advanced forces in a conflict. Since the nineteenth century, progressive European artists had often used the term to celebrate their work being at the forefront of culture. The fact that "The Irascibles" were featured in professional dress in a mainstream magazine also points to the fact that their reputation as marginalized bohemians, embodying the romantic ideal of the "starving artist," has been vastly overstated. Many of the Abstract Expressionist painters received favorable attention from the mass media relatively early in their careers.

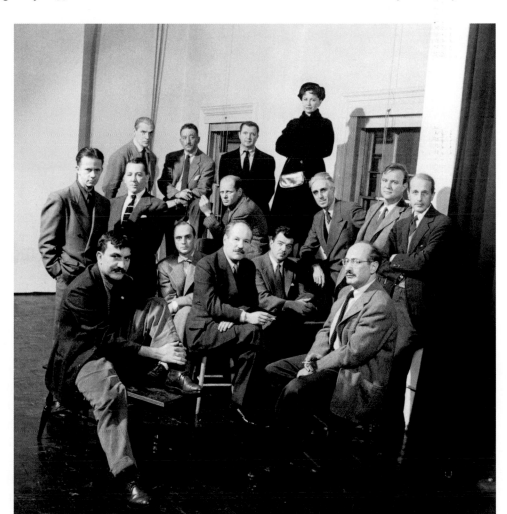

9.35 Nina Leen, photograph of 'The Irascibles', 1950, including William Baziates, James C. Brooks, Jimmy Ernst, Adolph Gottlieb, Hedda Sterne, Clyfford Still, Willem de Kooning, Bradley Walter Tomlin, Barnett Newman, Jackson Pollock, Theoros Stamos.

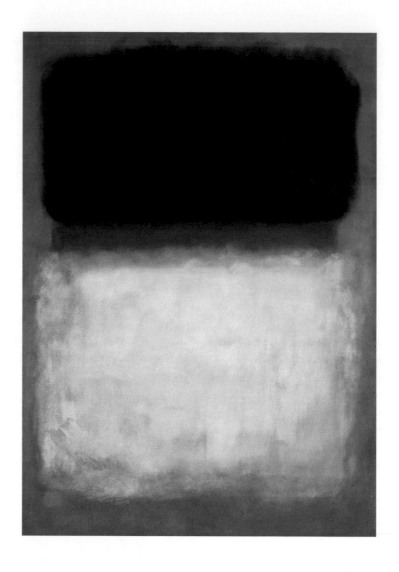

9.36 Mark Rothko, *Green on Blue*, 1956. Oil on canvas, 7ft 5¾ins x 5ft 3¼ins. University of Arizona Museum of Art, Tucson, Arizona.

the United States was a new superpower, France was rebuilding, but only with American financial help. In reality, the 1950s did witness a general shift of cultural centers in the West, from Paris to New York. However, Pollock did not live to see the worldwide ascendance of American painting that was recorded in a number of exhibitions in the late 1950s. Instead, he continued to express his quintessentially American qualities right up to his death in 1956 in a one-car drunken driving accident.

The other main current of Abstract Expressionist style, called "chromatic abstraction," was centered on the work of Mark Rothko. Rothko wanted his works to evoke "the timelessness and tragedy of the human condition," and his works go furthest in integrating an art of the inner mind with traditional religious content. Works like *Green on Blue* ▶**fig. 9.36** show his mature style, a unique blending of saturated fields of color. The painting is essentially an icon; it is intended to serve as an intermediary that facilitates religious experience. Paradoxically, the work of Rothko and Pollock, which is in many ways non-traditional in style, might recall the Renaissance debates about *colorito* versus *disegno*, color versus design or line (see chapter 5). In a broad sense,

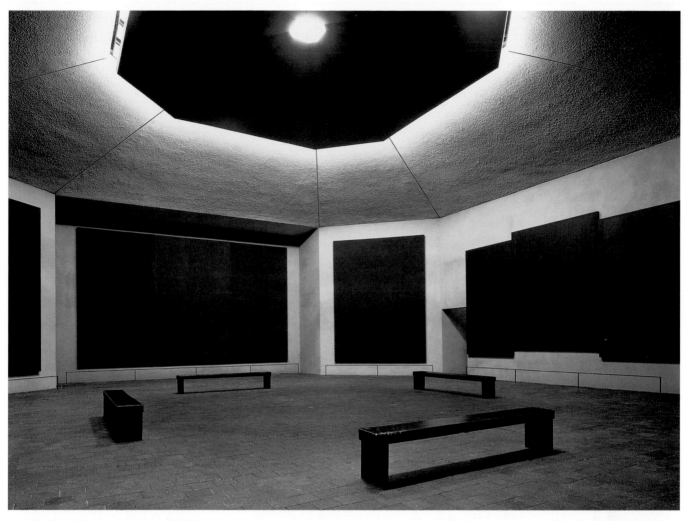

9.37 Mark Rothko, interior view of Rothko Chapel, oil on canvases, 1965–66. Dimensions variable. Houston, Texas.

Pollock's subdued color and web of drawing emphasizes *disegno*, while Rothko's harmonious color fields resonate with the sensual appeal of *colorito* painting. "I paint very large pictures. I realize that historically the function of painting large pictures is painting something very grandiose and pompous. The reason I paint them, however—I think it applies to other painters I know—is precisely because I want to be very intimate and human." Rothko intended his works to stretch from floor to ceiling, creating an environment charged with spirituality. He always wanted viewers to commune with the paintings. In many cases his wishes have not been followed, and many of Rothko's paintings are perched, like postage stamps, on the soaring walls of major museums. However, one of his last set of works, an ensemble of fourteen paintings made for an ecumenical chapel in Houston, Texas, preserves the artist's favored type of installation. The austere Rothko Chapel ▶**fig. 9.37**, built to an octagonal plan, has Rothko's paintings covering four of the walls. In three places the assembled canvases seem to represent the Christian Trinity. Although Rothko had a Jewish heritage, he wanted his art to reach out to members of multiple religious traditions.

European Postwar Art and the Mind

Surrealism was still a powerful force in the European artistic scene after World War II, when most artists associated with the group returned home from the United States. In addition to the continuing impact of psychoanalytic theory, many European artists also adopted ideas drawn from "existential" philosophy. This view of the "meaning of life" (or lack thereof) was explored by the French philosopher Jean-Paul Sartre (1905–80) in a series of essays, novels, and plays. Building upon the philosophy of the German Martin Heidegger (1889–1976), Sartre first succinctly outlined his philosophy in the novel *Nausea*, published in 1938. The protagonist, Antoine Roquentin, faces the quintessential existential paradox. He is completely free to control his own life, but is tormented by this freedom, which places a tremendous burden on him. Roquentin is forced to create meaning in a world that, in existential terms, is absurd and empty of any significance. Roquentin experiences this state of existence through an allegorical feeling of profound nausea. Sartre's play *No Exit* (1944) includes the immortal line "Hell is other people," an epitome of existential cynicism regarding meaningful human relationships. Existentialism offered an intellectual framework for artists to identify with the pervasive fear, loneliness, and anxiety of the postwar world.

The Swiss sculptor Alberto Giacometti (1901–66) had first joined the Surrealist group in the 1930s. After the war and his break with official Surrealism, Giacometti pursued a vision of the human figure that seems to be immersed in Sartre's existential questioning (the two were friends). The ghost-like figures in Giacometti's *The City Square* ▶**fig. 9.38** march mechanically through an empty space, crossing each other's paths, yet painfully alone. There is no feeling of human warmth in this Surrealist fantasy, where existentialist wanderers are lost in their search for meaning.

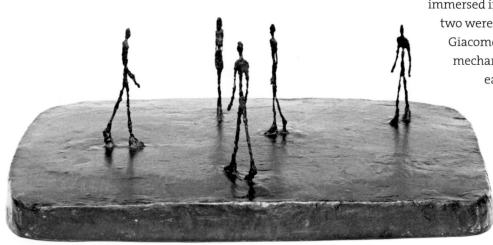

9.38 Alberto Giacometti, *The City Square*, 1948. Bronze, 8½ins x 2ft 1⅜ins x 1ft 5¼ins. The Museum of Modern Art, New York.

Jean Dubuffet (1901–85) was the most prominent figure in French abstract painting after the war. Following his first solo show in 1945, he became an influential speaker, notably on behalf of European abstract artists. He collected the art of children, recluses, spiritualists, and those suffering from mental illness, to which he gave the label "Art Brut," or "raw art." "Executed by people free of artistic culture," such art "addresses itself to the mind, and not to the eyes. It has been always considered in this way by primitive peoples, and they are right," he said. His collection was shown in Paris in 1967 and donated to the city of Lausanne in 1976. However outmoded Dubuffet's views on "primitive" art have become, such works were allied to his interest in the irrational. Dubuffet's own work has often been mistakenly described as "Art Brut." This confusion comes from the fact that he attempted to create works that rejected traditional notions of composition and finish. His painting *The Cow with the Subtile Nose* ▶**fig. 9.1** (see p. 270) is in a childlike style, depicting the cow in rudimentary outlines. It is a sort of

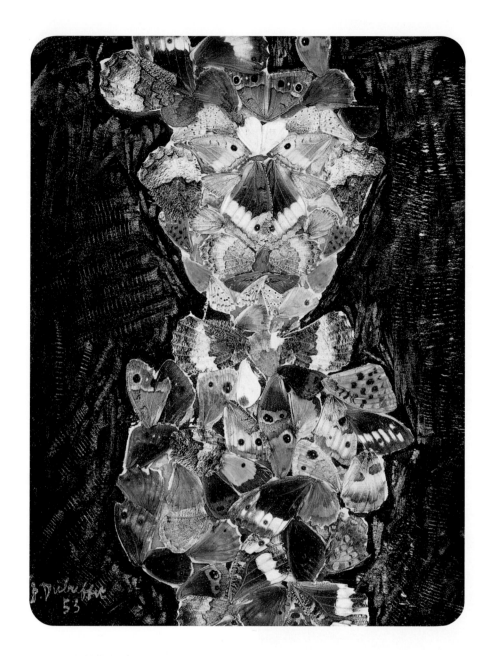

9.39 Jean Dubuffet, *The Squinter*, 1953. Butterfly wing collage, 9¾ins x 7ins. Private collection.

faux-naïf work, as Dubuffet purposely disregarded his own academic training in order to make a painting that lacks polish. He even outlandishly produced a picture out of a collage of butterfly wings. In *The Squinter* ▶**fig. 9.39** the central figure gazes at the viewer with the same serenity as the Cow with the Subtile Nose, but there is something sinister underlying the elegant surface of the portrait when one takes the dead butterflies into account. Nonetheless, despite the lurking sense of fear and anxiety, and despite its unusual medium, *The Squinter* has much in common with conventional French painting. Like Pollock and Rothko, Dubuffet intended his art to grapple with the meaning of human existence. All of these artists shared a faith in the idea that abstraction, far from being an exclusive, incomprehensible language that only the initiated can understand, is in fact a universal language of the inner mind.

Pop Art: Rejecting the Inner Mind

"The Pop artists did images that anybody walking down Broadway could recognize in a split second—comics, picnic tables, men's trousers, celebrities, shower curtains, refrigerators, Coke bottles—all the great modern things that the Abstract Expressionists tried so hard not to notice at all." As the artist Andy Warhol (1928–87) suggested in this statement, Pop art in the United States, Great Britain, and France developed in the 1960s as a clear rejection of the angst-ridden spirituality of the postwar abstract movements. These artists had little interest in the inner mind or

the "timelessness and tragedy of the human condition," as Rothko had put it. Rather, Pop artists sought to use irony, an indifferent, anti-expressionist attitude, and a realistic style in order to represent the outer world of urban commercial culture. The term "Pop," short for "popular," was coined in the late 1950s in the United Kingdom and soon became an umbrella term for a host of disparate art groups. The 1956 collage *Just what is it that makes today's homes so different, so appealing?* by the British artist Richard Hamilton (born 1922) is a parody of Western consumerism ▶**fig. 9.40**. The couple, themselves commercial icons of idealized physical beauty and sexuality, are surrounded by sarcastic references to popular culture, such as a television program, an advertisement for cleaning supplies, and a canned ham. They have no inner life, no questions about existence, no concern for their emotional and spiritual growth, and no difficulties with sexuality. In the modern Western world, the collage seems to say, people live outside themselves, not in an inner world dominated by emotional experience, but in a world of things.

9.40 Richard Hamilton, *Just what is it that makes today's homes so different, so appealing?*, 1956. Collage, 10¼ins x 9¼ins. Kunsthalle, Tübingen, Collection G.F. Zundel.

Further Reading

R. Abiodun, et al., *The Yoruba Artist: New Theoretical Perspectives on African Arts* (Washington, D.C., 1994), pp. 37–48

S. Barron and W.D. Dube, ed., *German Expressionism: Art and Society* (New York, 1997)

W.J. Campbell, *The Essential Surrealism* (New York, 2002)

W. Caruana, *Aboriginal Art* (London, 1993), pp. 21–96

W. Chadwick, *Women Artists and the Surrealist Movement* (Boston, 1985)

L. Danchin, *Jean Dubuffet* (Paris, 2001)

S. Foster, *Crisis and the Arts: The History of Dada* (Englewood Cliffs, NJ, 1996)

W.G. Fischer, *Egon Schiele 1890–1918: Desire and Decay* (Munich, 1998), pp. 146–169

A. Jonaitis, *Art of the Northern Tlingit* (Seattle, 1986), chapter 4, pp. 51–66

F.M. Naumann, et al., *Making Mischief: Dada Invades New York* (New York, 1996), pp. 177–208

K. Pepe and K. Varnedoe, *Jackson Pollock: New Approaches* (New York, 1999), pp. 87–137

N.J. Parezo, *Navajo Sandpainting: From Religious Act to Commercial Art* (Tucson, AZ, 1983)

H. Teiwes, *Kachina Dolls: The Art of Hopi Carvers* (Tucson, AZ, 1991), chapter 4, pp. 33–50

Source References

p. 282 "I value only those artists who really …"
Kandinsky, quoted in Richard Stratton's Preface to *W. Kandinsky, Concerning the Spiritual in Art*, trans. M.T.H. Sadler (New York, 1977), p. vii

p. 283 "The beginnings of Dada …"
Tzara, "Lecture on Dada" (1922), trans. in *The Dada Painters and Poets: An Anthology*, ed. R. Motherwell (Cambridge, MA, 1981), p. 250

p. 286 "Concurrence in Leonardo …"
Freud, "Leonardo da Vinci and a Memory of His Childhood" (1910), in *Standard Edition*, ed. J. Strachey, trans. A. Tyson, vol. 11 (New York, 1989)

p. 287 "It was, apparently, by pure chance …"
Breton, quoted in *Art in Theory 1900–1990: An Anthology of Changing Ideas*. ed. C. Harrison and P. Wood (Oxford, 1992), p. 434

p. 289 "pure psychic automatism …"
Ibid., p. 438

p. 289 "Shell Shock. How many a brief bombardment …"
Sassoon, *Sherston's Progress* (London, 1936)

p. 290 "Freud very rightly brought …"
Breton, quoted in C. Harrison and P. Wood, eds. (as above), p. 434

p. 291 "The content of dreams …"
Freud, quoted in C. Harrison and P. Wood, eds. (as above), p. 27

p. 294 "As beautiful as a chance …"
Ducasse, *Maldoror and The Complete Works of the Comte de Lautréamont* trans. A. Lykiard (Cambridge, MA, reprinted 1994)

p. 295 "Our goals: the independence …"
Breton and Trotsky, quoted in C. Harrison and P. Wood, eds. (as above), pp. 526–29

p. 297 "From now on we will wage …"
H. Chipp, *Theories of Modern Art: A Sourcebook by Artists and Critics* (Berkeley, CA, 1968)

p. 300 "Today when our aspirations …"
Gottlieb, quoted in C. Harrison and P. Wood, eds. (as above), p. 565

p. 305 "I paint very large pictures …"
Rothko, "A Symposium on How to Combine Architecture, Painting, and Sculpture," *Interiors*, 110:10 (1951), p. 104

p. 306 "Executed by people free of …"
Dubuffet, "Anticultural Positions," a lecture at the Arts Club of Chicago (December 20, 1951)

p. 307 "The Pop artists did images …"
A. Warhol and P. Hackett, *POPism: The Warhol Sixties* (New York, 1980), p. 3

Discussion Topics

1. Why are there different approaches to communal and individual spiritual concerns?

2. How does the concept of spiritual transformation operate in different societies?

3. Discuss the reasons behind the Nazi government's contempt for Expressionist art.

4. How is Abstract Expressionism's view of art and the mind different from that of Surrealism?

5. How is European postwar abstraction different from American?

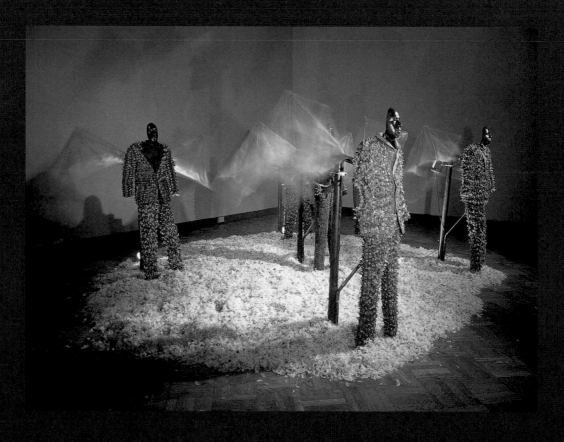

Identity in Contemporary Art

Throughout history, artists have sought to express aspects of their identities through their works. Artists have explored their individual identities, their often overlapping communal identities, and addressed issues of religion, politics, and sexuality. Historically, an artist's identity has often been narrowly defined. Until well into the twentieth century, artists were expected to be male and heterosexual. In the West, the artist was also assumed to be white and of European origin. From the civil rights movements of the 1960s onward, especially in the United States, this situation has changed dramatically, as artists who are not necessarily male, Caucasian, or straight have explored identities outside the boundaries established and sanctioned by tradition, while some white male artists have rethought their own heritage and position within the canon of conventional art history. Many recent artworks delve into controversial subject matter and provoke extremely negative reactions from those critics who believe that the art world is not the appropriate forum in which to pursue social protest. These critics have also decried the loss of traditional standards of decorum in some politically charged art. However, as much of this work has already proven to be among the most sophisticated and exciting ever produced, pieces that deal with issues of identity, no matter how contentious, have become part of the mainstream of the contemporary art world. In the 1990s the exploration of identity expanded from its initial roots in feminism and the politics of race, to include discussion of nearly every ethnic, sexual, or social identity possible. Today, artists can grapple with issues of gender and race while simultaneously succeeding as professional artists.

This chapter examines several different threads of the battle over identities. First, we look at the rise of feminist art in the United States in the 1960s and 1970s, and follow this movement as it was reconfigured both in the United States and in Britain in the 1980s. Second, we consider the work of people of African ancestry living in the West since the 1970s, with a special focus on the integration of feminist concerns with art that poses racial questions.

10.1 Albert Chong, *Winged Evocations*, 2001. Giant pinecones, cast bronze, raw hide, photographs, paper. Installation at Havana Bienal, Cuba.

The third section discusses artists from Africa, Asia, and the West Indies who are exploring their identity in terms of the complex diversity of the postcolonial world. Finally, we address multiculturalism, and show how various contemporary artists find their personal identity in the diversity of the ▸postmodern◂ world.

Key Topics

The explosion in the efforts of artists to explore issues in personal, social, and political identity in the latter half of the twentieth century.

▶ Redressing the balance: after centuries of social and political exclusion, feminist artists in the US expressed specifically female concerns and points of view in their, often collaborative, works.

▶ Subverting stereotypes: a second wave of international feminist art challenged the earlier celebration of the goddess–nurturer–mother roles.

▶ Challenging racial injustice: African-American artists have consciously undertaken projects that take their place in a wider movement for equality, to forge an identity for themselves and their community.

▶ Flux: a choice between global multi-culturalism and national ethnic identity is being explored by artists in post-colonial societies.

▶ Place in society: gay artists and artists of mixed ethnic background resident in the US have begun to create works that explore questions of particular importance to their own social groups, while invoking a multicultural identity.

Early Feminism

In 1963 an American housewife named Betty Friedan published a book called *The Feminine Mystique.* In it she derided the state of women's lives in the United States, noting that, forty-three years after the 19th Amendment had given them the right to vote, women were still discouraged from pursuing professional careers. Young girls were still taught to find happiness only in the domestic sphere. Friedan had touched a nerve in American society. In 1966 she continued her work by founding an influential feminist organization, the National Organization for Women (NOW). In the late 1960s feminism, "the movement for women's political, economic, social, and educational equality with men," became central to women's artistic production.

Women artists and art historians soon recognized that the art world, like that of many elite professions, was essentially a male preserve. Men did the majority of the making, explaining, buying, and selling of art. Through art, they celebrated masculine attributes of competition and virility, showing men who fight and win and rule. Women, meanwhile, appeared mainly in passive roles, often as inactive objects of men's desire. Of course, there had been successful women artists before the 1960s. However, as feminists noted, these artists had been under considerable cultural and economic pressure to conform to the dominant masculine styles and subject matter, and were rarely able to explore issues of concern to women. In addition, the art world rarely acknowledged them, so their names and work were largely lost to history. A new focus in art history as well as a powerful grassroots movement grew out of these concerns, and the stage was set for a new type of art that would explore the identity of women in Western society (see also inset, opposite).

Between 1971 and 1973 a series of women's artists groups formed in the United States and Great Britain. In Valencia, California, at the California Institute of the Arts, Judy Chicago (born 1939) and Miriam Schapiro (born 1923) founded the influential Feminist Art Project. Among the first overtly feminist artworks ever made was the series of installations constructed by college students at Womanhouse, a condemned house in Hollywood that

10.2 Sandra Orgel, *Linen Closet,* 1971. Mixed media installation at Womanhouse. CAL ARTS Feminist Arts Program.

students were allowed to reconfigure under Chicago and Schapiro's guidance. The artists of Womanhouse redesigned the rooms in order to create a critical statement

Sex Versus Gender

The term "sex" is biological in usage. Each person is born either male or female. But what then is "gender"? This word customarily refers to the social aspects of being male or female: the life experiences, expectations, professional roles, and abilities that are socially prescribed for women or for men. In its earliest usage in one's life, gender is what used to make people say that pink is a "girl's color" and blue is a "boy's color." This is not a biological fact, but a social convention: hence, it is about gender. Feminists have successfully argued that gender roles in society have overwhelmingly favored men's desires and abilities, generating for them a wider range of social and professional positions. It is no longer the case, however, that men "should" be doctors, women "should" be nurses.

on the domestic spaces that were central to most women's lives. These works included *Linen Closet* ▶**fig. 10.2**, a female mannequin confined in the house's linen closet, evoking the lifetime of stifling domestic servitude of which Betty Friedan had written so powerfully. In displaying the woman's nude body severed into pieces by the shelves, the artists of Womanhouse also alluded to the difficult issue of sexual violence that was of major concern to feminists. *Bridal Staircase* ▶**fig. 10.3** is more lighthearted: using the main stairway of Womanhouse as the customary tableau of a bride's grand entrance, it makes its statement through context: the identity of a young woman as bride is at odds with the whole concept of Womanhouse. There is great, and deliberate, irony that a communal house dedicated to finding new identities for women should be adorned with such a stereotypical scene.

10.3 Kathy Huberland, J. Huddleston, M. Salisbury, *Bridal Staircase*, 1971. Mixed media installation at Womanhouse. CAL ARTS Feminist Arts Program.

10.4 *Birth Trilogy*, photograph of group performance written and conceived by the Feminist Art Program Performance Group at Womanhouse, 1971. CAL ARTS Feminist Arts Program.

The artworks at Womanhouse reflected three of the central tenets of the feminist art movement: collaboration, satire, and innovative use of media. The installations at Womanhouse were never attributed to a single person, let alone to the professors who guided the projects, because the artists worked together as a creative consensus. This spirit of collaboration was in accord with the feminist contention that male-dominated societies valued individual endeavors over collective projects. Women artists sought to establish a spirit of communal success in their artistic undertakings by eliminating the past hierarchies that stressed a "master–apprentice" relationship. The second tenet, satire, became an effective strategy with which to criticize conventional identities. *Bridal Staircase*, for example, is purposely over-embellished in order to engage the viewer with lighthearted, yet pointed, humor. In remaking a house into a series of artworks that deconstruct the world of a housewife, the artists of Womanhouse continued the avant-garde tradition of using media in innovative ways that might surprise the viewer (see chapter 9). By transforming a real house into an artwork, yet preserving its function as a communal working space, the artists embarked on an original project that would prove influential for years to come.

Performances were another form of artistic production employed by feminist artists in this era (see insel). At the opening night of Womanhouse in 1972, several members of the group presented *Birth Trilogy*, a performance piece that explored the phenomenon of birth through a ritualized series of movements ▶**fig. 10.4**. This was not simply a re-enactment of events surrounding a birth; it was also infused with imagery

Performance Art

Artists since the early 1970s have experimented with new media that allow them to connect more effectively with viewers. Influenced by dance and theatrical productions, these "performance artists" create works that are acted out in front of a live audience and contain elements drawn from many different artforms. Because performance art has never been strictly defined, it allows artists the freedom to experiment with creative expression in countless ways.

10.5 Miriam Schapiro, *Connection*, 1976. Acrylic and handkerchiefs, 6ft × 6ft. Collection the artist.

celebrating women's spirituality. The environment and the players' movements were intended to reconnect the audience with the communal spirit of ancient Wiccan initiation ceremonies.

In 1975 in New York, Carolee Schneemann (born 1939) created her controversial performance piece *Interior Scroll*, in which the naked artist slowly withdrew a length of rolled-up paper from her vagina, reading the text as it emerged. Before this act, she had ritually painted herself in order to make her body feel sacred, as if she was preparing for a religious experience. She was also dealing with the taboos of menstruation and diverting attention to the female body away from traditional male voyeurism. Yet another dimension was added by the content of the text— a satirical commentary on the sexist columns of a New York film critic.

For feminists in the 1970s one of the most pressing issues was that artworks traditionally made by women, such as textiles and ▸ceramics◂, were dismissed by historians as "crafts," inherently less sophisticated than the male-dominated media of painting and sculpture. In addition, the producers of these objects were called "artisans," as opposed to the more exalted term "artist." Schapiro attacked this hierarchy in *Connections* ▶**fig. 10.5**, which is made from a collection of handkerchiefs that women she had met at various feminist gatherings sent her, as requested. The

10.6 Judy Chicago, *The Dinner Party*, 1979. Mixed media installation, 48ft × 42ft × 43ft. The Brooklyn Museum of Art, New York.

resultant work is a large painted quilt that not only celebrates Schapiro's years of collaborating with other feminists, but combines the "high" art of painting and the "low" craft of needlework.

One of the most ambitious art projects of the 1970s was Chicago's installation called *The Dinner Party* ▶**fig. 10.6**, which took five years to complete. While its imagery is clearly related to that of the Last Supper, the work was conceived as a message about influential women who have been, in Chicago's word, "swallowed" by history. The thirty-three place settings represent women who have made vital contributions to humanity yet were never invited to "sit at the table" with famous men. Each side of the equilateral triangle is dedicated to a broad historical era: the Greco-Roman period;

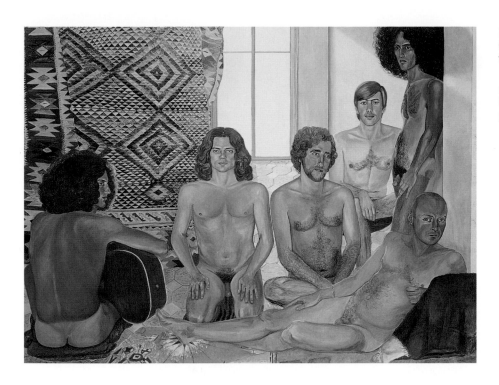

LEFT **10.9** Sylvia Sleigh, *The Turkish Bath*, 1973. Oil on canvas, 6ft 4ins × 3ft 4⅛ins. Collection the Smart Museum, University of Chicago.

BELOW **10.9a** Jean-Auguste-Dominique Ingres, *Turkish Bath*, 1862. Oil on canvas, 3ft 6½ins diameter. Musée du Louvre, Paris.

the nineteenth century, especially that of Jean-Auguste-Dominique Ingres (1780–1867). In Ingres's *Turkish Bath* ▶fig. 10.9a, it could be said that the women were portrayed as nothing more than objects of male sexual desire: passive, pliant, and with little influence over their own lives. Sleigh mocks this powerlessness in her painting by featuring leading American art critics (including her husband, Lawrence Alloway, shown reclining) in the vulnerable position of nude harem women. Like Edelson, she undermines traditional hierarchies through the use of humor.

Many early feminist artworks explored spiritual themes that would empower women; ancient goddess imagery thus provided a suitable spiritual outlet for those who felt that the major world religions were dominated by men. Much of this work was based loosely on newly discovered archeological proof of goddess worship in ancient Europe and Africa (see chapter 2). Inspired by frescos and statuettes from the Minoan culture of ancient Crete, Edelson made

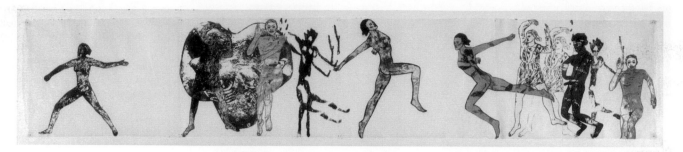

10.10 Nancy Spero, one panel from the series Rebirth of Venus, 1984. Relief print and collage on paper, each panel approx. 1ft 8⅛ins × 9ft 2⅝ins. Art Gallery of Ontario.

images of herself reaching for the skies and invoking the power of ancient goddesses. In 1977, she traveled to Yugoslavia in order to worship at a sacred cave that had been used by priestesses in the Neolithic era. Her photographs, documenting the rituals she performed there, *See for Yourself*, were distributed among feminist artists. Nancy Spero's (born 1926) series of paintings Rebirth of Venus ▶**fig. 10.10** is a fine example of goddess-inspired imagery. In this series Spero attempts to reclaim the Roman goddess Venus, an icon of masculine desire in Western art, as a source of spiritual power for women.

The Second Wave of Feminist Art

In December 1987 the New Museum of Contemporary Art in New York hosted a panel discussion titled "The Great Goddess Debate—Spirituality Versus Social Practice in Recent Feminist Art." This forum, featuring Nancy Spero, as well as art historians Kate Linker and Helen Deutsch, attempted to reconcile the first wave of feminist art-making strategies with subsequent theoretical developments. Linker and Deutsch argued that works such as those of Schapiro, Chicago, or Spero, however well intentioned, actually confined women to traditional categories such as nurturer, goddess, or mother. Linker and Deutsch asserted that feminist artists must make works that deal in a direct manner with gender roles in society. They felt that the focus on goddess spirituality could not be effective in changing the manner in which women were treated. In a nutshell, Linker and Deutsch felt that the work of too many feminists reflected an excessive concern with innate differences in biology, while ignoring the more important role of socially constructed gender (see inset, p. 313). For example, some feminists complained that Chicago's *Dinner Party* had reduced women to nothing but genitalia. Linker and Deutsch called upon artists to explain how society acted upon individuals.

Perhaps the first artwork that broached the issue of society's impact on the sexes was *Post-Partum Document* by Mary Kelly (born 1941) ▶**fig. 10.11**, a work completed the same year as the *Dinner Party*. This consists of a series of documents detailing her son's first years: feeding schedules, fecal stains, sleep records. The work's sophisticated grounding in psychoanalytic theory makes it difficult for the casual observer to grasp. It attempts to document the changes that occurred in her son as he grew from an infant to a young boy. Kelly observed and recorded the way in which social pressures molded a masculine identity before her eyes. Kelly's work implies a belief that soon became prominent in the art of feminists: that people's differences have much less to

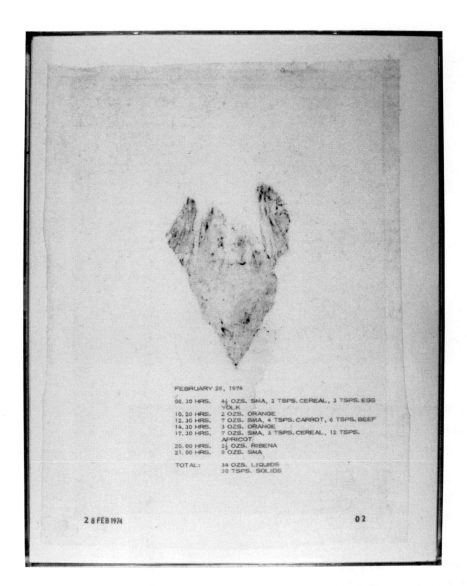

FEBRUARY 28, 1974

08. 30 HRS.	4½ OZS. SMA, 2 TSPS. CEREAL, 3 TSPS. EGG YOLK
10. 20 HRS.	2 OZS. ORANGE
12. 30 HRS.	7 OZS. SMA, 4 TSPS. CARROT, 6 TSPS. BEEF
14. 30 HRS.	3 OZS. ORANGE
17. 30 HRS.	7 OZS. SMA, 3 TSPS. CEREAL, 12 TSPS. APRICOT
20. 00 HRS.	2½ OZS. RIBENA
21. 00 HRS.	8 OZS. SMA
TOTAL:	34 OZS. LIQUIDS / 30 TSPS. SOLIDS

2 8 FEB 1974 0 2

10.11 Mary Kelly, *Post-Partum Document: Documentation I, analyzed fecal stains and feeding charts*, 1974. Perspex units, white card, diaper lining, plastic sheeting, paper, ink. Art Gallery of Ontario.

do with biology than with the pressures of society. For women themselves, this belief was first expressed by Simone de Beauvoir (1908–86) in her book *The Second Sex* (first published in French in 1949): "One is not born a woman, but rather, becomes a woman."

Two aspects of the style of *Post-Partum Document* became key to the second wave of feminist art in the 1980s. First, much of Kelly's work required the "viewer" to become a "reader." It was impossible to understand the work without reading from the many texts that adorned the walls recording the daily life of Kelly and her son. This text-based style created a common ground between feminist artists like Kelly and scholars who shared their goals (see also inset). Second, Kelly's work was not pleasurable to look at. This feature contrasts starkly with the traditional images made by men, many of which treat women as objects for men's visual delight. Publications by such scholars as Laura Mulvey and Griselda Pollock have encouraged feminist artists to break with the regimen of visual pleasure in order to contest the way in which women have conventionally been pictured in the arts.

Another artist who broached the issue of social roles in the United States was Cindy Sherman (born 1954). Her series Untitled Film Stills ▶**fig. 10.12** features self-portraits in which she has assumed the stereotyped characters of

Conceptual Art

The term "conceptual art," introduced in the 1960s, describes work that is essentially a record of the artist's creative thought process. Conceptual artists are not primarily concerned with the making of an object, but with thinking about something and expressing these ideas through artistic means. Thus, in *Post-Partum Document*, Kelly's concern was not with the exercise of sophisticated manual skills so much as with having viewers see how she *thought* to represent her experiences. The conceptual art category allows for virtually any object to be called art, as long as artists use it to illustrate their thought processes. The early twentieth-century works of Marcel Duchamp are often cited as precedents (see chapter 9).

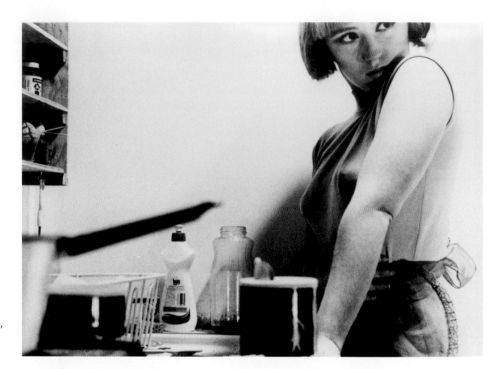

10.12 Cindy Sherman, *Untitled Film Still No 3*, 1977. Black and white photograph. Metro Images.

10.13 Barbara Kruger, *Untitled (Your Gaze Hits the Side of my Face)*, 1981. Photograph, 4ft 7ins × 3ft 5ins. Courtesy Mary Boone Gallery, New York, Collection Vijak Mahdavi and Bernardo Nadal-Ginard.

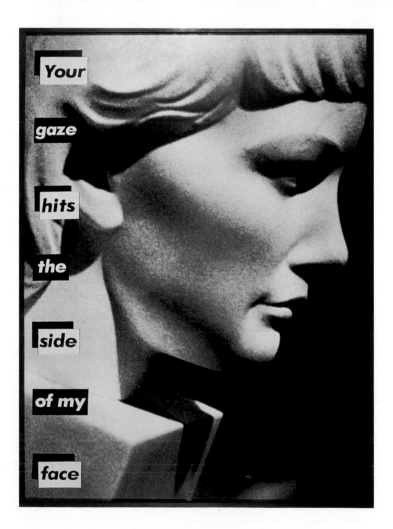

women in movies. The one reproduced here shows her as both *femme fatale* and vulnerable victim. The viewer is challenged to acknowledge the stereotypes, the standard oversimplified identities and preconceptions. Satire is used to subvert the identities assigned to women by the entertainment media; identities presented mainly as, in Sherman's words, "passive receptacles of male desire."

Barbara Kruger (born 1945) has produced photographic ▸silkscreens◂ similar to Sherman's in their sophisticated deconstructions of standard social roles. Kruger's art makes use of the language and imagery of advertising to convey its point. Her bold colors, sharp typography, and slogan-like messages turn product marketing into social protest. One of her most poignant images is *Untitled (Your Gaze Hits the Side of My Face)* ▶**fig. 10.13**, a work that depicts the aggressiveness of men in "consuming" women as visual objects as well as the threat of physical violence.

Male Superstars of the 1980s

Despite the increasing reputations of feminist artists in the 1980s, the art market in the United States and Europe was dominated by the rise of several celebrity male painters: David Salle (born 1952), Eric Fischl (born 1948), Francesco Clemente (born 1952), and Julian Schnabel (born 1951). In what may have been a backlash against feminist attempts to achieve equality, gallery owners tended to ignore most women artists, choosing rather to publicize these young male artists. Riding the art boom of the 1980s, they worked largely in traditional media and imagery (their output included several paintings featuring voyeuristic male fantasies of nude and vulnerable women), and embodied the idea of the "heroic-inspired" artist that was familiar and comfortable to the art-buying public. Their meteoric success appeared to confirm that the battle for equality in the commercial area was still far from over.

In 1984 a group of women artists, art historians, curators, and gallery owners formed an alliance dedicated to illuminating the continuing inequities of the art world (see also inset). The women called themselves the Guerrilla Girls, and they decided to use humor to engage people in their struggle. Their first target of protest was the International Survey of Painting and Sculpture, an exhibition at the Museum of Modern Art in which 90 per cent of the art was made by male artists. As the self-proclaimed "Conscience of the Art World," the Guerrilla Girls, wearing gorilla suits and masks that hide their identities, have published pamphlets, staged protests, pasted posters on walls, and given speeches in an effort to raise the consciousness of people involved in the arts. Like Barbara Kruger, they use the visual language of advertising to enhance the impact of their texts. One of their most widely published satirical broadsides is *The Advantages of Being a Woman Artist* (1989):

> Working without the pressure of success.
> Not having to be in shows with men.
> Having an escape from the art world in your four free-lance jobs.
> Knowing your career might pick up after you're eighty.
> Being reassured that whatever kind of art you make it will be labeled feminine.
> Not being stuck in a tenured teaching position.
> Seeing your ideas live on in the work of others.
> Having the opportunity to choose between career and motherhood.
> Not having to choke on those big cigars or paint in Italian suits.
> Having more time to work after your mate dumps you for someone younger.
> Being included in revised versions of art history.
> Not having to undergo the embarrassment of being called a genius.
> Getting your picture in the art magazines wearing a gorilla suit.

This type of alliance between different art professionals in pursuit of social change

represented a reinvention of the activist politics of the 1960s and early 1970s with a sophisticated sense of how to attract an audience's attention. During the 1980s and 1990s the feminist movement opened up to make alliances with other marginalized groups, especially people of color. Before discussing these contemporary multicultural artists, it is important to understand the background by looking at the work of African-Americans during the 1970s and 1980s.

Black Identity

A well-documented incident drew international attention to the issue of black identity in 1955 when Rosa Parks caused a bus boycott in Montgomery, Alabama, by refusing to give up her seat to a white man. This was an act of protest against the fact that Americans of African descent had to sit at the back of the bus. The struggle for civil rights for African-Americans in the United States had begun. During the ten years between the bus boycott and the passage of the Voting Rights Act in 1965, the country was torn apart by racial strife. The Voting Rights Act, which outlawed the widespread practice in the South of denying African-Americans the right to vote via petty electoral rules, was an enormous victory for those who fought against racial injustice. In 1966 the Black Power movement was founded in the United States, its leaders calling for a rediscovery of black America's African heritage. This ongoing struggle is fundamentally concerned with the issue of identity. African-American artists generally want to forge an identity separate from white American and European culture, to be celebrated and valued by society at large in their own right. At the same time, artists have attempted to contest the dominant stereotypes of African-Americans in the media and to join forces with non-artists to work for equality. Art is one of the tools that have played an important part in waging this struggle, as the poet bell hooks (she prefers not to capitalize her name) writes in her preface to an anthology of African-American women artists:

> I find compelling a radical aesthetics that seeks to uncover and restore links between art and revolutionary politics . . . I remain passionately committed to an aesthetics that focuses on the purpose and function of beauty, of artistry in everyday life, especially the lives of poor people, one that seeks to explore and celebrate the connection between our capacity to engage in critical resistance and our ability to experience pleasure and beauty. I want to create work that shares with an audience . . . the sense of agency artistry offers, the empowerment. I want to share the aesthetic inheritances handed down to me by my grandmother and generations of black ancestors.

Many African-American artists of the last three decades have shared these goals and commitments.

Faith Ringgold (born 1930), has been particularly successful in restoring African-American traditions and identities through her art. Having followed a traditional (European-based) college art curriculum in New York, Ringgold started her career in the 1960s with a series of huge canvases called The American People, thoughtfully expressing her feelings about the recent racial struggles of the United States. *The Flag is Bleeding* ▶**fig. 10.14**, a painting from the series, depicts anonymous figures (probably

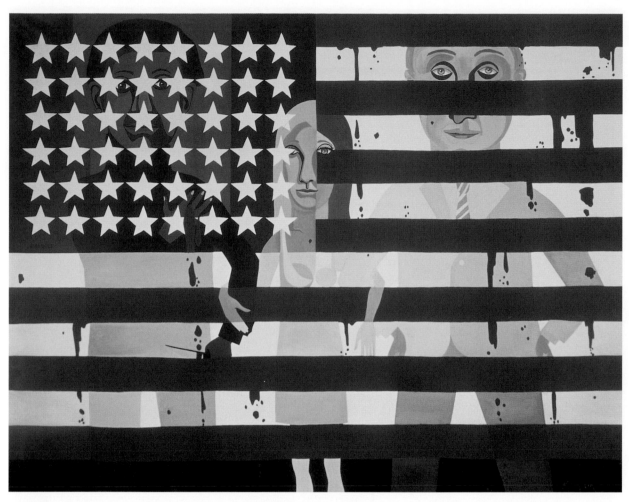

10.14 Faith Ringgold, *The Flag is Bleeding*, 1967. Oil on canvas, 7ft 8ins × 8ft.
Private collection.

civil-rights marchers), their arms linked, enmeshed in the stripes of an American flag. The stripes are blood-red and dripping. The work suggests the same sense of confinement as the *Linen Closet* at Womanhouse (see fig. 10.2). Most of Ringgold's representational paintings celebrate the cultural triumphs of twentieth-century African-Americans. In the early 1970s Ringgold also became involved in feminist politics, which she has integrated into her work ever since. Unfortunately, at this time there was not yet much of an effective alliance between feminists and black Americans. Nonetheless, Ringgold turned away from painting and toward needlework as a feminist assertion of the importance of conventional "women's" crafts, producing a series of "soft" sculptures made of textiles and several works that were influenced by African masks. When she went to Nigeria in 1977, she made a point of exploring traditional African art as source material.

Around 1982, Ringgold began her most famous series of works, the Story Quilts. In collaboration with her dressmaker mother, who helped her with the fabrication, and her daughter Michele Wallace, who assisted in the writing of the texts, Ringgold

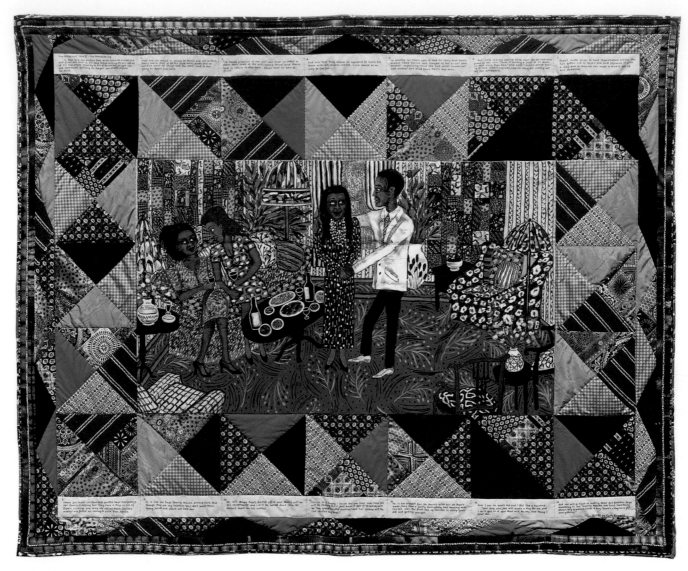

10.15 Faith Ringgold, *Bitter Nest Part 5: Homecoming*, 1988. Acrylic on canvas, fabric border, 6ft 4ins × 8ft. National Museum, Courtesy ACA Galleries, New York.

African-American Quilts

In the 1980s the stitching of quilts became an important means of expression for feminist and African-American artists. Considering that many beautiful nineteenth-century works had been made by women slaves, the re-evaluation of this work by committed artists seems natural. American slaves generally had produced two types of quilts: conventional patterns made of fine fabrics for the plantation owners, and works with African patterns and colors made of more modest fabrics for their own families. There is a certain irony, however, in the fact that quilt-making has come to be perceived as an African woman's artform, because in African culture textiles are not a common form of art. Where they are produced, for example in the Asante kingdom (see chapter 3), the weavers are of high status and thus, predictably, male. Women are almost completely excluded from African textile artistry.

The battle to have textiles taken seriously as artworks is far from over. A typical example of current attitudes can be seen in an article from the *New York Times* headlined "$1.2 million? How Much Is That Per Stitch?" The author questions the wisdom of paying so much for a work of needlepoint from 1750. In a decade that saw nineteenth-century paintings selling for fifty times as much, it is surprising that there was no article titled "$70 million? How Much Is That Per Brushstroke?"

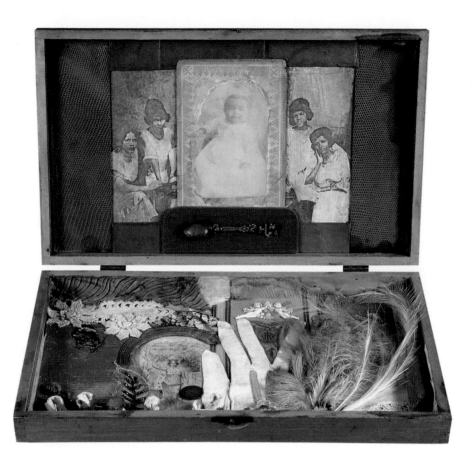

10.16 Betye Saar, *Shield of Quality*, 1974. Mixed media assemblage in box, 1ft 6ins × 1ft 2¾ins × 1in. Courtesy Michael Rosenfeld Gallery, New York. Collection the Newark Museum, Newark.

created mixed media works that expressed many different facets of her identity, ranging from the personal to the communal and juxtaposing elements of her feminist beliefs with her ancestral legacy. Ringgold's series of painted quilts, including *Bitter Nest Part 5: Homecoming* ▶**fig. 10.15**, chronicle the lives of residents of the Harlem neighborhood in New York. A modern variation on the tradition of history painting (see chapter 7), these quilts make a dramatic Western narrative out of ordinary people's lives, also incorporating the symmetry, decorative pattern, and repetitive aspects of African design (see inset, opposite).

A woman who shares Ringgold's reverence for ancestral traditions is Betye Saar (born 1926), an artist based in Los Angeles whose prolific output since the 1970s has engaged with many aspects of the African-American experience. Her series of reliquary boxes is especially evocative of the traditional art of West Africa. Among the Kota and Kongo peoples, the bones of ancestors kept in reliquary boxes are invested with spiritual powers. Saar's works, for example, *Shield of Quality* ▶**fig. 10.16**, are filled with American found objects that she has imbued with a sense of mystery, offering the viewer glimpses of her personal identity while also evoking the communal identity of her African ancestors.

The artist David Hammons (born 1943) also uses his African ancestry as the basis for his assemblages. In the 1970s Hammons attempted to erase all vestiges of white

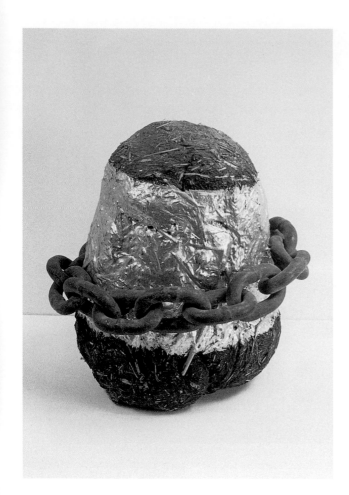

10.17 David Hammons, *Elephant Dung Sculpture*, 1978. Elephant dung, tin foil, chain, 7¼ins × 7ins. Jack Titton Gallery, New York.

European culture from his work and his life. He moved to predominantly black Harlem, had no telephone, and roamed the streets in an effort to absorb the culture of his people. He refused to make prints or oil paintings because of their European associations. He shunned the white collectors and gallery owners of New York. Instead he assembled a variety of objects, often drawn from the refuse of the street, to make politically and spiritually charged sculpture that he sold directly to other African-Americans. *Elephant Dung Sculpture* ▶**fig. 10.17** is one of a series of works (1978–84) based on his finding a piece of elephant dung at a circus. In this instance the elephant dropping is adorned with gold (in which Africa is rich) and tinted with the colors of the African liberation flag. Hammons has made these materials into a fetish, or object of supernatural powers, symbolic of the power of African people.

Keith Piper (born 1960) is a British artist of Caribbean descent whose work was inspired in part by the Black Power movement in the United States. In the late 1980s he came to public attention for his computer art exhibited in an installation format. Desktop computers with video projectors are used to create an environment in which the viewer can interact with the art by choosing what portion of the piece is viewed. Most of Piper's work confronts issues of race and class, particularly the history of slavery in Western Europe. His montages integrate samples of sounds and images from all aspects of European and Caribbean history, including references to religion, music, economics, and popular culture. The installation *Unrecorded Histories*, for example, is intended to evoke an art gallery setting; atop an antique desk and chair sits a computer screen, through which a viewer can select one of three programs. The program is then projected on a video screen that is ensconced in an ornate gilded frame. All three programs detail aspects of the slave trade in sounds and images documenting Christian missionary work, violence against slaves, and the state of slaves as commodities. Piper has an eye and an ear for evocative visual and auditory rhythms that work well together in a digital setting. The exciting possibilities for Piper's art lie in CD-ROM technology.

Lorna Simpson (born 1960) and Carrie Mae Weems (born 1953) are artists whose work confronts identity in terms of both gender and race. Some of their most fascinating pieces are captioned photographs. In Simpson's work, the captions and the pictures are often only indirectly connected, leaving the viewer to search for the work's meaning.

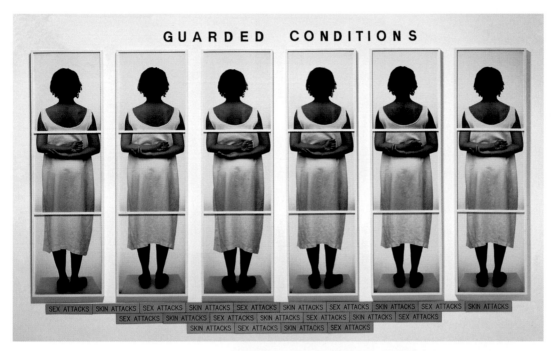

GUARDED CONDITIONS

10.18 Lorna Simpson, *Guarded Conditions*, 1990. Six color polaroid photographs with plastic plaque, 4ft 4ins × 8ft 9ins. Sean Kelly Gallery, New York.

For example, *Guarded Conditions* ▶**fig. 10.18** features six images of an African-American woman, cut and reassembled. She is shown from behind with a powerfully clenched fist. In contrast, the woman's arms are pinned, and made vulnerable, by a bar of the picture's frame. Her face is not shown, robbing her of an identity. Under these images appear the words "sex attacks" alternating with the words "skin attacks." Issues of sexual violence and racism are starkly addressed.

Weems takes an even more aggressive approach in her use of imagery. The protagonist of her photograph *Mirror, Mirror* ▶**fig. 10.19**, looking vulnerable in her slip, asks the fairytale question, "Mirror, Mirror, on the wall, who's the fairest of them all?" and is answered bluntly: "Snow White, you black bitch, and don't you forget it!" Feminist issues are here addressed by a person of color in a statement about both gender and race. The work considers the broader pressure on women for physical perfection and the particular focus of an African-American woman commenting on Western standards of female beauty that exclude her. Both woman and reflection in the photograph are Weems herself, adding an ironic twist.

African-American Art History

The development of scholarship focused on African-American art has since 1975 gone through some of the same phases as that of feminist art. Early studies tended to decry the lack of African-American representation in the art history canon and to search for an essential "blackness" in art. Then scholars sought to confront the standards of value on which the aesthetic decisions that excluded black Americans are based. Recent academic work has also aimed at confronting the negative stereotypes through which African-Americans are portrayed in history books, especially by white authors who do not consider themselves to be prejudiced. A key element of this trend is the recognition that race in itself is neither a unitary nor a fixed identity; rather, one's racial identity is but one part of the make-up of a person's sense of self. One's race is continually in a state of flux and is powerfully affected by other parts of one's identity, such as gender, social class, or sexual orientation. It is important to remember that race as a social category is not universally the same, but is constructed by society's members on a day-to-day basis. Several scholars of racial issues have emphasized that "white" is just as much a social construct as "black" is.

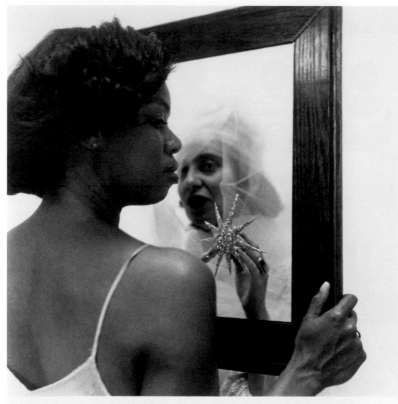

LOOKING INTO THE MIRROR, THE BLACK WOMAN ASKED,
"MIRROR, MIRROR ON THE WALL, WHO'S THE FINEST OF THEM ALL?"
THE MIRROR SAYS, "SNOW WHITE, YOU BLACK BITCH,
AND DON'T YOU FORGET IT!!!"

10.19 Carrie Mae Weems, *Mirror, Mirror*, from Ain't Jokin' series, 1987. Silver print (edition of five), 1ft 8ins × 1ft 4ins. P.P.O.W. Gallery, New York.

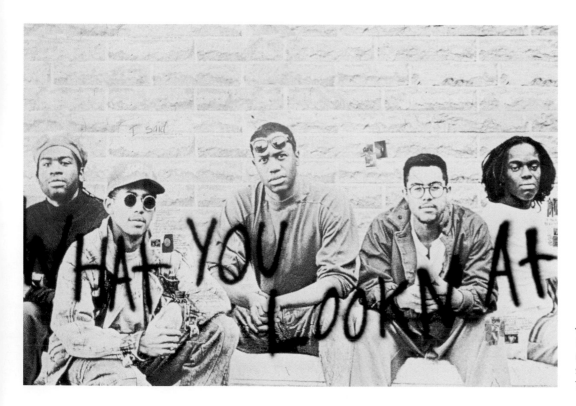

10.20 Pat Ward Williams, *What You Lookin' At*, 1992. Halftone dot mural print, color photographs, spray paint, and text, 3ft 6½ins × 7ft 10½ins. Collection the artist.

The art of Pat Ward Williams (born 1950) and Adrian Piper (born 1948) (no relation to Keith Piper) is unabashedly political. Williams has produced several works that address Caucasians' fears of other races. In his *What You Lookin' At* ▶**fig. 10.20**, for example, five young African-American men challenge the white viewer's gaze, as well as the viewer's unspoken thoughts and fears. The question of the title functions both in the momentary situation (the viewer's gaze upon the men's faces), and in a grander and more trenchant sense—why do white Americans focus their fears and hatreds upon black Americans?

Adrian Piper has said that art is "political communication that catalyzes viewers into reflecting on their own deep impulses." A major theme in Piper's art is her life experience as a woman of African-American descent whose skin is so light that she is often mistaken for a Caucasian. Piper, who is trained as a philosopher and university professor, addresses her ambiguous appearance in a direct manner, often through self-portraiture. For example, her pencil drawing *Self-Portrait Exaggerating My Negroid Features* ▶**fig. 10.21** shows her imagining herself with a clear and unproblematic identity. Piper has at times connected her art with her personal life, as texts from her Calling Cards series (1986) make clear:

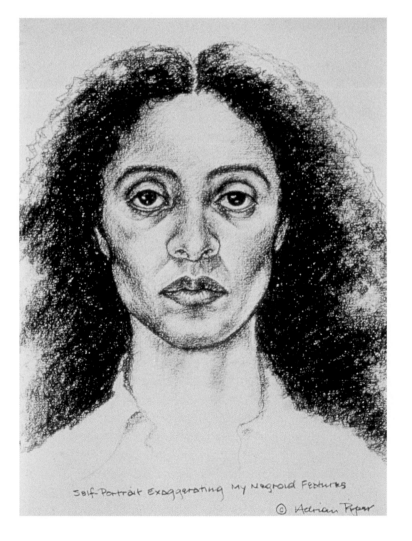

Self-Portrait Exaggerating My Negroid Features
© Adrian Piper

Dear Friend,
I am black.
I am sure you did not realize this when you made/laughed at/agreed with that racist remark. In the past, I have attempted to alert white people to my racial identity in advance. Unfortunately, this invariably causes them to react to me as pushy, manipulative, or socially inappropriate. Therefore, my policy is to assume that white people do not make these remarks, even when they believe there are no black people present, and to distribute this card when they do.
I regret any discomfort my presence is causing you, just as I am sure you regret the discomfort your racism is causing me.
Sincerely Yours,
Adrian Margaret Smith Piper

10.21 Adrian Piper, *Self-Portrait Exaggerating My Negroid Features*, 1980. Pencil and paper, 9ins × 12ins. Collection the artist.

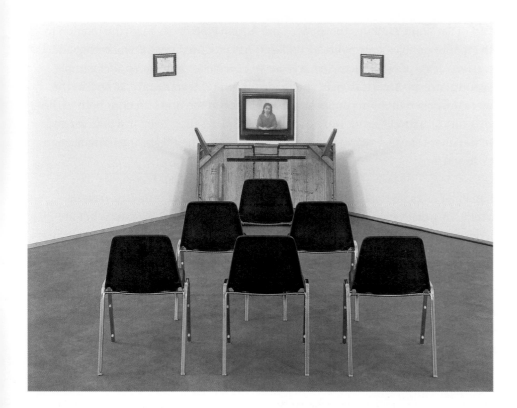

10.22 Adrian Piper, *Cornered*, 1988. Video installation with birth certificates, color video monitor, table, and chairs. Dimensions variable. Museum of Contemporary Art, Chicago.

Piper has at times specifically produced artworks that are directed at liberal white people who consider themselves to be politically progressive and free from racism. For example, her video installation *Cornered* ▶**fig. 10.22** confronts the underlying feelings of racism in white people. On the video screen Piper, whose race is not immediately apparent from her looks, recites directly: "I am black. Now let's deal with that social fact." The approximately fifteen-minute narrative continues with Piper explaining aspects of racial politics and especially how she herself often feels "cornered," not wanting to make an issue of race, but not wanting to be mistaken for a Caucasian. Piper does not limit herself to issues that confront only women and African-Americans. Instead, she constantly reminds |the viewer that she is concerned with any aspect of xenophobia, the irrational fear of people different from oneself. Piper asserts that, while she understands how the racism and xenophobia that plague society may well be indicative of ancient survival mechanisms, it is necessary to fight all signs of racist behavior. By considering her own ambiguous racial status through art, Piper has drawn attention to the complex multicultural identities addressed by many artists since the 1990s.

Postcolonial Identity in Asia, Africa, and the West Indies

The new postcolonial societies that have arisen in Asia, Africa, and the Americas are still grappling not only with difficult relationships with the West, but with issues of identity, migration, and nationalism. As artists have gained the freedom from repressive colonial governments to express their individual and communal identities, the social concept of identity remains in a state of flux. Globalization has complicated ideas about personal identity, through travel and through the technological advances of communication systems. Contemporary artists face a number of contradictory pressures in representing communal identity. They are sometimes pressured to embrace narrow national traditions, at other times they are pushed not to be "parochial" and embrace global multiculturalism. We focus here on a small selection of artists who are confronting these issues.

Indian and Pakistani Artists

Contemporary artists from India and Pakistan, countries in conflict on religious grounds, are exploring issues of identity largely because many of them have migrated away from their homeland. The Muslim painter Shahzia Sikander (born 1969, originally from Lahore in Pakistan) wanted to study in India, but, unable to get the necessary visa, went instead to the United States, enrolling in the Rhode Island School of Design in 1993. Her paintings revive the miniaturist style popular among Muslim painters for the past five hundred years, though she chooses to mix Hindu iconography with traditional Muslim scenes. In *Gopi Crisis* ▶**fig. 10.23** Sikander shows a conventional Persian landscape that is peopled by figures drawn from Hindu mythology. Other works deal with her identity as an Asian in the United States. She has referred to her migration as a "pleasing dislocation," and as a gesture has worn a Muslim veil in public for the first time in her life. *Venus's Wonderland* ▶**fig. 10.24** uses the painstaking miniature technique while combining imagery drawn from American and Asian sources. Here, a calligraphic border in a Persian style frames a series of female figures, all of whom wear veils. Much of the symbolism in this work, and others like it, is personal to Sikander, rather than communal, reflecting the Western influence that emphasizes the artist's imagination and subjective experience of the world. Sikander has discussed her complex identity as an artist with historians:

> For me, the challenge is always to find myself in all these categories and then discard the categories. So in a sense, it's again creating this dichotomy of experience where it's something that defines you and then you try to defy it. In that respect, it doesn't really matter whether one is being shown in the context of being Asian or Asian-American or Pakistani or American. They all have something to add in the larger picture.

Asian-American women artists have made important contributions to the cultural life of the United States and have received increasing recognition in the past few years. Annu Palakunnathu Matthew (born 1964) uses digital means to satirize the popular culture of India, where she grew up before migrating to the United States. In such works as *Kala Patti* ▶**fig. 10.25**, Matthew presents the viewer with a parody of a "Bollywood" movie poster (Bollywood is the nickname of India's enormous film industry in Bombay). *Kala Patti* draws attention to the stereotyped images of gender and skin color that are prevalent in India's popular culture. The exaggerated

10.23 Shahzia Sikander, *Gopi Crisis*, 2001. Watercolor, dry pigment, vegetable color, tea and photo-gravure, handmade wasli paper, 9½ins × 6ins. Courtesy Brent Sikkema Gallery, New York.

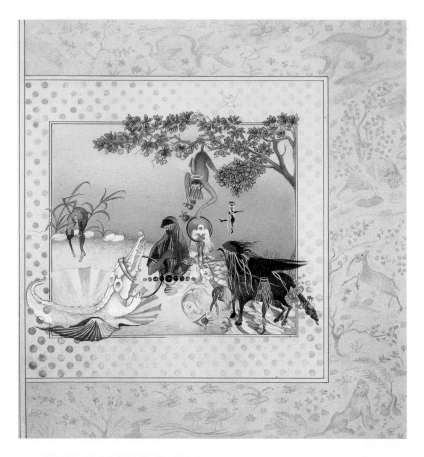

10.24 Shahzia Sikander, *Venus's Wonderland*, 1997. Vegetable color, dry pigment, watercolor, tea, handmade wasli paper. Courtesy Brent Sikkema Gallery, New York.

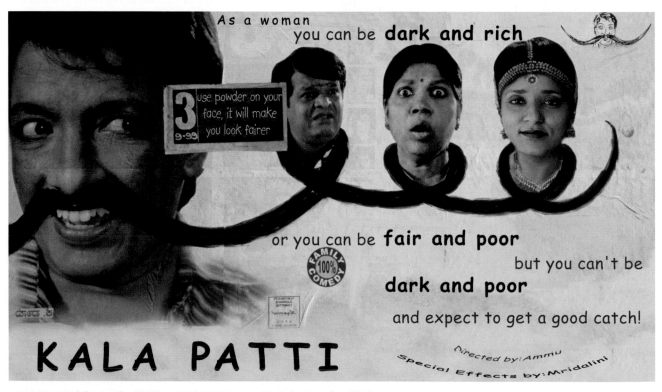

10.25 Annu Palakunnathu Matthew, *Kala Patti*, 2000. Digital print, 3ft × 6ft 6ins. Collection the artist.

10.26 Shelly Bahl, *Take Away* (detail), 2000. Ink on wallpaper, wood, glass, and ink on paper, 1ft 3ins × 1ft ½in × 1ft 4ins. Installation created for SAVAC (South Asian Visual Arts Collective). Baum Gallery of Fine Art, University of Arkansas, Conway.

expressions on the actors' faces and the overall slapstick quality of the piece are typical of Bollywood promotion departments.

An artist who lives in Canada, Shelly Bahl (originally from India), uses found objects combined with her own drawings to make installations that consider the appropriation of Asian culture in the West. *Take Away* ▶**fig. 10.26** places a number of clichéd Asian objects, such as the patterned wallpaper and a drawing of an exotic, sexualized Asian woman, in a familiar domestic setting. Bahl intends her installation as a commentary on the stereotypes that these objects invoke, part of what she calls "ethnic consumerism." Additionally, the viewer is included in the work by the process of taking away one of the "exotic" napkins, performing an act of consumption himself or herself.

Nigerian and South African Artists

Like India and Pakistan, Nigeria and South Africa were both long ruled by the British, and because of this colonial history many artists from both countries have migrated to Great Britain. The sculptor Sokari Douglas Camp (born 1958) has settled in London, though she often returns to her native Nigeria, renewing her ties to the Kalabari culture. At the same time, the act of sculpting itself shows Camp's distance from her ancestral traditions, because women are excluded from that art, which plays an important role in the Kalabaris' patriarchal religious traditions. Camp's *Self* ▶**fig. 10.27** is a self-portrait that shows her postcolonial environmental concerns, specifically the conflict over oil production by Western corporations in Nigeria. This type of free-standing cast sculpture comes out of the European tradition, but Camp has designed the figure in a way reminiscent of Kalabari masquerades.

Yinka Shonibare (born 1962) was born in London to parents of Yoruba ancestry. When he was four, the family returned to Nigeria, though Shonibare came back to Britain

when he was seventeen. One of the reasons that he features textiles in his work is because he sees the material as a metaphor for identity. "The fabric is not one thing, I am interested in those kinds of influences which make up so-called identity—the things we construct for ourselves." Shonibare's installation *Victorian Philanthropist's Parlor* ▶fig. **10.28** uses modern Dutch fabric made in England for the African market (and featuring Javanese ▸batik◂ designs). Shonibare argues that the layers of "identity" contained in this simple fabric symbolize the confused identity of modern people like himself.

In South Africa the careers of contemporary artists were complicated by the repressive apartheid regime, which was eventually dismantled in 1994. The Truth and Reconciliation Commission was set up in 1996 to review the horrors of the preceding regime and grant amnesty to perpetrators who confessed. Many South African artists deal with the legacy of apartheid in their work. For example, Sue Williamson's assemblage *Cold Turkey: Stories of Truth and Reconciliation* ▶fig. **10.29** features photographic documents mounted as if they were exhibits at

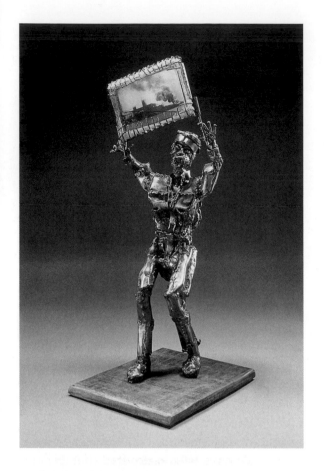

10.27 Sokari Douglas Camp, *Self*, 1998.
Steel, acetate, glass, and wood.
Collection Annette Bachner, USA.

10.28 Yinka Shonibare, *Victorian Philanthropist's Parlor* 1996–97. Reproduction furniture, fire screen, carpet, props, Dutch waxprinted cotton textile, dimensions variable: approx. 1ft 1in × 2ft 5ins × 16ft. Installation at Alternating Currents, the 2nd Johannesburg Biennial, 1997.

10.29 Sue Williamson, *Cold Turkey: Stories of Truth and Reconciliation*, 1996.
Lightbox, metal, electrostatic prints, 2ft¾in × 2ft 11⅞ins × 2¾ins.
National Museum of African Art, Smithsonian Institute, Washington, D.C.

10.30 Andries Botha, *Home*, 1997.
View from outside looking in.
Exterior: wood, artificial grass and
flowers, mild metal sheeting,
laminated lead, neon. Interior:
cotton, paper, hair, rubber, latex.
Shown at Alternating Currents, the
2nd Johannesburg Biennial, 1997.

a trial. Here, Williamson (born in England in 1941) recounts the arrest, torture, and disappearance of Sipho Mtimkulu, who was killed by government forces in 1963. These haunting photographs preserve the faces of many whose identities were erased through violence.

Another artist who sees the legacy of apartheid as central to South African identity is Andries Botha (1952). In Botha's mixed-media work *Home* ▶**fig. 10.30** he has put a sign on the door that recounts testimonies from the Truth and Reconciliation Commission.

> "I had a lot of respect for Sefola because of the way he acted during the process through which we killed him." Paul Van Vuuren, security policeman commenting on the bravery of Harry Sefola, killed during police interrogation. 11-29-96

> "He had been cut up like a goat. It would have been better if they had shot him rather than cutting him up in this way." Fanizini Dladla recounting the murder of his son Fox. 7-25-96

Botha's Afrikaans heritage complicates memorial works like *Home*. While some critics admire his attempt to come to grips with the past crimes of his people, others see a somewhat patronizing definition of black South Africans as victims and question Botha's right to make art out of atrocity.

West Indian Artists

In recent years, migration has also become a major subject for artists from the North American islands of Cuba and Jamaica, part of the West Indies. In seeking to explore issues of identity, many of them explore what Cuban poet and art critic Ricardo Pau Llosa has called "the art of being out of place."

10.31 Kcho (Alexis Leyva Machado), *Para Olvidar* (For Forgetting), 1995. Kayak and beer bottles, kayak 18ft. Installation view, CIAC, Montreal, courtesy Barbara Gladstone Gallery, New York.

Alexis Leyva Machado (born 1970), sometimes called Kcho, has created a series of ▸found-object◂ sculptures based on the rafts that Cubans make in order to cross over to the United States. In sentimental works like *Para Olvidar* (For Forgetting) ▶**fig. 10.31** Kcho focuses on the emotional and physical toll of migration, and yet he does not want his works to be narrowly defined by this one issue. The rickety boat floating on a sea of bottles is a metaphor not only for Cuban migration, but also for all of life's dangerous journeys. In a similar vein, Carlos Estevez's (born 1969) *Bottles to the Sea* ▶**fig. 10.32**, an installation shown at the Havana Bienal in 2001, poetically considers the nature of the "message in a bottle," a last-ditch form of communication. By presenting one hundred drawings, each above a fragile bottle into which they might be put, Estevez invites viewers to ponder his work, and perhaps to reflect on how best to transmit messages across cultures.

Raul Cordero's (born 1971) series of installations called Hello/Goodbye ▶**fig. 10.33** confronts the joy of welcomes and the pain of farewells in the context of the migration of Cubans to the United States. One recent work in the series featured a sign saying "Hasta Pronto! Goodbye Varadero," a facsimile of a sign at the Cuban tropical resort town of Varadero. On its reverse is another facsimile of a sign, declaring "Welcome to Fabulous Las Vegas Nevada," a city famous for luxury hotels and casinos.

10.32 Carlos Estevez, *Bottles to the Sea* (detail), 2000. Mixed media, dimensions variable. Installation.

10.33 Raul Cordero, *La experiencia Varadero, Las Vegas*, Hello/Goodbye series, 2000. Neon sign, lightbulbs, paint, steel, chairs, and stands, height 1ft 10ins. Iturralde Gallery, Los Angeles.

The Jamaican-born artist Albert Chong (born 1958) had produced a number of self-portraits called *Winged Evocations* ▶**fig. 10.1** (see p. 310). Bronze casts of his face are mounted on hybrid forms. Organized in a column, these angel-like creatures seem frozen, despite their mechanical wings flapping slowly back and forth. The floor of paper boats provides a soft, white, cloud-like space for these beings to inhabit. This work has had multiple incarnations. In 1998 it was presented as a spiritual meditation in an exhibition at the Allen Memorial Art Museum in Ohio. In 2001 at the Havana Bienal in Cuba, Chong reconfigured the work in order to represent the migration of people back and forth between the West Indies and the United States. He asked both Cubans and Cuban-Americans to provide statements on the issue of migration: Chong wanted to know what factors could make these groups want to change places, and either return to or leave Cuba.

Multicultural Art in the United States

Since the 1990s many American artists have sought to invoke a multicultural identity, one that combines the cultures of different nationalities, ethnicities, or religious traditions. Because many of these artists were immigrants to the United States, it is natural that they should be conflicted about their identity as they settled in a new country and culture. Furthermore, issues of sexual identity have been brought to the forefront. Gays, lesbians, and HIV+ people have all looked to the art world as a place to grapple with personal experience as well as with the broader politics of identity.

The 67th Whitney Biennial Exhibition of American Art (New York, 1993) represented a high-water mark for art about identity. The show was dedicated to the "construction of

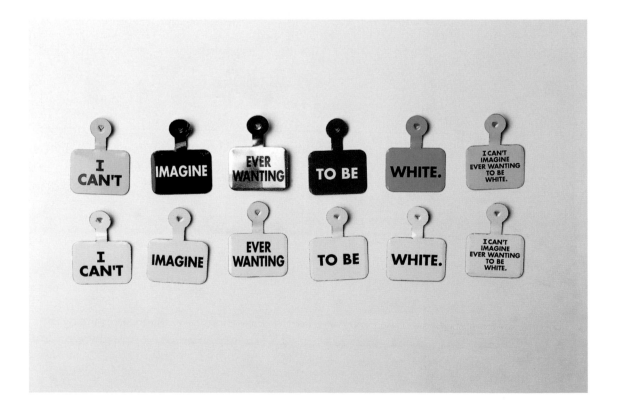

10.34 Daniel Martinez, *Study for Museum Tags: Second Movement (Overture)* or *Overture con Claque (Overture with Hired Audience Members)*, 1993. Mixed media. The Project, Los Angeles.

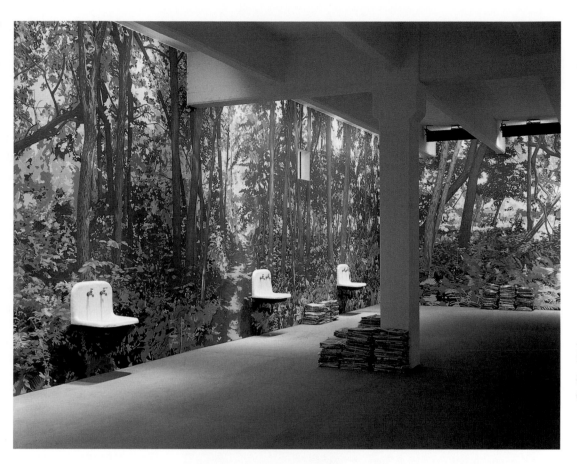

10.35 Robert Gober, *Newspaper (The Serious Bride)*, 1993. Installation at Dia Center for the Arts, New York.

identity." In the preface to the catalog, curator David Ross wrote: "The 1993 Biennial Exhibition comes at a moment when problems of identity and the representation of community extend well beyond the art world. We are living in a time when the form and formation of self and community is tested daily." At the Biennial, viewers were confronted with the issue of identity as they paid their entrance fee. In many museums, visitors are given small metal tabs that they attach to their shirts in lieu of a ticket, identifying themselves as a paying customer. The tabs are customarily designed only with the museum's initials "WMAA," but for this occasion Daniel Martinez (born 1957) from Los Angeles reconfigured six of them to feature the phrase "I can't imagine ever wanting to be white," both as one phrase and broken up into separate words. His *Study for Museum Tags: Second Movement (Overture) or Overture con Claque (Overture with Hired Audience Members)* ▶**fig. 10.34** is a conceptual artwork, offering an opportunity for Dada-like absurdity as different viewers of different races (with a variety of words pinned to their chests) mingled in the galleries. Notably, Martinez's work does not celebrate any special group or race; rather it confronts the fact of white domination of the United States.

The Biennial also confronted the issue of sexual identity. Robert Gober (born 1954), for example, showed his *Newspaper (The Serious Bride)* ▶**fig. 10.35**, which reflects some of the legal and aesthetic issues that homosexuals sometimes have to face. The work features stacks of recent newspapers, bound and ready to be discarded. At the top of

one pile a headline reads "Vatican Condones Discrimination Against Homosexuals," which is satirically juxtaposed with an idealized image of a young bride. The article is from the *New York Times*, but the photograph of the "bride" is in fact a self-portrait of the (male) artist wearing a wedding dress, thus drawing attention to the contradictions of heterosexual identity.

The battle over gay identity was given new urgency in the late 1980s by the specter of the AIDS epidemic, which initially drew the most attention in urban gay communities in the United States. Tony Kaye (born 1952) is one artist who has successfully integrated an identity politics based on HIV+ status. His *Please Touch* is a call to people not to be irrationally fearful of people who are HIV+. Volunteers who have the disease staffed the work, sitting next to a sign that reads "please touch." Passerbys were thus encouraged to reach out and shake hands, or hug, the HIV+ volunteers. Kaye installed the piece directly outside the Museum of Modern Art in New York, as an injunction to compare it with the artworks inside, all of which are distanced from the viewer by the customary command "Do Not Touch."

John Dugdale (born 1960) of New York has been living with AIDS since 1995. His work is among the two hundred offerings of the Virtual Museum, an on-line collection of work by artists who are HIV+ or who have AIDS. Founded by the Estate Project for Artists with AIDS, the Virtual Museum provides a place for artists whose careers have been cut short to display their work for posterity. The museum also features works from many prominent artists who have died of AIDS, such as Keith Haring (1958–90) and Robert Mapplethorpe (1946–89) (see also inset, opposite). The museum's organizers hope that the site will serve as a historical documentation of a disease that has taken a terrible toll on the art community of the United States.

The Californian Amalia Mesa-Bains (born 1950) deals with Latin-American identity in multicultural works that encompass artistic traditions of Anglos (white, English-speaking Americans), Native American Indians, Hispanics, and Spaniards. Her installations, such as *Emblems of the Decade: Borders* ▶**fig. 10.36**, made in collaboration with Victor Zamudio-Taylor, are based on the folkloric art of Mexican women, especially the making of domestic altars dedicated to relatives and saints. Taking up issues of both gender and ethnicity, Mesa-Bains synthesizes traditional and

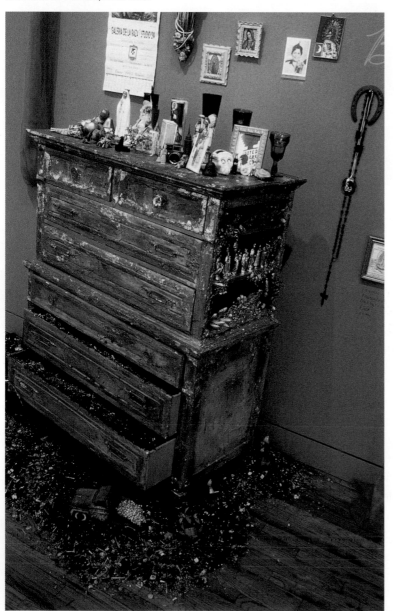

10.36 Amalia Mesa-Bains, Dresser from *Emblems of the Decade: Borders*, 1990. Mixed media. Installation at Studio Museum of Harlem, New York.

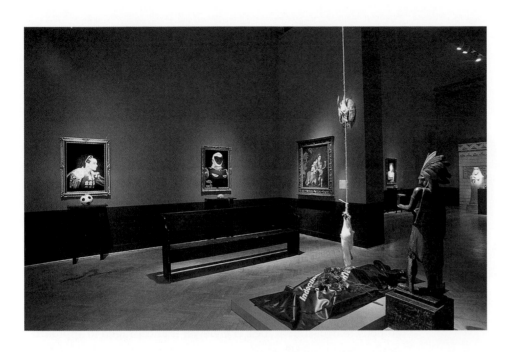

10.37 Guillermo Gómez-Peña and Roberto Sifuentes, *Temple of Confessions*, 1997. Mixed media. Installation at the Corcoran Gallery of Art, Washington, D.C.

modern objects in assemblages that project her complex understanding of her own identity. In this installation she juxtaposes traditional Mexican-American emblems, texts, and found objects with statistics. The numbers detail socio-economic realities that Mexican-Americans are forced to confront every day, including mortality statistics from the AIDS epidemic.

An intensely provocative artist who is straightforward in presenting the complexities of a Mexican-American identity is Guillermo Gómez-Peña (born 1955). His installation and performance piece titled *Temple of Confessions* ▶**fig. 10.37** was shown in the Corcoran Gallery of Art in Washington, D.C., where it caused an uproar among many of the gallery's patrons. The setting includes a great deal of iconography inspired by the Catholic Church,

1990: Culture Wars in the USA

The year 1990 proved to be a memorable one for artists who dealt with provocative identity issues. In that year, four American artists, Karen Finley, Tim Miller, John Fleck, and Holly Hughes, had their grants individually rescinded by the federally funded National Endowment of the Arts. Miller, Fleck, and Hughes all depicted gay identities in their work, while Finley struggled to come to terms with her personal identity in the context of feminist thought. The furor began when two journalists, Rowland Evans and Robert Novak, caricatured Finley's performance piece *We Keep Our Victims Ready* ▶fig. 10.38 in a widely syndicated newspaper column. In the work Finley had smeared her nude body with chocolate. She used chocolate because it looked like human excrement; Finley felt that women were "shat upon" in American society. Evans and Novak had not seen the performance but described it in their article as a flagrantly sexual work, and called Finley a "chocolate-smeared young woman." The public controversy resulted in years of legal wrangling and an unsuccessful attempt by some members of the U.S. Congress to abolish federal art funding altogether.

The second major controversy of 1990 involved the photographer Robert Mapplethorpe, whose work explores gay identity issues. The police closed a traveling exhibition of Mapplethorpe's work at Cincinnati's Contemporary Arts Center and the director of the museum, Dennis Barrie, was arrested on obscenity charges. The show, called The Perfect Moment, had included a handful of photographs that depicted explicit sexual acts being performed by gay men. In the fall of 1990, Barrie, who lost his job over the controversy, was acquitted in a jury trial.

10.38 Karen Finley, *We Keep Our Victims Ready*, 1990. Video still of a performance piece.

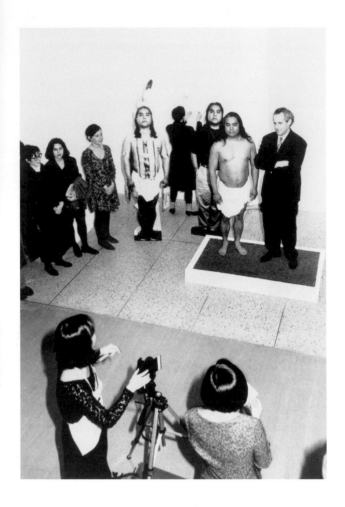

10.39 James Luna, *Take a Picture with a Real Indian*, 1991. Life-sized figures, black and white photographs mounted on foam core. Courtesy the artist.

including eight velvet paintings of contemporary "saints" and a richly evocative assemblage of Mexican-American objects, including cheap Tijuana souvenirs, all presented with satirical intent. Gómez-Peña calls this process "pop archeology." The centerpiece of the exhibit consisted of the artist and his collaborator Roberto Sifuentes sitting in elevated Plexiglas boxes. Sifuentes, dressed as a stereotypical Latino gang member, pretends to inject himself with heroin while using an American flag as a tourniquet. Through his slow, ritualized motions, he attempts to embody fearful stereotypes. The viewer is encouraged to approach Gómez-Peña himself, who is dressed as a traditional Indian god sitting under a neon sign which reads, "We Incarnate Your Fears." Then the viewer is invited to kneel before Gómez-Peña and speak with him through a microphone and headset. The artist wants the viewers to interact with him and to "confess" their own feelings and prejudices about Mexican-Americans. Some of these statements are recorded and played continuously in the gallery. The work not only confronts the audience with its own fears, but also allows it to interact meaningfully with the artist himself. The viewer ends up becoming part of the installation.

Native American Artifacts

One issue that has been of paramount concern to Native Americans in recent decades is the presentation in museums of their ancestral objects, including human bones, as a form of "art." While a federal law passed in 1990 requires museums to return these artifacts to their rightful owners, it does not apply to collections that do not receive federal funds. Controversy arose in 1992 involving items stripped from the bodies of the Lakota people killed in the 1890 massacre at Wounded Knee. The artifacts apparently were given to the museum at Barre, Massachusetts, by a collector, who had in turn bought them from the person who had contracted with the government to bury the Indians in mass graves. The objects themselves range from intricately beaded purses to the scalps of both an Indian and a Caucasian. At the time of the controversy, the museum curator was reported in the *New York Times* as saying, "I always thought of them as artworks. I'm sorry I did not realize the significance of these things." Chief Big Foot's descendants buried the most sacred artifact, a piece of his hair, in 2000. The definition of what constitutes "art" is continually being revised.

James Luna (born 1950) is a Native American artist whose installations make statements about multicultural identity issues in a manner similar to Gómez-Peña's. *Take a Picture with a Real Indian* ▶**fig. 10.39**, for example, consists of three lifesize photographs of himself in different types of dress. One of them shows Luna in full Native American regalia, the second in a simple breechcloth, and the third in khakis and a golf shirt, standard American leisurewear. A recorded voice in the gallery booms out like a vaudeville barker: "Take a picture with a real Indian tonight!" Luna has presented the non-Native American viewer with a chance to decide which stereotyped identity is more real to them. On some occasions, when Luna dresses in costume and replaces one of the cut-outs, the question of what makes a real Indian becomes even more ambiguous.

Luna has challenged other stereotypes in a series of photographs titled "Half Indian/ Half Mexican" ▶**fig. 10.40**. Again using self-portraiture, Luna has here dressed himself

10.40 James Luna, *Half Indian/Half Mexican*, 1990. Triptych of black and white photographs mounted on masonite board. Courtesy the artist.

to look like a "pure" Indian in one image and a "pure" Mexican in another. The middle image is a composite of these two stereotypes. Luna's personal experience—he was born to a Mexican father and a Native American mother—lies at the heart of this image.

A number of Chinese artists who work in the United States and Canada have lately placed the issue of identity at the core of their work. *A Book from the Sky* ▶**fig. 10.41** by Xu Bing (born 1955) takes up the issue of China's many ethnic and linguistic groups, united for five millennia by the written Chinese language (see chapter 5). Xu used a painstaking woodblock technique to print texts over a variety of scrolls and bound books. When the work was first exhibited in Beijing, viewers were faced with the

10.41 Xu Bing, *A Book From the Sky*, 1988. Carved woodblocks, bound hand-printed books, and ink on paper. Installation view (1992), Elvehjem Museum of Art University of Wisconsin-Madison.

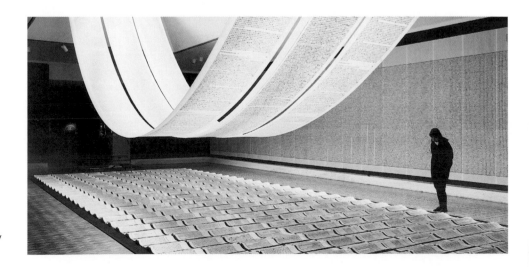

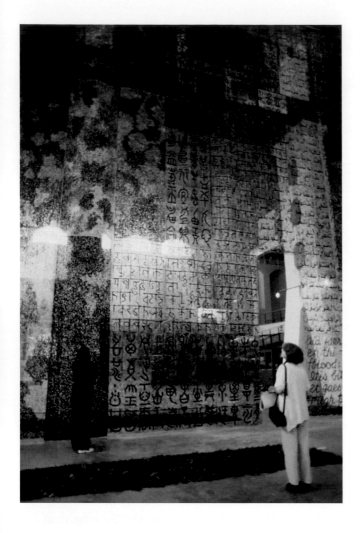

10.42 Wenda Gu, *United Nations-Africa Monument: The World Praying Wall*, 1997. Wall of pseudo-English, Chinese, Hindi, Arabic, and world ethnical maps made of human hair, 40ft × 44ft. Installation, with performance by South African choreographer Nomsa Manaka, for Alternating Currents, the 2nd Johannesburg Biennial, 1997.

sudden realization that the texts are not made up of Chinese characters, but of an incomprehensible parody of the written language. Once universal to the Chinese people and a symbol of unity, the calligraphy is now a stream of babble, representing the fractured nature of Chinese identity. The work also evokes the squashing of self-expression in China during the Cultural Revolution—the time Xu was growing up (see chapter 7). He settled in the United States in 1989.

Wenda Gu (born 1955) has a global outlook toward art. He took up the theme of global identity in his ongoing series United Nations-Africa Monument: The World Praying Walls ▶**fig. 10.42**, which he began in 1993. For these works Wenda collects hair from volunteers and weaves it into characters that resemble the elements of language. In 2000 he stated that he intended to complete one such work in every country around the globe. When he took his performance piece *Confucius' Diary* ▶**fig. 10.43** to Canada in 1999, he traveled around Vancouver meeting important government and corporate figures. He was dressed half in Chinese ceremonial dress and half in Western formal dress, while behind him trailed a live donkey. The work reinvented the fabled journeys of the philosopher Confucius, who had traveled around China's different provinces in an attempt to unite them under his tutelage.

10.43 Wenda Gu, *Confucius' Diary*, 1997. Photograph of a performance piece.

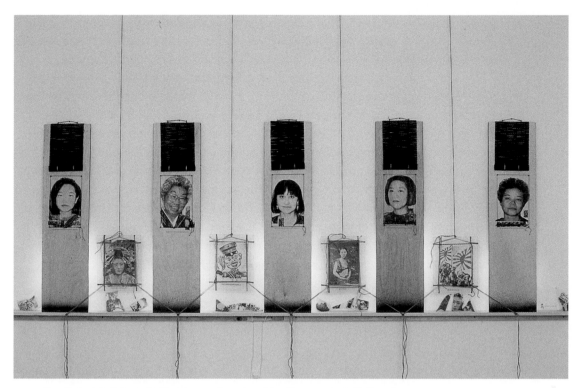

10.44 Tomie Arai, *Self-Portrait: Framing an American Identity*, 1992. Installation view. Mixed media, glass, silkscreen. Installation view, courtesy the artist.

The Japanese-American artist Tomie Arai (born 1949) used a strategy similar to that of James Luna in her installation *Self-Portrait: Framing an American Identity* ►**fig. 10.44**. A combination of photographs and silkscreened images integrates scenes from Arai's own life with media pictures that illustrate the conventional stereotypes of Japanese-Americans in the United States. In juxtaposing her own life experience with Western images of Asians as either dangerous and exotic, or servile (she has portrayed herself as the "Laundryman's Daughter"), Arai points to the difficulties of a life that bridges two cultures. Arai has also pondered issues of gender that relate to traditional Asian roles within a Western culture. As she put it:

> For Asian women, the discussion of feminism seemed to force women to make a choice between family and self. Coming out of a patriarchal society where the family is the central unit, to question this in a negative way made Asian women feel that a choice had to be made—it was difficult and awkward. It meant we had to deny our own culture.

Shirin Neshat (born 1957), originally from Iran, is now an American citizen. She produces poetic video works to illuminate the plight of women in strict Islamic countries. After emigrating to the United States in 1974, Neshat had been pursuing a career as an artist for nearly sixteen years when in 1990 she made a return trip to Iran, an experience that changed her whole outlook on art and life. Dramatic changes in the status of women had taken place since the Islamic revolution of 1979. Although the country had been progressing toward increasing women's role in society while she was there as a teenager, by 1990 the fundamentalist authorities had reasserted the ancient patriarchal suppression of women, denying them access to education,

property, and healthcare. Neshat returned from that trip determined to represent the gender politics of Islamic countries in an even-handed manner and went on to produce such works as *Rapture* ▶**fig. 10.45**, which has a musical score by Sussan Deyhim. It consists of two simultaneously displayed videos, one featuring men gathering at a fortress, the other showing women moving through the desert and the sea. The two thirteen-minute videos are presented in a darkened room so that the viewer stands between the two screens, and the men and women seem to be conversing across the viewer's space. The two separate groups go through a series of ritualized actions: marching, fighting, and praying. Sometimes the men watch the women, sometimes the women watch the men, at other times the groups seem oblivious of one another. Viewers become caught between observing the attractions of Islamic rituals and considering the reality of such separation. The black-and-white videos present many beautiful contrasts of tone and texture, starting with the juxtaposition of the women's black chadors (large veils or shawls, covering the women from head to foot) and the men's white shirts.

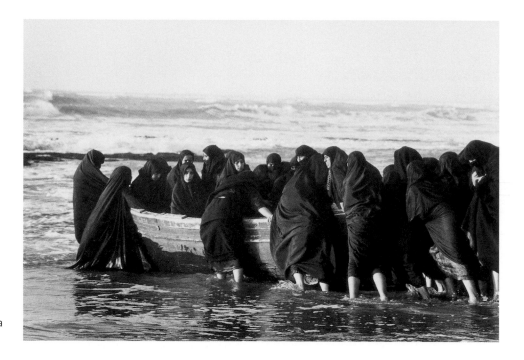

10.45 Shirin Neshat, *Untitled* (*Women Pushing Boat* from Rapture series), 1999. Black and white photograph, 3ft 8ins × 5ft 8¼ins. Production still, courtesy Barbara Gladstone Gallery, New York.

Shirin Neshat and Tomie Arai are distinct from most of the artists surveyed in this chapter because they do not deny the viewer visual pleasure. Both of them make elegant compositions that contrast sharply with, for instance, the banality of Daniel Martinez's metal tabs. Here then is the question that continues to confront artists concerned with identity politics: is it more important to present a strong activist message, or to make works that are visually appealing? There is no consensus on this issue, and it will probably remain at the heart of the art of identity well into this millennium.

Further Reading

S. Breitwieser, ed., *Double Life: Identity and Transformation in Contemporary Art* (Berlin, 2002)

M. Brenson, *Visionaries and Outcasts, the Nea, Congress, and the Place of the Visual Arts in America* (New York, 2001), pp. 14–38

N. Broude and M.D. Garrard, ed., *The Power of Feminist Art: The American Movement of the 1970s, History and Impact* (New York, 1994), pp. 174–207

R. del Castillo, T. McKenna, and Y. Yarbro-Bejarano, ed., *Chicano Art Resistance and Affirmation 1965–1985*, exh. cat., Wight Art Gallery of the University of California (Los Angeles, 1991), pp. 83–96

G. Gómez-Peña and R. Sifuentes, *Temple of Confessions Mexican Beasts and Living Santos* (New York, 1996)

R. Henkes, *The Art of Black American Women* (London, 1993), pp. 95–112

L. King-Hammond, ed., *Gumbo Ya Ya: Anthology of Contemporary African-American Women Artists* (New York, 1995), pp. 207–210

L. Lippard, *Mixed Blessings: New Art in a Multicultural America* (New York, 1990), pp. 19–56

M. Machida, et al., *Asia/America Identities in Contemporary Asian American Art*, exh. cat., The Asia Society Galleries (New York, 1994), pp. 65–110

R. Parker and G. Pollock, *Old Mistresses: Women, Art and Ideology* (London, 1986), pp. 1–49

S. Patton, *African-American Art* (Oxford and New York, 1998), pp. 232–266

R.J. Powell, *Black Art and Culture in the Twentieth Century* (London, 1997), pp. chapter 6, pp. 161–202

E. Sussman, et al., *1993 Biennial Exhibition: Whitney Museum of American Art*, exh. cat. (New York, 1993), pp. 12–35

M. Wallace, "'Why are There No Great Black Artists?' The Problem of Visuality in African-American Culture," in *Black Popular Culture, ed. G. Dent* (Seattle, 1992; New York, 1998), pp. 333–346

For the website Artists with Aids, visit: http://www.mhhe.com/frames

Source References

p. 321 "One is not born a woman…"
S. de Beauvoir, *The Second Sex* (1949), trans. H.M. Parshley (New York, 1953), p. 249

p. 324 "I find compelling a radical…"
hooks, quoted in preface to *Gumbo Ya Ya: Anthology of Contemporary African-American Women Artists*, ed. L. King-Hammond (New York, 1995)

p. 331 "Political communication that catalyzes…"
Adrian Piper: Reflections, 1967–1987, exh. cat., Alternative Museum (New York, 1987)

p. 333 "For me, the challenge…"
Sikander, quoted in an undated interview "A Conversation with Shirin Neshat and Shahzia Sikander" by the Society Asia (New York)

p. 336 "The fabric is not one thing…"
Shonibare, quoted in J. Weeks, "Popular Cultures: Installations by Michael Parekowhai, Ravinder Reddy, and Yinka Shonibare," *Carnegie Magazine* (May–June 2001)

p. 341 "The 1993 Biennial Exhibition…"
D. Ross, preface to *1993 Biennial Exhibition*, ed. E. Sussman et al., exh. cat., Whitney Museum of American Art (New York, 1993), pp. 8–11

p. 347 "For Asian women…"
Arai, quoted in L. Weintraub, *Art on the Edge and Over* (Litchfield, CT, 1996), p. 108

Discussion Topics

1. Why are feminist and African-American (men and women) artists concerned with issues of identity?

2. Compare African-American artists' uses of traditional African art with those of the twentieth-century European artists discussed in chapter 8.

3. Why are written texts so important to politically active artists?

4. Do you think that a work needs to be beautiful in order to be considered art?

5. Discuss the references you find to multicultural art in local newspapers or magazines.

6. What shapes your own sense of identity?

7. Should artists concern themselves with political causes?

8. What artists have you read about in other chapters of this book that strike you as having been concerned with identity?

Elements and Approaches to Art History

There are many different factors to consider when discussing a work of art. It is a comparatively recent development in human history that objects have been created primarily to be admired and evaluated as "art." In most societies in most periods, the artifacts that we now find displayed in museums and galleries and that we think of as "beautiful" were conceived and made to serve a function of some sort—perhaps ritual, perhaps purely practical. The context in which an object was created is thus critical to our understanding of its "meaning." Comparison of the works of Michelangelo (see figs. 5.25, 5.30, 5.31), the "Mound Builders" of North America (see figs. 1.9, 1.10, 1.12), and the brass sculptors of Benin (see figs. 3.19, 5.2) will not get us very far if we do not consider at some point why the works were made in the first place.

Works of art are often discussed in terms of their form and content—that is, how they are organized in purely visual terms, and what they show or mean. This is a useful way of organizing our ideas, although we will also need a precise vocabulary of terms relating to such things as style and medium if we are to analyze a work of art successfully. This section on the elements of art history and approaches to the subject is designed to help students acquire or consolidate such a vocabulary.

Form

Form refers to the visual organization of a work and usually excludes any consideration of its representational or intellectual content. The formal elements of a work of art or architecture include such basic qualities as line, shape, texture, value, and color.

Line A continuous mark drawn or painted on a surface to define space or contours, separating distinct areas. Line is also a feature of three-dimensional artworks, but this time physically defined using wire, tubes, struts, string, and the like.

Mass, Volume, and Space Terms used to describe the three-dimensional characteristics of objects. In sculpture and architecture, these dimensions are actual, or physical; in drawings, paintings, and other two-dimensional media they are simulated—in other words, illusory projections created by the use of techniques such as perspective.

Mass and volume Refer to the way in which an object appears to (or actually does) have weight and occupy space.

Space Describes the sense of three-dimensionality. Unfilled, or empty, areas are called negative space; solid, or filled-in areas, are known as positive space.

Texture The tactile quality of the surface of a material or object—smooth, rough, etc.—as perceived either using the sense of touch (how the surface of a sculpture, say, actually *feels* when it is touched) or using the sense of sight (how the surface of an object represented in a painting, say, is made to *look*).

Color The quality we perceive as color depends on our visual identification of the wavelengths of light that objects reflect or emit. Color has several distinct properties:

Hue This is usually what we mean when we use the word color. Orange, yellow, pink, etc. are hues. Red, yellow, and blue are called the primary colors (or hues) because all other hues (or secondary colors) can be producing by combining them in varying proportions.

Value This refers to the perceived degree of lightness or darkness of a hue and depends on the amount of light that any particular object's surface reflects. Dark green is said to have a deeper value than light green, which in turn is itself said to have a lighter value than dark green.

Intensity or saturation This indicates the degree of brightness or dullness of a hue. A vivid purple is of higher intensity; a dull purple is of lower intensity.

fig. 1 (see fig. 7.2) Jean-Antoine Watteau, *Pilgrimage to Cythera*, 1717. Oil on canvas, 4ft 2¾ins x 6ft 4⅜ins. Musée du Louvre, Paris.

Which is more important in a painting, the quality of the drawing or the use of color? At the beginning of the eighteenth century, artists were divided into two camps: the "Poussinistes" and "Rubénistes." The former insisted on the superiority of drawing, or line, which they thought more intellectual; the latter put sensual color first. Watteau was most definitely a Rubéniste, but that does not mean that he paid no attention to the formal arrangement of elements in his compositions. The air of spontaneity and informality suggested by this painting has been carefully contrived: the undulations of the grassy knoll in the foreground are harmoniously echoed in the swaying mass of the tree on the right and the swarm of cupids on the left.

Composition or design The organization or arrangement of different elements in a work to produce a unified whole. The question of how to represent three-dimensional reality in two dimensions has preoccupied artists—painters in the Western tradition in particular—over a very long period. Not surprisingly, a specialized set of practices (and accompanying vocabulary) evolved to deal with this key aspect of composition. Artists use spatial recession or pictorial depth to depict objects as apparently receding from the two-dimensional surface (or picture plane) of a work. The implied space behind this picture plane is called the picture space and contains three zones: foreground, middle ground, and background. At right angles to the picture space, and forming its floor, is the ground plane.

fig. 2 (see fig. 5.13) Ma Yüan, *Walking on a Mountain Path*, Southern Song dynasty, artist flourished c.1190–1230. Album leaf, ink, and colors on silk, 10¾ins x 1ft 5ins. National Palace Museum, Taipei.

This is a very subtle piece of work. The artist appears to have devoted all his attention to the left-hand side of the album leaf, where figures and natural details are massed, and yet it is the other, almost completely empty portion of the image that insistently draws our attention. This redirecting of the viewer's gaze is achieved by the dramatic diagonals of the tree branches and the direction in which the man is looking—all of these lines point to the top right-hand corner of the picture plane, where the bird is taking flight. Perhaps the artist uses this clever technical device to suggest something about mankind's place in nature. Paradoxically, the landscape seems even more vast as a result of not being depicted.

Style

Broadly speaking, style can be defined as the combination of constituent elements that makes the work of a particular artist, group of artists, or even whole culture visually distinctive. In this sense, style might include the characteristic use of particular media or recurrent choice of certain kinds of subject matter. But in more precise usage, style is concerned with the manner of execution of a work of art, that is, how it conveys its subject matter visually. A wide vocabulary has been developed to describe this second, somewhat slippery idea of "style." To art historians, the following terms are indispensable even though they are often somewhat ambiguous.

Representational and non-representational art

A *representational* work is one that seeks to portray the visual reality of its subject, e.g., a landscape, portrait, or scene from history. A *non-representational* work, on the other hand, does not attempt to depict things as they are found in the world. It may instead be concerned with conveying emotional states or purely intellectual concepts, or consist of an abstract arrangement of colors and patterns that has no intrinsic meaning. It may also begin with a real, visible subject and then abstract its elements so that the initial subject is no longer readily recognizable.

Linear

A style, especially in painting, that uses line, silhouette, and linear contours, rather than, say, color or light as its principal means of conveying its subject. By way of contrast, works in which shading or modeling dominate are said to be painterly. When applied to sculpture and architecture, the term linear refers to a style whose emphasis is on the exterior contours, or outline, of a form.

Realistic, Naturalistic, and Idealized

These are all representational styles that in some degree draw on the world of visual reality for their subject matter. In the most general use of the term, *realism* describes works that depict objects faithfully—or objectively—as they appear in everyday reality. More specifically, Realism (with a capital R) is the name of a nineteenth-century movement in painting and literature that, in reaction to the more subjective and high-flown style of Romanticism, concentrated on depicting the reality of modern existence, however disagreeable. *Naturalism* was a late nineteenth-century extension of Realism that sought to convey reality with uncompromising fidelity and, particularly in its literary form, emphasized the role of cultural and biological influences in determining human behavior. In contradistinction to realism and naturalism, *idealized* art seeks to improve on nature, depicting reality in a heightened, idealized form. Greek sculpture of the fifth century BCE showing the human body is a good example of idealized art.

Abstraction

An alternative to the realistic, naturalistic, and idealized styles. This term is used to describe two different kinds of art: work that does not seek to imitate external reality at all, being concerned with ideas, emotional states, or pure pattern instead; and work that gives an "abstract" treatment to actual, visible subjects. The mature paintings of Mark Rothko (see figs. 9.36, 9.37) are abstract in the first sense, cave art in the second. Many, perhaps even most, works contain elements of both realism and abstraction—consider, for instance, the Cubist works of Picasso (see fig. 8.9).

Medium

The medium of a work of art concerns the materials from which it is made. The choice of materials has a tremendous influence over the effects that the artist is able to achieve: for instance, the structural differences between examples of stone and steel architecture are in large part determined by the different capabilities of the materials, just as painters using oils or acrylics to portray the same subject will produce contrasting results owing to the different inherent qualities of their chosen medium. The number of different media used by artists today is vast and expanding all the time: found objects (such as Duchamp's Fountain, see fig. 9.18) and waste matter are as much the stuff of contemporary creativity as oil paints and Carrara marble. In the nineteenth century an object was unlikely to be considered worthy of the appellation "art" unless it had been created using traditional fine-art materials; nowadays almost anything can be considered as a "work of art" if its creator or finder declares it so.

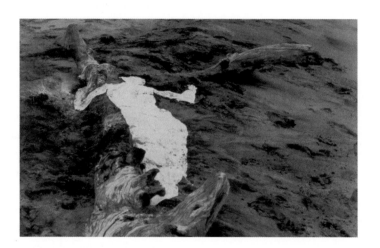

fig. 3 (see fig. 1.1) Ana Mendieta, *Untitled*, from the *Arbol de la Vida* (Tree of Life) series, 1976. Color photograph: earth/ body work with cloth and tree, 1ft 1¼ins x 1ft 8ins. Galerie Lelong, New York.

Is this a photograph of a work of art, or is the photograph the work of art itself? The medium is ambiguous. As an artist, Mendieta usually worked outside, in nature, rather than in a traditional studio space. Exposed to the elements in the Iowa landscape and not protected by the roof of a New York gallery, this ghostly fiber-and-wood arrangement, evocative of the traditional earth goddess or perhaps of Christ on the cross, was destined to be ephemeral; the photograph was therefore taken as a documentary record of the work. However, it is clear that the photograph was carefully arranged too—it shows all the signs of deliberate composition characteristic of a work of art. It was also the photograph that was sold and generated income for the artist. So the medium is both photographic print, and cloth, wood, and earth.

Painting There is a huge array of different kinds of painting, from wall painting and book illumination to hanging scrolls and easel painting. What they all have in common is their use of pigments—ground mineral or plant substances—to give color to the surfaces of objects and materials. The latter might include anything from walls and ceramics to canvas and textiles. The pigments are applied by mixing them with a liquid and transferring them to the surface of the inchoate artwork in a semi-fluid state. Listed below are some of the most popular kinds of painting media. Each medium has its own particular qualities and limitations, and is characteristic of a different period of art history.

Acrylic An easy-to-use modern synthetic paint that is thinned with water and usually applied to canvas. It produces particularly bright colors.

Encaustic A technique used by ancient Greek and Roman artists to decorate sculpture and architecture in which powdered pigments were mixed with hot wax. The medium, which produces rich colors, was revived in the twentieth century.

Fresco A wall-painting technique used to cover large surface areas, in which pigments are mixed with water and applied quickly to unset, wet plaster to produce very durable results. The most famous example of fresco painting is the ceiling of the Sistine Chapel by Michelangelo (see fig. 5.31).

Oil Pigments are mixed with linseed or other type of vegetable oil and applied to wood or canvas to create rich, luminous surfaces. In this technique, unlike say in fresco, colors can be blended to produce an enormous variety of effects.

Tempera A technique used in Western panel painting until the fifteenth century, in which pigments are mixed with egg yolk and gum and applied to wood. It was superseded in the Early Renaissance by the more flexible medium of oil painting.

Watercolor A type of painting first known in second-century BCE Egypt in which water-soluble pigments are applied to white or tinted paper in transparent washes of color.

Sculpture

Sculptures are three-dimensional works of art created by carving, modeling, or assembling a variety of materials. Examples may be freestanding and in the round—for instance, statues that can be walked around and seen from all sides—or executed in relief, so that the sculpted image projects out from a surface of which it is a part. The latter can be either high or low (bas) relief, depending on the degree to which the sculpted part projects out. There are two basic methods for creating sculptures:

Subtractive The artist begins with a block of non-malleable material, typically wood or marble, and cuts or abrades portions from it until the work is finished. Carving is a subtractive method and is so called because it involves taking away bits of material to produce the final form of the work.

Additive The artist uses malleable materials, such as clay or metal, and molds and shapes them in order to build up an image or form. Metal sculpture is usually created by welding while the metal is hot. Clay is a relatively brittle material, so more durable versions of clay additive sculptures have traditionally been produced by casting them in bronze or other metals using the lost wax (or *cire perdue*) method. This involves covering the original clay sculpture with wax and then encasing it in a further layer of clay. It is then heated so that the wax layer melts out through specially created openings and molten metal is poured in in its place. When the structure has had a chance to cool, the clay casing is broken away to reveal the finished sculpture in metal, which can then be polished.

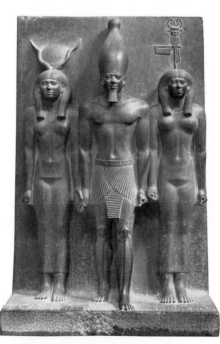

fig. 4 (see fig. 3.13) Triad of Khamerernebty, Menkaure, and Hathor, Giza, c.2500 BCE. Diorite, height 3ft 1³⁄₈ins. Egypt Museum, Cairo.

How "realistic" are the portraits of the historical personages shown in this high-relief sculpture? The bodies give some suggestion of anatomical accuracy, but are highly stylised; the faces show some individual traits, but give little suggestion of personality or character. Instead, the identities of the figures are established for their audience by their symbolic headdresses. Movement and spatial recession are suggested by the male figure's advanced left leg; the strong verticals of the bodies, with arms held tight by their sides, contrast with the horizontal of the man's belt and the diagonals of his skirt and the woman's horns. But the point—and strength—of the work is its confident immobility, expressive of conservative Egyptian society.

Architecture The study of architecture involves surveying the entirety of the built human environment, from the simplest ephemeral structure constructed in wood or ice to the most ornate and durable stone cathedral or steel-and-glass skyscraper. Architecture can be said to be both an art and a science, particularly since so much of architectural history is tied to technological advancements.

fig. 5 (see fig. 3.29a) Pantheon exterior, Rome, 118–28 CE.

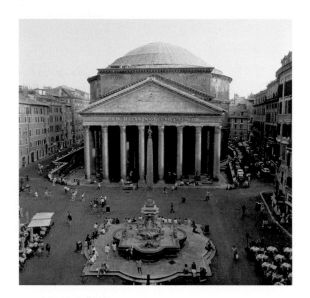

Architecture is not only concerned with resolving technical problems of spanning and enclosing space. The ancient Greeks, for instance, developed sophisticated decorative programs for their temples. This tradition is exemplified by the temple-like portico of the Pantheon, with its carved dedication to "all the gods" on its triangular entablature and granite columns topped with acanthus-leaf capitals typical of the Corinthian order. By the time the Romans rebuilt this portico in the first century CE, Greek technological know-how had been surpassed by superior Roman engineering skills. Using the most up-to-date materials and techniques—concrete and brick, and arches and tunnel vaults—behind the façade, the emperor Hadrian was able to add an enormous dome-covered circular space, a structure that would have been inconceivable using Greek building methods.

Until very recently, walls, whether consisting of masonry blocks, wooden posts, or any other material, had to bear the weight of the building's roof or ceiling—most masonry ceilings spanning open space in ancient and medieval constructions are elaborate solutions to the problem of how to transfer weight from themselves to the vertical uprights that support them. One of architects' central quests throughout history has therefore involved devising systems for spanning and containing space (walls and ceilings) while providing means of entry for people, vehicles, daylight, and air (doors and windows).

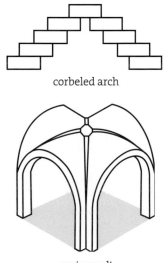

corbeled arch

groin vault

Post-and-lintel The earliest, most basic form of architectural construction, in which two vertical pillars, or "posts," support a third, horizontal member, or "lintel," laid across the top of them (see fig. 3.11).

Arch A curved structural element, in contrast to a flat lintel, that spans an opening. In its earliest form, courses or layers of stone were laid on top of one another in two separate but adjacent piles, with each fresh course projecting further inward until the two piles touched to form an enclosed opening called a *corbeled arch* (see diagram). Later, wedge-shaped masonry blocks, or voussoirs, began to be used. These were packed together with their narrow side toward the opening to create a *true arch* (see fig. 3.31).

Vault An arched roof or ceiling, usually made of brick, stone, or concrete, that spans an interior space. There are many different kinds of vault: the semi-cylindrical *barrel vault* made up of successive arches; the *groin vault*, created by intersecting two barrel vaults at right angles to one another (see diagram) and the *ribbed groin vault*, in which ribs are added to the groins for decorative and structural purposes, etc.

Steel frame A comparatively recent development in the history of architecture. Steel is a strong, malleable material that can be formed into a flexible skeleton so that walls no longer have to carry the weight of the building and can therefore be replaced with large expanses of glass window.

Photography

Still photography is a two-dimensional art form, first developed in the nineteenth century, in which a camera—an enclosed box-like device with a lens at the front—is used to produce an image on a light-sensitive plate or film placed within the camera.

Daguerreotype One of the earliest photographic processes, invented in 1839 by (and named after) the Frenchman Louis Jacques Mandé Daguerre. Here the image is fixed on a copper plate coated with light-sensitive material.

Calotype The first process to use a negative, which in black and white photography shows the image with all tones reversed; the advent of the negative meant that images were now infinitely reproducible in theory. The process was developed by William Henry Fox Talbot in 1841.

Wet-plate collodion process A process developed c.1850 allowing for short exposure times and fast print development, and producing images showing more detail and greater contrast than those resulting from the calotype process.

Graphic Arts

Without assistance from the graphic arts, most artists throughout human history would only have been able to create one copy of a work at a time—which places tremendous limitations on the number of people who would ever see examples of their art. Movable type was invented in China in the eleventh century CE and reached Europe about four centuries later; with it came printmaking techniques that allowed multiple exact reproductions of a single image to be made, permitting artists to circulate their works to a much wider audience and in a much cheaper format. An oil painting can only hang in one place at a time and, owing to the time and materials used in its creation, usually costs a lot of money. On the other hand, a woodcut, say, is cheaply produced and infinitely reproducible and can therefore be held in any number of hands simultaneously.

Of late, photography and digital technology have multiplied the options available for producing copies of works. Nonetheless, three basic, more traditional processes have dominated the printing of images throughout the history of art. These are called *relief printing*, *intaglio*, and *lithography*.

Relief printing This involves printing from the uncut raised parts of a carved surface, usually linoleum or wood. WOODCUT A design is cut into a wooden block using a gouge or knife. When a sheet of paper is brought into contact with the inked block, the cut-away areas appear white on the resulting print while the uncut areas appear black. It is difficult to achieve delicate effects using this medium (see, for example, fig. 6.27).

Intaglio This technique is the reverse of relief printing. An Italian word, *intaglio* means "to cut into"; in this process, it is the cut or incised areas under the surface of the plate that are printed. *Engraving* and *etching* are both forms of intaglio. In engraving, lines are cut into a metal (usually copper) plate using a special tool called a burin. The resulting printed lines are much sharper than can be obtained with a

woodcut. In etching, the metal plate is covered with a wax substance that is impervious to acid. The design is then cut into the wax with a needle, and the plate is dipped into an acid bath so that the exposed areas of metal are eaten away. During printing, it is these lines that take the ink and hence that form the printed image. Graduations of tone are possible using this printing method, so etching (see fig. 6.32) can produce much subtler effects than engraving.

Lithography No cutting or incising is necessary in this technique. The print is generated from a flat surface, usually either of limestone or zinc. Images with the quality of a drawing can be obtained using lithography, since the artist is able to draw his or her design directly onto the printing surface using a special kind of crayon (see fig. 7.19).

Textiles

With the exception of a few works of outstanding historical interest, such as the Bayeux Tapestry (see figs. 3.1, 3.49), textiles have not traditionally been considered a major art form in the West. In some degree, the curriculum at the Bauhaus (see chapter 8) and the feminist art of the last part of the twentieth century (see chapter 10) have begun to alter this perspective by insisting that textiles *can* be fine art. The same prejudice does not exist in all cultures, however, since in other parts of the world works created using animal or vegetal fibers, including wool, silk, cotton, and linen, have always been accorded much greater respect.

Appliqué A decorative technique in which pieces of cloth are sewn or fixed onto another piece of cloth to form a design.

Embroidery Decorative needlework sewn on to a piece of cloth or canvas to form a design (the Bayeux "Tapestry," discussed in chapter 3, is wrongly described as such, since it consists of wool *embroidered* on to linen).

Felting A method for making strong cloth in which fibers, usually of wool or bark, are matted together.

Tapestry A heavy textile with a design woven into the fabric itself, often used as a wall hanging.

Weaving A method for making a strong, durable cloth, in which warp threads are interlaced with horizontal (usually finer) weft threads, usually by passing them through a loom.

New Media

Throughout the history of art, there have always been new media: oil painting was an innovation of the Renaissance; photography changed artists' ideas and practices in the nineteenth century. So the visual arts have always been subject to change, but never at such a rapid pace as in the last half-century, when technological advances have hugely expanded the variety of artistic media currently in use.

Digital art A product of the computer age, this is an extraordinarily flexible medium that uses the rapidly evolving capabilities of digital technology to produce artworks. Computer scanners and photo-editing and painting programs in particular have revolutionized the way images can be manipulated and produced.

Video An art form that uses television as its medium. First developed in the 1960s, it breaks with key fine-art traditions in that the images are often seemingly hastily

produced and of poor quality, not aiming to fulfill traditional criteria of beauty. Video allows artists to tackle contemporary themes and readily incorporate the fourth dimension—time—into their works.

Installation A three-dimensional artwork that consists of a complete environment large enough for the viewer to move around in. It is not a traditional art object in that it is created to be experienced in space and time, not simply looked at from the outside. Installations are temporary, but can usually be re-created in different sites.

fig. 6 (see fig. 3.59) Skyline before September 11, 2001, with World Trade Center towers, New York City.

The "meaning" of a picture or image can never be entirely fixed by its maker; it is continually being changed by the passage of time and the various attitudes of the people who look at it. Jeff Greenberg's photograph of New York might be said to have taken on an unintended elegiac quality since the destruction of the World Trade Center towers, so dominant in the skyline here. The picture tells many other stories too—that of the rise to economic prominence of tiny Manhattan island, for instance, coinciding with the development of steel-frame technology. This allowed architects to build upward, so allowing them to pack a lot more domestic and business space into a few central square miles than would have been possible a century earlier. As the French novelist Louis-Ferdinand Céline commented, New York is a city standing up.

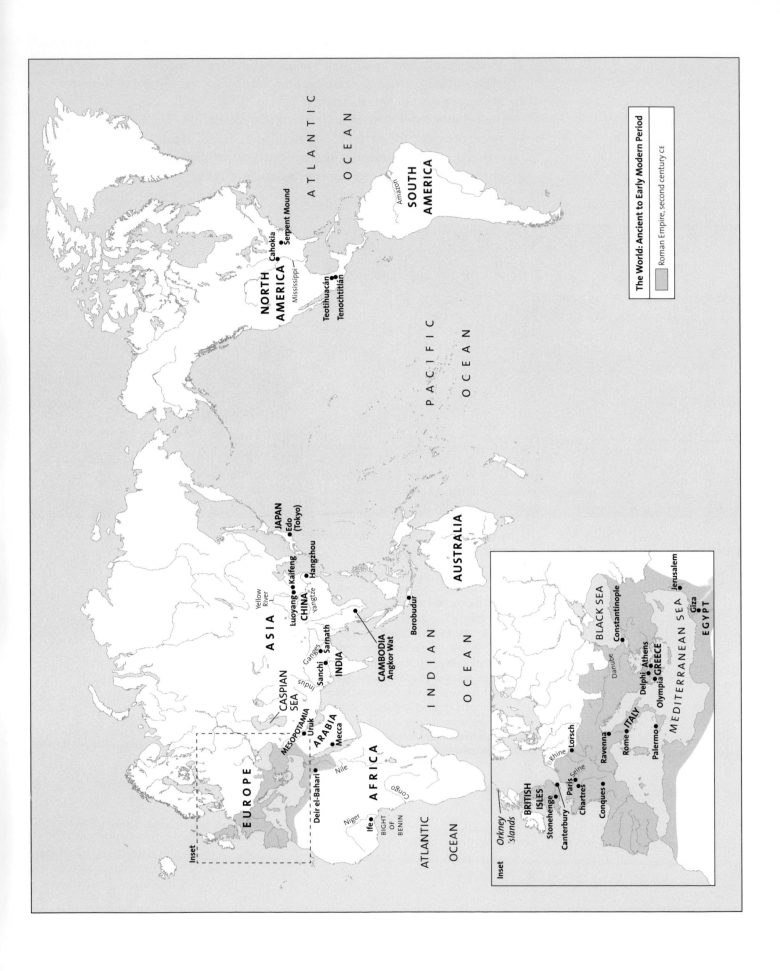

The World: Ancient to Early Modern Period

Roman Empire, second century CE

ATLANTIC OCEAN

SOUTH AMERICA

Amazon

NORTH AMERICA

Serpent Mound

Cahokia

Mississippi

Teotihuacán

Tenochtitlán

PACIFIC OCEAN

ATLANTIC OCEAN

ASIA

JAPAN

Edo (Tokyo)

Kaifeng

Hangzhou

Yellow River

Luoyang

CHINA

Yangtze

Sarnath

Gangus

Sanchi

Indus

INDIA

CAMBODIA

Angkor Wat

Borobudur

CASPIAN SEA

MESOPOTAMIA

Uruk

ARABIA

Mecca

AUSTRALIA

INDIAN OCEAN

EUROPE

AFRICA

Nile

Deir el-Bahari

Congo

Niger

Ife

BIGHT OF BENIN

Inset

Inset

BLACK SEA

Constantinople

Danube

Athens

Delphi

GREECE

Olympia

ITALY

Rome

Ravenna

Palermo

Lorsch

Rhine

Paris

Seine

Chartres

Conques

Canterbury

Stonehenge

BRITISH ISLES

Orkney Islands

MEDITERRANEAN SEA

Jerusalem

Giza

EGYPT

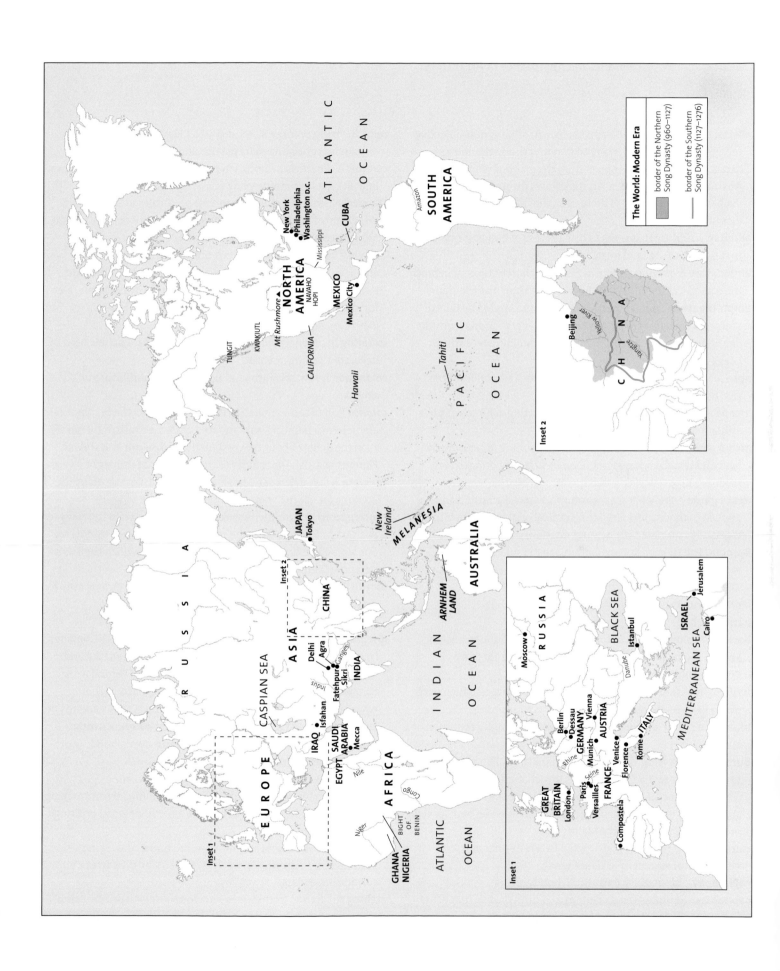

The World: Modern Era

border of the Northern Song Dynasty (960–1127)

border of the Southern Song Dynasty (1127–1276)

ATLANTIC OCEAN

New York
Philadelphia
Washington D.C.
Mississippi
CUBA
MEXICO
Mexico City
NORTH AMERICA
Mt Rushmore
NAVAHO
HOPI
KWAKIUTL
TLINGIT
CALIFORNIA
Hawaii

SOUTH AMERICA
Amazon

PACIFIC OCEAN
Tahiti

Inset 2
Beijing
CHINA
Yellow River
Yangtze

RUSSIA
ASIA
CHINA
JAPAN
Tokyo
New Ireland
MELANESIA
AUSTRALIA
ARNHEM LAND
Inset 2

CASPIAN SEA
Delhi
Agra
Fatehpur Sikri
Ganges
Indus
INDIA
Isfahan
IRAQ
SAUDI ARABIA
Mecca
EGYPT
Nile
AFRICA
Congo
Niger
BIGHT OF BENIN
GHANA
NIGERIA
EUROPE
Inset 1

INDIAN OCEAN

ATLANTIC OCEAN

Inset 1
Moscow
RUSSIA
BLACK SEA
Istanbul
Danube
Berlin
Dessau
GERMANY
Vienna
AUSTRIA
Rhine
Munich
Venice
ITALY
Florence
Rome
GREAT BRITAIN
London
Paris
Seine
Versailles
FRANCE
Compostela
MEDITERRANEAN SEA
ISRAEL
Jerusalem
Cairo

Glossary

(See also pp. 351–59, **Elements and Approaches to Art History**)

abstract A term that can be applied to: 1. Art that is **non-objective** relying on impulse and expression rather than attempting to depict any recognizable object from the exterior world, e.g., Abstract Expressionism. 2. Art that draws its images from the visible world, but renders them in abstract form, e.g., Cubism. (See also inset, p. 259.)

additive Sculpture that is made by a process of building malleable materials into the final form.

ambulatory A curving aisle in a Christian church running behind the main altar in the part of the building known as the choir.

amphitheater A circular or oval building surrounded by tiers of seats and used for entertainments such as gladiatorial contests, developed by the Romans, though often building on earlier Greek structures.

apse A semicircular, **vaulted** or **domed** recess, especially at the east end of a church.

arcade A series of arches, with their supporting columns or **piers**, either freestanding or attached to a wall.

arch A structural device used to span an opening other than by **post and lintel**, and used in the construction of bridges. (See inset, p. 70.)

avant garde A French term meaning "advanced guard," and applied to those considered to be radical or ahead of their times, especially to nineteenth-century artists or movements.

Baroque The sensual and exuberant artistic styles and architectural ornamentation of seventeenth-century Europe. The term can be applied more generally to any heavily ornamented style.

barrel vault see **vault**

basilica A **colonnaded** hall for public administration in ancient Roman towns, later adopted as a building type for Early Christian churches.

batik A process of dying fabric, originating in Java, in which parts not to be dyed are covered by wax.

bluestone A blue-grey sandstone containing a high proportion of clay.

buttress, buttressing The projecting supports built against a wall, usually to counteract the outward thrust of an **arch** or **vault**. In Gothic architecture, the **flying buttress** takes the form of a free-standing external **pier**, and the "flyer" is the slender arch (or half-arch) linking the pier to the wall.

cairn A mound of stones constructed to serve either as a geographical marker or as a memorial.

calligraphy fine, literally "beautiful," handwriting.

capital The decorated head of either a column or **pier**, that bears the weight of the structure above. See also **orders**.

cella The body, or inner sanctuary of a **Classical** temple (the remainder consisting of its portico and **colonnades**).

ceramic A nineteenth-century term embracing porcelain, faience, and all types of pottery made from clay and fired in a kiln.

Classical Historically, the term refers specifically to the art (and literature) of ancient Greece in the fifth century BCE, however it has gained a wider application to include the whole artistic production of the ancient Greek and Roman period. With a small "c" it is used to indicate an artwork, a "classic," that sets a standard as the best of its period, thus art historians can refer, for example, to the "classical tradition" in Buddhist India. (See inset, p. 140.)

coffering In architecture, the recessed geometrical panels used to decorate a ceiling or **vault**.

colonnade A row of columns, supporting an **entablature** or **arches**.

colorito Italian term applied to the use of color as the predominant element in a painting, as compared with the draftsmanship. By 1500 the debate about the rival merits of *disegno* (the style of Florentine artists) vs *colorito* (Venetian) was at its height.

concrete A fast-drying and hard volcanic sand, developed by the Romans for use in construction.

contrapposto In figurative artworks, a term applied to the twisted position of a body, where the weight appears to rest mainly on one leg, suggesting a relaxed figure but one in which there is a potential for movement.

diorite Geologically, a type of igneous rock, but the term is used by art historians to describe rock of a deep reddish-purple incorporating large crystals (also known as porphyry).

disegno Italian word meaning "drawing" or "design." The broader concept was explored by Alberti in the fifteenth century and encompassed the intellectual processes that lay behind a composition. The *arti del disegno* formed the basis of the education provided by Vasari in his academy (The Accademia del Disegno) founded in Florence, 1562. See also *colorito*, *istoria*.

dome An evenly curved, hemispherical **vault** over a building or room. See also **rotunda**.

Doric see **orders**

engraving An incised (sometimes known as *intaglio*) printmaking technique, the design being cut on to a metal or wood printing surface with a sharp tool.

entablature In **Classical** architecture, the horizontal elements. Supported by **columns**, it consists of the architrave, **frieze**, and cornice. See **orders**.

etching An incised (sometimes known as *intaglio*) printmaking technique, made by etching a design into a layer of wax on a

metal plate. The plate is bathed in acid which bites channels into the printing surface where the metal has been exposed.

expressionist Art that communicates emotion and feelings. Use of the term is not restricted to the Expressionist movement of the early twentieth century.

flying buttress see **buttress**

foreshortening The application of **perspective** in painting, or relief sculpture, to suggest that a single form (a limb, for example) protrudes from the **picture plane**.

form The physical characteristics of an artwork, which include line, shape, texture, value, and color, as opposed to its intellectual or emotional content.

forum The public space, surrounded by buildings, at the heart of an ancient Roman town.

found object An object not originally intended as art, but nonetheless presented as a work of art, or part of one. Also known by the French term, *objet trouvé*.

fresco A method of wall painting in which **pigments** in a water base are applied to wet plaster, into which they are absorbed, becoming fixed and insoluble. The Italian word means "fresh."

frieze The middle section of the horizontal **entablature** in the Classical **orders**. The term is also applied more generally to any decorated or sculpted horizontal band.

genre painting A representation of everyday life. The term genre can also be applied to sculpture representing such subject matter.

gestural Applied to a style of painting or drawing in which the artist's hand or arm movements are apparent in the finished work.

groin vault see **vault**

ground The surface on which a two-dimensional artwork is executed.

henge A circular monument dating from the Neolithic and Bronze Ages, usually consisting of a circle of vertically erected stones.

high relief see **relief**

icon A panel painting of a Christian subject, such as the Virgin, or a particular saint. Often small and portable, and sometimes believed to work miracles, these have been produced from the sixth century to the present, but especially by the Byzantines.

iconoclast Someone who destroys religious images or objects. The meaning extends also to a person who attacks established or traditional concepts.

iconography The visual conventions and symbols used to express ideas in a work of art.

illuminated manuscript (hence **illuminators**) A manuscript, or book, decorated by hand, often lavishly, with paintings or drawings.

illusionistic Term applied to the works of art (usually paintings) in which the objects depicted give the impression of being tangible and having both mass and volume.

installation A work of art, usually three-dimensional, that consists of an ensemble of objects set up according to the artist's design in a chosen location. Some installations may be disassembled and set up in alternative sites.

Ionic see **orders**

istoria A term first used in the fifteenth century to refer to complex narrative—usually figurative—paintings. Often used broadly to describe "history paintings," but to Alberti (1404–72) it implied some sort of higher moral purpose behind the work. See also *disegno*.

linear perspective Developed in fifteenth-century Europe, a means of conveying the illusion of depth on a two-dimensional **picture plane** by the use of lines converging at a vanishing point. Also known as scientific perspective.

lithograph A printmaking process using a flat stone (sometimes a plastic or metal plate) on to which the design is drawn in an oily crayon, to which the ink adheres.

lost-wax process A casting process in sculpture in which a clay model is covered with wax, and a further layer of clay. The wax is then melted away and molten metal poured in to fill the space. The clay can then be cracked away, revealing the metal sculpture. The French term *cire perdue* is sometimes used.

low relief see **relief**

mandala In Hindu and Buddhist art, any of various designs based on a circular diagram of the cosmos, having symbolic and spiritual meaning.

mandorla In representations of holy figures, the oval or almond shape, similar to a halo, that surrounds the body. (The halo is usually confined to the circular area behind the head.)

metope In the **Doric order**, the square element of the **frieze** area of the **entablature**. Metope panels contain carvings in **low relief**.

mihrab In a mosque, the niche in the *qibla* wall indicating the direction of Mecca.

monochrome A term used to describe a painting or drawing created using different values of a single color (especially shades of black, on a neutral background).

mosaic A two-dimensional artwork made of *tesserae*, small colored pieces of stone, **ceramic** or glass. Usually used on floors and walls.

mural A painting on a wall, usually but not always in **fresco**.

naturalism The attempt by artists to represent accurately and faithfully the actual (hence natural) appearance of things. Compare **realism**.

nave In church architecture, the central hall in which the congregation gather, flanked by aisles.

non-objective A term referring to art that does not represent or depict any known object. Sometimes referred to as non-representational.

oil paint A mixture of **pigment** and an oil such as linseed. The oil is

a flexible medium that allows for the distribution of the pigment, but which hardens when dry.

orders In Classical architecture an order consists of a column (with a base and shaft), **capital**, and **entablature**. Designed to give aesthetic definition and decoration to the **post and lintel** system, the **Doric** order is the most austere, and the **Ionic**, involving scrolled capitals, more decorative. Other orders include the Corinthian, the Tuscan, as well as composite versions. See also **metope**.

painterly In painting, the use of tone and brushstroke, rather than line, to define forms.

pastel A medium for drawing, made of pigment and a binding agent combined in a chalky-textured stick.

pediment The triangular area at the end of a gabled roof, often decorated with sculpture, particularly in ancient Greek architecture.

perspective An artistic device for representing objects in spatial recession, whether **linear** or aerial. See also **foreshortening**.

picture plane The flat surface of a picture, which, according to Western ideas of **perspective** acts as a two-dimensional 'window' on to a three-dimensional scene.

pier A solid masonry upright support (distinct from a column, which is made up of a base, shaft and **capital**).

pigment A powdered, colored material that is held together by a medium (such as gum arabic for **watercolor**, or oil in **oil paint**) that enables it to be evenly distributed and fixed to a **ground**.

pointillism The technique of applying dots of pure primary or secondary color in close proximity so that they combine visually when viewed from a certain distance.

post and lintel A simple system of construction for spanning an opening, consisting of vertical posts supporting the horizontal lintel.

postmodern Literally meaning "after modern" and applied to the arts and architecture, the term achieved common currency in the 1980s, but it is what historians call an "unstable" term because it means different things to different people. One definition, pertinent to the artworks discussed in chapter 10, is that is that it is "a postmodernism of resistance" and that the artists are influenced by a philosophy that challenges all hitherto accepted ideas about race, gender, sexuality, and the like.

print A work of art produced by any one of a number of printing techniques, including **engraving**, **etching**, **lithography**, **silkscreen** and **woodcut**.

qibla Strictly, the direction of Mecca, indicated in a mosque by the **mihrab**, to which Muslims must turn when praying; by extension, the wall in which the mihrab is placed.

realism The attempt by artists to depict life as it really is, using subject matter drawn from actual events, especially scenes from the daily life of the working-classes with no attempt to disguise

hardship, poverty, or grime. The term is also applied to mean the opposite of **abstraction**, and stylization, and its application is not restricted to the Realist movement of the nineteenth century. Compare **naturalism**.

relief Sculpture in which the forms protrude from the background surface. Called **high relief** when the figures extend outwards, in three dimensions, to a depth of at least half their natural form. **Low relief** (also known as bas relief) is relief sculpture in which the forms are flattened, projecting only slightly from the background.

ribbed vault see **vault**

Rococo The flamboyantly ornate, curvilinear style in architecture, and corresponding delicacy and freedom of painting style, that characterized the end of the **Baroque** period, particularly in France.

Romantic Emphasizing emotion and imagination, rather than intellect and logic, in Western art and literature, especially in the first half of the nineteenth century. Traditionally contrasted with Classicism.

rotunda A circular building or room, especially one that is topped by a **dome**.

roundel In architecture, a medallion or small circular window.

Salon French word meaning room, which, with a capital "S," identified exhibitions held in the Salon d'Apollon of the Louvre from the late seventeenth century, and which thereafter was applied to other official exhibitions held the Louvre and elsewhere in Paris in the course of the nineteenth century.

sarsen A form of silicified sandstone, boulders of which can be seen in megalithic monuments.

silkscreen A printmaking process in which ink is squeezed through a fine silk screen, parts of which have been masked by a stencil or other material. Also called serigraphy.

spolia Materials incorporated into a building that originate from an earlier construction, from which they have been removed.

still life A representation in two dimensions of inanimate objects—fruit, flowers, game or other foodstuffs, and ordinary household articles. This style of painting emerged as a popular genre in seventeenth-century northern Europe.

stupa A large hemispherical Buddhist shrine, erected to hold a relic or mark a holy site, the form evolving from earlier sacred Indian mounds.

subtractive A process in sculpture in which material is carved away (subtracted) in order to produce the final form of the work. Also known as reductive sculpture.

tapestry A heavy handwoven textile. The weaving technique allows for complex non-repetitive, often figurative, designs. Tapestry is often used for wall hangings.

tesserae see **mosaic**

transept The transverse arms of a cross-plan Christian church, placed at right-angles to the **nave**.

trilithon see **post and lintel**

trompe l'oeil A French term meaning "deceive the eye," applied in art to a painting whose main criterion for success is its ability to trick the mind into believing that the objects represented are real. See also **illusionistic**.

uki-e A style of **print** that emerged in Japan when the artist Toyoharu (1735–1814) applied Western perspective techniques to the indigenous **ukiyo-e** tradition.

ukiyo-e A movement of Japanese **genre** painting emerging in the sixteenth and seventeenth centuries, it is closely associated with the art of the popular **print** whose subject (representations of everyday life, portraits of well-known actors, and the like) had mass appeal.

vault, vaulting In architecture, the construction of a masonry ceiling based on the principles of the **arch**. The **barrel vault** (also known as a tunnel vault) is a series of coterminous arches, often requiring **buttressing**. The intersection of two barrel vaults, at right angles, forms a **groin vault**. The **ribbed vault** is a masonry ceiling in which arched diagonal ribs intersect at a central point to form a framework, and the wedge-shaped areas in between are then filled with lighter stone.

watercolor A mixture of **pigments** and gum arabic, dissolved in water. After application to an absorbent surface, such as paper, the gum acts as a drying agent.

woodcut A relief printmaking technique made by carving away areas of woodblock and inking the remaining surfaces.

ziggurat A rectangular mound or pyramid, built in recessive steps, with a temple at the top (see inset, p. 13).

Bibliography

General Survey Texts

L.S. Adams, *Art across Time* (Burr Ridge, IL, 1998, 2/2001)

F. Hartt, *Art: A History of Painting, Sculpture, Architecture* (New York, 1976, 4/1994)

H. Honour and J. Fleming, *The Visual Arts: A History* (Englewood Cliffs, NJ, 1982, 6/2002)

H.W. Janson, rev. A.F. Janson, *A History of Art* (New York, 1968, 5/1997)

M.K. O'Riley, *Art beyond the West* (London, 2001; New York, 2002)

M. Stokstad, *Art History* (Abrams, 1995)

R.G. Tansey, C.J. Mamiya and F.S. Kleiner, *Gardner's, Art through the Ages* (Fort Worth, 11/2000)

Chapter 1

C. Chippindale, *Stonehenge Complete* (Ithaca, NY, 1983, rev. 1994)

D.V. Clarke, T.G. Cowie, and A. Foxon, *Symbols of Power at the Time of Stonehenge* (Edinburgh, 1985)

M. Korp, *The Sacred Geography of the American Mound Builders*, Native American Studies, vol. 2 (Lewiston, NY, 1990)

A.T. Mann, *Sacred Architecture* (Rockport, MA, 1993)

P. Mason, *History of Japanese Art* (New York, 1993)

M. Miller, *The Art of MesoAmerican from Olmec to Axtec* (London, 1986)

P. Nabokov and R. Easton, *Native American Architecture* (New York, 1989)

E. Pasztory, *Pre-Columbian Art* (Cambridge, 1998)

E. Pasztory, "The Natural World as Civic Metaphor at Teotihuacan," in *The Ancient Americas: Art from Sacred Landscapes*, ed. R.F. Townsend (Chicago, 1992)

J. Perreault and P. Barreras del Rio, *Ana Mendieta: A Retrospective*, exh. cat., New Museum of Contemporary Art (New York, 1987)

J. Pomeroy, "Selections from 'Rushmore—Another Look' (with an Afterword)," in *Critical Issues in Public Art: Content, Context, Controversy*, ed. H.F. Senie and S. Webster (New York, 1992)

O. Rodriquez Roque, "The Exaltation of American Landscape Painting," in *American Paradise: The World of the Hudson River School*, exh. cat., Metropolitan Museum of Art (New York, 1987)

J. Sabloff, *The Cities of Ancient Mexico* (London, 1989)

A. Scheinker, "Buried in the Mounds: Excavating American Culture from Native American Artifacts," *Oculus: Journal for the History of Art* (Indiana University) 1:1 (1998), pp. 58–71

J.F. Sears, *Sacred Places: American Tourist Attractions in the Nineteenth Century* (New York, 1989)

H.F. Senie, *Contemporary Public Sculpture: Tradition, Transformation, and Controversy* (New York, 1992), especially chapter 4

P.C. Sherrod and M.A. Rolingson, *Surveyors of the Ancient Mississippi Valley*, Arkansas Archeological Survey Research Series, no. 28 (Fayetteville, AR, 1987)

H.C. Shetrone, *The Mound Builders* (New York, 1930)

R.A. Williamson, *Living the Sky: The Cosmos of the American Indian* (Boston, 1984)

Chapter 2

Antiquity/General

R. Brilliant, *Arts of the Ancient Greeks* (New York, 1973)

J. Campbell, *The Hero with a Thousand Faces* (Princeton, NJ, 1949, reprinted 1988)

M. Gimbutas, *The Language of the Goddess* (San Francisco, 1989)

R. Osborne, *Archaic and Classical Greek Art* (Oxford, 1998), especially chapter 9, pp. 75–85, 169–174

J. Pedley, *Greek Art and Archaeology* (Englewood Cliffs, NJ, 1993), pp. 166–181, 198–212

J.J. Pollitt, *Art and Experience in Classical Greece* (Cambridge, 1972), pp. 27–36

M. Robertson, *A Shorter History of Greek Art* (Cambridge, 1981), especially chapter 5, pp. 79–89

B.G. Walker, *The Woman's Encyclopedia of Myths and Secrets* (San Francisco, 1983), especially entries on *Apollo, Buddhism, Ishtar, Jesus Christ, Kore, Mary, Siva, Virgin Birth*

Christian Europe

J. Beckwith, *Early Christian and Byzantine Art* (Harmondsworth, 1970 and 1979)

R. Branner, *Chartres Cathedral* (New York, 1969), especially pp. 194–97

R. Cormack, *Byzantine Art* (Oxford, 2000)

K. Corrigan, *Visual Polemics in the Ninth-century Byzantine Psalters* (Cambridge, 1992)

A. Katzenellenbogen, *The Sculptural Programs of Chartres Cathedral* (Baltimore, 1959; New York, 1964), especially chapter 3

P. Kidson, *Sculpture at Chartres* (London, 1958)

T.F. Mathews, *Clash of Gods: A Reinterpretation of Early Christian Art* (Princeton, 1993)

J. Welch Williams, *Bread, Wine, and Money: The Windows of the Trades at Chartres Cathedral* (Chicago, 1993), especially chapter 3

Hindu and Buddhist

T.R. Blurton, *Hindu Art* (Cambridge, MA, 1993)

F. Bunce, *A Dictionary of Buddhist and Hindu Iconography* (New Delhi, 1997)

R. Craven, *Indian Art* (London, 1997)

R.E. Fisher, *Buddhist Art and Architecture* (London, 1993)

J.C. Harle, *The Art and Architecture of the Indian Subcontinent* (New Haven, 1986)

S. Lee, *A History of Far Eastern Art* (New York, 1973)

J. Munsterberg, *Art of India and Southeast Asia* (New York, 1970)

M.K. O'Riley, *Art beyond the West* (London, 2001; New York, 2002)

P. Pal, "Symbols of the Buddha Sakyamuni," *Light of Asia: Buddha Sakyamuni in Asian Art*, mus. cat., Los Angeles County Museum of Art (Los Angeles, 1984)

——, *Indian Sculpture*, Los Angeles County Museum of Art (Los Angeles, 1986)

B. Rowland, *Art and Architecture of India* (Harmondsworth, 1953), chapters 9 and 10

Aztec

J. Broda, D. Carrasco, and E. Matos Moctezuma, *The Great Temple of Tenochtitlan: Center and Periphery in the Aztec World* (Berkeley, CA, 1987)

E. Matos Moctezuma, *The Great Temple of the Aztecs* (London, 1988)M.K. O'Riley, *Art beyond the West* (London, 2001; New York, 2002)

E. Pasztory, *Aztec Art* (New York, 1983)

——, *Pre-Columbian Art* (London, 1998)

R.F. Townsend, "The Renewal of Nature at the Temple of Tlaloc," *The Ancient Americas: Art from Sacred Landscapes* (Chicago and Munich, 1992)

Chapter 3

Middle East and Africa

M. Blackmun Visonà, et al., *A History of Art in Africa* (New York, 2001)

S.P. Blier, *Royal Arts of Africa* (London, 1998)

A. Duchâteau, *Benin: Royal Art of Africa* (Munich, 1994)

D. Fraser and H.M. Cole, *African Art and Leadership* (Madison, 1972)

P. Girshick Ben-Amos, *The Art of Benin* (Washington, D.C., 1995)

H.A. Groenewegen-Frankfort and B. Ashmole, *Art of the Ancient World* (Englewood Cliffs, NJ, and New York, 1971)

S. Lloyd, *Art of the Ancient Near East* (New York, 1961)

N. Luomala, "Matrilineal Reinterpretations of Some Egyptian Sacred Cows," *Feminism and Art History: Questioning the Litany* (New York, 1982)

L. Meyer, *Art and Craft in Africa* (Paris, 1995)

E. Porada, with the collaboration of R.H. Dyson and contributions by C.K. Wilkinson, *The Art of Ancient Iran: Pre-Islamic Cultures* (New York, 1969)

R. Winks, et al., *A History of Civilization* (Englewood Cliffs, NJ, 1992)

Rome, Byzantium and Medieval Europe

J. Beckwith, *Early Christian and Byzantine Art* (Harmondsworth, 1970 and 1979)

D. Bernstein, *The Mystery of the Bayeux Tapestry* (Chicago, 1986)

G. Bovini, *Ravenna Mosaics* (New York, 1978)

R. Cormack, *Byzantine Art* (Oxford, 2000)

C. Head, *Imperial Byzantine Portraits* (New Rochelle, NY, 1982)

H. Kähler, *The Art of Rome and Her Empire* (New York, 1963 and 1965)

R. Krautheimer, *Early Christian and Byzantine Architecture* (Harmondsworth, 1965 and 1979)

H.P. L'Orange, *Studies in the Iconography of Cosmic Kingship* (New Rochelle, NY, 1982)

F. Mütherich and J. Gaehde, *Carolingian Painting* (New York, 1976)

J. Snyder, *Medieval Art* (Englewood Cliffs, NJ, 1989)

R. Stalley, *Early Medieval Architecture* (Oxford, 1999)

M. Stokstad, *Medieval Art* (New York, 1986)

O. von Simson, *Sacred Fortress: Byzantine Art and Statecraft in Ravenna* (Princeton, NJ, 1987)

J.B. Ward-Perkins, *Roman Imperial Architecture* (Harmondsworth, 1970 and 1981)

O.K. Werckmeister, "The Political Ideology of the Bayeux Tapestry," *Studi Medievali*, 3rd series, 17 (1976), pp. 535–95

India, Southeast Asia, and Hawaii

W.E. Begley, "The Myth of the Taj Mahal and a New Theory of Its Symbolic Meaning," *Art Bulletin*, 61 (1979), pp. 7–37

T. Cummins, "Kinshape: The Design of the Hawaiian Feather Cloak," *Art History*, 7:1 (1984), pp. 1–20; also in *The Arts of Africa, Oceania, and the America: Selected Readings*, ed. J. Berlo and L. Wilson (Englewood Cliffs, NJ, 1993)

A. D'Alleva, *Art of the Pacific* (London, 1998)

C. Holt, *Art in Indonesia* (Ithaca, NY, 1967)

S. Lee, *A History of Far Eastern Art* (New York, 1973)

M. Klokke, "Indonesian Art," in M. Girard-Geslan, et. al., *Art of Southeast Asia* (Paris, 1994/New York, 1998), pp. 342–354

J. Miksic, *Borobudur: Golden Tales of the Buddhas* (Jakarta, 1990)

J. Munsterberg, *Art of India and Southeast Asia* (New York, 1970)

G. Necipŏglu, "Taj Mahal," review of W.E. Begley and Z.A. Desai,

Taj Mahal: The Illumined Tomb (1989), *Journal of Society for Architectural Historians*, 51:3 (1992), pp. 341–44

P. Rawson, *The Art of Southeast Asia* (London, 1967)

Chapter 4

Greek

B. Ashmole, *Architect and Sculptor in Classical Greece* (New York, 1972)

R. Brilliant, *Arts of the Ancient Greeks* (New York, 1973)

P. Fehl, "The Rocks on Gods and Men in the Parthenon Frieze," *Journal of the Warburg and Courtauld Institutes*, 24 (1961), pp. 1–44 in Vincent J. Bruno, ed., *The Parthenon* (New York, 1974)

R. Meiggs, "The Political Implications of the Parthenon" in Vincent J. Bruno, ed., *The Parthenon* (New York, 1974)

J. Neils, "Reconfiguring the Gods on the Parthenon Frieze," *Art Bulletin*, 81:1 (1999), 6–17

R. Osborne, *Archaic and Classical Greek Art* (Oxford, 1998), especially chapter 9

J. Pedley, *Greek Art and Archaeology* (Englewood Cliffs, NJ, 1993), especially chapter 8

J.J. Pollitt, *Art and Experience in Classical Greece* (Cambridge, 1972), especially chapters 2 and 3

M. Robertson, *A Shorter History of Greek Art* (Cambridge, 1981), especially chapter 5

L.V. Watrous, "The Sculptural Program of the Siphnian Treasury at Delphi," *American Journal of Archeology*, 86 (1982), pp. 159–72

Medieval Christian

B. Abou-el-Haj, "The Urban Setting for Late Medieval Church Building: Reims and Its Cathedral between 1210 and 1240," *Art History*, 11:1 (1988), pp. 3–88

P. Brown, *The Cult of the Saints: Its Rise and Function in Christianity* (Chicago, 1981)

E. Dahl, "Heavenly Images: The Statue of Ste. Foy of Conques and the Signification of the Medieval 'Cult-Image' in the West," *Acta ad Archeologiam et Artium Historiam Pertinentia*, 8 (1978), pp. 175–91

D. Freedberg, *The Power of Images: Studies in the History and Theory of Response* (Chicago, 1989), p. 90

P. Geary, *Furta Sacra: Thefts of Relics in the Central Middle Ages* (Princeton. NJ, 1978 and 1990)

L. Nees, *Early Medieval Art* (Oxford, 2002)

A. Petzold, *Romanesque Art* (New York, 1995)

M. Stokstad, *Medieval Art* (New York,1986)

J. van der Meulen, "Angrenzende Bauwerke der Kathedrale von Chartres," *Jahrbuch der Berliner Museen*, 16 (1974), pp. 5–45

J. Welch Williams, *Bread, Wine, and Money: The Windows of the Trades at Chartres Cathedral* (Chicago 1993)

Islamic

S. Blair and J. Bloom, *Images of Paradise in Islamic Art*, exh. cat., Hood Museum of Art (Darmouth, TX, 1991)

B. Brend, *Islamic Art* (Cambridge, MA, 1991)

R. Ettinghausen and O. Grabar, *The Art and Architecture of Islam: 650–1250* (Harmondsworth, 1987), especially chapter 2

O. Grabar, *The Formation of Islamic Art* (New Haven, 1973), especially chapters 3 and 5

R. Hillenbrand, *Islamic Art and Architecture* (London, 1999), especially chapter 1

——, *Islamic Architecture: Form, Function, Meaning* (New York, 1994)

J. Hoag, *Islamic Architecture* (New York, 1977)

R. Irwin, *Islamic Art* (London, 1977)

Other

L. Lippard, *Mixed Blessings: New Art in a Multicultural America* (New York, 1990)

K.A. Marling, *Graceland: Going Home with Elvis* (Cambridge, MA, 1996)

Chapter 5

Benin

M. Blackmun Visonà, et al., *A History of Art in Africa* (New York, 2001)

S.P. Blier, *Royal Arts of Africa* (London, 1998)

A. Duchâteau, *Benin: Royal Art of Africa* (Munich, 1994)

P. Girshick Ben-Amos, *The Art of Benin* (Washington, D.C., 1995)

Chinese Painting

R. Barnhart, et al., *Three Thousand Years of Chinese Painting (The Culture and Civilization of China)* (New Haven, 1997)

S. Bush, *The Chinese Literati on Painting* (Cambridge, MA, 1971)

J. Cahill, *The Painter's Practice* (New York, 1994)

A. Clapp, *The Painting of T'ang Yin* (Chicago, 1991)

C. Clunas, *Art In China* (Oxford, 1997)

J. Rawson, *The British Museum Book of Chinese Art* (London, 1997)

M. Sullivan, *The Three Perfections: Chinese Painting, Poetry and Calligraphy* (London, 1974; New York, 1980 and 1999)

R.L. Thorp and R.E. Vinograd, *Chinese Art and Culture* (New York, 2001)

Italian Renaissance

S. Baldassari and A. Saiber, *Images of Quattrocento Florence: Selected Writings in Literature, History, and Art* (New Haven, 2000)

E. Barker et al., *The Changing Status of the Artist* (New Haven, 1999)

M. Baxandall, *Painting and Experience in Fifteenth Century Italy* (Oxford, 1974)

A. Blunt, *Artistic Theory in Italy 1450–1600* (Oxford, 1962)

R. Cocke, *From Magic to High Fashion: The Classical Tradition and the Renaissance of Roman Patronage, 1420–1600,* (Wallingford, PA, 1993)

M.D. Garrard, *Artemisia Gentileschi: The Image of the Female Hero in Italian Baroque Art* (Princeton, NJ, 1989)

F. Hartt, *History of Italian Renaissance Art* (New York, 1972)

D. Kent, *Cosimo de Medici and the Florentine Renaissance: The Patron's Oeuvre* (New Haven, 2000)

R. King, *Brunelleschi's Dome* (New York, 2000)

H. Klein and H. Zerner, *Italian Art 1500–1600* (Evanston, IL, 1990)

D. Mateer, *Courts, Patrons, and Poets* (New Haven, 2000)

D. Rosand, *Painting in Cinquecento Venice* (Cambridge, 1997)

New Ireland

A. D'Alleva, *Arts of the Pacific Islands* (New York, 1998)

Mughal Art

M. Brand and G. Lowry, *Akbar's India: Art from the Mughal City of Victory*, exh. cat., Asia Society Galleries (New York, 1985)

A. Fazl, *Akbarnama*, trans. H. Beveridge (Delhi, 1972)

A. Okada, *Master Artists of the Imperial Mughal Court* (Bombay, 1991)

A. Poster, *Realms of Heroism Indian Paintings in the Brooklyn Museum*, exh. cat. (New York, 1994)

M.S. Randhawa and J.K. Galbraith, *Indian Painting: The Scene, Themes and Legends* (Boston, 1968)

G. Sen, *Paintings from the Akbarnama: A Visual Chronicle of Mughal India* (Varanasi, 1984)

S.P. Verma, *Art and Material Culture in the Paintings of Akbar's Court* (New Delhi, 1978)

French Art and Louis XIV

R. Berger, *A Royal Passion: Louis XIV as a Patron of Architecture* (Cambridge, 1997)

A. Blunt, *Art and Architecture in France 1500–1700* (Harmondsworth, 1970)

P. Duro, *The Academy and the Limits of Painting in Seventeenth-century France* (Cambridge, 1997)

M. Gareau, *Charles Le Brun: First Painter to Louis XIV*, trans. K. Sermat (New York, 1992)

F. Haskell, *Patrons & Painters* (New York, 1963)

J.R. Martin, *Baroque* (New York, 1977)

Chapter 6

Early Collections

M. Beard and J. Henderson, *Classical Art* (Oxford, 2001)

B. Buettner, "Past Presents: New Year's Gifts at the Valois Courts," *Art Bulletin*, 83:4 (2001), pp. 598–625

W. Chadwick, *Women, Art, and Society* (London, 1990)

A.D. Hedeman, *The Royal Image: Illustrations of the "Grandes Chroniques de France," 1274–1422* (Berkeley, CA, 1991)

J. Marquardt-Cherry, *Objects of Personal Significance*, exh. cat., Museum Exhibits USA, Mid-America Arts Alliance (Kansas City, MO, 1996)

W. Muensterbuerger, *Collecting: An Unruly Passion* (Princeton, NJ, 1994), especially chapter 4

J.M. Muller, *Rubens: The Artist as Collector* (Princeton, NJ, 1989)

C. Sterling, *Still Life Painting: From Antiquity to the Present Time* (New York, 1959. rev. 2/1981)

A. Sutherland-Harris and L. Nochlin, *Women Artists 1550–1950*, exh. cat., Los Angeles County Museum of Art (New York, 1976)

P. Taylor, *Dutch Flower Painting 1600–1720* (New Haven, 1995)

Eighteenth and Nineteenth Centuries

J.S. Boggs, et al., *Degas*, exh. cat., Metropolitan Museum of Art, New York (New Haven, 1988)

T.J. Clark, *The Painting of Modern Life: Paris in the Art of Manet and His Followers* (Princeton, 1984)

A. Duchâteau, *Benin: Royal Arts of Africa* (Munich, 1994)

P. Girshick Ben-Amos, *The Art of Benin* (Washington, D.C., 1995)

G. Heard Hamilton, *Manet and His Critics* (New Haven, 1954)

E. Lipton, *Alias Olympia* (New York, 1992, reprinted 1999)

P. Mason, *History of Japanese Art* (New York, 1993)

A. McClellan, *Inventing the Louvre: Art, Politics, and the Origin of the Modern Museum in 18^{th}-century Paris* (Berkeley, CA, 1994)

M. Narazaki, *Hokusai: "The Thirty-six Views of Mt. Fuji"* (Tokyo, 1968)

M. Narazaki and S. Kikuchi, *Utamaro* (Tokyo, 1969)

J. Rewald, *The History of Impressionism* (New York, 1973)

M.F. Symington Sanger, *Henry Clay Frick: An Intimate Portrait* (New York, 1998)

B. Thompson, *Impressionism: Origins, Practice, Reception* (London, 2000)

T. Vettros, *The Elgin Affair: The Abduction of Antiquity's Greatest Treasures and the Passions it Aroused* (New York, 1997)

E. White, *The Flâneur: A Stroll through the Paradoxes of Paris* (London, 2001)

C. Whitford, *Japanese Prints* (New York, 1978)

Twentieth Century

L.H. Nicholas, *The Rape of Europa: The Fate of Europe's Treasures in the Third Reich and the Second World War* (New York, 1994)

C. Moorhead, *Lost and Found: The 9000 Treasures of Troy* (London, 1994), especially chapters 15 and 16

B. Rose, *American Art since 1900* (New York, 1967, rev. 1975)

Sensation, exh. cat., Royal Academy of Arts (London, 1997)

M. Simon, *The Battle of the Louvre: The Struggle to Save French Art in World War II* (New York, 1971)

Chapter 7

Rococo to French Neoclassicism

A. Boime, *Art in the Age of Revolution 1750–1800* (Chicago, 1987)

A. Braham, *The Architecture of the French Enlightenment* (Berkeley, CA, 1980)

T. Crow, *Painters and Public Life in Eighteenth-century Paris* (New Haven, 1985)

J. Plax, *Watteau and the Cultural Politics of Eighteenth-century France* (Cambridge, 2000)

E.A. Sayre, A.E. Perex Sanchez, and M. Jupe, ed., *Goya and the Spirit of the Enlightenment*, exh. cat., Museum of Fine Arts (Boston, 1989)

American Revolution

D. Bjelajac, *American Art: A Cultural History* (London, 2001)

F.K. Pohl, *Framing America: A Social History of American Art* (London, 2002)

M. Trachtenberg and I. Hyman, *Architecture, from Prehistory to Postmodernity* (New York, 2002)

French Nineteenth Century

T.J. Clark, *The Absolute Bourgeois: Artists and Politics in France 1848–1851* (London, 1973)

——, *The Painting of Modern Life: Paris in the Art of Manet and His Followers* (Princeton, 1984)

S. Faunce and L. Nochlin, *Courbet Reconsidered*, exh. cat., Brooklyn Museum (New York, 1988)

R.L. Herbert, *Impressionism: Art, Leisure and Parisian Society* (New Haven, 1988)

J. Rewald, *The History of Impressionism* (New York, 1973)

J. Roos, *Early Impressionism and the French State* (Cambridge, 1996)

G. Weisberg, *The European Realist Tradition* (Bloomington, IN, 1982)

Mexico

L. Folgarait, *Mural Painting and Social Revolution in Mexico, 1920–1940* (Cambridge, 1998)

L. Hurlburt, *The Mexican Muralists in the United States* (Albuquerque, NM, 1989)

A. Rodriguez, *A History of Mexican Mural Painting* (London, 1969)

Russia

S. Baron and M. Tuchman, *The Avant Garde in Russia 1910–1930*, exh. cat., Los Angeles County Museum of Art (Boston, 1980)

J. Brooks, *Thank You, Comrade Stalin! Soviet Public Culture from Revolution to Cold War* (Princeton, NJ, 2000)

Great Utopia: The Russian and Soviet Avant-Garde 1915–1932, exh. cat., Guggenheim Museum (New York, 1992)

C. Lodder, *Russian Constructivism* (New Haven, 1983)

China

J. Andrews, *Painters and Politics in the People's Republic of China* (Berkeley, CA, 1994)

J.F. Andrews, et al., *A Century in Crisis: Modernity and Tradition in the Art of Twentieth-century China*, exh. cat., Guggenheim Museum (New York, 1998)

H. Evans, ed., *Picturing Power in the People's Republic of China* (Lanham, PA, 1999)

P. Powell, *Mao's Graphic Voice: Pictorial Posters from the Cultural Revolution*, exh. cat., Elvehjem Museum of Art (Madison, 1996)

Chapter 8

Neo-Impressionism

T.J. Clark, *The Painting of Modern Life: Paris in the Art of Manet and His Followers* (Princeton, NJ, 1984)

J. Halperin, *Félix Fénéon: Aesthete and Anarchist in Fin-de-siècle Paris* (New Haven and London, 1988)

L. Nochlin, *The Politics of Vision: Essays on Nineteenth-century Art and Society* (Boulder, CO, 1989)

Modern Art in Paris

D. Cottington, *Cubism* (Cambridge, 1998)

J. Freeman, *The Fauve Landscape* (New York, 1990)

C. Harrison et al., *Primitivism, Cubism, Abstraction: The Early Twentieth Century* (New Haven, 1993)

G. Perry, *Women Artists and the Parisian Avant-Garde: Modernism and Feminine Art, 1900 to the late 1920s* (New York, 1995)

W. Rubin, ed., *Picasso and Portraiture: Representation and Transformation*, exh. cat., The Museum of Modern Art (New York, 1996)

S. Whitfield, *Fauvism* (London and New York, 1996)

German Expressionism

T. Benson, *Expressionist Utopias: Paradise, Metropolis, Architectural Fantasy*, exh. cat., Los Angeles County Museum of Art (Los Angeles, 1993)

R. Heller, *Brücke: German Expressionist Prints from the Granvil and Marcia Specks Collection*, exh. cat., The Gallery (Evanston, IL, 1988)

J. Lloyd, *German Expressionism: Primitivism and Modernity* (New Haven, 1991)

P.H. Selz, *German Expressionist Painting* (Berkeley, CA, 1957)

Futurism

G. Berghaus, *Futurism and Politics: Between Anarchist Rebellion and Fascist Reaction, 1909–1944* (Berlin, 1996)

R. Cork, *Vorticism and Abstract Art in the First Machine Age*, 2 vols. (London, 1996)

P. Hulten, ed., *Futurism and Futurisms* (New York, 1986)

M. Kirby and V.N. Kirby, *Futurist Performance: Includes Manifestos, Playscripts, and Illustrations* (New York, 1987)

The United States: Color and the Future

S.A. Buckberrough, *Sonia Delaunay: A Retrospective*, exh. cat., Albright-Knox Art Gallery (Buffalo, NY, 1980)

J. Damase, *Sonia Delaunay: Fashion and Fabrics* (New York, 1997)

H. Duchting, *Delaunay* (New York, 1994)

S. Eskilson, "Color and Consumption," *Design Issues*, 18:2 (2002), pp. 17–29

——, "Thomas Wilfred and Intermedia," *Leonardo*, 36:1 (2003), pp. 65–68

G. Levin, *Synchromism and American Color Abstraction 1910–1925* (New York, 1978)

R. Marchand, *Advertising the American Dream: Making Way for Modernity 1920–1940* (Berkeley, CA, 1985)

Weimar Germany

R. Bridenthal, Atina Grossman, and Marion Kaplan, ed., *When Biology Became Destiny: Women in Weimar and Nazi Germany* (New York, 1984)

M. Droste, *Bauhaus 1919–1933* (New York, 1998)

B. McCloskey, *George Grosz and the Communist Party: Art and Radicalism in Crisis, 1918 to 1936* (Princeton, 1997)

P. McGilligan, *Fritz Lang: The Nature of the Beast* (New York, 1997)

Chapter 9

Aboriginal Art

W. Caruana, *Aboriginal Art* (London, 1993)

H. Morphy and M.S. Boles, *Art From the Land: Dialogues with the Kluge-Ruhe Collection of Australian Aboriginal Art* (Charlottesville, VA, 1999)

P. Sutton, ed., *Dreamings: The Art of Aboriginal Australia* (New York, 1988)

Yoruban Art

R. Abiodun, et al., *The Yoruba Artist: New Theoretical Perspectives on African Arts* (Washington, D.C., 1994)

H.J. Drewal, *Yoruba: Nine Centuries of African Art and Thought* (New York, 1989)

Native American Art

C. Feest, *Native Arts of North America* (London, 1980)

A. Jonaitis, *Art of the Northern Tlingit* (Seattle, 1986)

N.J. Parezo, *Navajo Sandpainting: From Religious Act to Commercial Art* (Tucson, AZ, 1983)

H. Teiwes, Kachina Dolls: The Art of Hopi Carvers (Tucson, AZ, 1991)

S. Walens, "The Weight of My Name is a Mountain of Blankets," *Celebration: Studies in Festivity and Ritual*, ed. V. Turner (Washington, D.C., 1982), 178–89

L.C. Wyman, *Southwest Indian Drypainting* (Santa Fe, NM, 1983)

Expressionism

C. Bailey, ed., *Gustav Klimt: Modernism in the Making* (New York, 2001)

S. Barron and W.D. Dube, ed., *German Expressionism: Art and Society* (New York, 1997)

W.G. Fischer, *Egon Schiele 1890–1918: Desire and Decay* (Munich, 1998)

P. Greenhalgh, *Art Nouveau: 1890–1914* (New York, 2000)

J. Leggio and K. Varnedoe, *Vienna 1900: Art, Architecture & Design*, exh. cat., The Museum of Modern Art (New York, 1986)

Dada

S. Foster, *Crisis and the Arts: The History of Dada* (Englewood Cliffs, NJ, 1996)

S. Freud, *Jokes and Their Relation to the Unconscious* (1905), trans. J. Strachey (London, 1960; New York, 1972)

F.M. Naumann, et al., *Making Mischief: Dada Invades New York* (New York, 1996)

N. Sawelson-Gorse, *Women in Dada: Essays on Sex, Gender, and Identity* (Boston, 1998)

Surrealism

W.J. Campbell, *The Essential Surrealism* (New York, 2002)

W. Chadwick, *Women Artists and the Surrealist Movement* (Boston, 1985)

W. Chadwick, ed., *Mirror Images: Women, Surrealism, and Self-representation* (Boston, 1998)

R. Krauss and J. Livingston, *L'Amour Fou: Photography and Surrealism* (New York, 1985, reprinted 2002)

J. Mundy, ed., *Surrealism: Desire Unbound* (Princeton, NJ, 2001)

Abstract Expressionism

K. Pepe and K. Varnedoe, *Jackson Pollock: New Approaches* (New York, 1999)

S. Polcari, *Abstract Expressionism and the Modern Experience* (Cambridge, 1993)

W.J. Rushing, *Native American Art and the New York Avant-Garde: A History of Cultural Primitivism* (Austin, TX, 1995)

European Abstraction

L. Danchin, *Jean Dubuffet* (Paris, 2001)

J. Dubuffet, *Jean Dubuffet: Towards an Alternative Reality* (New York, 1987)

A. Schneider, *Alberto Giacometti: Sculptures Paintings Drawings* (Munich, 1997)

Chapter 10

Feminist Art

N. Broude and M.D. Garrard, ed., *The Power of Feminist Art: The American Movement of the 1970s, History and Impact* (New York, 1994)

B. Friedan, *The Feminine Mystique* (New York, 1963)

A. Jones, *Sexual Politics* (Berkeley, CA, 1996)

R. Parker and G. Pollock, *Old Mistresses: Women, Art and Ideology* (London, 1986)

G. Pollock, *Vision and Difference: Femininity, Feminism and the Histories of Art* (London, 1990)

R. Rosen and C.C. Brawer, *Making Their Mark: Women Artists Move into the Mainstream, 1970–1985*, exh. cat., Cincinatti Art Museum (New York, 1989)

African American Art

R. Henkes, *The Art of Black American Women* (London, 1993)

L. King-Hammond, ed., *Gumbo Ya Ya: Anthology of Contemporary African-American Women Artists* (New York, 1995)

J.T. Marquardt-Cherry, "African American Women's Confrontational Art," *Exposure 33*, 1:2 (2000), pp. 53–60

S. Patton, *African-American Art* (Oxford and New York, 1998)

R.J. Powell, *Black Art and Culture in the Twentieth Century* (London, 1997)

M. Wallace, "'Why are There No Great Black Artists?' The Problem of Visuality in African-American Culture," in *Black Popular Culture*, ed. G. Dent (Seattle, 1992; New York, 1998), pp. 333–46

Multicultural Art

S. Breitwieser, ed., *Double Life: Identity and Transformation in Contemporary Art* (Berlin, 2002)

M. Brenson, *Visionaries and Outcasts, the Nea, Congress, and the Place of the Visual Arts in America* (New York, 2001), pp. 14–38

R. del Castillo, T. McKenna, and Y. Yarbro-Bejarano, ed., *Chicano Art Resistance and Affirmation 1965–1985*, exh. cat., Wight Art Gallery of the University of California (Los Angeles, 1991), pp. 83–96

G. Gomez-Pena and R. Sifuentes, *Temple of Confessions: Mexican Beasts and Living Santos* (New York, 1996)

L. Lippard, *Mixed Blessings: New Art in a Multicultural America* (New York, 1990)

M. Machida, et al., *Asia/America Identities in Contemporary Asian American Art*, exh. cat., The Asia Society Galleries (New York, 1994), pp. 65–110

E. Sussman et al., ed., *1993 Biennial Exhibition*, exh. cat., Whitney Museum of American Art (New York, 1993)

L. Weintraub, *The Decade Show: Framework of Identity in the 1980s*, exh. cat., Museum of Contemporary Hispanic Art (New York, 1990)

——, *Art on the Edge and Over: Searching for Art's Meaning in Contemporary Society 1970s–1990s* (Litchfield, CT, 1996)

Picture Credits

Laurence King Publishing Ltd, the authors and the picture researcher wish to thank the institutions and individuals who have kindly provided photographic material for use in this book. Museum and gallery locations are given in the captions; other sources and copyright information are listed below.

1.1, 22 Courtesy of the Estate of Ana Mendieta
1.2 Robert Harding Picture Library, London/C Bowman
1.3, 11 Werner Forman Archive, London
1.4 Robert Harding Picture Library, London/Robert Estall
1.5 Robert Harding Picture Library, London/Adam Woolfitt
1.6 Robert Harding Picture Library, London/G M Williams
1.7 Japan Information & Cultural Centre, Japanese Embassy, London
1.8 Art Archive, London/Aikawa Archaeology Museum
1.10 Network Photographers, London/Georg Gerster
1.12 Corbis/Michael S Lewis
1.13 Robert Harding Picture Library, London/Richard Ashworth
1.14 Collection of the New-York Historical Society #1858.11.13
1.15 From Vol 2. *American Scenery* by Nathaniel Parker Willis/ Private Collection
1.16 Robert Harding Picture Library, London/D Jacobs
1.17 Photo Dia Art Foundation, New York/Nancy Holt. © Estate of Robert Smithson/VAGA, New York/DACS, London 2003
1.18 Outdoor Sculpture Collection, Western Washington University, Bellingham. Funding from the Virginia Wright Fund, the National Endowment for the Arts, Washington State Arts Commission, Western Washington University Art Fund and the artist's contributions. © DACS, London VAGA, New York 2003
1.19 University of South Florida. Solar Rotary was made possible by Florida's Art in State Buildings Program and sponsored by The Tampa Tribune. © DACS, London VAGA, New York 2003
1.20 Photo © Dia Art Foundation, New York/John Cliett
1.21 Courtesy Dia Center for the Arts, New York. Photo James Turrell. © James Turrell

2.1 Art Archive, London/Christies/Eileen Tweedy
2.3 Scala Istituto Fotografico Editoriale, Florence
2.4, 8 Alison Frantz Collection, ASCSA
2.5 TAP, Athens
2.6 Bildarchiv Preussischer Kulturbesitz, Berlin. Photo Jurgen Liepe
2.7 Deutsches Archäologisches Institut, Athens. #75.885
2.9 Marie Mauzy, Athens
2.11 © Vincenzo Pirozzi, Rome (fotopirozzi@inwind.it)
2.12 Art Archive, London/Dagli Orti
2.13 State Historical Museum, Moscow. #Cod. 129, folio 67r
2.14 AKG Images, London/Raimer Hackenberg
2.15 Sonia Halliday Photographs, Weston Turville, UK
2.16 E Boudot-Lamotte
2.17 © Studio Fotografico Quattrone, Florence
2.18 Robert Harding Picture Library, London/Richard Ashworth
2.19 British Museum, London. #OA1872.7-1.70
2.20 British Museum, London. #OA 1872.7-1.59
2.21 Nelson-Atkins Museum of Art, Kansas City. Purchase Nelson Trust. Photo Robert Newcombe. #34-7
2.22 AKG Images, London/Jean-Louis Nou
2.23 Bildarchiv Preussischer Kulturbesitz, Berlin. Photo Iris Papadopoulos
2.25, 26 Dinodia, Bombay
2.27 Werner Forman Archive, London
2.28 Corbis/Sakamoto Photo Research Laboratory
2.29 © Cleveland Museum of Art 2003. The Norweb Collection. #CMA1950.579
2.30 Art Archive, London
2.31, 32 Art Archive, London/Dagli Orti

3.1, 8, 44, 47, 49 Bridgeman Art Library, London
3.2 Institute of Archaeology Library, University of London
3.5, 13 Fotoarchiv Hirmer Verlag, Munich
3.6, 42 E Boudot-Lamotte
3.7 Sonia Halliday Photographs, Weston Turville, UK/C Rising
3.9 AKG Images, London/François Guenet
3.10 © Paul Maeyaert
3.11 Werner Forman Archive, London
3.14 AKG Images, London/Erich Lessing

3.15 Robert Harding Picture Library, London/Ellen Rooney
3.16 Robert Harding Picture Library, London/Eitan Simanor
3.17 Robert Harding Picture Library, London/Gavin Hellier
3.18 Photothèque André Held, Lausanne
3.20 Werner Forman Archive, London
3.21 R Bradbury
3.22 British Museum, London. #1953Af5.1
3.23 Herbert M Cole
3.24 Associated Press/Greg Gibson
3.25 British Museum, London. #1909,12-10.1
3.26, 29a, 30, 32, 35, 36, 37 © Vincenzo Pirozzi, Rome (fotopirozzi@inwind.it)
3.27 Fototeca Unione, Academia Americana, Rome
3.33 Art Archive, London/Dagli Orti
3.34 Sonia Halliday Photographs, Weston Turville, UK/Polly Buston
3.38 Art Resource, New York/Alinari, Florence
3.39 G E Kidder Smith, New York
3.43 © Cameraphoto Arte, Venice
3.45 Scala Istituto Fotografico Editoriale, Florence
3.46 Bildarchiv Marburg, Germany
3.48 Bayerische Staatsbibliothek, Munich. #CLM 14000 f.5v + 6r
3.50 Robert Harding Picture Library, London/Luca Tettoni
3.51 Corbis/Charles & Josette Lenars
3.52 Robert Harding Picture Library, London/Naga Productions
3.53 Robert Harding Picture Library, London/Gavin Hellier
3.54 British Museum, London. #HAW 133
3.55, 56 Robert Harding Picture Library, London/Roy Rainford
3.57 Robert Harding Picture Library, London/John Ross
3.58, 59 Robert Harding Picture Library, London/Jeff Greenberg

4.1, 23, 28, 35, 37, 38, 39 Sonia Halliday Photographs, Weston Turville, UK
4.2 Dimitri Benetos, Athens
4.4, 17 Fotoarchiv Hirmer Verlag, Munich
4.7, 9, 12 Craig & Marie Mauzy, Athens
4.8, 10 Alison Frantz Collection, ASCSA
4.13 Ancilla Antonini/Parrochia di S. Giovanni Battista Museo del Duomo, Monza
4.14 British Library, London. #Caligula A.xiv, f.18r
4.18 AKG Images, London
4.20 AKG Images, London/Stefan Drechsel
4.21, 33 © Paul Maeyaert
4.22, 25 Art Archive, London/Dagli Orti
4.24, 42 AKG Images, London/Erich Lessing
4.26 courtesy Yolanda M Lopez
4.27 Robert Harding Picture Library, London/Peter Scholey
4.29 Janet Marquardt
4.30, 40 © Angelo Hornak, London
4.32 Anthony F Kersting, London
4.34 Robert Harding Picture Library, London/Walter Rawlings
4.36 Corbis/Philip James Corwin
4.41 Robert Harding Picture Library, London/Mohammed Amin
4.43 Metropolitan Museum of Art, New York. Harris Brisbane Dick Fund. #39.20
4.44 AKG Images, London/Jean-Louis Nou

5.1 Scala Istituto Fotografico Editoriale, Florence
5.2 British Museum, London. #1898,1-15.44
5.3 Werner Forman Archive, London
5.9 Bridgeman Art Library, London/Museum of Fine Arts, Boston, Special Chinese and Japanese Fund
5.10 Freer Gallery of Art, Smithsonian Institution, Washington DC. Gift of Charles Lang Freer. #F1914.53
5.12, 14 Unei Kyoryokukai
5.15 Honolulu Academy of Arts, Hawaii. Gift of Mrs Carter Galt. #1666.1
5.17, 18, 19, 22, 24, 25, 27, 34 © Studio Fotografico Quattrone, Florence
5.20 Art Archive, London/A Dagli Orti

9.14 Artothek, Weilheim. © DACS 2003

9.15 © Art Institute of Chicago. Arthur Jerome Eddy Memorial Collection. #1931.511. © ADAGP, Paris and DACS, London 2003

9.16 Kunsthaus, Zurich

9.17 Scala Istituto Fotografico Editoriale, Florence. © DACS 2003

9.18 Sidney Janis Gallery, NY. © Succession Marcel Duchamp/ADAGP, Paris and DACS, London 2003

9.19 Bridgeman Art Library, London. © Succession Marcel Duchamp/ADAGP, Paris and DACS, London 2003

9.20 Scala Istituto Fotografico Editoriale, Florence. © ADAGP, Paris and DACS, London 2003

9.21 Scala Istituto Fotografico Editoriale, Florence. © Succession Miro, DACS 2003

9.22 Scala Istituto Fotografico Editoriale, Florence. © ADAGP, Paris and DACS, London 2003

9.23 Peggy Guggenheim Collection, Venice. The Solomon R Guggenheim Foundation, New York. Photo © 2003 Solomon R Guggenheim Foundation/David Heald. © Salvador Dali, Gala-Salvador Dali Foundation, DACS, London 2003

9.25 Telimage, Paris. © Man Ray Trust/ADAGP, Paris and DACS, London 2003

9.26 Thames & Hudson: Whitney Chadwick: Women Artists and the Surrealist Movement. © ADAGP, Paris and DACS, London 2003

9.27 Scala Istituto Fotografico Editoriale, Florence. © DACS 2003

9.28 AKG Images, London. © 2004 Banco de Mexico. Diego Rivera & Frida Kahlo Museums Trust, Cuauhtémoc, Mexico

9.30 Corbis/Bettmann

9.32 © Adolph and Esther Gottlieb Foundation, New York. #4660

9.33 San Francisco Museum of Modern Art. Albert M Bender Collection. Photo Don Myer. #45.1308. © Pollock-Krasner Foundation. ARS, NY and DACS, London 2003

9.34 Metropolitan Museum of Art, New York. George A Hearn Fund. #1957.92. Photograph © The Metropolitan Museum of Art. © Pollock-Krasner Foundation. ARS, NY and DACS, London 2003

9.35 Rex Features/Nina Leen/© Time Inc

9.36 University of Arizona Museum of Art. Gift of Edward J Gallagher Jr. © Kate Rothko Prizel and Christopher Rothko/DACS 1998

9.37 Rothko Chapel, Houston. Photo Hickey-Robertson © Kate Rothko Prizel and Christopher Rothko/DACS 1998

9.38 Scala Istituto Fotografico Editoriale, Florence. © ADAGP, Paris and DACS, London 2003

9.39 © ADAGP, Paris and DACS, London 2003

9.40 Kunsthalle, Tübingen, #S-A 29-1 © Richard Hamilton 2003. All rights reserved, DACS

10.1 Courtesy Albert Chong

10.2, 3, 4, 5 Miriam Schapiro

10.6, 7 The Dinner Party Trust. Through the Flower/Judy Chicago. Collection of the Brooklyn Museum of Art. Gift of the Elizabeth A Sackler Foundation. Photo Donald Woodman. © Judy Chicago

10.8 © Mary Beth Edelson

10.9a © Sylvia Sleigh

10.9b © Photo Josse, Paris

10.10 Art Gallery of Ontario, Toronto. Gift of Sandra Simpson, 1992. #93/24.1-.7. © NANCY SPERO and Galerie Lelong, New York

10.11 © Mary Kelly

10.12 Metro Pictures, New York

10.13 Courtesy Mary Boone Gallery, New York. Collection of Vijak Mahdavi & Bernardo Nadal-Ginard

10.14, 15 © Faith Ringgold.

10.16 Courtesy of the artist and Michael Rosenfeld Gallery, New York, NY. Collection of the Newark Museum, Newark, NJ. Purchase 1998 The Member's Fund

10.19 Courtesy Carrie Mae Weems

10.20 Courtesy Pat Ward Williams

10.21 © Courtesy Adrian Piper Research Archive & Paula Cooper Gallery

10.22 Museum of Contemporary Art, Chicago. Bernice and Kenneth Newberger Fund. #90.4 a-p. © Courtesy Adrian Piper Research Archive.

10.25 Courtesy Annu Palakunnathu Matthew

10.26 Courtesy Shelly Bahl. Collection of the Baum Gallery of Fine Art, University of Akransas, Conway

10.27 Courtesy Sokari Douglas Camp

10.28 Courtesy the artist and Stephen Friedman Gallery. Collection of Eileen & Peter Norton, Santa Monica. Commissioned by London Printworks

10.29 Courtesy Sue Williamson

10.30 Courtesy Andries Botha

10.32 Courtesy Carlos Estevez and Massachusetts College of Art. Photo Antonina Roslokken

10.34 Courtesy Daniel Martinez

10.35 Courtesy Dia Center for the Arts, New York. Photo Bill Jacobson. © Robert Gober Studio

10.36 Courtesy Steinbaum Krauss Gallery, New York. © 1995 Mesa-Bains. Photo George Hirose

10.37 Courtesy Corcoran Gallery, Washington DC. Photo Peter Harholdt. © Guillermo Gomez-Pena and Roberto Sifuentes/La Pocha Nostra

10.38 © Karen Finley. courtesy Electronic Arts Intermix (EAI), New York

10.39 Photo Sheldon Collins

10.40 Photo Richard Lou

10.41 © Xu Bing

10.42, 43 Courtesy Wenda Gu

10.44 Courtesy Tomie Arai

10.45 Courtesy Barbara Gladstone Gallery, New York. Collection of Broad Art Foundation, Santa Monica

Elements and Approaches to Art History pp.351–359

1 © Photo Josse, Paris/Musée du Louvre, Paris

2 National Palace Museum, Taipei

3 Courtesy of the Estate of Ana Mendieta & Galerie Lelong, New York

4 Phototheque André Held, Lausanne

5 © Vincenzo Pirozzi, Rome (fotopirozzi@inwind.it)

6 Robert Harding Picture Library, London/Jeff Greenberg

Index